Organized and edited by Stephanie Barron and Maurice Tuchman

This exhibition is funded in part by a grant from the National Endowment for the Humanities, by an indemnity from the Federal Council on the Arts and Humanities, and by a grant from the Shubert Foundation.

Los Angeles County Museum of Art

Hirshhorn Museum and Sculpture Garden
Smithsonian Institution, Washington, D.C.

Distributed by The MIT Press Cambridge, Massachusetts, and London, England

The **A**v**a**n**t** G**a**r**d**e in **R**ussia

1910–1930

New Perspectives

Published by the
Los Angeles County Museum of Art
5905 Wilshire Boulevard
Los Angeles, California 90036

Distributed by
The MIT Press
Cambridge, Massachusetts 02142

Third printing, 1986
Copyright © 1980 by
Museum Associates of the
Los Angeles County Museum of Art

Library of Congress
Cataloging in Publication Data

The Avant-Garde in Russia, 1910–1930: New Perspectives

 Bibliography: p.
 1. Avant-garde (Aesthetics)—Russia—Exhibitions.
2. Arts, Russian—Exhibitions. 3. Arts, Modern—20th
century—Russia—Exhibitions. I. Barron, Stephanie.
II. Tuchman, Maurice. III. Los Angeles Co., Calif.
Museum of Art, Los Angeles.

NX556.A1A93 700'.947'074019494 80-16404

ISBN 0-262-20040-6 [MIT]
ISBN 0-87587-095-3 pbk. [Museum of Art]

Edited by Jeanne D'Andrea
and Stephen West

Designed in Los Angeles
by Louis Danziger

Text set in Helvetica typefaces
by R S Typographics, Los Angeles

 Exhibition Itinerary

Los Angeles County Museum of Art
July 8–September 28, 1980

Hirshhorn Museum and Sculpture Garden
Smithsonian Institution, Washington, D.C.
November 20, 1980–February 15, 1981

Foreword

In the past twenty years American museums have presented landmark surveys of the major European developments in the history of twentieth-century art. Fauvism, Cubism, Futurism, and Surrealism have in their turn been surveyed, illuminating their historical and aesthetic accomplishments. Yet of all the significant modern art movements, the one that has been the least studied and exhibited is the remarkable achievement of the avant-garde active in Russia immediately before and following the Revolution of 1917.

Ten years ago Los Angeles presented the *Cubist Epoch* exhibition. Now, with the support of the Hirshhorn Museum and Sculpture Garden, the Los Angeles County Museum of Art has organized the first major museum survey devoted exclusively to the Russian avant-garde. The exhibition and accompanying catalog describe the goals and efflorescence of Russian modernism and its waning in the late 1920s when the avant-garde impulse was no longer tolerated by the Soviet government. The art of this movement, while long accorded great importance by scholars and artists, has been relatively inaccessible to the American public. Only the Museum of Modern Art in New York has significant holdings in this field. The purpose of this exhibition and catalog is to recognize, sixty years after its high-water mark, this astonishingly experimental and creative movement. No serious study of twentieth-century art has been written without the inclusion of Kazimir Malevich; an examination of his colleagues and rivals, students and teachers, is long overdue in order to assess the fertile years of the Russian avant-garde.

Any exhibition of this magnitude cannot be conceived or realized without the continued confidence and cooperation of many lenders. We would like to extend our grateful thanks to the 107 individuals, galleries, and public institutions from North and South America, Western Europe, and Australia who have graciously parted with their works to make this exhibition in Los Angeles and Washington, D.C., possible.

The Avant-Garde in Russia 1910–1930: New Perspectives has received a major grant from the National Endowment for the Humanities, and most foreign loans have been indemnified by the Federal Council on the Arts and Humanities. A production of the historic opera *Victory Over the Sun* to be presented in Los Angeles September 5–7, 1980, has been made possible by a grant from the Shubert Foundation, New York. ●

Earl A. Powell III
Director
Los Angeles County Museum of Art

Abram Lerner
Director
Hirshhorn Museum and Sculpture Garden

Acknowledgments

■ An exhibition of this magnitude requires several years of work and the cooperation of many individuals and institutions. This project began in 1976 when we proposed to our Board of Trustees the first American museum survey of the Russian avant-garde, that originative twentieth-century movement which hitherto had been virtually ignored. An astonishing amount of material has found its way to the West in the past half-century, and our travel and research determined that there was more than enough art in the West to mount a major exhibition and prepare an accompanying publication. From the start, we planned to assemble the exhibition by using exclusively Western resources, and our Board of Trustees gave us the essential support and encouragement to realize the project. The early and enthusiastic commitment from Abram Lerner, director of the Hirshhorn Museum and Sculpture Garden, to participate with us in the venture proved a crucial factor. In 1979 we were awarded a major grant from the National Endowment for the Humanities and an indemnity from the Federal Council on the Arts and Humanities. The Shubert Foundation in New York granted additional funds to recreate the historic opera *Victory Over the Sun* at the Los Angeles County Museum of Art. The Museum's Modern and Contemporary Art Council has been generous in its support of this project since its inception.

To assemble more than 450 examples of the Russian avant-garde in various media from over 100 lenders has been an arduous and exciting adventure, and it has involved close relationships with many individuals. Our search would not have been as successful without the gracious and wholehearted cooperation of Jean Chauvelin in Paris; Antonina Gmurzynska and her daughter Krystyna Rubinger in Cologne; Eric Estorick, Annely Juda, and Cavan O'Brien in London; and Ingrid and Leonard Hutton in New York. Each has given generously of his knowledge and experience in this field.

The lenders, who are listed separately in this catalog and who have agreed to part with their works for the exhibition first in Los Angeles and then in Washington, D.C., have our grateful thanks, for without them this exhibition would not be possible. We must, however, mention here those lenders of key works who at an early stage gave us a firm commitment of their participation: Edward E. de Wilde, director of the Stedelijk Museum, Amsterdam; Thomas M. Messer, director of the Solomon R. Guggenheim Museum, where the George Costakis Collection is currently housed; William Rubin, director of the department of painting and sculpture at the Museum of Modern Art, New York; William S. Lieberman,

formerly director of the department of drawing at the Museum of Modern Art and currently curator of twentieth-century art at the Metropolitan Museum of Art; Dieter Honisch, director of the Berlin Nationalgalerie; Rudi Fuchs, director of the Stedelijk van Abbemuseum, Eindhoven; Pontus Hulten, director of the Centre Georges Pompidou, Paris; and Evelyn Weiss, curator of the Museum Ludwig, Cologne. Among the many individuals who have lent extensively we must acknowledge the generosity of Mr. and Mrs. Herman Berninger, Mr. and Mrs. Roald Dahl, Mr. and Mrs. Ahmet Ertegün, Marc Martin-Malburet, Baron Heinrich Thyssen, and several collectors who have asked to remain anonymous.

In preparing this exhibition and catalog, we have had extraordinary cooperation from scholars and museum colleagues in America and Europe. In particular we would like to thank Dr. John E. Bowlt, who has worked with us on every facet of the catalog and has made many valuable suggestions in his capacity as our advisor. In December 1976 Dr. Jelena Hahl-Koch joined our team in Los Angeles as researcher, working closely with us especially on *Victory Over the Sun.* She has continued to contribute much time and energy in Germany; on our behalf she consulted with Eberhard Steneberg, who gave graciously of his knowledge of this period. Gail Harrison Roman has located the large presentation of Russian avant-garde books in this exhibition. Her thoroughness and availability during the past two years have been a model of collaboration. Dr. Alma H. Law has been particularly helpful in areas of theater and reconstructions. Dr. K. Paul Zygas has given us excellent guidance in the area of architecture and has supervised the reconstruction of several models on our behalf. Szymon Bojko of Warsaw, whose insights have been extremely important to us, has graciously made available his vast archives of the Russian avant-garde, which has yielded a great number of photographs published here.

Our presentation has been enriched by conversations with each contributor to the catalog and with several others, including Troels Andersen, Emilio Bertonati, Germano Celant, Michael and Susan Compton, David Elliot, Michail Grobman, Françoise and Donald Karshan, Miroslav Lamac, Jean-Hubert Martin, and Stanislas Zadora in Europe. In America, Meyer Schapiro, Vladimir Markov, Jay Leyda, Dorothea Carus, Marvin Sackner, Thomas P. Whitney, and S. Frederick Starr have willingly shared their ideas about this rich period. In addition we would like to acknowledge the contributions of Dr. Gilman Alkire, Avigdor Arikha, Robert Benedetti, Michael Blankfort, Joanna Drew, Alan Fern, Nina Gabo,

James Hayward, R. B. Kitaj, John Kluge, Hilton Kramer, Brian O'Doherty, William Olander, Richard Oldenberg, Robert Gore Rifkind, and Joel Thome. The generous collaboration of Ericka Hoffmann Koenige and Rolf Hoffmann in the production of the newly created costumes has been a source of gratification and joy to us.

We would like to thank those who have over the past four years worked with us in the Department of Modern Art on this project. Lucinda Barnes corresponded with numerous lenders and carefully compiled our initial checklist. Katherine Hart, now assistant curator, helped in many phases of this project and particularly in the production of the catalog. Anne Ayres, research assistant, patiently and carefully helped to complete the checklist and coordinate the essays; she has also developed many of the educational components that accompany the exhibition. Stella Paul, curatorial assistant, worked diligently, thoroughly, and always cheerfully on the endless details of the final stages of production. Anne Ayres and Stella Paul wrote the catalog entries that often represent the first publication in English on these artists. Kenyon Kramer, research assistant, has monitored catalog details and material from the Bojko archives and assisted in the installation design, always keeping our department in good humor through long hours. Our departmental secretary, Barbara McQuaide, has efficiently and cheerily handled the thousands of items of correspondence and has seen this publication through several retypings. Museum Service Council volunteer Grace Spencer has been resourceful in uncovering archival material.

In the Museum we would like to thank Myrna Smoot, coordinator of curatorial programs, who worked efficiently with us on all budgetary matters and was always encouraging. The editorial skills and judgment of Stephen West, editor, under the direction of Jeanne D'Andrea, curator of exhibitions and of publications, have enabled twenty manuscripts and pages of our own texts to be carefully read, edited, and prepared for print; their thoroughness and dedication are to be commended. Betty Foster has provided invaluable help as a volunteer proofreader. William Lillys, education consultant, has worked closely with us in developing a broad range of interpretive components for the exhibition. The photography staff of Adam Avila and Kent Kiyomura, first under the direction of Edward Cornachio and then John Gebhardt, has responded to our constant deadlines with remarkable efficiency. The registrar's department, under the capable leadership of Patricia Nauert, has negotiated the delicate arrangements to assemble and travel this show. Philippa Calnan, public information officer, and assistant Christopher Knight have responded creatively to the challenge of promoting this exhibition. Lawrence Morton, adjunct curator of music, has been a constantly valuable resource and has scheduled a remarkable concert in conjunction with this exhibition. The complex installation of the show was imaginatively and efficiently carried out under the leadership of James Kenion, head of technical services, with the cooperation of the operations and carpentry staff. Virtually every department in the Museum has become involved in the exhibition and contributed to its success. Our thanks to the numerous Museum Service Council volunteers who have provided capable typing and translation services.

Staff members of the Hirshhorn Museum and Sculpture Garden who played key roles in the presentation of this exhibition in Washington include Stephen E. Weil, deputy director; Nancy F. Kirkpatrick, administrator; Douglas Robinson, registrar; and Joseph Shannon, exhibits and design. Cynthia Jaffee McCabe, curator for exhibitions, served as coordinator of the Hirshhorn Museum showing and related events.

We have been fortunate to work with Louis Danziger, the designer of this catalog, and with architects Frank Gehry and Greg Walsh, the designers of the installation, who share a passion for the art of the Russian avant-garde.

The keen interest evinced in this project during the past four years by artists, collectors, and colleagues has been a source of exceptional gratification to us.

Stephanie Barron
Maurice Tuchman

Lenders to the Exhibition

Adler/Castillo Inc., New York
Albright-Knox Art Gallery, Buffalo, New York
Art Gallery of Ontario, Toronto
The Art Institute of Chicago
Ars Libri Ltd., Boston
Australian National Gallery, Canberra
Galerie Bargera, Cologne, West Germany
Celeste and Armand Bartos Collection
Mr. and Mrs. Herman Berninger, Zurich, Switzerland
John E. Bowlt
Bruce Fine Art Ltd., London
Mr. and Mrs. Edgar H. Brunner, Bern, Switzerland
Busch-Reisinger Museum, Harvard University,
 Cambridge, Massachusetts
Jay S. Cantor, Beverly Hills, California
Carus Gallery, New York
Galerie Jean Chauvelin, Paris
Arthur and Elaine Cohen
The George Costakis Collection
Mr. and Mrs. Roald Dahl
Dallas Museum of Fine Arts, Texas
Roger Diener, Basel, Switzerland
Parmenia Migel Ekstrom
Peter Eisenman
Mr. and Mrs. Ahmet Ertegün
Rosa Esman Gallery, New York
Mr. and Mrs. Eric E. Estorick
Ex Libris, New York
Ella Jaffe Freidus, New York
Miriam Gabo
Nina S. Gabo, London
Bruce and Kathy Gallagher-McCowan, New York
George Gibian, Ithaca, New York
Antonina Gmurzynska, Cologne, West Germany
Galerie Gmurzynska, Cologne, West Germany
Michail Grobman, Jerusalem, Israel
The Solomon R. Guggenheim Museum, New York
Wilhelm Hack Museum, Ludwigshafen, West Germany
Hamburger Kunsthalle, Hamburg, West Germany
Leonard Hutton Galleries, New York
Indiana University Art Museum, Bloomington
Institute of Modern Russian Culture, Blue Lagoon,
 Texas
Sidney Janis Gallery, New York
Mr. and Mrs. German Jimenez, Caracas, Venezuela
Annely Juda Fine Art, London
Donald Judd
Collection van Laack Company, West Germany
La Boetie, Inc., New York
Alma H. Law
Madeleine Chalette Lejwa, New York
Mr. and Mrs. H. C. Levy
Jay Leyda
Los Angeles County Museum of Art
Diane Love and George Friedman

Mr. and Mrs. Curtis Lowell, Mexico
Mrs. Louis Lozowick
Collection Martin-Malburet
Franz Meyer, Basel, Switzerland
Miami University Library, Oxford, Ohio
Galleria Milano, Milan, Italy
Dr. John Milner, Newcastle-upon-Tyne, England
Mississippi Museum of Art, Jackson, The Lobanov
 Collection
Donald Morris Gallery, Detroit, Michigan
Musée National d'Art Moderne, Centre Georges
 Pompidou, Paris
Museum Ludwig, Cologne, West Germany
Museum of Art, Rhode Island School of Design,
 Providence, Rhode Island
The Museum of Modern Art, New York
Museum of Modern Art, Oxford, England
Harry C. Nail, Jr.
National Gallery of Art, Washington, D.C.
National Gallery of Art Library, Washington, D.C.
Nazca Gallery
Louise R. Noun
Colin Osman (Creative Camera), London
Alexandre Polonski
Alexander Rabinovich
George Riabov, New York
The Robert Gore Rifkind Collection, Beverly Hills,
 California
The Robert Gore Rifkind Foundation, Beverly Hills,
 California
Guido Rossi, Milan, Italy
Robert and Maurine Rothschild Collection
Collection Rubinger, Cologne, West Germany
Ruth and Marvin Sackner
Mr. and Mrs. A. L. de Saint-Rat, Miami University,
 Oxford, Ohio
David Segal, Cambridge, Massachusetts
N. Seroussi, Galerie Quincampoix, Paris
Robert Shapazian Inc.
Staatliche Museen Preussischer Kulturbesitz,
 Nationalgalerie, Berlin
Stedelijk Municipal Stadtisches van Abbemuseum,
 Eindhoven, The Netherlands
Stedelijk Museum, Amsterdam, The Netherlands
Ronald and Suzanne Tepper
Theatermuseum, Cologne, West Germany
Thyssen-Bornemisza Collection, Lugano, Switzerland
Robert L. B. Tobin
University of Southern California Architecture and Fine
 Arts Library, Los Angeles
Samuel Wagstaff
Thomas P. Whitney, Connecticut
Yale University Art Gallery, New Haven, Connecticut
K. P. Zygas
Several anonymous lenders

Contributors

Anne Ayres
Research Assistant, Modern Art
Los Angeles County Museum of Art

Stephanie Barron
Associate Curator, Modern Art
Los Angeles County Museum of Art

Margaret Bridget Betz
Art Historian
The Graduate School and University Center
of the City University of New York

Alan C. Birnholz
Associate Professor, Department of Art History
State University of New York at Buffalo

Szymon Bojko
Art Critic
Warsaw, Poland

John E. Bowlt
Professor, Department of Slavic Languages
The University of Texas at Austin
Director, Institute of Modern Russian Culture
at Blue Lagoon, Texas

Boris Brodsky
Professor
Theater Institute, Moscow

Magdalena Dabrowski
Assistant Curator, Department of Drawings
Museum of Modern Art, New York

Charlotte Douglas
Assistant Professor, Department of History of Art
Ohio State University, Columbus

Michail Grobman
Russian emigré artist
Tel Aviv, Israel

Jelena Hahl-Koch
Curator
Stadtische Galerie im Lenbachhaus
Munich, West Germany

Roman Jakobson
Professor Emeritus, Department of Humanities
Massachusetts Institute of Technology, Cambridge

Alma H. Law
Resident Scholar, Russian Institute
Columbia University, New York

Jean-Claude Marcadé
Lecturer
University of Paris IV—Sorbonne, Paris

Valentine Marcadé
Art Historian
Paris

Stella Paul
Curatorial Assistant, Modern Art
Los Angeles County Museum of Art

Vasilii Rakitin
Art Historian
Moscow

Gail Harrison Roman
Art Historian
Columbia University, New York

Dimitri Sarabianov
Professor and Chairman,
Department of Russian Art History
Moscow University

Maurice Tuchman
Senior Curator, Modern Art
Los Angeles County Museum of Art

Kestutis Paul Zygas
Assistant Professor, School of Architecture
University of Southern California, Los Angeles

Contents

1910–1930
Russian Political Life
Russian Art, Literature, Drama
Western Events
Margaret Bridget Betz

1930–1980
European Exhibitions
United States Exhibitions
Publications
Special Events
Gail Harrison Roman

■ The avant-garde culture that flourished in Russia immediately before and after the Revolution of 1917 generated one of the great art movements of the twentieth century. The Russian avant-garde achieved breakthroughs in painting, sculpture, theater, film, photography, literature, design, and architecture. It involved a way of thinking that encouraged tremendous experimentation and that was linked strongly to socio-political issues. Unlike the more familiar Futurist, German Expressionist, and Surrealist movements, it has not received significant attention in books and exhibitions and thus is comparatively unknown. Even the absence of a convenient "ism" or "ist" indicates the relative lack of recognition accorded this movement.

No phase of art making was unaffected; yet the Russian avant-garde does not constitute a style. Unlike Impressionism, Fauvism, Cubism, or Surrealism, there are no specific characteristics to describe "Russian Avant-Gardism." The very nature of this movement is such that it encompasses a variety of styles—beginning with a very Russian folk-derived style, followed by interpretations of Cubism and Futurism, and evolving into two unique schools of thought—Suprematism and Constructivism—which were based on the rejection of other styles. The movement culminated in Productivism, which is not a stylistic term but a description of art used for utilitarian and popular purposes. One is accustomed to think of styles in formal terms; in the Russian avant-garde movement there is no unifying theme or element which joins all of its creative manifestations. It is a movement characterized by an extraordinarily high level of experimentation and cross-fertilization among all the arts. This far-reaching movement did, however, produce two primary styles of art, Suprematism and Constructivism, each with distinguishing traits and with "schools" or followers. The movement also encompassed two secondary styles: Neo-Primitivism and Cubo-Futurism. Perhaps only German Expressionism, developing in the two decades before 1928, parallels the Russian avant-garde. Both encompassed all the arts; in each, many of the participants were politically active, and both ended abruptly as totalitarian governments came to power.

Abstraction, the single most important characteristic of the art of this century, developed simultaneously in France, Germany, the Netherlands, Italy, Russia, and America. With the exception of the Russian contribution, these achievements have been documented thoroughly by exhibitions and publications. Only one monograph by Camilla Gray published in 1962 exists in English on the Russian contribution; only in the past ten years have museums begun to mount exhibitions devoted to the art of the Russian avant-garde. By 1936 Alfred Barr had presented his landmark survey of Cubism, twenty-six years after Picasso and Braque began painting in this new manner. For forty years the outstanding accomplishment of the Russian avant-garde has been inaccessible to the public, and for the most part unpublished. Only occasionally have we been able to see indications of

its richness. The many experiments in all areas ceased when the political climate was no longer hospitable. Extraordinary artistic breakthroughs seemed to vanish without a trace. Many of the artists died in the 1920s, some of them totally forgotten; others fled the Soviet Union or disappeared mysteriously in the Stalinist purges. As a result, the West has had to rediscover this great movement and examine its impact on the twentieth century. The Los Angeles exhibition and its catalog represent an attempt to reconstitute the history of the Russian avant-garde. One of their aims is to stimulate further research and study—leading to specialized exhibitions and books that will enable us to learn more about this unusually rich and complex movement.

In the years immediately following the Russian Revolution of 1917, reigning political powers elevated a cultural avant-garde to a level never since attained by modernism. For this brief time, the culture of the avant-garde was synonymous with official cultural policy: its leaders were empowered to establish government-sponsored art schools, museums, theaters, and an entire system that espoused some of the newest, tradition-breaking, utopian concepts. Never before, and never since, has the avant-garde been so allied with reigning political powers and been in such a strong position to effect its revolutionary concepts.[1] This union lasted no more than a few years; by the late 1920s, the Soviet regime began to denounce the avant-garde in favor of a more propagandistic aesthetic oriented to the masses, and the child "Socialist Realism" was born. Though new official policy was not codified until 1934, critics and art historians began to champion more traditional painting which was more accessible to the unsophisticated masses. The reign of the avant-garde had ended.

The greatest repository of the Russian avant-garde is in the Soviet Union. In museum basements and storerooms, in closets, under beds, rolled up out of sight, the art of this period is inaccessible to the public. It is not recognized by the Soviet government and is unavailable to the ordinary Soviet citizen. Even the Soviet art historian runs great risk in dealing with the Russian avant-garde. While different organs of the government do assume different postures in confronting this material, full recognition of the Russian avant-garde in the Soviet Union is far from a reality. Occasionally, works are made available for exhibition outside the country, but usually at the tremendous cost of aesthetic and political compromise. Attempts from the West to organize any exhibition of this rich treasure of material are thwarted by Soviet politics and bureaucracy which inevitably tamper with the context in which the works are to be exhibited. Such has been the fate, to a greater or lesser degree, of exhibitions in the past decade. In 1971 the *Art and Revolution* exhibition at the Hayward Gallery, London, opened with one room sealed by Soviet officials because they objected to the works which were "abstract and decadent." The Soviet Ministry of Culture made it clear at the time that it would remove everything it

I would like to thank Robert Gore Rifkind for many thoughtful suggestions concerning this essay. In addition, I am grateful to Gail Harrison Roman, Christopher Knight, and K. Paul Zygas for carefully reading and commenting on this text.

1. The ambitious program of the Mexican muralists beginning in the 1920s, which involved the close collaboration of the artists and the government, was certainly fueled by the example of the Russian avant-garde.

had lent unless the British agreed to close off the objectionable room. *Russian and Soviet Painting* in 1977 at the Metropolitan Museum of Art had only a few works of the avant-garde amid many examples of icons, realism, and Socialist Realism. The recent and largest exhibition *Paris-Moscou* at the Centre Georges Pompidou in Paris in 1979, with a catalog written primarily by Soviet art historians, included the greatest number to date of avant-garde works from the period 1910–30, but there too the organizers were forced to include many examples of non-avant-garde, traditional work. Consequently, the publications that have accompanied these "official" exhibitions have had to subscribe in part to an acceptable interpretation of the period. Interestingly, it has been the private galleries in Milan (Galleria del Levante), Paris (Galerie Jean Chauvelin), Cologne (Galerie Gmurzynska), London (Annely Juda Fine Art), and New York (Leonard Hutton) that have pioneered this movement in advance of museums, producing the best catalogs, complete with scholarly essays. Any serious study is indebted to these vanguard gallery exhibitions.

The Los Angeles exhibition is the first large-scale presentation of the Russian avant-garde ever attempted without Soviet loans. It is thus the first major exhibition of this material by an American museum to be mounted without the need to gain official Soviet sanction to borrow certain works of art. The amount and quality of the material that has found its way to the West in the past sixty years is extraordinary. However, the provenance or history of ownership of many of these works is difficult or impossible to record. This is complicated by the unfortunate fact that some works attributed to the Russian avant-garde but actually executed in the last few years have appeared on the current art market. Since even most of the genuine works do not have a provenance, some confusion surrounds the works of this period in the West. In preparing this exhibition we have consulted with more than a dozen leading experts in America and Western and Eastern Europe to arrive at our final choice, applying, as always, standards of American exhibitions and scholarship. In this exhibition, unlike the recent *Paris-Moscou* show, we focus solely on the achievement of the Russian avant-garde. Though lacking some of the masterpieces that remain in the Soviet Union, we have attempted to assess the period itself, not in terms of official Soviet policy—which considers it an aberrant prelude to the reign of Socialist Realism—but as a movement that engendered an entirely new way of thinking about and making art. The validity of the decision not to include Soviet loans is made apparent by the recent collapse of Soviet-American détente. Certainly, had the exhibition been dependent upon Soviet loans, the success of the project would be in serious question.

Unfortunately, due to the fragile materials often used in the three-dimensional works and the official censure of many of the artists, many of the works from this period have been lost or destroyed. Original sculptures by Rodchenko, the Stenberg brothers, and Gabo, reliefs by Tatlin and Puni, and paintings by Mansurov and Kliun have been lost. They are known to contemporary audiences only through reconstructions. These were executed either in the 1920s by the artists themselves, recently by them or their families, or recently by scholars or galleries. While the fidelity of these reconstructions varies in terms of material and scale, they are our only tangible indication of the work of some artists. Many of the recent reconstructions vary greatly in quality from the original and should be considered for their educational value and not as works of art; they are illustrations of principles and concepts of the revolutionary era.

The two decades (1910–30) spanned by this exhibition encompass the growth and maturation of the Russian avant-garde and its waning by the end of the 1920s. In 1934, three years before Nazi Germany officially declared the German Expressionists "degenerate," a formal proclamation was issued at the First All-Union Writers' Conference in Moscow. This declaration in effect codified the censure of the avant-garde that had begun in the mid-1920s. By the 1930s Socialist Realism was in full procession. Thus, the focus of this exhibition is the period immediately preceding and following the Revolution of 1917, years that were also revolutionary in painting, sculpture, music, literature, theater, architecture, design, film, photography, and typography. During these years there was an unprecedented interaction among artists working in different media: poets and musicians painted, painters designed for the theater, they collaborated on illustrated books, painters and sculptors designed utilitarian objects, and many proclaimed their ideas in manifestos. Men and women worked together in astonishing numbers; many artists were married to one another, or related by family; it was a movement with an extraordinarily high number of qualified women artists. In the vanguard were highly articulate and intelligent artists. Experimental and avant-garde by any standard, it is they who were given the reins by the post-Revolutionary government. Their discoveries in this period—the freshness of their ideas—should excite and inspire subsequent generations.

The essays in this catalog focus on particular artists and issues of the period; they also correspond to areas of emphasis within the exhibition. This introduction is not intended to give a comprehensive view of the period, but rather to provide the tools with which to grasp the scope and breadth of the catalog and exhibition. It is hoped that the reader will come to an appreciation of the brilliance of the artists at work during these years, and to accord them the place in modern history that they share with their more familiar European and American confreres.

■

The emergence of the avant-garde in Russia was marked by the beginning of Neo-Primitivism; at the same moment Cubism, German Expressionism, and Futurism were flourishing in Western Europe. In Munich, the *Blaue Reiter* artists (many of whom, including Kandinsky, were Russian) were beginning to exhibit. Russian artists participated in Secession exhibitions in Vienna, Berlin, and Munich, and artists there were aware of the developments in Russian art ▶

before they were known in Paris. Kandinsky's important text *Über das Gestige in der Kunst (Concerning the Spiritual in Art)* was published in German before it appeared in his native language. Beginning in 1906, however, two Russian art collectors, Ivan Morozov and Sergei Shchukin, began to bring back to Russia extraordinary examples of the most advanced work being done in Paris by Picasso, Matisse, Gauguin, Maurice Denis, and others. Artists like Natalia Goncharova and Mikhail Larionov had access to these collections, now in Soviet state museums, which contained some of the best holdings of these Western artists' works. Toward the end of the 1910s Russian artists began to travel to Paris to study and to exhibit their own work.

Between 1908 and 1912 artists such as Goncharova, her lifelong companion Larionov, and the Burliuk brothers began to paint vigorous Neo-Primitive portraits and still lifes in bright colors, inspired by Russian folk art such as the *lubok* (hand-colored peasant woodcuts) and by children's art (cat. nos. 12, 20, 106, 107, 171). Moving away from the traditional easel painting style identified with the French School and toward a more Russian-oriented art, their work soon affected that of Kazimir Malevich, Vladimir Tatlin, and Marc Chagall.

The artist-organized *Jack of Diamonds* exhibition in Moscow in 1910 brought together contemporary works by French, German, and Russian artists. Here the work of Gleizes, Metzinger, Le Fauconnier (from Paris), Kandinsky and Jawlensky (Russians in Munich) were exhibited together with Russians working in Russia (Larionov, Goncharova, Lentulov, and Konchalovsky). Characteristic of the avant-garde Russian artists' work was the use of bright colors, simplified forms, and a disregard for traditional values of perspective. After the exhibition, the Russian artists split into two camps: the Russian-oriented one led by Larionov and Goncharova and the French-oriented one led by Konchalovsky, Lentulov, and others (cat. nos. 64, 103, 107, 392).

In March 1912 Larionov organized in Moscow what can now be seen as the culminating exhibition of the Neo-Primitivist movement: *The Donkey's Tail* (cat. nos. 109, 114, 393). For the first time Larionov and Goncharova exhibited along with Malevich and Tatlin in the first large-scale, wholly Russian avant-garde art exhibition. To this show of 307 works, Goncharova and Larionov sent 94, Tatlin 43. Many of Tatlin's contributions were costume designs in which his disregard for traditional perspective was pronounced and aspects of his imagery and composition bore a distinct resemblance to Russian icon painting. Even as early as 1913, Tatlin's predilection for the relief instead of the plane is evident in his designs with their caricature-like curves and centrifugal spatial arrangements. The public reaction to *The Donkey's Tail* was one of immense ridicule and outrage, and many of the works were censured and confiscated.

By 1913 a new style was announced by Larionov with the exhibition *The Target* and the publication of the "Rayonist Manifesto."[2] In this document, Larionov outlined the principles of Rayonism: "The style of Rayonist painting promoted by us is concerned with spatial forms which are obtained through the crossing of reflected rays from various objects, and forms which were singled out by the artist" (cat. nos. 66, 110, 120, 394). In its principles, Rayonism owes much to contemporary styles in France—Cubism and Orphism— as well as to Italian Futurism. Although Rayonism was a short-lived style (ending in 1914, shortly before Larionov and Goncharova moved to Paris), its importance to the history of this period is great.

Immediately preceding the outbreak of the War there emerged the last Russian interpretation of a new Western movement—Cubo-Futurism. Larionov, Goncharova, and Malevich are strongly identified with this style which involved the close relationship of painting and literature. These works show a reliance on earlier primitive works with the addition of more architectonic, tubular figures set in stylized positions against a background of geometric, cylindrical shapes. Cubo-Futurist book design, too, conveys the close interaction of artists and writers in the emerging avant-garde (cat. nos. 16, 17, 80, 99, 100, 111, 175, 176).

The interaction among artists and poets at this time led to a number of inventive and experimental creations. The atmosphere of prewar Russia is recalled for us by ROMAN JAKOBSON, the eminent linguist, in an interview with DAVID SHAPIRO, which is the second essay in this catalog (p. 18). Jakobson, who was a poet writing under the name Aliagrov, collaborated with the artist Olga Rozanova. His reminiscences of this period and his friendship with Malevich, Maiakovsky, and others is the first published account of his experience in those years.

One work effectively symbolizes the interaction among artists and the extraordinary experimentation in St. Petersburg and Moscow at this time: the collaboration in 1913 of painter Malevich, poet Kruchenyk, and painter-musician Matiushin on the Futurist opera *Victory Over the Sun*.[3] This production may be seen as one of the boundaries dividing the old art from the new. It is the "story" of a group of strongmen who try to conquer the sun, thereby upsetting all traditional values. The opera is almost totally abstract: the text is composed of alogical and nonsensical phrases. The music is atonal, using an out-of-tune piano and a chorus singing off key. The sets and costumes by Malevich rely on geometric shapes and nonrepresentational planes and volumes (cat. no. 172). One of the backdrops includes a square which is divided diagonally into two areas, one white, one black. While not yet named "Suprematism," these drawings represent a definite turning point in the Russian avant-garde. Malevich's seminal importance and his development from the Cubo-Futurist into the leader of the Suprematist style and the creation of *White on White* and *The Black Quadrilateral* is traced by JEAN-CLAUDE MARCADÉ (pp. 20–24).

The development of the Russian avant-garde movement is not linear; it cannot be seen as a succession of styles or ideas flowing directly into one another. Rather, the multi-

2. According to T. Longuine in *Goncharova et Larionov*, Paris, 1917, p. 28, note 39, Goncharova was the first to use this term.

3. Performed three times in Luna Park in St. Petersburg in December 1913, this opera will be recreated September 5–7, 1980, at the Los Angeles County Museum of Art by California Institute of the Arts. The Museum is grateful for the support of the Shubert Foundation for its grant to realize this production.

dimensionality of the participants and the chaos of the political environment contribute to a richly interwoven fabric that is designated "the Russian avant-garde."

The years from 1914 until immediately after the Revolution of 1917 are the zenith of the avant-garde movement in Russia. Many avant-garde Russian artists who had been living abroad were forced to return home: Chagall, Puni, Altman, and Bogoslavskaia from Paris; Lissitzky from Darmstadt; Kandinsky from Munich. It was a time of strength and unification for most of the artists, for during these six years Russia was in effect isolated from Europe. In this extraordinary vacuum, some of the most significant art, literature, theater, and poetry was conceived and produced. Perhaps no other moment in history has known such creative growth in the face of the kind of political, social, and economic upheaval brought about by the First World War and the Revolution. The leading artists of this period shared a belief in the coming political revolution. Their aim was to produce a new art for the people, not for the elite: an art that would contribute to society and parallel new concepts in economics and politics. They believed that all art should be rethought and rearranged—nothing a priori would exist. In art as in politics they supported a total break with the past. That they did not succeed and later modified their views does not detract from the significance of their achievement.

An exhibition in Petrograd organized by Puni in 1915, *First Futurist Exhibition of Pictures: Tramway V*, was the occasion for many of these recently returned artists to exhibit with those who had remained at home. In this exhibition the contrasting personalities of Tatlin and Malevich emerged as the two forces of the avant-garde: leaders of Constructivist and Suprematist styles respectively. Tatlin showed the more radical pieces, reliefs in which he introduced pieces of iron, glass, and wood projecting from the plane into space itself (cat. nos. 363, 364, 365, 367). As a style, Constructivism is characterized by a concern with volume rather than the plane, and with the use of non-art materials in their existing forms and colors. Tatlin was investigating the rejection of traditional art, and was moving toward an anti-art conception of aesthetics. His investigations into a "culture of materials" and the subsequent interest in this area by Rodchenko, Popova, Puni, and Malevich are discussed in MAGDALENA DABROWSKI's essay, "The Plastic Revolution: New Concepts of Form, Content, Space, and Materials in the Russian Avant-Garde" (pp. 28–33). This was sculpture made in a new way. Only Picasso, a few years before, had explored the idea of three-dimensional works composed of distinct elements. This was not traditional sculpture, which was modeled, carved, or cast, but rather constructed sculpture. The artists of the Revolutionary period were all seeking a new vocabulary. It was to be a peculiarly Russian art, reflecting modern Russian society, the Russian public, Russian conditions, and a Russian sensibility. By doing this, and seeming to reject all Western influences, they proceeded to create original definitions for color, materials, light, space, and texture (cat. nos. 274, 279, 280, 281, 284, 368, 395).

In December of 1915 Malevich and Tatlin publicly unveiled their new work at an exhibition in Petrograd organized by Ivan Puni entitled *The Last Futurist Exhibition of Pictures: 0–10*. In her catalog essay CHARLOTTE DOUGLAS discusses this historic exhibition and the emerging relation between Malevich and Tatlin (pp. 34–40). There Malevich introduced the style known as Suprematism, the ultimate reduction of painting to essential forms, to pure geometric shapes without color (cat. nos. 182–90, 192–200). It was a path toward the quintessence of "art for art's sake." A mystical thinker and eloquent writer, Malevich developed the first theory of pure painting, a theory which is really only beginning to be understood. Russian emigré artist MICHAIL GROBMAN writes in this catalog about the spiritual side of Malevich's persona (pp. 25–27) and the differences between Suprematism and Constructivism. Other artists in the 0–10 exhibition, including Popova, Udaltsova, Puni, and Kliun, showed their work as part of either the "Malevich Suprematist faction" or the "Tatlin Constructivist faction" (cat. nos. 241, 242, 274, 279). Soviet art historian DIMITRI SARABIANOV discusses the work of Popova (cat. nos. 238–72) in this catalog (pp. 42–45). The 0–10 exhibition itself can be seen as a break with past traditions—such as French-inspired Cubism, Russian Cubo-Futurism, or Neo-Primitivism. The Suprematist and Constructivist work at this exhibition set the stage for the decade to follow.

Of the younger artists who gathered around Malevich and Tatlin, Alexandr Rodchenko is one of the most prominent and versatile. His work—first in painting and then in three-dimensional objects, and in photography and typography—expanded the concepts promoted by these two pivotal figures (cat. nos. 292–321). Following his first contact with Malevich and Tatlin, Rodchenko vacillated between pure Suprematist painting and three-dimensional constructions, creating work that synthesized the two points of view. His pioneering experiments in photography are the subject of JOHN BOWLT's essay in this catalog (pp. 52–58). Gustav Klucis, a close associate of Malevich in 1918–19, is discussed by Soviet art historian VASILII RAKITIN in this catalog (pp. 60–63). Not satisfied with the unreality of pure Suprematism, Klucis was instrumental in confronting both the plane and the relief (cat. no. 98).

Not only did the Russian Revolutionary period see great advances in the plastic arts, but it was equally extraordinary for the experiments being carried out by many of these same artists in typography and theater. In theater, artists, playwrights, poets, musicians, and designers began working together in the 1910s and early 1920s in unusual, often radical productions. ALMA H. LAW discusses "The Revolution in the Russian Theater," in which Meierkhold played such an important role (pp. 64–71). The years 1917 to 1922 were among the most exciting and innovative in Russian theater history. For many of the artists, the theater was a place to work out new aesthetic concepts; it was a logical extension of their desire to make art for the masses, to move away from hermetic studios and the refined atmosphere of traditional art to produce an art in keeping with modern times and in the interest of the common man. Stage design was no longer merely decorative, but the synthesis of the new forms and materials employed by the artists. Artists designed sets, ▶

costumes, and lighting, wrote scripts, and occasionally even acted in these performances. In these productions tension with the audience was considered vital (cat. nos. 54–56, 322–23, 340, 348–58, 381–83, 440–47).

For the avant-garde artist, the theater became an important link between their art and life in a society undergoing mass revolution. While they were passionately concerned with evolving new aesthetic theories and ways of thinking about art, they were fervently committed to building a modern Soviet society. They believed that art — and they as artists — had an important mission. Defining that mission proved difficult. The theater provided a way to transcend pure painting — or art for art's sake. In working with actors, directors, and writers on a production for the public, they could apply their new theories on art to a wider audience. It was not an enormous leap for an artist like Popova to progress from designing theater costumes to designing cloth for popular consumption. And Tatlin was able to use modern materials like metal in his constructions as well as in the political monuments and utilitarian objects that he designed shortly thereafter. Previously the artists' works had been small; with the advent of the theater, scale no longer confined them.

The artists' activities in the theater led naturally to a new kind of art—mass performances that began as celebrations of the anniversary of the Revolution of the First of May. Polish art historian SZYMON BOJKO discusses this in his essay "Agit-Prop: The Streets Were Their Theater" (pp. 72–77). Not only did the artists plan and direct these mass spectacles —often literally involving casts of thousands—but they also designed decorations for the streets and buildings. These examples of mass theater were a way to bring art and life even closer; the citizenry of Russia became the artists' collaborators. To communicate new political ideas to the illiterate masses who lived outside the cities, the artists decorated trains, boats, and even carts with slogans and information which circulated in the countryside, bringing news of the Revolution. This "agit-prop" or agitational propaganda was again a natural outgrowth of the artistic fervor of the time. (Photographs of agit-prop appear throughout the catalog.)

Perhaps the single most ambitious work that captures the spirit and the zeal of these artists is Tatlin's *Monument to the Third International* of 1919. This tower, which was never actually built, was conceived to be twice the height of the Empire State Building, made of iron and glass, and capable of rotation. The building was to be an information center: various levels would house lecture halls and news bulletin centers, with telegraph, radio, loudspeakers, and screens for projection. Though it was developed only as far as the model stage, it has remained a symbol of the utopian world the artists wanted to create (cat. nos. 370, 371).

The official sanction given the avant-garde during the Revolution and immediately thereafter empowered a group of young, experimental, revolutionary artists to carry out their manifestos, goals, and desires, perhaps for the first time in history. They were authorized to establish museums, acquire works of art, and set up art schools, all based on their very recent experiments in art. Ironically, the Soviet Union was the first country to exhibit abstract art officially on a wide scale.

The organization of art schools was also affected by the revolutionary artistic spirit. In Moscow, in Vitebsk, and in Petrograd, old schools were closed and then reopened with new faculty and programs. At first, open admission policies were established, and students could determine their own courses of study. The history of the Russian avant-garde is inseparable from the history of the most influential art school of the period: Vkhutemas. Like the Bauhaus in Germany, the Vkhutemas had an exceptionally innovative faculty and sought to apply new concepts of art to all areas of life. One of the specific goals of the Vkhutemas was the preparation of artists to enter industry and to contribute in other ways to the new post-Revolutionary society. Vkhutemas, which came under the general direction of the Institute of Artistic Culture (Inkhuk), is discussed by SZYMON BOJKO in this catalog (pp. 78–83). The visionary thinking that eventually resulted in this school was a program for Inkhuk initially conceived by Kandinsky. It was a program that incorporated Suprematist and Constructivist ideas, as well as his own theories of non-objectivity. Unfortunately, the program was strongly opposed by the Constructivists and was rejected; shortly thereafter, a discouraged Kandinsky left Russia for Germany, where he joined Walter Gropius in establishing the Weimar Bauhaus. The relationship between Kandinsky and the avant-garde and the interaction between Germany and Russia is discussed by JELENA HAHL-KOCH; included in her text are many previously unpublished letters (pp. 84–90).

As new art schools were emerging in Moscow and Petrograd, there was also important activity in outlying areas. The Ukraine was especially rich in artists of this generation; this phenomenon is discussed by VALENTINE MARCADÉ in this catalog (pp. 46–50). The city of Vitebsk was also a center of avant-garde activity after the Revolution. In 1918 Chagall, who had returned from Germany at the start of the War, was appointed director of the Academy in Vitebsk. His successor was young Vera Ermolaeva, who invited the revolutionary Malevich to join the faculty (cat. nos. 22, 23, 47). Malevich inspired the students with his ideas and enthusiasm; one by one they became his disciples. At the school during this period was El Lissitzky, a friend of Chagall. Lissitzky was attracted by Malevich's Suprematist theories, but his own training as an engineer, architect, and graphic artist caused him to evolve his own style, a unique combination of Constructivism and Suprematism. In 1919 he painted his first "Proun," which he described as "a changing-trains between architecture and painting" (cat. nos. 122–38). BORIS BRODSKY and ALAN BIRNHOLZ discuss Lissitzky's development and influence in this catalog (pp. 92–97 and 98–101).

Lissitzky is best known as the leading book designer of modern times. Certainly modern typographical design traces to this period, and Lissitzky's examples are among the finest. In this catalog GAIL HARRISON ROMAN discusses the revolution in Russian avant-garde typography and book design (pp. 102–9). In concept, content, and design, these remain high-water marks in the history of the modern book. It was the intermingling of the word and image that contributed to this, for these were not traditional illustrated books. Many involved sound poetry, *zaum,* alogical words, Suprematist

compositions, photography, and photomontage (cat. nos. 13, 67, 142, 156, 171, 176, 307, 321). As stage design was no longer mere decoration, but rather an integral element in a theatrical production, so too was book design. Roman focuses on several key examples of book design, all of which are in the exhibition.

In 1921 Rodchenko, together with Exter, Popova, Stepanova, and Vesnin, organized an exhibition in Moscow called 5 x 5 = 25. Each of the five artists contributed five works of art; the catalog contained original works by each artist. Several of these extremely rare documents are presented in this exhibition (cat. nos. 259, 301, 347, 398). The 5 x 5 = 25 exhibition was a turning point for the participating artists, for with it they denounced art for art's sake and rejected studio art in favor of industrial design. This was thought to be more in harmony with current political thought. For the Suprematists and Constructivists alike, a commitment to industrial design — to porcelain, furniture, fabric, architecture, and theater—was natural in the 1920s. Many of the most avant-garde artists, including Malevich, Lissitzky, Tatlin, and Rodchenko, as well as Popova, Exter, Stepanova, Chashnik, Suetin, and Udaltsova, turned to design. Perhaps the coincidence of a mass-oriented political structure along with the evolution of highly abstract and utopian ideas about art left the artists no course other than that of Productivism. A logical extension of their theories was the application of those principles in a broader context—one that would embrace the desideratum that art be created for a utilitarian purpose.

Russian avant-garde art from the 1920s consists of fewer paintings and sculpture and many more utilitarian objects, unfinished projects or designs for objects, architectural plans and models, innovations in book design, and collaborations in film (cat. nos. 26, 31, 32, 266–72, 361, 362). Just as the period 1917 to 1922 was so fertile in theater collaboration, the 1920s and 1930s was an extraordinary moment for experimental and avant-garde film techniques and for collaboration between filmmakers such as Eisenstein, Kulashov, and Vertov and artists such as Rodchenko, Stenberg, Vesnin, and Tatlin. Film as the ultimate popular art—the legacy of theatrical performances, the agit-prop, and mass spectacles—dealt with political, social, and aesthetic issues of the day.

Once the great exported exhibition of Russian art was held in 1922 in Berlin at the Galerie van Diemen, official Soviet sanction began to be withdrawn from the avant-garde (cat. no. 149). The death of Lenin in 1924 marked the beginning of a power struggle between Trotsky and Stalin, who in 1927–28 would be victorious. The resolution adopted in 1925 by the Communist Party Central Committee, "On the Party's Policy in the Field of Artistic Literature," called for an art "comprehensible to the millions." By the late 1920s art historians and critics began to conform to the government's general policy which discouraged experimental art, and increasing attention was paid to the return of traditional painting. In 1932 a decree was issued "On the Reconstruction of Literary and Art Organizations," which disbanded all cultural groups. Artists were forced to join the Union of Artists, and in 1934 the First All-Union Congress of Soviet Writers ratified the new style of Socialist Realism to which all artists were required to adhere.

While architecture was the last art form to come under the restrictions of the new Soviet policies, it also suffered the most. Architectural projects in the 1920s often remained only on the drawing board or in model form because of financial and material constraints, as well as emerging political conditions (cat. nos. 380, 384, 385, 389, 390). A few outstanding buildings were actually completed, but they are generally the exception. In this catalog PAUL ZYGAS discusses the Constructivist nature of much Russian avant-garde architecture, with strong reference to the Vesnin brothers' Palace of Labor (pp. 110–17).

The 1920s in the new Soviet Russia thus began as a time of unparalleled support for avant-garde beliefs and activities. These years provided artists with the opportunity to transform their theories, worked out in the 1910s, into a practical art that coincided with the wish for a society of the masses. No longer was art for art's sake an honorable intention; more important was the effectiveness of the artist in communicating to the new society. Yet there is no doubt that in the 1920s there was also a great weakening of that protean creature the Russian avant-garde, much of it stemming from the political stranglehold that was slowly but surely applied to it by the government. Schools and museums were closed, entire artists' studios were destroyed, artists themselves disappeared or were forced to work in the Socialist Realism style. The tradition of the avant-garde has been upheld in the West — it is here that many of the artists fled, here that so many of their works have found an enthusiastic response, and here that scholarship and exhibitions have recently proliferated. The growth of interest in this era is charted in GAIL HARRISON ROMAN's chronology (pp. 272–85). The interest that this movement continues to have for contemporary Western artists is discussed by MAURICE TUCHMAN (pp. 118–21). Yet this brilliant, powerful, and extraordinary moment in the history of the culture ended ignominiously. It is the ironic legacy of this great movement that it had to be rediscovered in the West. ●

Art and Poetry: The Cubo-Futurists

Roman Jakobson

An Interview with David Shapiro

Eminent linguist Roman Jakobson (b. 1886) has been involved with the Russian avant-garde since its inception; in 1916 under the pseudonym Aliagrov he contributed poems to *Zaumnaia Gniga*, a milestone book of Russian Futurism produced in collaboration with A. Kruchenykh and O. Rozanova. Here excerpts of an interview with poet and critic David Shapiro are published. The entire manuscript—much of it dealing with the literary avant-garde—is on file at the Los Angeles County Museum of Art.

David Shapiro: You have written about the work of Khlebnikov with great passion. Do you think that there is a relationship between the phonological element — hypostasized in Khlebnikov's poems — and the abstract art of Malevich and others?

Roman Jakobson: Of course, of course. Artists such as Malevich discussed the relation between *zaum* (music, transconscious languages, the utilization of constructions of sounds without words) and abstract painting. Oh, we discussed this a great deal!

DS: You have said in one of your essays, "On the Auditory and the Visual," that imitation is the easiest pathway for the visual, and that music tends away from imitation. Is it also easier for poetry to take the anti-mimetic path, the phonological path, than for painting?

RJ: I don't know. Perhaps on the one hand it's easier in painting because you have the tradition of ornament, which is not representational. Of course what is made now is not ornament, but at any rate it is a new experiment in the field of non-representative visual art; whereas with language you are accustomed to have only sounds combined into groups which have meanings. And to liberate the sound pattern from meaning was perhaps more exclusive. On the other hand, I must say all of us were perfectly conscious. We knew very well that there were children's folktales that contained sounds without meaning; we were aware of incantations and glossolalia. And this played a great role. My first conversation with Khlebnikov occurred when I brought him texts that I collected for him of children's folklore and incantations that were completely *zaum,* without any words. So it was hard to say which was more difficult and which was easier, but in most cases the difficulties were of different kinds.

DS: In the Linguistics Circle and among the young poets and painters, was there a utopianism, almost Fourierism, in which poetry and painting functioned as social critique?

RJ: No, there was only the question of their close interconnections; there was the possibility of making publications of poems with montage, with collage, of including different, non-representational attempts at graphics or painting. Yet I would not say that this produced some questions of high sociological import.

DS: In terms of the connections between painting and literature, do you feel that there was almost always a visual component in Maiakovsky's poetry, since he had been an art student?

RJ: Yes, this is clear not only about Maiakovsky but also about the early Russian Futurists. That was the closest link between visual art and poetry.

DS: Would you say that among the young scientists in the Moscow Linguistics Circle the sense of painting was also strong?

RJ: Absolutely. All of us were very much more connected with visual arts than with music.

DS: Do you have memories of the production of *Victory Over the Sun?*

RJ: When I learned it would be performed, I wanted very much to walk the distance between Moscow and Petersburg. I was young, it was a great distance. I was a Muscovite in school and I could not go. I was extremely interested in it, and

I read it immediately after it was published. The music was played for me by Matiushin, the composer. But unfortunately I didn't see it. It was an important phenomenon.

DS: Do you have any particular memories of painters with whom you had contact?

RJ: Of those painters who are well known, one of the first with whom I came into contact was Malevich. He wanted me to go with him to Paris, because he didn't speak French and I had spoken it from childhood, and also because I was very theoretically oriented at that time. He wanted me to do an exhibition of his work there and to explain and interpret his paintings. That was Malevich. Then I also had a close relation with a painter — one of the greatest painters, completely different from all others — Filonov. Recently there was an exhibition of his work, although one cannot see the great majority of his more radical paintings. You know this is a great scandal caused by true bureaucrats, who close off the most interesting Russian and Western paintings under poor environmental conditions in cellars. This is a scandal, because it would show the greatness of the art of the Russian avant-garde.

DS: When Marinetti visited Russia he termed the Russians "false Futurists." Is it possible that the real future inside Futurism is a sense of conflict and change?

RJ: I met Marinetti in Moscow one evening in February, I think it was, of 1914. They needed me because very few of the Futurists knew other languages, and he spoke only Italian and French. So I was the translator and the interpreter, between them and Marinetti. And he said, "Look, I am not against Russia. I admire Russia, and especially I admire Russian women; but Russian poetry, it's not Futuristic." And I said, "I understand you perfectly; you admire Russian women because you understand them, but you don't admire Russian poetry because you don't understand it."

DS: Contemporary American work sometimes looks very much like Russian work; sometimes it is said that the Russian avant-garde is an influence, sometimes that it's a precursor and a parallel. Some people say that you cannot compare the two at all, that there are merely formal comparisons and we should be skeptical of these. In general, what would your bias be in viewing these different phenomena in abstract art — say, the work of Malevich with that of contemporary abstract artists whose forms may look like Malevich's — particularly since we dwell in a new socio-historical situation? Would you tend to be very skeptical about this parallel?

RJ: No, on the contrary. I would say I'm for comparison. I would compare the things that are completely distinct one from another, compare them, and be cautious. I can speak indirectly: there was a specialist in art who saw some beautiful jewelry, but not in context; he saw it in a Berlin museum and said, "How strange it is that all these beautiful things are white!" He forgot that Negroes are black. The point is to compare and remember the background.

DS: And qualitative comparisons?

RJ: Measurements are good, as we say, for potatoes. As Pushkin said, "What is greater? The aroma of the lilac or the rose? . . . The aroma of herring."

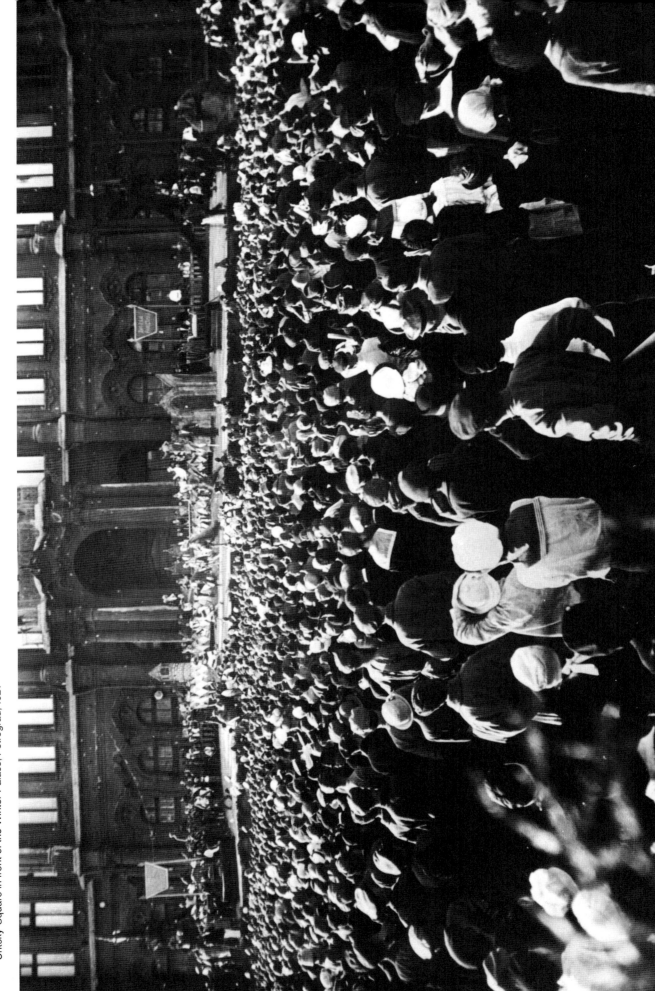

Ballet-pantomime *Fuente Ovejuna* being performed on
Uritsky Square in front of the Winter Palace, Petrograd, 1921

K. S. Malevich: From *Black Quadrilateral* (1913) to *White on White* (1917); from the Eclipse of Objects to the Liberation of Space

Jean-Claude Marcadé

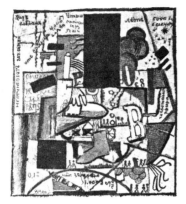

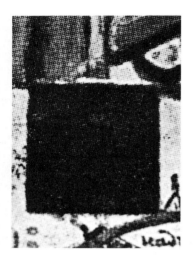

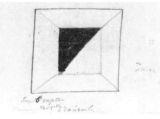

1.
Kazimir Malevich (1878–1935)
Sketch of Curtain for the Opera "Victory Over the Sun", c. 1913
Location unknown (reproduced in *The One and a Half-Eyed Archer* by the poet Benedict Livshits, Leningrad, 1933)

2.
Detail of fig. 1

3.
Kazimir Malevich
Sketch for Backdrop of Scene V, "Victory Over the Sun," 1913
Theater Museum, Leningrad

■ The invention of Suprematism remains one of the most powerful enigmas of twentieth-century art. It involves an artistic invention that has no common denominator with what is called "abstract art." The neologism "abstraction"—as it is used in art history to refer to the new pictorial mode of the twentieth century in which nothing recognizable appears on the canvas — is a highly ambiguous term, as the recent analyses of Emmanuel Martineau have shown.[1] The confusion comes from not distinguishing between the two levels of meaning of the term "abstraction": (1) horizontally, through works termed abstract (thus an historical, stylistic, semiological, and iconological qualification) and (2) vertically, as a revelation of the pictorial as such, beyond forms and colors or through them (one sees, then, that "all art is abstract in itself," according to Matisse,[2] and that twentieth-century abstraction is but a particular case, an extreme case of creation in general).

It is possible to follow the development of the art of Kandinsky, who is held to be the founder of abstraction, through Impressionism, Jugendstil, Fauvism, and Symbolism toward the progressive disappearance of the object in the interests of representing the "interior sound" of things, or rather of a figuration, a "visualization," of the interior vision of things. Kandinsky's pictorial activity progresses from representation of the phenomenological world to an abstract interpretation, in the etymological sense,[3] of this world. Kandinsky's abstraction is found at two levels. As *Kunstwollen* (will to form), it remains Symbolist in the sense that the *Weltanschauung* (world view) of the painter is based on a dualism between an interior and an exterior,[4] a materiality and a non-materiality.[5] "Form is the material expression of abstract content," Kandinsky wrote.[6] "Inner necessity" *(vnutrennaia neobkhodimost)* is the only immutable law of art in its essence.[7] Feeling is the spiritual vehicle of this interior necessity, thanks to which there is a perfect equivalence between external form and its interior sound. On the other hand, as a system of representation, as a realization of "inner necessity" by means of a canvas, Kandinsky's abstraction attempts to "transfigure" objects, to "transcend the material forms,"[8] and to do this requires "a composition purely, infinitely, and exclusively based on the discovery of law, of the combination of movement, of consonance and dissonance of forms, a composition of drawing and color."[9] Without any doubt, Kandinsky was one of the first to formulate this principle of the autonomy of artistic creation, of giving form to artistic material.[10] But if the referent is no longer mimetic, in the sense that Aristotelian mimesis is to be understood,[11] that is, as imitating nature, all the same there is a referent in Kandinsky: the interior world. The object is no longer material

but spiritual, yet the object still remains the painter's end.

There is a complete difference between Kandinsky's aesthetic and that of Cubism. The former is clear on the level of vocabulary. Kandinsky constantly uses musical terms, for his abstraction of the 1910s is based on the model of musical abstraction.[12] The Cubists, on the contrary, speak of construction, developing the famous precept of Cézanne in his letter to Emile Bernard of April 15, 1904: "Render nature in terms of the cylinder, the sphere, the cone."[13] The material object does not disappear in Cubism; it is decomposed, "pulverized" (as N. Berdiaev puts it in his article on Picasso),[14] and recomposed, reconstructed, according to a pictorial logic of exclusively volumes, relationships, tonal values, and contrasts. For their part, the Futurists stressed the principle of dynamism. On April 11, 1910, the "Manifesto of the Futurist Painters" signed by Boccioni, Carra, Russolo, Balla, and Severini proclaimed "that universal dynamism must be rendered in painting as a dynamic sensation."[15] Here is a new interpretation of the object, as would be the case in Russia in Larionov's Rayonism, where the object is reduced to the sum of the rays that emanate from it.

This brief review of the principal pictorial currents between 1910 and 1913 gives the background for the emergence of Suprematism — the most radical pictorial endeavor of the twentieth century. Between 1912 and 1914 Malevich combined the principles of Cubism (stereometric treatment of forms, construction of a space) and of Futurism (decomposition of movement) in a series of pictures. He grouped a part of the series under the name "transrational realism" *(zaumny realism):* for example, *The Morning After the Snowstorm in the Village* in the Guggenheim, *The Perfected Portrait of Ivan Vassilievich Klyunokov* in the Russian Museum in Leningrad, and *The Knife-Grinder* in the Yale University Art Gallery. Another part he named "Cubo-Futurist realism": for example, *The Samovar* in the McCrory Collection.[16] Onto the "Cubo-Futurist" system was grafted the "alogist" system; examples of this are *The Cow and the Violin* in the Russian Museum in Leningrad and *The Englishman in Moscow* in the Stedelijk Museum, Amsterdam. Here, painting definitively loses its status as representative of the perceptible world, thanks to a gesture introducing the absurd. In the first picture, a cow destroys the violin — a Cubist representation object; in the second, a real spoon is glued atop the figure of *The Englishman,*[17] mockingly opposing the material, palpable object and the painted object. The overflow of a world other than that of logic or appearance is seen in the main figure in *The Englishman in Moscow;* cut in two vertically, on one side are the elements of his

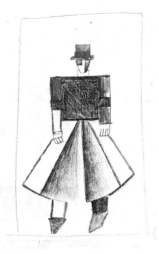

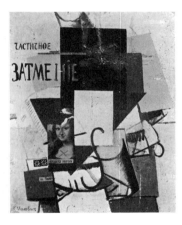

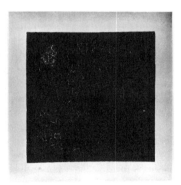

4.
Kazimir Malevich
Costume Sketch of the Gravedigger for "Victory Over the Sun," 1913
Theater Museum, Leningrad

5.
Kazimir Malevich
Composition with Mona Lisa, 1914
Oil on canvas and collage
62 x 49.5 cm. (24⅜ x 19½ in.)
Private Collection, Leningrad

6.
Kazimir Malevich
Black Quadrilateral, 1913?
Oil on canvas
116 x 116 cm. (45⅝ x 45⅝ in.)
Tretiakov Gallery, Moscow

social face, and on the other, those of his unconscious. Significantly, *The Englishman in Moscow*—to a large extent a program-poster—bears the title "Partial Eclipse" in painted Cyrillic letters scattered over the entire surface. This term offers a new insight into the stage Malevich had reached by 1913 when he was working on the pictorial-scenic conception of the opera *Victory Over the Sun* with the composer and painter Matiushin and the poet-theoretician Kruchenykh.[18] The image of "the eclipse" refers to the eclipse of the sun, which the men of the future, the *budetlyane,* have vanquished. The sun is the symbol of the illusory world of the past, "full of the melancholy of errors, of affectations, and of genuflections" (scene V). "Our face is dark/Our light is on the inside" (end of scene IV), says Kruchenykh's libretto. And the choir chants,

> We are free
> The sun is broken...
> Hail darkness! (scene IV)

The sun is the figurative world; the world of objects is eclipsed by black. Furthermore, it is in sketches for *Victory Over the Sun* (figs. 1, 2) that a black quadrilateral appears for the first time in Malevich's oeuvre. In the wake of Camilla Gray,[19] a great deal of attention has been accorded the sketch for scene V of the opera, which depicts a quadrilateral cut diagonally, one part black, the other, white (fig. 3). We should immediately note, as did Rainer Crone,[20] that it is not a square but a quadrilateral tending toward a square with a figurative image of the "partial eclipse" as well. A completely black quadrilateral appears in the sketch for the *Gravedigger* (fig. 4).[21] This quadrilateral is not totally square either, and it still retains a symbolist figurative meaning: it forms both the torso of the *Gravedigger* and the end of a coffin where the corpse of the sun of appearance lies. There is also a gesture, as in the *Composition with Mona Lisa* (fig. 5).[22] The same term is written with a brush onto this work as onto *The Englishman in Moscow:* "Partial Eclipse." Eclipse of what? The only immediately recognizable figurative element is the pasted reproduction of the Mona Lisa; attached to this reproduction is a newspaper clipping with the mention "Apartment for sale"; and a little lower down another small newspaper clipping reading "In Moscow." Thus it is with a humorous gesture that the entire humanist-figurative tradition of the West from the time of the Renaissance is rejected.

"If the masters of the Renaissance had discovered the surface of painting, it would have been much more exalted and valuable than any Madonna or Mona Lisa," Malevich asserted in one of his first texts.[23] An "iconoclastic" gesture is appended: like graffiti, two crosses cancel out the face and throat of Mona Lisa, that is, the painted flesh ("A face painted in a picture gives a pitiful parody of life," wrote the painter).[24] It is a matter then of a still partial eclipse of the "sun of Western painting," the Mona Lisa, $\epsilon\check{\iota}\delta\omega\lambda\upsilon$ par excellence of figurative expression. The large black quadrilateral did not yet manage to eclipse totally the different forms distributed in Cubist perspective across the flat surface. But this was the last step toward the total eclipse represented by the *Quadrilateral* (fig. 6) in the Tretiakov Gallery[25] in Moscow, shown for the first time in the last Futurist exhibition, *0–10,* in Petrograd at the very end of 1915.[26] I say "quadrilateral" and not "square" because it was precisely the first term that Malevich himself used in the exhibition catalog *(chetyreugolnik* = quadrilateral). Moreover, the rarely reproduced work[28] shown in 1915, the famous "black square," is no more "square than the *Red Square, Peasant* in the Russian Museum (Leningrad) also shown at *0–10* under the title *Painterly Realism of a Peasant Woman in Two Dimensions,"*[29] nor than the "white square" in the Museum of Modern Art in New York. In fact, Malevich above all asserted "quadrilaterality" as such, as opposed to triangularity, which for many centuries has symbolically represented the divine. In an unpublished text of the 1920s, Malevich formulated this aphorism: "The form of modernity is the rectangle. In it four points triumph over three points *(Forma sovremennosti priamougolnik. Torzhestvo chetyretochie nad troetochim.)"*[30] Is there a contradiction here? No, for as Malevich wrote in May 1915, the black square is "the embryo of all potentials..., the father of the cube and the sphere, and in paintings its dissociations *(raspadenie)* bear a wonderful culture."[31] All the "geometric" pictorial unities of Suprematism are only combinations *derived* from the primordial square form, the fundamental unity toward which they all tend. The cube, the rectangle, axonometry in general, have no value in themselves. So the problem of the "fourth dimension" that plagued European artists about 1910 was only a secondary, accessory, derivative factor for Malevich.[32] In fact, the problem of Suprematism is not a problem of geometry; rather, it is the problem of the pictorial as such, and the pictorial is flat, colored surface, absolute planarity; the dimension of this planarity is the *fifth dimension* or economy. "People ought to examine what is painterly, and not the samovar, cathedral, pumpkin, or Mona Lisa," Malevich wrote.[33] If painting were summed up as a flat surface saturated with color with quadrangular variations, one would remain in the area of figuration, or representation, of symbolism.

It is absolute non-objectivity *(bespredmetnost)* that the Suprematist pictorial action makes visible, and this absolute non-figuration does not represent but very simply is; it presents the non-objective world, "puts forth" it, makes it "vorstellig" ►

(according to Heidegger in *Vom Wesen der Wahrheit,* paragraph 2). Here the iconoclasm that had been a purifying gesture during the pre-Suprematist period transforms into the triumphs of the icon as picture. Most critics have seen the advent of the "black square" as a nihilist or iconoclastic manifestation. Emmanuel Martineau has shown that the iconoclasm of Malevich "only acts upon the imago and leaves intact ... the field of the icon as rigorously non-imitative 'similitude.' "[34] It is not by chance that Malevich himself called his *Black Quadrilateral* "the face of the new art ... a living, royal infant,"[35] "the icon of my time."[36] There is no iconoclasm or nihilism there, or these words are meaningless. It is no longer a question of symbolic, polemic, or programmatic gesture, but of pure pictorial, "apophatic" gesture (if I am permitted this theological term) — that is, the negative revelation of *that which is,* the manifestation of that which does not appear. The way in which the *Quadrilateral* (the "black square") was hung at the *0–10* exhibition has not been emphasized: it was hung high in the corner like the central icon of the "beautiful corner," that spot in all Orthodox homes located in the main room; the principal icon (Christ Blessing, or the Mother of God) was placed, in theory, facing east with a candle burning before it and with other icons hanging on the two adjacent walls.[37] There could be no better indication, in an exoteric fashion, than this of the profoundly iconic character of *Suprematism of Painting,* in keeping with the name Malevich gave his pictorial iconostasis in the *0–10* exhibition.[38]

The advent of the "black square" in the work of Malevich as well as in twentieth-century art in general strikes us by its abrupt, unexpected, and unpredictable nature; if one follows the progress of quadrilaterals and of black in the Cubo-Futurist-Alogist works of 1913–14, those pictures are all without exception saturated with forms. The pure, naked forms of the *Square, Circle,* and *Cross* create a sharp contrast by their minimalism. According to Anna Leproskaia, Malevich's assistant in the 1920s, the painter "did not know, did not understand what exactly constituted the black square. He realized that this was such an important event in his artistic career that for a whole week (so he himself related) he could neither drink nor eat nor sleep."[39] Aside from the anecdote, there is something pathetic in the birth of the "black square" which cannot be circumscribed by semiological analysis alone, even though, as Dora Vallier has shown,[40] this aspect must not be neglected. An entire tradition, chiefly American, of "conceptual art" and "minimal art," which in fact lays claim to Wittgenstein's maxim "the meaning is the use," could consider Malevich as one of its ancestors. This is so even if, in Malevich, thought never destroys the pictorial but brings about its triumph. When Malevich wrote that "The system, hard, cold, and unsmiling, is brought into motion by philosophical thought,"[41] or "in one of its stages, Suprematism has, through color, a purely philosophical movement,"[42] that does not mean that the philosophical movement and the pictorial movement are separate moments in the work; then it would be a question of "philosophical painting" with a philosophical subject. It means rather that the pictorial and the philosophical (the noetic) coalesce in a single action, an action that makes "the world as non-objectivity" visible. Malevich wrote that there is *only a single living world,* precisely the non-objective world. Just as "we are the living heart of nature,"[43] the painter makes the life of the world appear on the canvas: "each form is a world,"[44] the Wisdom, the Sophia. "I have untied the knots of wisdom and set free the consciousness of color."[45] "The globe is simply a lump of intuitive wisdom that must run over the paths of the infinite."[46] Thus Suprematism, through its different stages (static and dynamic), is a purely (economically) pictorial manifestation of nature as birthplace of being, of life, of nature as space. From the *Black Quadrilateral,* a total eclipse of objects, to *White on White* (fig. 7) in the Museum of Modern Art, New York,[47] it is the space of the world that emerges through the "semaphore of color" ("At the present time, man's path lies through space, and Suprematism is a color semaphore in its infinite abyss").[48] Malevich dates the creation of "white Suprematism" to 1917,[49] and according to him these works were shown in 1918 "at an exhibition." To our present knowledge, there is no trace of an exhibition of Malevich's works in 1918.[50] But that is not the main point; what is important is that "white Suprematism," with the *White Square* as the legendary pole of the "black square," is the culminating period of pictorial Suprematism. Having attained zero with the "black square," that is, Nothing, as "the essence of distinctions," "the world of non-objectivity,"[51] Malevich "explored" beyond zero the space of Nothing. Quotes in which Malevich insistently reiterated the words "space," "non-objectivity," and "nothing" proliferate: "[The Suprematist] plane surfaces are the seeds of space saturated with color";[52] "The square equals feeling, the white background equals nothingness";[53] "I have torn through the blue lampshade of color limitations and come out into the white."[54] The critical literature has stressed the mythology of flight, aviation, and space to conquer, found in all fields at the start of this century and propagated in the arts by Futurism.[55] But it would be erroneous to think that Suprematism "paints space." One might say, rather, that space, as "liberated nothingness," paints itself onto the Suprematist flat surface. Suprematism frees space-nothingness from figurative weight,

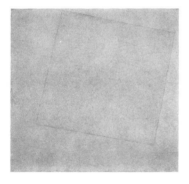

7.
Kazimir Malevich
Suprematist Composition: White on White, 1918?
Oil on canvas
79.4 x 79.4 cm. (31¼ x 31¼ in.)
Collection, The Museum of Modern Art, New York

"annuls the thing as a painterly framework, as a means."[56] Just as "the miracle of nature is that it all is contained in a small seed, and yet this 'all' cannot be embraced,"[57] so "man's skull ... is equal to the universe, for in it is contained all that it sees in it."[58] In the same vein one might say that the Suprematist painting is equal to the universe, it is nature; the cosmic stimulus passes through it, the cosmic flame which "wavers in the inner man without purpose, sense, or logic."[59]

Although Malevich, with pedagogical intent, wanted to explain in his Bauhaus text of 1927 (fig. 8) what conditioned artistic vision in different periods in terms of the environment, this does not mean that Suprematism is the pictorial reproduction of that environment (an aerial view of the earth). It means that the environment has made the Suprematist consciousness possible. Aerial vision has not given rise to new geometric forms abstractly conceived by being viewed from above. It explains the Suprematist liberation from the terrestrial gravity of objects, their annihilation in the "liberated nothingness." Malevich called Suprematism "a new realism" insofar as it embraces the only true reality of the non-objective world. ●

Translated from the French by Sherry Goodman

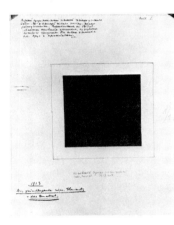

8.
Kazimir Malevich
Sketch for Black Quadrilateral for Malevich's Treatise "Die gegenslandslose Welt," published by the Bauhaus in 1927
26.5 x 21.5 cm. (10⅜ x 8½ in.)
Kunstmuseum, Basel

1. Alfred H. Barr already pointed out the ambiguity of the term "abstract"; see his introduction to *Cubism and Abstract Art,* New York, 1936; see also Emmanuel Martineau, *Malevitch et la Philosophie,* Lausanne, 1977, pp. 15–61. The criticism which can be leveled at Martineau's theses is that of apriority: for him there is only one valid "abstraction," "abstractio ad" (ibid., p. 32), which is "a liberation of freedom" (ibid., p. 33), a *pure freedom,* without any referent other than itself. With reference to this Abstraction (which in my opinion belongs solely to Suprematism), Martineau (1) groups together the three great founders, Kandinsky, Malevich, and Mondrian, while in fact three radically different pictorial processes are in question; and (2) treats as "vulgar abstraction" all those pictorial processes which presume to be "abstractio ab," freedom *from* the object or "ex-traction" of the spiritual in the material.

2. Henri Matisse, *Ecrits à propos de l'art,* Paris, 1972, p. 252.

3. Cf. Cicero: "A corpore animus abstractus," *De Divinatione,* 1:66.

4. V. Kandinsky, "Pismo iz Miunkhena" (Letter from Munich), *Apollon,* no. 4, 1910, pp. 19–20. We are depending solely on the Russian texts written by Kandinsky in 1909–11, texts which are persistently ignored and to which Valentine Marcadé drew attention in *Le Renouveau de l'art Pictural Russe, 1863–1914,* Lausanne, 1972, pp. 149–53. (See Jelena Hahl-Koch's essay in this catalog—ed. note.)

5. V. Kandinsky, "Soderzhanie i Forma" (Content and Form), in the catalog of the "Second Salon" of V. Izdebski in Odessa in 1910–11, p. 14.

6. Ibid., p. 15.

7. Ibid.

8. V. Kandinsky, "Pismo iz Miunkhena" (Letter from Munich), *Apollon,* no. 7, April 1910, p. 14–15.

9. V. Kandinsky, "Pismo iz Miunkhena" (Letter from Munich), *Apollon,* October–November 1910, p. 16.

10. In Russia, the principle of autonomy of creation triumphed at the beginning of the 1910s in literature, theater, music, and the plastic arts; let us briefly recall the literary manifesto in the *Gifle au goût public* almanac (1913) and its proclamation of the "self-developed word" (*samovitoe slovo*); the poetic method of Khlebnikov and Kruchenykh; the creation of the "Moscow Linguistics Circle" in 1915, one of whose founders was Roman Jakobson; Meierkhold's theater; Stravinsky's music; Larionov's Rayonism; Tatlin's reliefs, etc.

11. E. Martineau, "Mimésis dans la Poétique: pour une solution phénoménologique," *Revue de Métaphysique et de Morale,* Paris, October–December 1976, pp. 438–66.

12. J.-Cl. Marcadé, "La Victoire sur le Soleil ou le merveilleux futuriste comme nouvelle sensibilité," *La Victoire sur le Soleil* (edition of the libretto in Russian and in French), Lausanne, 1976, pp. 78–82.

13. See Liliane Brion-Guerry, *Cézanne et l'expression de l'espace,* Paris, 1978, pp. 117–19.

14. N. Berdiaev, "Picasso," *Sophia,* Moscow, no. 3, 1914, pp. 57–62.

15. See G. Lista, *Futurisme: Manifestes, Documents, Proclamations,* Lausanne, 1973, p. 165.

16. See the exhibition catalog for *L'Union de la Jeunesse* in St. Petersburg in 1913–14. In an unpublished letter from Xana Boguslavskaia-Pougny of January 22, 1914, to the engraver Jean Lébédeff (I. K. Lebedev), concerning the Russian entries at the *Salon des Indépendants* in Paris, the *Samovar* of Malevich is called "réalisme cubo-foutouristique" (*sic*) and the *Portrait of M-r Klunkoff* (*sic*) is qualified as "réalisme scientifique." (See this letter in extenso in J.-Cl. Marcadé, "Quelques faits méconnus ou inédits sur les rapports artistiques franco-russes avant 1914 (Notes paracritiques)," *Cahiers du Musée National d'Art Moderne,* no. 2, 1979.)

17. See Y. Tugendhold, "Futuristicheskaia Vystavka 'Magazin'" (The Futurist Exhibition "Magasin"), *Apollon,* no. 3, 1916. This use of everyday objects in a pictorial composition, such as the thermometer glued onto *Warrior of the First Division* (1914) is "pre-Dada," but it does not have the same function as in the contemporary "ready-mades" of Duchamp, for these objects are integrated into a pictorial ensemble.

18. Charlotte Douglas, "Birth of a 'Royal Infant': Malevich and *Victory Over the Sun*," *Art in America,* vol. 62, no. 2, March–April 1974, pp. 45–51; J.-Cl. Marcadé, *"La Victoire sur le Soleil...*," pp. 65–97.

19. Camilla Gray, *The Great Experiment: Russian Art 1863–1922,* London, 1962, chapter V (Suprematism).

20. Rainer Crone was one of the first to insist on this point. See Crone, "Zum Suprematismus—Kazimir Malevič, Velimir Chlebnikov und Nicolai Lobačevskij," *Wallraf-Richartz-Jahrbuch,* Band XL, 1978, p. 144; Crone, "Zur Bedeutung der Gegenstandslosigkeit bei Malevich und ihre Beziehung zur poetischen Theorie Khlebnikovs," in French in *Cahier Malévitch,* Lausanne, 1980.

21. This sketch was reproduced for the first time in the bilingual edition of *La Victoire sur le Soleil,* p. 62. See D. Karshan, "The Graphic Art of Kasimir Malevich: New Information and Observations," *Suprématisme,* Galerie Jean Chauvelin, Paris, 1977, pp. 51–52.

22. See *Composition with Mona Lisa* in *Kasimir Malewitsch: Zum 100. Geburtstag,* Galerie Gmurzynska, Cologne, 1978, p. 209 (the critical texts of this catalog are in German and English).

23. K. Malevich, "From Cubism and Futurism to Suprematism: The New Realism in Painting," 1916, *Essays on Art,* ed. Troels Andersen, New York, 1971, vol. I, p. 25.

24. Ibid., p. 38.

25. Found at the Tretiakov Gallery in Moscow under the title *Black Square. 1913* (79 x 79 cm., no. 11225). The work was at the Museum of Pictorial Culture; this explains why Malevich was unable to take out the work, which was so crucial for his art, to the 1927 Berlin exhibition. The *Black Square* entered the Tretiakov Gallery in 1929. To our present knowledge, it is the only "Black Square" painted by Malevich before this date. The *Black Square* (111 x 111 cm.) in the Russian Museum in Leningrad (reproduced in Camilla Gray, *The Great Experiment*) is not from 1913. According to Malevich's students, it would have been executed—the same as the *Circle* and *Cross* (in black with the same dimensions) in the same museum—in the 1920s by Malevich's studio at the Institute of Artistic Culture (Inkhuk) in Petrograd. (See Troels Andersen, *Malevich,* Stedelijk Museum, Amsterdam, 1970, p. 40, note 3.) The photography and the commentary of A. Nakov in *Malévich: Ecrits,* Paris, 1975, p. 74, are pure fantasy.

26. On *The Last Futurist Exhibition of Pictures: 0–10,* see E. Kovtun, "K. S. Malevich. Pisma k M. V. Matyushinu" (Letters to M. V. Matiushin), *Iezhegodnik Rukopisnovo Otdela Pushkinskogo Doma,* Leningrad, 1976, pp. 177–84. An English translation of an excerpt from this article appeared under the title "Suprematism as an eruption of universal space" in *Suprématisme,* Galerie Jean Chauvelin, pp. 23–28. See also E. Kovtun, "The Beginning of Suprematism," *Kasimir Malewitsch,* Galerie Gmurzynska, pp. 196–231.

27. Andersen, *Malevich,* p. 162 (the translation of *chetyreugolnik* as "square" is inexact).

28. The best reproduction of the *Black Quadrilateral* was made by Miroslav Lamač in his article in the Czech review *Vytvarné Umění,* 1967, no. 8–9, p. 384.

29. E. Kovtun, "The Beginning of Suprematism," p. 206, indicates that on the back of this picture Malevich wrote "Peasant Girl. Supranaturalism." Differing with E. Kovtun, I think that the term "supranaturalism" is late, "post-Suprematist."

30. "Obyvatel Schitaet..." (Le petit bourgeois considère...), loose sheet, private archives, Leningrad. See also the drawing of the *Black Quadrilateral* made for the book of Malevich, *Die gegenstandslose Welt* (1927) in the Öffentliche Kunstsammlung in Basel.

31. Quoted by E. Kovtun, "The Beginning of Suprematism," p. 204.

32. Certain authors tend to inflate the problem of the "fourth dimension" in Malevich. See the important works of Linda Henderson, *The Artist, "The Fourth Dimension,"* and *Non Euclidean Geometry 1900–1930: a Romance of Many Dimensions,* Yale Univ. Ph.D. diss., University Microfilms, Ann Arbor, Michigan, 1975, and "The Merging of Time and Space: 'The Fourth Dimension' in Russia from Ouspensky to Malevich," *The Structurist,* no. 15–16, 1975–76, pp. 97–108; see also Susan Compton, "Malevich and the Fourth Dimension," *Studio International,* vol. 187, no. 965, April 1974, pp. 190–95; Jean Clair, "Malévitch, Ouspensky et l'espace néo-platonicien," *Malevitch, Actes du Colloque International,* Lausanne, 1979, pp. 15–29.

33. K. Malevich, "On New Systems in Art" (1919), *Essays on Art,* p. 109.

34. Emmanuel Martineau, preface to K. Malevich, *Ecrits II. Le Miroir Suprématiste,* Lausanne, 1977, p. 33.

35. Malevich, "From Cubism and Futurism to Suprematism," p. 38.

36. Letter to Alexander Benois, May 1916; see Malevich, *Ecrits II,* p. 46: "I have only one icon, naked and without a frame (like my pocket), the icon of my time, and it is difficult to contend with."

37. Formerly, each person entering the main room turned toward the "Beautiful Corner" and crossed himself.

38. The best reproduction of the "Malevich corner" at *0–10* is in Malevic, *Scritti,* Milan, 1977, p. 153.

39. Anna Leporskaia, "The Beginnings and The Ends of Figurative Painting and Suprematism," *Kasimir Malewitsch,* Galerie Gmurzynska, p. 65.

40. Dora Vallier, "Malévitch et le modèle linguistique en peinture," *Critique,* May 1975, pp. 284–96; see also Crone, "Zum Suprematismus."

41. Malevich, "Non-Objective Creation and Suprematism," p. 121.

42. Ibid., p. 38.

43. Malevich, "From Cubism and Futurism to Suprematism," p. 24.

44. Ibid., p. 38.

45. Ibid., p. 40.

46. Malevich, "On New Systems in Art," p. 104. It would be interesting to follow in Malevich's philosophy the Russian sophiological tradition, the one found in V. Solovyov, P. Florenski, S. Frank, Prince Evgenij Trubetskoy, and S. Bulgakov.

47. If, as I think, the white picture in the bottom row of photograph F, reproduced by Andersen, *Malevich,* p. 63, as representing a row from the personal exhibition of Malevich in Moscow in 1919, is the *White Square* in New York, then this picture was hung upside down from its present position. Turning this picture upside down causes an internal dynamism in the bluish white quadrilateral in the white waves of Impressionist brushwork.

48. Malevich, "Non-Objective Creation and Suprematism," p. 121.

49. Letter to the editors of *Sovremennaia Arkhitektura,* no. 5, 1928, p. 157; French trans. in Malevitch, *Ecrits II,* p. 113.

50. See Andersen, *Malevich,* p. 163. Malevich's statement corresponds to that of the great sculptor Antoine Pevsner. See Pevsner, "Rencontre avec Malévitch dans la Russie d'après 1917," Malévitch, *Ecrits II,* pp. 191–93. A. Pevsner does not remember exact dates, but his recounting of facts is often right. E. Kovtun is inclined to believe that *White Suprematism* appeared at the *Jack of Diamonds* exhibition in Moscow in 1917: "Suprematism as an eruption of Universal Space," p. 26, note 10. At this exhibition, fifty-nine pictures of "suprematism of painting," without particular titles, were shown—that is, twenty-one more than at *0–10* two years earlier.

51. K. Malevich, "The Suprematist Mirror," *Essays on Art,* p. 225.

52. Letter to M. V. Matiushin, June 1916.

53. Quoted by Miroslav Lamač and Jiří Padrta, "The Idea of Suprematism," *Kasimir Malewitsch,* Galerie Gmurzynska, p. 155.

54. Malevich, "Non-Objective Creation and Suprematism," p. 122.

55. See John E. Bowlt, "Beyond the Horizon," *Kasimir Malewitsch,* Galerie Gmurzynska, pp. 232–52.

56. Malevich, "Non-Objective Creation and Suprematism," p. 121.

57. K. Malevich, "God is Not Cast Down," *Essays on Art,* paragraph 7, p. 193.

58. Ibid., paragraph 9.

59. Ibid., paragraph 5, p. 190.

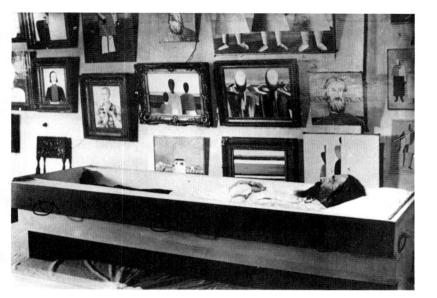

Malevich died, they hid his body in the earth and forgot about him. The living soul of Malevich wanders in this epoch, though not his loves and not his kindred. After years of oblivion they seize on the name of Malevich, stick to it like pieces of colored paper, and as if it were his body exhumed from the grave, gorge on it as on a dainty and fashionable dish.

Malevich—a vogue; Malevich—a topic of market speculators; Malevich—the theme of literary cannibals: these are not Malevich, nor will they be. The real Malevich, the revolutionary and prophet, has up to now been hermetically sealed off from the gaze and satisfied finger of the intellectual.

In order to comprehend Malevich it is necessary to comprehend the spirit and letter of the mystic-revolutionary.

A crude and fundamental mistake almost all investigators of the Russian avant-garde make is that they—as Linnaeus did in the natural sciences—define as spiritual the obvious connection between art and external formal signs, without understanding the inner logic. With such forms Malevich struck at the Constructivists, at those same Constructivists who were not only strange to him but whom he fought with all his life. It is not in the least surprising that our consumer society, in the person of good-humored consumers of the history of art, prefers to regard Malevich as a forefather of the refrigerator or hair-dryer and completely ignores and can't comprehend the fact that Malevich is one of the great prophets of the twentieth century.

The greatness of Constructivism is its revolutionary practice. Constructivism is the struggle against aristocratic pretentiousness; it is the symbol of the lofty development of capitalist society. "Constructivism is the well-formed child of industrial culture," Alexei Gan says. It changes forms, working disinterestedly in the name of social ideals. Constructivism is the condition of building a house for the as yet unborn man, because Constructivism comes from science, from precise thoughts, from technology. And science is indifferent, it outdistances humanity and is not rattled that atomic energy is controlling orangutans and that computer-electronic programs are feeding rhinoceroses to the machine. The greatness of Constructivism, like the greatness of law, is that it works on society but is independent of it. Constructivism is the divine gun, and not only the weapon but more: Constructivism doesn't meddle with the inner spirituality of mankind; it simply creates the material forms that are of maximum convenience to civilization.

Malevich and Suprematism: everything's opposite; everything's the other way round. Malevich's line is not a sign of logic, it is a sign of spiritual purity. The *Black Square* of Malevich is a symbol of spiritual not physical construction. Malevich is a body with the spiritual flesh and blood of a biblical prophet. The quest for Malevich is a search for God, far from the poesy of technological minds; so it's not surprising that Malevich scorns or refuses to recognize technology but yearns, above all, for the reconstruction of the inner world of humanity. Constructivism is the measure; Malevich craves the immeasurable.

"Nothing exists individually, and that's why perhaps there's no such thing as an object or a thing, and why it's crazy to try to attain them," says Malevich. But Tatlin at the time is stirred to things as object, as a practical aesthetic, because he believes in their beneficent influence on society.

"The first watchword of Constructivism is: Down with speculative activity in artistic work," proclaims Gan. Malevich already had insisted that art is not thing-making but, in its primal action, a speculative thinking. Art is mentality; the opposite of art is things.

At a time when Constructivists announced "irreconcilable war on the arts" (Gan) and proclaimed "intellectual-material production" (Gan), Malevich announced an irreconcilable war on things in the name of pure, divine thought. When Malevich says, "May the overthrow of the old world of art be penciled on your palms," it is not the negation of a style in the name of some other style; it's not the demolition of things in the name of new things, as with the Constructivists. It is the subversion of the art-aim of things themselves. To Malevich Constructivism is also the old world of art because the struggle of Constructivism with the Baroque ensues not from spiritual differences of structure but from culture's new Oedipus complex.

The Constructivists were the big kids of their day, the new socio-ideological kids of the epoch. They were conceived in wombs of capitalist art in order to declare natural war on their bellies. In all of his relations with the revolutionary epoch, Malevich is a kind of prophet and priest whose spiritual gaze reveals the supra-temporal perspective of human existence. ▶

Constructivism is the building of the new world via the suffering of negation; Suprematism is the principle distinct from standard aims. Suprematism is his family of artistic Judaism, not, however, having shades of contact with the pagan worship of the thingdom of the world. Suprematism is the way to God. The world in its blindness did not see that Malevich, long before had left the limits of art, had constructed a mystic-visual system whose aim was moral improvement and movement along paths to the Absolute. After an early Christianity, Malevich had a second experience, full of a feeling for the idea of an absolute God in pagan surroundings. And once again, this is articulated in a period of great spiritual upheaval and uncertainty.

"What can one embrace when neither line nor plane nor volume exists, when nothing, that is, can be measured, and geometry is thus conditioned visibility, not existing shape" —in this way Malevich recalls geometry from the province of prophecy to, the region of pure and absolute mystic experience.

"Man, the seed-bearer, contained the universe and yet in his time was not able to examine it," Malevich says. The black square is the seed which exhibits the same universe that until now has been hidden from the eye by gossipy critics who tried cramming down our throats the fact that this same "black square" was nothing but a rough sketch of an inkstand, a bedpan, or a steamship—in short, that a Constructive element had been permitted in building the aforementioned objects.

"Nature is hidden in the infinite and many-sided and does not reveal itself in things." Malevich says much here, with words that shape his attitude toward a philosophy of technology. "What in reality we call infinity is not a so-called weight or measure or time or space or the absolute or the relative as it is sketched into shape. It can perhaps be neither represented nor conceived." With such words Malevich is forgiven his former artistic pronunciations, because from here his own mysterious path to the monk Rublev and Savanarola begins. Constructivism turned the face of art toward life; Suprematism is art turned toward eternity.

■

"Through all his productions, man in the hope of arriving at God or perfection seeks to attain the throne of thought as the absolute way in which he will act not as a man but as a god, because on it he is incarnated, becoming ideal." This is the key to the way Malevich comprehends his work. Art and production are Malevich's understanding of the way to the attainment of spiritual perfection, for human beings and for society. Just when Constructivists were stopped, Malevich accomplished gigantic work, continuing, not letting up for an instant. Constructivism is the pure dream and the work of youth; Suprematism is the mature, mystic program of perfection.

"Mankind moves toward absolute thought through its productions." Thus Malevich at once uplifts the object and reveals its temporal and secondary place. These words are one of

the reasons why Malevich was the object of violent attacks in Russia at this time. Soviet party ideologues—however paradoxical this may seem—demonstrated greater intellectual maturity than Western historians of the artistic avant-garde. Malevich was not recognized in Russia despite his total vindication of all the artistic styles of the twentieth century, because for party artists the mystical philosophy of Malevich appeared ideologically harmful and dangerous. "And many thought," Malevich says, "that socialist art meant drawing intelligible donuts; moreover, they thought that cars and the rest of technological life served merely for the convenience of economic coffee-shop affairs."

"The perfection of action into pure thought will be attained when thought is the means of reincarnation." Malevich is thus immersed in the chasm of practical mystics, and with word and gesture he overcomes the violent limits of the system and takes on the God-wrestling temptations of a biblical soul. So the Suprematist construction of Malevich is nothing else but this same attempt at conquering time and space by a visual means which is the experience of teaching the consciousness of the superman. Art for Malevich is the instrument of religious consciousness; he writes repeatedly of it, underlines it, and together with it unceasingly and definitively opposes the ideologues' Constructivist teachings.

Malevich goes far, identifying the worship of pagan-technology which replaces God with a system of scientific thought that overcomes the physical weakness of humanity. He shuns, like an authentic mystic, the profound dualism of such a condition, one in which religion takes possession of the problems of the spirit, yet technology is the naked body of physical life. Malevich is both spiritual and material: an idea that is unique; two principles that do not clash one with another, that are not born hostile but exist in wholeness and indivisibility. He deciphers the observed and tangible world, the code of the spiritual and eternal problem of existence. The problem of Malevich is the problem of a religious philosopher, not a social worker—this is the cardinal distinction between Suprematism and Constructivism. The right angle, the line, the circle are the general material results of two great movements of thought, Suprematism and Constructivism, but with different aims, different methods, with only style seeming the identifying invisible link. "Thus one man constructs a life or building according to material laws or realities, another according to spiritual ones; they both can see, but the materialist sees that the man with spiritual realism builds a building without a solid foundation, and doesn't even believe a foundation exists. The other meanwhile observes the materialist: the objective results of his realities don't exist because there is only subjectivity for everybody." Malevich sees a way out of subjectivism's blind alley by an increase of religious consciousness through the baggage of technical thoughts.

"The unique superior God is the ideal of the Religious and Civic technical school." This mystic idea of the unified world puts Malevich above Christian dualism or a pagan passion for socialism (a passion expressed as Constructivism).

Malevich creates the term "excitation," and this term appears as a key to understanding Constructivist style as distinct from other geometries.

All Constructivist experience is created by a higher logic, because in Constructivist thought the logical structure of organized space is concerned with the control of morality and socialist happiness. Through geometry, the Constructivists arrive at the alternative to injustice, in precise shapes filled with color; with air and sunlight the Constructivists search for the medicine for human imperfection. Constructivist principles built a contrast to the plastic experience of the pre-Constructivist world.

With his terminological "excitation" and his plastic experience, Malevich's plastic dynamic never violated the line of the earth's attraction and never moved in obedience to it. Even in early Malevich work, we observe cosmogonic compositions based on inner volitional connections. "Excitation" is the free creative power that assimilates man with God. Thus the terminological Malevich interprets the biblical "according to the form and in the image of Divinity."

"The pursuit of an ideal culture brings to mind boys blowing soap bubbles." Thus Malevich defined the world of art in the name of art. He flung our consciousness to the limits of the childlike play of art, to the limits of utilitarianism and consumerism, to the limits of the kingdom of things.

"Today an intuition in the world changes the system of our green world of flesh and bone, resulting in a new economic order, the constitution of which is mined by our creative brains for the perfecting—according to subsequent plans—of its progress into the illimitable, where the philosophy of contemporaneity reposes, where the just are setting our creative days in motion." These words of Malevich essentially extend into our era. ●

Translated from the Russian by Jack Hirschman

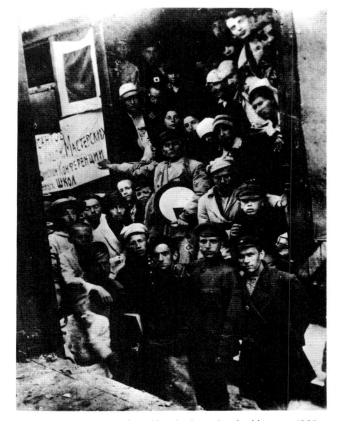

Malevich with students from Unovis departing for Moscow, 1920

The Plastic Revolution: New Concepts of Form, Content, Space, and Materials in the Russian Avant-Garde

Magdalena Dabrowski

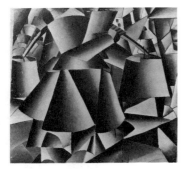

1.
Kazimir Malevich (1878–1935)
Woman with Water Pails: Dynamic Arrangement, 1912
Oil on canvas
80.3 x 80.3 cm. (31⅝ x 31⅝ in.)
Collection, The Museum of Modern Art, New York

2.
Mikhail Larionov (1881–1964)
Beach, 1912
Oil on board
33 x 39.5 cm. (13 x 15½ in.)
Private collection

1. For historical background and basic analysis of the different movements, see Camilla Gray, *The Great Experiment: Russian Art 1863–1922*, New York, 1962.

2. For a detailed discussion of the Neo-Primitivist movement in Russian art, see John E. Bowlt, "Neoprimitivism and Russian Painting," *Burlington Magazine*, vol. CXII, 1974, pp. 133–40.

■ In the first quarter of the twentieth century, as Russian political and social systems were undergoing critical upheavals, a concurrent revolution in the visual arts was taking place. During these crucial years the whole notion of art was to be redefined. The emergent avant-garde aspired to a totally new system of visual aesthetics, introducing a variety of artistic concepts that ran counter to those traditionally related to the art of painting: subject matter, verisimilitude, and illusionistic perspectival space. As a result, long-established definitions of the work of art were severely challenged and the boundaries between the conventional categories of painting, sculpture, and architecture were blurred.

Avant-garde developments that began with Neo-Primitivism in 1908 and culminated in Constructivism in the 1920s were inspired by the exploration of native sources such as folk art and icon painting as well as by new aesthetic issues raised by recent Western movements: Cubism and Futurism. These were known to the advanced art community through the two famous art collections of Morozov and Shchukin in Moscow and through direct contacts with the Parisian and Italian artistic communities established by Alexandra Exter, Liubov Popova, Nadezhda Udaltsova, and others. Moreover, a plethora of art revues—*Zolotoe Runo (The Golden Fleece), Apollon, Vesy (The Scales)*—the native and foreign newspapers available in Russia, and numerous art exhibitions provided exposure to the newest and most advanced trends in Western art. All of this stimulated the search for a new aesthetic language compatible with the modern reality of industrialized Russia. In the new atmosphere, Russian avant-garde artists attempted to create a native modern idiom that would, in a manner similar to Cubism in France and Futurism in Italy, reflect and satisfy the formal and psychological preoccupations of the modern age. In this spirit they pretended to reject all Western influences, while at the same time assimilating them and making them the basis for further pictorial experiments. They elaborated new roles for form, content, color, light, material, texture, construction, space, and dynamics, which during the following decades would contribute to the pictorial vocabulary of numerous non-objective artistic tendencies in the West, from the geometric abstraction of the 1920s and '30s to such postwar trends as kinetic and minimal art.

This formal revolution occurred in different stages. These have been identified with a sequence of "isms" (Neo-Primitivism, Cubo-Futurism, Rayonism, Suprematism, Constructivism, and Productivism), which, although interrelated, by no means present a linear development.[1] Essentially, they varied in the degree of emphasis on the spiritual, philosophical, and formal aspects of art and artwork. The general trend led from the revision of the aesthetic theory of "art for art's sake," and the search for "pure" art, to its rejection as hermetic and irrelevant to the new historical conditions, followed by a transition to an anti-aesthetic concept of art.

The early stages were marked by an attempt to revitalize art and by a struggle for the recognition of painting as an autonomous or self-referential entity. Verisimilitude as a criterion was discarded. Here one can include the efforts of Neo-Primitivism, Cubo-Futurism, Rayonism, and Suprematism. The later phase of this artistic revolution—Constructivism—sought to go beyond the traditional painters' means. In terms of formal innovations it signified a radical break with aesthetic concepts of the earlier, pictorial stages and created a new relationship between form-space-material and function. It promoted "real"—three-dimensional—objects in real space as the only relevant medium of expression. In its final phase, Constructivism postulated utilitarianism of the object as the only socially acceptable art form. Only utility was believed to establish a true dialogue between art and the masses.

The shift in aims of the avant-garde introduced a new understanding of creative principles. An important impulse in this respect was provided by Russian artists' exploration of their national cultural heritage. In this new source of inspiration for the revival of "pure art" they discovered formal and conceptual characteristics that coincided with modern conventions of pictorial expression, such as anti-illusionistic, two-dimensional composition. Neo-Primitivism, in its rejection of classical Western influences and its rediscovery of native Russian art (folk art and icon painting), brought into focus the importance of the qualities inherent in painting itself: color, line, form, and their compositional organizations.[2] Although the exponents of Neo-Primitivism (Larionov, Goncharova, and Malevich) still retained a sense of narrative and elements of figuration in their canvases, they rejected traditional formal conventions (fig. 1). The illusion of three-dimensional forms set in receding space was replaced by flat, heavily delineated shapes of unmodulated, high-keyed colors organized into planar compositions in a manner reminiscent of the popular folk woodcut (the *lubok*) or icon. The academic hierarchy of compositional parts was replaced by an overall image of equal pictorial value and looser structure.

By its concentration on the formal elements of painting, Neo-Primitivism contributed to the reformulation of aesthetic concepts of content, form, and space. These found their logical extension in subsequent Russian modernist movements and culminated in the creation of non-objective art. A

3.
Vladimir Burliuk (1886–1917)
Portrait of the Poet Benedikt Livshits,
1911
Oil on canvas
45.7 x 35.5 cm. (18 x 14 in.)
Ella Jaffee Freidus
(cat. no. 19)

4.
Pablo Picasso (Spanish, 1881–1973)
Dryad, 1908
Oil on canvas
184.3 x 108 cm. (72½ x 42½ in.)
The Hermitage Museum, Leningrad

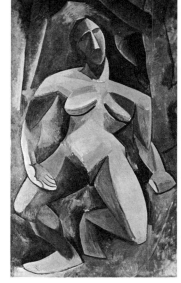

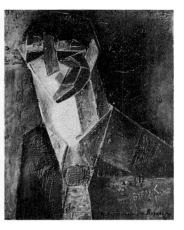

3. For a discussion on Rayonism, see M. Dabrowski, "The Formation and Development of Rayonism," *Art Journal*, vol. XXXIV, no. 3, spring 1975, pp. 200–207; John E. Bowlt, *Russian Art of the Avant-Garde: Theory and Criticism 1902–1934*. New York, 1976, bibliography III: Non-Objective Art, p. 319.

4. See *Poshchechina obshchestvennomu vkusu (A Slap in the Face of Public Taste)*, Moscow, December 1912, pp. 95–101, trans. Bowlt, *Russian Art*, pp. 69–77.

5. Ibid., p. 74.

6. See Mikhail Larionov, *Luchism (Rayonism)*, Moscow, 1913; Larionov, "Luchistaya Zhivopis," *Oslinyi Khvost i mishen (The Donkey's Tail and Target)*, Moscow, 1913, trans. Bowlt, *Russian Art*, pp. 87–100; Kazimir Malevich, "Non-Objective Creation and Suprematism," *Essays on Art 1915–1933*, New York, 1971, pp. 120–22; Nikolai Tarabukin, *Opyt teorii zhivopisi*, Moscow, 1923, pp. 44–49, French trans. in Nikolai Taraboukine, *Le dernier tableau*, Paris, 1972, pp. 103–10.

7. Picasso's *Dryad*, one of his most famous works of 1908, was originally in the Shchukin Collection in Moscow (Sch. Coll. cat., 1913, no. 173) and might have been known to the artists since the collection was accessible to the public then for visits once a week. Moreover, the artists were familiar with the work of Picasso through Alexandra Exter, who according to the poet Benedikt Livshits brought a photograph of Picasso's painting from her trip to Paris in 1911 and continued to be an important emissary of contemporary French art in Russia. See B. Livshits, *L'archer a un oeil et demi*, Lausanne, 1971; B. Livshits, *The One and a Half-Eyed Archer*, trans. Bowlt, Newtonville, Massachusetts, 1977.

pioneering attempt in this direction was Mikhail Larionov's Rayonism, which emerged about 1912 (fig. 2).[3] The final and crucial steps, of the greatest consequence for the later decades of our century, were Malevich's Suprematism (1915–18) and Tatlin's Constructivism. From that point on, the meaning of a work of art was contained not in the representational quality of the picture, but in the pictorial elements themselves, in their mutual relationships and interaction. Conversely, according to the almost simultaneously evolved philosophy of the "culture of materials," initiated about 1914 by Vladimir Tatlin and fully realized in Constructivism, material and its inherent form-creating abilities established a new artistic content.

In pursuit of new artistic content, the investigations into the nature of the intrinsic attributes of painting stimulated the formulation of such essential concepts as surface-plane *(ploskost)* and texture *(faktura)* as well as that of color as a material equal in creative and emotive powers to "real" materials like wood, iron, or glass. The Constructivists further added the factor of tectonics *(tektonika)* or the dynamic principle of construction based on motion-producing asymmetry.

The concept of surface-plane or flatness implied the equation between the composition as the result of assembling material components of the picture and the basic attributes of the canvas, its length and breadth—in other words, the affirmation of the picture as a two-dimensional object devoid of any illusion of extension into depth. All the compositional elements became reduced to the same fundamental element: the plane. Variations in the shapes—more or less precisely defined—indicated relative positions in space. This principle was effectively explored by Larionov in his Rayonist style, by Malevich in his Cubo-Futurist style and to a much greater degree in his Suprematist works, as well as by Exter, Popova, and Rodchenko.

The concept of surface-plane was first consciously posed as an important aesthetic issue by David Burliuk, one of the leaders of Cubo-Futurism, in the first Cubo-Futurist anthology of poems, prose, and essays on art, *A Slap in the Face of Public Taste*, published in Moscow in December 1912.[4] The essay identified this notion as a uniquely modern twentieth-century phenomenon, first fully explored by Cubism, and the author perceptively traced its origin back to Cézanne and his painterly vision of "nature as a plane." This was conceived as a series of visual experiences of the objects situated in different planes in depth but in pictorial terms forming a single-plane surface construction, which only by the intensity of color and the textural quality of the surface conveyed the spatial dimension. Burliuk in fact identified the flatness with "a visual sensation, refined and broadened immeasur-

ably (compared with the past) by the associative capacity of the human spirit."[5] One can recognize here affinities to the Schopenhauerian idea of "world as will and representation," a popular notion of the time. Thus, in fact, the flatness of depiction becomes identified with the reconstitution of the initial moment of visual sensation before the faculty of cognition overtakes the process of perception of objects as forms in the round. Later, Larionov in his *Rayonist Manifesto*, Malevich in his writings, and Tarabukin in his critical work *Opyt teorii zhivopisi (An Attempt at a Theory of Painting)* attribute to the "surface-plane" an essential role as carrier of meaning.[6] This notion took on a dominant importance to the point that art achieved complete non-objectivity, as in Suprematism and particularly in the later decades of our century when the flatness of the picture became its sole content in, for example, Reinhardt's black or red paintings or the works of Kelly, Ryman, and Serra.

The issue most closely related to the "surface-plane" was that of *faktura*, or texture, defining the character of the pictorial surface, or the result of the treatment of surface. Here two different lines of thought emerged: the analysis of the possibilities offered by experimentation with pictorial elements on the one hand and material ones on the other. Eventually, in conjunction with the newly developed interest in "modern" materials, the problem of texture became a seminal one for the understanding of the Tatlin-propagated philosophy of the "culture of materials."

Stimulated by the recent discoveries of Cubism concerning textural possibilities such as collage, the Russians went further in developing new roles for surface texture. Early examples of various textural explorations are seen in works such as Vladimir Burliuk's *Portrait of the Poet Benedikt Livshits* of 1911 (fig. 3) and Mikhail Larionov's Rayonist paintings. Burliuk's work, although still a traditional portrait depiction, represents an attempt to assimilate certain influences from Cubism much in the manner of Picasso's *Woman with Pears* (1909, private collection, New York) or *Dryad* (1908, Hermitage; fig. 4),[7] with additional emphasis on ▶

5.
Mikhail Larionov
Glass, 1912
Oil on canvas
104.1 x 97.1 cm. (41 x 38¼ in.)
The Solomon R. Guggenheim Museum,
New York

8. See Larionov, *Luchism*.

9. The text on "Faktura" ("Texture") was the second of the essays by David Burliuk contained in the anthology *A Slap in the Face of Public Taste*, pp. 102–10; see also Gray, *The Great Experiment*.

10. Excerpts from Markov's statements are published in English translation in Bowlt, *Russian Art*, pp. 23–38.

11. For a discussion of Tatlin's work and philosophy, see Margit Rowell, "Vladimir Tatlin: Form/Faktura," *October*, vol. 7, winter 1978, pp. 83–108.

12. This was one of the postulates in her statement in the catalog of the *Tenth State Exhibition: Non-Objective Creation and Suprematism*, Moscow, 1919; trans. Bowlt, *Russian Art*, pp. 146–48.

textural qualities. The thick layers of pigment make up an uneven, crust-like surface of highly reflective quality. Consequently, the form appears almost convex, as if modeled in low relief.

Gradually the texture reveals itself as an increasingly important element of the content of painting, as shown in Larionov's Rayonist works: *Glass* (1912, Guggenheim Museum, New York; fig. 5); *Rayonism in Red* (1912, private collection, New York); and *Rayonist Painting* and *Untitled* (both 1913, private collection, France). This interest in pursuing innovative textural solutions is spelled out in Larionov's "Rayonist Manifesto" published in June 1913.[8] Explaining his viewpoint concerning the basis of the appreciation of a work of art, Larionov contends that the mutual relationships and structure, of color, line, and texture condition the emotive aspect of painting. Emotive power can be especially well conveyed through textural variations due to the thickness of paint application, area covered, kinds of brushwork, and consequently varied light-reflecting capacity. For example, small, short brushstrokes produce a flickering, almost nervous, evocation of light and an agitated texture, while longer, smoother brushwork results in a more peaceful yet energetic and consistent texture identified with a stream of light and less fragmented form. The use of various colors or of a single color can lead to innovative textural experimentations, which bring pictorial masses alive and create dynamic form. The interest in texture thus relates to the notions of technique and *matière*. The latter continues and elaborates the concern originated with the Impressionists: stress on the physicality of the painted surface. In an analogous way, Larionov concentrates his attention on this major aspect of painting—its physical surface as the main carrier of expressiveness. The surface is then understood in a two-fold way as a flat, pictorial plane and as a textural, hence three-dimensional, construction.

Larionov's textural pursuits were part of a more general preoccupation with texture as a vital component of the new plastic vocabulary. In 1912 David Burliuk[9] discussed it in his article "Faktura" ("Texture"). Later it was broadly treated by Vladimir Markov (Waldemar Matvejs) in a 1914 pamphlet, *Printsipy tvorchestva v plasticheskikh iskusstvakh; Faktura (Principles of Creation in the Plastic Arts; Texture)*, published in St. Petersburg.[10] Ascribing to *faktura* a high priority among the painterly elements, Markov analyzes the basic factors determining it and affecting its changes. Among them he includes material, light, brilliance of color, colored pigments, action of one material on the other, and the technical treatment or manipulation of the material. The mutual relationships and interaction of any of these factors decisively affect the textural aspect of the surface. For Markov, material is at the core of *faktura* or the surface condition. Thus he clearly

makes a distinction between the painterly and the material texture. This latter concept is best embodied in the philosophy of the "culture of materials" propagated by Tatlin and made tangible in his corner- and counter-reliefs of 1914–15. According to this principle, every material has its properties *sui generis,* which dictate a logical form that expresses these qualities best. But Tatlin does not subscribe to Markov's idea that the tools or technical manipulation of the material might improve or increase textural expressiveness. He remains very pragmatic in his adherence to the intrinsic qualities without violating the integrity of the material and destroying its substance.[11]

The question of painterly texture was among the focal points in the work of several artists associated with the Inkhuk (Exter, Popova, Rodchenko, Rozanova, and Stepanova) and was part of their search for a new visual language. Rodchenko, in his process of reduction of the formal vocabulary, retained texture as one of the attributes able to convey the dynamic quality of the picture. His *Black on Black,* 1918 (Russian Museum, Leningrad; fig. 6) masterfully achieves motion by the manipulation of a simple, compass-drawn ellipse intersecting a circle on plain black background. The shiny surface of the ellipse against the matte texture of the circle, placed on the differently brushed matte square of the canvas, produces different vibrations and reflections of light and sets the image into motion.

Popova felt that "Texture is the content of painterly surfaces."[12] Compositions such as *Pictorial Architectonic* (fig. 7) of 1918 and, especially, reliefs in which three-dimensional yet always planar forms make use of varied surface treatments to create a dynamic whole, as in *Composition* of 1918 (Ludwig Museum, Cologne), demonstrate her preoccupation with texture. Popova's textural and formal explorations seem dependent upon Cubism, known to her firsthand from her Parisian years. A student of Le Fauconnier and Metzinger during 1912–13, she assimilated some of their formal vocabulary and created her own abstract idiom, "the painterly architectonics." These were compositions of geometric color-planes organized at varying angles, often intersecting or superimposed, solidly structured, forming the "architecture" of colors and forms. This interaction of colors and forms points also to the influence of Malevich's Suprematism. It was especially the architectonic or structural element that was for Popova the true value of painting. She saw it as a composite of four parts: painterly space (equated with Cubism), line, color (equated with Suprematism), and texture. The pictures were built or "constructed" out of these elements. The architectonic structure of these new material components created a new spatial environment, a function of the play of form, color, and light.

The stress on structure and the quest for in-

6.
Alexandr Rodchenko
Non-Objective Painting: Black on Black, 1918
Oil on canvas
29.5 x 29.5 cm. (11⅜ x 11⅜ in.)
Russian Museum, Leningrad
(A variant of this work from the Museum of Modern Art, New York, appears in this exhibition as cat. no. 291.)

7.
Liubov Popova (1889–1924)
Pictorial Architectonic, 1918
Oil on burlap
45 x 53 cm. (17¾ x 20⅞ in.)
Thyssen-Bornemisza Collection, Lugano, Switzerland
(cat. no. 251)

13. Ibid.

14. Catalog of the exhibition *5 x 5 = 25,* Moscow, September 1921, p. 1.

15. K. S. Malevich, "Suprematism. 34 Drawings." *Essays on Art 1915–1928,* Copenhagen, 1968, vol. I, pp. 123–28.

16. Bowlt, *Russian Art,* pp. 146–48.

17. Vasilii Kandinsky, *Concerning the Spiritual in Art,* (1912), trans. New York, 1947. These theories were further elaborated in Kandinsky's second book, *Point and Line to Plane,* published in the series of Bauhaus books in 1926; trans. The Solomon R. Guggenheim Foundation, New York, 1947.

novative spatial solutions were among the fundamental aims of the avant-garde, particularly from 1918 on. Construction—understood as both the process of formation and a metaphorical order of the work of art—became one of the basic tenets of the Constructivist philosophy and the new plastic language best suited to the reality of the new historical conditions occasioned by the October Revolution. This concept was one of the most radical and extremely modern contributions to the new visual idiom of contemporary art. It rejected as passive, and therefore not truly creative, the conventional notion of composition as an organization of forms on the surface of the canvas. The latter was linked to an elitist conception of high art unfit to satisfy the aspirations of a proletarian mass society. Construction was seen as emblematic of the new fusion of art and life and as such was conceived as an active process of assembling the material or pictorial composite parts to create and to imply three-dimensionality and dynamic space. Popova aptly formulated construction as "the sum of energy of its [painting's] parts."[13] Her architectonic compositions of 1917–18 indicate this preoccupation with structure, color, and form as the factors whose interaction energizes the canvas and imparts to it a dynamic dimension. Similarly, Varvara Stepanova pointed out in 1921, in her statement in the catalog of the *5 x 5 = 25* exhibition, that "composition is a contemplative attitude of the artist to painting; construction...an active, creative one."[14]

Popova shares the same approach when she stresses the element of energetics as a vital part of the construction. The concept of energetics recurs in the ideas of the avant-garde especially from 1916 on, as if pointing to Western, especially de Stijl, painters' search for a means of imparting dynamic quality to the picture. Malevich speaks of energetics conveyed by the relations of color.[15] Similarly, Popova announces that "color participates in energetics by its weight."[16] She defines energetics as "direction of volumes and planes and lines or their vestiges and all colors." In visual terms this might be best translated in her *Dynamic Construction* of 1919. Energetics and weight as stated by Malevich or Popova undoubtedly have connection to the new theories of relativity, the Futurist denial of gravity and preoccupation with the importance of movement and depiction of form or matter in motion. The Futurists tried to "energize" the canvas through the use of repeated rhythm of line; Malevich attempted this via the use of colors, juxtaposed in various shapes in, for example, *Suprematist Painting: Black Rectangle, Blue Triangle,* 1915, (Stedelijk Museum, Amsterdam; fig. 8). The forms and saturation of the hue determine the "weight" of a color. Every color at its fullest conveys the impression of being subject to the laws of gravity.

Color used in different shapes, and in varying saturations and surface qualities, has the ability to generate different impulses. Varying the intensity of color results in tension between the component parts and thus imparts kinetic energies to the composition. The dynamic potential of tonal variations within a single color is best witnessed in some of Malevich's Suprematist canvases: *Suprematist Composition: White on White,* 1918 (Museum of Modern Art, New York) or *Suprematist Painting,* 1917, (Stedelijk Museum, Amsterdam). Interestingly, for all his preoccupation with the manipulation of color, Malevich did not explore the textural possibilities of color and did not see texture as an element that might "energize" or add weight to the canvas. His colors are generally very evenly brushed, seldom indicating variations in texture.

Although in a different manner, the expressive values of colors and their ability to "energize" the canvas were central to the artistic practice and theory of Vasilii Kandinsky. In his *Concerning the Spiritual in Art* Kandinsky pointed out correlations among colors, forms, and their expressive qualities, explored eventually in his compositions.[17] His theories emphasized the associative spiritual aspect of form and color as a means of expressing the inner meaning of the human soul. In this respect they differ essentially from the preoccupations of the avant-garde, which focused more on purely formal pictorial issues that expressed the modern age of dynamism and the machine.

Color, line, and plane are traditional painters' means. When used to convey conceptualized images they become abstract components of pictorial space, defining spatial substance and complying with the spatial exigencies of the two-dimensional format of the picture. In the Constructivist process of reduction of the repertory of forms, line was of ▶

8.
Kazimir Malevich
Suprematist Painting: Black Rectangle, Blue Triangle, 1915
Oil on canvas
66.5 x 57 cm. (26⅛ x 22½ in.)
Stedelijk Museum, Amsterdam
(cat. no. 184)

9.
Alexandr Rodchenko
Line Composition, 1920
Colored inks
32.4 x 19.7 cm. (12¾ x 7¾ in.)
Collection, The Museum of Modern Art,
New York, Given Anonymously

18. Alexandr Rodchenko, "Line,"
trans. *From Surface to Space, Russia
1916–24,* Galerie Gmurzynska,
Cologne, 1974, pp. 65–67.

19. "Alexandr Rodchenko," ed. Andrei
B. Nakov, *Arts Magazine,* vol. 47, no. 6,
April 1973, p. 31.

20. See Larionov, *Luchism.*

21. For an in-depth discussion of
the Russian theories of the fourth
dimension, P. D. Uspensky, and the
correlations with the art of Malevich,
see Linda Dalrymple Henderson, "The
Merging of Time and Space: The
'Fourth Dimension' in Russia from
Uspensky to Malevich," *Soviet Union,*
vol. 5, part 2, 1978, pp. 171–203.

primary interest to such artists as Rodchenko and Exter. In 1921 Rodchenko made public his essay on the role of line.[18] Considering it as a pictorial counterpart of rhythm, Rodchenko developed his linear works, such as *Line Composition* of 1920 (Museum of Modern Art, New York; fig. 9), in which the new expressive plastic values were conveyed through objective reductivist means. The original imagery resulting from the manipulation of a compass and ruler was reduced to a simple trace of color, devoid of all subjective elements or any notion of style. These works were the intermediate stage leading to spatial constructions in which the thin ribs characteristic of the "Hanging Constructions" of about 1920 are the three-dimensional counterparts of the line in space. Their rhythmic movement and marked position in space created the volumetric space of the sculpture conceived as the skeleton of its volume, with the structure exposed and the internal space completing the form. Thus, kinetic rhythms defined sculptural form without mass.

Exter developed her own logic of the system of line based on the principle that "in order to define a line in motion it is necessary to have besides this line, another line situated in the same space."[19] She experimented with this principle in her "Line-Force Constructions" of 1919–20, Constructivist dynamic compositions such as *Construction of Lines* of 1923 (fig. 10), and eventually realized it in her innovative costume and theater designs of the 1920s such as those for the film *Aelita* (1924). Her compositions or, rather, line and color constructions, show solidity and stability of organization, creating dynamic, often accordion-like space by their positioning in relation to each other. Line and color become the basic interpretive vehicles of texture and spatial relations. Line is affirmed as the most objective means of expression; by being directional or synonymous with the vector of force, it becomes dynamic. In this context Exter also underlined the importance of energetics, viewing line as a sequence of energy points set in logical relationships and affected by certain optimal stress. This aspect was demonstrated pictorially by the use of dotted lines in her early drawings of the 1920s. The dotted lines were to transmit the sensation of dynamic structure of line and, consequently, the underlying framework of the pictorial construction, conceived as a part of dynamic space.

Space, and especially the concept of dynamic space, was a fundamental issue in the pictorial activity of the Russian avant-garde. This issue marked a pivotal point in the transformation of the means of expression in non-objective art. Although the ultimate aim—to express dynamic space and, through it, dynamic form of the work of art—was common to all, there were essential differences in the intentions, approaches, and results arrived at by different artists.

Beginning with Neo-Primitivism, artists looked for a means to eliminate illusionistic space and to affirm the two-dimensionality of the canvas. While this seems to be achieved by Larionov's Rayonism and later Malevich's Suprematism by their use of flat forms, their respective use of the diagonal (whether as a simple colored line in Larionov or as a line of thrust in Malevich) ultimately contradicts the two-dimensionality of the picture and creates spatial ambiguity. Although united in the quest for dynamism, the two artists are interested in different aspects of space. Larionov alludes to three-dimensionality or to a rotating space in constant flux, realized through the elaborate surface pattern of intersecting lines. Malevich's space is neutral, unstructured, boundless, cosmic—enveloping the flat, solid forms sliding, floating, falling, or ascending along their own axes. Yet both artists relate the notion of dynamic space to the concept of the fourth dimension.

The Russian, and particularly Malevich's, conception of dynamic space was influenced appreciably by the current theories of the fourth dimension, postulating the interaction between time and space. The analysis of the nature of space and time using certain methods of hyperspace philosophy provided a premise for effective exploration of the ambiguity resulting from the negation of illusionistic space and the affirmation of the flatness of the picture plane. To Larionov this meant an extratemporal perception of space[20] and to Malevich an additional conceptual dimension conforming to, and stimulated by, such contemporary theories of the fourth dimension as those expressed by the Russian physicist H. Minkowski in *Space and Time* and the Russian philosopher and mystic P. D. Uspensky in his *Tertium Organum.*[21] This enriched concept of space was to allow the spectator a new, more complete, combined perception of time and space.

The preoccupation with the concept of the fourth dimension originally was posed with regard to Cubism. It was the subject of analysis of such different artists as Gleizes, Metzinger, and Duchamp, who saw it as the spatial fourth dimension; van Doesburg, who equated it with time; and the Italian Futurists Boccioni and Severini, who considered it as a temporal vision of matter in motion. The most popular interpretation of the fourth dimension was that of "a higher spatial dimension." Only after Einstein's hypothesis of the space-time continuum in 1905 did the equation of the fourth dimension with time begin to replace the old nineteenth-century notion of a spatial, geometric fourth dimension. This theory allowed the artists greater freedom of interpretation of pictorial concepts.

Attempting to expand the limits imposed by traditional easel painting, different artists approached this issue from quite opposite vantage

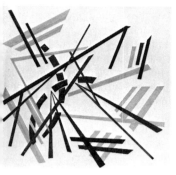

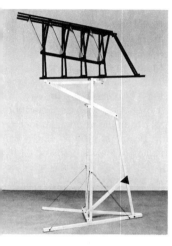

10.
Alexandra Exter (1882–1949)
Construction of Lines, 1923
Watercolor and gouache on paper
56 x 56 cm. (22 x 22 in.)
Galerie Jean Chauvelin, Paris
(cat. no. 53)

11.
Georgii Stenberg (1900–1933)
KPS 13, 1919; reconstruction 1974
Wood, iron, and glass
224 x 71 x 133 cm. (88¼ x 28 x 52⅜ in.)
Galerie Jean Chauvelin, Paris
(cat. no. 339)

22. N. Tarabukin, *Ot molberta k mashine*, Moscow, 1923, p. 8.

23. N. Tarabukin, *Opyt teorii zhivopisi*, pp. 63–64.

points. Malevich in his Suprematism strove for the spiritual, a higher intuition, infinite space. The Constructivists—Tatlin, Gabo, Rodchenko, and Popova—sought to form concrete physical spaces without resorting to the traditional three-dimensional conventions of sculpture. As the recent exhibition *The Planar Dimension: Europe 1912–1932* made clear, their works, which were designated "constructions" (to differentiate them from sculpture), were three-dimensional organizations of planar elements, as though they were pictorial surfaces detached from the wall and organized in the space in front of the wall. As the critic Tarabukin aptly remarked in 1923 while discussing the corner-reliefs of Tatlin in his *Ot molberta k mashine (From the Easel to the Machine),* although extending into the space of the viewer, they were essentially to be looked at from a single-pictorial vantage point.[22] They were conceived within a frontal plane, as if placed in front of a wall, and introduced real space as a pictorial factor necessary for the viewer's perception of form as complete. Among the best examples of this approach are Tatlin's reliefs, constructions by Gabo such as *Head of a Woman,* 1916–17 (Museum of Modern Art, New York), and his *Construction in Space,* 1927 (Philadelphia Museum of Art), Pevsner's *Bust,* 1923–24 (Museum of Modern Art, New York), and Popova's *Composition,* 1918 (Museum Ludwig, Cologne).

A highly significant feature of these constructions was that they were composed of materials often found at random and until then not associated with "high art." Most frequently these novel materials were wood, metal, tar, and glass. They were used for their inherent formal, textural, and coloristic possibilities, and not for their associative and narrative value as additional pictorial elements, which was still the case in Cubist collages or constructions.

Iron and glass especially were valued as the "modern" materials of the machine age dominated by technology. This experimentation with "modern" industrial materials would be an influence on the members of the Bauhaus, particularly Moholy-Nagy in, for example, his plated metal sculptures of the early 1920s.

Several artists, including Exter, considered pictorial elements as the "equivalents" of "real" materials; thus, from 1921 on, Exter worked on her "color constructions," organizations of color planes at differing angles and projecting the quality of an arrangement in depth. The sense of depth was enhanced by the carefully calculated play of light, which energized the surface as it acted upon the multi-colored planes. The Cubist-derived, fragmented planes seemed to rotate in various directions, creating a three-dimensional color structure. Light in this context acted as a form- and space-creating agent. It assumed an analogous role when it was reflected from real materials or textured surfaces; it "played" on the rhythmic elements, complementing the volumetric form. It can be considered a replacement for modeling in sculpture. But in contrast to modeling, light as a form-creator is an active component.

Light also evokes a three-dimensional, dynamic space. By its constantly changing character, it introduces a new "inherent" quality into a work of art—movement, an essential part of the open dynamic space. In Constructivism, dynamic space formed one of the most crucial components of a "product," understood as synthesis of material, volume, and construction. Perhaps the best example of the control of dynamic space is represented by Lissitzky's "Prouns," which achieve a synthetic organization of related flat and illusionistic elements in which space becomes architectural and volumetric. Making use of Malevich-derived forms, which in Malevich show total dependence on flatness and are entirely unvolumetric, Lissitzky introduces the play of dynamic forces by using the approach of an architect. Applying axonometric drawing or stereometric forms, he bridges the boundaries of painting and architecture to promote a reading of his construction that explores the viewer's perception of object and space in time.

The succeeding step in this transition from surface to space was the actual material construction of the kind represented by Rodchenko's *Constructions of Space* or the Stenberg brothers' "KPS" series (fig. 11). These open structures, assembled from authentic industrial materials, achieved a "realness" by their bold engineering and their integration with the viewer's space. This was achieved through the elimination of the pedestal and integration of the internal and external space. Their open volume created a spatial illusion simultaneously from without and within. They also represented the synthesis between the "technological" and the "artistic"—of which the ultimate example was to be Tatlin's *Monument to the Third International.*

In his *Opyt teorii zhivopisi (An Attempt at a Theory of Painting),* written in 1916 and published in 1923, Tarabukin wrote:

> All the art of the past and the present which we have integrated into schemes of "vision" and "knowledge" acquires a certain functional dependence on the external world and, perhaps, can be measured by the same criteria. But new criteria are needed for the truly new art, for the art of Picasso, Tatlin, the Suprematists, and the Non-Objectivists.[23]

The search for these new criteria and their visual counterparts was the cause of the intellectual effervescence of the avant-garde, a search that stimulated the formulation of conceptual ideas that retain their pertinence and influence even today. ●

1. Dates in this essay are the Russian "old style" dates in use before the October Revolution. To convert them to contemporary Western dates, add thirteen days. The opening date of *0–10* has sometimes been given as December 17, presumably because this date appears on the brochure distributed by Tatlin at the exhibition. The date on the announcement poster, however, and newspaper notices put the opening on December 19.

2. The term "Futurist" at this time in Russia was applied more broadly than in Western Europe to the most radical styles of the Russian avant-garde.

3. The artists in *0–10* were N. Altman, X. Boguslavskaia, V. Kamensky, A. Kirillova, I. Kliun, K. Malevich, M. Menkov, V. Pestel, L. Popova, I. Puni, O. Rozanova, V. Tatlin, N. Udaltsova, and M. Vasileva. The exhibition catalog lists 154 works, but the exact number of works exhibited may vary. Puni's notations, which appear on the catalog reproduced in H. Berninger and J.-A. Cartier, *Pougny*, Tübingen, 1972, pp. 58–59, suggest that Rozanova exhibited two works not indicated in the catalog.

4. Alexei Morgunov and Alexandra Exter had exhibited in *Tramway V* but did not appear in *0–10*. Vasilii Kamensky, although not indicated in the *Tramway V* catalog, did appear in that exhibition. The group's new exhibitors at *0–10* were Altman, Kirillova, Pestel, Menkov, and Vasileva.

5. Letter of February 21, 1914: Archive of the Russian Museum, Leningrad, f. 124, no. 40. An English translation appears in K. S. Malevich, *The Artist, Infinity, Suprematism*, ed. Troels Andersen, trans. Xenia Hoffman, Copenhagen, 1978, p. 208.

6. Letter of July 1915: quoted in E. F. Kovtun, "K. S. Malevich, pis'ma k M. V. Matiushinu," *Ezhegodnik rukopisnogo otdela Pushkinskogo doma na 1974 godu*, Leningrad, 1976, p. 181.

The Cubo-Futurists assembled everything onto a square and broke them up, but they didn't burn them up. Too bad.

Kazimir Malevich

■ *The Last Futurist Exhibition of Pictures: 0–10* opened a few blocks from the Winter Palace at the gallery of Nadezhda Dobychina on December 19, 1915 (fig. 1).[1] Between the canvases painted with colored squares and the rough geometrical structures of wood and metal, visitors could look out through the gallery windows at Petrograd's ornate palaces and the stately trees and intricate fencing of the Summer Park; the exhibition inside must have seemed all the more stark and bizarre. The public was incredulous; journalists felt bored and foolish to the point of being unable to bring themselves to report what they saw. Some returned to their editors with clever copy, but few, alas, with descriptions of the works. Still, most writers understood something new had happened in art, for while sculpture seemed to have emerged into the three-dimensional world out of contemporary painting, painting had reverted to nothing but squares on canvas. This was "The Last Futurist Exhibition," they said, because the Futurists could go no further with their experiments—there was nowhere to go.[2] This was the end of "modern art"; a return to more sensible and understandable styles might now be expected.

They were right in a way. *0–10* did indeed mark the end of Russian Cubo-Futurism, but it was also the beginning of work so new and fertile that we now regard it as a landmark in the history of modern art. At *0–10*, Kazimir Malevich revealed his transition from Cubo-Futurism to Suprematism, a geometric style of painting that rejected visual references to objects and has had a dramatic impact on generations of artists (fig. 2). *0–10* also presented Vladimir Tatlin's "counter-reliefs" (fig. 3), an important departure from his earlier work and his primary contribution to modern styles. We can recognize now that the counter-reliefs contained the seeds of his famous *Model for the Monument to the Third International* and the *Letatlin* flying machines. The stylistic discoveries of Tatlin and Malevich, which seem to us already fully developed in 1915, have been considered two distinct approaches to the art of this era: homage to visual fact through the nature of materials and the invocation of essence in geometries. This essay will explore the origins of the historic exhibition that first presented the new styles and examine a sampling of the work shown there. Its object is to establish a wide view of pre-Revolutionary Russian avant-garde art while giving particular consideration to the new work of Malevich and Tatlin. It will suggest that in fact these two principal exhibitors at *0–10*, rather than representing two divergent modes of thought, were a that moment closer in theory and practice than ha previously been recognized.

0–10 showed more than 150 works by 14 ar ists.[3] In retrospect, it is clear that the exhibition as a whole had relatively little visual or theoretic homogeneity, that alliances had been made mor for personal reasons than on the basis of share stylistic commitments or aesthetic theory. By th end of 1915, most of the members of the Russia avant-garde had been in their own country continu ously for some two years. Alexandra Exter, Vasi Kandinsky, Natan Altman, Maria Vasileva, Liubc Popova, Nadezhda Udaltsova, Ivan Puni, an others who had been living or traveling in the We had returned between the end of 1912 and mic 1914. Wartime Moscow and Petrograd were gri and isolated; but, although their earlier grouping changed, Russia's "artistic youth"—many of the still in their twenties—continued to thrive. Xar Boguslavskaia and Puni, both of whom had inde pendent means, undertook the financial backing several avant-garde projects, among which wer the *Tramway V* exhibition in March 1915 and *0–10* December.

The two exhibitions had many of the sam contributors: nine of *0–10*'s fourteen artists ha shown together the previous March.[4] But certa relationships were strained. The bitter animosit that existed between Tatlin and Malevich late 1915 is legendary: each would have preferred tha the other be excluded from *0–10*. But their hostilit had reached such a pitch—reportedly it came t fisticuffs—relatively recently. Both Malevich ar Tatlin had exhibited in Larionov's *Donkey's Tail*, an both had formally joined the Petersburg Union Youth early in 1913. A year later, when the Unic was split by personal conflicts, Tatlin and Malevic left it about the same time. Although they bot took part in the last Union show, which closed January 1914, on February 21 Malevich wrote Olga Rozanova, "I. Morgunov and Tatlin have de initely ceased to be members of the Union."[5] year later both artists exhibited, apparently with out incident, in *Tramway V*, and soon after plar were laid for *0–10*.

In July 1915, three months after *Tramway* closed, Puni wrote to Malevich: "We have to paint lot now. The hall is very large and if we—1 people—paint 25 pictures each, then it will only ju be enough."[6] The artists did not work together, a though certain groupings can be discerned. Som of the participants, including Altman, Puni, ar Boguslavskaia, lived and worked in Petrograc Popova and Udaltsova frequented Tatlin's Mosco studio, while Malevich, who had been workin out his new style (fig. 4) alone for some tim eventually—presumably in the fall—took other

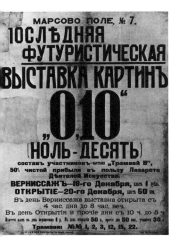

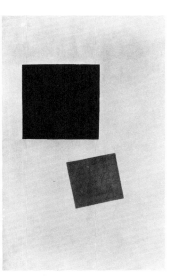

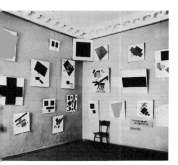

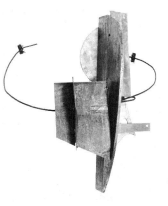

including Ivan Kliun, Mikhail Mendov, and Alexei Morgunov, into his confidence. Malevich made an attempt to keep his work secret from outsiders, but in the end his attempt was largely unsuccessful. Toward the end of September, Puni walked into Malevich's studio unexpectedly: "I was caught like a chicken in soup. I was sitting there; I had hung up my work and was working. Suddenly the doors opened and Puni comes in. So, the work has been seen. Now, no matter what, it is necessary to put out a brochure about my work and to christen it, and that way give notice of my rights as author."[7] The consolidation of his position as the originator of a totally new direction in art depended, in Malevich's view, upon an effective explanation of the new style's philosophical underpinnings and upon the collaborative action of a group. In September and October he worked to convince his friends to publicly reject Cubo-Futurism and adopt Suprematism at *0–10*. On the day before Puni's unexpected entrance into his studio, Malevich had written to his friend Mikhail Matiushin about the reactions of his colleagues: "In Moscow they are beginning to agree with me that we have to appear under a new flag. But I just wonder, will they produce a new form?" And a few days later: "In Moscow now the critical question of creating a movement has been raised, but how and what, no one knows, and they are asking me to read something from my notes. …In Moscow already many people know about my works, but they just don't know anything about Suprematism….Morgunov has given up completely and has fallen into a terrible state."[8]

As the time of the exhibition grew closer and it was necessary to make a decision about style, it became clear that only Malevich was ready to commit himself to the extreme and uncompromising Suprematism. "Everything has begun to turn around. The whole group of our exhibiting circle has filed a protest against the fact that I am leaving Futurism and that I want to write a few words in the catalog and call my things Suprematism. This is the reason: 'That we all also are no longer Futurists, but we still don't know how to define ourselves, and we have too little time to think about it.'"[9] Because Malevich received less than the wholehearted support of his friends, the statement to accompany his works grew to primary importance: "The brochure plays a large role for me. They've deprived me of my rights, but I'll get out of it. The name everyone knows already, but no one knows the content. *Let it be a secret.*"[10]

The others in the show and the works they sent to it demonstrate that they were indeed far from a stylistic breakthrough of the sort envisioned by Malevich. Many of the works show a preoccupation with three-dimensional and optical effects and a proto-Constructivist interest in structure. Natan

Altman and Maria Vasileva had not been in *Tramway V* and were probably introduced into *0–10* through their acquaintance with Puni and Boguslavskaia. The four artists had been in Paris together in 1911 and 1912; Altman had worked in Vasileva's studio there, the so-called "Russian Academy," as had Boguslavskaia. Although in 1915 Altman could not be considered strictly a member of the avant-garde, he had strong ties to it: his friendship with the *zaum* poet Alexei Kruchenykh and Baranov-Rossiné, the painter and sculptor, went back to the time they were classmates at the Odessa Art School. Through 1914 Altman's work had been predominantly a pleasant and decorative prismatic Cubism, reminiscent of the contemporary work of the *Jack of Diamonds* group, but his *Still Life* submitted to *0–10* was subtitled "faktura (space) volume," thus betraying analytical interests common to other *0–10* contributors.

Nadezhda Udaltsova, Liubov Popova, and Vera Pestel also had spent time in Paris, by and large at the studios of Metzinger and Le Fauconnier. By the time of *0–10* they had been working in Tatlin's Moscow studio for more than a year. To *0–10* Popova sent several small Cubist canvases, ▶

7. Letter of September 25, 1915:
quoted in ibid., pp. 180–81.

8. Letters of September 24 and 28,
1915: quoted in ibid., p. 187. The
absence of Morgunov and Exter from
0–10 has not yet been adequately
explained.

9. Letter of November 22, 1915:
quoted in ibid., p. 188.

10. Letter of November 25, 1915:
quoted in ibid., p. 189.

11. In Puni's copy of the *0–10* catalog, reproduced in Berninger and Cartier, *Pougny*, pp. 58–59, prices of some of the works are noted.

12. Liubov Popova, *Objects*, State Russian Museum, ZhB 1636; *Still Life (Grocer's Shop)*, State Russian Museum, ZhB 1618; *The Traveler*, Norton Simon Inc. Foundation (reproduced in Camilla Gray, *The Great Experiment: Russian Art 1863–1922*, New York, 1962, p. 206); *Person + Air + Space*, State Russian Museum, ZhB 1324 (reproduced in Gray, *The Great Experiment*, p. 185). One of Popova's paper reliefs was exhibited recently (no. 33) in *The Planar Dimension* exhibition at the Guggenheim Museum, New York.

13. Nadezhda Udaltsova, *Kitchen*, State Russian Museum, ZhB 1542.

14. It is entered by hand in Puni's copy of the *0–10* catalog. See Berninger and Cartier, *Pougny*, p. 59.

15. Olga Rozanova, *Writing Desk*, State Russian Museum, ZhB 1615; *Work Box*, State Tretiakov Gallery (reproduced in *Russian Art of the Avant-garde*, trans. and ed. J. E. Bowlt, New York, 1976, p. 104); Xana Boguslavskaia, *Toilet*, (reproduced in *Ogonek*, March 15, 1915, and in Berninger and Cartier, *Pougny*, p. 40.

16. Ivan Kliun, *Gramophone*, State Russian Museum, ZhB 1690.

17. Tatlin had had previous showings of his reliefs. For five days in May 1914—from the 10th to the 14th—he opened his studio to visitors for two hours each evening. The invitations to this showing called the new work "synthetic-static compositions." For an hour each evening during the showing the poet Sergei Podchaevsky (who had also taken part in the Union of Youth exhibition the previous November) declaimed his "post-zaum" poetry. (See Tatlin's invitation to L. Zheverzheev, Archive, State Russian Museum, f. 121, ed. khr. 117, no. 61.) Reliefs, then called "painting-like reliefs," were also shown the following March at *Tramway V* in Petrograd and in Moscow at *The Exhibition of Painting, 1915*.

such as *Objects* (fig. 5), a work which, like her earlier *Violin*, is based on the repetition of planes of partially enclosed curvilinear forms overlaid to impart an illusionistic depth to the work. Even the lettered "TEL" and the fragment of a telephone number that occupy the top left and right of the canvas are drawn three-dimensionally, and serve to emphasize the constructive, rather than the surface, character of the picture. Another work apparently included in *0–10* under the title *Still Life* relies upon the familiar Cubist devices of painted wood grain, curvilinear forms within enclosing rectangular areas, and a wallpaper motif. Hardly an outstanding work, it demonstrates Popova's late interest in French Cubism. More typical of Popova at this time, and exemplary of one aspect of Russian painting, was her *Traveling Woman* (fig. 6), a large canvas divided vertically into a number of major parallel segments; shaded, volumetric forms are repeated as the angle of viewing varies from plane to plane. Although the movement produced is clearly linear and horizontal across the surface, the whole canvas is kept active by the absence of a ground line and by extensive, witty, volumetric detail.

Popova produced a number of such highly decorative and mobile works in 1915, but they are perhaps less interesting than her smaller, looser still lifes or her portraits, in which the suggestion of motion is attenuated. She sent several portraits to *0–10*, at least one of which—to judge by the price—must have been fairly large.[11] *Person + Air + Space* from this period shows a warmly colored, seated figure looking left; rendered in exaggerated planar perspective, it emerges from a cool, almost luminous context of translucent planes and volumes. Such works, although heavily dependent on optical effects, are subdued in color and without wit. They lean toward a quiet monumentalism and timelessness, a feeling that was lost as Popova pursued her implied constructions into painted paper reliefs.[12] Like Popova, Udaltsova showed a variety of work at *0–10*. *Kitchen* is a freely rendered Cubist work based on monochromatic, symmetrical planes, while *Show-Window Motif* displays some of the interests Udaltsova shared with Popova: patterning, illusionistic depth and volume, and an almost classical symmetry.[13]

Unlike Popova and Udaltsova, Olga Rozanova had not lived in Western Europe, and her work, although varied, is quite different from theirs. Rozanova had been a leading member of Petersburg's Union of Youth and had worked closely with the Cubo-Futurists and Malevich in 1913. By 1915 she was working in a flat, precisely ordered style, perhaps derived from collage. One of her most notable works of this type is *Writing Desk*, a painting that in all probability was shown at *0–10*.[14] It brings together a number of natu-

ralistically rendered objects in a shallow, synthetic Cubist painted assemblage. The forms and lettering produce a quiet, harmonious composition which is technically competent and aesthetically pleasing. The subject of the work, expressed by the objects—a ruler, a barometer—and the integrated works and numerals, is "measures and changes," a subject that in itself is expressive of the last—intellectual and logical—phase of Cubo-Futurism. In Rozanova's *Work Box* (fig. 7) at *0–10* and in Boguslavskaia's *Toilet* at *Tramway V*, we can see a similar approach to composition.[15]

Rozanova's clean, structured look was shared by another of the early Suprematists, Ivan Kliun, who sent old as well as new work to *0–10*. His paintings from 1914 such as *Gramophone* are based on large, well-defined, proto-Constructivist structures against a Cubist ground. Geometries are emphasized, machine parts are rendered volumetrically with draftsmanlike care, and colors are restrained. Kliun's sculpture such as *Passing Landscape*, which was shown at both *Tramway V* and *0–10*, was finely constructed on a hanging back plane, repeating built-up forms that conveyed a sense of motion in time. It has the same refined intellectuality as Rozanova's *Writing Desk* or his own *Gramophone*.[16]

In contrast to such rationality, Tatlin's approach to nature was essentially lyrical; in this respect his constructions are closely related to his earlier paintings. Although by the time of *0–10* Tatlin had been constructing reliefs for two years, his counter-reliefs probably had taken form only during 1915.[17] As the name suggests, they were not reliefs at all, but assemblages meant to be hung without a backing that would have limited or defined their physical extension. The "corner" and "center" counter-reliefs attempted to avoid such delimitation, with its implicit reference to painting and the canvas, through hanging arrangements that visually minimized the role of the supporting structures. The body of the corner reliefs was built more or less vertically, in opposition to more or less horizontal supports. These were integrated so carefully into the composition that they gave the impression of being primarily a visual counterbalance to the central organization, with their role as support only secondary. A major corner counter-relief shown at *0–10* (fig. 8), for example, consisted of a vertically oriented assemblage, primarily of metals, supported in space by an opposing oblique arrangement of ropes and pulleys under tension (derived perhaps from Tatlin's experience as a sailor), and which swept up from the floor from right to left, spanning a corner of the room about three-quarters of the way along its length. The body of the work was held rigidly in place by six thin ropes passing behind and through some of its elements. Its posi-

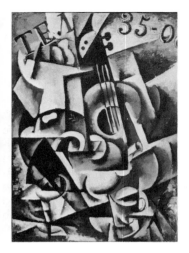

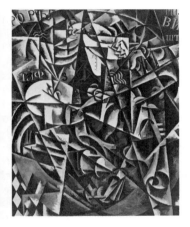

5.
Liubov Popova (1889–1924)
Objects, 1915
State Russian Museum, Leningrad

6.
Liubov Popova
Traveling Woman, 1915
Oil on canvas
158 x 123.5 cm. (62¼ x 48⅝ in.)
The George Costakis Collection
(cat. no. 242)

18. For a more extended discussion of this and other aspects of Tatlin's work, see Margit Rowell, "Vladimir Tatlin: Form/Faktura," *October,* winter 1978, pp. 83–108.

7.
Olga Rozanova (1886–1918)
The Workbox, 1915
Oil, paper collage, lace on canvas
58 x 33 cm. (22⅞ x 13 in.)
Tretiakov Gallery, Moscow

8.
Vladimir Tatlin
Counter-Relief, 1915 (from *0–10*
exhibition)
Presumably lost

9.
Vladimir Tatlin
Counter-Relief (Corner), 1915
Reconstruction by Martyn Chalk,
1966–70, from photographs of 1915
original
Iron, zinc, aluminum, wood, and paint
78.7 x 152.4 x 76.2 cm. (31 x 60 x 30 in.)
Annely Juda Fine Art, London
(cat. no. 365)

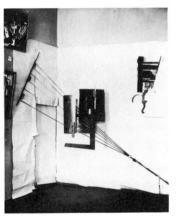

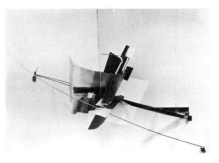

tion well to the right of the corner accentuated the spacial ambiguity, since it hung neither parallel to the wall nor centered in the corner.

In spite of the great variety and prosaic quality of their materials—tin, glass, gesso, plaster, tar—the assemblages are striking in their harmoniousness and their natural, even classical proportions. The corner reliefs have a sense of weightlessness, derived not only from their "floating" in mid-air and their spaciousness created by the absence of a fixed background, but also by the upward thrust of the works, the diagonals of the compositions, and the tilted installations. Tatlin brought his materials into such careful balance that we are not aware of their weight, but only of their texture and structural harmony. In doing away with obvious support—both the back plane of a relief and the ground plane of traditional sculpture—Tatlin appears to do away with gravity itself. The treatment of individual elements within the composition produces the same sense of natural weightlessness. Tatlin's sheets of metal are thin and individually "light," and they are assembled to extend outward into space rather than to agglutinate around a central core (fig. 9). In spite of the exceeding deliberateness and complexity with which the counter-reliefs have been constructed and the attention given to surface and texture, they avoid a "worked" look, the material is bowed, bent, and pierced, but not twisted, sculpted, nor its nature violated.

It is questionable whether Tatlin's constructions were ever what we understand today as Cubo-Futurist. Tatlin had initially allowed recognizable objects to reverberate, however slightly, within his reliefs, but in 1915 that dimension of the work is gone. His interest by the time of *0–10* was, in addition to visual and physical balance, in revealing the form of the structure from its constituent materials. Tatlin's focus upon material—its texture, how it acted, how it could be worked—was part of his fundamental interest in nature itself. Like the sailor whose speed and angle of inclination result from placing a hull and sail in a specific orientation to the wind, Tatlin, a sailor, sought the natural forces in his structures, their alignment with the wider universe, their "vitally necessary form."[18]

It was just such a cultivated feeling for nature (and concern for the artist's materials which revealed it) that Tatlin and Malevich had in common at this time. Although they were very different men, their shared interests were fundamental ones and probably account for the bitterness of their antagonisms in the second half of 1915. One can imagine that if they had not been at odds with each other, Tatlin would have been in sympathy with Malevich's statement about recognizing and revealing in sculpture the properties of materials. This tenet was rather over-dramatically stated in the bro- ▶

10.
Kazimir Malevich
Suprematism, No. 50, 1915
Oil on canvas
97 x 66 cm. (38¼ x 26 in.)
Stedelijk Museum, Amsterdam
(cat. no. 181)

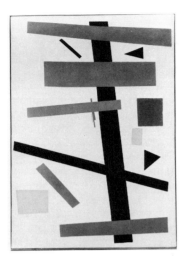

19. K. S. Malevich, *Ot kubizma k suprematismu,* Petrograd, 1916 (1915), pp. 13–14.

20. Ibid., pp. 5, 9, 13.

21. Letter from Malevich to Matiushin, October 19, 1915: quoted in Kovtun, "K. S. Malevich...," p. 188.

22. Malevich, *Ot kubizma...,* p. 12.

23. Reproduced in *Ogonek,* January 3, 1916, and in Berninger and Cartier, *Pougny,* p. 6.

24. M. Matiushin, "O vystavke 'posslednikh futuristov,'" *Ocharovannyi strannik,* spring almanac, 1916, p. 17.

chure Malevich sold at *0–10:*

The human form is not intrinsic in a block of marble. Michelangelo in creating David did violence to the marble; he deformed a piece of good stone. It didn't become marble, it became David.

And he erred deeply if he said that he drew David out of the marble.

The ruined marble was defiled first by the thought of Michel about David, whom he squeezed into the stone and then set free, like a splinter from a foreign body.

From marble it is necessary to draw out those forms which would flow out from its own body, and a carved cube or other form is more valuable than any David.[19]

It would be a mistake to attribute the origin of such ideas to one or the other artist. For more than a decade the primary interest of every phase of Russian modernism had been an art in harmony with, and expressive of, the natural universe. Cubo-Futurism had attempted to force the viewer into a direct confrontation with universal reality; by 1915 both artists were looking elsewhere for method, but the purpose remained. It seems reasonable to suppose that the search for a universal art, revealed through the qualities of materials, natural balance, and the illusion of weightlessness, had initially been shared. Expressive of their common devotion to alliance with nature was the eventual desire of both artists for natural flight.

In Suprematism, Malevich said, he was looking for "inherent form" which "flows out of the painted mass," a "painted form as such," concepts which he considered an extension of Cubism (fig. 10). Suprematism's other aspiration, "purely colored motion," Malevich thought of as the essential element of Futurism. Form is elicited by reducing the medium to its most fundamental properties—in painting, to mass and color. In such a form there lives, like energy within an atom, all the creative potency of art. The viewer perceives it intuitively, as sensation. Thus, for example, sensations of space or motion can be engendered by simple color masses. Suprematism was named for the ascendency of such fundamental properties of paint and painting over the object.[20]

When Malevich presented Suprematism to his fellow artists in the fall of 1915, he did not intend its tenets to be restricted to painting. On the contrary, he believed that the new form for painting had essentially been found, and he encouraged others to search for inherent form in poetry, music, and sculpture. "Contemporary music must move toward expression of the musical layers," he told a group of annoyed colleagues in October; it "must have the length and thickness of musical masses moving in time," and he called for static as well as

dynamic musical sound masses.[21] Malevich's interest in the three-dimensional physicality of sculpture as a more complete reflection of the universe can be seen in such Cubo-Futurist paintings as *The Woodcutter* (fig. 11), and was similar in its aspiration to the universality conveyed by the sculptural quality of Tatlin's nudes. In this respect the earlier work of the two artists played a similar intermediary role. In his brochure written for *0–10,* Malevich recognized the importance of sculpture to Cubo-Futurism:

Cubo-Futurist pictures were created according to several principles:
1) Artificial painting of sculpture (modeling of forms)
2) Real sculpture (collage), relief, and counter-relief
3) The word[22]

As we have seen, many of the exhibitors at *0–10* still relied upon three-dimensional and collage effects in painting. Malevich's attempt here to relegate Tatlin's counter-reliefs to the realm of Cubo-Futurism, however, is clearly mistaken. In effect, Tatlin had already done what Malevich was still asking of his colleagues; in Malevich's own terms the counter-reliefs are Suprematist in nature. They are essential sculpture, derived from the physical and visual properties of the material without external reference to objects of the visible world. Like Malevich's paintings, the counter-reliefs give rise to strong sensations of the natural world. The functional definition of Tatlin's "vitally necessary form" and of Malevich's "inherent form" are inevitably similar.

Malevich's exhortations to his own colleagues to develop Suprematism in sculpture produced less successful results. In response to Malevich's urging, both Kliun and Rozanova attempted new sculptural forms; for *0–10* Rozanova made at least two pieces of sculpture, *Automobile* and *Bicyclist (Devil's Walk).*[23] While we cannot now call these works Suprematist, neither are they Cubo-Futurist; rather, they are the closest we have seen so far to conceptual representation. In accordance with Malevich's precepts, and despite their titles, no attempt was made in these works to depict motion through its optical effects (as had been done, for example, in Kliun's *Passing Landscape*). Instead we are given *signs* of motion or its physical force and direction, as in the dangling weight in the corner of *Automobile* or the arrow and rings of *Bicyclist.* The works are enigmatic because their simplicity and coarseness, while seeming to preclude all contrivance and meaning, masks a strong appeal to the intellect. Neither illusionistic, abstract, nor aesthetic, the works refer, but only on a symbolic level. Matiushin aptly characterized them as "humorous works for young Martians."[24]

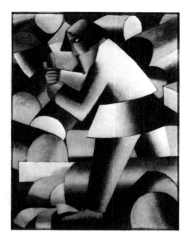

25. Anonymous review in *Petro-gradskie vedomosti*, December 22, 1915, quoted in Kovtun, "K. S. Malevich …," p. 182, and reproduced in Berninger and Cartier, *Pougny*, p. 57. Kovtun comes to the firm conclusion that this passage must refer to Kliun's sculpture.

26. Ivan Puni, *Game of Cards*, location unknown, (reproduced in *Ogonek*, March 15, 1915; Berninger and Cartier, *Pougny*, p. 44; and Rowell, *The Planar Dimension*, p. 25); *Composition with Accordion*, State Russian Museum, ZhB 1521 (reproduced in Berninger and Cartier, *Pougny*, p. 181). Herman Berninger gives the date of the reconstruction of *Relief with Hammer* as 1921 (personal communication).

27. *Hairdresser*, Musée National d'Art Moderne, Centre Georges Pompidou, Paris, and *Washing Windows*, private collection, are reproduced in Berninger and Cartier, *Pougny*, pp. 66, 67. The documentation of *Green Board* and several "Suprematist" works by Puni at *0–10* is problematic because they are not listed by title in the catalog, nor is this author aware of their appearance in installation photographs. *Green Board* is mentioned in just one newspaper review of the exhibition. In any case, reliefs such as the reconstructed *Sculptures* and *Cubo-Sculpture* (nos. 30, 31, and 32 in Rowell, *The Planar Dimension*), exhibited recently at the Guggenheim Museum, illustrate that when Puni did attempt Suprematist sculpture he relied on objects, letter-ing, and illusionistic devices and was reluctant to move very far from the canvas. It seems clear that Puni's most advanced and interesting work at the time of *0–10* remains his experiments with Cubo-Futurism.

11.
Kazimir Malevich
The Woodcutter, 1912
Oil on canvas
94 x 71.5 cm. (37 x 28⅛ in.)
Stedelijk Museum, Amsterdam

Kliun's *Cubist at Her Toilet* (fig. 12), a witty assemblage showing a life-size woman at her dressing table, is clearly Cubo-Futurist in nature and probably was done before the artist began to experiment with Malevich's ideas about sculpture. The catalog for *0–10* lists fourteen other pieces of sculpture by Kliun, of which only one, *Flying Sculpture,* bears a specific title. Seven are given the general notation "Basic principles of sculpture," and two others, "Sculpture on a plane." At this time no satisfactory descriptions of these works are available. They may be what one journalist referred to as "spheres, cubes, bars, etc.," sculpture "of the same sort" as Malevich's painting.[25]

Puni's contributions to the March *Tramway V* exhibition had revealed his evolution toward Cubo-Futurism. The simplest extension of his col-lage technique and synthetic Cubist structure into built-up planar forms of real materials occurs in *Game of Cards.* In composition, although not in its use of images, this work is similar to Malevich's *Desk and Room* and *Musical Instrument/Lamp.* *Composition with Accordion* follows the develop-ment of Cubo-Futurism in its alogical combination of illusionistically painted objects, enigmatic words, and attached wooden pieces. *Relief with Hammer* (fig. 13), a work known only from a reconstruction, would seem to be the logical outcome of this process. Here three tilted planes serve as the background for a centered whole object. This is Cubo-Futurism three-dimensionalized, the rotated back planes serving simultaneously as the Cubist environment and the "canvas" for the materialized illusionistic object.[26] Nine months later, at *0–10,* Puni pursued this line of reasoning in his *White Ball in a Green Box.* Although Cubo-Futurist in concept, Puni's substitution of a box divided crosswise into green and black areas for the abstracted planes of *Relief with Hammer* allowed the sculpture an exis-tence apart from three-dimensionalized painting. The artist seems to have taken the final step in this process with his *Green Board,* in which the object finally asserted the independence that had been inherent in the alogism of Cubo-Futurism since 1913. The two documented paintings in *0–10* by Puni, *Hairdresser* (fig. 14) and *Washing Windows,* as well as the newspaper descriptions of his *Clerk* and *Man in a Bowler Hat,* testify to his Cubo-Futurist orientation at this time.[27]

Although at the end of 1915 we can still find distinctions between the work of those artists who had studied in the West and those who had not, the particular compass of interests evident at *0–10* characterizes the whole Russian avant-garde at that time. Generally, we see that both the synthetic Cubist roots of those who had remained at home and the Cubism of Gleizes and Metzinger favored by those who had been abroad had developed by ▶

12.
Ivan Kliun (1873–1943)
Cubist at Her Dressing Table,
(exhibited 1915)
Mixed media
Presumably lost

13.
Ivan Puni (1894–1956)
Still Life–Relief with Hammer, (1920s reconstruction of 1924 original)
Gouache on cardboard with hammer
80.5 x 65.5 x 9 cm. (31⅝ x 25¾ x 3½ in.)
Collection Mr. and Mrs. Herman Berninger, Zurich
(cat. no. 274)

14.
Ivan Puni
Coiffeur (Hairdresser), 1915
Oil on canvas
87 x 69 cm. (34¼ x 27⅛ in.)
Musée National d'Art Moderne, Centre Georges Pompidou, Paris

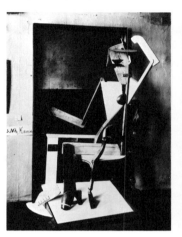

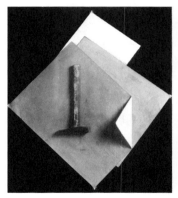

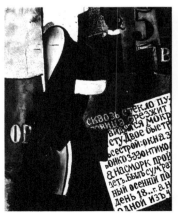

15.
Kazimir Malevich
Suprematist Architecton, No. 3, 1922
Painted wood on base
5 x 37 x 19.5 cm. (2 x 14⅝ x 7⅝ in.)
Galerie Jean Chauvelin, Paris
(cat. no. 217)

28. Linda Dalrymple Henderson, "The Merging of Time and Space: The 'Fourth Dimension' in Russia from Ouspensky to Malevich," *Soviet Union,* vol. 5, pt. 2, 1978, pp. 171–203.

29. For some time it has been assumed that Malevich came to Uspensky through Matiushin, and so it is curious to note that Matiushin does not appear to be aware of the source of Malevich's style, but instead criticizes him for insufficient understanding of the new dimension. "Color should become higher than form, to the extent that it isn't poured into squares, triangles, etc." Matiushin, "O vystavke 'posslednikh futuristov,'" p. 17.

30. Donald Judd, "Malevich: Independent Form, Color, Surface," *Art in America,* March/April 1974, p. 53.

this time into styles that focused on structure and composition, three-dimensional and other illusionistic effects, and, in certain cases, sequential motion. The work was objective, with both figures and still lifes as subjects, a late Cubo-Futurism, inventive and refined. There seems to have been very little drive toward abstraction, but the interests manifested in this painting would emerge later in Popova's painted reliefs (fig. 6), Puni's illusionistic constructions, and finally in Constructivism per se. The main exceptions to this characterization, of course, are Tatlin, Malevich, and those whom Malevich prodded into trying forms divorced from objects. The most advanced work in this group seems to have been in sculpture, probably because of innate three-dimensional interests and because Malevich was pushing in that direction. But since all of these works have now unfortunately disappeared, it is difficult to be sure of exactly what they were.

At *0–10* both Malevich and Tatlin mounted a new attempt at an absolute art through the self-sufficiency of materials and their interaction with the natural universe. Malevich attempted his "absolute creation" not through the Platonic perfection of geometries, but through the suppression of objects and the exposure of paint in "masses" of color. The form of such masses, of course, did not present any "typical" or "given" shape, as did Tatlin's sculptural materials, and on the basis of the work of Linda Henderson it now seems probable that Malevich's Suprematist elements, while emerging from previous work, were triggered by his acquaintance with the hyperspace philosophy of C.H. Hinton and P.D. Uspensky and its pictorial analogies.[28] Not only would these examples have solved Malevich's problem of the form of paint by allowing large areas of undifferentiated color, but such painted elements had already been shown to be related to natural, cosmic processes and might therefore be expected to produce the universal sensations the artist sought.[29] While Tatlin's combinations of materials allowed him to contrast their several natures with

one another, Malevich was faced with the problem of exploring the possibilities inherent only in paint as it is applied to canvas. The resolution of this medium into masses and color and the resulting implied motion or lack of it was augmented, as were Tatlin's counter-reliefs at this time, by a deliberate lack of "refinement," which exposed the natural properties of the medium. Donald Judd remarked on this when some of the *0–10* works were in New York:

> Malevich paints in a freewheeling, practical way. In the Suprematist paintings there are no carefully painted areas or precise edges; there is not much sense and not much more evidence of adjustment....Malevich paints...with the knowledge that color, form and substance are what matter and that care doesn't have much to do with these.[30]

While both Tatlin and Malevich were keenly aware of the relationship of the work of art to the natural world, their individual conceptions of that world were far from identical. The sensations elicited by Tatlin's counter-reliefs (and their ultimate referents) are those of the organic world, recognizable and human: trees, earthy textures, close juxtapositions, a sweep of wind. And while in Tatlin's work there is often a strong upward movement, it is at most a movement to the sky as we perceive it from the earth. But "space is bigger than the sky" for Malevich, who had to see far beyond the earth to overcome the influence of objects. His natural world is cosmic in scale, a world more suited to painter than to sculptor. Yet there can be no doubt that despite all their differences each artist was inspired by the other. *Zero–ten,* just when Tatlin and Malevich were so personally estranged, was perhaps their closest approach in art, but the works that followed shortly after bear witness to each other: Malevich's cities for "earth dwellers" (fig. 15) which float, like the counter-reliefs, caught between opposing physical forces, and Tatlin's "Monument," tipped to our planetary axis and enclosing Malevich's moving geometries. ●

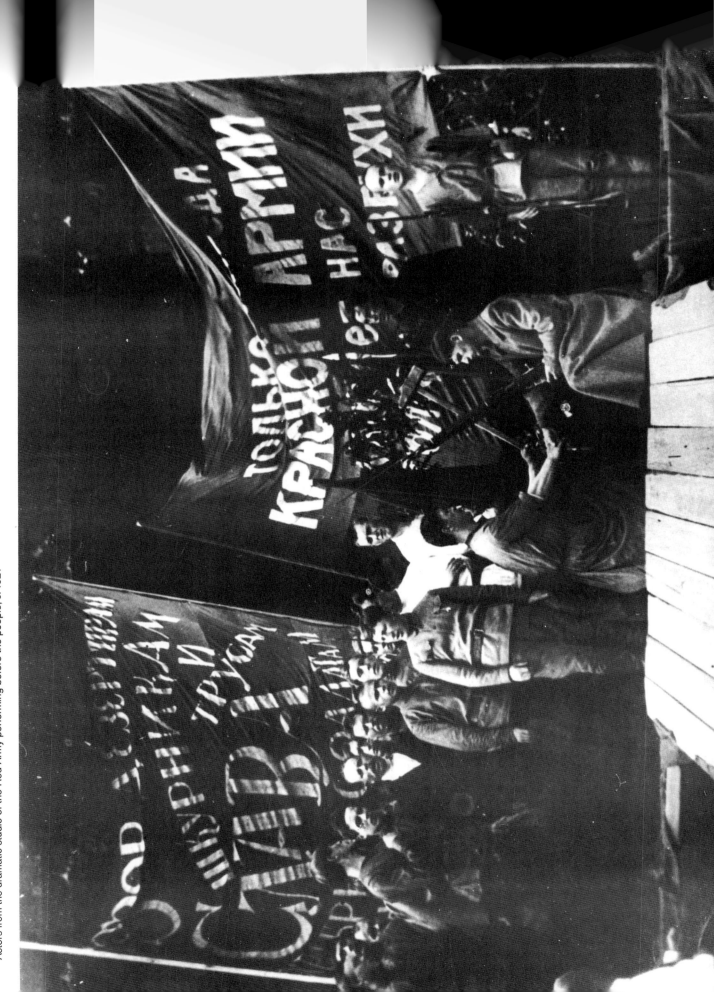

Actors from the dramatic studio of the Red Army performing before the people, c. 1921

The Painting of Liubov Popova

<div align="right">Dimitri Sarabianov</div>

1.
Installation photograph of Liubov Popova's 1924 posthumous exhibition in Moscow. (Painting over doorway is cat. no. 238)

2.
Liubov Popova (1889–1924)
Italian Still Life, 1914
Oil on canvas, wax, paper collage
61.9 x 48.9 cm. (24⅜ x 19¼ in.)
Tretiakov Gallery, Moscow

1. See John E. Bowlt, "From Surface to Space: The Art of Liubov Popova," *The Structurist,* Saskatoon, Canada, no. 15–16, 1976, pp. 80–88.

■ In recent years the name of Liubov Popova (1889–1924) has attracted increasing attention and popularity. Popova has become almost a symbol of the new movements in Russian art, a symbol of their transformation during the avant-garde period and the affirmation of their principles. Popova belonged to the extraordinary group of Russian women artists that included Exter, Goncharova, Stepanova, Rozanova, and Udaltsova. Like Rozanova, Popova died prematurely. But unlike Rozanova, who died in 1918 and hardly witnessed the brilliant climax of the post-Revolutionary Soviet avant-garde, Popova was one of its consistent representatives. In fact, Popova died just as the avant-garde movement was entering a state of decline, when many sensed the imminent conclusion to its brief flowering. Thus, unlike her fellow artists, Popova was not obliged to change her artistic system, to hesitate or to subject herself to criticism. Her development was logical; it attained its zenith, and then came to an abrupt end. This might account for the aesthetic quailty of Popova's artistic career—a career surrounded by the romance of struggle, of great dynamism, and of indefatigable search (fig. 1).

Liubov Sergeevna Popova was born April 24, 1889, of a wealthy and cultured merchant family in the village of Ivanovskoe near Moscow. Her father was a well-known philanthropist in Moscow circles, and he was fond of music and the theater. The family lived on their estate not far from Moscow and the children were tutored at home. Later the family moved to Yalta in the Crimea and then settled in Moscow in 1906. There Popova finished a two-year course of study in the literature department of Alferova's gymnasium. At eighteen she began to study painting, at first in the private studio of Stanislav Zhukovsky and then with Konstantin Yuon. During the late 1900s and early 1910s Popova visited several cities of Old Russia. In Kiev the work of Mikhail Vrubel made a deep impression upon her; in St. Petersburg she studied the Hermitage collections; she visited the ancient towns of Novgorod, Pskov, Rostov, Yaroslavl, Suzdal, Yuriev-Polsky, and Pereslavl, noting especially the ancient Russian painting and architecture. In 1910 Popova made her first trip abroad, to Italy, where she was particularly impressed by Giotto and Pinturicchio. Her attraction to modern painting began in 1912, and during that year she worked in the studio known as The Tower, where she became acquainted with Viktor Bart, Vladimir Tatlin, Anna Troianovskaia, and Kirill Zdanevich. Later she became a friend of Nadezhda Udaltsova. That same year Popova—like many other Russian artists of that time—was introduced to the collection of Sergei Shchukin, and influenced by the new French art she left for Paris, where she worked in Metzing-

er's studio during the winter of 1912–13. Udaltsova and Vera Pestel also visited Metzinger's studio. On her return to Moscow, Popova continued to work intensely, using the studios of Tatlin and Alexei Morgunov, where, incidentally, she befriended Alexandr Vesnin. Just before the First World War Popova went back to Paris. Accompanied by her friends Vera Mukhina and Iza Burmeister, she returned to Russia via Italy to see the Giotto frescoes in the Arena Chapel in Padua. At the end of 1914 Popova showed her works for the first time at the *Jack of Diamonds* exhibition in Moscow.

This period—from the Zhukovsky studio to her first exhibition—can be regarded as that of Popova's apprenticeship. Within the space of a few years Popova made great progress, starting with landscapes and still lifes dependent on a traditional, realist approach only slightly modified by Fauvist innovations. Her simple landscapes with their compact fields and hay-cocks, with their houses and washerwomen, have an ingenuousness and an openness; they express the artist's preference for bright colors, malleable textures, and painterly dynamics. Such works, however, preserve a traditional Russian structure, remaining either "pure" landscapes or landscapes with elements of domestic genre.

In the early 1910s, the Jack of Diamonds group attained increasing momentum. These artists at first combined Neo-Primitivism with a subdued Cubism borrowed from the French; they soon followed with their own distinctive interpretation of Cubism. Popova's apprenticeship encompassed this particular trend in Moscow painting, but, as with Fauvism in the preceding years, her interest in Cubism simply adjusted her own vision, without changing it in any drastic way.

For Popova, Paris was a turning point. Her study with Metzinger and Le Fauconnier gave a new direction to the investigations that she had undertaken in the previous years.

John Bowlt is justified in drawing an analogy between Popova and Braque, Picasso, and Le Fauconnier;[1] however, the French influence is only one of several sources for Popova. Her 1913 composition with two female figures and her *Seated Nude* and *Standing Nude* testify to Popova's contact with Tatlin, for this was precisely the time when she was working in his Moscow studio on the Ostozhenka. Some of Popova's drawings of nudes are very close to Tatlin's. First and foremost, Popova reveals the constructive basis of her drawings; she attaches the legs, arms, and head to the trunk as if they were hinged: the body thus seems to be composed of planes. In contrast to her Parisian mentors, Popova gravitated toward the three-dimensional, often resorting to foreshortening, unusual viewpoints, or fragments of objects. On the other

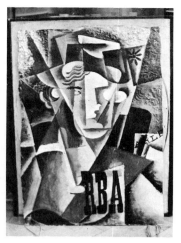

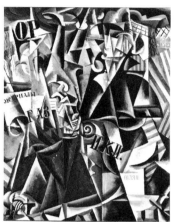

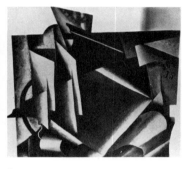

3.
Liubov Popova
The Philosopher, 1915
Private Collection, Moscow

4.
Liubov Popova
The Traveler, 1915
Oil on canvas
142.2 x 105.4 cm. (56 x 41½ in.)
Norton Simon Museum of Art at
Pasadena, California

5.
Liubov Popova
Volumetrical and Spatial Relief, 1915
Location unknown

2. Usually mistitled *Painterly Relief*
and misdated 1916.

3. Popova's notes. Author's archive.

hand, French artists were more concerned with imposing the composition on the flat surface. Some of Popova's still lifes of 1913 show a sense of volume, an inclination toward foreshortening, and an attempt to organize the objective world within a depicted space.

What is the derivation of Popova's bias toward three dimensions? It could be explained as a leftover from her natural inclination to perceptive reality. But she renewed her concern with three-dimensionality after that phase, although in a different way; three-dimensionality came to be rendered not by illusion but by the transference of volumes into real space. However, Popova's entry into real space in her work did not last long. After 1915 she interrupted her spatial experiments for a long period, returning to them only toward the end of her life. This exploration was encouraged by the researches of other Russian artists of the mid-1910s.

From 1913 on, Popova evolved in a consistent, swift, and logical manner. While pursuing her own aims and formulating her own language, Popova also responded to the investigations of her older colleagues, above all Malevich and Tatlin, whose investigations were central to her work throughout her life.

Popova's researches into the organized quality of the planar dimension were facilitated by the examples of Braque and Picasso. Her *Italian Still Life*, 1914 (fig. 2), *Violin* (1915), her still lifes with a guitar or with clocks, and her *Objects in a Dye-Works* (1914) testify to this "assimilation of the plane." Although such works contain a "French selection of objects," there are Russian things, too, such as the painted trays so beloved by the Jack of Diamonds artists *(Still Life with a Tray*, 1915). The planar surface here is emphasized by the use of collage, by insertions of various kinds, by stick-ons of oilcloth, wallpaper, etc. In *The Violinist* Popova foregoes foreshortening and paints an oval into the rectangle of the canvas; by laying the oval on the surface evenly she predetermines the subsequent stratification of the objects and their parts. Popova superimposes these layers so thickly that the spatial dynamic or development can scarcely be felt.

It was more difficult to reach such a resolution in the figure compositions which, like the still lifes, still occupied Popova. In 1914 she painted *The Smoker* and in 1915 *The Pianist.* That same year she painted two works that mark the high point in this stage of her career, *The Philosopher* (fig. 3) and *The Traveler* (fig. 4 and variants). In contrast to the earlier nudes, all these paintings have a thematic base and in some cases they are portraits (*The Philosopher* portrays Popova's brother).

The colorful paintings *The Philosopher* and *The Traveler* can be regarded as mature, independent works. In them Popova has brought the figural

form to the threshold of abstracted form, and she now crosses the boundary that Malevich had established in similar compositions such as his *Knife-Grinder*. Popova submits more readily to the planar sense, pushing all the elements of the composition toward the surface of the canvas. She uses lines and sometimes angles to break up the field of the painting so that individual rhythms are generated within the individual parts. In contrast to purely Cubist works, the main purpose of *The Traveler* is not to fragment the figure into separate elements, but rather to create a whole, autonomous organism—not of the figure but of the painting itself. Consequently, a harmony of non-objective components begins to dominate Popova's work, a principle expressed clearly and consistently in the two versions of *The Traveler* (Norton Simon Museum of Art at Pasadena, and Costakis Collection) and in *Head of a Woman,* 1915 (Costakis Collection).

A composition resembling the *Head of a Woman* is the *Portrait* of 1915 which might seem to provide an unexpected entry into real space—in the form of a relief. But it only seems unexpected, and in fact Popova often resorted to the painterly relief in 1915—in such works as *Volumetrical and Spatial Relief* (fig. 5)[2] and *Jug on a Table (Relief)* (wood, cardboard, oil). This move into real space was a logical one. Before that Popova had eliminated the illusion of three-dimensionality from her work, and had confirmed the primacy of the tactile plane. Her spatial research led her naturally to discover real space. Tatlin's experiment in 1914 with his first counter-relief acted as a definite temptation to Popova. As far as we know, Popova's spatial experiments in this area all date from 1915. Even at the $5 \times 5 = 25$ exhibition in 1921, Popova wrote that "all the compositions here are depictive and should be regarded only as a series of preparatory experiments towards concrete material constructions."[3] Popova underestimates painting as such in this statement, an attitude clearly identifiable with the Productivists of the early 1920s, but even so, these works did not claim to be three-dimensional and were strictly limited to a concern with the plane.

One could give the conditional title of Futurist to Popova's works of 1914–15, conditional only because they cannot be associated with the main tenet of the Futurist credo. For the most part Popova's large canvases are stable, confined, harmonious works. The light emanating from the objects gradually fades, emphasizing color and later the paint itself. Popova was not being especially original in this inconsistent application of Futurism. All Russian painting of the so-called Cubo-Futurists was rarely consistent in its interpretation of the Futurist method. With this proviso in mind, we can examine Popova's own formulation of her development: "After my Cubist period [the problem of ▶

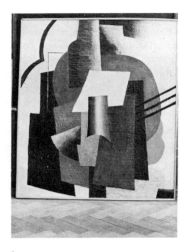

6.
Liubov Popova
Architectonic Composition, 1917–18
Oil on canvas
Private Collection, Moscow

4. Popova's words. See the catalog of the *Tenth State Exhibition: Non-Objective Creativity and Suprematism*, Moscow, 1919, p. 22.

5. See Larissa A. Shadowa, *Suche und Experiment: Russische und Sowjetische Kunst 1910 bis 1930*, Dresden, 1978, p. 122.

6. Author's archive.

7. See N. L. Adaskina, "L. Popova o sootnoshenii tsveta i formy," *Trudy VNIITE, Tekhnicheskaia estetika / 17. Problemy obraznogo myshleniia i dizain*, Moscow, 1978, pp. 97–100.

form] follows my Futurist period [the problem of movement and color], and after abstracting parts of the object there follows the abstraction of the object itself, logically and inevitably; and that is the path to non-objectivity."[4]

The breakthrough to non-objectivity was made in 1915, and Popova approached this turning point in a logical manner, influenced by the general development of Western European and Russian painters, especially Malevich. At this juncture we should mention the milieu in which the young Popova was working in the mid-1910s. On returning from Paris she came into even closer contact with the representatives of the Russian avant-garde. She exhibited in Petrograd and Moscow *(Tramway V, 0–10, The Store)* and in 1916 at the *Jack of Diamonds* again, where she showed her first non-objective work called "Painterly Architectonics." Popova worked with remarkable intensity and was especially drawn to the avant-garde trends. She dreamed of uniting the leftist artists and in the winter of 1914–15 opened her apartment for meetings of fellow artists that included lectures by Udaltsova, Vesnin, and others. After acquainting herself with the Suprematist works of Malevich, Popova became close to the Supremus group which included Udaltsova, Rozanova, Kliun, Markov, Arkhipenko, Pestel, Kruchenykh, and others.[5]

Popova continued to study ancient Russian art. Especially interested in icon painting, she revisited the old Russian towns many times (Vladimir, Vologda, Kirillov). She also visited Turkistan, where she gave particular attention to its ancient architecture while studying and copying its ornaments. In 1916 she wrote from Samarkand to her friend A. Vesnin: "Fantastic architecture! Frontal and exclusively decorative. The facade does not express the plan or forms of the entire building, but the dimensions, the equilibrium of proportions, the decorativeness of color, the ornaments (all faced with colored tiles, many of which have crumbled) create a unique impression."[6]

One can assume that the ancient art of icon painting on the one hand, and the architecture of Samarkand on the other, helped Popova to attain the new level that she reached at that time. From 1916 to 1921 (when Popova concluded her work in easel painting and graphics) her art showed great growth. During this period Popova gave her pictures conditional titles. In 1916–18 she created paintings with the title "Painterly Architectonics." In 1919 she fell gravely ill and hardly worked, but she returned to normal life and began to work again in 1920. As a rule, the works of this period are entitled "Painterly Construction." From 1921 there are a number of paintings with the title "Spatial-Force Construction."

One cannot examine Popova's "Painterly Ar-

chitectonics" individually, but rather can describe their common qualities. Many of the forms in her non-objective painting have a "figurative derivation." The cylindrical volumes seem to come from the paintings depicting fluted curtains or tin utensils; the semi-cylinder or cone passes from the relief to the flat painterly image; the planes, circles, and ovals migrate from her still lifes and figures at tables.

Popova was working out specific principles of composition at this time, and she observed them without fail (fig. 6). In combining various forms—rectangles, squares, triangles, circles, ovals, and semi-cylinders superimposed upon the surface—Popova endeavored to create a harmonious arrangement of objects. As a rule, her figures gravitate toward the center, interweave, and are stratified and imposed one upon the other. When Popova introduces volumetric forms they are placed in shallow spaces. In plastic or painterly dynamics Popova occupied first place among her Suprematist colleagues. She possessed great strength, a quality especially evident in her large canvases. With unflagging energy she "advances" planes into the pictorial space, superimposes them one upon the other, welds them together, fastens them. Popova builds, and paintings rise up like the facades of majestic buildings. Color plays a primary role in this "construction."[7] Not by chance do the titles of her paintings contain the word "architectonics."

Harmony in the work of Popova, as in that of many artists in the early non-objective period, is a kind of utopia expressed in an abstract, painterly, plastic language. It rises above the dissonances of the world, reminiscent of the High Renaissance in Italy, where at first painting was accompanied by architecture—more often recreated in painting than in actual fact. Popova's "Painterly Architectonics," Malevich's "architectons," Tatlin's counter-reliefs (full of architectural potential), or the architectural investigations undertaken by other avant-garde painters demonstrate the organic connection between such painterly harmony and the notion of perfected construction.

While learning a great deal from Malevich, Popova was also a supporter of Tatlin's world view. Popova, as it were, integrated these two lines of development that were so alien to each other (primarily because of the personal enmity between Malevich and Tatlin). The Tatlin principle tended to dominate, thanks to Popova's adherence to the earthly dimension, and her move into Constructivism and industrial art in the early 1920s was inspired by Tatlin rather than Malevich. Tatlin blazed the trail; Popova embarked upon it without reservation. Malevich, however, long resisted the application of art to practical ends.

7.
Liubov Popova
Space Construction: Vern 34, c. 1921
Watercolor and gouache on paper
35 x 27.5 cm. (13¾ x 10⅞ in.)
The George Costakis Collection
(cat. no. 258)

8. On these aspects of Popova's work, see E. Murina, "Tkani L. Popovoi," *Dekorativnoe iskusstvo SSSR,* Moscow, no. 8, 1967; L. Zhadova, "L. Popova," *Tekhnicheskaia estetika,* Moscow, no. 11, 1967; E. Rakitina, "Liubov Popova: Iskusstvo i manifesty," *Khudozhnik, stsena, ekran,* ed. E. Rakitina, Moscow, 1975, pp. 152–65; L. Adaskina, "Liubov Popova: Put stanovleniia khudozhnika-konstruktora," *Tekhnicheskaia estetika,* no. 11, 1978, pp. 17–23; L. Adaskina, "Problemy proizvodstvennogo iskusstva i tvorchestva L. S. Popovoi," *Khudozhnestvennye problemy predmetno-prostranstvennoi sredy,* Moscow, 1978; John E. Bowlt, "From Pictures to Textile Prints," *The Print Collector's Newsletter,* New York, March–April 1975, pp. 16–20.

During her last years, Popova also began to seek forms that are better described by the term "fourth dimension" than by the conventions of everyday, earthly life. In her late "Painterly Architectonics" and "Painterly Constructions" Popova sometimes rejected the principle of the closed and intrinsic composition. Her rhythmical repetitions, her diagonal, intersecting lines leading from one corner of the pictorial surface to the other, direct the viewer's eye beyond the confines of the pictorial surface. The idea of harmony does not disappear, but it is extended to wider spaces by the rational confrontation of the individual parts and the viewer's imagination. Her later works, such as "Spatial-Force Construction," are subject to a different set of conventions. More often than not, these later works are built upon horizontal, vertical, or inclined lines, intersecting and floating so as to speak within an abstracted space (fig. 7). The composition loses stability, and the notion of harmony ceases to act as the basis of the artistic image.

The list of works found in Popova's studio after her death contains *Spatial Construction in Planes and Edges* for the year 1922, and among her drawings of this time we find a number of sketches for volumetric constructions. Once again Popova enters into real space, thereby joining the general tendency of the Russian avant-garde at that time.

This marked the end of Popova's development in painting, for in her last years she ceased to paint. Beginning in 1920 she concentrated her efforts on analytical work in Inkhuk, on teaching at Vkhutemas—where, with other artists, she gave an introductory course in the so-called Basic Department *(Discipline No. 1: Color)*—on stage design (Law essay, fig. 2), on printing, and on designs for mass spectacles (Zygas essay, figs. 13–15). Popova undertook these activities alongside her work on painting.

After she gave up painting, Popova devoted herself to textile design, working at a textile factory, the former Zindel Works (fig. 8).[8] She died there on May 25, 1924. In the diverse activities of her last years Popova put into practice the principles she had already discovered in her painting. ●

Translated from the Russian by John E. Bowlt

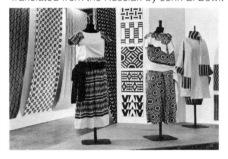

8.
Popova's textile and costume designs shown in installation photograph of *Art in Revolution* exhibition, Hayward Gallery, London, 1971

1. See K. Malevich, "Glavy iz avtobiog-rafii khudozhnika," N. Khardzhiev, *K istorii russkogo avangarda*, Stockholm, 1976, pp. 103–23. French translation in *Malévitch. Actes du Colloque International tenu au Centre Pompidou*, Lausanne, 1979, pp. 153–68.

2. See B. Livshits, *Polutoraglazyi stelets*, Leningrad, 1933; French trans. *L'Archer à un oeil et demi*, Lausanne, 1971; English trans. John E. Bowlt, *The One and a Half-Eyed Archer*, Newtonville, Massachusetts, 1977.

3. My archive contains a facsimile of an unpublished letter from D. D. Burliuk to V. E. Tatlin written probably in 1913: "Dear Tatlin: Go down to Kherson and then to 'Bratany.' From Kherson send a telegram to Burliuk as to when you will be arriving, c/o Chernodolinsky. Zagaidachnyi is here, and we'll be very pleased to see you. Bring your friend with you, of course. We'll get some work done. It'll be interesting, fascinating, useful. I have already written to you in Constantinople. Best wishes. Zagaidachnyi, my brother and I are wait-ing for you. David Burliuk. Chernianka, Tauride Province."

4. Earliest of Russian modern art movements, the Wanderers were a group of thirteen artists who traveled about the countryside c. 1863, seeking to make their art "useful" to society.

5. In an unpublished letter to D. D. Bur-liuk, V. Izdebsky writes: "To organize my Salon I went abroad in 1908 and then again at the beginning of 1909. I visited Rome and Vienna, but I didn't like what I saw. Both trips I concentrated on the French artists of Paris, and Alexandre Mercereau helped me in this. I made him my plenipotentiary. The First International Exhibition was opened in Odessa—on which street I don't re-member. But I can say that this Salon was next door to the Public Library; my second Salon, which was only Russian artists, opened on Sofiisky Street at the end of 1910, and thereafter it went to Nikolaev where it stopped because of the several thousand ruble loss (about five thousand) that I made on my ex-hibitions. My expenses included trips abroad, shipping and insurance of the pictures, renting premises, personnel, etc." (D. Burliuk Archive, Syracuse University Library.)

The efflorescence of Ukrainian art began in the seventeenth century and lasted until the eigh-teenth. Kiev, the most ancient Russian city, came to be the center of cultural life, and its Kievo-Mogiliansky Academy (which had various names from 1634 until the beginning of the nineteenth century) attracted all the intellectual forces of the country. The style of the Ukrainian portrait, its graphic art, Baroque architecture, and religious music served as models for other Slavic peoples, including the Russians. The enforced russifica-tion of the Ukraine that began under Catherine the Great (1762–96) put a halt to the natural devel-opment of this original and distinctive civilization. The St. Petersburg Academy of Arts became the only higher educational establishment in the whole of the Russian Empire where artists, engravers, sculptors, and architects were able to receive aca-demic diplomas. Students from all the provinces aspired to enroll there. After graduating, some of them returned to their native towns while others went abroad for a time—or forever. One result of this policy of intellectual centralization in St. Petersburg and Moscow was that Russian cul-ture was much enriched at the expense of the mul-tinational elements that fused with the very heart of the Russian population.

Within the diverse community of writers and artists, however, Ukrainians could be distinguished by their innate qualities: epic humor, bright and vigorous style, hyperbole of form, rich artistic fan-tasy, opulent and exuberant composition, and use of traditional motifs from popular art. To a greater or lesser extent a resonance, expressing the dis-tinctive features of an entire nation, can easily be perceived in the work of those artists, writers, and poets who, while no longer living in the Ukraine, have nevertheless preserved the specific charac-teristics, the spirit and ambience of the Ukraine. Among the many examples of twentieth-century art, we have only to regard the humor and imagi-nativeness of Larionov (his mother was born in the Ukraine), the peasantlike color range of Kazi-mir Malevich (assimilated from early childhood in the Ukraine),[1] or the variegated palette of S. I. Delaunay-Terk (Sonia Delaunay), who had never forgotten the Ukraine of her youth. One can exam-ine the Ukrainian aspect of the heroic, fantastic visions of the poet Velimir Khlebnikov or the impas-sioned phraseology of David Burliuk and Alexei Kruchenykh, so typical of the exuberant language of the free Cossacks. As for the prose of Soviet writers such as Isaak Babel, Mikhail Zoshchenko, or—on a different level—Ilf and Petrov (who wrote only in Russian), it could never have been created by Great Russians from the north, neither its bi-planar style, its linguistic richness and color, nor its cerebral play of invented syllogisms from everyday conversational slang.

In spite of the subtle and deliberate pulveriza-tion of artistic forces, in spite of a very limited con-cern on the part of the public at large, and in spite of the difficulties linked to the endeavor to establish new artistic conceptions, the fire of Ukrainian cul-tural life was never extinguished. Private studios were organized and historic exhibitions were opened. In Kiev in 1908 David Burliuk showed works by the avant-garde artists at the *Link* exhibi-tion. To a certain extent, the Ukraine might even be considered the cradle of the artistic revolution. It was, after all, at Chernianka, Count Mordvinov's estate near Kherson, where Burliuk senior was es-tate manager, that Russian Futurism was born—baptized "Hylaea," the Greek name of the Ukrai-nian Tauride.[2] Almost all the members of the artistic and poetic avant-garde visited Hylaea: Larionov born in Tiraspol, came there in the summer of 1910 Khlebnikov and Benedikt Livshits came there in 1911; Sagaidachnyi, an artist from the Union of Youth, and Tatlin came in 1913.[3] *Link* was the first challenge issued in the Ukraine to the outmoded realism of the Wanderers[4] and to the refined aes-theticism of the Symbolists and the Style Moderne of the "World of Art" artists.

The sculptor Vladimir Izdebsky organized his *International Salon* in Odessa in 1909–10 and his second *Salon* at the end of 1910. The progressive artists of the time took part in the first *Salon*—Rus-sian, German, and French—and works by the Symbolists, the Impressionists, the pre-Cubists and the Expressionists were represented (a total of 776 items). The catalog contained articles by Iz-debsky himself and by Vasilii Kandinsky, Nikolai Kulbin, and Arnold Schönberg.[5] The Izdebsky *Sa-lons* enabled the public to see for themselves that paths to the creation of new forms of plastic expres-sion would have to be sought with renewed energy.

By comparison, the young art students of Kharkov realized just how unprepared they were and how essential it was to find experienced guid-ance. They attended the art schools of their own city such as The Blue Line, headed by the artist E. Agafonov, or another studio called Budiak (Dan-delion). Vykus, a purely literary studio, also existed at this time and was considered to be the most Futurist.

Another art group known as The Ring held its first exhibition in Kiev in 1914. Its members grouped around the artist Alexandr Bogomazov, whose work synthesized all the preceding aesthetic trends of the early twentieth century: Expressionism, Fu-turism, Neo-Primitivism, abstraction. His art was distinguished by the soft contours of its lines, the harmonic resonance of its colors, the free con-struction of its pictorial plane, the cohesion of its painterly elements (fig. 1). In its painterly aspect,

46

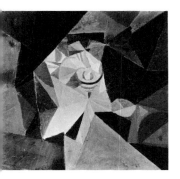

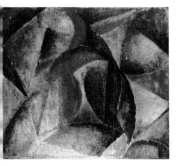

Alexandr Bogomazov (1880–1930)
Abstract Composition, 1914–15
Oil on canvas laid down on board
44.5 x 46.5 cm. (17½ x 18¼ in.)
Fischer Fine Art Ltd., London

2.
M. Boichuk
Head of a Woman, 1910s
Location unknown

3.
Viktor Palmov
Color Painting, 1920s
Collection Ivakine, Kiev

6. In 1772 Lvov—after the first division of Poland—went to Austria together with part of the Western Ukraine. From 1919 to 1939 Lvov belonged to Poland. Only in 1939 did Lvov become a provincial center of the Ukraine.

7. See Vadim Pavlovsky, *Vasil Krichevsky*, New York, 1974.

8. On Abram Manevich, who lived in New York from 1922 until his death in 1942, see Ilia Ehrenburg, "Vystavka A. Manevicha," *Parizhskii vestnik*, March 8, 1913, no. 10; A. Lunacharsky, "Abram Manevich," *Prozhektor*, September 23, 1928, No. 39 (157), pp. 13–14.

9. Sergei Tratiakov and N. Aseev, *Khudozhnik V. Palmov*, Chita, 1922, p. 26.

10. See Z. V. Kucherenko, *Vadim Meller*, Kiev, 1975 (in Ukrainian); D. Gorbachev, *Petritsky*, Moscow, 1971 (in Russian).

Bogomazov's work is close to the art of the Russian members of the Munich group (Vladimir Bekhteev, V. Kandinsky, A. Jawlensky).

The fall of the Russian Empire after World War I prompted the secession of the Ukraine, and in January 1918 it was proclaimed an independent sovereign power. The Civil War (1918–20), however, stormed across the land, bringing terrible calamities to the people. The Ukraine became an arena of bloody battles between the Whites and the Reds. Kiev changed hands eleven times—which, inevitably, brought bloody reprisals to the civilian population. Railroad transportation was disrupted, and food deliveries from the villages to the big town virtually ceased. People suffered from a lack of fuel and from epidemics. Hospitals were full to overflowing with wounded and there were no drugs, no medical help. Yet, in spite of this total collapse of normal conditions, the major cities of the Ukraine—Kharkov (the Ukrainian capital from 1919 until 1934), Kiev, Odessa, and Lvov (most of its population is Ukrainian)[6]—continued to organize exhibitions, public lectures, and splendid theatrical productions.

An event of great national significance was the opening of the Academy of Arts in Kiev early in February 1917. Initially eight professors made up the basic faculty, and each had complete freedom in his choice of program and pedagogical system. Elected first rector of the Academy was V. Krichevsky, a famous landscapist, graphic artist, and architect who attempted to create a neo-Ukrainian style of architecture.[7] The Academy contained eight studios by the fall of 1918: M. Boichuk headed the composition studio, Fedor Krichevsky and A. Murashko taught studio painting, N. Burachek and A. Manevich were in charge of the landscape studio,[8] and Y. Narbut headed the graphics studio. Each of these artists was distinctive in his style, in his artistic evolution, and in his conception of the role of art under the new historical conditions. M. Boichuk, who had spent many years in Paris where he worked and exhibited, avidly supported the idea of collective creativity exercised by the medieval guilds; he consciously aspired to develop essential forms for an "art of the masses," relying upon the ancient traditions of anonymous Ukrainian artists (fig. 2).

The antipode to the monumental art of the Academy was the art produced by the two main avant-garde trends: Cubo-Futurism and Constructivism. In Kiev, Viktor Palmov (fig. 3) was at the center of the former direction, "a Futurist or, rather, a Cubo-Futurist because the problems of mass and force interaction are resolved with particular importunateness and inventiveness via the color and texture of his vital compositions."[9] As for Constructivism, this found extensive application in

4.
Vadim Meller (1884–1962)
Construction, 1920s
Location unknown

5.
Anatolii Petrisky (1895–1964)
Composition, 1922
Location unknown

the "productional art" of the 1920s and in theatrical presentations. The costumes and décor of Vadim Meller (fig. 4) and Anatolii Petritsky (fig. 5) have particular charm, originality, and color.[10] Both of these artists, although different stylistically, applied themselves to studio painting, book design, and revolutionary spectacles.

There were a few artists who stood quite alone; they refused to espouse the local, domestic trends and instead gave their emphatic support to European movements—avoiding the slightest shade of conventionality, provincialism, or any kind of "local color." The most important of these were Andreenko and Kovzhun, who pursued analytical Cubism and left the Ukraine in the early 1920s to ▶

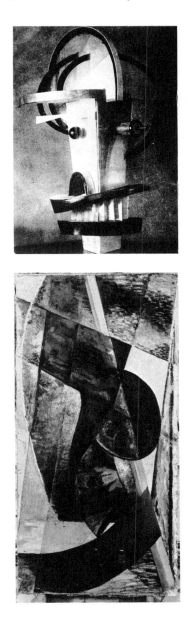

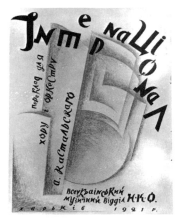

6.
Vasilii Ermilov (1894–1968)
Book Cover, 1921

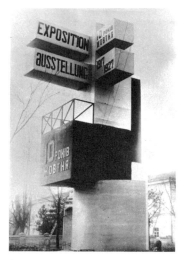

7.
Vasilii Ermilov
Rostrum for Tenth Anniversary of the Revolution, Kharkov, 1927

11. Valerii Polishchuk, *Vasil Ermilov*, Kharkov.

12. Zinovii Fogel, *Vasilii Ermilov*, Moscow, 1975, p. 26.

work abroad. The sculptor Archipenko, who left the Ukraine for Paris in 1908, followed the example of his colleagues. Archipenko merits the highest praise for his resolution of the problem of correlating hard elements (wood, stone, marble) with elements of spatial planes (equal in their compositional importance). Moreover, beginning in 1912 he began to integrate convex and concave forms with a supplemental, diverse texture in a color scale of thick tones. The influence of the Parisian-based Archipenko on Russian artists—Ivan Kliun, Naum Gabo, Jacques Lipchitz, Osip Zadkine—is very evident, as is his influence on Vasilii Ermilov, one of the principal artists of the Ukraine.

Ermilov was one of the most significant figures among the artists of Kharkov. He was a member of the Gub. ONO Art Committee (Gub. ONO was the Provincial Department of Popular Education), and he took an active part in finding work for artists and in organizing exhibitions.

Beginning in 1919, Ermilov began to work in two quite different directions: on the one hand, he fulfilled government commissions, and on the other, he carried out his own individual research. Ermilov distinguished himself in both by his original style of painting, by his harmony of color and lines, and by the impeccable proportions of his compositional structure.

Ermilov first emerged as an official professional artist when he worked on the decorations for the popular festival of May 1, 1919, in Kharkov. He decorated the central square and the houses of the adjacent streets with shields, arcs, huge stenciled portraits of leaders, and posters carrying graphic slogans. V. D. Polishchuk, the comrade-in-arms of Ermilov, his first biographer, and an acute observer of that epoch, recalled with obvious pride those days long gone by:

This was the great "dictational" period of our art. All the streets and houses were strident with the colors, slogans, flowers, shields, and arcs of Ermilov. This was the spirit of the revolution in colors. There had never been anything like it before, and to our great misfortune, none of it was saved for posterity. That was the unique style of the time.[11]

According to Ermilov—and in complete agreement with the views of the "production artists"— "that epoch demanded not 'academic' portraits and landscapes, but agitational monumental murals, severe constructions, expedient and necessary objects which organized and ordered their life and work."[12]

In 1920 Ermilov received first prize for his design project for the facade of the Shevchenko Theater in Kharkov where the Fourth All-Ukrainian Congress of Soviets took place. Encouraged by his success, Ermilov continued to work on monumental, decorative murals in all manner of buildings, adjusting the subject matter to the aims of the emerging proletarian culture. In 1920, for example, Ermilov decorated the walls of the Central Garrison Red Army Club using a Constructivist style painted in tempera. The subject for the auditorium was labor—the worker, the peasant, the Red Army soldier.

In the decoration of the lounge, the composition corresponded to the slogans "factories and plants to the workers; land to the peasants; education for all; peace to the huts, war to the palaces." The chess room was designed in the form of a chess board on which the red pawns were attacking their white opponents. In the gym, the wall space assigned to the figures harmonized well with the volume of the interior. The only assistant whom Ermilov invited to help him was the signboard painter Shuk. Ermilov and Shuk painted the agit-train *Red Ukraine* in 1921; in the words of Ermilov, it eventually became like "a painted wedding chest on wheels." Although the agit-train was intended for political propaganda, it was actually an extension of the traditional patterns of popular Ukrainian art, like those of embroideries, stove tiles, and all manner of peasant utensils for domestic use. The repeated motif of the sun's disc on the train cars was borrowed by Ermilov from the ancient Slavic images in which the sun embodied the awakening of nature, the source of life, fertility, and happiness.

This correlation of architectural and Constructivist forms and the traditional ornament of popular art also served for the decoration of book covers, advertisements, and political posters. Ermilov created his own particular typography in 1918: he spaced out his letters in an arbitrary curving arrangement, each of the letters differing sharply from the next in size, color, and style (fig. 6). This approach was somewhat reminiscent of the Old Church Slavonic script that the chroniclers used when copying monastic codes and holy books. Ermilov's thirty-meter poster of 1920 representing idle locomotives against the background of the walls and chimneys of idle factories is very typical. "The dead steam-engines, the idle factories await the Donbas coal." The train, according to the novelist Joseph Kessel, was one of the great myths of the Revolution, embodying the power of the machine, its speed of movement and intoxicating freedom. Also in 1920 Ermilov's topical pictures with their militant captions in verse began to appear regularly in the *Ukrosta* windows on the main street in Kharkov. Ermilov borrowed this method of political propaganda from the poet Maiakovsky.

On the occasion of the tenth anniversary of the Revolution in 1927, Ermilov designed a rostrum or stand in Kharkov (fig. 7). Very modern in style and

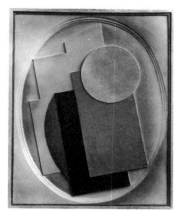

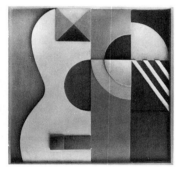

13. Ibid., p. 40.

14. Komashko wrote: "I assert that under the guise of 'Boichukism' we can see an obvious example of how hostile forces are undermining the ideology of the dominant proletarian class by means of art—both in the USSR and in the Ukrainian SSR. We can also see how opportunists are making every effort to disguise this hostile ideology by, as always, using 'revolutionary' phraseology and 'Marxism.'" *Chervonyi shliakh (Krasnyi put)*, no. 5, 1931, p. 104.

15. Ibid., p. 105.

16. Ibid., p. 108.

17. Ibid., p. 106.

18. Fogel, *Vasilii Ermilov*, p. 39.

19. Ibid., p. 19.

form, this was "first and foremost an architectural construction in which the supportive and the constructive elements are inseparable from the purely decorative aspect; they are all created in the classical, constructive spirit, and they constitute an artistic, architectural whole."[13] Using the same constructive method, Ermilov also built two mobile, collapsible "wall-newspapers" for the 1928 international exhibition in Cologne: *The Generator* and *Kanatka*. These installations were highly unusual, original pieces by virtue of their combination of various printed scripts with colored wood and brass components in a very appropriate color scheme (black, white, crimson, brick red, and brick green).

The last government commission that Ermilov fulfilled in Kharkov was for the House of the Pioneers in 1934–35. He designed the interior spaces and their fixtures, including the furniture, toys, and rugs made at a factory from his designs. Judging from the surviving photographs, from the designs, and from the testimony of the artist himself, we are able to gain a good impression of the complexity and extraordinary proportions of the entire composition.

When the capital of the Ukraine was once again transferred to Kiev in 1934, Ermilov was asked to design and equip a whole range of buildings: the House of Defense, the exhibition rooms of the theater museum, the Ukrainian pavilion interiors for the All-Russian Agricultural Exhibition. It has been impossible to find even a trace of these works from 1936–37—an indication that they were totally destroyed as a result of the persecution of formalist artists at that time. An illustration of how accounts were reckoned among artists is provided by the public lecture delivered by the mediocre but aggressive artist Anton Komashko, at the Kharkov Institute of Arts. His lecture was published in 1931 in Ukrainian.[14] "There is no point in pretending that a proletarian class art is growing, when some people are still against Lenin's national policy of art."[15] "The proletarian wing of the AKhChU (Association of Artists of the Red Ukraine) had to make every effort to smash the hostile forces which, by disguising themselves, managed to foist themselves upon the Association under the pretense of creating a Soviet artistic culture and a national Ukrainian form. What I have in mind are the petit-bourgeois Ukrainian artists with their chauvinistic 'spirit' of Kievan patriotism."[16] A champion of "the interpretation of the October Revolution and the implementation of art education for the masses in the spirit of Leninism,"[17] Komashko supported the move to eradicate the new aesthetic research in art.

From the late 1930s until the early 1960s, Ermilov secured his livelihood by conforming to the norms of the quasi-classicism of the Stalinist state.

Although his activities as an official artist were diverse and fruitful, they did not utilize the full potential of his aesthetic research and creativity. Throughout his life, Ermilov "continues to work on the problems of color, volumetrical form, visual gravity, texture."[18] As early as the First Proletarian Exhibition of 1919, Ermilov presented his pictures-cum-objects as color compositions of wood, glass, and metal—correlations of geometric figures such as a square, a cube, a circle, and a triangle (fig. 8). This allowed Polishchuk to call the Ermilov of this period an "artist-Suprematist,"[19] i.e., a disciple of Kazimir Malevich's aesthetic system. There are no really serious grounds, however, for supporting such an assertion since Ermilov was a long way from artistic philosophizing. Sometimes his paintings do have an external, iconographic resemblance to Malevich's Suprematism, although, essentially, they are very different. If, for Malevich, color served to dissolve the outlines of the object, Ermilov, on the other hand, tried to attain a maximum precision of volumetrical, concrete form through his color variations (fig. 9).

Ermilov tried to utilize all possibilities in his new combinations of materials, introducing real volumetrical objects of everyday use into his constructions of the early 1920s, for example, a knife and a box of matches with a semi-circular metal cut-out. As early as 1914 Russian artists began to use the most diverse elements in their pictures including appliqués (collage) of different colored papers and cut-outs. At the exhibition *0–10* in Petrograd in 1915–16, I. Kliun placed an ordinary house fan on his painting; the poet Vasilii Kamensky put a mouse-trap in his relief (1915); Ivan Puni glued a plate to a wooden board (1915); Kazimir Malevich fastened a real thermometer to one of his paintings at *The Store* exhibition organized by Tatlin in 1916.

These everyday domestic objects, however, were an intrinsic part of the new construction of pictorial space and did not possess a negative, conceptual character. The Russians did not differentiate between the act of destruction and the act of creating new forms: Tatlin's counter-reliefs are a graphic example of this—works in which the combination of various materials transforms the traditional texture of ornaments carved from metal and other materials; now they are extended into new and absolutely non-objective forms. Tatlin the "Constructivist," rather than Malevich, was the artist who may have had some influence on Ermilov, as with his counter-reliefs. However, the resemblance between Ermilov and Tatlin is very slight. Tatlin's counter-reliefs rely on a maximum convex structure, on the combined natural nuances of the materials without the addition of color. (See Dabrowski essay.) They have, moreover, a dynamic ▶

20. Ibid., p. 18.

21. The theatrical design collection of Mr. and Mrs. N. D. Lovanov-Rostovsky contains some very rare decorative works by the Ukrainian artists M. Andreenko, A. Bogomazov, V. Meller, A. Petritsky, and A. Exter.

potential, exposing the spontaneous instant of movement—just as the Italian Futurists do, particularly Boccioni. But Ermilov's "experimental compositions" are static, constructed according to a strict symmetry of form and color.

Clearly, we should look for the real source of Ermilov's "experimental compositions" in the work of his fellow countryman Alexandr Archipenko, an artist whom he felt himself close to although Archipenko had emigrated to Paris in 1908. According to Archipenko himself, he began to create his sculpto-painting from wood, glass, and metal as early as 1912; the sculptural painting is polychromatic, made by analogy with the high reliefs on the ancient Russian churches of the Vladimir-Suzdal Princedom, and painted like the flat capitals on Romanesque temples. The sculpto-paintings are striking not only in the uniformity of their constructive forms, but also in their decorative elements as, for example, the corrugated ornament of *The Bather,* 1915 (Philadelphia Museum of Art). Ermilov used this in his *Composition with a Window* of 1922, as he also did the conic, round surface slightly in relief on a smooth square plane (cf. Archipenko's *Woman with a Fan,* formerly in the collection of G. Falk).

We are no longer aware of the speed with which information about the European art world reached Russia and the Ukraine. For example, Archipenko created his sculpto-painterly composition *Woman in Front of a Mirror* in 1914, and by the end of 1915 Kliun had reproduced an analogous construction under the title *A Cubist at Her Dressing Table* (fig. no. 12, in Douglas essay).

In 1927 Ermilov sent eighteen works to the ARMU (Association of Soviet Artists of the Ukraine) exhibition in Kharkov (Ermilov was an active member of ARMU). These included six experimental compositions, five plaques with letters, four landscapes, two commercial posters *(The Red Candymaker* and *Read the Books of V. Polishchuk),* and one still life. Apart from the lettering plates and the posters, these works integrated various elements—oil and wood, glass, copper, and enamel. Ermilov made audacious combinations of form and color—proving the extent to which he had mastered the intricate technique of painterly texture. In Zinovii Fogel's opinion, Ermilov's works "were amazing in their virtuosity, the mastery evi-

dent from the way the materials had been treated and in the unfailing taste with which the textures had been selected and combined"[20]—not to mention the richness of Ermilov's palette numbering 350 tones of the primary colors. Ermilov also took part in the First All-Ukrainian Exhibition, organized in Kharkov in November 1927 on the occasion of the "Tenth Anniversary of October." Here he displayed some of the works that he had shown at ARMU. But the storm clouds had gathered above the Constructivist artists and, apart from Ermilov, the other participants refrained from showing their so-called "formalist" works.

Not despairing, Ermilov tried to work on "utilitarian-productional" art. In 1929 he attempted to turn his efforts to the theater—an activity in which Ukrainian artists of the 1920s were unequalled for vibrant décors, inventive and novel constructed moving parts, splendid costumes, and audacious sets.[21] For the unrealized production of Lesia Ukrainka's *Lesnaia pesn (Song of the Forest)* Ermilov did a series of costume and set designs. His final but vain attempts to return to a free art came during the last years of his life. In 1961 he made a project for a "Monument to the Epoch of Lenin," light and beautiful in form, reminiscent in its conception of Lipchitz's bronze *The Bather* of 1915 (Hirshhorn Museum and Sculpture Garden, Washington, D.C.). In 1967 he constructed an imposing, interesting maquette for a memorial museum to Picasso—a cylindrical form on a tall base standing at the top of a flight of steps which served as the decorative foundation of the entire building. Unfortunately, these projects never materialized, although in them Ermilov remained loyal to his irreproachable sense of proportion, precision of line, and harmonic combination of parts within a single whole.

If the name of Ermilov and some of his fellow Ukrainians—Bogomazov and Petritsky—have become known to some degree in the West, this is because their works have been shown here. Unfortunately, to this day both the works and the names of primary Ukrainian artists are still unfamiliar to the Russians. Their works lie hidden away under lock and key. ●

Translated from the Russian by John E. Bowlt

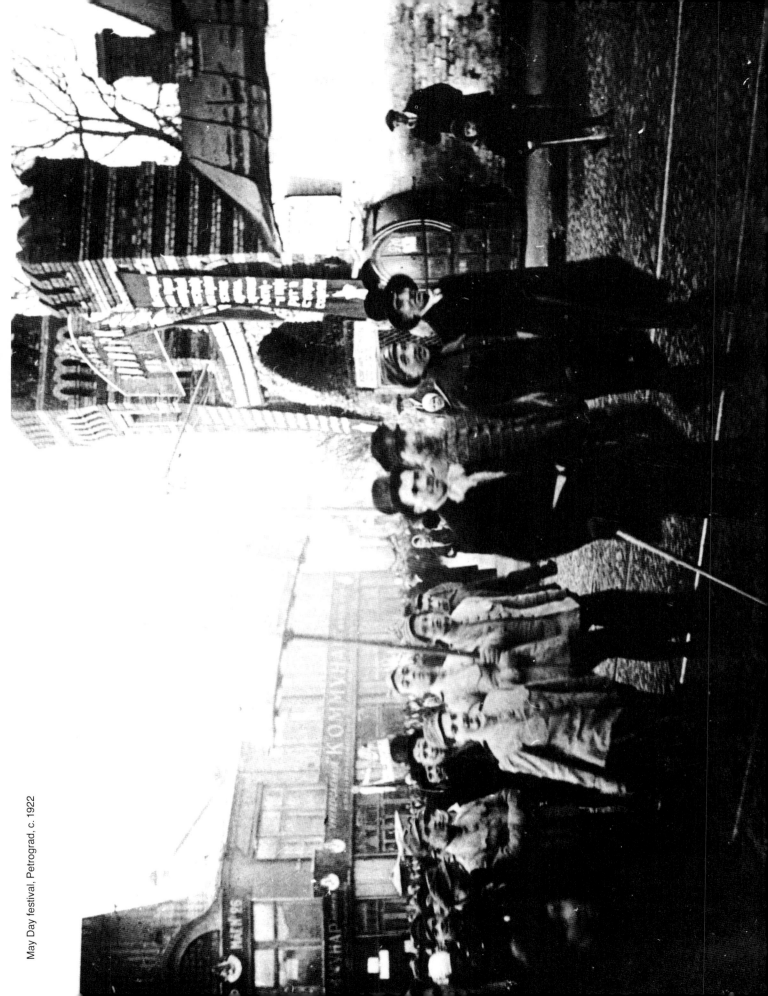

May Day festival, Petrograd, c. 1922

Alexandr Rodchenko as Photographer

John E. Bowlt

1. The most comprehensive sources of information on Rodchenko as painter, designer, and photographer are G. Karginov, *Rodtchenko*, Paris, 1977; *Alexander Rodchenko*, exh. cat., Museum of Modern Art, Oxford, and other institutions, 1979. On Rodchenko as photographer, see *Rodtschenko: Fotografien 1920–1930*, ed. E. Weiss, Cologne, 1978. This was published in connection with an exhibition of Rodchenko's photographs at the Museum Ludwig, Cologne, 1978. The present essay is a rather different version of the one published there in German translation.

2. Of the few studies available, the following are particularly useful: S. Morozov, *Russkaia khudozhestvennaia fotografiia; ocherki iz istorii fotografii 1859–1917*, Moscow, 1955; M. Nappelbaum, *Ot remesla k iskusstvu*, Moscow, 1958; L. Volkov-Lannit, *Iskusstvo fotoportreta*, Moscow, 1967. There is no serious Western publication on the subject, although the question of Russian/Soviet photography will be receiving attention in subsequent issues of *History of Photography* under the editorship of Heinz K. Henisch (Pennsylvania State University). Some relevant information is provided by Juliusz Garztecki, "Early Photography in Poland," *History of Photography*, University Park, Pennsylvania, vol. 1, no. 1, 1977, pp. 39–62. Also see S. Compton, "Art + Photography," *The Print Collector's Newsletter*, New York, March/April 1976, pp. 12–15.

3. Letter from Vereshchagin to Vladimir Stasov dated December 31, 1881, in *Perepiska V. V. Vereshchagina i V. V. Stasova*, ed. A. Lebedev, Moscow, 1951, vol. 2. p. 105.

4. See O. Brik, "Foto-kadr protiv kartiny," *Sovetskoe foto*, Moscow, no. 2, 1926, pp. 40–42.

■ Alexandr Mikhailovich Rodchenko (1891–1956) is now widely appreciated for his abstract painting, his freestanding and hanging constructions, and for his polygraphical experiments.[1] But his photographic work was just as innovative and deserves particular attention. The question of photography in Russia and the Soviet Union is still an obscure one, and even in Soviet scholarship it has been relegated to a secondary position, at least in relationship to the visual arts as a whole. In the context of the nineteenth century such neglect can, perhaps, be understood since the Russian photographer was as much affected by the general realist orientation as were his colleagues in the other arts, and he scarcely exploited the intrinsic, aesthetic components of the photographic art. Only with the advent of Mikhail Kaufman, Georgii Petrusov, Sergei Tretiakov, V. L. Zhemchuzhnyi, and, of course, Rodchenko and his disciples such as Eleazar Langman, did Russian photography command a high status as an artistic medium possessing unprecedented potential for objective and subjective expression. That photography is a malleable and plastic art is demonstrated nowhere more clearly than in the photographs of Rodchenko: whether he concentrated on fact, as in the sports scenes of the 1930s, or on form, as in the shots of glass surfaces in 1928, Rodchenko's photographic style was subtle, emotive, idiosyncratic. The purpose of this article is to examine both the fact and the form of Rodchenko's photographic endeavour and to place this in the general framework of Russian photography.

What was the historical context that Rodchenko, the photographer, entered? The nineteenth-century Russian photographer was no less enterprising than his European and American counterparts.[2] Thanks to such able photographers as Maxim Dmitriev and Sergei Lobovikov, we now have a valuable visual archive of types, rituals, personalities, and places of pre-Revolutionary Russia. Although portraiture was the most successful genre, the Russian photographer Ivan Barshchevsky, for example, also rendered an essential service by recording the art and architecture of ancient Russia. He also did much to advance his métier by publishing specialist magazines, establishing societies such as the Russian Photographic Society, and organizing national and international exhibitions. Still, nineteenth-century photography in Russia was, as elsewhere, severely handicapped by a single historical circumstance: while, in the mid-nineteenth century, photography and painting proceeded from the same "optical" derivation—that is, from a naturalist representation of reality—only painting changed its style radically as the century advanced. Despite the many attempts to treat the photographic print cosmetically, it remained

primarily a means of instantaneous fixation. Rarely was the Victorian photograph photographic. If the traditional photographer did concern himself with aesthetic and formal issues, then, as Brik, Rodchenko, and Nikolai Tarabukin would repeat in the 1920s, he tried to adjust his craft to the methods and criteria of studio painting. Consequently, the "best" photograph—duly retouched, tinted, and smudged—was the one that resembled an oil, a watercolor, or an etching.

On the other hand, nineteenth-century photography exerted an appreciable influence on the development of Russian painting. Many of the Russian Realists, not least Ivan Kramskoi, Ilia Repin, Ivan Shishkin, and Vasilii Vereshchagin, were impressed by the photograph, especially during the 1870s, and some even worked as photographic retouchers. In their attempts to transmit detail and contrast, they were sometimes accused of concocting "painted photographs of nature,"[3] a not unjust criticism. The individual leaves rendered so accurately in Shishkin's *Morning in a Pine Forest* of 1889 or the fretwork on Vereshchagin's *Gates of Tamerlane* of 1872–73 are little more than documentary records, and as Brik would have said fifty years later, could have been made by a camera just as effectively and in a fraction of the time.[4] The influence of photography, however, on nineteenth-century Russian painting was not entirely pernicious. If the French Impressionists resorted to the principles of photography with positive results for their art, then the Russian Luminists, like their American counterparts of the Hudson River School, were no less indebted. Those qualities that we identify with the landscapes of Bierstadt, Church, Heade, and Lane, and that derived in part from an awareness of the photograph—brilliant and refractive light, strong horizontal structure, attention to detail, panoramic space—were also manifest in the work of Arkhip Kuindzhi. The audacious spectral contrasts and light effects of Kuindzhi's landscapes, his steroscopic views of the River Dnepr, his sunsets, and his experiments in light/shade contrasts (e.g., *The Birch Grove* of 1879) both separated Kuindzhi from the usual didactic work of his Realist contemporaries and at the same time anticipated some of the remarkable discoveries in pure painting of the twentieth-century avant-garde.

Kuindzhi was an exception, and for the most part his colleagues did not borrow from photography with such beneficial results. For better or worse, the uneasy alliance between painting and photography of the 1870s and 1880s was broken with the advent of more progressive trends in Russian art. Russian Symbolism, with its rejection of the world of appearances, had little contact with photography (even though Symbolist writers such as

5. B. Livshits, *The One and a Half-Eyed Archer*, trans. John E. Bowlt, Newtonville, Massachusetts, 1977, p. 167.

6. Vladimir Maiakovsky, "Teatr, kino, futurizm," *Kinozhurnal*, Moscow, July 27, 1913. Translation in Jay Leyda, *Kino*, London, 1960, pp. 412–13.

7. A reproduction of one of these photographs can be found in *Malevich*, ed. T. Andersen, exh. cat., Stedelijk Museum, Amsterdam, 1970.

8. These are vogue words of the Soviet 1920s and can be translated as "purists, applied artists, and productional mystics." The description is from *Lef*, Moscow, no. 2, 1923, p. 174.

9. Varst (Stepanova), "O rabotakh konstruktivistskoi molodezhi," *Lef*, No. 3, 1923, p. 53.

Andrei Bely and Alexandr Blok loved to have their pictures taken). Cubo-Futurism and the various non-objective schools that followed also had little use for the conventional photograph. The poet Benedikt Livshits, a Russian Futurist and cosignatory of the famous manifesto *A Slap in the Face of Public Taste* (1912), emphasized the reactionary connotation that photography had for him and his friends when he compared the "1890s peering out of plush family photo-albums with bronze clasps"[5] with the unorthodox and contemporary art that he supported.

Although Russia did not have a "Futurist" photography, experiments in avant-garde cinematography were undertaken and widely discussed. As early as 1913 Maiakovsky wrote an article on Futurism and the cinema,[6] and the following year saw the production of *Drama in the Futurists' Cabaret 13* starring David Burliuk, Natalia Goncharova, et al.; Maiakovsky, Burliuk, and Kamensky starred in the Futurist adaptation of *Creation Can't Be Bought* produced in 1918. But such cinematographic work was, essentially, reproductive; it was still part of the Naturalist tradition and hardly exploited the intrinsic components and potentials of photography and film. Even the snapshots of the Futurist personalities, such as the double exposures(?) of Alexei Kruchenykh, Malevich, and Mikhail Matiushin (1913),[7] were documents and not "photography as an end in itself." On the other hand, photography itself impressed members of the avant-garde, and Mikhail Larionov, like the Italian Futurists, approached a high-speed photographic effect in his Rayonist paintings of 1912–13. Photography was also used as a creative component in Cubo-Futurist painting, i.e., as part of the collage systems in the compositions of Malevich and Alexei Morgunov about 1914. In *Woman at an Advertisement Pillar* (1914), for example, Malevich used part of a photograph of a dancing couple both to remind the viewer of the kind of announcement that an ad pillar of this kind carried and also, by juxtaposing it with illogical elements and planes of color, to disrupt any normal semantic progression in the picture. The result is a *transrational* painting, even though the photographic ingredient is, once again, illustrative and auxiliary.

The introduction of photographic fragments into the Cubo-Futurist painting at once combined two pictorial disciplines that, while mutually influential, had rarely been mixed; and it is significant that precisely at the moment when the whole purpose of image reproduction and imitation was being questioned—by the Cubo-Futurists in Russia and by the Futurists and Dadaists in Western Europe —painting and photography joined forces. How did this sudden confrontation affect photography? Unfortunately, and unexpectedly, it did not stim-

ulate the development of abstract photography in Russia, and despite the use of photocollage in paintings such as *Woman at an Advertisement Pillar,* the possibilities offered by photocollage and photomontage remained unexplored until after the Revolution. Even the experience of the First World War did not attract photomontage artists in Russia, and the most effective posters and illustrations on military themes were executed by painters, not by photographers, especially by representatives of the avant-garde such as Maiakovsky, Malevich, and Lentulov working in the traditional format of the *lubok* (a cheap, hand-colored broadside).

Rodchenko himself began to use photographs in collages in 1919 in a series of "Dadaist" compositions incorporating cigarette packs, tickets, colored paper, and photographic details. Rodchenko also used this method as an illustrative system for Ivan Aksenov's *Gerkulesovy stolby (Pillars of Hercules)* in 1920 (not published). Between 1920 and 1922 Rodchenko gave increasing attention to the photograph, at first as a simple element of design and then as an aesthetic unit in its own right. The real stimulus to Rodchenko's deep interest in the photograph as a creative medium derived from his conclusion in 1921 that the traditional studio arts had reached an impasse and that other contemporary disciplines offered artistic results more appropriate to the time.

In September 1921 Rodchenko, together with Alexandra Exter, Popova, Stepanova, and Alexandr Vesnin, organized the exhibition *5 x 5 = 25,* to which he contributed *Line, Check,* and three monochrome canvases of yellow, red, and blue. This exhibition marked a turning point in the creative careers of Rodchenko and his colleagues, for immediately thereafter they publicly rejected studio art and voiced their allegiance to industrial design. Rodchenko's service to the development of Soviet design in porcelain, furniture, architecture, and the theater forms the subject of a separate study, and detailed discussion of this falls outside the scope of the present essay. But mention should be made at least of the patient and productive endeavors by Rodchenko to develop the program for the Department of Metalwork at Vkhutemas and to oppose the many "anti-Contructivist" factions both inside and outside the school—the *"chistoviki, prikladniki, proizvodstvennye mistiki."*[8] As Stepanova wrote in her review of the first exhibition of industrial projects by Rodchenko's students in 1923: "The exhibition is the first breakthrough by Constructivist students in their struggle against the contagion of aestheticism. This is a brilliant demonstration of the fact that the discipline of the material design of an object has nothing in common with the thing's aesthetic composition; the latter leads merely to just another new artistic style."[9] ▶

1.
Alexandr Rodchenko (1891–1956)
Rodchenko's Mother, 1924
Photograph
39 x 29 cm. (15⅜ x 11⅜ in.)

2.
Alexandr Rodchenko
Cogwheels, 1930
Photograph
6.5 x 10 cm. (2½ x 3⅛ in.)

10. From *Pravda*, Moscow, March 30, 1924. Quoted from L. Volkov-Lannit, *Alexandr Rodchenko risuet, fotografiruet, sporit*, Moscow, 1968, pp. 25–26.

11. From the manifesto "Tovarishchi, formovshchiki zhizni" in *Lef*, no. 2, 1923, p. 4. Translation in John E. Bowlt, *Russian Art of the Avant-Garde: Theory and Criticism 1902–34*, New York, 1976, p. 201.

12. The collection was called "Tam, gde delaiut dengi" and was published in the journal *Tekhnika i zhizn*, Moscow, 1924.

13. The book was not published, but some of Rodchenko's illustrations (on which Stepanova also worked) appeared in *Novyi lef*, Moscow, no. 1, 1927, between pp. 18 and 19.

Rodchenko's own contribution to utilitarian design was varied and original, especially in the context of commercial advertising. With Maiakovsky, who often wrote the captions, Rodchenko produced about fifty advertising posters and about one hundred signboards between 1923 and 1925. Maiakovsky and Rodchenko accepted commissions from all manner of Soviet enterprises—from cigarette manufacturers and book publishers to makers of babies' comforters and candies. Although Rodchenko composed his first collages using photographs in 1919, designed his sensational photomontage cycle for Maiakovsky's *Pro eto (About That)* in 1923, and began to photograph professionally in 1924, he rarely employed photographs in his advertising designs. He preferred to rely on his experience as a technical draftsman and to reduce the design to simple, laconic, and vivid forms, to vibrant colors, and to a dynamic, often diagonal superimposition of text on image. The newspaper *Pravda* described the new endeavor in the following manner in 1924:

> Maiakovsky and Rodchenko...are making new candy wrappers, designs and agit-captions.... The agitational importance of this undertaking consists not only in the two-line captions, but also in the replacement of those old "candy" names and designs by ones which show distinctly the Revolutionary, industrial orientation of the Soviet Republic. Because the taste of the masses is formulated not only by, say, Pushkin, but also by every wallpaper design, by every candy wrapper design.[10]

This attitude toward social reality—that mass taste is influenced by the design of everyday objects rather than by the models of "high art"—was closely identifiable with the group known as *Lef* (Left Front of the Arts) established in Moscow in 1923 by Boris Arvatov, Osip Brik, Nikolai Chuzhak, Kushner, Maiakovsky, Sergei Tretiakov, et al. The journal of the same name (1923–25) advanced their credo loud and clear in a series of manifestos in the first numbers: *"We summon the 'leftists,'"* the revolutionary *Futurists,* who have given the streets and squares their art; the *Productivists,* who have squared accounts with inspiration by relying on the inspiration of factory dynamos; the *Constructivists,* who have substituted the processing of material for the mysticism of creation."[11] Rodchenko was a keen supporter of *Lef,* and from the very beginning designed the journal's covers and was represented there by text or image. In 1927 the group revived the journal under the title of *Novyi lef* (New Left) and focused attention on the new arts of cinematography and photography, especially of Rodchenko. In 1929 the group changed its name to *Ref* (Revolutionary Front), and the following year, under both internal and external pressures, it disinte-

grated. Even though Rodchenko's alliance with *Novyi lef* was an uneasy and controversial one (as his polemics with Kushner illustrate very clearly), it served as a necessary outlet for his photographic work, reproducing snapshots and stills from movies in which he was involved (such as Lev Kuleshov's *Your Acquaintance* of 1927 and Leonid Obolensky's *Albidum* of 1928). The closure of the journal in 1928 and the disbandment of the group were a great loss to Rodchenko the photographer, the designer, and the theorist.

While Rodchenko may have neglected the photographic element in his advertisements, he was, by 1923, artistically prepared to enter the world of photography; it was a logical and inevitable step. What is remarkable here is the rapidity with which Rodchenko became a serious and innovative photographer, testing many instruments and techniques until he acquired a German-made Leica in 1928—thenceforth his most reliable and most flexible camera. Rodchenko's first published work in 1924 (his collection illustrating the people and procedures of the Soviet Mint)[12] was not distinguished by any experimental quality, but his photographic portraits of the same period—of his mother (fig. 1), Maiakovsky, and others—were unprecedented in the history of Russian photography. Rodchenko contributed some of them to the comprehensive exhibition *Ten Years of Soviet Photography* in Moscow in 1928. By the mid-1920s Rodchenko was making audacious experiments with photography and concentrating—briefly—on the "how" rather than the "what," as his cartoons for Sergei Tretiakov's book *Samozveri (Self-Animals)* of 1926 and his transparent still-lifes of 1928 indicate very clearly.[13] Although Rodchenko still proved his political reliability on many occasions—for example, by designing the twenty-five photo-posters for the album *Istoriia VKP (b) v plakatakh* (History of the All-Union Communist Party [Bolsheviks]) and by collaborating with Boris Barnet on the propaganda movie *October in Moscow* both in 1927—he came under increasing attack for his "formalism." By the late 1920s, in fact, Rodchenko's photographic work seemed to earn nothing but censure from critics and artists alike—from the Russian Association of Proletarian Photographers, from the journal *Sovetskoe foto (Soviet Photo)* to which Rodchenko contributed, from his own pupils such as Semen Fridland and I. Sosfenov, and even from his own colleagues in the *Lef* group, especially Boris Kushner and Tretiakov.

In 1922 Rodchenko joined the staff of Gan's magazine *Kino-Fot,* contributing regularly to its cover design. This marked the beginning of a productive alliance with the movie industry, during which Rodchenko worked with the country's leading directors and cameramen: as Shklovsky wrote

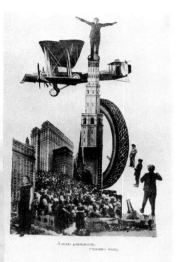

3.
Alexandr Rodchenko (text by Vladimir Maiakovsky)
Pro eto, 1923
Letterpress
22.1 x 14.7 cm. (8¾ x 5¾ in.)
Australian National Gallery, Canberra (cat. no. 305)

14. V. Shklovsky, "Alexandr Rodchenko—khudozhnik-fotograf," *Prometei*, Moscow, no. 1, 1966, p. 402.

15. Klucis discussed the propaganda function of photomontage in his article "Fotomontazh kak novyi vid agitatsionnogo iskusstva," *Izofront: Klassovaia borba na fronte prostranstvennykh iskusstv*, ed. P. Novitsky, Moscow-Leningrad, 1931, pp. 119–34. It is of interest to note that Solomon Telingater and Sergei Tretiakov published a study of John Heartfield—*Dzhon Khartfild*—in Moscow in 1936.

16. NEP (New Economic Policy), inaugurated by Lenin in 1921, allowed for a partial return to a capitalist style of economy and produced a new kind of bourgeoisie. The NEP period ended in 1929.

7. N. Tarabukin, *Iskusstvo dnia*, Moscow, 1925, p. 122.

8. A. Gan, "Rodchenko," *Zrelishcha*, Moscow, no. 1, 1922, p. 9.

9. The phrase belongs to the artist and writer Alexei Remizov and appears in his book *Podstrizhennymi glazami*, Paris, 1951, p. 72.

"He showed the path of Revolutionary Soviet cinematography to Dziga Vertov, Lev Kuleshov, Sergei Eisenstein."[14] Between 1927 and 1930, for example, Rodchenko contributed set designs to more than five movies including Kuleshov's *Your Acquaintance,* 1927 (also known as *The Journalist);* Rodchenko also designed the poster for Vertov's *Kinoglaz (Ciné-Eye)* in 1924 and the poster and prospectus for Eisenstein's *The Battleship Potemkin* (1925). It is tempting to infer that Vertov borrowed some of Rodchenko's photographic methods, especially his angles "from below up and from above down" for *Man with a Movie Camera* (1929) and that Rodchenko, in turn, derived new subjects from this film for works such as *Street. Driver* (1930) and *Cogwheels* (1930, fig. 2).

From collage and poster art it was a short step to photomontage and to the memorable illustrations for Maiakovsky's poem *Pro eto (About That)* of 1923 (fig. 3). An obvious stimulus to Rodchenko's interest in photomontage was his acquaintance with the experimental work of John Heartfield and George Grosz, examples of which Maiakovsky brought from Berlin in 1922. The illustrative and expository force of *Dada-merika,* 1919 (Grosz and Heartfield), *Dada Photomontage,* 1919 (Heartfield), and similar compositions prompted Rodchenko to use photomontage in his cycle of pictures for *Pro eto.* Actually, Rodchenko was responsible only for the cutout and montage, not for the photographs themselves which were taken by the young photographer A. Shterenberg. *Pro eto* was one of several experiments in photomontage that Rodchenko undertook (mention might also be made of his illustrations to Maiakovsky's *Razgovor s fininspektorom o poezii* [*Conversation with an Inspector of Finances About Poetry*] of 1926) but for him it was not a medium of central concern. In any case, by 1923 photomontage was not a novel phenomenon, and remarkable results had already been achieved by Raoul Hausmann, Max Ernst, Hannah Höch, Heartfield, and Grosz; in Moscow Gustav Klucis had already produced his first photomontage in 1919 and he, together with Lissitzky, Senkin, and Telingater, was soon to establish an effective school of propaganda photomontage.[15]

Pro eto treats primarily of the poet's unrequited love, of his jealousy and frustration, but the affair is described in the setting of contemporary Soviet conditions and touches on topical themes such as the new bourgeoisie (resulting from NEP),[16] Marx, the Kremlin, jazz, etc. Rodchenko illustrates the story by juxtaposing images of the hero and heroine (Maiakovsky and Lily Brik) with fragments of this reality—a telephone, a dancing couple, a samovar, an airplane, etc. Rodchenko, like Maiakovsky himself, parodied and hyperbolized the poet's mood as well as the Soviet middle class, but as illustrations to the love affair, these photomontages evoke a sense of wistful irony, of personal tragedy, not of the universal malaise and intense bitterness typical of contemporary German photomontage. Rodchenko's photomontages for *Pro eto* were eccentric, amusing, even frivolous, but essentially they had very little to do with photography. As the critic Tarabukin wrote in 1925, *"Photomontage has not created any reform in photography itself. The snapshots that the photomontagist uses are still naturalistic."*[17] Rodchenko's acquaintance with the process of photomontage did, however, heighten his awareness of the texture, luminosity, and contrast inherent in a photograph. Moreover, as he worked on *Pro eto,* Rodchenko displayed an acute interest in general photographic developments in Western Europe, such as at the Bauhaus under Moholy-Nagy, and when he was in Paris in the spring of 1925, in connection with the Soviet contribution to the *Exposition internationale des arts décoratifs,* he was also able to broaden his knowledge of modern photographers and photography. Still, the real stimulus to Rodchenko's debut as a professional and experimental photographer in 1923–24 came from another source—namely, his training as an abstract artist.

Early in 1922 Gan wrote of Rodchenko: "By projecting perpendicular planes painted different colors, and by intersecting them with lines of deep direction, he has proved that color serves only as a conditional means of distinguishing one plane from the next. In advancing along this path, he has said that as soon as he finds *another* way of distinguishing one plane from another, he will use it."[18] It is important to note that before he renounced painting and entered industrial design in 1921, Rodchenko was investigating and exploiting specific artistic properties such as the dynamism of line and the whole notion of planarity *(ploskostnost)* and, in general, was attempting to remove conventional perspectives and progressions from his work. Rodchenko was not alone in his researches, and many other artists of the avant-garde—not least Exter, Lissitzky, Popova, and Alexandr Vesnin—were trying to flee their "servility to Euclid."[19] Popova, for example, dismissed the logical sequence of cool to warm colors, and in her "Architectonic Compositions" might place red above black but pink underneath, or she might place blue above yellow and then fuse both. Lissitzky also denied the normal perception of space and equilibrium by constantly asserting and canceling direction. In his "Prouns," for example, Lissitzky often refuses to allow surfaces to meet, thus frustrating the very human desire for lines to converge and solids to touch.

Like Popova, Rodchenko also "distrusted" color, realizing that each color is heavily imbued with traditional narrative and symbolic connotations ▶

4.
Alexandr Rodchenko
Pine Tree in Pushkin Forest, c. 1927
Photograph
29 x 23 cm. (11⅜ x 9 in.)
Robert Shapazian, Inc., Fresno,
California
(cat. no. 317)

5.
Alexandr Rodchenko
Pioneer with a Horn, 1930
Photograph
37 x 29.5 cm. (14⅝ x 11⅝ in.)

20. N. Tarabukin, *Opyt teorii zhivopisi,* Moscow, 1923, p. 16.

21. A. Rodchenko, "Line," in *Von der Fläche zum Raum/From Surface to Space,* exh. cat., Galerie Gmurzynksa, Cologne, 1974, p. 67.

22. A. Rodchenko, "Krupnaia bezgramotnost ili melkaia gadost?" *Novyi lef,* No. 6, 1928, p. 43.

23. See A. Rodchenko, "K foto v etom nomere," *Novyi lef,* No. 3, 1928, pp. 28–29.

24. From a lecture by Popova on the production of *The Magnanimous Cuckold* which she gave at Inkhuk in April 1922. Quoted in E. Rakitina, "Liubov Popova: Iskusstvo i manifesty," *Khudozhnik stsena ekran,* ed. E. Rakitina, Moscow, 1975, p. 154.

25. Opinions on iconic space, opposing that of Rodchenko, are presented in L. Zhegin, *Yazyk zhivopisnogo proizvedeniia,* Moscow, 1970 (Zhegin was a painter and a contemporary of Rodchenko); B. Raushenbakh, *Prostranstvo i ploskost v drevnerusskoi zhivopisi,* Moscow, 1976.

(for example, yellow = the sun) and that the progression cool/warm was a superfluous addition to painting. Rodchenko maintained, as did Gan and Tarabukin, that color in this respect, with "perspective, light and shade, movement, space, and time,"[20] was an empirical element in painting. This assumption accounts, on the one hand, for Rodchenko's contribution of three monochrome canvases of *Pure Yellow, Pure Red,* and *Pure Blue* to the exhibition *5 x 5 = 25* in 1921, and also for his experiments in "noncolor" painting of 1918–21 in black, gray, brown, and white (for example, *Black on Black* of 1918).

While regarding color as "conditional," Rodchenko gave particular attention to line as the most dynamic ingredient in the work of art. He wrote in 1921: "line has conquered everything and has destroyed the last citadels of painting—color, tone, texture and plane.... Line has revealed a new world view—to construct essence and not to depict...to build new, expedient, constructive structures in life, and not from life or outside life."[21] The graphic foundation evident in works such as *Linear Construction* (1918) and the several ruler-and-compass linocuts of that period carries a severe angularity and simplicity; it might almost be taken as a preparatory study for a photographic composition. Apart from the constant play of black and white in the linear works of this time, there are a number of other important points of convergence: a single diagonal often serves as the axis of the composition (compare the vertical paintings of 1920 with *Pine Tree* of 1927 [fig. 4] or *Pioneer with a Horn* of 1930 [fig. 5]); a single basic form is often repeated and modified (compare *Geometric Composition* of 1918 with *Stereotypes* and *Cogwheels* of 1930); a simple grid sometimes organizes the whole picture (compare such drawings of 1919–20 with *Girl with a Leica Camera* of 1934). In other words, some of Rodchenko's photographs may be regarded as figurative extensions of his earlier abstract graphic schemes.

The above-mentioned parallels between Rodchenko's experimental photographs of the middle and late 1920s and his non-figurative paintings and drawings do not fully elucidate the most dramatic element in his photographic work—namely, his extraordinary angles of observation ("from all viewpoints, but not from the 'belly-button'").[22] Obviously there were other sources for the development of Rodchenko's photographic perspective. We can detect another source of inspiration in his abstract work, but this time in his three-dimensional constructions of 1918–21. In some of these Rodchenko rejected the single, stationary view of the artifact and substituted a "multi-perspective" for the traditional "belly-button" one. In addition to five plywood pieces of 1918, Rodchenko also designed six constructions in 1920–21 that folded up into a single plane: one square, two circles, one hexagon, one oval, one triangle. Rodchenko was particularly interested in the economy of form and in the interaction of material and space and in the viewer's perception of that interaction. Rodchenko's "Hanging Constructions" of 1920 (fig. 6), for example, were to be viewed precisely "from below up," as were some of his transparent still lifes of 1928.[23] As a matter of fact, Rodchenko introduced a similar method into some of his stage designs since, like Popova, he felt that the theater could leave behind the "frontal, visual character [of art] which hindered one from examining its function simply as a fluent and working process."[24] In Maiakovsky's *Klop (Bed Bug),* produced by Vsevolod Meierkhold in 1929, Rodchenko designed a series of wooden frames which he placed at strategic intervals on the stage. As the actor moved about the stage, his vision of the environment changed drastically because the slats and limbs of the constructions served as an Op-Art mechanism, almost as a piece of cinema in relief. This was a simple device which Popova had already used in *The Magnanimous Cuckold* in 1922 and which Stepanova had developed the same year in *Tarelkin's Death.*

Rodchenko's contention that painters and photographers of the past had generally rendered reality "from the belly-button" was equally applicable to the theater (the action is played out against the middle ground of the auditorium) and even to literature (characters and episodes are described at eye level and at a middle distance). Of course, there are exceptions to this assumption. Even if, as Rodchenko maintained, icons and Oriental landscapes were painted from the belly-button in spite of their foreshortenings and inverted perspectives,[25] artists in the European tradition had occasionally approached their subjects from varying aerial viewpoints, sometimes from several simultaneously. Such a combination of perspectives is apparent, for example, in Lucas Cranach's *St. Jerome* of 1526, an elliptical composition that places the viewpoint both "from above down" and "from below up." One artist of the twentieth century who repeated this distortive process and whom Rodchenko knew was Kuzma Petrov-Vodkin.

In 1911 Petrov-Vodkin painted an oil entitled *The Novgorod Kremlin.* It is a view of one of the towers and of part of the wall, but rendered in such a way that they appear to be falling onto us: the viewer, as it were, stands on the bank just below the wall and watches the silhouette of the tower cutting diagonally into the dark blue sky. The effect is startling and reminds us at once of Rodchenko's "from below up" photographs taken diagonally, especially *Balconies* (1928) and *By the Monument to Liberty on Soviet Square* (1927). Petrov-Vodkin used this

6.
Alexandr Rodchenko
Oval Hanging Construction, 1920
Painted plywood and wire
83.5 x 58.5 x 53.3 cm. (33 x 23 x 21 in.)
The George Costakis Collection

Alexandr Rodchenko
Krasnaia armiia (The Red Army), 1938
Book, published in Moscow-Leningrad

6. K. Petrov-Vodkin, "Prostranstvo vklida," *K. Petrov-Vodkin: Khlynovsk Prostranstvo Evklida Samarkandiia,* ed. Iu. Rusakov, Leningrad, 1970, p. 559.

7. For details on OST, see V. Kostin, *OST,* Leningrad, 1976. There is a very striking similarity between Luchishkin's painting *The Balloon Has Flown Away* 1926, illustrated in Kostin between pp. 48 and 49) and Vitalii Zhemchuzhnyi's untitled photograph published in *Novyi lef,* no. 4, 1927, between pp. 16 and 17.

8. N. Punin, *Tsikl lektsii,* Petrograd, 1920, p. 17.

9. See, for example. B. Eikhenbaum, Literatura i kino" in his *Literatura Teoriia, kritika, polemika),* Leningrad, 1927, pp. 296–301; V. Shklovsky, Poeziia i proza v kinematografii," *Poetika kino,* ed. B. Eikhenbaum, Moscow-Leningrad, 1927, pp. 139–42.

10. Rodchenko, "Krupnaia bezgramotnost," p. 43.

11. The critic was I. Bokhonov. Quoted in Volkov-Rannit, *Alexandr Rodchenko,* p. 96.

12. V. Rodchenko made this observation concerning the "actual fact of asphalting" in her recent article on her father. See V. Rodchenko, "Alexandr Rodchenko i Moskva pervoi piatiletki," *Revue fotografie,* no. 1, 1977, p. 28.

13. O. Brik, "Ot kartiny k foto," *Novyi lef,* no. 3, 1928, p. 32.

kind of viewpoint in many other paintings such as *Midday: Summer* (1917), where the focus is "from above down," and *Self-Portrait* (1921). There is no evidence to assume that Rodchenko was especially attracted to the work or personality of Petrov-Vodkin, although they were in direct contact immediately after the Revolution. In any case, Petrov-Vodkin arrived at a "non-Euclidian" space through a subjective, cosmic perception: he argued that the eye always apprehends nature slightly from above and from the side and that, consequently, verticals became inclined while horizontals became curved and assumed depth; the result, he continued, was the physical contact of all objects with the universe, opening "unbounded vistas."[26] It would be rash on our part to assume that Rodchenko was influenced precisely by this argument, but we should at least recognize that what Rodchenko was trying to do in photography was paralleled by similar investigations by painters at approximately the same time. The work of members of OST (Society of Easel Painters)—for example, Sergei Luchishkin and David Shterenberg —was especially relevant to this context.[27]

Rodchenko's eccentric viewpoints in his photographs quickly earned him the title of "formalist," and in the late 1920s he was accused of giving more attention to the "how" than to the "what." Rodchenko was, indeed, interested in the formal aspects of photography, and to a certain extent transferred the ideas of the school of literary critics known as the Formalists to the discipline of photography. Obviously, Rodchenko was familiar with their basic concepts since one of their foremost members, Viktor Shklovsky, was his personal friend and colleague on the staff of *Lef.* The Formalists maintained that a work of literature (art) relies for its effectiveness on a complex of devices or methods, one of the most important being that of "estrangement" or "alienation": by making the ordinary extraordinary, the author gives the reader a unique vantage point vis-à-vis a character or locus. The author can "make it strange" through hyperbolic metaphor (as, for example, Gogol did in his character descriptions in his novel *Dead Souls*) or through the adaptation of an unusual point of observation (as, for example, Tolstoi did when he described part of a hunt scene in *Anna Karenina* through the eyes of a hare). Rodchenko repeated this device of "estrangement" in many of his photographs—to the point where some subjects became almost unrecognizable (for example, *Pioneer with a Horn*) much to the bewilderment and indignation of the traditional viewer. Rodchenko's (brief) conception of the photograph as a "professional organization of material elements"[28] in which social considerations were not primary became, therefore, a key issue of criticism

and censure in the 1930s (just as Petrov-Vodkin's spherical perspective did).

Despite the above, Rodchenko's affinities with the literary Formalists (who, incidentally, gave considerable thought to the theory of film and photography) should not be exaggerated.[29] Although optical experiment was crucial to some photographs of the late 1920s, this never replaced the figurative image completely. Rodchenko did not engage in abstract photography or film even though he knew of the photograms of Moholy-Nagy and Man Ray and, presumably, of the abstract movies of Hans Richter and Viking Eggeling. For all the criticism leveled at him in the 1930s, Rodchenko the photographer was nearly always concerned with the *fact,* whether it was Maiakovsky (1924), the construction of the Leningrad Highway (1929), or horse racing (1935). What annoyed observers was the form that Rodchenko gave to the fact. As he wrote in 1928, "When I present a tree taken from below like an industrial object such as a chimney, this is a revolution in the eyes of the philistine.... In this manner I am expanding our conception of the ordinary, everyday object."[30] Indignation ran so high during the 1930s that the most absurd criticisms were advanced. Referring to Rodchenko's *Pioneer Girl* of 1930, one critic asked, "Why is the *Pioneer Girl* looking upward? That has no ideological content. Pioneer Girls and Komsomol Girls should look forward."[31]

For Rodchenko, as for Brik and Chuzhak, fact was part of a process, a still from a movie. Fact was the jumper *about* to attain the zenith of his arc (1937), the swimmer *about* to enter the water (1936), the ship *about* to enter the lock gates (1933), the street in the *process* of being asphalted (1929).[32] As Brik emphasized in his important article of 1928 called "From the Painting to the Photograph," the new reality was a total, collective one: "For the modern consciousness, the individual can be understood, can be appreciated only in his general connection with all other individuals, with those who, in the pre-October consciousness, were valued as mere background."[33] Rodchenko's concern with process, formation, and transformation prompted him to photograph in cycles, to compose factographic records and albums such as *From Merchant Moscow to Socialist Moscow* (1931), *The Red Army,* 1938 (fig. 7) and above all the "White Sea Canal" volume of the journal *SSSR na stroike (USSR in Construction)* (1933). The White Sea Canal project of 1930–33 was Rodchenko's most dramatic experience of social metamorphosis. Constructed by prisoners, the canal was regarded by many as a testing ground not only for the strength of Soviet technology, but also for the re-education of the antisocial individual into a useful member of the collective. Rodchenko tried to ▶

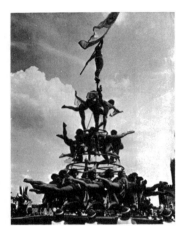

8.
Alexandr Rodchenko
Pyramid, 1935
Photograph
40 x 29 cm. (15⅛ x 11⅜ in.)

34. From A. Zhdanov's speech at the First All-Union Congress of Soviet Writers, Moscow, 1934; quoted in Bowlt, *Russian Art of the Avant-Garde*, pp. 293–94.

35. Quoted in Karginov, *Rodtchenko*, p. 193.

36. "Programma fotosektsii obedineniia 'Oktiabr,'" *Izofront*, p. 150.

37. A. Rodchenko, "Perestroika khudozhnika," *Sovetskoe foto*, no. 5–6, 1936, p. 19.

38. Ibid.

express this sense of anticipation, optimism, and transformation in his two thousand photographs of the canal. No matter how the camera has photographed the toiling masses on the canal—from above down, from below up, from the side—the fact of the construction, its continuum, is omnipresent.

In aesthetic and formal terms, Rodchenko's photographs from about 1928 to 1930 are of great "photographic" value, but the thematic, propagandistic photographs of the mid-1930s—the epoch of Socialist Realism—also have immediate emotional appeal. The shots of mass gymnastics (fig. 8), of street scenes, of the circus—with their dazzling sunshine, their fast movement, their affirmation of the collective—these illustrations contain, whether intended or not, the essence of the Socialist Realist ideal: "romanticism of a new kind, a revolutionary romanticism...supreme heroism and grand prospects...a ceaseless aspiration onward."[34] Rodchenko's photographs of this period display the same rhythm and tempo that we feel in the Soviet mass song, in the panoramic paintings of abundant harvests, or in the oratory of Stalin. But in a time of mass oppression, these healthy bodies and smiling faces were mendacious. They were symbols, perhaps, of the future, but they had very little to do with the present. Rodchenko himself was one of the many artists commanded to smile while his artistic and material life became more and more intolerable.

Rodchenko's unenviable position in the late 1920s and 1930s is indicated by the treatment he received from the group October. Founded in 1928, October encompassed various artistic activities, although it concentrated on the industrial and applied arts. This, together with its emphasis on the proletariat and on contemporaneity, recalled the ideas of Lef and Constructivism and is confirmed by the original list of members that included Sergei Eisenstein, Alexei Gan, Gustav Klucis, El Lissitzky, Diego Rivera, Rodchenko, Sergei Senkin, Stepanova, Solomon Telingater, and Alexandr and Viktor Vesnin. October held one exhibition in June 1930 at which photography and photomontage were well represented by Klucis, Lissitzky, Rodchenko, Senkin, and Stepanova. Until that moment, October maintained a very tolerant attitude toward experimental design and photographic work; but under increasing pressure from rightist critics it was forced to adopt a severe, "anti-Formalist" line immediately after the exhibition. As a result of internal reorganization and abrupt change in artistic policy, Rodchenko was expelled from October in 1931 for attempting to "put proletarian art on the path of Western advertisement art, formalism, and aestheticism."[35] Although remaining members of October maintained their interest in photography up until the disbandment of the group in 1932, they concerned themselves solely with the social and documentary value of the medium and condemne any vestiges of "abstract, 'leftist' photography b Man Ray, Moholy-Nagy" (and, by implicatio Rodchenko).[36]

Rodchenko's expulsion from October coi cided with a number of other unsavory episodes: 1930 he was forced to resign from the Vkhute (Higher State Art-Technical Institute) and h Department of Metalwork was closed dow Maiakovsky's suicide in the same year depriv him of a close friend and ideological ally. A Rodchenko mentioned at the 1936 "Debat on Formalism and Naturalism in Photo-Art": "M mood was a decadent one. So on purpose I bega to do the most extraordinary perspectives. But the lashed out at me all the same. I could have given u photography and gone to work in other areas, but give up just like that was impossible. So I we away."[37] Rodchenko, no doubt, did not exaggerat when he added that his destination—the constru tion site of the White Sea Canal—"was a passpo to real life....I photographed simply, giving n thought to formalism."[38] Whether or not Rodche ko's canal photographs were of real life, he st underwent severe censure and ostracism. (In 193 for example, he was excluded from the Soviet ph tography exhibition in Pittsburgh.) Yet Rodchenk was tenacious, and amid political intrigues ar cultural ignorance he continued to photograph: h served as a press photographer for the journals 3 *dnei (30 Days)* and *Za rubezhom (Abroad);* betwee 1933 and 1941 he, together with Stepanova, d signed ten special issues of the propaganda mag zine *SSSR na stroike (USSR in Construction);* an together, they also designed several luxury editio on, for example, the First Cavalry (1935–37) ar the Red Army (1938).

However acrimonious the atmosphere at th "Debate on Formalism and Naturalism in Phot Art," however vapid the opinions expressed by fe low photographers and critics on Rodchenko, th very fact that his photographic method formed th principal occasion for the polemics indicated th strength of his influence and the threat it posed conservative elements. Rodchenko worked on as photographer and painter (he resumed painting 1935) until shortly before his death, but he spent th twenty years following the "Debate" in enforce obscurity and isolation. Only in 1957, a few month after he died, was he honored with his first one-m exhibition at the House of the Journalist in Moscov

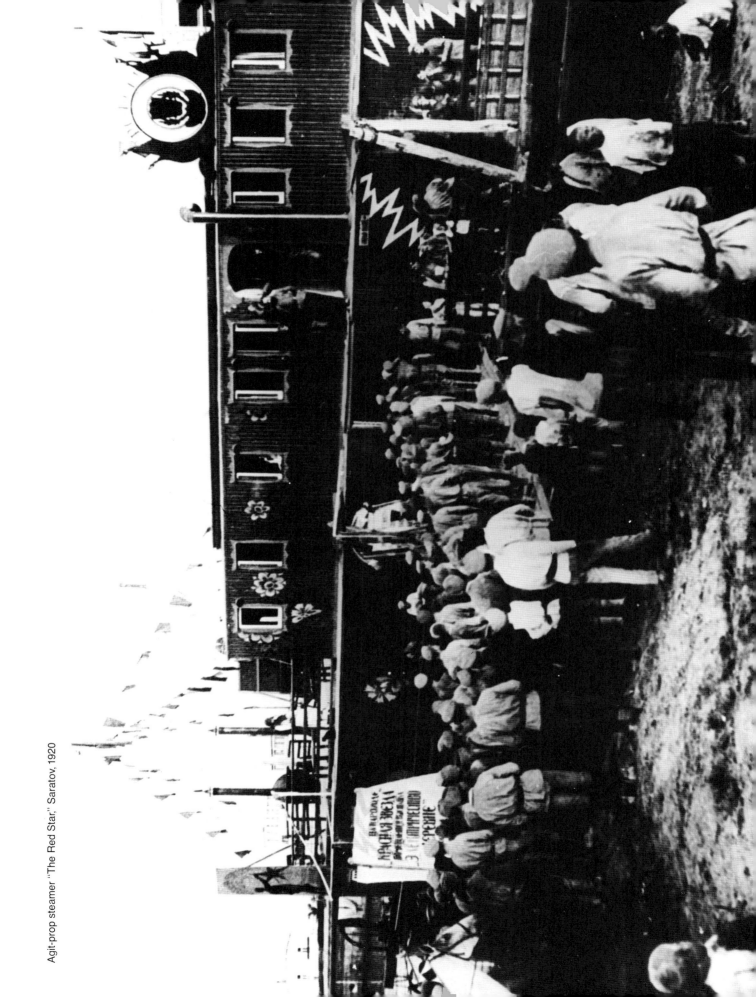

Agit-prop steamer "The Red Star," Saratov, 1920

Gustav Klucis: Between the Non-Objective World and World Revolution

Vasilii Rakitin

1. Gustav Klucis, *Autobiography,* 1930s. Manuscript in the archive of the artist's widow, V. N. Kulagina-Klucis (b. 1902). As an artist in her own right, Kulagina did a number of art works together with Klucis. I feel bound to express my gratitude to her for the opportunity of working on the Klucis archive and for the generous assistance that she gave me. My interest in the Klucis heritage was also inspired to a considerable extent by my cataloging of the Klucis works in the George Costakis collection, part of which is now in the Tretiakov Gallery and part of which is now in the West. The Museum of Latvian and Russian Art in Riga also has a large Klucis collection, which was shown at the Klucis retrospective there in 1970; see *Katalog vystavki proizvedenii Gustava Klutsisa,* Riga, 1970.

As for the Klucis bibliography, a number of articles (in Russian) can be mentioned from various years: V. Kostin, "Fotomontazh i mekhanicheskie oshibki 'Oktiabria,'" *Za proletarskoe iskusstvo,* Moscow, no. 7–8, 1932; A. Eglit, "Pionery latyshskogo sovetskogo izobrazitelnogo iskusstva," *Isskusstvo,* Moscow, no. 7, 1979; L. Marts, "Gustav Klutsis," *Tekhnicheskaia estetika,* Moscow, no. 1, 1968; N. Shantyko, "Klutsis—illiustrator Maiakovskogo," *Khudozhnik,* Moscow, no. 2, 1970; L. Oginskaia, "Yazykom fotomontazha," *Tvorchestvo,* Moscow, no. 4, 1970; L. Oginskaia, "Tvorchestvo khudozhnika leninskoi temy," *Dekorativnoe iskusstvo SSSR,* Moscow, no. 4, 1970; L Oginskaia, Khudozhnik-agitator," *Dekorativnoe iskusstvo SSSR,* no. 5, 1971. Klucis himself was also active as a theoretician and critic of photomontage. See his "Fotomontazh kak sredstvo agitatsii i propagandy," *Za bolshevistskii plakat,* Moscow, 1932; "Fotomontazh kak novyi vid agitatsionnogo iskusstva," *Izofront,* Moscow/Leningrad, 1932; and his introduction to the catalog of the exhibition *Die Photomontage in der USSR,* Stuttgart-Berlin, 1931.

2. On the history of the project, see Sergei Senkin and Gustav Klucis, "Masterskaia Revoliutsii," *Lef,* Moscow, No. 1, p. 5. It is of interest to note that the authors selected Nikolai Bukharin's slogan—"We need Marxism + Americanism"—as one of their epigraphs.

3. The color course was usually taught jointly by a specialist in color science and an artist.

4. Explanation of 1928 on the version of *Project for a City of the Future.*

■ Gustav Klucis, who is now achieving renown within the history of the Russian avant-garde, was one of the stellar heroes of its post-Revolutionary development. But his artistic biography encompassed a mere two decades.

"Fantastic work. Looking for new media. Surface. Space. Construction. Photomontage."[1]

Klucis was born in Latvia near Volmar (now Valmier) on January 4, 1895, of a working family. He attended a seminary in Volmar and later, in 1913–15, enrolled in art school in Riga and then in Petrograd. Klucis took part in both the February and the October Revolutions as a rifleman and machine-gunner. While living in Petrograd, however, he did not give up his interest in art; he attended the school of the Society for the Encouragement of the Arts and designed sets for the Okhtenskii Workers' Theater.

Beginning in the spring of 1918 Klucis lived in Moscow where Latvian units guarded the Kremlin, the new residence of the Russian government, now transferred from Petrograd. "Commissars and Letts are not to be taken prisoner," was an unwritten rule of the Civil War.

In the fall of 1918 Klucis was sent to study at the second Free Art Studios. His first teacher there was Konstantin Korovin, the famous Russian Impressionist. But Klucis the revolutionary very soon transferred to the studio of an artist closely associated with the revolution in art: Kazimir Malevich. After Malevich left for Vitebsk, his studio was supervised by A. Pevsner. Klucis visited Malevich there and twice showed his work with Unovis—Malevich's group of disciples—in 1920 in Vitebsk, and in 1921 in Moscow.

In August 1920 Klucis showed his non-objective painting, his graphic designs, reliefs, and constructions together with Pevsner and Naum Gabo. This exhibition was held for one night only in a summer pavilion on Tverskoi Boulevard (now Gorky Street) in Moscow, not far from the Chamber Theater (before the Revolution this pavilion had housed a café popular with artists). In 1921–23 Klucis worked with the members of Inkhuk. He took part in their theoretical debates and showed his works at their regular in-house exhibitions—works that he regarded as models for a new artistic methodology.

While still a student in 1919 Klucis supported the objective method of art education. But he felt that the very interesting introductory foundation courses at the Vkhutemas in 1920–23 were, for him, too abstract. They were too far removed from the actuality of artistic life and from the new functions of art vis-à-vis reality that were then emerging. Together with Sergei Senkin, Klucis defended his own particular project for a "Studio of the Revolution"; he proposed replacing traditional art depart-

ments (painting, sculpture, graphics) with a studio of experimental agitational art (agit-art or propaganda art).[2] He felt that once and for all art had advanced into the street.

During 1920–22 Klucis made a series of suspended constructions and in 1922 made a series of agit-constructions for the street. From 1924 until 1930 he headed the color courses at Vkhutemas-Vkhutein.[3] During the 1920s his artistic attention gradually shifted toward printing and poster design, and he began to apply the methods of the poster to exhibition and street design. Klucis established photomontage as the basis of a new mass art. During the 1930s, when the poster and the art of printing underwent radical changes, Klucis turned his attention to studio graphics and figurative painting. In 1937 he went to Paris, where he took part in the design and installation of the Soviet pavilion at the World's Fair. Except for a trip to Denmark in 1921, this was his first time abroad. In 1938 Klucis was arrested; the entry "Nationality: Latvian" in his résumé had become a fateful one. Klucis died in one of the Kazakhstan camps in 1944.

"...view from all sides."[4]

Klucis came into close contact with Malevich in the winter of 1918–19. The phase of White Suprematism, crucial in Malevich's creative development in 1917–18, had come to its conclusion. Malevich now regarded the implementation of the notion of volumetrical Suprematism to be essential.[5] In his pedagogical system Malevich defined the "general direction of the studio: Cubism, Futurism, Suprematism as the new Realism of a painterly world view,"[6] and proposed that students work both in painting and in volume (for the time being this still meant Suprematist sculpture for Malevich).

Within such an environment of radical research the students' artistic psychology changed swiftly. Still, even in such a milieu Klucis' rapid and impetuous development was a rare phenomenon, demonstrating an exceptional talent. His first major work of the winter of 1918–19, *The Red Man,*[7] is already an independent work, even though its points of derivation are manifest: African art and Picasso's *Violin* can be seen through the prism of the concepts of the Malevich circle—but not by a pupil blindly in love with the mentor. Klucis brings together and reconciles the nature of the plane and the nature of the relief. Limited to a single color scale—brick red—the painting indicates the artist's interest in the effect of textures. We see, therefore, that Klucis has here determined one of his most important "themes" at what is essentially the beginning of his career.

Klucis borrowed a great deal from Suprematism. At the same time, however, like the "Prouns" of El Lissitzky and the contemporaneous, still unfamiliar, works of S. Senkin, Klucis' constructions

1.
Gustav Klucis (1895–1944)
Dynamic City, 1919–20
Oil on wood
87.5 x 64.5 cm. (34½ x 25⅜ in.)
The George Costakis Collection

2.
Gustav Klucis
Radio Announcer Lenin
Maquette
h: 107 cm. (42⅛ in.)
Collection, The Museum
of Modern Art, New York

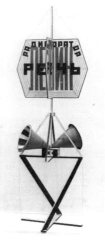

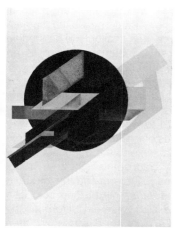

5. The ideas of volumetrical Suprematism go back to 1915 when Suprematist principles were applied to sculpture (Ivan Kliun). Volumetrical experiments and elaborations attracted a number of students in Malevich's studio in the Second Free Art Studios (Svomas) in the 1918–19 academic year, including S. Senkin (Senkin in conversation with the author, December 1966). The Klucis archive contains a drawing (dated 1919) of a project for a vertical, volumetrical, Suprematist construction.

6. Projected program for Malevich's studio, 1919. Typescript.

7. Oil on canvas, 84 x 45 cm., Tretiakov Gallery, Moscow, formerly in the George Costakis collection.

8. *Dynamic City,* winter of 1919–20, wood, oil, 87.5 x 64.5 cm., George Costakis collection.

9. Two works of the "Axiometric Painting" series were purchased from Klucis by the Museum Bureau of the Department of Visual Arts, Narkompros. One of them is now in the Tretiakov Gallery—*Axiometric Painting. Non-Objective Composition,* 1920, oil on canvas.

10. From the diary of V. N. Kulagina-Klucis, entry for March 7, 1922.

11. V. Shklovsky, "Ob iskusstve i revoliutsii," *Iskusstvo kommuny,* Petrograd, no. 5, 1919.

12. All of Klucis' agit-constructions for the Fourth Comintern Congress were printed as individual lithographic editions.

13. Klucis also intended to decorate the October festivities with such constructions for Red Square. A sketch for this decoration survives.

represent a movement away from the Suprematism of the 1910s. The unreality of the Suprematist environment now becomes more concrete, as Klucis, like a designer, researches the details of his painterly, architectonic constructions. He attains a totality and intensity here by juxtaposing many planes. The correlation of spatial gravities generates the sensation of a dynamic, one might even say cosmic, body moving along an axis. It would not be stretching the point to speak of futurological associations here. Titles such as *Dynamic City* (fig. 1),[8] which in 1928 is changed to *Project for a City of the Future,* seem very appropriate, although Klucis did not refer to actual architectural implementation. Similarly, concepts such as "Axiometric Painting"[9] also have a scientific meaning.

Klucis attains an artistic totality in his constructions through his juxtaposition of many planes that are subtly "stratified" by means of the textures. Lightness and heaviness now become emotional, spatial characteristics. These constructions are tactile, physical, but they are not heavy; they do not "fall" into the pit of space—volume is free from mass, thanks to the skillful resolution of color tone problems. The locale is light-bearing, it assimilates and absorbs light, while the space is accommodated within the internal structure of the work. In other words, what is occurring here is a kind of synthesis of the Suprematist spatial system and the ideas of Gabo's non-objective, structural Constructivism with its new comprehension of the interrelationships of line, volume, and space, with its affirmation of intellectualism as a new artistic code.

Gustav...intends to rebuild the world and the universe, he talks a lot about the fourth dimension....Some people ask "What's that?" Indeed, "What's that?" really must be defined. If it's not a cow, maybe it's a house?[10]

Klucis' painterly constructions can easily be imagined existing beyond the plane. His graphic designs are often perceived as projects for an actual reality of some kind. It is logical that in 1920–22 Klucis himself tried to implement the system of his ideas within a multi-dimensional, real space. He was especially interested in suspended constructions which, according to photographs and chance sketches that have survived, were of two types.

The first type was a kind of soaring "architecton," oriented along a dynamic, diagonal, "Suprematist" axis. The architectons made by the Malevich circle in the 1920s were enclosed, plastic, architectonic models, while in Klucis' pieces the entire rhythmic structure is exposed and intricate spatial connections arise within the linear correlations. Rodchenko liked Klucis' suspended constructions very much—Rodchenko himself was interested in such problems then—and Malevich

knew about them. In a word, Klucis' suspended constructions represented one of the most important documents in the polemical debate by various artists concerning the potentials of the non-objective object.

Futurism was one of the purest accomplishments of man's genius. It indicated just how high the level of understanding the laws of creativity had become. And it really hurts to read the toadies in newspaper editorials who have now jumped on the bandwagon of Futurism.[11]

Many of the avant-garde artists of the post-Revolutionary period affirmed art to be not only autonomous in relation to life, but also an institution operative outside life altogether. "Creativity as such" proved to be a powerful stimulus to the development of art and imbued it with an active, formative function. After the Revolution many of these artists were confronted by a dilemma: how to coordinate (indeed, was it worth coordinating?) the world of their own free creativity and the practical demands of the new social life in the context of art. For people of Klucis' generation this was not a problem: for them the Revolution was the only reality. Accepting the ideas of contemporary form in art, they aspired to integrate the new form and the new social reality in the space of life itself. The collective consciousness of that era—the "mass man"—abolished, as it were, the notion of individual studio art. It was logical that Klucis, a man of his time, favored an art of the street, a mass art rather than his own non-objective work. He attempted to transfer his experiments in construction to the street.

In 1922 he initiated his series of agit-constructions which were intended to be installed in time for the Fourth Comintern Congress[12] and the fifth anniversary of the October Revolution in Moscow.[13] Most of these constructions are so-called "Radio Announcers" (fig. 2). The Radio Announcer differed from most Suprematist (Vitebsk, Smolensk) and Constructivist (Moscow) agit-constructions by virtue of its universal and functional objective. It accommodated several functions simultaneously: (1) loudspeaker, (2) screen, (3) rostrum for public speakers, (4) newspaper and book kiosk. The Radio Announcer was a light, collapsible construction. Two were built, including the Radio Announcer called *The International,* which was in- ▶

14. Diary of Kulagina-Klucis.

15. G. Klucis: from rough notes for his *Autobiography*, 1930s.

16. Second, third, and fourth groups of projects. See below for excerpts from the program.

17. Typescript, 1926.

18. Typescript, 1927?

19. Klucis first used photomontage in his design for a *panneau* for the Fifth Congress of Soviets in Moscow in 1918 (the design is in the Museum of Latvian and Russian Art in Riga). Alexei Gan's first experiments in photomontage were also done in 1918.

stalled on Tverskaia Street by the Hotel Nerenzee where the Comintern delegates were staying. The slogans and agit-prop itself were already everyday things, but what attracted attention was the extraordinary appearance of the construction against the background of the street. The agit-constructions occasioned unusual emotional responses. Their artistic simplicity was very compelling, and they gave rise to a sense of *joie de vivre,* of lightness and clarity. They represented a new kind of street folklore, a style determined by formal accomplishments of the highest order; or, more precisely, a street folklore as a model for the revolutionary epoch of machine and industry. For Klucis these words were synonymous.

Klucis applied his experience of the agit-construction to poster and exhibition design (fig. 3). He was not alone in this, since other artists also applied their experiences to what became a new, integrated, collective language of the street.

> On February 14, 1925... Maiakovsky made an appearance at Vkhutemas. It was a new kind of audience, timid, not like the one at Vkhutemas in 1920–22 which had been so mischievous, noisy, full of life.[14]

A confirmed revolutionary, Klucis lived honestly and openly. For him world revolution was a concrete reality, not a dream. He believed that an Americanized socialism, a kingdom of technology, science, and reason would come to peasant Russia. Like Lissitzky, like the Moscow Constructivists and Productivists, he measured socialism by the European categories of progress and felt that the ideal social structure would become a reality. He paid no attention to actual contradictions and, consequently, he was a happy man. He sensed the harmony of his epoch. He was always more "leftist" than the down-to-earth politics of art; he breathed the air of this grand social vista with no wish to sit passively and merely reflect it. Always active and energetic, he continued to pursue his artistic direction, often in spite of the political reality of the time; revolution is the style of life, the means of action is experiment. "Revolution demands from art forms that are absolutely new, forms that have not existed before."[15]

How could this fervor of artistic invention still be expressed at a time when the heroic era of the avant-garde in art already was destined to become a mere memory? This was not an easy question even for such an intransigent and strong-willed man as Klucis.

On the one hand, he continued his pedagogical experiments at Vkhutemas/Vkhutein. Proceeding from the experience of Russian non-objective art and the European science of color (W. Ostwald), Klucis worked out his courses in color. In the Wood and Metal Department, Klucis worked closely with

Lissitzky, Rodchenko, and Tatlin, and many projects were undertaken jointly.[16] Klucis posed the problem in a very concrete manner: "Color is to be studied as a tangible, industrial material and not as an aesthetic appendage."[17]

The entire program is divided into four groups of projects. 1st Group: (a) acquaintance with the basic (typical) properties and qualities of color as applied to wood and metal industry and the methods of their manufacture. (b) texture in its relationship to the quantity of color surface and its [color's] intensity. 2nd Group: color, planar, and relief form and the interrelationship of these aspects. 3rd Group: color as a means of expressing volumetrical form on the surface and in space. 4th Group: color as a means of spatial expression."[18]

These projects were implemented in the form of graphics, volumes (reliefs, models), and paintings. The purpose of all this was to encourage a conscious, scientific attitude toward form.

On the other hand, Klucis endeavored to create a style for the new mass art, one that was to be optically "striking." He endeavored to train the viewer to perceive the language of new forms without letting him grow accustomed to form. Form is invention. The old slogans of the avant-garde were now tested out in a new social context. A slogan is a theme, but it must become a fact of art if it is to "work."

The range of methods that could be used was very broad. It included the dynamic organization of the plane (the school of Suprematism) and sometimes even the paradoxes of Dada. The work of art now came to be seen as montage. Klucis' experiments with photographic textures of 1918–19 assumed a new force and relevance. Photomontage supported the orientation toward the need for art to have a concrete effect. For the time being, photomontage reconciled both the spectator who demanded a social response and the artist enthused by the aesthetics of a new field of art.[19]

Photomontage strove to become the primary art of the day. It seemed to be all-powerful. Klucis, who on the whole preferred individual effort to a collective *Sturm und Drang,* became one of the initiators of the October association. Just one more effort and the new style of mass art, an art of social fervor and contemporary form, would be accomplished! The October association stood for Westernism, rationality, and the dogma of revolution—it was intellectualism in the cultural revolution. Such fervor contained an "alibi"; it seemed to coincide with the zealous construction schemes of the First Five Year Plan; it was a "theoretical extension" of this fervor for life. The artistic results are obvious, but this very endeavor seemed to be a libertarian act in the context of the

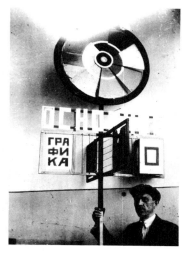

3.
*Klucis with a Three-dimensional
Emblem,* c. 1925–26
Photograph

20. Diary of Kulagina-Klucis.

21. *Unovis,* Vitebsk, 1920.

complex life of Russia at that time. But it is not politic to hasten with accusations, and we will not accuse those who believed that industrialization would solve all problems and that it would open the gates to the "paradise" of a new life, the "Soviet dream." The Five Year Plan turned the life of the masses upside down, it provided them with new slogans, with a new consciousness. Klucis turned his attention to this new collective consciousness. If the life drama of some was very real, the enthusiasm of others was no less so. This was also a truth. Klucis the poster designer, an artist engaged by the era in which he lived, worked with this positive reality, and like any artist, even in the most confining situation, Klucis retained his artistic independence. This was not the independence of the jester at a medieval court, but a fanatical belief in the necessity and strength of the new art.

Documentation + graphic precision + acuity —the interplay of various scales, the unexpected interaction of fragments, the dynamic interchange of frames—here you have a kind of political fresco. At least, Klucis' best posters withstand such a definition.

Klucis was closely involved with the ideas of cinematic montage, and there are points of contact between his aesthetic and Dziga Vertov and Sergei Eisenstein. Klucis did not detach his own work from the general development of photomontage in the USSR and the West. In the historical period of 1928–33, the epoch of the First Five Year Plan, Klucis emerges as the most characteristic artist, more so than Rodchenko or Lissitzky. Klucis was the man who expressed the fervor of that era.

> May 20, 1933. Malevich visited us today. He's put on a lot of weight. Haven't seen him in eleven years. He related some scandalous things—how he was being persecuted in Leningrad....He was having a really hard time, couldn't get any work....A sad story.[20]

To discover that epoch in the posters and book designs of Klucis is an objective and historical fact. Actually there is a whole series of conflicts here. The disharmony between the new aesthetics and historical actuality became ever more apparent, and by the mid-1930s the psychological climate had changed dramatically. Art now aspired to a social classicism. Fervor was replaced by a stipulated program as people pretended that utopia had become fact—an idyllic decoration concealed a complex and menacing reality. Still, when we examine Klucis' posters of those years we are astonished to see how much the poster tells us about the epoch, notwithstanding the fact that its very clear function was, it would seem, to eulogize. The exultant masses, the airplanes above the squares, the strong, smiling leaders on their rostrums—these are the new idols of the masses. Highly skilled, even

virtuoso art; but fervor? The fervor in Klucis' posters is one thing, but these wonderfully hypnotic, cold compositions are another. Klucis the artist survived Klucis the revolutionary. The spirit of Stalinism is quite recognizable in these posters, and no doubt historians of Soviet society will often treat them as such.

> The behest of Suprematism is higher than the behest of Communism.[21]

An artist such as Klucis can quite easily confuse any piece of research, even the briefest. He was a pupil of Malevich, although he supported a different philosophy. He did not retreat from Malevich, but he was not a textbook Suprematist, either. He was close to El Lissitzky and yet in conflict with him—their mutual influences and insults have yet to be elucidated. Klucis joined the Constructivist movement, although he did not reject Suprematism. Klucis designed Maiakovsky's books, but for Klucis, the inventor of artistic forms, the art of Alexei Kruchenykh was a far greater source of inspiration. Klucis and Kruchenykh worked closely in the early 1920s. An artist of the photomontage and the photo-fresco poster, an artist who more than anyone defined the poster style of the First Five Year Plan and, indeed, of street design itself, Klucis was publicly accused on more than one occasion of "not showing the class enemy" in his posters. An artist of super-optimistic, highly illusionistic posters carrying the faces of the leaders in the mid-1930s, Klucis himself fell a victim to Stalin's Great Terror and genocide in 1938—for being a Lett. A Communist since 1919 and prepared to defend the Revolution with his rifle, Klucis paid no heed to formalities—so he was twice almost expelled from the Party, once in 1924 for supporting the program of the opposition and another time in 1931 for not attending meetings.

For the adepts of the artistic avant-garde, Klucis is one of several artists who has every right to be considered a classic. He might well have become one of the "new leftists" and might have understood the fanatics of the Chinese Cultural Revolution. His artistic biography indicates how complex, how tense the interrelationships of art and politics in Soviet Russia were: it could carry the subtitle "The Story of How 'Leftist' Revolutionary Art Became Superfluous in the USSR."

The threads of Klucis' biography are confused and tangled. It is impossible to separate political tendentiousness from the artist's own creative value in order to "fuse" the two within the integrated personality of the artist. Nevertheless, the diapason of Klucis' talent does justify any such endeavor. ●

Translated from the Russian by John E. Bowlt

The Revolution in the Russian Theater

<div align="right">Alma H. Law</div>

1. From a speech given at an open debate on ZORI, November 22, 1920, in *V. E. Meierxold—Statii, pisma, rechi, besedy (V. E. Meierkhold–Articles, Letters, Speeches, and Conversations)*, Moscow, 1968, vol. II, p. 17. For a translation of the entire speech, see Edward Braun, *Meyerhold on Theatre*, New York, 1969, pp. 173–74.

2. Konstantin Rudnitskii, *Regisser Meierxold (Meierkhold the Director)*, Moscow, 1969, p. 203. Meierkhold twice revised his production, in 1933 and 1938 (his last completed work in the theater). In all *Masquerade* was performed more than five hundred times after the Revolution up until 1941, plus at least two hundred times in concert. The sets and costumes were destroyed during the Seige of Leningrad, but it was revived for a final concert performance after the war with Yuriev, then over seventy, in his original role of Arbenin.

3. The production was based on Fernand Crommelynck's *Le Cocu Magnifique* in a translation by Ivan Aksyonov.

4. For Golovin's sketches of costumes, settings, and properties, see *"Maskarad" Lermontova v teatralnykh eskizakh A. Ia. Golovina (Lermontov's "Masquerade" in A. Ia. Golovin's Theatrical Sketches)*, ed. Iu. U. Nribylskii, Moscow, 1941.

5. Bootblack and rouge substituted for paint, with lacquer for attaching false beards used as a fixative. Much of the construction was simply left unpainted.

We are not making a mistake when we bring our theater into complete contact with the contemporary world. Nor are we mistaken in attracting the Cubists and Suprematists because our style is changing and we need a setting resembling the one we will be playing against tomorrow. The contemporary theater wants to move outdoors. We want our backdrop to represent either an iron smokestack or the sea, or to be something constructed by mankind.[1]

<div align="right">V. E. Meierkhold</div>

■ On Saturday evening, February 25, 1917, as the first shots of the Revolution were ringing out in the streets of Petrograd, a few blocks away at the Alexandrinsky Theater a glittering first-night audience watched the premiere of Vsevolod Meierkhold's (1874–1940) production of Lermontov's *Masquerade.* In preparation for almost five years, this lavish spectacle with sets designed by Alexander Golovin (1863–1930) was one of the most beautiful ever seen on the Russian stage (fig. 1). It also proved to be, as one writer observed, "a grim requiem for the Russian Empire."[2]

Just five years later, in April 1922, quite a different audience crowded into the shabby, unheated auditorium of the former Sohn Theater on what is now Maiakovsky Square in Moscow to witness the first showing of Meierkhold's *The Magnanimous Cuckold.*[3] And what confronted the noisy gathering of workers, soldiers, and students was also light-years away from the gossamer stage curtains, the elegant furniture, candelabra, china, glassware, and even playing cards that Golovin had designed for *Masquerade.*[4] Under the harsh, white glare of spotlights, there stood silhouetted against the fiery red brick walls of the theater a light, three-dimensional wood construction (fig. 2). Designed by Liubov Popova (1889–1924) and put together out of materials at hand by a carpenter and members of Meierkhold's Theater Workshop, it cost a total of only 200 rubles, a paltry sum at that time.[5]

Nothing illustrates more dramatically the astonishing revolution that took place in the theater in this brief time span than does the difference between these two productions. And if *Masquerade* marked the end of an era, just as clearly Popova's combination of platforms, stairs, and ramps was to mark the beginning of a new one in which functionalism and machine art would become the predominant aesthetic in the theater. The name given to this new movement was Theatrical Constructivism. It launched one of the most exciting periods of artistic innovation the theater has seen in this century, and its influence is still very much with us even today.

Popova's setting for *Cuckold,* which became a *locus classicus* of the new movement, marked the culmination of a radical change in the role of the

artist in the theater and in the nature of stage design that was already underway at the beginning of the century. It saw the establishment of the artist as a close collaborator with the director, musicians, and actors in the creation of a theatrical production. Not surprisingly, many artists also turned to directing themselves, among them Yurii Annenkov (1889–1974), whose production of Tolstoi's *The First Distiller* in 1919 was one of the first to bring the circus into the theater.

This revolution in the theater also saw the replacement of stage design as a decorative "picture," an artifact independent of the other elements of a production such as gesture, movement, music, and dialogue, by a perception of it as a dynamic interaction of forms and materials in time and space. The object replaced illusion, just as in theory the carpenter was to replace the artist. Even the

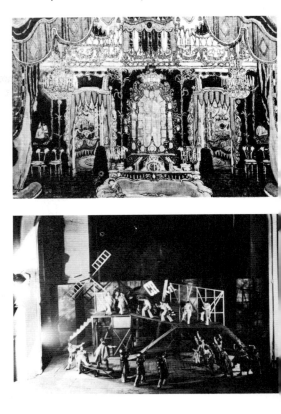

1.
Masquerade, 1917 (scene 2, masquerade ball)
Alexandrinsky Theater, dir. Vsevolod Meierkhold (1874–1940)
Artist: Alexandr Golovin (1863–1930)

2.
The Magnanimous Cuckold, 1922 (scene from act 3)
Meierkhold Theater, dir. V. Meierkhold
Artist: Liubov Popova (1889–1924)

6. Elena Rakitina, "Ot kvadrata k orsheru" ("From the Square to the Torchère"), *Dekorativnoe iskusstvo SSSR (Decorative Art of the USSR)*, no. 137, April 1969, p. 28.

7. Andrei B. Nakov, "Painting and Stage Design: A Creative Dialogue," *Artist of the Theatre Alexandra Exter,* New York, 1974, p. 12.

8. Alexandr Tairov, *Notes of a Director,* trans. William Kuhlke, Coral Gables, Florida, 1969, pp. 106–7.

vocabulary of stage design underwent a change. Scenery *(dekoratsiia)* was replaced by the more aptly descriptive "object formulation" *(veshchest-vennoe oformlenie),* from the word *veshch* (object or thing), which by the early 1920s became one of the most widely used terms in aesthetics. A construction was a *veshch.* A production was a *veshch,* not a representation of something. And talk was no longer of "props" *(butaforiia),* but of "requisitions," objects purchased ready-made.[6]

For the artist, the theater became an important laboratory for working out artistic concepts. Both Kazimir Malevich (1878–1935) and Alexandra Exter (1882–1949), for example, gave credit to their theatrical experience for new breakthroughs in their art. As Andrei Nakov has pointed out, "in the same way that his décor for Kruchenykh's play *Victory Over the Sun* (1913) helped Malevich approach a new and freer conception of geometric elements and brought him to Suprematism, similarly work that began as experiments in the theater—of a very different kind to be sure—led Exter to establish the groundwork for the very important chapter of Constructivist painting."[7] Furthermore, at a time when there was little money for new buildings or huge monuments, the theater gave artists an opportunity to realize on a large scale the constructions they designed in their studios.

It was not until the 1880s that stage design had begun to gain recognition in Russia as a legitimate art form. Its acceptance at that time was largely due to Savva Mamontov (1844–1909), the railway tycoon who hired the leading artists of the day, among them Konstantin Korovin (1861–1910), Victor Vasnetsov (1848–1916), and Mikhail Vrubel (1856–1910), to paint the décor for his amateur theatrical and operatic productions. While Mamontov's influence soon spread to the imperial opera and ballet theaters, it was only with the founding of the Moscow Art Theater in 1898 that it began to be reflected on the dramatic stage. Inspired by the Meinengen Players who had twice toured Russia, the founders of the Art Theater, Konstantin Stanislavsky (1863–1938) and Vladimir Nemirovich-Danchenko (1858–1943), spared no energy or expense in making their settings as authentic as possible. They discarded the illusionistic backdrop and strove to create on the stage a *world*, "which would allow both the audience and the actor himself...to believe that they were dealing not with the stage, but with real life."[8]

But even as Stanislavsky and his actors were traveling across town in 1902 to study the Moscow flophouses for their production of Maxim Gorky's *The Lower Depths,* the foundations of naturalism were being rocked by the Symbolist playwrights whose works suggested a higher, far less tangible reality. The decade that followed saw the advent of the Symbolist movement in the theater. Led by Meierkhold and artists like Sergei Sudeikin (1882–1946), Nikolai Sapunov (1880–1912), and Nikolai Yulanov (1875–1949), it marked the beginning of experimentation with non-representational stage techniques. Symbolism's greatest contribution to stage design was to remove the clutter of detail that had invaded the theater in the pursuit of authenticity and to introduce a stylized setting, making use of a few significant details, often of exaggerated proportions. Influenced by artist-theoreticians like Gordon Craig (1872–1966), Adolph Appia (1862–1928), and Georg Fuchs (1886–1949), stylization also brought with it an appreciation of architectural forms and lighting as expressive means.

In one production after another, Meierkhold tried everything from eliminating the stage curtain (as early as 1906 for a production of Ibsen's *The Ghosts* in Poltava) to the use of multiple levels and area lighting to eliminate scene changes (Wedekind's *Spring Awakening* in 1907). For Leonid Andreev's *Life of a Man* (1907) at the Komissarzhevsky Theater in St. Petersburg, Meierkhold and artist Victor Kolenda (1872–1945) discarded the conventional stage set entirely, using drape and area lighting to achieve a sculptural effect. Much of this experimentation was aimed not only at doing away with painted set decoration, but also at solving a problem that was to plague both director and artist in the next few years: the creation of a harmonious synthesis between the three-dimensionality of the actor's body and the stage environment.

At a time when Meierkhold, for all of his innovative activity, remained curiously attached to Golovin and other members of the "World of Art" group, elsewhere in St. Petersburg two key members of the emerging avant-garde were already laying new groundwork for Theatrical Constructivism: Vladimir Tatlin (1885–1953) and Kazimir Malevich. Both Tatlin's costume designs for *Emperor Maximilian and His Disobedient Son Adolph,* produced by the Union of Youth in 1911, and Malevich's cardboard costumes and papier-mâché heads for the Futurist opera *Victory Over the Sun,* two years later for the same organization, suggested a new sense of volumetric form on the stage. But it was another artist, Alexandra Exter, who was to make the most significant advances toward Theatrical Constructivism in the years just before and after the Revolution. Her collaboration with Alexandr Tairov (1885–1950), following her return from Paris in 1914, resulted in a series of unforgettable productions at the Kamerny Theater in Moscow and established her place as one of the foremost stage designers of the twentieth century.

Alexandr Tairov was one of the first theater directors to recognize and embrace the Cubo- ▶

9. Ibid., p. 21.

10. Margarita Vasilevna Davydova, *Ocherki istorii russkogo teatralno-decoratsionnogo iskusstva XVIII-nachala XX veka (Excerpts from the History of Russian Stage Design in the Eighteenth and the Beginning of the Nineteenth Century)*, Moscow, 1974, pp. 174–76.

Futurist movement in painting. When he founded the Kamerny Theater in 1914, he rejected both the Moscow Art Theater's documented realism and Meierkhold's stylized theater. Tairov sought to create a "synthetic" theater that would "fuse all the arts of spectacle—scene design, costuming, and lighting."[9] He wanted to create a "scenic atmosphere" that would harmonize physically with the actor's three-dimensional body and at the same time express through mass, line, and color the mood of the play.

With Exter's passion for movement and her interest in the dynamic use of color and sculptural effects in her painting, she was ideally suited to execute Tairov's ideas. In 1916, for her first production at the Kamerny Theater, *Famira Kifared (Thamyras Cytharede)* by Innokenty Annenskii (1856–1909), Exter created a stylized image of ancient Greece based on Tairov's conception of the play as a contrast between the Dionysian and Apollonian principles of tragedy (fig. 3). An elevated platform was extended across the stage with broad blue steps leading up to it, flanked by large blue stonelike cubes, some of them tumbled on their sides. On the platform, severe black cones suggesting cypress trees were outlined against a monochromatic backdrop that was illuminated by a diffused light. Exter saw her costumes as non-objective constructions in motion within the overall stage design. She turned the actors into "living sculptures," even going so far as to paint the Satyrs' bodies in order to highlight the musculature in action. Exter linked the rhythmical movements of the performers with the volumetric forms of the décor so that the contrast between the tall, mournful figure of Famira, slowly mounting the steps, and the wild dancing of the Satyrs was echoed and reinforced by a juxtaposition of the measured flow of the steps and the broken rhythm of the overturned stones.[10]

For Oscar Wilde's *Salome* the following season, Exter used massive columns and arrangements of steps in earth tones set against an abstract sky whose color changed to reflect the emotional atmosphere of the action. And in *Romeo and Juliet* (1921), Exter's third production at the Kamerny, she introduced independent movable platforms and mirrors reflecting the actors' movements (fig. 4). Its complex structure and the overuse of movable curtains made it the least successful of Exter's designs. Absent was that harmonious unity between design and production that had made *Famira* so noteworthy.

Exter's designs exerted a powerful influence on other artists working in the theater, including Alexandr Vesnin (1883–1959) who designed the Kamerny Theater's production of Claudel's mystico-religious *Tidings Brought to Mary* in 1920 as an experiment in "Gothic Cubism" and Racine's

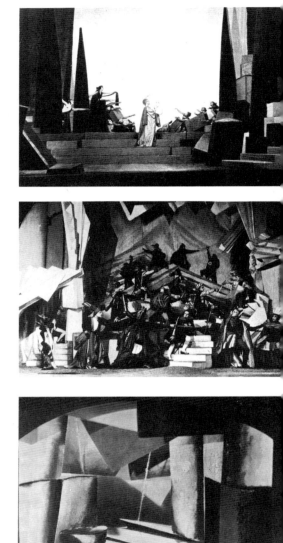

3.
Famira Kifared, 1916 (scene from production)
Kamerny Theater, dir. Alexandr Tairov (1885–1950)
Artist: Alexandra Exter (1882–1949)

4.
Romeo and Juliet, 1921 (act 3, scene 1)
Kamerny Theater, dir. Alexandr Tairov
Artist: Alexandra Exter

5.
Phèdre, 1922 (maquette of set)
Kamerny Theater, dir. Alexandr Tairov
Artist: Alexandr Vesnin (1883–1959)

11. Aleksandr Fevralskii, *Pervaia sovetskaya piesa (The First Soviet Play)*. Moscow, 1971, pp. 71–72.

12. For a detailed account of Dmitriev's design for *Dawns*, see Nikolai Chushkin, "Vladimir Dmitriev," *Teatr*, August 1975, pp. 81–90.

Phèdre in 1922, as a study in "Neoclassical Cubism." One of the Kamerny Theater's most successful productions, *Phèdre* was extraordinarily simple and harmonious in its conception. A series of sloping planes, suggesting the deck of a listing ship, were flanked by a huge cylinder at the right and several rectangular three-dimensional forms at the left (fig. 5). Tautly angled colored backdrops traversed by two heavy cords suggested the sails and prow of a Greek ship. Vesnin's costumes were also conceived in the same classical vein, preserving in severely stylized form the helmet, shield, tunic, and footcovering of Greek dress. The production marked the culmination of everything Tairov had been seeking in the name of "synthetic" theater.

Although Tairov's collaboration with artists like Exter and Vesnin marked an important step in revolutionizing scenic design, it was Meierkhold who decisively set the future course of the theater in the turbulent days following the Revolution. Tairov was not a man of the masses and he insisted on the right of art, theater included, to remain independent of current political events. In sharp contrast, Meierkhold welcomed the Revolution when it came in 1917. He was one of the first artists to lend his support to the new Bolshevik regime. For the first anniversary of the Revolution, Meierkhold also staged the first Soviet play, *Mystery-Bouffe,* Vladimir Maiakovsky's parody of a medieval morality play in which the international proletariat is led to a mechanized promised land. For this production at the Petrograd Conservatory, Meierkhold broke with the World of Art group and invited Malevich to design the sets and costumes.

Unfortunately no pictures or sketches remain of the production, for indeed it must have been striking. According to Alexandr Fevralsky, "Hell was represented by a red and green Gothic hall resembling a cave with stalactites." Paradise, which was intended to parody the symbols and iconography of Byzantine frescoes, consisted of a "nauseating combination" of aniline pink, blue, and violet "cakes" (supposedly clouds) against a gray background. A Suprematist canvas, against which was placed something resembling a huge machine, represented the Promised Land.[11] All evidence points to the fact that Malevich's conception left much to be desired when realized on the stage. The canvas-covered, three-dimensional hemisphere representing the Earth, for example, proved to be so fragile that most of the action in Act I had to take place in front of it. Nevertheless, for Meierkhold it represented a significant break with the past and a first step toward a new dynamic form of theater.

The following year, when Meierkhold staged Emile Verhaeren's *The Dawn (Les Aubes)* as the inaugural production at his new R.S.F.S.R. Theater

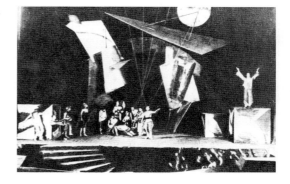

6.
The Dawn, 1920 (scene from production)
R.S.F.S.R. Theater, dir. V. Meierkhold
Artist: Vladimir Dmitriev (1900–1948)

in Moscow, he invited the young artist Vladimir Dmitriev (1900–1948) to create the scenic designs (fig. 6). For this epic drama of world revolution set in the city of Oppidomane (from the Latin *oppidum magnum),* Dmitriev designed a city of "iron and lead" reflecting in a very abstract manner certain geographical details of ancient Rome, such as the Aventine Hill, "frozen into an image of the city in general."[12] The set consisted of a number of stationary red, gold, and silver cubes, cylinders, and planes with intersecting ropes attached to the flies. Stationary cubes at either side served as platforms for the actors, and steps spiraling from the orchestra pit linked the auditorium to the stage. In all, the setting was very reminiscent of Tatlin's "counter-reliefs." It also reflected the influence of Exter's work at the Kamerny Theater, although it lacked her dynamic sense of rhythm.

Meierkhold planned the production of *The Dawn* as a political meeting with a chorus in the orchestra pit and actors placed in the auditorium to stimulate audience response. Flyers were floated down from the balconies, and announcements were made that shouting and whistling were allowed during the performance. On those nights when there were organized contingents of soldiers in the auditorium, their responses gave the production a stirring sense of immediacy, especially at that moment when the Herald would report actual victory bulletins from the Crimean front.

For his second, and last, production at the R.S.F.S.R. Theater, Meierkhold mounted a completely rewritten version of *Mystery-Bouffe.* Meierkhold first invited Tatlin to design the sets and costumes and when he was not available, Meierkhold turned to Georgii Yakulov (1884–1928). The design he submitted, an amphitheater in the spirit of the Renaissance, hardly coincided with the contemporary context of the play. Meierkhold finally put together a group of three artists, Vladimir Kharkovsky (b. 1893), Anton Lavinsky (1893–1968), and as costume designer Victor Kiselyov (b. 1895), and set them to work. What they created was a light construction made of wood out of which were formed ▶

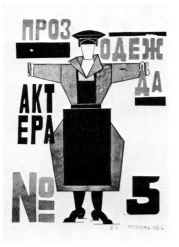

7.
Mystery-Bouffe, 1921 (1924 reconstruction of maquette)
R.S.F.S.R. Theater, dir. V. Meierkhold
Artists: Vladimir Kharkovsky (b. 1893), Anton Lavinsky (1893–1968), and Viktor Kiselyov (b. 1895)

8.
The Magnanimous Cuckold, 1922 (Sketch of work uniform "prozodezhda" for Nursemaid)
Meierkhold Theater, dir. V. Meierkhold
Artist: Liubov Popova

now an ark, now the heaped-up land of clouds (fig. 7). The ark even more vaguely resembled a boat than in the first production—only details: a prow, a deck, a captain's bridge, which together with the sloping ramp below it gave a suggestion of the three levels of the medieval mystery. The proscenium was eliminated entirely, and a huge semiglobe marked "the earth" reached right out into the audience. When it was turned it revealed the opening of Hell on the other side. The production was filled with acrobatics and circus tricks. One of the devils was even played by a clown, Vitalii Lazarenko (1890–1939), who descended a wire for his entrance.[13]

Alexei Granovsky (1890–1937) went still further in his production of *Mystery-Bouffe* for the delegates of the Third Congress of the Komintern in June 1921, by staging it right in a circus. Drawing on Natan Altman's (1889–1970) experience in designing mass spectacles in Petrograd, this *Mystery-Bouffe* made use of 350 actors and ballet dancers who performed on 4 circular ramps leading down into the circus arena and in the orchestra shell, which was joined to the arena by stairs. The action, which included dancing and an abundance of circus tricks, exploded and seemed to erupt everywhere in the amphitheater.

The circus was only one of the places where theater was likely to turn up in the years immediately following the Revolution. At times, life itself threatened to become one huge mass spectacle. Every holiday and anniversary saw streets and public squares transformed into outdoor stages decorated by the leading artists of the avant-garde. In Petrograd, on November 7, 1920, a crowd of more than 100,000 people watched *The Storming of the Winter Palace* as it was re-enacted by some 10,000 participants in a producton directed by Nikolai Evreinov (1879–1953) with sets designed by Yurii Annenkov. Agit-ships and trains took performers out into the countryside to bring the message of the Revolution to a largely illiterate peasant population. (See S. Bojko, "Agit-Prop" essay.) The Blue Blouse movement, launched by Boris Yuzhanin in 1923, became one of the most widespread forms of theatrical entertainment in the post-Revolutionary period. An outgrowth of the "living newspaper," it involved more than 100,000 participants in some 484 professional troupes and 8,000 amateur groups at the height of its popularity in the late 1920s. Many well-known writers and artists, including Maiakovsky, Osip Brik (1888–1945), Sergei Yutkevich (b. 1904) and Boris Erdman (1899–1960), contributed to the movement's monthly magazine of materials for club use.

In January 1922, Meierkhold began work on his production of *The Magnanimous Cuckold*. With the closing of the R.S.F.S.R. Theater in September of the preceding year, he now found himself in need of some type of utilitarian set that could be erected anywhere, even out-of-doors, and that required neither trained technicians nor special machinery. As he later wrote:

With this production we hoped to lay the basis for a new form of theatrical presentation with no need for illusionistic settings or complicated props, making do with the simplest objects which came to hand and transforming a spectacle performed by specialists into an improvised performance which could be put on by workers in their leisure time.[14]

Meierkhold found the solution he was looking for in the work of the Constructivists, particularly the spatial apparatus designed by the Stenberg brothers, Georgii (1900–1933) and Vladimir (b. 1899), which he had seen exhibited at the memorable Constructivist exhibition in 1921 and at Liubov Popova's "preparatory investigations" for the *5 x 5 = 25* exhibition later that year. The Constructivists' anti-aesthetic approach, which replaced decoration with functionalism, made them a natural ally in Meierkhold's fight against traditional theatrical décor. Meierkhold had worked with Popova and Vesnin on an unrealized project for a mass performance called *Struggle and Victory* in April 1921. Now, at his invitation, Popova joined the staff of his Theater Workshop.

The actual design for *Cuckold* went through a number of transformations. Meierkhold first approached the Stenberg brothers, but this collaboration rather quickly broke down following the preparation of some preliminary sketches. Meierkhold next turned to Popova but she at first refused. Popova was reluctant to incur the wrath of the Constructivists who had, after all, proclaimed the death of all art, including theater. Meierkhold finally turned the planning over to his own workshop and commissioned Vladimir Liutse (1903–1970) to build the maquette. Nevertheless, it was Popova who came in at the last minute to rework the design decisively by changing the proportions and the placement of the basic modules. Popova also designed the costumes. Intended as the prototype of a "work uniform" *(prozodezhda)* for actors (fig. 8), they consisted of a simple, two-piece, blue outfit to which were added individualizing details such as a scarf or apron.

In its final form, Popova's Constructivist set proved to be truly revolutionary. While it was at an opposite extreme from the cozy interior of the old watermill in which Crommelynck located the action of his play, the two basic mountings connected by a bridge retained all the essential elements: doors, windows, stairs, and even the suggestion of the millrun. At the same time, the construction was so perfectly thought out that all of its components

13. Valerii Bebutov, "Nezabytoe" ("Unforgotten"), *Tvorcheskoe nasledie V. E. Meierxolda (Meierkhold's Artistic Legacy)*, Moscow, 1978, pp. 272–81. Bebutov was co-director with Meierkhold of *Mystery-Bouffe*.

14. V. E. Meierkhold, "Kak byl postavlen Velikodushnyi rogonosec" ("How *The Magnanimous Cuckold* Was Staged"), *V. E. Meierxold—Statii*, vol. II, p. 47.

15. From a lecture given by Popova at the Institute of Artistic Culture, Moscow, in April 1922. Quoted in Elna Rakitina, "Liubov Popova. Iskusstvo i manifesty" ("Liubov Popova: Art and Manifestos"), *Khudozhnik stsena ekran (Artists of the Stage and Screen)*, ed. E. Rakitina et al., Moscow, 1975, p. 154.

16. I. A. Aksyonov, "Prostranstvennyi konstrukitivizm na scene" ("Spatial Constructivism on the Stage"), *Teatralnyi oktiabr (Theatrical October)*, Leningrad/Moscow, 1926, sb. 1, p. 34.

17. Mikhail Zharov, *Zhizn, teatr, kino (Life, Theater, Cinema)*, Moscow, 1967, p. 171.

18. "Beseda s V. F. Stepanovoi" ("A Talk with V. F. Stepanova"), *Zrelishcha*, Moscow, 1922, no. 16, p. 11. Compare the costumes for the "Children," for example, with Stepanova's designs for sports clothes in *Lef*, no. 2, 1923, p. 66.

were constantly drawn into the actors' play. It is precisely this kinetic quality that, in fact, made it so remarkable. Even the wheels and sails contributed by turning at crucial moments "to underscore and emphasize the kinetic meaning of each moment of action."[15]

By defining and structuring the spatial limits of the playing area, the construction aided the actors in much the same way that a properly designed machine enables a worker to perform more efficiently. And as a showcase for demonstrating the efficacy of the biomechanical exercises Meierkhold was then developing in his Theater Workshop, the construction was a startling revelation. As Aksyonov pointed out, "with this mounting it was possible to play as with a fan or a cape."[16]

The actors quickly discovered that the most effective parts of Popova's construction were those parts, such as the revolving door, that gave the actors something to play *with*. It was this principle of "objects for play" that Meierkhold would develop in his further explorations of Constructivism. For his production of *Tarelkin's Death* in 1922, which he staged as a montage of circus attractions, Varvara Stepanova designed special furniture intended specifically as instruments for play (fig. 9).

The most theatrical of Sukhovo-Kobylin's nineteenth-century trilogy, *Tarelkin's Death* is a bitter satire of tsarist police methods. In order to escape his debts and make a new fortune, Tarelkin steals some papers and fakes his own death. He is caught, however, when the police official Rasplyuev, himself a petty criminal, and Varravin come to search Tarelkin's apartment. Tarelkin, who has assumed the identity of a recently deceased neighbor by the name of Korylov, is arrested and grilled in an attempt to extract a confession that he is actually a vampire and part of a grandiose conspiracy. Upon threat of exile to Siberia or death, Tarelkin finally confesses and turns over the stolen papers. Penniless and with his new identity of Korylov, Tarelkin is set free. The play ends with his appeal to the audience for a job.

Each piece of stage furniture Stepanova designed for the production was constructed in such a way that it would either jump, collapse, or in some other way respond to the actor's actions. One chair, for example, was built with springs so that the seat dropped when anyone sat on it; and the stool had a piston that fired a blank cartridge. Even the table could collapse, and then pop back up by itself.

Although in practice the furniture proved to be quite unreliable, it nevertheless provided the actors with some remarkable possibilities for "play." Mikhail Zharov, the actor who played the role of the laundress Brandakhlystova, describes in his memoirs the acrobatics required to pass through the

huge "meat grinder" leading to the prison cell:

I climbed the ladder to the top of the construction and from there dove head first, landing on the "meat grinder" blade, which was made of rigid plywood. Taking the handle of the "meat grinder," Kachala and Shatala then cranked me as I lay on one of the four blades of this complicated construction. ... I made a half circle and on reaching the bottom, I crawled into the cage, which also represented the "cooler."[17]

Stepanova also designed the costumes of gray yellow canvas with blue black patches and stripes. They were based on two principles: first, to "underscore the bending of the limbs and the movements of the different parts of the human body," and second, to create some "prototypes of sports costumes (children and creditors) and work uniforms (woman's — Brandakhlystova, military — Okh, Rasplyuev, and others)."[18] Unfortunately, under the harsh glare of the military spotlights Meierkhold used to illuminate the stage, the costumes became a confusing mass of blobs when seen from the auditorium. They neither enhanced the actors' movements nor did they sufficiently differentiate the various characters.

Following *Tarelkin's Death*, Meierkhold gave up the idea of building special play constructions and turned to the use of real objects. For *The Earth in Turmoil* (1923) Popova again joined Meierkhold to create a Constructivist setting using real objects with defined functions in everyday life. Objects such as automobiles, motorcycles, and mobile kitchens, once regarded as outside the limits of art, now suddenly became the aesthetic components of it. Such documentary authenticity was particularly appropriate for this agit-prop production that on a number of occasions was performed out-of-doors, once before an audience of 25,000. ▶

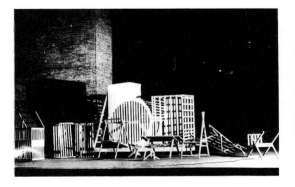

9.
Tarelkin's Death, 1922 (stage furniture)
Meierkhold Theater, dir. V. Meierkhold
Artist: Varvara Stepanova (1894–1958)

19. Elena Rakitina, *Novye printsipy scenicheskogo oformleniia v Sovetskoi teatralnoi dekoratsii 20-x godov (New Principles of Stage Formulation in Soviet Theatrical Decoration in the 1920s)*, abstract of dissertation, Moscow, 1970, p. 8.

20. Abram Efros, *Kamernyi teatr i ego xudozhniki 1914–1934 (The Kamerny Theater and Its Artists 1914–1934)*, Moscow, 1934, p. xxxvi.

21. Ivan Aksyonov, *Zrelishcha*, Moscow, no. 21, 1923, p. 8.

The success of Popova's design for *Magnanimous Cuckold* very quickly brought an end to the Constructivists' resistance to work in the theater, and it was not long before Constructivism became the dominant factor in stage design. The effect was immediate and dramatic. One need only compare, for example, the rococo exuberance of Yakulov's sets for *Princess Brambilla* (fig. 10), at the Kamerny Theater in 1920, with the intricate system of ladders and screens Yakulov devised for Lecoc's operetta *Girofle-Girofla* (fig. 11) just two years later. These eccentric and colorful "machines" brought a new spirit to the Kamerny Theater and launched a style that Tairov would continue to develop in his subsequent productions. Unlike Exter's designs in which the actor became "a module in the system, but also a slave to it,"[19] here was a system of form in motion which "worked for and with the actors, giving them ... what they needed in the course of the action."[20]

It was the Stenberg brothers who most successfully developed the concept of Theatrical Constructivism in a series of remarkably effective constructions at the Kamerny Theater beginning with *The Storm* (with Konstantin Medunetsky) in 1924. Like Popova, and Stepanova to a lesser degree, the Stenbergs regarded the actor as the central focus of the theatrical production. They created a setting that was both functionally effective for the actor and remarkably economical in means (fig. 12). Photographs hardly do justice in suggesting the dynamic possibilities of their stage constructions—for example, the movable bridges in *The Storm* or the extremely laconic system of steplike platforms for Shaw's *Saint Joan* in 1924.

With its emphasis on functionalism, Constructivism gave to the theater a new ideal of beauty based on simplicity, proportion, and the use of real materials. In actual practice, it was an ideal that proved to be tantilizingly elusive and one few artists were able to achieve. As Ivan Aksyonov pointed out in early 1923:

> So-called stage constructivism, which started out with the broadest program of completely rejecting aesthetic methods on the stage, too quickly began to show signs of being extremely ready to adapt itself to its surroundings. It has now degenerated into a decorative device, although admittedly of a new style.[21]

Much of what was called "Constructivism" at the time was, in fact, simply another form of illustrative decoration which, like the painted backdrop of the pre-Revolutionary theater, served mainly to delight the eye of the spectator. At times, the fascination with machinery threatened to become an end in itself, as was the case, for example, with Annenkov's factory setting for A. N. Tolstoy's *The Revolt of the Machines* at the Bolshoi Dramatic Theater in

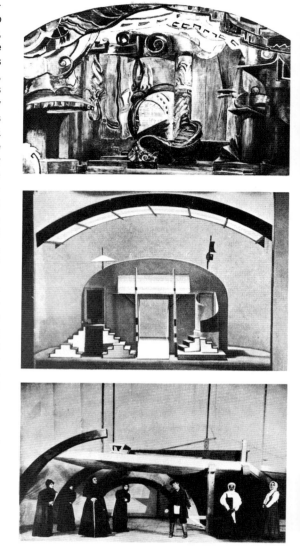

10.
Princess Brambilla, 1920 (sketch of set design)
Kamerny Theater, dir. Alexandr Tairov
Artist: Georgii Yakulov (1884–1928)

11.
Girofle-Girofla, 1922 (maquette of set)
Kamerny Theater, dir. Alexandr Tairov
Artist: Georgii Yakulov

12.
The Storm, 1924 (street scene)
Kamerny Theater, dir. Alexandr Tairov
Artists: Georgii Stenberg (1900–1933) and Vladimir Stenberg (b. 1899)

Lenningrad (1924). Even Vesnin's extraordinary urban environment of elevators, stairs, and platforms for *The Man Who Was Thursday* (fig. 13) at the Kamerny Theater in 1923 was more appropriate in expressing the spirit of city life than it was as a functional "machine for actors."

Nevertheless, Constructivism brought to the theater a new flexibility and freedom, an awareness that a theatrical performance can take place almost anywhere and with a minimum of physical properties. Constructivism restructured the spectator-performer relationship by bringing the actors out from behind the footlights and returning theater, in spirit if not always in fact, to the public square where the audience could surround it on all sides. There can be no question that, if experimentation had not been cut off by the advent of Socialist Realism in the early 1930s, Constructivism would have led to a redesigning of the theater building itself. Witness, for example, Meierkhold's plans for his new theater (fig. 14), unfortunately never completed, or his pupil Nikolai Okhlopkhov's experiments with theater in the round in the mid-1930s at the Theater of the Revolution. Even in the darkest days of the Stalin era, Constructivism never disappeared completely from the stage, and with the revitalization of the Soviet theater in the past two decades it has once again gained wide recognition as the major form of theatrical design. ●

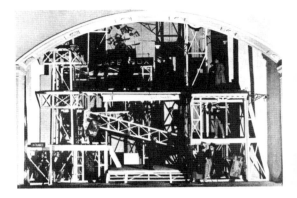

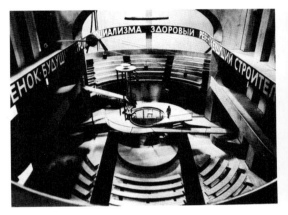

13.
The Man Who Was Thursday, 1923
(street scene)
Kamerny Theater, dir. Alexandr Tairov
Artist: Alexandr Vesnin

14.
El Lissitzky's (1890–1941) setting for
Sergei Tretiakov's discussion-play
I Want a Child, 1928–29.

■ The overthrow of the aristocracy in Russia, the revolutions of February and October 1917, a bloody civil war, foreign intervention and the blockade it introduced; destruction and hunger on one hand, the toil and pathos of creating the foundations of a new system on the other—all this had drawn vast human masses into participating in politics. Throughout the immense territories of the former empire, the illiterate, bullied peasants were suddenly uprooted from their patriarchal existence, from a state of degradation, and thrown into a whirl of events whose mechanism was unfamiliar to them. The peasants were part of a gigantic theater in which life itself was often at stake. This theater never allowed for nuance, individualization, or psychological interpretation, encouraging instead a strict categorization. One either talked of the "reds" or of the "whites." Activities consciously intended to awaken emotional states in the masses, to encourage them to become involved, were based on contrasts and simplified truths. A specific kind of expression was born: inspired from without, it resulted from the hybridization of art, theater, proletarian poetry, folklore, music, dance, and films. It was called "agit-prop," and in fact it laid the foundation for popular and populist culture.

Time—pitiless as a rule to works originating from summary public commissions and from the centers of power—has been lenient to the art that brought relief during the Revolution. It did not deprive it of permanent artistic values or of humanism. History has ennobled the mass-meeting style of Maiakovsky's poetry, the agitational range of Vertov's film-truth, the tendentious impact of Meierkhold's and Tairov's staging, the agitational blatancy of the "Rosta windows" posters, as well as the many unrealized artistic ideas of the monumental propaganda plan.

By using art in an educational or didactic manner, for political reasons, the artists were not guilty of compromise; in fact, this may have been regarded as a virtue. The concurrence of art and revolution had formed a base for joint action. Lunacharsky, the People's Commissar for Education, had such an arrangement in mind when he wrote, "If the Revolution can give art its soul, then art can endow the Revolution with speech." But to create significant works of art within the framework of agit-prop was more complicated than Lunacharsky had suggested it would be on various occasions. Artists pursued their own aims, stemming from immanent laws of art and from its internal development. They did not always have to be identified with views held by politicians on what art of the new community should be. It is generally known how distrustful Lenin was of non-realist art, with what reluctance he tolerated Lunacharsky's sympathies for the innovators, and how soon the Bolsheviks limited the influence of the advocates of Futurism on cultural developments. Yet, after all, it was exactly these artistic groups that provided the ideas that ensured the popularity of agit-prop, thereby raising the prestige and attractiveness of the Revolution itself.

There were numerous sources for the evolution of the agit-prop. Many scholars in the West mistakenly give sole credit to the avant-garde for creating mass art. The powerful language of the agit-prop—its syntax, articulation, and iconography—had many roots: historic and contemporary, traditional and innovative, secular and religious.

The Folk Source. The society was rural, deeply bound to the rhythm of work in nature, with peasant customs, legends, and a naive belief in the salvation of the world. Apart from a love for rich ornamentation, Russian folk art had a tendency to moralize. Functioning within a peasant community, it posed questions about the ethics of existence. It contained as much good nature, nostalgia, and melancholy as it did sheer vitality. Heroes of the *lubok*— people and animals drawn from life, from fables, and from history handed down from generation to generation—appeared as models for morality, with an element of burlesque laughter added. A sense of community and freedom, of robust and coarse laughter, stifled and covered with a layer of puritanism and officialdom, inhered very strongly in the cultural tradition. Buffooneries, carnival processions, jesters, and masqueraders were introduced during the reign of Peter I and continued to appear in folk interludes and carnival shows. The figure of Petrushka is proverbial; he was the chief persona in the puppet theater, a guide in the world of laughter who provided Stravinsky with a ballet theme.

An opinion persists concerning the lack of humor in the Revolutionary period, of an absence of the comic arts, based on a conviction that revolutionary asceticism dominated the world of politics and ideology in the 1920s. Such an opinion has not been shaken by the literary works of Babel, Zoshchenko, Ilf, and Petrov, nor by films such as the fairytale-like comedy directed by Lev Kuleshov in the style that parodied the American western *Mister West v strane bolshevikov (Mr. West in the Land of the Bolsheviks)*. Nor was humor to be found in cabarets, propaganda shows, living newspapers such as the *Siniaia bluza (Blue Blouse)* (fig. 1), and the intimate theaters where the eccentric talents of Eisenstein and Yutkevich reigned.

In the journal *Zhizn iskusstva (Life of Art)* of September 18, 1923, however, an article by its editor entitled "The Foxtrot—a New Kind of Pornography" stated: "The European bourgeosie has invented a new kind of pornography—in the form of a fashionable dance, the Foxtrot.... This

1.
Actors at cabaret *Siniaia bluza*
(Blue Blouse)

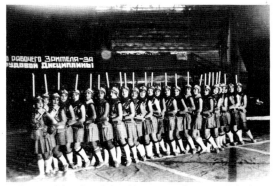

1. In conversation with the author, winter 1978.

yellow epidemic of the European bourgeoisie has gradually dominated our theaters, just as it had previously conquered the restaurants. As long as the plague has not penetrated deeply into our theatrical life and struck root there, and so long as it has not yet contaminated our art, we should put a stop to it; that is, we should forbid the performance of these disgusting dances. There is no place for them in the revolutionary republic."

Recently Maria Siniakova (a member of the Futurist circle and friend of Khlebnikov and Maiakovsky) and her sister Oksana (widow of the poet Aseyev) recalled the events of a New Year's Eve party in 1925–26.[1] The party was given in Maria's studio in the attic of a multi-story building in Moscow. There was no elevator, the staircase was unlit, and the food and wines were very frugal. Yet the piano resounded with the syncopated rhythm of a foxtrot and everybody danced—the young and the old, artists, directors, poets, painters, musicians, and political figures—including Tyshler, Sterenberg, Roskin, Maiakovsky, Aseev, and Eisenstein and his cameramen. All the revolutionary young people of Moscow were seized by a rage for the foxtrot. It appealed to them: it was resiliently rhythmical, light, and gay. The women exposed their legs with their short skirts and bared their neck, arms, and backs; one could say it was Art Deco of a poor sort, full of coarse simplicity and resourcefulness (fig. 1). "Inside us," said Maria, "we had youth and joy. We lived on art. Those were times of hope and fantasy." This account by the painter, one of the few living artists of the epoch, provokes reflection. In apartments and studios of the intellectual and artistic elite of the Revolution, just as once in literary salons of the progressive Russian intelligentsia, standards were established and spiritual values were chosen. Those values maturing within the avant-garde would soon reach a mass audience through innumerable invisible channels. The intellectuals and artists set on a revolutionary course had decidedly rejected the cultural residue and the middle-class ideals of the old Russia; without hesitation they referred to the authentic cultural achievement of the rural population and of the proletariat.

The Sanctum. Christendom and the Russian Orthodox Church, liturgy, the heritage of theological thought, and the visual symbols of faith consolidated by generations—these presented inexhaustible strata of emotional behavior and models to be adapted by the avant-garde and its agit-prop. One cannot understand the tensions, obstinacies, and accumulation of class hatred—and at the same time the heroism—that were let loose among the masses without realizing the whole weight of mysticism and religious ecstasy contained in the Orthodox Church. The icon, for example, one of the most common images, related to every vital event in communal and private life. It embodied the beginning and the end of all temporary things. According to elaborate rules, the painter of an Old Russian icon embodied ritual and carnal purity. Not surprisingly, the metaphysics of the icons fascinated generations of artists, including the avant-garde. Malevich mentions in his autobiography that it was due to this type of painting, which did not recognize linear perspective or illusory space, that he understood in his youth the emotional peasant art. He noticed clearly two lines in Russian art—one, the courtly, originating from ancient times, the other, a peasant one, leading from the icons to decorated utilitarian objects. The interaction of the sanctum and of plebeian mythology, of the irrational and of peasant sobriety, was developed and transformed in later agitational activities, on posters, and in decorations for manifestations and marches. In visual agitation we often find figures readily transferred from icons, such as St. George on horseback meting out proletarian justice, with only a change of dress and accessories from the original. In verbal slogans we discover Gospel texts, adapted by the people as banal truths. Thus the phrase from the Epistle of St. Paul to the Thessalonians, "He who does not work, does not eat," plebeian and moral, was quoted anonymously in the First Constitution of the Russian Federation. Goncharova's fascination with the spiritual culture of the people, national and sovereign, independent of foreign influence, was combined with granting superiority to art that had sacred foundation. She maintained that "religious art and art glorifying the state were always the most perfect, largely because they sprang from tradition and not from theoretical premises." The attitude of the painter, who herself came from a rural family, reflected the state of mind of the educated community. A discovery of one's own geneology in a naive, peasant viewpoint on the one hand, and an Eastern mysticism on the other, as an antidote to Western rationalism, led to a quaint mixture of notions, simultaneously progressive and conservative.

As one of the supports of the Old Russian culture, the Sanctum appeared in mass art in the form

of popular myth bound to the partriarchal system of ethical norms. The plebeian soil of Orthodox religion was still so untainted by dead dogma, so alive and capable of regeneration, that it was impossible to reject. Mystical and religious thinking, which has for centuries formed the spiritual image of the nation, did not stop on the threshold of October 1917. Church banners, crosses, and portable icons were replaced with red flags, carried at first in a way reminiscent of a religious rite. Though the songs chanted during the marches had nothing in common with Orthodox church singing, the exalted fervor of the singers was similar. Though public manifestations established their own lay ritual, they still had for a long time an aura of the religious procession (fig. 2).

Yet the internal interlacing of the two worlds, based on custom and tradition, had another side —more manifest, aggressive, and blasphemous. Religious cult elements had penetrated mass cultural activities with negative and caricatured intentions when, as a result of class division, the clergy took to the Counter-Revolutionary side of the barricade. The struggle against the clergy took a particularly drastic form, appealing to intolerance and an instinct for violence, insulting both the faithful and persons of a critical disposition. On the artistic level, however, the anticlerical agit-prop did not propose anything of value.

Prototypes of the Agit-Prop. Popular art immediately following the Revolution, transforming town space into symbolic space, drew its origin from historic sources, both national and foreign. The latter can be traced to the era of the French Revolution, which for the first time in modern Europe had associated art with the dynamics of assemblies, marches, and feasts. By 1918 a Russian translation appeared of an authoritative study by Julien Tiersault on songs and celebrations of the French Revolution. Large spectacles produced according to scenarios by French artists (some were even designed by David) appeared to contain the origins of later allegories and symbols. The example of Jacobin France helped to illustrate the principles of crowd participation in paratheatrical projects, as well as the ability to merge various media into one style in a spectacle.

Among the archetypes of Russian spectacles are eighteenth-century firework displays and celebrations of the three-hundredth anniversary of the rule of the Romanov dynasty. Pyrotechnics had reached a high level of artistry during the reign of Peter I, who had rightly judged its propagandistic and entertainment values. Firework displays and illuminations were integrated with presentations of allegorical programs and paintings of a political nature. Such scenes, recorded in numerous etch-

ings, were invaluable material in designing similar mass activities in Petrograd on the anniversaries of the Revolution. On the other hand, references to the example of occasional decorations, made by order of the Court and overloaded with ornament, were made at first reservedly. As time went by, it was exactly this baroque and veristic style prone to theatrical pomp (fig. 3) that ironically became a characteristic of visual taste of the worker and peasant authority. Only the avant-garde, however, conscious as it was of the destructive possibility of art, was opposed from the very beginning to the baroque, classicist, and pompous tendencies threatening art and culture in general. Nor did it join the stream of demystification of the Sanctum. Two small antireligious books written and illustrated by Maiakovsky in 1923 could have been accepted by the believing rural reader, since they contained popular wisdom and plebeian humor, allowing for a fraternization of man and God. It was only from the

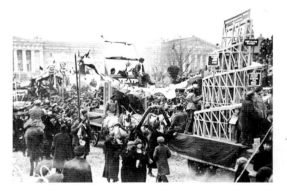

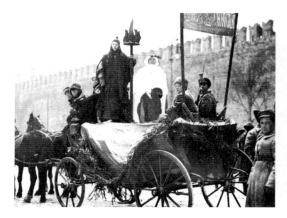

2.
Agit-procession, second anniversary of the October Revolution, Moscow, 1919 (To the right: replica of Vladimir Tatlin's *Monument to the Third International*)

3.
Agit-procession, second anniversary of the October Revolution, Moscow, 1919

avant-garde circles that warnings emanated against any sanctification of revolutionary ceremony and abuse of the cult of a leader. When a newspaper ran an advertisement urging the sale of mass-produced busts of the deceased Lenin, the *Lef* magazine (No. 1, 1924), edited by Maiakovsky, reprinted the advertisement in full, giving it a title "Do Not Traffic in Lenin" and adding a commentary "We are against it" (this page was later removed from library collections in the Stalinist period).

Additional prototypes were furnished in publications established by workers' organizations which developed increasingly at the end of the nineteenth century in Germany, England, France, and the United States. This movement brought the nuclei of socialist iconography, allegories, and symbols of the revolutionary outlook to Russia. They were created by anonymous draftsmen and leftist artists: Steinlen, Grandjouan, Heine, and Biro, with Kollwitz, Grosz, Masereel, and Gropper following in the early twentieth century. The anti-bourgeois ideal of life was propagated by illustrated reviews such as *Simplicissimus, L'asiette au beurre,* and *Le petit sou.* In Russia, due to tsarist censorship, ideograms of the workers' movement came to light only in the wake of the 1905 revolution, although instances of political satire occurred earlier. In spite of their short lives, magazines *(Satirikon, Strely, Ahupel, Adskaia pochta,* etc.) became a platform for satirical drawings, preparing the ground for agit-prop. Satire taken from life, such as that found in the spoken word, in writing, drawing, or song, appeared as archetypes of political nomenclature, serving as the raw material for productions and activities of the agit-prop. As with any convention, this one also quickly lost its freshness. Yet before this happened, examples of class interpretation of events, attitudes, and behavior managed to stir emotions—to achieve an artistic synthesis of the changing world. This was accomplished by the imagination of artists, by their real concern for the fate of their country, and, what is most essential, by the possibility of expression in practically any visual style (figs. 4a, 4b, 5).

It is sufficient to compare typical agit-prop works of the period—posters by Maiakovsky, Moore, Lissitzky, and Lebedev, occasional decorations by Altman, Chagall, Malevich, Puni, and the Stenberg brothers, "radio announcers" (mechanical objects) by Klucis, and paintings on propaganda trains—with analogous works of visual propaganda of World War II in order to notice the stereotyped aesthetic uniformity of the latter. Opposing artistic trends—Realism, Cézannism, Colorism, Cubism, Futurism, Suprematism, and Constructivism—defined in their own language of form their relation to reality. "The revolution of substance—Socialism,

Anarchism—is unthinkable without the revolution of form—Futurism," wrote Maiakovsky in "An Open Letter to Workers." In agit-prop art, plebeian, conservative, innovative, and moderate tendencies interacted. For that reason one can speak of a new faction of artists who did not consider themselves as the avant-garde and were not included with the "left." Agit-art sought contact with the public in all areas. Making use of the traditional media, it approached new and more dynamic ways of intensifying visual-motive-and-audio sensations, anticipating many later media and methods. A simple enumeration of the most important forms in which art appeared gives an idea of its scope:

Banners; stenciled posters ("Rosta Windows"); prints—lithographed posters, postcards, cartoons, and press illustrations; paintings on moving objects—trains (fig. 5), steamers, trams (figs. 4a, 6), roundabouts; paintings on utensils—propaganda plates, fabric featuring ideograms of a ▶

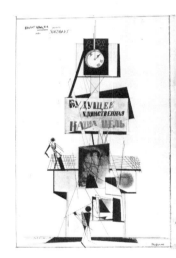

4b.
Alexandr Rodchenko (1891–1956)
Design for Agit-kiosk, 1919

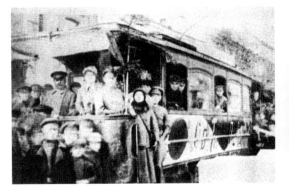

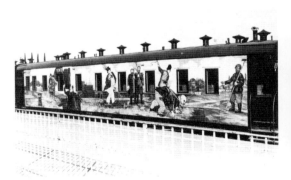

4a.
Kazimir Malevich (1878–1935)
Exterior Design for Agit-prop Streetcar, 1918

5.
S. Tixonov
Exterior Design for Car of Agit-train "Red Kazak," 1928

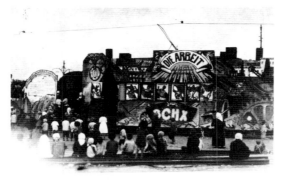

6.
Agit-prop streetcar, 1918

7.
Celebrating the Red Army's first anniversary, Petrograd, 1919

8.
Mass spectacle, "The Overthrow of the Tsarist Regime," with participation of actors from the dramatic studio of the Red Army

9.
Plan for the mass spectacle re-enactment of "The Storming of the Winter Palace," Uritsky Square, Petrograd, November 7, 1920

10.
Mass spectacle re-enactment, "The Storming of the Winter Palace," Petrograd, November 7, 1920

2. Anatol Stern, *Legendy nashykh dnei (Legends of Our Days)*, 1969.

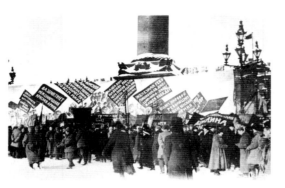

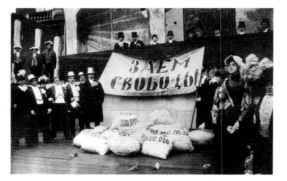

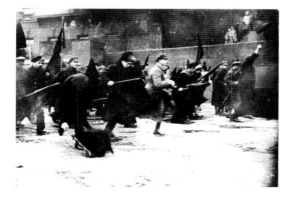

new way of life; wall paintings—public buildings, exhibition pavilions; monumental sculpture—monuments, commemorative sites, necropolises; townscape decor—street and square decorations, masking of tsarist monuments (fig. 7), marches, festivals, and carnivals; occasional spatial constructions—speakers' tribunes, kiosks (fig. 4b), commercial stalls, tram stops, propaganda stands; theatrical and paratheatrical spectacles (fig. 8)—satirical stage shows, masque theaters, puppet shows for adults, "living newspapers," open-air spectacles; "film-truth"; music-massed industrial sounds—blasts of factory sirens, rhythmic machine noises. Not counting the documentary film, the popular art closest to contemporary understanding was probably the spectacular in which the boundaries between art and non-art, or audience and actors, professional or amateur, were blurred. While making room for audience participation, for the identification of one person with a group, the spectaculars were like the medieval mystery plays. They contained the nucleus of the open theater in its present-day sense, foreshadowed the programmed "son et lumière" spectacular, as well as continued the tradition of Russian folk shows *(balagan)* and attempted to theatricalize life itself—an idea of the reformers of the Russian theater.

Apart from Meierkhold and Tairov, these reformers included Nikolai Evreinov, forgotten by now, an enthusiast of the theater, a director, playwright, theoretician, writer, and the moving spirit of the spectacular *The Storming of the Winter Palace* (figs. 9, 10). For Evreinov, man's whole life and the history of mankind made great theater. *Homo ludens* developed in play-theater or amusement-theater, and in folk rituals shaped several thousand years ago. "When I use the word *theater,*" wrote Evreinov, "I imagine first of all a child, or a savage man, and everything that is inseparable from their insatiable hunger for transformation, from that which proves that they do not agree with the everyday world, alien to them, and out of which results the change of this world for another, creatively conceived and accepted by them of their own will."

It was after many years that Evreinov returned, in a published letter to a Polish writer, Anatol Stern, to his thesis on the theater of life. "Hasn't the world literally become a theater for war action, where mad directors tell tragic actors, sometimes playing their parts against their will, to kill people?…After all, it was Marcus Aurelius who said of life that it was a play which one can leave before the end of the spectacle, but it is not easy. Why? Because man pays too much for the possibility of taking part in it."[2]

Translated from the Polish by Andrzej Wojciechowski

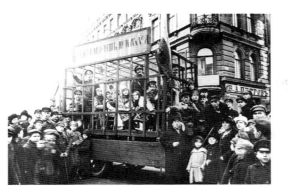

11.
Street performance, Moscow, May 1, 1920

12.
Mass performance, "Toward a Worldwide Commune," on the steps of the Exchange Building, Petrograd, 1920

13.
Mass spectacle re-enactment, "The Storming of the Winter Palace," Petrograd, November 7, 1920

14.
Mass spectacle on Nevsky Prospekt, May 1, 1921; performance in the lobby of the Theater of Musical Comedy

15.
Preparations for a street carnival by the students of Vkhutemas/Vkhutein at the Park of Culture and Rest, Moscow, 1928

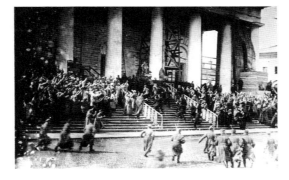

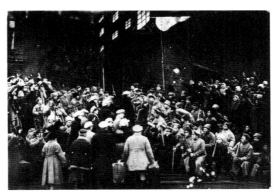

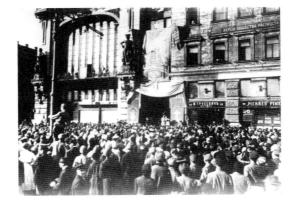

A List of the More Important Public Fêtes in 1918–29

1918
May 1, Petrograd—spectacular based on illumination, fountains, and fireworks on Neva River, with the participation of flotillas and bands.

Petrograd—the first experimental performance of a concert by factory and ship's sirens; repeated in Nizhny Novogorod.

1920
May 1, Petrograd—spectacular of The Mystery of Liberated Labor in front of the Exchange; designed by N. Dobuzhinsky and Y. Annenkov; mass scenes directed by Annenkov, S. Maslovsky, and A. Kugel; cast of 2,000, audience of 35,000.

May 1, Moscow—spectacular of History of the Three Internationals on the Khodynka fields (fig. 11).

May 1, Irkutsk—spectacular of The Struggle of Labor Against Capital.

June 20, Petrograd—spectacular of The Blockade of Russia on the Kamennyi Ostrov island, in a natural amphitheater; designed by S. Radlov and V. Khodasevich; cast of 10,000, audience of 75,000.

Stanitsa Krymskaia in the Kuban—re-enactment of the Revolutionary Tribunal, Judgment over Wrangel.

July 19, Petrograd—spectacular Toward a Worldwide Commune in front of the Exchange; designed by N. Altman, directed by N. Petrov, Radlov, V. Soloviev, and A. Pyotrovsky; cast of 4,000, audience of 45,000 (fig. 12).

November 7, Petrograd, third anniversary of the Revolution—re-enactment of the Storming of the Winter Palace (fig. 13), staged in the Uritsky Square; directed by N. Evreinov; designed by Annenkov; cast of 10,000, audience of 100,000.

1921
Petrograd—spectacular of the Paris Commune Day, staged in the Insurrection Square, around the statue of Tsar Alexander III.

May 1, Petrograd—mass spectacle on Nevsky Prospekt, performance in the lobby of the Theater of Musical Comedy (fig. 14).

1922
Baku, fifth anniversary of the Revolution—spectacular with a cast of choirs, the Caspian Flotilla, artillery guns, and hydroplanes.

1923
Moscow, sixth anniversary of the Revolution—spectacular of the Symphony of Factory Sirens; music directed by A. Avraamov.

1927
Leningrad—re-enactment of Memories of the Storming of the Winter Palace.

1929
Moscow—carnival procession in the Park of Culture and Rest (fig. 15).

As a set of ideas, the Bauhaus experiment became consolidated in the European art tradition at the begnning of the twentieth century. It produced a legend that ushered in a style and a model of life. The Bauhaus offered a tempting alternative of harmony between the world of things and the spiritual life of man—between cognizance and feeling. The well-known Bauhaus legend is joined today by the myth of a kindred experiment of the same period: the Vkhutemas, a school of art and a center of creative inspiration, which occupied in post-Revolutionary Russia the same place which the Bauhaus did for the Left in Weimar Germany. The name Vkhutemas, a contraction of *Vysshie Khudozhestvenno-tekhnicheskie Masterskie,* or Higher Art and Technical Studios, has appeared for some time in publications and at times is also used as a symbol of an intellectual and artistic spirit of the Revolution's new art. The history of the Bauhaus and of the Vkhutemas belongs to the ethos of the avant-garde. Both centers are its pride, and its unfulfilled utopia; both made a deeper and more durable impact on culture and history than such didactic institutions usually did. There remains for each a legend for succeeding generations; the legend of the Vkhutemas, as distinct from that of the Bauhaus, has been based thus far mainly on reports that were emotional in nature. In the period of struggle against Formalism, the legacy of the Vkhutemas had been rejected for ideological reasons and this circumstance may have stimulated the legend. To make things worse, a substantial part of the student work, diplomas, experiments, and the achievement of academic groups was dispersed or destroyed. A collection of documents and essays, currently being prepared by a group of Soviet art historians, will be the first important attempt at vindicating this unique experiment. The present article can draw attention to some aspects of this development.

Prologue. At the beginning of 1918, on the ruins of the art school system of tsarist Russia, there began to appear the roots of a new structure. There was a close connection between governmental initiatives in art and education and the attitude of artists. This led to a concept of a school that departed from tight formulae and endorsed an open arrangement, merging didactic aims with purely theoretical experiments. This idea took the form of a school accessible to those without previous educational requirements; self-management by the students prevailed and the school encouraged any worthwhile research or exploration. The name, the "Free State Art Studios," included emphasis on their non-bureaucratized form of functioning. They were established in Moscow in the autumn of 1918 on the foundation of the abolished school system of the tsarist regime and were numbered I and II. They were joined by representatives of all the artistic groups of the period. The students could, therefore, gain an artistic outlook in the studios of Malevich, Tatlin, Yakulov, or Exter, or find their place within the more moderate constellations of Lentulov, Mashkov, or Kuznetsov. Another loose form of activity was offered by a small group appearing from 1919 under the name of *Zhivskulptarkh,* a term combining painting, art, and architecture. Whereas at the Free Studios emphasis was laid on the formal aspects of visual art, here there was a program that combined art and architecture. Though the *Zhivskulptarkh* did not assume teaching functions, ideas for interdisciplinary activities matured here. It was the proving ground for the future co-founders of Vkhutemas.

Vkhutemas, the Idea. The school was officially established in December 1920, but its social justification and theoretical assumptions had matured earlier. A resolution of the Council of People's Commissars, signed by Lenin, stated briefly that the aim of the Vkutemas was to train artists of high quality for the benefit of the national economy. The allocation of special food rations to students and teachers in the years of widespread famine bears witness to the importance accorded the school in the educational hierarchy. The tasks were wide-ranging as there was not yet an industry awaiting cooperation with the artists, nor industrialized building construction, nor the indication that such progress would soon follow. The Vkhutemas, therefore, originated in a dream, in revolutionary romanticism. Anticipating reality, utopia became a driving force of the artistic movement that identified itself with socialism.

Yet the concept of the Vkhutemas was not as uniform as that of the Bauhaus; it was subject to constant revisions as the proletarian culture developed. Debate occurred within three main areas: the advocates of pure art, *chistoviki,* from the Cézannists to the Suprematists, questioned the usefulness of services rendered by art to practical public demand; the "applicants," *prikladniki,* tended toward restoring the rank of artistic crafts and decorative art, convinced that the way to a new culture was through the simple dissemination of aesthetic objects; the Constructivists and the Productivists, *Proizvodstvenniki,* desired to achieve at the Vkhutemas the ideal of rational man freed from a bourgeois inheritance. They had in mind reactions and experiences held in common, as well as the whole visual environment.

In no capitalist countries was there such an upsurge of violent opposition to contemplative art, and nowhere else, including the intellectually restrained Bauhaus, was there a recourse to radical

*A version of this article was originally published in *Arts and Artists,* December 1974. We thank the editors for permission to use this material.

acts such as self-destruction and rejection of the value of artistic experience. The radical slogan of "art is dead" was used to impress. How much presentiment of a real crisis of art was in it, how much dogma, and how much mere pose, who can say today? By questioning the reason for the existence of art, the Russian innovators shared characteristics with the whole of the European avant-garde, an interest for theoretical investigations of the form of expression.

Ideological disputes took place at the Institute of Artistic Culture (Inkhuk) that had a direct bearing on the future shape of Vkhutemas. Kandinsky, who pleaded for the establishment of a center for theoretical thinking, was the real master-spirit of the Vkhutemas. He envisioned a school that would serve as an experimental base for artistic research and practice as well as for study on the interdependence of the arts. Kandinsky, in his report delivered in 1920 at the National Conference on Art Education, said:

> Recently, there appeared two significant processes: a deep insight within each branch of art, a tendency to analyze its own categories, as well as to understand their essence and value; and simultaneously, a process of coherence of the arts. It becomes a natural phenomenon, that by studying their own problems in depth, the individual arts observe with interest the neighboring disciplines, so as to master their methods with the aid of which the same problems can be solved.

The experiments made at the Vkhutemas have shown that art can be reduced to individual parts that remain in a determined, mathematical scheme of dependence. Recognizing the principle of universalism in art, Kandinsky recommended an analysis of the media of expression from the viewpoint of their reactions on the mental and physical constitution of man. These propositions were taken over by a "group of objective analysts" acting within the Inkhuk. The spokesman of the Basic Division was Ladovsky, who brought scientific aspirations to the Vkhutemas. His innovations included the psycho-technical method in the architect's work and the theory of spatial combinatories based on a mathematical formula. Until its dissolution in 1924, the Inkhuk functioned informally as a center for programmed instruction. This tendency was dominant when Kandinsky resigned from the Vkhutemas as a result of differences of opinion, and the leadership of the school was taken over by the Productivists, most of whom were among its teaching staff.

Vkhutemas: the Structure and Program. At first the Vkhutemas presented a coherent didactic and academic whole from the conceptual point of view, combining the interpenetrating areas of classical and design discipline. Its integration was apparent in both vertical and horizontal profiles in all branches—something quite unknown in the practice of art studies even in the Bauhaus. The school, numbering on the average about 1500 students, had independent faculties of architecture, painting, sculpture, and metal and woodworking design, as well as a Basic Division and a Workers' Preparatory Faculty, the *Rabfak*. In 1927 one of a series of reforms occurred resulting in a change of name to the Vkhutein, a contraction of the name of the State Higher Art and Technical Institute. The structural reform led to a progressively looser union of the component parts. This development provided the background of an extended crisis and the Vkhutemas practically disintegrated into separate specialized institutes. The dissolution of the Vkhutemas in 1930 formally sealed this regression.

Yet in its best period, the Basic Division was an integrating element in the life of the school. It played a role similar to the Vorkurs at the Bauhaus, although on a much larger scale, since here all the innovative ideas, as well as the methodological and educational experiments, converged. Each attempt at reducing the rank of the Division met with opposition from professors and students. It was characteristic that the students intervened in the selecting of a representative teaching staff. They demanded, for instance that Pevsner be invited as a professor, and conversely they took action aimed at removing artists who, in their opinion, held conservative views. In 1926 the program of the Division was reduced from two years to one. Lunacharsky proved to be the Basic Division's ally. Reviewing the annual school exhibition of 1928, he wrote:

> The first thing which I would like to appraise positively is the advances of the Basic Division. As a matter of fact, this preliminary study in which students master the elements of all the visual arts—by means of isolated disciplines of line, color, space, mass, etc.—is a permanent legacy of our quests in the early period following the Revolution. This heritage should not be yielded to anyone.

For its innovative methodological work the Division was awarded the only prize in this class at the *Arts Déco* exhibition in Paris in 1925. Only from written evidence do we know what was exhibited there. Included was an analysis of the legibility of lettering in various space conditions; exercises to express weight, mass, and dynamics; color problems, together with perception of color phenomena; and a study of textures.

The structure of the Division, and even the terminology, bears the impact of originality. Particular attention is drawn to the replacement of tra- ▶

ditional terminology by a new one, closely following the language of science. It is possible that such investigations were influenced by the school of Formalism in Russian linguistics of the period.

The Division consisted of four separate sections, called Focuses, *kontsentry*. The Graphic Focus carried out a remarkably modern program in terms of graphic subjects and typography. It can be deduced from extant exercises that line was used as an element of construction and not only to express the appearance of an object. (Lecturers in this section were Favorsky, Pavlinov, Miturich, Rodchenko.) The Planar-Color Focus was a study of optically active surfaces and their formal characteristics. Its underlying proposition was: "Since a definite color, presentation, and compositional form corresponds to every kind of surface, it is necessary to study the surfaces of planes, the voluminar and mobile surfaces." It is evident that this focus dealt with the basic categories of painting. The Focus was divided into a system of studios, referred to as disciplines, including the discipline of pictorial space (under the direction of Vesnin and Popova), exposure of form by light (Osmerkin), construction of mass and space (Udaltsova), or construction (Rodchenko). The Volume-Grid Space Focus was reduced to preparatory instruction in sculpture but as a result of the lack of individuality in the lectures it was not of major importance. The Space Focus, on the other hand, was an exceedingly important element of the coherent system of art education. It was based on a study of properties and principles of composition of spatial forms. Irrespective of later specialization, it introduced all the students to the rudiments of architectural thought. (Lecturers were Ladowsky, Dokuchaev, Balikhin, Krynsky.)

The organization of the Basic Division, as well as of the whole of the Vkhutemas, was thus so complex that the mastering of subjects did not take place in isolation but in the conditions of interaction and complementation. Another general methodological direction envisaged the creation of natural team work as an antidote to traditional individualism. The team spirit was to remove the barriers of narrow professionalism and promote a sense of cultural unity. Apart from the course of studies, this aim governed the whole of the intellectual outlook of the Vkhutemas: the work of the academic groups, activities of collectives of the Productivists, publications, exhibitions, and contacts with the trade unions as well as with industry. The personal model of the new type of artist, as it was said then, was to be found in an originator who was prepared to work with others and was familiar with strict logic. Theoretical discussions and the school practice produced a profile of a worthwhile model of an "art engineer" or "art constructor." First and foremost, he was supposed to be a person with a developed

creative sense, an inventive instinct, and a critical attitude. Yet the danger of a pragmatic and vulgar interpretation of the ideals of Productivism was not disregarded. A resolution passed by the Senate warned against making any division between art and productive design, as "Such differentiation distorts the tasks and nature of the Vkhutemas."

A double standard of values produced a threat of internal tensions. This, in turn, provided grounds for decentralizing tendencies; for example, attempts at breaking away the Faculty of Architecture. The school passed through an unstable period; the atmosphere of conflict was exemplified in an inventive spectacle, *Khozhdenie po mukam (Walking through Torment),* presented in 1923 by the Basic Division. This condition is also evident in articles and press polemics; for example the text of a statement, "Fall of the Vkhutemas" (*Lef,* 1923).

Perhaps the most stability was reached by the Faculty of Metal and Woodworking, directed by Rodchenko (and for a time also by Lissitzky), which could be regarded as a forerunner of modern studies in industrial design (fig. 1). The texts of extant programs, detailed instructions for exercises, works for diploma theses, and other documents of the Faculty merit great respect due to their pioneering character. They contain a vision of new definitions of the visual arts and of popular art of the present century. The vision is still unfulfilled, and this is why we speak of a legend. ●

1.
Chair (diploma work) from Rodchenko's workshop at Vkhutemas/Vkhutein

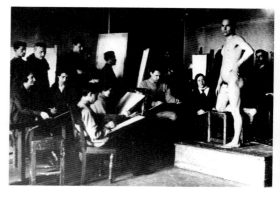

Vkhutemas, unidentified male model. 1922–23?

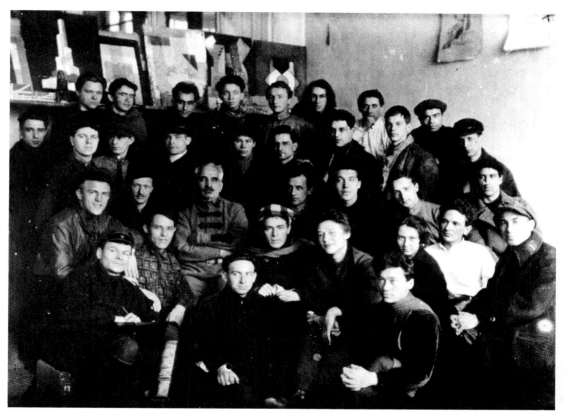

Basic design course at Vkhutemas (before 1926)

Vkhutemas, examination session, n.d.

Party at Vkhutemas, 1920s

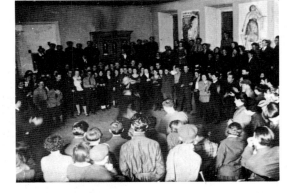

Preparation for the carnival at
Vkhutemas/Vkhutein, 1928

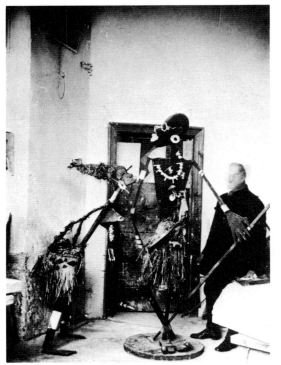

The Vkhutemas: an Interim Schema

Basic Division			Departments	Department Sections	Department Instructors
	Three focii (kontsentry) (N. Ladovsky's "psycho-analytic" method used as framework for Basic Division's curriculum) Two year course, 1920-25 One year course, 1926-30		**Departments** Second to fifth year of study after Fall 1926		

Graphic Focus	Instructors: I. Efimov, V. Favorsky, V. Kiselev, P. Miturich, R. Pavlinov, A. Rodchenko

Printing and Polygraphy

Section 1: **Graphic Arts**

Section 2: **Printing Technology and Techniques**

Instructors: L. Bruni, V. Favorsky, P. Miturich, D. Moor, I. Nivinsky, P. Novitsky, P. Pavlinov, N. Piskarev — N. Sheverdaev and others

Planar Color Focus	Instructors: L. Popova, Color Construction A. Vesnin, Color Construction A. Osmerkin, Exposure of Forms by Light Fedorova, Exposition of Light I. Kliun, Suprematism A. Drevin, Simultanism N. Udaltsova, Construction of Mass and Space A. Exter, Rhythm of Mass; Transition from Nature to Abstraction
Program developed by V. Favorsky 1922-23	

Painting

Section 1: **Easel Painting** — Pedagogic section

Section 2: **Monumental Painting** — Murals, frescoes

Section 3: **Decorative Painting** — Set design for stage, film, and mass festivals

Instructors: A. Drevin, V. Favorsky, S. Gerasimov, R. Falk, K. Istomin, D. Kardovsky, P. Konchalovsky, P. Kuznetsov — I. Mashkov, A. Osmerkin, A. Shevchenko, B. Uitz and others

Textile

Section 1: **Weaving**

Section 2: **Printing and Dyeing**

Instructors: N. Bavstruk, M. Bezzubets, D. Gruin, A. Kuprin, L. Maiakovskaia, G. Makarov, A. Shagurin, M. Tikhomirov — N. Sobolev, P. Viktorov and others

Volume-Space Focus	Volume Construction Instructor: A. Lavinsky Spatial Construction Instructors: N. Dokuchaev, V. Krinsky, N. Ladovsky

Volume Focus 1925-30

Sculpture

Section 1: **Monumental Sculpture**

Section 2: **Pedagogic Sculpture** — Prepared future teachers of sculpture

S. Bulakovsky, I. Chaikov, I. Efimov, A. Golubkina, S. Konenkov, B. Mukhina-Zamkova and others

Ceramics

Section 1: **China-Faïence**

Section 2: **Glass**

Section 3: **Clay**

I. Chaikov, I. Efimov, I. Kitaigorodskov, A. Kuprin, P. Kuznetsov, D. Shterenberg and others

Space Focus 1925-30

Woodworking 1920-28 / **Wood and Metal Working 1928-30** / **Metalworking 1920-28**

Section 1: **Construction** — Product design

Section 2: **Composition** — Materials, surfaces, finishes

G. Klucis, 1924-?, Color studies
El Lissitsky, 1925-?, Furniture design
I. Lamstov, ?-?, Nature of materials
A. Malishevsky, 1920-?, Technical
Dean:
A. Rodchenko, 1920-30, Design, Metal constructions

Architecture 1920-26

Section 1: **"Academic Group"** — I. Zholtovsky

"New Academy" — 1922-?, I. Golosov, K. Melnikov

Section 2: **"New Research Group"** — Autonomous section of the architectural faculty

Laboratory Model Studio — A. Efimov, Obligatory to all students

Monumental Architecture — V. Krinsky

Communal Architecture — ?

Planning Section — N. Dokuchaev

Decorative-Spatial Section — N. Ladovsky

Architectural Laboratory 1927-30 — N. Ladovsky

N. Dokuchaev, A. Efimov, A. Elkin, M. Ginzburg, I. Golosov, V. Kokorin, V. Krinsky, A. Kuznetsov, N. Ladovsky, K. Melnikov, R. Muratov, E. Norbert, V. Semenov, A. Shchusev, S. Toropov, A. Vesnin, L. Vesnin, I. Zholtovsky and others
Deans:
A. Rukhliadev, I. Rylsky

Architecture Fall 1926-30

Section 1: **Housing**

Section 2: **Public Buildings/Industrial Complexes**

Section 3: **Planning and Design of Public Spaces**

Experimental Institute 1920-26 — N. Ladovsky

Compiled by Kestutis Paul Zygas, Stephanie Barron, and Szymon Bojko. Design and typography by Joe Molloy.

Kandinsky's Role in the Russian Avant-Garde

Jelena Hahl-Koch

I begin with two undisputed facts in the history of Russian art:

(1) the major credit for having founded and theoretically consolidated abstract painting around 1910–11 is due to Vasilii Kandinsky;

(2) from 1910 to 1922, Russia played a leading role in the history of art for the first time because of the Cubo-Futurists, Rayonists, Suprematists, and Constructivists.

One can assume a causative relation between the two, yet surprisingly the question of Kandinsky's influence and the correlation between him and the other Russian artists has not been resolved. Although there were no major artists in Russia who were directly influenced by Kandinsky's style, the situation was quite different in Germany. In 1922 Ilia Ehrenburg called the work of Kandinsky's German successors "a belch of literary painting."[1] Yet in 1920 Konstantin Umansky wrote, "If anybody, it is Kandinsky, who deserves the title 'The Russian Messiah.' With his work, he prepares the way for the victory of absolute art, but non-objective art takes a different route today. Kandinsky's art found the necessary supplementation in Suprematism."[2] The most detailed writing on this subject thus far comes from Troels Anderson.[3] The present essay will add to the known literature with unpublished documentation from Western and Russian sources.[4]

Despite his internationalism, Kandinsky remained a Russian. When he left his homeland in 1896 at the age of thirty, his personality was already firmly established; yet as an artist he needed contact with the West, since he found Russia still too backward for his ideas. A few weeks after his arrival in Munich, he registered in the art school of the Slovenian Anton Ažbè, where there were many Russians: Alexei Jawlensky, Igor Grabar, Dmitry Kardovsky and others.[5] Jawlensky introduced Kandinsky to the salon of his friend Marianna Verefkina, where he found an international, although predominantly Russian, circle of educated, art-oriented people, including occasional visitors like V. Borisov-Musatov and S. Diaghilev. In 1902 Kandinsky reported his activities in an article called "Correspondence from Munich," which appeared in Diaghilev's Russian magazine *Mir iskusstva (The World of Art)*. Kandinsky continued to maintain contact with Russia through his participation in exhibitions, including the *Exhibition of Southern Russian Artists* in the fall of 1901, which received much negative criticism.[6] Kandinsky answered such reviews with a sharp polemic, "Criticism on the Critics," in the Moscow paper *Novosti dnia (News of the Day)* of April 17 and 19, 1901. According to Kandinsky's notebook entries he participated in Russian exhibitions in 1902 in Odessa and Petersburg; in 1903, in Odessa and Moscow; in 1904, in Moscow and Petersburg. Two of the five paintings exhibited in 1904 in Petersburg are best described by the famous Symbolist poet Alexandr Blok in the magazine *Vesy (The Scales)*.

Kandinsky's visits to his relatives in Odessa are documented for 1901, 1903, and 1904. In 1904 in Moscow Kandinsky published his volume *Stikhi bez slov (Verses without Words)*, twelve black-and-white woodcuts; the following year he exhibited in Moscow, with the Moscow Association of Artists. In Petersburg, Kandinsky probably exhibited annually after 1904; he participated in 1906 in the New Society exhibition organized by his former Munich colleague, D. Kardovsky. On November 27, 1906, Kandinsky wrote to Mikhail Shesterkin, the organizer of the Association of Artists exhibition, concerning the twenty-one pictures that were sent from the exhibition in Odessa to Moscow. On October 11, 1907, he wrote about a new exhibition in Moscow and Petersburg: "Whether Petersburg finally made up its mind about the exhibition, the one in Odessa is going to be closed within the next few days."[7]

In the first issue of *Apollon* in October 1909, Kandinsky began a column called "Letter from Munich" which continued until 1910. In his second "Letter" he discussed the New Artists Association in Munich, which he had founded, and expressed the hope that it would "expose itself to the judgment of the Petersburg public" after its planned tour through Germany. Unfortunately this did not materialize. In 1908–9, however, Kandinsky and several Russian members of the New Artists Association—Jawlensky, Verefkina, as well as Vladimir Izdebsky and David Burliuk, who delivered the second introductory speech after Kandinsky—had exhibited their works in the gallery of Sergei Makovsky, the publisher of *Apollon*. Makovsky was the first ardent promoter of the Lithuanian artist Chiurlionis, who lived from 1908 to 1909 in Petersburg and exhibited his attempts at a synthesis of music and art.[8]

Kandinsky did not visit Russian again until October 1910, when he had contact with the older members of the avant-garde—N. Kulbin, V. Markov, and V. Izdebsky.

In 1910 Kandinsky began to correspond with Kulbin, who devoted himself to promoting the avant-garde. The

1. I. Ehrenburg, *A vse-taki ona vertitsa*, Moscow/Berlin, 1922, p. 84.

2. K. Umansky, *New Art in Russia*, Potsdam/Munich, 1920, pp. 20, 22.

3. T. Andersen, "Some Unpublished Letters by Kandinsky," *Artes Periodical of the Fine Arts II*, Copenhagen, 1966. For a discussion of Kandinsky's connections with Russian intellectual and artistic life, see John E. Bowlt and Rose-Carol Washton Long: *Vasilii Kandinsky: "On the Spiritual in Art,"* Newtonville, Massachusetts, 1979.

4. A more detailed discussion will be published together with Kandinsky's writings in seven volumes, edited by H. K. Roethel and J. Hahl-Koch.

5. For further contacts, see J. Hahl-Koch, "Kandinsky and Kardovsky," *Pantheon IV*, 1974, p. 387.

6. In the papers *Iuzhnorusskoe obozrenie*, October 3, 1901, and *Odesskie novosti*, October 9, 1901.

7. Both letters are in the archives of the Tretiakov Gallery.

8. While some of his paintings are "abstract," they are different from Kandinsky's. Kandinsky in all probability knew about Chiurlionis' work through Makovsky and *Apollon*. In April 1910 Chiurlionis' *Cemetery* was reproduced. In 1911 Makovsky wrote on the occasion of the premature death of Chiurlionis, and in March 1914 another article appeared on him by V. Ivanov. Kandinsky also would have learned of him from Marianna Verefkina, whose relatives lived in Vilnius, where Chiurlionis lived and exhibited from 1907.

following are previously unpublished excerpts:[9]

Kuokkala, May 19, 1911
Dear Vasilii Vasilievich,
As you know, the All-Russian Congress of Artists is scheduled for December, and you will be playing a very active role in it with your papers.

Exhibitions will be organized at the Congress, and progressive groups may be represented at two of them. ... The "Triangle" exhibition at the All-Russian Congress (in the building of the Academy of Arts) will have an informal jury. If any of the Russian members of your society... would like to take part in this exhibition, their works will not be subject to a jury, but will be placed separately in the same space as the "Triangle" and with your society's placard...we can try to ensure that contemporary painting is far removed from academic painting.... It is almost certain that among the Congress exhibitions there will be an exhibition from the Society of Art [Society of Integrated Art] or ARS. This Society was organized this spring. Its principles are: (1) to be progressive; (2) to integrate the arts, to aspire toward a general synthesis of art.

Despite the fact that the Society has only recently been organized, everything is going very well. It has eight sections, each autonomous with regard to its referees and to its particular functions, although all the sections will work together. I invited A[natolii] Drozdov to organize a music section, which includes almost all the progressive Russian composers.... S. Gorodetsky is in charge of the literature section (A. Blok, Auslender et al.), and N. N. Evreinov in charge of the theater section. One of the original organizers, V. S. Karlovich, has put together an architecture section, and Fokin has proposed to arrange a choreography section, although who knows if he'll have the time to do so. Still, that section will be implemented. I am organizing a painting and sculpture section, which includes A. M. Matveev the sculptor, the artist Chekhonin, M. N. Yakovlev, D. D. Burliuk, V. D. Burliuk.... It would be great, if all those from your group who wish to join our society would do so.

Please be so kind as to suggest to your society's members that they take part in the temporary exhibitions here and send something to be shown at the Congress.

St. Petersburg, October 10, 1911
Dear Vasilii Vasilievich,
First of all, let me thank you for your kind recommendation of new members for the Art Society....Thanks for the *Blaue Reiter* prospectus. I would be delighted to see my article "Free Music" in your journal.... I really like the idea of the *Blaue Reiter*.

I have just returned from the south where I visited Izdebsky in Odessa. ... Izdebsky had also received an invitation to participate with his Salon in the All-Russian Congress of Artists exhibition. He would like to work there in concert with me which I don't mind at all....

As for your question about the concerns of ARS, I'll respond in a separate letter. Everything is going well in spite of the Society's young age—or, rather, because of it. The sections are in good hands. No dilettantism as of yet....

I do hope you manage to implement your ideas. Your activities have my wholehearted support.

N. Kulbin

Kandinsky's responses to Kulbin explore the possibility of creating closer contacts between avant-garde groups in Munich and Petersburg.[10] Kandinsky suggests that Kulbin make contact with German artists, in particular with the composer Arnold Schönberg. In December 1912 Schönberg was in Petersburg and wrote a card to Kandinsky and Kulbin which he co-signed with Dobychina, whose Petersburg gallery planned a large Kandinsky exhibition in 1913 and wanted to publish his "Retrospect" in the same year. Neither plan was realized.

In February 1910 he published a deluxe anthology of essays, *Studio impressionistov (Studio of the Impressionists)*, containing Velimir Khlebnikov's "Incantation by Laughter," which dates the beginning of the Russian Futurist movement.[11] In a letter from David Burliuk to Kulbin of June 9, 1912 we can trace Kulbin's involvement with the avant-garde:

The coming season will be quite unusual, great activity and a lot of important things are to be expected: (1) exhibition in Moscow; (2) exhibition in Petersburg and discussions. V. Kandinsky will be in Moscow in the winter. Prepare yourself for the winter. Write hard polemic articles for the variety volumes *Jack of Diamonds*. Something about the theater would be good.[12]

Kandinsky was aware of Kulbin's important role in unofficial Russian art policy. When he spoke to Herwarth Walden, the famous promoter of avant-garde art in Germany and the editor of *Sturm* about including Kulbin's pictures in an exhibition in the Berlin *Sturm*, he declared: "He is an artist too, and *as far as I know*, not worse than some Russians whom we invite. Besides he is also 'politically important.'"[13] Kulbin, like Kandinsky, argued for the synthesis of all the arts: "It is about time to recognize that there are not arts, but only one art, which is indivisible." Like Kandinsky in *Concerning the Spiritual in Art*, Kulbin writes of the phenomenon of hearing ▶

9. Both letters belong to Kandinsky's estate, Gabriele Muenter and Johannes Eichner Foundation, Munich. I thank the foundation for the permission to publish these and other letters for the first time.

10. N. Khardziev, "Maiakovsky i zhivopis," *Poeticheskaia kultura Maiakovskoga*, ed. N. Khardziev and V. Trenin, Moscow, 1970.

11. K. Chukovsky, "Ego-futuristy i Kubo-futuristy," *Shipovnik*, Petrograd, 1914, no. 22, p. 127.

12. Khardzhiev, *Poeticheskaia kultura*, p. 13.

13. Postcard (underlining by Kandinsky) dated July 20, 1913, Library of the Prussian Culture Foundation, Berlin, which I thank for permission to publish these and other letters by Kandinsky to Walden for the first time.

colors and about the coordination of the spectral-colors with the music scale.[14]

On December 29 and 31, Kandinsky's *Concerning the Spiritual in Art* was read; it was published later.[15] Kandinsky's most important writing was not as well known in Russia as it was in Germany; however, its essential features were known to the most important members of the Russian art movement. On February 12, 1912, Kulbin was supposed to repeat the reading at the first lecture evening of the "Jack of Diamonds," but it did not happen. Another lecture by Kandinsky was planned for December 10 in the Artistic and Theatrical Association in Petersburg, to be read by its president Boris Kurdinovsky, who had written to Kandinsky, "Your lecture has given much to me and the audience."[16]

Kulbin had been active as an art promoter since 1908; he gave lectures and organized exhibitions, like *Wreath-Stephanos* of 1919, *Studio Impressionists* of 1910, and *Triangle* in which the brothers Burliuk and Alexandra Exter participated. Thanks to his prominent position, his financial situation and his "venerable" age, Kulbin was able to be of great help to the poor, young art-revolutionaries. In many respects Kulbin's interest in the "entire work of art" and the synthesis of all the arts was similar to Kandinsky's, although Kandinsky maintained his line of thinking even after 1917, when it was no longer fashionable.

Correspondence exists between Kandinsky and the sculptor, painter, and theoretician Vladimir Markov, (W. Matvejs).[17] Matvejs was represented in important avant-garde exhibitions including the *Union of Youth,* Izdebsky's second exhibition in 1911, and the *Donkey's Tail* in Moscow, 1912. In the first and second issue of *Soiuz molodezhi (Union of Youth),* in April and June 1912, he wrote about the "Principles of the New Art" and declared himself as a theoretician of intuition, irrationality, and the divine in art. Again we find here almost verbatim Kandinsky's leading motif about "inner necessity": "no striving, no direction of a line or a thought is accidental and aimless, but caused by some inner necessity."[18]

Matvejs hoped for an exchange of ideas with Kandinsky. He wrote to him from his trip to Europe in 1912 with the hope of meeting him in Munich. He sent him the first issue of *Union of Youth.*[19] On February 7, 1912, Kandinsky thanked him for

the article "which interested me very much" and continue[d] "I am very glad that your association pursues such importa[nt] and congenial goals."[20] On July 19, 1912, he announced h[is] readiness to exhibit in Petersburg and his plan to be [in] Russia in the fall and winter. He stayed in Moscow from t[he] end of October until December 13. On July 29, 1912 Ka[n]dinsky answered Matvejs' questions about books on the ne[w] art—Metzinger, Gleizes on Cubism, and the *Blaue Reiter*. [He] also mentions P. Konchalovsky's visit with him in Munich[,] which means another contact with an artist who contribut[ed] to Izdebsky's second exhibition in 1910–11, the *Jack of Di[a]monds,* and the *Union of Youth* exhibitions. In a letter [of] January 18, 1913, to Herwarth Walden, Kandinsky said: "[To] the Union of Youth belongs Mr. Matvejs, who once corr[e]sponded with you about an exhibition of mine for Petersbu[rg.] I am not too interested in joining there. Actually, rather n[ot.] The real name of Matvejs is Markov, address Art Acaden[y,] Petersburg."[22]

Another important interaction with the Russian ava[nt] garde was through the sculptor, painter, and art organiz[er] Vladimir Izdebsky from Odessa, who had come to Muni[ch] at the turn of the century to study painting.

Kandinsky attempted in vain to publish his prose-poe[m] "Zvuki" with Izdebsky in 1911. He exhibited fifty-three wor[ks] in Izdebsky's second exhibition in 1910–11.[23] He wrote t[he] article "Content and Form" and translated an article by Schönberg for the catalog. David Burliuk also participated [in] this exhibition. In the fall of 1910 Kandinsky invited David a[nd] his brother Vladimir to take part in the second exhibition [of] the "New Artists Association, Munich." Two letters by Dav[id] Burliuk about this are in Kandinsky's estate (G. Muenter a[nd] J. Eichner Foundation, Munich).

<div align="right">July 9, 19[12]</div>

Dear Vasilii Vasilievich,
We're very sorry that you won't be here for such a lo[ng] time. We were hoping to see you, looking forward to [it.] We agree to dispatch four works each at our o[wn] expense—*just let us know when to send them, wher[e] and how many.* We sent things to the Salon d'automn[e] and it cost 50 rubles (five small pictures each) and, [of] course, the works were rejected. Alexandra Alexa[n]drovna Exter was in Paris this winter. She writes that [Le] Fauconnier suggested organizing a Russian section [at] the Salon des indépendants: they'll provide (he prom[]ised) a room (perhaps we could get a hall?). That's ve[ry]

14. "Free Art as the Basis of Life," *Studio of the Impressionists,* Petersburg, 1910.

15. *Trudy Vserossiiskogo sezda khudozhnikov v Petrograde dek. 1911– yanv. 1912,* Petrograd, 1914, vol. 1. By 1913 it almost appeared in Moscow as an illustrated book in the publishing house Iskusstvo (Art) of Angert and Shor, but it was delayed until 1914 and ultimately did not get published.

16. Kurdinovsky to Kandinsky, December 1, 1912, G. Muenter and J. Eichner Foundation, Munich.

17. It is still the same person, and not as the Soviet art historian D. Sarabianov writes: "des théoricien tel que Matvei et Markov" in "L'Art russe et soviétique," *Paris/Moscou 1900–1930,* Musée National d'Art Moderne, Centre Georges Pompidou, Paris, 1979, p. 44.

18. V. Markov: "Printsipy novogo iskusstva," *Soiuz molodezhi,* no. 1, Petersburg, April 1912, p. 6.

19. Matvejs to Kandinsky, G. Muenter and J. Eichner Foundation, Munich.

20. Kandinsky to Matvejs, Russian Museum, Leningrad.

21. T. Andersen, "Some Unpublished Letters," p. 95. Kandinsky to Matve[js,] Russian Museum, Leningrad. Andersen brings the mentioned letters more in detail.

22. Kandinsky to Walden, Library of the Prussian Culture Foundation, Berlin.

23. *International Exhibition of Pictures, Sculpture, Engravings and Dra[w]ings,* 1909–10; *Salon 2, International Art Exhibition,* 1910–11. Accordin[g] to Burliuk, these were mostly small landscapes done with a palette kni[fe] (D. Burliuk, "Our Friendship with Kandinsky," *Color Rhyme,* nos. 51–52[,] 1962–63, p. 9).

tempting—otherwise one would drown, go by unnoticed in that sea of paintings. Vasilii Vasilievich, write to him, enter into an alliance (please answer regarding that).

Receiving no reply, Burliuk wrote again:

August 27, 1911

Dear Vasilii Vasilievich...
We would not wish to break with you, i.e. [we would like] to take part in all your enterprises. Le Fauconnier suggested to Exter that she organize a hall of Russian painting at the Salon des indépendants. It would be great if someone who lived nearer such as yourself would undertake that. Let's arrange a group appearance: your society plus us, and we'll select the Moscow artists.

In 1902, Kandinsky met David Burliuk.[24] Kandinsky was not in Ažbè's art school any more, but he probably met Izdebsky through other Russians in Munich or came in contact with him in Odessa. In 1909 Izdebsky became a member of the New Artists Association, Munich. Kandinsky was represented with seven paintings and three woodcuts in Izdebsky's *First International Exhibition* in Odessa. This exhibition contained 800 works of new Russian and Western art; it was shown in Odessa in December 1909 and traveled until June 1910 to Kiev, Riga, and Petersburg. Besides the "Munich Russian" artists, Larionov and Exter represented the younger generation.

David and Vladimir Burliuk wrote a short introduction to the exhibition catalog of the New Artists Association. At Kandinsky's request the *Blaue Reiter Almanach* also included an article by D. Burliuk, "Russia's Savages," a condensed version of "A Word to the Russian Artists," written for the All-Russian Artists Congress.

In addition to Kulbin's article about "free music," the *Blaue Reiter Almanach* contained several contributions by other Russians, including V. Rozanov, Leonid Sabaneev on Skriabin, and a poem by Mikhail Kuzmin; an essay by Nadezhda Briusova was omitted at the last moment.

The Burliuk brothers participated in the first exhibition in the spring of 1912, along with Goncharova (three paintings), Larionov *(Head of a Soldier),* Malevich *(Head of a Farmer).* Kandinsky's membership in the Jack of Diamonds is closely connected with David Burliuk. In the first exhibition in December 1910, Kandinsky showed four pictures; in the second, in 1912, six. That same year copies of *Concerning the Spiritual,* which had appeared in Germany at Christmas 1911, were sold in Russia.

In March 1912 Kandinsky sat next to David Burliuk at an evening of discussions of the Jack of Diamonds.[25] He wrote to Kandinsky on April 9, 1912:

On about April 15 I'm going to Berlin with my father. I'll spend two days there and then probably go to Nauheim, a spa where papa will take the waters. I'll be free, so I'll

drop by to see you if it's not too far (I don't have an atlas and can't find the place). I would like to look around Berlin, i.e., from the viewpoint of modern painting. Let me know who's important there in this respect. I'd like to work a little in Germany, maybe some place in the country—despite my more than grandiose plans to visit Paris and London (I really must). ... Viktor Khlebnikov is here. I'll bring his article with me or mail it to you—it's about his discoveries in history and geography. He should be published, but for some reason or other it's always the less worthy writers that are published in Russia. Khlebnikov has no energy for this at all.

I'm interested whether Foma Alexandrovich (Thomas von Hartmann) wrote substantially and frankly about the Jack of Diamonds? I exploited him a bit (for thirty rubles). I needed the money, so I "sold" him two pieces. Maybe this dampened his ardor—he's a "soft" guy. I'm very interested in what you're doing in painting right now. S. I. Shchukin expressed particular interest in your work at the *Jack of Diamonds.*

I would very much like to put some of my better works at your disposal. (Do please answer me in Berlin, *poste restante* for David Burliuk. I hope that I will be able to visit with you.)[26]

At the end of 1912 Burliuk published together with his poetic and artistic friends (A. Kruchenykh, V. Maiakovsky and others) the first important manifesto of Russian Futurism, *A Slap in the Face of Public Taste (Poshchechina obshchestvennomu vkusu).* In a letter from D. Burliuk to composer Mikhail Matiushin of December 17, 1912 (in the Tretiakov Gallery) the participants are listed as including "probably Kandinsky and Kruchenykh." This happened one day before the printing! The letter continues: "Tomorrow 500 copies will be ready." Kandinsky wrote his friend Hartmann on June 24, 1912, "Burliuk and Konchalovsky were here. Both are full of plans and complain very much that you don't like the *Jack of Diamonds.* Between us, Burliuk made me some offers. In late fall I hope to take part in person in some of the enterprises in Moscow."[27] It seems Kandinsky was ready for some cooperation. Nevertheless, his poems were printed in the *Slap in the Face* without his expressed consent. With typical Futurist audacity, the book was bound in sackcloth, printed in a provocative style, and attacked classical and symbolistic artists and poets. Kandinsky could not condone this. He found it necessary to maintain his distance from it, by putting a respective note into the Moscow papers *Russkoe slovo (Russian Word)* and *Muzyka (Music),* which ends: "I have the greatest sympathy for all honest and creative experiments, and I am even ready to excuse some rashness and immaturity of young authors. These weaknesses will disappear as time goes on with the right development of their talent. Under no circumstances, however, do I go along with ▶

24. Burliuk, "Our Friendship," p. 9.

25. D. Burliuk, "Our Friendship," pp. 9 ff.

26. Letter in G. Muenter and J. Eichner Foundation, Munich.

27. Khardziev, "Maiakovsky," p. 18. No wonder Hartmann did not like the *Jack of Diamonds,* nor the cheeky D. Burliuk. The quoted letter from Burliuk explains some of it.

the tone in which the prospect is written and I categorically condemn this tone, whoever the author may be."[28] This note is symptomatic of the entire relationship between Kandinsky and the Russian Futurists. There remained an insurmountable barrier between them, based in part on the following:

(1) *A generation gap.* The Futurists were all about twenty years younger than Kandinsky.

(2) *Kandinsky's relationship to the Symbolist movement.* Kandinsky can be associated with the Symbolist movement because of his aesthetic and "over-aesthetic" theories, his deep-seated romantic philosophy, his striving for a synthesis of the arts, his deep scorn of materialism and with it of every purpose-art or productivism. This and the generation gap were the reasons why Kandinsky associated more with the "older, more settled gentlemen" of the young art movement: Kulbin, Matvejs, and Izdebsky. As a painter, though, Kandinsky was far ahead of his own generation.

(3) *Family background and cultural standard.* Like almost all the Symbolists, Kandinsky came from highly social and educated surroundings. By contract, the Futurists were unsophisticated and much less formally educated. They were the first generation of Russians to successfully promote new talent. In Russia at this time, it was easier for those without the burden of traditional education to forge new paths in art. If the Symbolists did not succeed in overthrowing traditional values, the Futurists did, quickly and vehemently.

(4) *Kandinsky's personality* was rooted in his family background. He had a quiet nature, a reserved and discreet way, which made it hard for him to accept the noisy commercial commotion and the intentional public scandal created by David Burliuk, Maiakovsky, Malevich, and others. Burliuk also recognized the difference, or he would not have mentioned that Kandinsky came from a "good family" and that he was "a polite man, with a soft voice and friendly manners. ... He sure was an example of the refined European culture."[29] Kandinsky certainly respected Goncharova, Larionov, Malevich, and the Burliuk brothers as artists; otherwise he would never have invited them to his exhibitions. His attitude toward his fellow Russians is revealed in his previously unpublished letters to H. Walden. On October 12, 1913, he wrote, "How I would love to succeed in Moscow. Here [in Odessa] there is no climate for such hopes. ... I had a lot of trouble in Moscow, too. The different 'radicals' fight each other and splinter their strength unnecessarily. I had planned to arrange for Der Sturm an exhibition that was not only radical but comprehensive as well. I have done a lot but encountered enmity with the moderate ones. In anger, I dropped the whole thing. With one moderate one, I became friendly however. This

is a sensitive, delicately thinking artist, Yakulov."[30] As f as the different groups are concerned, Kandinsky stoo impartially above the fights. After the founding of tl Donkey's Tail he immediately wanted to know mo about it.[31]

Kandinsky's great readiness to help young colleagues well known. Sometimes, however, it became too much f him. On June 24, 1913, he complained: "Goncharova asks n to send back her paintings and drawings, which were in tl *Blaue Reiter* and are now in Budapest, because she is a ranging an exhibition in Moscow. Also the *Still Life w Lobster,* which she gave me as a gift, she wants for h exhibition. So be it! Something as boring as the colleague of whom one takes care and to whom one gives a helpii hand, is not easily to be found anywhere! One loses a interest in bothering with them." And concerning the defar ing manifestos of the Italian and Russian Futurists, he wro on November 15, 1913, to Walden: "I observed it as long a live, that people who are really good in something (no matt in which field) never speak condemning about sombo else's *ability,* especially not in public and even less in tl style of a school boy." For this reason, after the event with *Slap*... Kandinsky was considerably more reserved. On M 10, 1913: "We talked at that time about the Russians. t course, I am not against their participation. *Real* strong orig nality I don't find in the items—but also many others v miss this feature. But I would not like to invite the peop personally, since their kind of art-propaganda became ve obnoxious to me. I am giving you here the addresses There followed the addresses of Larionov, Goncharov D. and V. Burliuk.

On May 11, 1913:
I am coming again with two plans. It is about my exhil tion and my book [*Concerning the Spiritual*...]. All tl latest news I get from Russia shows me vividly hc readily and systematically my cause is being ignore lately. I participated after a long pause in an exhibition Moscow, two years ago with three paintings, whic aroused especially strong interest. This year I left tl Association because I did not like the whole situatic and the tone of the exhibition, of the lectures, etc., it w repulsive to me. The public, who asked for my picture was told the Germans (!) were not invited this year! would be especially important to me to be represente in Petersburg and Moscow with a good collection. N Matvejs has approached you already in this matt I shall also ask Kulbin, who is also doing somethii with the "Association" for which I have written a lectu in the fall of 1912.

28. *Muzyka,* May 4, 1913, p. 6. B. Livshits' article had also been printed without his knowledge. In *Poltoraglazyi strelets (The One and a Half-Eyed Archer)* Leningrad, 1933, p. 128, he says concerning Kandinsky, he had been "a fortuitous person" in the group.

29. Burliuk, "Our Friendship," p. 9.

30. Library of the Prussian Culture Foundation, Berlin. All following letters to Walden are from this library.

31. Kandinsky to Goncharova, March 1, 1911. See Khardziev, *Poetiche kaia Kultura,* p. 358.

Kandinsky was no longer especially eager to participate in the *Jack of Diamonds* exhibition. On July 5, 1913 he wrote to Walden from Moscow that Jack of Diamonds was planning (after an exhibition of 400 paintings the previous year) to show 600 paintings the following winter, and since there was a shortage of works, to invite foreign groups. "I answered rather clearly, that we would participate if we had free shipping, exhibition space, insurance, etc. The secretary is anxious to talk to me again." Yet there was no break in the connection, some further plans existed; in a postcard from Russia dated August 2, 1913, he wrote, "I shall soften Burliuk's bad manners in my translation." And when Kandinsky lived in Moscow again in 1914–15, he became the godfather of Burliuk's second son. On February 25, 1914, he wrote a judgment of Alexandra Exter as an artist: "Three years ago we rejected her paintings in the 'New Artists Association.' She was not without talent, but weak, accidental. Several months ago, Kulbin asked me to mediate with you an exhibition of this lady." After seeing many photos, he gave his judgment: "...I find only some of it rather good...that however the things are not worse than many others, which are being exhibited" and he closed saying that he "cannot recommend the pictures, *especially*."

In 1914 Kandinsky again took part in the Spring Exhibition in Odessa, which included sixty pictures from *Jack of Diamonds.* He wrote an essay for the catalog.

Like many Russians, Kandinsky returned home at the beginning of World War I. In 1915 he participated in *Exhibition of Painting, 1915* in Moscow and the exhibition of the *Leftist Movement* in Petersburg. His role in the art policy of the early Soviet era has already been described in detail.[32] Even if we only summarize his most important accomplishments between 1918 and 1921, they are abundant. One must consider that these years were a rare, stimulating time—an atmosphere of art experimentation and innovation in which all artists joyfully participated. Kandinsky called it enthusiastically "Spring of Art" in an article for a German newspaper in February 1919. The question is how much Kandinsky actually contributed and how integrated he became into the new Soviet art life.

The first reservation arises when we read Kandinsky's memories: "When I came to Moscow at the beginning of the Great War, said one of my colleagues to me: Well, now we shall paint nationalistic pictures? I myself asked then: And after the end of the war? Already they sang national songs in almost all countries, but I was glad that I was not a singer."[33] He was neither nationalistic, nor would he ever become a Communist. Thus, it was almost surprising that he was allowed to work and create peacefully until 1921, when he emigrated for the second and last time. At the instruction of Lunacharsky, Tatlin came to Kandinsky in 1918 and asked for his cooperation. Kandinsky became a member of Narkompros (People's Commissariat for Enlightenment), but he emphasized that he wanted nothing to do with politics.[34]

He soon became acquainted with Tatlin's work and was impressed by its originality. He also met Popova, Udaltsova, and Rozanova through Narkompros. Although he respected their painting, he did not find he had much in common with them. For one year Kandinsky became the publisher of the magazine *Iskusstvo (Art)* in which his article "About Stage Compositions" of 1912 was being printed. This is to be seen in connection with his work in the theater and film section of the IZO. His *Retrospects,* which had appeared in 1913 in Germany, was the first publication of the new art publishing house in 1918 in Soviet Russia. One can say it was high time and also be reminded that his efforts to publish *Concerning the Spiritual* in Russia failed again. At the end of 1918, when contact with foreign countries was once again sought, Kandinsky was the first commissioner for Germany in the international bureau of the Department of Fine Arts. Two of his articles give proof of his efforts in that task.[35] Kandinsky's greatest achievement between 1919 and 1921 was the installation of twenty-two provincial museums. His young wife, Nina, helped him as his secretary; we have relied on her knowledge and good memory. In 1919 Kandinsky founded the Museum for Artistic Culture in Moscow and became first director. But when he co-founded the Academy of Aesthetics at the beginning of 1921, he only could become vice-president because he was not a party member. The Academy, however, as well as the Institute of Artistic Culture (Inkhuk), which was founded by the IZO in 1920, followed to a great extent Kandinsky's teaching methods. Their basis was Kandinsky's perennial idea of the synthesis of all the arts.[36] Although he became a teacher at Vkhutemas (Higher Art-Technical Studios), K. Umansky wrote in 1920 that Kandinsky was the only important Russian artist who did not want to use his educational power in order to influence the young painters with propaganda. "One could also doubt, whether Kandinsky as an artist and teacher could attract those Russian art students, whose sympaties lay either with the utmost manifestations of materialism, or (rarer) with the pseudo-abstract (Suprematists and non-objective) tendencies in art.[37] Future events proved Umansky right. By the end of 1920 Kandinsky left the Inkhuk and Rodchenko, who had run a studio under Kandinsky's direction, reorganized Inkhuk to- ►

32. Umansky, *New Art;* W. Grohmann, *Kandinsky,* Cologne, 1951; Andersen, "Some Unpublished Letters"; Bowlt, *Russian Art of the Avant-Garde,* New York pp. xxxv and 196 ff.; N. Kandinsky, *Kandinsky and I,* Munich, 1976.

33. Kandinsky, "Questions and Answers" (1935), *Essays about Art and Artists,* ed. M. Bill, Bern 1955, p. 155.

34. N. Kandinsky, *Kandinsky and I,* Munich, 1976, p. 86. Kandinsky himself remembers: "I have absolutely no interest in politics, I am totally unpolitical and was never active in politics. (I have never read newspapers)." *Artists Write to W. Grohmann,* ed. Karl Gutbrod, Cologne, 1968, p. 46.

35. "Shagi Otdela izobrazitelnykh iskusstv v mezhdunarodnoi khudozhestvennoi politike," *Khudozhestvennaia zhizn,* Moscow, no. 3, 1919, pp. 16–18; "O velikoi utopii," ibid., no. 3, 1920, pp. 2–4.

36. See the resume of a lecture in *Vestnik rabotnikov iskusstv,* 1921, no. 4–5, pp. 74–5, reprinted in T. Andersen, pp. 106–7.

37. "Kandinsky's Role in the Russian Art Life," Ararat, 2nd special edition, 1920, p. 28.

gether with Stepanova, Babichev, and Bruisova.[38] It became increasingly a source of "production art," which is exactly that purpose-directed art that Kandinsky (with his anti-materialistic attitude) fought as long as he lived. The "spiritual" in art, Kandinsky's lifelong interest, moved more and more into the background.

Suprematism was the only remaining idealistic art, but not for long. In the 1920 exhibition organized by the Moscow IZO (Visual Arts Department) Narkompros, especially strongly represented were Kandinsky and Rodchenko "who to this day lead the leftist movement," reported D. Melnikov in the same year. Now, it was *how* a painting was executed, and not *what* it depicted that was important.

One more step along this path and the object proves to be superfluous, a hindrance to the artist's revelation of the purely 'painterly element.' The materiality of the painterly elements now becomes of primary importance and hence we have the beginnings of non-objective art: Kandinsky is its ideologist and practitioner.

Strictly speaking, Kandinsky is "five minutes to" Suprematism. He does not utter the final word, he does not dot his "i's." His paintings still contain vague allusions to real life forms, albeit in an embryonic state. Other non-objective artists advance further, e.g., Malevich, who, in order to reveal the "painterly element," takes his forms from plane geometry. This is pure abstraction. With this, painting is castrated, creativity dies.[39]

With this remarkable judgment Melnikov comes from an entirely different direction to the same result as Umansky, whose observation is quoted at the beginning of this article. It surprises us less today, because of our distance from that time, than it would have surprised Kandinsky or Malevi The differences between Kandinsky and Malevich mad more difficult for them to judge objectively each other's and theory. With Malevich there was at least no limitatior materialism, which estranged him from almost all the ot young artists. As far as painting is concerned, Kandinsky w really too "individualistic," much too concerned with his o inner necessity, to be able to learn anything from anybod this late time in life. It cannot be denied, however, that arrived at geometrical shapes later than the other Russia Yet, while a direct influence cannot be proved, the entire ra development of Russian art in this period is not imagina without Kandinsky's immense achievements. One can ag with Umansky that "all the young Russian art moveme lead back to Kandinsky—in different degrees of the crit ability of transformation."[40]

For Kandinsky, working in Russia became more a more difficult: his programs were rejected as too roman individualistic, and psychologistic. In 1921 he had one m exhibition and at the end of the year, shortly before the fi prohibition of abstract paintings, he left his homeland Germany to assume a teaching position in the more toler surroundings at the Bauhaus.

In 1925 a last echo appeared in *Sovetskoe iskuss (Soviet Art)*; in its column "Foreign Countries" were f reproductions of Kandinsky's newest works along wit short unsigned notice about his further development tow a non-objective art and the great interest of the capitali world (including North America) in this art movement an Kandinsky.

Translated from the German and Russian by Louise Weingarte and John E. Bowlt

38. This is the same musician and musicologist Nadezhda Briusova, whose contribution to the *Blaue Reiter* was planned, not the Symbolist poet Valerii Briusov, as T. Andersen believes ("Some Unpublished Letters," pp. 106–7).

39. D. Melnikov, "Po povodu 'levoi zhivopisi na 19 gosudarstvennoi vystavke," *Tvorchestvo*, Moscow, no. 7–10, 1920, pp. 42–44.

40. "Kandinsky's Role," p. 29.

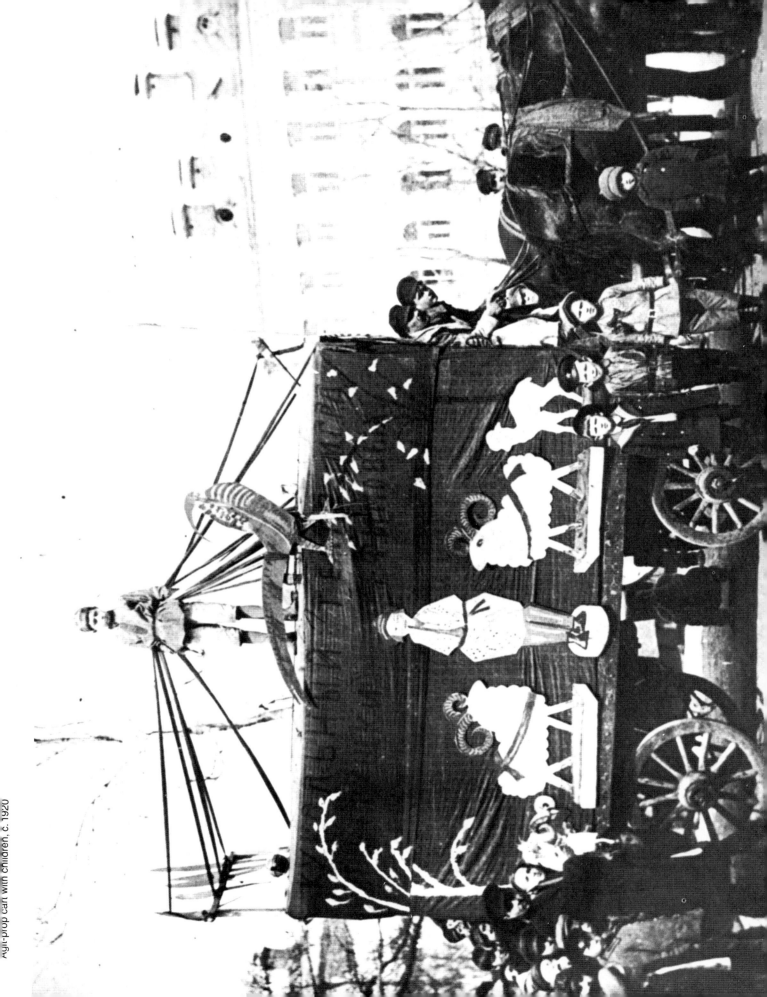

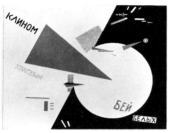

1. Sophie Lissitzky-Küppers, *El
Lissitzky: Life, Letters, Texts,* London,
1968, p. 354.

*This essay is dedicated to Mr. and
Mrs. F. Henrion

In contrast to most representatives of the Russian avant-garde, El Lissitzky (1890–1942) does not occupy the first rank of innovators in the true sense of the word, for he drew upon the ideas advanced and supported by his brilliant colleagues. However, he adapted these ideas in such diverse ways that this in itself has ensured him a prominent place in the history of twentieth-century culture. Lissitzky's research in the application of abstract artistic ideas culminated in their complete transformation and in the emergence of new concepts that exerted a decisive influence on art and design for several decades to come.

By 1919 Lazar Lissitzky was a well-known book designer and illustrator, seeking to establish a Jewish national style. In that year he took charge of the department of architecture and the graphics studio at the Vitebsk Popular Art School where Chagall represented one artistic extreme. After the Revolution this small Jewish town became the stage on which Chagall, the artist, presented the drama of universal cataclysm. At the other extreme was Malevich, the artist who continued his experiments in constructing a new pictorial space.

Lissitzky was invited to Vitebsk as an artist close to Chagall, but once there he became deeply influenced by Malevich. This was a radical and unexpected turning point, and even today it remains a mystery. Lissitzky switched from book design and immersed himself in developing his "Prouns," published as a series of lithographs in Russia in 1920 and in Germany in 1923 (fig. 1). The essential idea of the Prouns was that properties of objects that cannot be apprehended by the senses can be revealed in infinity. Within Suprematist space, unconfined by the horizon or by points of convergence, the object acquires a geometric purity, volume is flattened and the plane changes to line, the view from above is joined with the view from the side which, in turn, is joined with its frontal aspect. Space ceases to be a vacuum between objects and becomes spherical or arched. Consequently, space elongates, bends, and shortens the object, forcing it to soar, to revolve, and to cut into the next object. Objects, now liberated from gravity, move along spiraling, circular, or elliptical orbits, while the composition itself loses any sense of top and bottom.

The Prouns were an experiment to subject the object and space to a Suprematist reexamination. But they differed from Malevich's compositions in that, for Lissitzky, the Proun was an intermediate step, more a "laboratory" of artistic investigation than a final artistic result. Malevich's Unovis denoted the Affirmation of the New in Art. Lissitzky's Proun was merely a project, although a Project for the Affirmation of the New on a cosmic scale. Lissitzky wrote: "The Proun creator concentrates in himself all the elements and methods and w these he forms *plastic elements,* which exist ju like the elements of nature, such as H [hydroge and O [oxygen] and S [sulphur]. He amalgamat these elements and obtains acids which bite in everything they touch."[1]

Lissitzky's poster *Beat the Whites with the R Wedge* (1919) demonstrated how the Proun w able to move beyond the frame while remaining planar composition (fig. 2). The phonic scr sounded as an incantation while the inevitability the red triangle, breaking the white circle, seem to be a magic sign denoting the destruction the enemy.

Although Lissitzky's works of 1919–20 are ve different from Chagall's of that time, it would imprudent to affirm that the turning point in L sitzky's career just then meant that he had co pletely broken with the recent past. Lissitzky cou scarcely have rejected so suddenly his notion of t marvelous sense of festivity—a sense that is ider fiable with Lissitzky's early, Chagall-like illustr tions, but which had little to do with everyday real The world view of this grandson of a Smolensk h maker could hardly have been so very differe from that of the son of a Vitebsk barber, howev distinctive the particular plastic forms of their a Writer Ilia Ehrenburg, who contrasted the roman visionary Lissitzky with Lissitzky the artist and p saic constructor of logic, was perhaps a superfic observer.

From 1920 on, Lissitzky lived for the most p in Moscow. Despite the artistic environment of t Institute of Artistic Culture (Inkhuk) in 1921, L sitzky apparently did not find what he sought the The Inkhuk members analyzed light, color, a rhythm according to a purposeful program, but isolation from the other components of the artis totality. The idea of "de-struction" was so foreign Lissitzky that even in his Prouns, an integral part the history of Suprematism, he did not decompo form, but rather aspired toward its synthesis. It w not by chance that in his book *Die Kunstism* Lissitzky contrasted "Prounism" to Suprematis asserting that the former was, essentially, a diff ent movement. Lissitzky's experiments proved be fairly close to those of Vladimir Tatlin, and t proximity, in turn, might explain the otherwise i explicable opposition that Lissitzky always ma ifested towards Tatlin.

Lissitzky's compositions for the opera *Victo Over the Sun* by Alexei Kruchenykh (1920), whi were republished as a cycle of lithographs in 192 bear the imprint of the joint influences of Malevi and Tatlin (fig. 3). Lissitzky juxtaposed his own cc ception to that of Malevich, who had worked Victory Over the Sun in 1913. For Malevich t opera had served as a pretext for elaborating

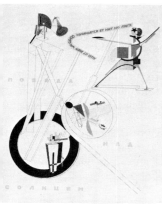

El Lissitzky
The Mechanical Setting from the portfolio *Victory Over the Sun*, 1920–21
One of the ten lithographs and collage, with table of contents
53 x 45.4 cm. (21 x 17¹³/₁₆ in.)
Collection, The Museum of Modern Art, New York, Purchase. 143.44.1

El Lissitzky
Proun Space, 1965 reconstruction of 1923 original
Painted wood
300 x 300 x 260 cm. (118⅛ x 118 x 102⅜ in.)
Collection Stedelijk van Abbemuseum, Eindhoven, The Netherlands
(cat. no. 155)

first Suprematist decorations, whereas Lissitzky now replaced the decorations with his "Spectacle Machine," whose parts could go up and down and move along a horizontal while transferring the personages of this "electro-mechanical theater of the future" through space. The idea of the "Spectacle Machine" obviously relies on Tatlin's experiments, since it embodies the notion of the dynamic, architectural city center that is evident in Tatlin's *Monument to the Third International,* a notion that Lissitzky felt to be a "magnificent, but amorphous spectacle." Tatlin's idea is manifest in Lissitzky's introduction to the lithograph edition of *Victory Over the Sun,* where Lissitzky emphasizes that color should be understood not as a means of defining the image but as a conditional denotation of properties of the material.

The personages whom Lissitzky called "figures" were artificial beings, faceless, like machines but endowed with personalities like people. The impetuous "Innovator," the static "Sportsmen," and the bow-shaped "Toady" are reminiscent of Golem in Mikhail Broderzon's *Legend of Prague,* the celebrated scroll-book that Lissitzky illustrated in 1917, True, these new Golems are not sculpted from clay in the form of a medieval rabbi and they are not brought to life by the *cabala.* In Lissitzky's view they are meant to embody a synthesis of art, science, and technology, yet they can be explained only by reference to a system of magical signs.

The conquered sun is a symbol of the old world. This theme of doing battle with the sun was not only favored by Kruchenykh in 1913, but it also appeared in V. Khlebnikov and Maiakovsky (in his poem "I and Napoleon"). With Kruchenykh and Khlebnikov the theme denoted an appeal to destroy, for Maiakovsky it denoted a tragic conflict. As for Lissitzky in 1920, *Victory Over the Sun* served as an occasion for continuing his "cosmic" experiments. As if he were "condensing" the principle of the Proun, Lissitzky claimed the "magical" power of the artist to compel the cosmos to manifest its anthropomorphic derivation, for—in Lissitzky's eyes—Mankind was the concentration of the Cosmic.

The above, perhaps, represents what I find most important in the art of Lissitzky: the fusion of scientific thought and mysticism and the extraordinary expression of this in images. The "electro-mechanical theater" was created by a person for whom legend is nobler than reality, for whom the magical fairytale is a bridge between refined scholasticism and the confusion of mundane life. In 1920 the future father of Constructivism not only retained his childhood belief in magic (just as Chagall did), but also cherished the hope of becoming a magician himself.

Lissitzky took his farewell of the personages in the books that he illustrated in 1917 and thereby seemed to expel man from his art. The exclusive subject of his artistic research now became the cosmos, and consequently his art confined itself to the problems of abstraction. However, when Lissitzky became co-editor with Ilia Ehrenburg of the journal *Veshch/Gegenstand/Objet* (cat. no. 145) in 1922 and began to propagate the new movement of Constructivism, he was unable to return to any specific point of reality. The term Constructivism designated the creation of a material environment capable of changing the nature of man—hence the need for a certain degree of "documentality" even in abstraction.

Lissitzky's attempt to integrate what would seem to be the incompatible was realized in his illustrations to Ehrenburg's *Six Tales with Easy Endings* of 1922 (cat. no. 149). All six illustrations are partial collages carrying a figure soaring in Suprematist space and set into the graphic sheet. The fact that we see a human figure not created by the artist but brought by him from the real, "three-dimensional" world is emphasized by the depiction of the figure by photographic means. It is possible that, whether Lissitzky intended it or not, each of the six collages demonstrated that man loses not only his individuality but also his spirituality when placed in the Suprematist space of the Proun. Evidently this disturbed Ehrenburg and even Lissitzky himself. In any case, they decided not to include the illustrations in the actual edition.

Quite probably, the negative result of this experiment inspired Lissitzky to organize a collision between the Proun and the human being, unique and real. This occurred in 1923 at the *Grosse Berliner Kunstausstellung, (Large Berlin Art Exhibition)* where Lissitzky was given a separate room. Lissitzky decided not to hang his paintings and graphic works on various stands, but to transform the six surfaces of the almost cubic space (four walls, floor, and ceiling) into huge Prouns painted in sparse black, white, and gray tones. Today it is impossible to reconstruct the real effect of the interpenetrating surfaces of the *Proun Room* (fig. 4) on the viewer. What was the role of rhythm here, an element that Lissitzky did not regard as so absolutely important as did other artists of the avant-garde? What was the role of light? What was the significance of these restrained accents of color? We are now unable to conceive at all clearly the effect of the particular Suprematist symbols that, in fact, comprised the single spatial symbol of the *Proun Room.* Yet, all subsequent experiments in modern art that include the viewer in relation to an environment derive from this first attempt devised by Lissitzky in Berlin in 1923.

▶

5. El Lissitzky
Internationale Kunstausstellung,
Dresden, 1926
Installation photograph

2. El Lissitzky and Hans Arp, *Die Kunstismen,* Erlenbach-Zurich, 1925, p. vii.

The move from the photographic depiction of man "floating" in the Suprematist space of the graphic sheet to the tangible man in a space transformed into infinity through Suprematist symbols was, it would seem, an inevitable development. But in fact this could not have been achieved without the consciousness of artists of their right to deal with a "new man." Lissitzky overcame this ethical barrier when he had felt himself to be a Magus endowing his Golems with life, that is, when he created his figures for *Victory Over the Sun.*

In 1924, in a tiny *pension* on the outskirts of Locarno, El Lissitzky and Hans Arp worked out a categorization of the basic trends in art and artistic thinking over the previous ten years (1914–24):

Filmism / Constructivism / Verism / Prounism / Compressionism / Merzism / Neo-Plasticism / Purism/Dadaism/Simultanism/Suprematism/ Cubism/Futurism/Expressionism[2]

In contrast to those representatives of Russian culture who were émigrés in the West, Lissitzky, sent to Berlin as commissar for the *Erste Russische Kunstausstellung* in 1922, felt himself to be the apologist of the New Russian Art. His mission was the integration of the Russian avant-garde into the mainstream of European culture. Lissitzky's co-editorship with Arp of *Die Kunstismen* (cat. no. 162) was actually the result of a chance meeting (Lissitzky, incurably ill, was receiving treatment at a tuberculosis sanatorium), but it also symbolized a unity of artistic aspirations. *Die Kunstismen* was conceived not as a literary elucidation of the latest artistic doctrine—a very popular format at that time—but as the affirmation of a new world with its own spatial and rhythmic correlations unlike those of everyday, a world created by artists. Each section in *Die Kunstismen* designated the limits of this world, and each reproduction served not to illustrate but to symbolize one or another art trend. The tiny portrait of each artist reproduced in the margins gave the artistic idea being discussed a certain personal character. At the same time, the formal organization of the book, constant and integrated throughout the text, denoted that the separate aspects of this intricate unity were of equal value and importance.

As the force behind the *Proun Space* of 1923 and *Die Kunstismen* of 1924, Lissitzky proved to be the most suitable candidate for the position of designer for the modern art section at the *Internationale Kunstausstellung (International Art Exhibition)* in Dresden (fig. 5). Apparently Lissitzky received the invitation in 1925; the exhibition itself opened in 1926. For Lissitzky this work was a continuation of *Die Kunstismen.* It entailed the logical transfer of works of art from the surface of the typographical sheet to the space of the exhibition room and gave Lissitzky the opportunity to create his own order in the world of intricate spatial con-

structions. Lissitzky characterized the project in th[e] following manner:

Place and purpose • The great internation[al] picture reviews resemble a zoo, where th[e] visitors are roared at by a thousand differe[nt] beasts at the same time. In my room the ob[b]jects should not all suddenly attack the viewe[r]. If, on previous occasions in his march-past [in] front of the picture walls, he was lulled by th[e] painting into a certain *passivity,* now our de[e]sign should make the man *active.* This shou[ld] be the purpose of the room.

Demands of the exhibited object • The mate[e]rial for the design of the new painting is col[or]. Color is an epidermis covering a skeleton. Ac[c]cording to the construction of each skeleto[n] the epidermis is pure color or tone. Each de[e]mands a different manner of isolation an[d] illumination. Just as the best acoustics ar[e] created for the concert hall, so must the be[st] optics be created for this showroom, so that a[ll] the works may achieve the same degree [of] effectiveness.

Approach •
(a) One can try to create the best backgroun[d] for the pictures with the resources of pai[nt] itself. For each picture one paints, a rectang[le] in a corresponding color on the wall and th[e] task is done; but there stands the wall itself a[s] a picture in front of me, and to nail a Leonar[do] onto a wall by Giotto is surely nonsensical.
(b) In the room which I was given, I did not se[e] the four walls as supporting or protectin[g] screens but rather as an optical backgroun[d] for the painting. Therefore I resolved to trea[t] the wall surfaces as such.
(c) The room ought to contain several work[s] but I have made it my aim to avoid a crowde[d] impression.
(d) The light, in which the effect of color orig[i]nates, could be controlled.
(e) The room should not have a privat[e] drawing-room style of decoration. It shou[ld] present a standard for rooms in which new a[rt] is shown to the public.

The solution to (a) and (b): I have place[d] thin laths (7 cm. in depth) perpendicular to th[e] wall at regular intervals of 7 cm. and I hav[e] painted them white on the left side, black on th[e] right side, and the wall itself gray. So you se[e] the wall gray from the front, white from th[e] left, black from the right. According to th[e] standpoint of the viewer, the pictures appea[r] on white, black, or gray — they acquire [a] threefold life....

The solution to (d): The room has the whole ceiling as its skylight (stretched, unbleached calico). I have colored this along one frontal wall with blue, along the other with yellow, so that one is coldly illuminated and the other warmly illuminated.

The solution to (e): By designing according to these clear principles we have succeeded in realizing not just the usual arts-and-crafts object but a type of room which we hope will become the standard.

The effect · On entering the room (the entry and exit are one, and in form are suggestive of pedestals for sculptures) one is confronted by a gray wall surface, adjoining a white one on the left side and a black one on the right side. Through the varying widths of the frames the visual axes are shifted from the symmetrical axes of the doors, thus creating the rhythm of the whole. With every movement of the spectator in the room the impression of the walls changes — what was white becomes black and vice versa. Thus an optical dynamic is generated as a consequence of the human stride. This makes the spectator active. The play of the walls is complemented by what is visible through the shimmering frames. The open-pattern masking surfaces are pushed up or down by the spectator, who discovers new pictures, or screens what does not interest him. He is physically compelled to come to terms with the exhibited objects.[3]

The success of the innovation of the Dresden temporary exhibition inspired the Kestner Society to commission Lissitzky to repeat the same solution for a permanent exhibition space. However, in the Hanover project the light came not from above but from the side, and this compelled Lissitzky to make some modifications in the design. For example, he inserted rotating vitrines for graphic works in the window recesses, something that the Dresden space had not had. There had not been any sculpture at Dresden, but in Hanover Lissitzky put an Archipenko piece in front of a mirror so that it could be seen simultaneously from various sides.

In the main, both spaces were identical, and in both projects Lissitzky attempted to remove any influence of one piece on another. Lissitzky's comparison of the correctly organized exhibition space with the concert hall in which the spatial layout guarantees good acoustics was not fortuitous. Lissitzky had managed to change the content of a single formal scheme in *Die Kunstismen;* the rhythm of each page being turned always created a full spread that constituted a single enclosed composition. As far as the exhibition was concerned, an analogous result was achieved in that the "optical

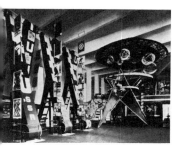

6.
El Lissitzky
International Pressa Exhibition,
Cologne, 1928
The entrance hall
Installation photograph

3. Lissitzky-Küppers, *El Lissitzky,*
p. 354.

background" of the exhibition was neither a constructive support for the picture (which Lissitzky himself noted), nor represented a boundary of the room itself. The optical background was a space with its own constant physical depth, equal in width to 7 cm. and with its own optical depth constantly changing as the spectator moved about. The painting in front of the spectator took on a completely different color and textural quality, a different spatial correlation from the paintings adjacent to it. The position occupied by the painting nearest the spectator remained stable, but the spectator had only to move a few steps away and a new painting would enter this position while the former one would "move" into different spatial conditions. The optical background did not connect but rather disconnected the individual works, creating, as it were, perceptional caesurae; no longer a continuum, "exhibitional time" now became an interrupted condition rather like the sense of time experienced by the reader leafing through an album.

The *Self-Portrait* of 1924, created by the superimposition of three negatives one upon the other, was entitled by Lissitzky—significantly—the *Constructor.* A hand with compasses is projected onto the face of a man in a sweater through whom can be seen the tiny squares of graph paper. The eye of the face seems to be afire in the palm of the hand, expressing a unity of idea and will, the artist's single and concentrated idea of creativity. We see here the creator of a material environment that can transform human nature; this is not a constructor in the usual sense of the word. He is no longer a magician endowing inanimate objects with anthropomorphic properties as he utters his powerful incantations, but, rather, a demiurge.

For Lissitzky this was a new self-awareness, and it can easily be discerned in the character of his "game" of individual artifacts or micro-worlds which was the entire point of the Dresden exhibition. Here, too, the discipline of linear and geometric forms was not rational. Here, too, Lissitzky remained a romantic. Beneath the order that he had created there lay a creative will knowing no boundaries, but seeking ardently to find them. This is something that Europe had given Lissitzky when he was a student at the Darmstadt Polytechnikum before the First World War, and now, as the acknowledged leader of Constructivism, he continued to expose himself to it. Lissitzky's attitude toward Europe was always one of respect and now, at the center of the European artistic avant-garde, he felt himself to be a real European.

The Soviet pavilion for the international *Pressa* exhibition in Leipzig (1928) presented Lissitzky with new questions (fig. 6). Soviet publications of that period were identifiable by their gray paper, their uneven type, and their lackluster colors. The new ▶

ideas that Soviet newspapers, magazines, and brochures were broadcasting to the world were presented in a form that the Western reader found most unattractive. It was essential to find a way of revealing the immanent meaning of each exhibit, to place it in an environment whereby the artifact would lose its Prescription and acquire its Meaning. The exhibition of Objects (which the Dresden show had been) must be replaced by the exhibition of Ideas.

But that was only one part of the endeavor. The theme of the *Pressa* exhibition served as a pretext for displaying the new world in the arena of the old. This took Lissitzky far beyond the fairly generous boundaries normally reserved for the artist in the European tradition. At the same time, Lissitzky was rather more closely connected with the old world than with the new—he had been cut off from Russia by his several years in the West and also through his marriage to Sophie Küppers, daughter of a very cultured German family. Lissitzky was able to imagine the world in which he believed, but he was unable to depict the world that really existed. The apostle was forced to take the role of the prophet. The symbolism applied to the *Pressa* exhibition (so very different from conventional Soviet symbolism of that period) was a direct result of this role change.

The five-pointed star at the center of the Soviet pavilion at *Pressa* came from the cover of the catalog for the *Erste Russische Kunstausstellung* of 1922 (Lissitzky was sent by Narkompros to supervise its organization). Initially, the design had been applied to the flat surface of the printed page and now it was transformed into three dimensions. Not only that, but a red disc above the star carried a text that rotated in a spiral: "Workers of all countries, unite!" —which bore a meaning far beyond that of a political slogan, calling upon all workers of all inhabited worlds to unite. The central installation was a cosmic symbol and the wire "planets" hanging below the disc left no doubt about this. Six wide-belted, moving belts were linked to the central installation, and these carried posters from floor to ceiling proclaiming the achievements of the Soviet Union.

If, at the 1926 exhibition, Lissitzky had made use of an optical dynamic, here he applied mechanical dynamics for the first time. It might have seemed that the dynamic of the poster—already a developed medium by then—was but a short distance from the dynamic of the exhibition, but in fact it was Lissitzky who was destined to cover that distance. The commercial poster affects only one specific area of consciousness, but Lissitzky tried to grip the entire consciousness of the spectator. The posters moving through space were less a device for attracting the spectator's attention than a symbol of the movement and development of the new society.

The *Pressa* pavilion provided the spectator with several dimensions that corresponded to the "semantic level" of the various parts of the exhibition. The cosmos as embodied by the central installation and the belts were above; the three-dimensional stands for "Women's Press," "Workers' Press," "Army Press," etc., acting as "frontispieces" for the various special sections, were below, their volumetrical figures seemed to "derive" from the central installation. Thus the spectator, so to speak, looked at the exhibits as if they had been brought from the cosmos. To use the terminology of the time, these were "second generation figurines," since they expressed the same idea of man being a concentration of the cosmic that Lissitzky had elaborated in *Victory Over the Sun.*

If each exhibit at the Dresden show was to have been viewed as an independent piece and as equally valid as the next one—Lissitzky's objective had been to remove any influence of one object on another—the *Pressa* pavilion was constructed on the principle of commentary and contact among the pieces on display. While denied any independent formal value, the exhibit acquired the infinitely important and ultimately cryptic meaning of a bearer of truth: the aggregate of these unprepossessing and unattractive units formed a kind of Holy Writ.

The huge photomontage by Lissitzky and Senkin installed around the pavilion was a complex rhythmical and spatial organism. The individual elements were either pushed out from the wall or were recessed into it, and like the optical background at Dresden, they "destroyed" the boundaries within the pavilion. Not in vain did Lissitzky call his photomontage a "photo-frieze." The Soviet people photographed at study, at work, and in their everyday lives are interrelated by the very meaning intrinsic to all the works on display—and this, in turn, deprived the photographic depiction of its specificity, changing it into a symbol. The idea of "documentary abstraction" of 1922 had not been forgotten. The title of the photo-frieze, "The task of the press is the education of the masses," demonstrates that Lissitzky, the greatest book designer of the twentieth century, regarded the press as much more than a mere agent of enlightenment. For him the function of the press was to educate, to remake the human species.

At first glance the *Internationale Hygiene Ausstellung* (Dresden, 1930) would seem to be a development of the ideas implemented at the *Pressa* exhibition. In actual fact, Lissitzky proposed many new methods which really belonged to the future: for example, the "floating layout," the computed positive motion, the rows of identical posters attached to the ceiling (and therefore outside the spectator's active perception but affecting his subconscious), the introduction of a movie camera, etc. In this way, Lissitzky laid the foundation for a

aspects of contemporary exhibitions utilizing the motion pictures.

But as it happened *Hygiene* did not provide a new conception of the exhibition space and, as a whole, was inferior to *Pressa*. Perhaps this was the result of the character of the theme itself. Lissitzky had had the opportunity to juxtapose the "Press" to the "Millions" as the instrument of their education. However, the subject of hygiene is always dissolved or neutralized by questions of society and the family, and Lissitzky was unable to repeat such juxtapositions here. He was able to "develop" the theme of *Pressa* in the form of a multi-stage system of symbols, whereas he was forced to "surmount" the theme of "Hygiene." Consequently, the *Hygiene* exhibition had a rather mannerist character—the "Exhibition of Ideas" turned into the "Exhibition of Devices." The devices were certainly new, effective, and very clever, but this did not change the real state of affairs.

In the *Pressa* show, Lissitzky set himself an aim that, in its grandeur, was comparable to the creation of a medieval cathedral. Moreover, he achieved this aim: using an artistic synthesis, he built a model of the world and extended filaments that connected man with the cosmos. In doing this, Lissitzky discarded the European tradition while remaining a genuine European. However, his notion that the printed word does not express the thoughts and aspirations of the millions, but presides over them as a force invoked to change mankind, is certainly not of European origin. It rejects the role imparted to the Scriptures in the strange culture of the pious and haughty expounders of the Torah.

The people in the photo-frieze are not the crowd without whom the art of the street loses its meaning (the *Pressa* pavilion was a direct development of the ideas of the "art of the street," although the conditions were entirely inappropriate). The people in the photo-frieze are the human species, and, with the fervor of a biblical prophet, Lissitzky the artist leads them to the Promised Land. At the Dresden exhibition in 1926, Lissitzky still endeavored to determine the limits of his competence. But at the 1928 exhibition he seemed unable even to recognize them. ●

Translated from the Russian by John E. Bowlt

El Lissitzky and the Spectator: From Passivity to Participation

Alan C. Birnholz

One of the principal themes in the art of El Lissitzky (1890–1941) was the search for ways to compel the spectator to act. Throughout his career Lissitzky sought, often ingeniously, to jolt the viewer out of what the artist considered a loathsome tradition of passivity and inertia and into a vigorous, dynamic interaction with the work of art and its environment. In this essay I will focus on three questions: why Lissitzky wanted the spectator to be active, how he achieved this goal, and what the significance of his quest is. In all matters of history, events are "overdetermined"; that is, there are always more causes to explain why things happen than the historian may wish—or be able—to discuss.[1] In this article I want to begin by pointing out the multitude of forces that motivated Lissitzky to do what he did with regard to the spectator.

Lissitzky was hardly alone among Russian avant-garde artists in his desire to create an active spectator. Looking back at the art of the past, Lissitzky, along with Suprematist and Constructivist contemporaries like Malevich, Tatlin, and Rodchenko, wanted to bring about an art that was truly modern. One of the many ideas in their concept of modernity in art involved getting away from a centuries-old tradition: the tradition of the viewer who remained a static onlooker and who only seldom was moved—either physically or emotionally—by the work of art.[2] An active spectator was new, modern, and desirable. Since the avant-garde took pride in breaking with the past, the lack of an active spectator in the past constituted a good reason to create one.

But when I talk about Lissitzky's relationship with "tradition," I must be careful, because artistic traditions were anything but monolithic. His ideas grew out of many traditions that often contradicted one another. Although he condemned the stasis and inertia of the spectator before 1900, Lissitzky must have realized—as one observer remarked during the 1920s—that his exhibition rooms were linked to the dynamism of the Baroque.[3] This perceptive remark reminds us that viewers prior to 1900 were often anything but passive. Accounts of nineteenth-century exhibitions, for example, are filled with a sense of the physical as well as intellectual and emotional activity of the spectators. This activity became more and more intense as exhibitions of modern art grew increasingly scandalous. What Lissitzky wanted to do, then, was to continue rather than break with this tradition, but with the added desire to control the spectator's actions and not leave them to chance.

This idea of the active but controlled spectator has its roots in other traditions especially relevant for Lissitzky. One of these was the Russian tradition. In the course of Russian art history there was a strong belief that art must not just be, but do; art must have some redeeming social purpose.[4]

Along with this went an interest in how art was displayed. Icons, for example, customarily placed in corners in Russian homes or in rows on the church iconostasis, required a prescribed set of physical responses: approaching, bowing, kissing the panel, and so on.[5] In the late 1800s the Peredvizhniki (Itinerants or Wanderers), later revered as one of the first avant-garde groups in Russia, paid much attention to bringing art physically as well as emotionally to the people. The relationship between the art object and the viewer was long regarded in Russia as a dramatic and dynamic one. Lissitzky's art can be seen as an effort to continue and intensify this relationship.

Another influence on Lissitzky was the Jewish tradition. Despite his repeated denials of religious belief—denials that were de rigueur for the avant-garde—Lissitzky remained profoundly affected by his Jewish past.[7] In his art he took over several Jewish themes and ideas and modernized (i.e., secularized) them. Art had supplanted religion, just as the modern world had supplanted the old world and its concept of God.[8] But what lived on in Lissitzky were old beliefs in new forms. The participant in Jewish rituals was always an active individual whose own movements accorded with the belief that God "manifests Himself in *events* rather than in *things*, and these events can never be captured or localized in things."[9] Lissitzky's conception of the experience of looking at art as an event arose, in part, from his Jewish background.

Still another tradition affecting Lissitzky was the much more recent one of the Russian avant-garde. At exhibitions of this outrageous art, the sheer physicality of the viewer was much in evidence. Fights among spectators and artists were not uncommon. With the Revolution of 1917, the desire arose to make art contribute meaningfully to arousing support for the Bolsheviks. Outdoor exhibitions, festivals, pageants, re-enactments of celebrated moments of the Revolution: art truly went "into the streets" and made people no longer simply observe, but also participate.

Added to the impact of these traditions were other forces leading to the active spectator. For one, there were frequent comparisons of the new art to machinery and to the theater, both of which were characterized by movement and a sense of drama. Many artists shared with Lissitzky the belief that the pace of the modern world was accelerating. Change and process were considered to be inherently modern and, therefore, good. Change was everywhere and it must now play a major role in art. All around him Lissitzky encountered the

1. I borrow this view of history from Peter Gay. See, for example, his *Art and Act: On Causes in History—Manet, Gropius, Mondrian*, New York, 1976, pp. 1–14.

2. El Lissitzky, "Exhibition Rooms," *El Lissitzky: Life, Letters, Texts*, ed. Sophie Lissitzky-Küppers, Greenwich, Connecticut, 1968. p. 362.

3. Siegfried Giedion, "Live Museum," ibid., p. 379.

4. John E. Bowlt, *Russian Art 1875–1975: A Collection of Essays*, New York, 1976, p. 174.

5. Alan C. Birnholz, "Forms, Angles, and Corners: On Meaning in Russian Avant-Garde Art," *Arts*, vol. 51, no. 6, February 1977, p. 107.

6. For an excellent discussion of the *Peredvizhniki*, see Elizabeth Valkenier, *Russian Realist Art*, Ann Arbor, Michigan, 1977.

7. Alan C. Birnholz, "El Lissitzky and the Jewish Tradition," *Studio International*, vol. 186, no. 959, October 1973, pp. 130–36.

8. See Lissitzky's conclusion to "Suprematism in World Reconstruction," *El Lissitzky: Life, Letters, Texts*, p. 330.

9. Abraham Joshua Heschel, "Symbolism and Jewish Faith," *Religious Symbolism*, ed. F. Ernest Johnson, New York, 1955, p. 57. The emphasis is Heschel's.

view that the times were epitomized by events. He reflected this view in his wish to create an appropriately active spectator.

There is one other factor to consider in explaining Lissitzky's interest in movement in general and in the active spectator in particular: the artist's own personality. Reyner Banham described it well when he wrote that Lissitzky was "one of the great 'ideas-men' of the Modern Movement."[10] He was remarkably gifted in imagination—and ever restless in his rush to move on to the next project. In my view, there is a basic connection between Lissitzky's personality and his interest in making the spectator active. Indeed, Lissitzky's art as a whole may be seen as a reflection of the anxiety, both personal and professional, that he faced throughout his life.[11]

How did Lissitzky create this active spectator? Except for a few cases in which the spectator was actually encouraged to move a work of art,[12] Lissitzky's "Prouns" (the term he coined to identify his "new art") let the experience of movement occur wholly inside the spectator's head. All of the Proun compositions in this exhibition are built on the theme of movement. In each of them certain devices—tangent relationships, vigorous contrasts, thrusting diagonals—appear again and again to convey to the spectator the sense that the forms he sees are moving at the same time that the spectator begins to conceive of his own movement. But a few moments must pass before the spectator becomes truly conscious of this movement. In *Proun 30T*, for example, there is a cross pattern in the lower center. As we follow the dark strips we may wonder if they might somehow be bent and/or if our position has inexplicably shifted. Many of the quadrilaterals in *Proun 30T* imply exact rectilinearity at first, only to become in time less and less involved with truly parallel lines. One of the greatest of the Proun paintings, *Proun 99* (Brodsky essay, fig. 1), is a marvel of subtle devices all contributing to the idea of movement. There is an endlessly fluctuating pattern in the grid at the bottom, the cube hovers miraculously between the adjacent curves. The cube itself is transformed into a three-sided open box, then back to cube, then back to a box—and so on forever.[13] In the end, all we can be certain about is that the forms in this painting and our vantage point have entered an essentially dynamic relationship.

All this movement, of course, takes place in the mind of the viewer, as the paintings themselves do not change and, except for relatively slight movements on our part, neither do we. It was in other works that Lissitzky truly forced the spectator to act. One purpose of the famous poster *Beat the Whites with the Red Wedge* (Brodsky essay, fig. 2) of 1919–20 was to convince the viewer of the legitimacy of the Bolshevik cause and of its inevitable victory. Lissitzky did not want the spectator merely to look at this poster, but instead to go out and strive vigorously for the Revolutionary cause. In another example of Lissitzky's advanced typography, *For the Voice* of 1923, the size, color, and organization of letters change both to make the book more interesting visually and to push the viewer beyond reading silently to himself and toward declaiming in public. One does not just read these poems; one speaks them out loud and, when the typography suggests, begins to shout as well.

The most significant example of a Lissitzky work bringing about an active spectator occurs in the *Prounenraumen,* the Proun rooms. In the *Proun Space* included in this exhibition (Brodsky essay, fig. 4) the spectator finds himself in an environment that responds directly to every one of his movements at the same time that it raises him up to the utopian world Lissitzky envisioned. Another Proun room was the *Abstrakte Kabinett* done in Hanover in 1927, later destroyed and recently reconstructed. Here Lissitzky's interest in the active spectator climaxed. The viewer had no choice but to participate in the process going on around him. Slats set perpendicular to the walls created light-dark patterns that changed with each step taken by the spectator. Works of art were placed on movable supports so that the spectator could shift the objects as he saw fit, even covering over those works he did not like. Modern illumination and rotating display cases contributed further to the all-enveloping presence of movement, movement that responded with great subtlety to the actions of the individual viewer. In the following year, at the Soviet display for the International Press Show in Cologne (Brodsky essay, fig. 6) large belts with messages set the tone for a total experience based again on change, movement, and action.[14] Even during the 1930s, when the advent of Socialist Realism and deteriorating health forced Lissitzky to undertake less ambitious projects, he still explored the concept of the active spectator.[15]

Taken as a group, these works reveal basic aspects of Lissitzky's ideas about the spectator. First, the rate of change always was comprehensible, never overwhelming. It is as if Lissitzky took the viewer into the new, somewhat frightening world of modern art gently, by the hand. Second, Lissitzky always remained in control of the situation. The individual spectator had some room for his own choice to come into play, but only within limits set by the artist. That is to say, the spectator can move the works of art around the *Abstrakte Kabinett,* but only in a restricted number of ways. Third, to refer to the *individual* spectator is proper because Lissitzky, it seems, was unable to think in terms of a truly mass audience for his work. A Proun painting, print, or environment is always ▶

10. Reyner Banham, *Theory and Design in the First Machine Age*, New York, 1960, p. 193.

11. On Lissitzky and anxiety, see Kenneth Lindsay's review of Lissitzky-Küppers in *Art Bulletin*, vol. 54, no. 3, September 1972, pp. 369–71, and Alan C. Birnholz, "El Lissitzky, the Avant-Garde, and the Russian Revolution," *Artforum*, vol. 11, no. 1, September 1972, pp. 70–76.

12. See the comments on *Proun 6B* in Alan C. Birnholz, "El Lissitzky's Prouns," *Artforum*, vol. 8, no. 3, November 1969, p. 69. For an interesting discussion of this phenomenon, see Lindsay, *Art Bulletin* review, p. 371.

13. I first noted the spatial ambiguities of *Proun 99* in "El Lissitzky's Prouns," *Artforum*, vol. 8, no. 2, October 1969, p. 66.

14. I was wrong when I once commented on the rapid movement at this exhibition ("El Lissitzky, the Avant-Garde, and the Russian Revolution," p. 75). Sophie Lissitzky-Küppers stresses a much gentler rate of movement *(El Lissitzky,* Galerie Gmurzynska, Cologne, 1976, p. 18).

15. See the illustrations of Lissitzky's works from the 1930s in Lissitzky-Küppers, *El Lissitzky: Life, Letters, Texts, passim.*

an intimate, private experience. In the *Abstrakte Kabinett* or the *Proun Space* in this exhibition, one is made conscious of his own individual being. Even in architecture Lissitzky did not—could not—envision large numbers of people. Note, for example, that in the photomontage for the *Lenin Rostrum* of 1924—its dynamism evident in the omnipresent diagonals, the projected slogans, and the suggestion of moving, mechanized parts—Lenin is hardly shown addressing a throng. The *Wolkenbügel,* also of 1924, similarly was envisioned as dynamic—the glass exterior permitting a glimpse into the moving people and parts inside, while traffic and pedestrians move below—but again the illustrations significantly leave out the crowd. One reason for Lissitzky's growing estrangement from the Soviet political leadership by the mid-1920s had to do, I suspect, with the conflicts between his individual-oriented art and the regime's demand for a mass, "socialist" art.

Once we consider Lissitzky's ideas in relation to what the Soviet government wanted, the question of the meaning and significance of his interest in the active spectator arises. This, too, is a complicated issue. We must ask, in turn, what the significance of the active spectator was for the spectator himself, for the work of art, and for Lissitzky and the avant-garde movement in Soviet Russia.

The stimulus to act affected the spectator in two principal ways. The spectator was now invited, indeed encouraged, to share with the artist the marvelous experience of creating the work of art. Since the object either suggested infinite transformability, as in the Proun compositions, or else it was situated in an environment that demanded the spectator's physical interaction with it, as in the Proun rooms, the point was made clear that no longer did the artist and the artist alone enjoy and possess the role of creator. Of course, Lissitzky was neither the first nor the only artist to bring the spectator into the creative act; much of the history of art would make sense from the perspective of how artists have engaged the spectator intellectually, emotionally, as well as physically. But with Lissitzky the spectator *must* recognize and deal with his own creative potential. The result, as Lissitzky wrote in 1920, is that "the private property aspect of creativity must be destroyed" because "all are creators and there is no reason of any sort for this division into artists and non-artists."[16]

The other main effect on the now active spectator involved a major theme among Russian avant-garde artists: the theme of labor. Adolf Max Vogt has perceptively shown how concerned the Russian modernists were with having their works of art and architecture relate to the Revolution's stress on Labor with a capital L.[17] Put bluntly, to understand the complex nature of a Proun is hard work. In the *Abstrakte Kabinett* this mental labor has been compounded by the physical work the spectator must perform. And since the spectator must now work, he recognizes how far he has come from the pre-Revolution concept of art as self-

indulgent pleasure, relaxation, and escape for the well-to-do. To transform art-viewing into labor, with all of its positive connotations after 1917, resulted in helping to legitimize the act of making and looking at the new art. Perhaps Lissitzky's insistence on forcing the spectator to work was analogous to what Susan Sontag recently wrote about taking photographs in our own day: the act of picture-taking "appeases the anxiety which the work-driven feel about not working when they are on vacation and supposed to be having fun. They have something to do that is like a friendly imitation of work."[18]

The active spectator, then, leads to changes in the nature of the art object itself. As a process and ongoing event rather than a static, self-contained thing, the work of art becomes increasingly interesting, dynamic, open-ended. It becomes, in a word, modern. But one aspect of its modernity is that the art work remains at the center of events, while the spectator, intellectually and/or physically, revolves around it much as, to borrow Lissitzky's own analogy, the planets revolve around the sun.[19] By retaining this position at the center, the art work emerges as the all-important factor in the creation of the modern age. But how ironic is this result! Just as so many Russian avant-garde artists talked about the death of art, they held on, as Lissitzky did, to a fascination with the power of art and to a faith in the ability of art to build the new order.

If the centrality of the work of art is not new, the blurring of the lines separating it from its dynamic surroundings and equally dynamic spectator is. This dynamic situation forces an unanswerable question: where, precisely, is the art object? Since the object cannot be exactly placed in terms of time (art now is process) or location (art now is environment), the effect is to recall the urge toward the mysterious, the irrational, and the illogical that I have observed elsewhere throughout Lissitzky's art and that others have traced in Russian and northern European art in general.[20] In Lissitzky, art is not separate and distinct from life. Instead, art intensifies our awareness of the process of life.

This fusion of art and life makes added sense once we consider the meaning of the active spectator for Lissitzky and for the Russian avant-garde. The interest in movement and hence in life reflected the heightened consciousness of death shared by Russian modernists. As Robert C. Williams recently pointed out, the Russian avant-garde, "intensely aware of death…sought to eternalize its youth through innovation, and achieve a kind of immortality."[21] For Lissitzky, an artist seldom in robust health and suffering from tuber-

16. Lissitzky, "Suprematism in World Reconstruction," p. 329.

17. Adolf Max Vogt, *Russische und französische Revolutions-architektur,* Cologne, 1974, pp. 141–82.

18. Susan Sontag, *On Photography,* New York, 1977, p. 10.

19. Lissitzky, "Suprematism in World Reconstruction," p. 328.

20. For Lissitzky as romantic, see Alan C. Birnholz, "Time and Space in the Art and Thought of El Lissitzky," *The Structurist,* nos. 15/16, 1975–76, p. 89. See also Margaret Betz, "From Cézanne to Picasso to Suprematism: The Russian Criticism," *Artforum,* vol. 16, no. 8, April 1978, pp. 34, 35, and Robert Rosenblum, *Modern Painting and the Northern Romantic Tradition,* New York, 1975.

21. Robert C. Williams, *Artists in Revolution: Portraits of the Avant-Garde 1905–1925,* Bloomington, 1977, p. 186 and *passim.*

culosis by 1923, this awareness of death was if anything still more intense. In making the spectator act—and live—Lissitzky revealed to us yet another side of his personality.

By encouraging the spectator to act, Lissitzky also sought another goal of great importance for him and his modernist contemporaries. These artists often spoke about and undoubtedly believed in the superiority of the avant-garde artist to the rest of society. In doing so, they shared an attitude evident among vanguard artists throughout Europe.[22] But the Russians, and espcially Lissitzky, also wanted to be respected, if not venerated, for their presumably revolutionary contribution to the new society. By making the spectator act, by making him take part in the work of art, Lissitzky hoped the spectator would come to understand the

new art and to accept it—and the artist who had created it. Of course this art was not accepted in Soviet Russia, neither by the regime nor by the people at large. But in later years and in other places (as this exhibition demonstrates) this notion often appeared of bringing the spectator into the work of art as one way to have him recognize the relevance of the art object.

Lissitzky's art functioned, then, as a challenge and opportunity to the spectator. This art is difficult; it is often incomprehensible. It is likely that the spectator will invest much time and energy in it without receiving immediate rewards. But the sense of understanding, once achieved, is marvelous indeed. Throughout his work Lissitzky held out an open invitation to the spectator to join in the creation of the new art and, with it, the new society. ●

22. See Renato Poggioli, *The Theory of the Avant-Garde,* Cambridge, 1968.

The Ins and Outs of
Russian Avant-Garde Books:
A History, 1910–1932*

Gail Harrison Roman

*This essay was prepared with the assistance of Douglas Brenner and Paula Spilner and is dedicated to Arthur A. Cohen.

1. This work bears comparison with Filippo Marinetti's "Futurist Manifesto," published in Le Figaro in February 1909. Both announced new trends in art and literature, although Sadok sudei did so more subtly; that is, by example rather than through polemics. Sadok sudei, however, rejects—as Marinetti did not—conventional organization and mise en page. Within three years both the Russian and the Italian Futurists were to alter radically the look of the printed page, with innovative typography and exciting layouts. See A. A. Cohen, "Futurism and Constructivism: Russian and Other," Print Collector's Newsletter, vol. VII, 1976, pp. 2–4.

2. V. Kamensky, Put entuziasta (Journey of an Enthusiast), Moscow, 1931, p. 109; trans. in V. Markov, Russian Futurism: A History, London, 1969, p. 9.

3. In 1914 a book of alleged "children's poems and drawings" was brought out by Kruchenykh (who listed himself as the "collector" of these works): Sobstvennye razskazy i risunki detei (Actual Stories and Drawings of Children). Since Kruchenykh is known to have taken liberties with language and to have devised unusual means of presenting his writings, he may very well be the "actual author" of these works. Although the language is rather sophisticated for child-authors (listed as aged 7 to 10 years), the drawings manifest both the naive rendering and the bold stroke typical of children's art. Nevertheless, these stylistic devices were also characteristic of the Russian Neo-Primitivist and Futurist artists.

4. There is little agreement about the labeling of the many avant-garde groups that existed, co-existed, and feuded during the early 1910s. The term "Futurist" subsumes many of them although it does not hint at the rich variety of artistic and literary groups in Russia. For detailed discussions of these artistic and literary movements, see J. E. Bowlt, ed., Russian Art of the Avant-Garde: Theory and Criticism, 1902–1934, New York, 1977; Bowlt, Russian Art 1875–1975: A Collection of Essays, New York, 1976, nos. IV–VIII; C. Gray, The Great Experiment: Russian Art, 1863–1922, London, 1962, chapters 3–6; G. Harrison and A. A. Cohen, Constructivism and Futurism: Russian and Other (Ex Libris 6), New York, 1977, nos. 1–434; Markov, Russian Futurism.

5. Trans. V. Markov, Russian Futurism, p. 46.

6. Ibid. The emphasis on the word "we" in the fourth section anticipates the Constructivists' collectivist approach to art and life.

■ This exhibition is the first to present a collection of Futurist and Constructivist books and periodicals with the purpose of displaying the revolution in typography and book design that was initiated by the twentieth-century Russian avant-garde. The influence of these artists persisted from 1910 until well into—and even in spite of—the Stalinist cultural repressions of the 1930s. The survival of a large number of these works is in itself remarkable: fragile objects, weakly bound and printed on poor quality paper, they were published in small editions and usually regarded as ephemera. Until the late 1960s, Russian avant-garde books and journals were virtually ignored in art historical or bibliographic literature, largely due to Western ignorance and Soviet neglect. But more recently the publication of many fine works on the subject has at last provided scholars and laymen with extensive detailed information on the text illustration and history of these books. References to this recent literature appear in the Notes. The following essay explores the cultural and aesthetic motivations that underlay the Russian revolution that occurred on the printed page.

■

The overthrow of traditional cultural values and the political revolutions that established the Soviet Union and the Weimar Republic in the aftermath of World War I had already begun in the work of the Russian avant-garde as early as 1910. In April of that year, a group of artists and writers clustered around David Burliuk (1884–1961) including such major innovators as Velimir Khlebnikov (1885–1922) and Vasilii Kamensky (1884–1961) published a miscellany entitled Sadok sudei (A Trap for Judges).[1] Unusual in format, this small-scale book was printed on the reverse side of wallpaper cut down to page size. Although marginal notations furnish a rough guide to its contents, the absence of an index and the lack of spacing between entries resulted in a text that is sometimes hard to follow. The book's provocative title, coined by Khlebnikov, expresses its authors' contemptuous assumption that conventional critics would undoubtedly fall into a trap of misjudgment in reviewing the new literature and its novel presentation. As Kamensky later admitted, the contributors' intention was above all to shock, "to throw a bombshell into the joyless, provincial street of the generally joyless existence."[2]

In 1913 a second edition, Sadok sudei II, stated this aim even more emphatically by proposing an ideological manifesto for progressive artist-writers that outlined thirteen new principles of creativity. These principles demand a radical rejection of traditional linguistic and literary forms while affirming the importance of personal freedom in literary creation. Inclusion of a poem written by a thirteen-

year-old child affirmed the avant-garde's interest in simple language and direct expression.[3] This revolt against conventional verbal forms not only heralded a revolution in typography, but also marked the widespread growth of anti-bourgeois attitudes among young artists and writers.

The economics of printing and publishing enforced the small format and edition size (usually under 1,000 copies) of most early avant-garde books. This history is further complicated by individual misfortunes; for example, since the printer's bill for the 300 copies of Sadok sudei I was never paid, all but the twenty copies taken by Kamensky remained in the warehouse and have since disappeared.

In the years immediately following the publication of Sadok sudei I, a number of so-called "Futurist"[4] miscellanies appeared, which delivered pronouncements on the new creative arts. Of particular note is an anthology-cum-manifesto of 1912, entitled Poshchechina obshchestvennomu vkusu (A Slap in the Face of Public Taste) and bound in sackcloth covers (fig. 1). Its joint authors, many of whom had been contributors to Sadok sudei II, included Burliuk, Khlebnikov, and Kamensky, along with Alexandr Kruchenykh (1886–1969), Vladimir Maiakovsky (1893–1930), and Vasilii Kandinsky (1869–1944). The title, apparently given by Burliuk, is an obvious gesture of hostility and scorn for the bourgeois public. Signed by Burliuk, Kruchenykh, Maiakovsky, and Khlebnikov, this polemical manifesto is an attack on traditional writers and celebrated masterpieces of the past: "Throw Pushkin, Dostoevsky, Tolstoi, et al. overboard from the Ship of Modernity."[5] Modern poets, they argued, must be granted four basic rights:

(1) to enlarge vocabulary in its scope with arbitrary and derivative words (creation of new words);

(2) to feel an insurmountable hatred for the language existing before them;

(3) to put aside in horror, from our proud brow, the wreath of dirt-cheap fame, which you have fashioned from bath-house veniks ("swishes");

(4) to stand on the solid block of the word "we" amid the sea of boos and indignation.[6]

Ironically, many of the entries in the anthology fall short of these revolutionary goals, although Khlebnikov's "neologisms" successfully demonstrate the "creation of new words" decreed in the manifesto.

Neologisms, or new and often bizarre combinations of syllables and words, were an aspect of zaum. Derived from za, meaning "beyond," and um, meaning "mind" or "reason," the term is an abbreviation for zaumnyi iazyk ("transrational language") and an extension of zaumnaia mysl

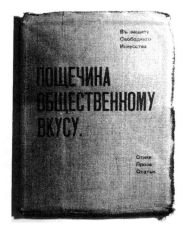

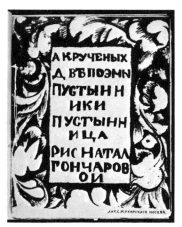

7. For further elaboration on *zaum*, see Markov, *Russian Futurism*, and V. Barooshian, *Russian Cubo-Futurism, 1910–1930*, The Hague, 1973.

8. For a discussion of Russian Symbolism, see Bowlt, *Essays*, nos. III, IV; and Gray, *The Great Experiment*, chapter 2.

9. See Cohen, *Constructivism and Futurism*, S. Compton, *The World Backwards: Russian Futurist Books, 1912–16*, London, 1978: and H. Wescher, *Collage*, New York, 1978.

1.
Cover
Poshchechina obshchestvennomu vkusu (A Slap in the Face of Public Taste) by D. and N. Burliuk, A. Kruchenykh, V. Kandinsky, B. Livshits, V. Maiakovsky, V. Khlebnikov
Moscow, 1912
113 pp. with sackcloth covers
Ex Libris 6., no. 37
24.1 x 18.7 cm. (9½ x 7⅜ in.)
Australian National Gallery, Canberra
(cat. no. 13)

2.
Title page designed by Natalia Goncharova (1881–1962)
Pustynniki (Hermits) by A. Kruchenykh
Moscow, 1913
22 pp. with 16 lithographs by N. Goncharova
19.1 x 14.6 cm. (7½ x 5¾ in.)
Ex Libris 6, no. 123
Australian National Gallery, Canberra
(cat. no. 67)

3.
Page with typographical design by Vasilii Kamensky (1886–1961)
Futformy. Pervyi Zhurnal Russkikh (Futurists: First Journal of the Russian Futurists) by D. Burliuk, V. Kamensky, V. Khlebnikov, V. Maiakovsky, and others
Moscow, 1914
160 pp. with lithographs by A. Exter, D. Burliuk, and V. Burliuk
Ex Libris 6., no. 40
26 x 20 cm. (10⅝ x 7⅞ in.)
Australian National Gallery, Canberra; Mr. Alexander Rabinovich
(cat. no. 18)

("transrational thought"). The brainchild of the two leading exponents of Russian Futurism, Khlebnikov and Kruchenykh, *zaum* aimed at the development of a universal language based on pure abstract ideas expressed either by the separate sounds of language or by meaningless combinations of existing phonemes.[7] As masterfully handled by Kamensky, Guro, and numerous others, *zaum* ultimately replaced verbal description with "verbal texture" and provided the means for denying the traditional narrative and decorative functions of word and image that had governed Russian Classicism, Romanticism, Realism, and even Symbolism. This break with the past was hardly complete, since these linguistic experiments grew in part out of Symbolism, which had been the prevailing artistic mode at the turn of the century.[8] According to Symbolist aesthetics, both verbal and pictorial imagery must transcend the natural world and express meaning by affect and implication. The Russian avant-garde criticized the deluxe illustrated editions of Symbolist literature for what appeared to be an inescapable imprisonment in the individual word (or image) at the same time that they carried the Symbolists' experimental approach to fever pitch.

Although conversant with contemporary movements in Western art, the avant-garde vowed to create a wholly *Russian* art of the future, and even though foreign influences and parallels are evident in their work,[9] the Russian innovators *did* achieve their stated goal—if only for a brief moment in history—largely because their language provided the means to create a truly revolutionary

art form. The logical concomitant to these linguistic and literary experiments was a revolution in illustration and typographical design. Of course, many Futurist books and miscellanies contained Neo-Primitivist, Cubo-Futurist, and Futurist illustrations which, regardless of their novel style, were set *en page* or *hors-texte* in traditional layouts, as can be seen in both editions of *Sadok sudei*, Kruchenykh's *Pustynniki/pustynnitsa (Hermits/Hermit Woman)* (fig. 2), and numerous others. There are, however, notable examples of startling, bold, suggestive—or, at the very least, unusual—typography and design. In order to convey expressively their exploration into the root structure and affective meaning of words, the Futurists produced books in a variety of typefaces (often combining manual and mechanical lettering), dynamic layouts, and an experimental fusion of pictorial and verbal imagery. In revolt against the purist aesthetics of Symbolism, the Futurists (and later the Constructivists) employed innovative devices in their typographical design and book illustration (fig. 3). Rejecting the precision and symmetry of printed type as repetitive and dry, they preferred, whenever possible, to lithograph handcrafted text, which was often composed *en page* with greater attention to pure innovation and design than to narrative logic and readability.

Kruchenykh's use of *zaum* and his collaboration with various artists during the early 1910s demonstrates these new principles of design. In *Vzorval (Explodity)*, 1913, the text of which was printed by hand with pencil and rubber stamp, Kruchenykh's preference for free language was manifested in the ▶

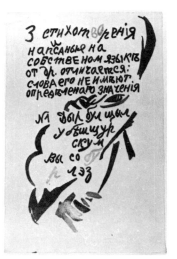

4.
Interior page designed by Olga
Rozanova (1886–1918)
Vzorval (Explodity) by A. Kruchenykh
Petrograd, 1913
22 pp. with lithographs by N. Gon-
charova, N. Kulbin, K. Malevich, and
O. Rozanova
Ex Libris 6, no. 130
19.1 x 13 cm. (7½ x 5⅛ in.)
Robert Shapazian Inc.,
Fresno, California
(cat. no. 176)

10. For examples and further elabora-
tion, see Markov, *Russian Futurism,*
especially chapters 4, 5; P. Ducharte,
*L'Imagerie populaire russe et les livrets
gravés, 1629–1885,* Paris, 1961.

11. Trans. Markov, *Russian Futurism,*
pp. 202–3.

12. See an example of this on exhibition
on the "Chronicle" page of *SA,* no. 1,
1926, p. 16.

13. S. Bojko, *New Graphic Design in
Revolutionary Russia,* New York, 1972,
p. 14.

14. See A. Kruchenykh, *Sdvigologiia
russkogo stikha (Shiftology of Russian
Verse),* Moscow, 1923; Markov, *Russian
Futurism,* pp. 342, 348, 359, 368.

form of nonexistent words and meaningless se-
quences, organized aurally (fig. 4). Lithographs by
Natalia Goncharova (1881–1962), Nikolai Kulbin
(1868–1917), Kazimir Malevich (1878–1935), and
Olga Rozanova (1886–1918) appear both as full-
page illustrations and as abstract elements inte-
grated with the narrative. Bold, linear strokes
animate the text pages with dynamic lines that
seem to "explode" in many directions—a sug-
gestion of energy that can be interpreted as a
metaphor for the Futurists' enthusiasm for city
life and for their simultaneous destruction of the
old and creation of the new.

Igra v adu (Game in Hell), a handwritten litho-
graphic publication of 1913, written jointly by Khleb-
nikov and Kruchenykh and illustrated by Malevich
and Rozanova, combines Futurist abstraction with
Neo-Primitivist imagery (fig. 5). During 1912–13,
Kruchenykh had been aiming at the development
of primitivistic forms in his poetry. Of course, a
movement toward simple, direct, and unsophis-
ticated expression had already arisen in Russian art
at the beginning of this century as a reaction in
part against Symbolism and (Western-oriented)
"decadence." But the motivation for the new
forms, which can be observed in works by Khleb-
nikov, Kruchenykh, Goncharova, Malevich, and
Mikhail Larionov (1881–1964), came from native
Russian sources such as Old Church Slavonic writ-
ing and the art of the peasant *lubok* (woodcut).[10] The
poem *Igra v adu* concerns a card game between
devils and sinners in hell. The theme reflects folk
traditions of demonic creatures and the taunts of
hell, and Kruchenykh printed the text in a free in-
terpretation of Old Church Slavonic lettering. The
bold, almost crude, lines of the art and calligraphy in
Igra v adu plus the swirling forms and the grotesque
imagery of the illustrations and text achieve a re-
markable synthesis of narration and illustration.
The use of Old Church Slavonic as well as foreign
letters and words—another corollary of *zaum*—
can also be found alongside more modern Russian.
An extreme example appears in *Pervyi zhurnal
futuristov (First Journal of Futurists),* 1914 (fig. 3), in
which foreign calligraphy applied to Cyrillic ele-
ments attracts the reader's attention through their
unusual, often a-contextual placement. Being at
first unrecognizable, they necessarily function on
a pictorial rather than on a verbal level.

Kruchenykh was inspired by both the structural
properties and the aural qualities of language. In
Vzorval he declared: "On April 27, at 3 p.m., I mas-
tered all language in a momentary flash. Such is a
poet of modern times."[11] Accordingly, he included
phonetic poetry allegedly written in Japanese,
Spanish, and Hebrew, whose sounds mimic those
of these foreign languages. During the 1920s the
Constructivist periodical *Sovremennaia arkhitek-*

tura (Contemporary Architecture) contained a sec-
tion of Cyrillic lettering designed in imitation of
Oriental calligraphy,[12] a device that expressed the
movement's zealous internationalism.

There were also specifically native sources for
the new typography. In *Vzorval,* for example,
Kruchenykh announced for the first time that lin-
guistic devices employed by Russian religious
sectarians had been motivations for his *zaum.*
Reference has been made above to the *lubok* and
to calligraphic designs based on Old Church
Slavonic, but the appearance of the latter in
Malevich's treatise of 1920, *Suprematizm,* is par-
ticularly noteworthy. As Bojko has pointed out, it
was in this work that Malevich also "expounded the
bases of his aesthetic theory of an auto-lithographic
technique which retained manual printing."[13] This
combination of lettering inspired by Old Church
Slavonic with an autographic approach summa-
rized many Futurist interests and attests to their
influence on Malevich's independent development
in 1920 (fig. 6).

The concept of *sdvig* (dislocation or shift) that
is observable in Malevich's painting can also be
found in contemporary literature. *Sdvig* refers to
the Cubist and Futurist device of representing
portions of figures or objects completely indepen-
dent from the whole. Elements of *zaum* in litera-
ture—especially neologisms and distortions based
on fragmentation—are comparable to *sdvig* in
painting. Just as *sdvig* accounts for free-floating,
often non-objective forms on the canvas, so *zaum*
elements became the subject of typographical
emphasis through boldface print, broken lines,
and designed characters signaling "shifts" in
language.[14]

Artists and writers shared these innovative
concepts of dislocation and distortion even though
their individual styles differed greatly. What all the
members of the avant-garde shared was the inten-
tion of using new forms to create a new society in
which art and literature would play a seminal and
organizational role. The creative outburst that oc-
curred from about 1910 to 1930 was by no means
confined to book production. It can also be ob-
served in painting and sculpture, architectural
models and drawings, and in industrial and domes-
tic design. The new art was occasionally metaphys-
ical in content, socio-political by implication, kinetic
in potential, and abstract or non-objective in form.
But in all of its variants it consistently embodied the
experimental and aggressive approach with which
the avant-garde attempted to redefine life itself
through art.

The dramatic expectations and frenetic activity
that occurred in the wake of the Revolution affected
the Futurists so profoundly that they joined the
Constructivists, whose activist, optimistic, and

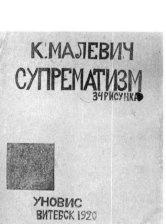

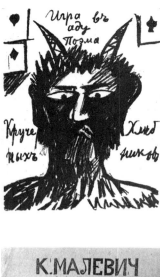

5.
Cover by Natalia Goncharova
Igra v adu (Game in Hell) by
V. Khlebnikov and A. Kruchenykh
Petrograd: first edition, 1912
16 lithographs by N. Goncharova
18.5 x 14.5 cm. (7⅜ x 5¾ in.)

6.
Cover designed by Kazimir Malevich
(1878–1935)
Suprematizm: 34 risunka (Sup-rematism: 34 drawings)
Vitebsk, 1920
34 lithograph drawings, 4 pp. text
Ex Libris 6, no. 198
21.9 x 17.8 cm. (8⅝ x 7 in.)
Mr. and Mrs. Roald Dahl, England;
Marc Martin-Malburet, Paris;
Dallas Museum of Fine Arts
(cat. no. 207)

7.
Cover of issue no. 1, by Alexandr
Rodchenko (1891–1956)
*Lef (Levyi front iskusstv) (The Left Front
of the Arts)* ed. V. Maiakovsky
Moscow, 1923
256 pp.
Ex Libris 6, no. 154a
23.8 x 15.9 cm. (9⅜ x 6¼ in.)

15. In Soviet parlance, the word "prop-aganda" does not have the negative
connotation it bears in the West, being
used rather in the sense of didactic
information.

16. In *Mena Vsekh (Exchange of All)*,
Moscow, 1924. For some discussion, see
Gale Weber, "Constructivism and Soviet
Literature," *Soviet Union,* University of
Pittsburgh, vol. 3, part 2, 1976,
pp. 294–310.

17. As their title indicates, the Formalists
were literary historians and critics who
valued form above all other elements
of poetry and prose. They attempted to
establish a science of literature based
on a study of literary devices and an
evolution of styles and genres, which
excluded all non-literary factors. Their
rejection of Marxist ideological, socio-
logical, and biographical criteria for
literary analysis brought negative
reaction from Soviet officialdom in the
late 1920s. Among the Formalists were
Brik, Shklovsky, and Roman Jakobson
(b. 1896).

communistic outlook they often shared. Inspired by
the political cataclysm which appeared to realize
the futuristic thinking and anti-traditional attitudes
that had nurtured their work since 1910, these art-
ists sought to transform every medium—including
books and journals—into a vital creative agent
within the newly formed Soviet Union. With that end
in mind, they applied their talents less to the fine
arts than to propaganda.[15] Following the revolu-
tionary artistic dictum of agit-prop (an abbrevia-
tion for "agitational propaganda"), they strove to em-
body Soviet socio-cultural values in books, jour-
nals, posters, signboards, street murals, and in
domestic and industrial design. Because of con-
fusion surrounding any definition of the purpose
of art during the post-Revolutionary period, in
addition to the general scarcity of materials and
inconsistent patronage, much Russian art and
architecture of the early 1920s exists only in the
form of drawings and models. Fortunately, the
small size of books, the availability of printing
presses, and an urgent need to disseminate ideas
and information rapidly created an atmosphere
especially well suited to book production.

Their formalist tendencies and Futurist heri-
tage kept the Constructivists from adopting the
hack-realistic manner that later characterized reac-
tionary, Stalinist-dictated Socialist Realism. For
Constructivists, the dynamic forms inherited from
Futurism—whether a graphic or painted stroke, a
sculptural mass, or an architectural member—
optimistically signified the aspirations and upward
mobility of the Soviets' new world. Moreover, it ex-
pressed the power and excitement of the me-
chanical age. The Constructivists surpassed the
Futurists in their attempt to unite art and life in their
work by creating objects of everyday use, and with
this pragmatic if utopian technology in mind, indus-
trial terminology and methodology permeated the
artistic vocabulary and practice of the Construc-
tivists during the post-Revolutionary period.

In Constructivist book design, a rational order
replaced the random linguistic distortions of Fu-
turism. Nevertheless, the Futurists Kruchenykh and
Maiakovsky continued to dominate the literary
scene in the postwar years in Russia. Kruchenykh's
work became clearer and more legible but Maia-

kovsky actually crystalized his brilliant Futurist
style under the influence of revolutionary activity
and polemics. Indeed, Maiakovsky declared that
there had been no Futurism prior to the Revolution
of October 1917. To add to the confusion, the term
"Futurist" continued to be applied to literature even
after Constructivism had replaced Futurism as the
dominant style in art. Once there was no longer any
need to shock the bourgeois public, Futurist litera-
ture could be transformed to express the frenzy and
optimism of the post-Revolutionary years. The new
writing relied on excited rhythms, exclamatory
phrases, and polemical passages rather than on
the more internal approach to language that had
been applied in the heyday of *zaum*. Literature con-
tinued to provide a foil for artists' book designs: inno-
vative layouts, a variety of typefaces, and unusual
illustration survived from Futurism, but the Construc-
tivists turned book production into a more overtly
rational and content-conscious art.

Although it is impossible to identify any literary
style as "Constructivist," there was a group active in
the early 1920s, led by Igor Selvinsky (1899–1968)
and Kornelii Zelinsky (b. 1896), that called itself the
Literary Center of Constructivists. Their self-styled
identification as "constructors" rather than authors
indicates a conscious desire to play a role in build-
ing a new world.[16]

Many artists and writers continued to asso-
ciate in working groups, as they had before the
Revolution. The most prominent group of the 1920s
was *Lef (Levyi front iskusstv,* or *Left Front of the
Arts),* officially organized by Maiakovsky in 1923. Its
most significant activity was the publication of a
journal bearing the group's name (1923–25).
Maiakovsky was the editor-in-chief, working closely
with a collective editorial board; Alexandr Rod-
chenko (1891–1946) was the principal designer,
notably of the covers (fig. 7); and Gosizdat, the
official state publishing house, was the publisher.
Futurists, Constructivists, and Formalists[17] all
rallied behind *Lef,* and its contributors included
such important writers and critics as Nikolai Aseev
(1889–1963), Osip Brik (1888–1945), Viktor
Shklovsky (b. 1893), Sergei Tretiakov (1892–1939),
and artists of the stature of Anton Lavinsky (1893–
1968), Liubov Popova (1889–1924), and Varvara ▶

8.
Page 67 from *Lef*, no. 2 (see fig. 7)
180 pp.
Ex Libris 6, no. 154a
24.4 x 15.6 cm. (9⅝ x 6⅛in.)
Alma H. Law, Scarsdale, New York
(cat. no. 307)

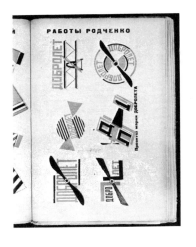

18. R. Sherwood, "Introduction to LEF," *Form*, nos. 10, 19, p. 29. For additional information on *Lef*, see S. Bann, ed., *The Tradition of Constructivism*, New York, 1974, pp. 79ff; Bowlt, *Russian Art*, pp. 199ff.

19. See *Maiakovskii: 20 ans de travail*, Musée National d'Art Moderne, Paris, 1975–76, pp. 64–69; also pp. 76–79 for their collaborations on posters.

20. There is some controversy as to whether this distinction properly belongs to Rodchenko or to Gustav Klucis. See S. Compton, "Art and Photography," *Print Collector's Newsletter*, vol. VII, 1976, pp. 12ff. Whatever the internal developments in Russia, parallel discoveries and innovations in photography and photomontage were occurring in Germany at the same time.

21. Some of Lissitzky's influence may subsequently have been transmitted to the United States in the 1930s and early 1940s by German artists fleeing Hitler and his reactionary cultural policies. Lissitzky's calligraphic design for Pelikan ink, for example, can still be found today in printers' trade manuals.

Stepanova (1894–1958). Contributions by Kruchenykh and Maiakovsky appeared frequently, and even writers who did not actually belong to the "left front," such as Isaak Babel (1894–1941) and Boris Pasternak (1890–1960), occasionally submitted their work. *Lef*'s ideology of Comfut (abbreviation for "Communist-Futurism") was expressed in poetry, prose, criticism, and illustration. As stated in Maiakovsky's autobiography of 1923, "one of the great achievements of *Lef* [is] the de-aestheticization of the productional arts, productivism. A poetic supplement: agit art and economic agitation: the advertisement."[18] However, by the time of the publication of the final issue of *Lef* in 1925, the number of printed copies had fallen from 5,000 in 1923 to a low of 1,500. Although Maiakovsky blamed this decline on a lack of interest among the publishing bureaucracy, the truth was that *Lef* was unenthusiastically received by a public that preferred a more straightforward, practical approach to literature. With increasing effect, the original criticism aimed at the Futurists—i.e., that the masses found them incomprehensible—was in turn leveled against *Lef*, until its publication was at last terminated by Gosizdat.

The pages of *Lef* are filled with explanations and discussions of the *Lef* philosophy—referred to as "Futurist" partly because of the literal meaning of the word and partly as an affirmation of continuity in the Russian avant-garde. There were articles (occasionally in English and German) exhorting the readers to celebrate revolutionary principles and to participate in collective-production projects. *Lef*'s Constructivist illustration and typography included geometric textile designs by Popova, kiosk designs by Lavinsky, advertising posters by Rodchenko, and sports clothing by Stepanova; boldface and varied typography provided textual emphasis and dynamic arrangements of words and non-objective elements such as lines demarcating sections of text (fig. 8).

The covers of *Lef* (fig. 9)—as well as those of its successor, *Novyi lef (New Left)* of 1927–28—were designed by Rodchenko, who used similar Constructivist typography, photomontage, and photography for the numerous book covers that he designed in the 1920s for writings by Maiakovsky and others.[19] Rodchenko claimed to be the first to introduce photomontage into the USSR [20] and maintained that his experiments with this novel medium led him to reassess the entire art of photography. Thus, during his *Lef* years, Rodchenko attempted to destroy "old" photography in order to create a new language more appropriate to modern Soviet life. His unusual combinations of typographic and pictorial images were calculated to focus the viewer's attention on their internal construction and dynamic interaction, most often expressed two-dimensionally along diagonal axes. The typographical design of Rodchenko's *Lef* covers is emphatic, geometric, and mechanically precise, while colored geometric elements and letters contribute to a coherent system of spatial dynamics. The unusual viewpoint of Rodchenko's photographs—notably in *Novyi lef* but elsewhere as well—were his own version of agit-prop: visually stimulating explorations of the world through photography while actually exploiting the printed image for compositional concerns.

The non-objective styles of Suprematism and Constructivism were not at first judged to be in conflict with the utilitarian principles of new Soviet art. On the contrary, their innovative forms and inherent dynamism were considered inspirations to the "new art" that would be applied to large-scale public projects rather than to individual private commissions. This art would become accessible to the public, not by virtue of its narrative, but through mass exposure. As we have already seen in the case of *Lef*, these same principles were eventually turned against the modernist artists by the masses, who considered their work incomprehensible, and by the official bureaucracy, which in 1932–34 condemned modernist trends in art and literature as useless and decadent. Ironically, these artists—who had been dubbed "leftists" in the initial post-Revolutionary enthusiasm for their work—were judged failures by the very contemporaries whose lives they had sought to transform.

The outstanding typographer and designer of the 1920s was El Lissitzky (1890–1941). A study of his works suggests the breadth of creativity and innovation in the Soviet book during the 1920s and early 1930s. Like Rodchenko, Lissitzky designed photomontage covers for books and especially for periodicals, and along with the members of *Lef* he was inspired by the social and artistic development promised by the Revolution. Despite Lissitzky's many accomplishments in painting, photomontage, architecture, and criticism, his exhibition and book designs were primarily responsible for the dissemination of Soviet Russian culture abroad. His frequent trips between Russia and Germany during those decades, and the numerous exhibitions and exhibition catalogs that he designed for export to Germany, spread his work across Europe.[21] The pictorialization of the printed word that characterized Lissitzky's work during the 1920s and 1930s was especially successful on a large scale and was enthusiastically received. In one catalog, published for the Soviet Pavilion at the International Press Exhibition in Cologne in 1928, a fold-out section illustrated exhibits drawn from all aspects of Soviet life, which were captioned with posterlike slogans. The catalog (cat. no. 166) preserves this remarkable design in an equally remarkable format.

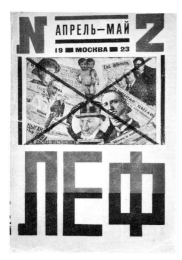

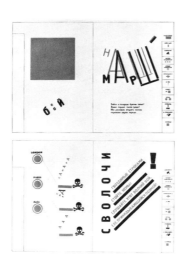

9.
Cover of *Lef*, issue no. 2, by Alexandr Rodchenko (see fig. 8)
Australian National Gallery, Canberra (cat. no. 315)

10.
El Lissitzky (1890–1941)
Cover design for Vesch/Gegenstand/Objet., 1921–22
Ink and collage on paper
31.5 x 23.6 cm. (12⅜ x 9¼ in.)
Stedelijk Municipal Stadtisches Van Abbemuseum, Eindhoven, Netherlands (cat. no. 147)

11.
Interior pages designed by El Lissitzky
Dlia golosa (For the Voice) by V. Maiakovsky
Berlin, 1923
61 pp. with lithographs by El Lissitzky
Ex Libris 6, no. 194
19.1 x 13.2 cm. (5⅛ x 7½ in.)
Stedelijk Municipal Stadtisches Van Abbemuseum, Eindhoven, Netherlands;
Peter Eisenman, New York;
George Gibian, Ithaca, New York (cat. no. 156)

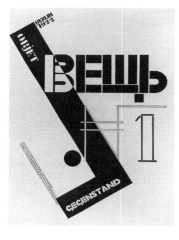

22. See K. P. Zygas, "Veshch, Gegenstand, Objet," *Oppositions*, no. 5, 1976.

23. Lissitzky referred to artists and designers as "constructors." Alexei Gan's book *Konstruktivizm*, published in Tver in 1922, lists the authors of a printed challenge to pure art as "The First Working Group of Constructivists."

24. For a detailed study of Lissitzky's artistic production and philosophy, see A. Birnholz, *El Lissitzky*, Ph.D. diss., Yale University, 1973; S. Lissitzky-Küppers, *El Lissitzky: Life-Letters-Text*, London, 1967.

25. *Merz*, no. 4, 1923, trans. Lissitzky-Küppers, *El Lissitzky*, p. 355.

26. Ibid., nos. 95–105.

Lissitzky's collaboration with Ilia Ehrenburg on a trilingual periodical published in Berlin in 1922, *Veshch/Gegenstand/Objet* (fig. 10), the first pro-Soviet journal published in the West, created another important vehicle of the Russian-German cultural exchange. The editors' goal was to represent the new objective basis for art. The printer's rule plays both a decorative and a contextual role in clarifying the trilingual sections, but it is the stunning color and Constructivist typography of Lissitzky's covers that make *Veshch* a major design artifact.[22]

In propagating the concept of the "artist-engineer," Lissitzky encouraged designers to adapt industrial, mass-production techniques to various media, ranging from architecture and furniture to exhibitions and books.[23] Opposed to the subjectivity and randomness of Futurism, Lissitzky advocated an objective and utilitarian approach to art, work, and life.[24]

Lissitzky's "manifesto," "The Topography of Typography," published in 1923, declared among other points the following:
(1) the words on the printed sheet are learned by sight, not by hearing;
(2) ideas are communicated through conventional words, the idea should be given form through the letters;
(3) economy of expression—optics instead of phonetics;
(4) the designing of the book-space through the material of the type, according to the laws of typographical mechanics, must correspond to the strains and stresses of the content;
(5) the design of the book-space through the material of the illustrative process blocks, which give reality to the new optics. The supernaturalistic reality of the perfected eye;

(6) the continuous page sequence—the bioscopic book.[25]
In this manner Lissitzky invested lettering and its composition *en page* with an emotional/intellectual task that transcends the traditional purpose of book production—and this was his lasting contribution to the history of print and design.

Lissitzky's collaboration with Maiakovsky in 1923 produced one of the most remarkable books ever published: *Dlia golosa (For the Voice)* (fig. 11). Lissitzky designed, or "constructed," this edition of Maiakovsky's thirteen often-quoted poems which, as the title indicates, were meant to be read aloud. In order to facilitate oral presentation, Lissitzky created a thumb-indexed format. The book was published in Berlin, where Gosizdat had a branch office at the time, and Lissitzky's page-by-page sketch layout was set—with astonishing accuracy—by a German compositor who did not know Russian! Lissitzky remarked that "The book is created with the resources of the compositor's type case alone. The possibilities of two-color printing (overlap, cross hatching, and so on) have been exploited to the full. My pages stand in much the same relation to the poems as an accompanying piano to a violin. Just as the poet in his poem unites concept and sound, I have tried to create an equivalent unity using the poem and the typography."[26] The poems range from leftist political incitement to amusing urban observation, and they are dominated throughout by graphic constructions in color, which convey the quick-paced rhythm, the excitement, and the furor of Maiakovsky's revolutionary writings. In *Dlia golosa,* Lissitzky accomplished all of his typographical goals: produced mechanically, according to a functionalist rationale, the book's design, layout, and illustrations combine to reinforce the emotional and intellectual impact of the text. ▶

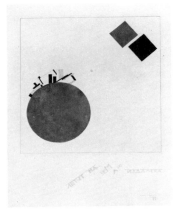

12.
El Lissitzky
Study for page for *A Suprematist Story About Two Squares in 6 Constructions,* 1920
Watercolor and pencil on cardboard
25.7 x 20.3 cm. (10⅛ x 8 in.)
Collection, The Museum of Modern Art, New York
The Sidney and Harriet Janis Collection
(cat. no. 140)

27. Ibid., nos. 80–91. Also J. E. Bowlt, "El Lissitzky," *El Lissitzky,* Galerie Gmurzynska, Cologne, 1976, p. 53. Friendship with the Soviet cinematographer Dziga Vertov may have been an inspiration for Lissitzky's documentary approach to book art and production: his tableaux unroll before our eyes as if frames from a movie.

28. Although Lissitzky and Rodchenko inevitably dominate any study of Constructivist book design as the most influential and representative designers of their generation, one cannot overlook the work of Ivan Kliun (1876–1942), Gustav Klucis (1895–1944), and Solomon Telingater (1903–1969). Their Constructivist book compositions—geometric designs, bold typography, dynamic layouts—also stand out as innovative and "revolutionary."

29. Lebedev's simple and bold style adapted equally well to poster production and to book designs. Along with Maiakovsky, he was one of the principal "constructor/designers" for ROSTA (Russian Telegraph Agency), which in the 1920s bore the official responsibility for agit-prop poster production.

30. See A. Senkevitch, *Soviet Architecture, 1917–1962: A Bibliographic Guide to Source Material,* Charlottesville, 1974.

Lissitzky's most famous book, *Pro dva kvadrata (Of Two Squares)* (fig. 12), was conceived in Vitebsk in 1920 while Lissitzky was lecturing on typography at the art school Unovis and published two years later in Berlin. Dedicated "to all, all children," this witty graphic presentation signifies the imposition of order and clarity (here, the red square) on chaos (the black square). This is also an obvious metaphor for the Russian Revolution and the subsequent triumph of the Bolsheviks. Lissitzky explained that he had "set out to formulate an elementary idea, using elementary means, so that children may find it a stimulus to active play and grownups enjoy it as something to look at. The action unrolls like a film. The works move within the fields of force of the figures as they act: these are squares. Universal and specifically plastic forces are bodied forth typographically."[27] Besides illustrating Lissitzky's theories of typography, the dynamic arrangement of geometric forms and letters— and their interaction with each other and with the background of the page—also relate to his contemporaneous experiments with "Prouns," in which geometric forms interact in space. In addition, the almost immediate appearance in 1922 of a Dutch translation of *Two Squares* in no. 10/11 of *de Stijl* magazine exemplifies the strong affinity between Dutch and Russian art that existed in the postwar years.[28]

The posters and children's book of Vladimir Lebedev (1891–1967), the fairytales of Goncharova, and the periodical *Zhar-ptitsa (The Firebird)* are notable anomalies in the development of Russian avant-garde book design. Lebedev's compelling pictorial imagery derives its force from a strong, clear composition based on simple geometric principles and simple, strong, colored shapes. Although one can trace his figures to the heavy lines and broad, flat planes of the *lubok,* they also reflect contemporary artistic tendencies toward linear and planar abstraction.[29]

Goncharova's illustrations for a 1921 French edition of Pushkin's fantasy "Tale of Tsar Saltan…" is a lavish production on Japan paper, adorned with full-page abstact floral designs that also surround the pages of text (fig. 13). Decorative lettering and clichés at the beginning of each section recall medieval illumination and also repeat the colors of the surrounding design, yet the richly polychromatic, nearly abstract full-page illustrations attest to Goncharova's Russian heritage. Even though the artist had lived in Paris for nearly a decade, her work continued to show the unmistakable influence of Nikolai Rerikh (1874–1947) and Ivan Bilibin (1876–1946), the latter of whom had also illustrated Pushkin's fairytales at the turn of the century. Goncharova's designs distill the flavor of Russian folk art, combined with a vivid synthesis of Art Nouveau,

Neo-Primitivism, and Cubism. Perhaps her absence from Russia since 1913 enabled Goncharova to break free of the Futurist prejudice against elaborate and decorative book design, and since other Russian emigrés to Paris such as Boris Zvorykin (1872–1941?) produced similar "revival" works, one may infer that they shared a sense of artistic and personal nostalgia.

The periodical *Zhar-ptitsa,* published in Paris and Berlin during the early 1920s, was intended to present Russian art and literature abroad in the form of illustrated short stories, poetry, theatrical design, and critical essays. Named for the most popular Russian fairy tale, "The Firebird," it contains examples of Russian folk art and of the folk-art revival of the turn of the century. The richly colored lithographic covers of *Zhar-ptitsa,* designed by Bilibin, Goncharova, Larionov, and others, epitomize "native" Russian art of the 1920s which flourished, ironically, far from Russian soil. At home, this art was scorned by Futurists and Constructivists alike as derivative and retardataire, and it was rejected by officialdom as frivolous and unedifying. Soviet experiments in typographical design and book layouts continued well into the 1930s, notably in periodical literature and in the journals of architectural associations that illustrated and discussed contemporary work in both Russia and the West.[30] The most important of these publications was *Sovremennaya arkhitektura (Contemporary Architecture),* or *SA,* produced by the Union of Contemporary Architects (OSA) under the editorship of Mosei Ginzburg (1892–1946) and Alexandr Vesnin (1883–1959). A Constructivist cover design (fig. 14) by Alexei Gan (1893–1942) announced *SA's* boldly modernist stance, which assumed an almost excessive enthusiasm for technology and a fascination with the West that focused on the work of Walter Gropius, Le Corbusier, Erich Mendelsohn, and Frank Lloyd Wright.

As an architect in his own right, Lissitzky was affiliated with the Association of New Architects (Asnova), whose journal, *Isvestiia Asnova (Asnova News),* he co-edited along with Nikolai Ladovsky (1881–1941), in addition to designing its typography and layout. This heavily illustrated work aimed at developing and publicizing rational, technological means for improving the quality of life through architecture and town planning. Its design is based on the dynamic placement of photographs and varied letter sizes and shapes within vertical and horizontal layouts.

Later architectural periodicals lack the boldness and vigor of these Constructivist examples, but the influence of Constructivism in cover designs and title pages lasted well into the mid-1930s in *Sovetskaya arkhitektura (Soviet Architecture)* and *Arkhitektura SSSR (Architecture USSR).* The

13.
Title page by Natalia Goncharova
Conte de Tsar Saltan et de son fils le glorieux et puissant Prince Gvidon Saltanovich et de sa belle princesse cygne (Tale of Tsar Saltan and of his Son the Glorious and Powerful Prince Gvidon Saltonovich and of his Beautiful Swan Princess)
Paris, 1921
48 pp. unbound with hand colored illustrations by N. Goncharova
Ex Libris 6, no. 288
29.8 x 22.9 cm. (11¾ x 9 in.)
Stravinsky-Diaghilev Foundation, New York;
Robert L. B. Tobin, New York
(cat. no. 75)

31. Bowlt, *Russian Art*, pp. 288–90.

32. Ibid., p. 293. This excerpt from Andrei Zhdanov's speech at the First All-Union Congress of Soviet Writers in 1934 was later incorporated into the Charter of the Union of Soviet Writers of the USSR.

pages of *USSR im Bau* and its English counterpart, *USSR in Construction,* which were based on *SSSR na stroike* and produced for export, carry some of the finest photographic layouts and photomontages ever designed by Lissitzky, Rodchenko, and their colleagues. These magazines demonstrate the lingering influence of Constructivism even in the 1930s, represented by a preference for geometric patterns in nature, a camera eye that views the world as an energy-charged surface on which interaction among figures and objects takes place, photomontage, and the overlapping of illustrations *en page.*

The postscript to the relatively short life of the Russian avant-garde is sad but logical, given its historical context. The emphasis on *formal* qualities of design—no matter how profoundly it may have been inspired by social or political motives—became increasingly distasteful to a Soviet audience beset with the practical problems of survival and social reconstruction. The final death knell was sounded by the "Decree on the Reconstruction of Literary and Artistic Organizations," issued on April 23, 1932, by the Central Committee of the All-Union Communist Party. Fearing that the independent course chosen by many artists and writers during the 1920s might become "an instrument for cultivating elitist withdrawal and loss of contact with the political tasks of contemporaneity and with the important groups of writers and artists who sympathize with Socialist construction," the Committee assumed responsibility for all artistic organization and administration.[31] From 1934 on, the Committee

sanctioned the exclusive practice of Socialist Realism; namely, the depiction of "reality in its revolutionary development...truth and historical concreteness of the artist's depiction must be combined with the task of ideological transformation and education of the working people in the spirit of Socialism."[32]

For book design and production this decree signified a return to traditional, non-experimental formats and typography. Text and illustration were henceforth mandated to be concrete, straightforward, and didactic. Some "bibliographic heroes and heroines" accepted the Socialist-Realist mode; others were absorbed into artists' collectives; and many disappeared and died, presumably in labor camps during the late 1930s. Maintaining a patriotic stance and wanting to bring international attention to Soviet achievements with exhibitions abroad, Lissitzky continued to act as a cultural ambassador to Germany during the 1930s. Rodchenko had already declared in 1928 that the artistic and educational potential of photography dominated his interest; in the following decade, he turned his attention almost exclusively to photography. As a photographer of sporting events and landscapes, his political sensibilities were perhaps not irrevocably affected by the demands of Socialist Realism. But there is little evidence of any underground *samizdat* movement that might have extended the life of Futurism or Constructivism. It is only now, in retrospect, that we can begin to appreciate just how revolutionary the Russian avant-garde was. ●

14.
Cover design by Alexei Gan
(1889–1942)
Sovremennaya arkhitektura "SA"
(Contemporary Architecture) ed.
M. Ginsburg and A. Vesnin
Moscow, 1927
Ex Libris 6, no. 243
Peter Eisenman, New York
(cat. no. 412)

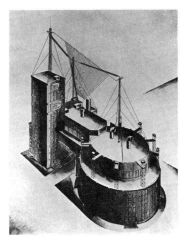

2.
Vesnin brothers
*Perspective Drawing of the Palace of
Labor,* 1923

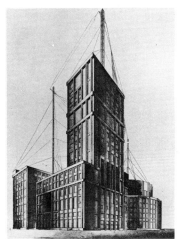

1. Illustrations appear in the following
key works of the period: Walter
Gropius, *Internationale Architektur,*
Munich, 1925, p. 28; Adolf Behne, *Der
moderne Zweckbau,* Munich, 1926,
p. 57; Erich Mendelsohn, *Russland,
Europa, Amerika,* Berlin, 1929, p. 149;
El Lissitzky, *Russland,* Vienna, 1930,
pp. 13, 53; *L'architecture Russe en
URSS,* Editions Albert Morance, Paris,
1926, pp. 1–5.

2. Consult and compare: V. V. Kirillov,
Put poiska i eksperimenta, Moscow,
1974, pp. 142–44; V. Khazanova,
*Sovetskaia arkhitektura pervykh let
Oktiabria,* Moscow, 1970, pp. 136–46;
A. Kopp, *Town and Revolution,* New
York, 1970, pp. 54–58.

■ Of all the entries to the 1922 competition for a Palace of Labor in Moscow, only the project by the Vesnin brothers (figs. 1–8) continues to attract critical attention. One reason for this interest is the project's historical importance—specifically, its formative influence on the development of Constructivist architecture. Another reason, equally important and more intriguing, is the design's curious genesis and relationship to Cubo-Futurism. In the 1920s these factors were overshadowed by the arguments waging for and against modern architecture. In that polemical context, the Vesnin entry was seen as a resounding affirmation of the new style's legitimacy. But today, with modern architecture firmly established, the polemical issues of the competition are no longer paramount, and we are able to discuss the Vesnin project with detached, non-partisan candor.

Formal inconsistencies mar this collaborative venture by Leonid A. Vesnin (1880 – 1933), Viktor A. Vesnin (1882 – 1950), and Alexandr A. Vesnin (1883–1959). The picturesque quality of the massing is inconsistently related to the symmetrical plan; the treatment of the structural cage is indecisive; the fenestration is irresolute; and facades are ambivalent. These flaws weaken the design and explain to some extent the jury's decision to award the Vesnins third prize. Ironically, despite the project's inadequacies, it nonetheless exerted considerable influence on Soviet architecture during the 1920s. When the competition was announced in September 1922, modern architecture had not yet excited the imagination of Russian architects; when the competition ended in May 1923, a firm basis had been established for a distinctive architectural aesthetic — Constructivist architecture. Clearly, something momentous had occurred during the interval: the Vesnins' entry for the *Palace of Labor* appeared at a propitious moment, and their project acted as the energizing catalyst.

The Vesnins' *Palace of Labor* established Constructivist architecture as an aesthetic in its own right. The project marks the emergence of a formal vocabulary soon to be consolidated and developed into a design idiom clearly different from its western European counterparts. This new imagery proved to be vastly influential, because during the next ten years Constructivist architects refined the approach first taken by the Vesnin brothers. For that reason alone, their competition entry merits recognition.

But even if the Vesnin project's effect on modern architecture in Soviet Russia had been negligible, there still remains sufficient cause for admiration. While the other competitors resorted to Neoclassical or industrial imagery, the Vesnin brothers forged ahead with a minimal architectural language then untried but by now taken for granted.

By contrast, the Neoclassical entries emphasized the projects' palatial connotations; other entries stressed industrial connotations. But the Vesnin brothers rejected Neoclassical imagery as well as the naive technological symbolism typified by entries that, for instance, sported industrial cranes or proposed buildings that resembled turbines. Alongside these representative projects of contemporary Soviet architecture, the Vesnin design stands apart as an extraordinarily inventive departure from the prevailing norm.

The architectural press of Western Europe clearly sensed the project's innovations—so much so, in fact, that the Vesnins' *Palace of Labor* was quickly recognized as one of modern architecture's canonical images. The elevation of the design to authoritative status came by virtue of its publication in several early guides to modern architecture.[1] By contrast, none of the other entries to the Moscow competition received comparable recognition.

Inclusion among the milestones of the "heroic period" of modern architecture, however, was a mixed blessing. On the one hand, illustrations in the Western press provided the Vesnins' project with the coverage and exposure that it deserved. The same press, on the other hand, gave scant notice to the actual evolution and background of the Vesnins' design. Since it was obviously a design for a modern building, critics presumed that the project's genesis represented a case study in orthodox modern design procedures.

The actual evolution of the project was overlooked chiefly because the prevailing generalizations about modern architecture seemed adequate as explanations. Some authors explained modern architecture by stressing its underlying political, social, and ideological motivations, i.e., its technocratic and socialist ambitions, its positivist and utopian aspirations. Others preferred to discuss it as an outgrowth of practical building technique and/or as a rational response to functional needs. As current histories and guidebooks continue to discuss modern architecture in these terms, it is not surprising to find the Vesnin project being so evaluated.[2]

On second thought, one realizes that the other entrants to the *Palace of Labor* competition were no less optimistic about socialism, no less pro-Communist than the Vesnin brothers. Even the designers of the Neoclassical projects were solidly behind the recently self-installed Soviet government. And as for the entries flaunting industrial imagery, we can be quite certain that their authors fervently admired engineering forms and a version, admittedly bizarre, of the machine aesthetic. The important generalizations about modern architecture are, therefore, grand indeed: they encompass truly potent designs as well as marginal

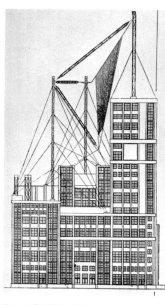

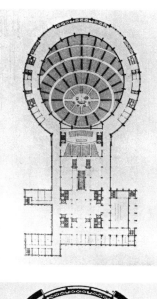

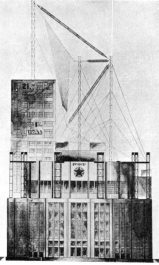

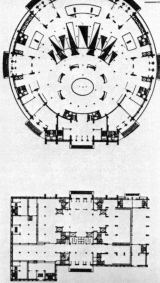

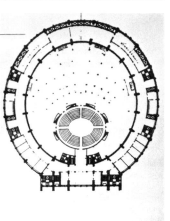

3.
Vesnin brothers
Front Elevation of the Palace of Labor, 1923

4.
Vesnin brothers
Rear Elevation of the Palace of Labor, 1923

6.
Vesnin brothers
Plan of Fifth Floor of the Palace of Labor, 1923

7.
Vesnin brothers
Ground Floor Plan of the Palace of Labor, 1923

8.
Vesnin brothers
Plan of Third Floor of the Palace of Labor, 1923

3. For the *Palace of Labor* competition's chronology and complete program, see V. Khazanova, *Iz istorii sovetskoi arkhitektury 1917–1925 gg., Dokumenty i materialy*, Moscow, 1963, pp. 146–53.

5.
Vesnin brothers
Section Drawing of the Palace of Labor, 1923

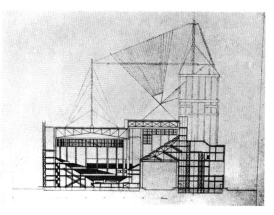

projects which completely misinterpreted modern sensibilities.

Because these generalizations are so inclusive and because any given ideological position will generate projects ranging from the exceptional to the ordinary, discussions about form and formal analyses become crucial. Formal considerations not only provide the basis for qualitative judgments within an ideologically circumscribed set of projects, but they also provide the tools to study them in detail. A project's internal consistency, its relation to the client's program, and the genesis and development of the design are all susceptible to compositional and formal analyses. In addition, when a particular design is studied in detailed, formal terms, unexpected discoveries frequently come to light that question doctrinaire interpretations.

Before looking at the Vesnin project in detail, the *Palace of Labor*'s functional requirements must first be outlined. The public bodies that established the competition were reacting to some of Moscow's most pressing needs. First, they envisioned an auditorium with a seating capacity of 8,000 and with a stage large enough to accommodate a presidium of 300. Smaller auditoriums, a dining hall for 6,000, a museum of social science, and a library with reading rooms completed the list of public facilities. Various professional organizations were to be given new offices and appropriate service facilities. Finally, the Moscow Soviet of the Communist Party, or Mossoviet, was to be provided with offices, work rooms, press rooms, and an auditorium seating 2,500 with room for a 100-member presidium on stage. This entire complex, the most important public building of its time in the USSR, was to be situated in the center of Moscow between Okhotnovo and Revolution Squares. The competition, announced in September 1922, ended in May 1923.[3]

The Vesnin brothers responded with a project that completely satisfied these requirements. To facilitate circulation, they placed the large au- ▶

11.
Alexandr Vesnin
Construction, c. 1920–21
Charcoal on paper
32 x 25.5 cm. (12½ x 10 in.)
Private Collection
Photo: Courtesy Rosa Esman and
Adler/Castillo Galleries

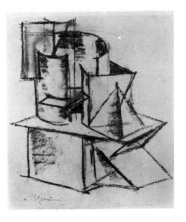

4. Khazanova, *Sovetskaia*, p. 140.

5. Ibid., p. 141.

6. Camilla Gray, *The Great Experiment: Russian Art 1863–1922*, New York, 1962, p. 86.

ditorium at one end of the site and all the other facilities at the other end. A driveway (thirty-eight meters wide and thirty-four meters high) in between linked the Okhotnovo and Revolution Squares. In effect, the large auditorium, now seating 9,000 and renamed the Great Hall, was situated on its own island, enabling the public to enter and leave from all sides. A bridge covered the driveway and connected the Great Hall to the rest of the complex. The 2,500-seat Mossoviet Hall was located inside the bridge and adjacent to the Great Hall. On special occasions, the iron curtain separating the two spaces could be retracted to create an 11,500-seat amphitheater (figs. 5–8).

Across the driveway, a lower block and a seventeen-story tower (132 meters high) completed the design (fig. 1). Moscow's central radio station, an astrophysical observatory, a weather station, an information bureau, a museum of social science, and a library with reading rooms were all accommodated within the tower. From its upper floors above the driveway two screens were hung, the higher screen giving time of day and weather reports, the lower screen flashing political news to the public on the sidewalks below. The ground floor housed the dining hall for 6,000, the electric power generator, and various other service and utility rooms. Smaller lecture halls, workrooms, administrative offices, and support facilities filled the remaining spaces. Stairs, elevators, and escalators connected the floors and provided easy communication between the public and the various officials and bureaucrats working inside. The crowning feature — a network of antennas, radio masts, and stabilizing wires capped the entire *Palace of Labor* complex.[4]

The resolution of the complex building program into a workable project was an exacting and difficult undertaking, especially as the design had few precedents. Yet for all the special effort expended, the Vesnins described the process in terms that fit virtually any architectural commission:

We . . . set for ourselves the task of creating the architectural image of a new palace—a palace for the nation's masses. Consequently, we considered that the image could only be created by the correct architectural organization of the plan, and by converting the social-utilitarian functions into the building's architecturally expressive content. While working on the plan, we simultaneously worked on the sections, facades, perspectives, and axonometrics, that is, on the entire spatial-volumetric composition which inevitably realized the final image for the Palace of the masses.[5]

Although the Vesnins recount their project's development as straightforward and virtually inevitable, their own drawings and sketches supply information that reveals a much different story (figs. 9–10). Long before the competition was even conceived by the responsible public agencies, Alexandr Vesnin had already shown his preference for the spatial-volumetric mode of composition that was to suffuse the *Palace of Labor* design. This compositional mode may be traced from 1918 to 1922 in his paintings, stage sets, and designs for a mass festival (figs. 9, 11–15). Contrary to what one might expect, the imagery is not even vaguely Constructivist; instead, his earlier productions can only be described as "Cubo-Futurist."

Pending further studies, generalizations will have to suffice about Cubo-Futurism as a term and as an episode in Russian modernism. Camilla Gray, one of the first to study the subject, outlines the movement's salient features:

While intrinsically bound up with, and owing much to, contemporary western European movements — reflected in its name — Cubo-Futurism was a movement peculiar to Russia and immediately preceded the schools of abstract painting which arose in Russia during the years 1911–21, in which the Russians emerged at last as pioneers in the "modern movement."[6]

Cubo-Futurism developed in two different areas—literary and artistic—which are easy to distinguish. The literary Cubo-Futurist included poets, writers, and critics as famous as V. Maiakovsky, V. Khlebnikov, A. Kruchenykh, D. Burliuk, N. Aseev, and O. M. Brik, among others. The artists were no less illustrious since the "big four"— Larionov, Goncharova, Malevich, and Tatlin—were all Cubo-Futurists about 1912–14.

In 1913 the literary Cubo-Futurists marked their debut with the manifesto *A Slap in the Face of Public Taste*; the Cubo-Futurist artists had marked theirs with the March 1912 *Donkey's Tail* exhibition. Although the "big four" also displayed many of their earlier paintings, this exhibition marks the high point in the presentation of Cubo-Futurist imagery; they then went their separate ways and other artists continued to develop the Cubo-Futurist formal vocabulary.

A normative Cubo-Futurist painting is Malevich's *Head of a Peasant Girl* (Stedelijk Museum, Amsterdam), perhaps his best in this oeuvre. The identical formal language, now translated into three-dimensions, is clearly recognizable in Petr Miturich's 1920 *Constructions* (fig. 16). Similar formal preoccupations are to be found in Alexandr Vesnin's contemporary work. Note for instance his sketch of about 1920–21 for a *Construction* (fig. 11), which firmly documents his familiarity and dependence on Cubo-Futurism at this time. The dense compaction of elementary geometric volumes illustrated in this sketch was soon put to use. His

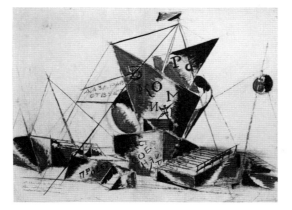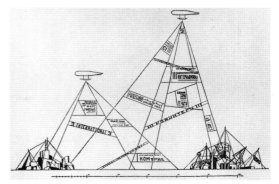

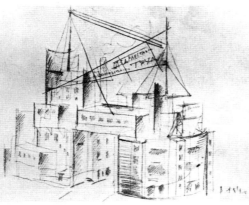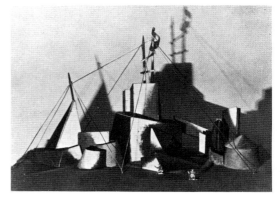

9.
Alexandr Vesnin
Drawing for a Monument for the Third Congress of the Communist International, 1921
Gouache on paper
53 x 70.5 cm. (20¾ x 27¾ in.)
Collection, The Museum of Modern Art, New York
Acquired through the Mrs. Harry Lynde Bradley and the Katherine S. Dreier Bequests
(cat. no. 380)

10.
Vesnin brothers
Preliminary Sketch for the Palace of Labor, 1922–23

12.
Alexandr Vesnin
Stage Set for "Phèdre," 1922
Cardboard model
Location unknown

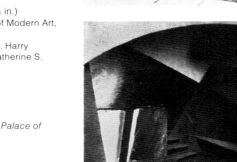

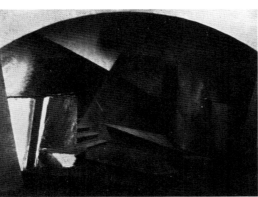

13.
Alexandr Vesnin and Liubov Popova
(1889–1924)
Sketch for the Struggle and Victory of the Soviets (mass festival), 1920
Location unknown

14.
Alexandr Vesnin and Liubov Popova
Model of "The Capitalist Fortress" for the *Struggle and Victory of the Soviets* (mass festival), 1920
Location unknown

15.
Alexandr Vesnin and Liubov Popova
Model of "The City of the Future" for the *Struggle and Victory of the Soviets* (mass festival), 1920
Location unknown

16.
Petr Miturich (1887–1956)
Construction No. 18, 1920
Ink on paper
Destroyed by the artist

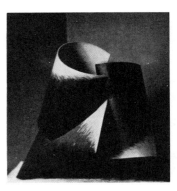

▶

7. René Fülöp-Miller and Joseph Gregor, *The Russian Theater,* trans. Paul England, London, 1930, p. 63.

8. René Fülöp-Miller, *The Mind and Face of Bolshevism,* trans. F. S. Flint and D. F. Tait, London, 1927, pp. 148–49; for the original German text, see Fülöp-Miller, *Geist und Gesicht des Bolschewismus,* Vienna, 1926, pp. 202–3.

stage set for Racine's drama *Phèdre* (fig. 12) is unquestionably a direct descendant of Cubo-Futurist imagery, already a decade old when the play premiered on February 8, 1922. Another much more ambitious set for the *Struggle and Victory of the Soviets* continued to enlarge the uses of Cubo-Futurist imagery. This design establishes the *Palace of Labor*'s Cubo-Futurist ancestry and lineage.

During the summer months of 1920, Vsevolod Meierkhold, Liubov Popova, and Alexandr Vesnin made elaborate plans for the spectacular showpiece. Although the contribution of each is difficult to ascertain, we expect that Meierkhold, as the director, orchestrated the monumental scenario and crowd movements, while Popova and Vesnin, as the artists, created the set designs. The festival, scheduled for May 1921 in Moscow's Khodinsky Field, was to augment the celebrations arranged for the Third World Congress of the Communist International (Komintern) convening June 22 to July 12, 1921. Plans for the *Struggle and Victory of the Soviets* were canceled in the fall of 1920, and instead Maiakovsky's *Mystery-Bouffe,* a play in verse, was presented in German to the assembled delegates.[7] In preparation for the canceled mass festival, however, Popova and Vesnin produced models and sketches, photographs of which have fortunately survived.

The overall picture can be seen in the sketch reproduced as figure 13. Two dirigibles are shown moored to the ground and to two irregular massings placed about fifty meters apart. Banners are suspended from the airships' mooring lines, and their slogans, such as "Proletariat Unite" and "Long Live the Communist Third International," summarize the drama's political message. On the left, the craggy massing represents the "Capitalist Fortress" (fig. 14). On the right, the grouping crowned by antennae, trussed cranes, and the wheels of industry represents the Communist "City of the Future" (fig. 15). Between these two symbolic forms and below the fluttering aerial backdrop, the following saga was to unfold:

200 riders from the cavalry school, 2,300 foot soldiers, 16 guns, 5 aeroplanes with searchlights, 10 automobile searchlights, several armored trains, tanks, motorcycles, ambulance sections, detachments of the general recruiting school, of the associations for physical culture, the central direction of military training establishments were to take part, as well as various military bands and clubs.

In the first five scenes the various sections of the revolutionaries were to have combined to encircle the "Capitalist Fortress" and, with the help of artillery corps, to surround it with a curtain of smoke. Concealed by this dense

screen, the tanks were to have advanced to attack and stormed the bastions, while the flame throwers were giving out an enormous fireball of changing outline. The silhouette of the illuminated smoke would finally have represented a factory with the watchword of the fight inscribed on the walls:

"What work has created shall belong to the workers."

After a great parade of troops, the gymnastic associations on motor-vans were to have shown the people of the future engaged in throwing the discus and gathering hay into sheaves. Then a general dance, with the motto "Hammer and Sickle," was to introduce motions representing industrial and agricultural work, the hammer bearers from time to time crossing in a friendly way their instruments with the sickles of the other group. Rhythmic movements performed by the pupils of the public training schools were to have symbolized the phrase:

"Joy and strength — the victory of the creators"; now nearing, now retreating from the tribunal, they were finally, in conjunction with the troops, to have been effectively grouped in the "City of the Future." The final items of the performance were to have been provided by a display of flying by aeroplanes, with searchlights, fireworks, and a great choral singing, accompanied by the orchestras.[8]

The *Struggle and Victory of the Soviets* mass festival relied on Cubo-Futurist forms, now enlarged to architectural scale, to represent both the "Capitalist Fortress" and the "City of the Future." With this use for mythic propaganda, the previously neutral formal vocabulary became an ideological accomplice and lost its political innocence. In iconographic terms, the depiction of the victorious Communist "City of the Future" through industrial and Cubo-Futurist imagery was especially potent because the Vesnins amalgamated precisely these two components into their *Palace of Labor* design.

Alexandr Vesnin's drawing for a *Monument to the Third Communist International* (fig. 9) marks an intermediate stage in the transformation. Specifically, its aggressive Cubo-Futurist volumes clearly derive from the "Capitalist Fortress" and "City of the Future" set pieces of the canceled mass festival. The slogans — "Long Live the Third Komintern!" and "Proletariat of the World Unite!" — also reappear, but have now been painted on the angular volumes, thereby solidifying the iconographic continuity. These and similar Communist exhortations will reappear again when Cubo-Futurist forms will have been transformed into their Constructivist equivalents.

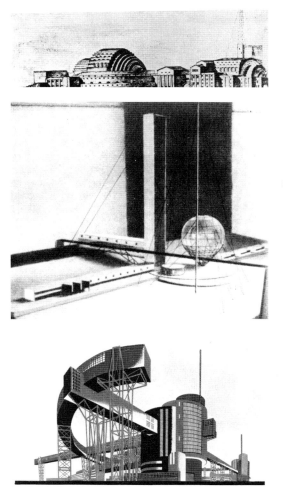

17.
Ilia Golosov (1883–1945)
Side Elevation of the Palace of Labor,
1923

18.
Ivan Leonidov (1902–1959)
Model of the Lenin Institute, 1927

19.
Yakov Chernikhov (1889–1951)
Architectural Fantasy No. 28, 1933

The preliminary sketch for the *Palace of Labor* (fig. 10) records the crucial moment when Cubo-Futurist volumes have begun their metamorphosis into Constructivist forms. The planes, previously warped and with changing surface color from red to black, have now lost their astringency. The Cubo-Futurist imagery has been disciplined as the volumes and planes are made to conform to orthogonal geometries. Only the guy wires, stabilizing the masts and the antenna, are kept to echo the angularities of the *Struggle and Victory* sets and the *Monument to the Third Communist International* drawing. The slogan "Long Live Labor!" hoisted above the entire assemblage maintains the iconographic continuity with the previous set and monument designs. But the picturesque massing and the almost random pile of discrete volumes are all clearly dependent on the earlier Cubo-Futurist formal exercises, especially Alexandr Vesnin's *Construction* (fig. 11).

Throughout the entire process of transforming Cubo-Futurist forms into Constructivist forms, the Vesnins always kept the strongly independent, perceptually legible volume as a constant. This is patently obvious in the preliminary sketch (fig. 10) since the various programmatic functions (radio station, auditorium, weather bureau, etc.) are each assigned to and contained within a discrete, separate volume. Although the Cubo-Futurist design discussed above did not see completion, they established a method of composition which became Cubo-Futurism's primary legacy to Constructivism. Thereafter, Constructivist designers formulated the equation of functional integrity with volumetric identity.

When this Constructivist equation is followed to its logical conclusion, one specific function is assigned to each volume and every volume is physically isolated or clearly articulated from all others. Consider, for example, the designs by Ivan Leonidov (fig. 18) and Iakov Chernikov (fig. 19) created in 1927 and 1933 respectively. But in the 1922 design for the *Palace of Labor,* the Vesnins were not yet as familiar nor as confident with the Constructivist design equation as their successors were to become. Besides, in 1922 the Vesnins were still contending with the design precepts and modes of composition sanctioned by the Ecole des Beaux-Arts.

The best-known illustrations of the *Palace of Labor* (figs. 1, 2) show it as a complex of bold volumes arranged for picturesque effect. These drawings give little indication that the building is actually organized along major and minor axes, i.e., in a Beaux-Arts manner. But plans reveal that a major axis bisects the Great Hall, the smaller Mossoviet Hall, the bridge above the driveway, and the administrative corpus (figs. 6–8). The axis ▶

9. *The International Competition for a New Administration Building for the Chicago Tribune MCMXXII*, Chicago, 1923, pp. 1–6.

10. Khazanova, *Iz istorii*, pp. 152–53.

finally emerges on the third floor in a monumental porch (four stories high and three bays wide) on the building's narrower but principal facade. Minor axes flank the major axis or intersect it at right angles. And in accordance with Beaux-Arts compositional precepts, these secondary axes coincide with the circulation system: driveway, entrances, corridors, and lobbies.

Externally, none of this is apparent because the Vesnins took pains to belie the *Palace of Labor*'s underlying axial organization. The entire complex may be summarized diagrammatically in plan as an "O" combined with a "T." The "O" represents the Great Hall; the upright of the "T" represents the Mossoviet Hall in the bridge above the driveway. A center line, i.e., the major axis, aligns these two elements as well as the equal arms of the "T" which accommodated all the other facilities within the tower or the lower blocks of the administrative corpus. As the arms of the "T" were to house small lecture halls, administrative offices, radio station, weather bureau, dining hall, etc., the Vesnins could position these facilities in a variety of configurations. They kept the plan's bilateral symmetry virtually intact but disregarded the three-dimensional implications of a symmetrical plan.

Instead of recognizing the center line and distributing the facilities equally to both arms of the "T," the Vesnins emptied one arm of its functional loads and overloaded the other arm. This became the seventeen-story tower which by virtue of its inflated bulk and corner position assumes exaggerated importance. The tower, in fact, attempts to preempt the importance of the Great Hall, which in terms of enclosed space was the largest single component in the entire complex. By contrast, the tower did not house any one facility but was created by placing a lecture hall, the library with reading rooms, a museum of social science, the information center, the weather bureau, the astrophysical observatory, and the radio station one above the other. This design strategy emptied the other end of the administrative corpus and left an immense niche, four bays wide by four bays deep. In plan the niche cannot be hidden (figs 6, 7), but in elevation or perspective (figs. 2, 3) the niche is effectively masked by a shallow, eight-story, protruding block that also works to counterbalance the tower's visual weight.

All in all, the Vesnins' *Palace of Labor* represents an inconsistent design on several fronts. The preliminary sketch (fig. 10) securely binds the project's final version to its Cubo-Futurist sources. The preliminary sketch also indicates the extent to which the Vesnins were free to manipulate the building's functional components. Of the many possible configurations, they chose to follow established Beaux-Arts planning precepts to generate the tightly organized plan. On this axial plan they superimposed the various facilities, not according to any discernible, internal logic, but for the effects of a picturesque Cubo-Futurist massing. And for stronger effect they insisted on creating a seventeen-story tower which, in fact, was not necessitated by the *Palace of Labor*'s internal spatial requirements or the pressures of a constricted urban site.

The creation of a tower at the expense of a gigantic niche and porch carved out of the building's front and sides reveals the Vesnins' fascination with the skyscraper image. Their presentation drawing (fig. 2) creates the impression that the *Palace of Labor* was a skyscraper, yet the elevations (figs. 3, 4) show that this resulted from the distortions of perspective. In reality, the tower consists of a small, six-story-high addition grafted to a modest ten- or eleven-story building complex. It is likely that the worldwide publicity of the *Chicago Tribune* competition (June 10 through December 3, 1922)[9] encouraged the Vesnins to attempt a skyscraper image no matter what inconsistencies or inconveniences the venture might entail. As the entries for the *Palace of Labor* competition were submitted in February 1923 (winners were announced on May 24, 1923, after a public exhibition),[10] ample time was available for the illustrations and publicity surrounding the *Chicago Tribune* competition to reach the Vesnins and to embolden them with aspirations for a skyscraper in the center of Moscow.

Like most of the entrants of the *Chicago Tribune* competition, and like other architects designing skyscrapers in the 1920s, the Vesnins encountered difficulties in finding a suitable expression for a skyscraper's underlying structural skeleton. The Vesnin design team modulated the skeletal framework in the interest of expressing internal functional subdivisions on the building's exterior. For this reason, license was frequently taken with both the horizontal and vertical structural members. In the principal facade, for instance, columns are omitted on two floors to express the major axis and the monumental porch. The roof slabs and selected floor slabs are treated, in Beaux-Arts fashion, as cornices creating major subdivisions within each facade. Finally, the corner columns are handled not as structure but as vertical terminations to the sides of both facades which are meant to be seen frontally. Such treatment of structure in compositional terms underscores, once again, the Vesnins' affinities to the Ecole des Beaux-Arts.

In short, the Vesnins resorted to Beaux-Arts planning and compositional precepts to discipline and organize their underlying Cubo-Futurist massing. The reinforced-concrete skeletal frame, for its part, was manipulated to suggest the variety of differentiated spaces housed within. Simulta-

neously, the skeletal cage made obvious reference to high-rise construction techniques even though the building was to be placed on an extensive urban site and even though its programmatic functions need not have been stretched and contorted into a stubby skyscraper. But of all the debts incurred by the Vesnins during the *Palace of Labor*'s design process, the one owed to Cubo-Futurism generated the highest returns. Cubo-Futurism acted as a visual solvent obviating references to historical architectural styles and existing building prototypes. Furthermore, Cubo-Futurist forms were susceptible to diverse transformations, including the unexpected metamorphosis into forms now labeled "Constructivist."

Explaining the Vesnins' *Palace of Labor* as the result of a metamorphosis, from a distinctive Cubo-Futurist formal vocabulary into a distinctive Constructivist one, has hopefully resolved some questions about the origins of Constructivist form. Contrary to subsequent aspirations and achievements by Constructivist architects, the genesis of the Vesnins' design owed little to programmatic considerations, to the "machine aesthetic," or to the Vesnins' ideological preferences. And contrary to functionalist belief, architectural form did not take care of itself. In the *Palace of Labor,* the Vesnins drew from existing typologies to create an unprecedented architectural configuration which, in turn, affected the entire complexion of Constructivist architecture. ●

■ The striking formal similarities between the Russians' advanced art of the 1910s and 1920s and contemporary art, especially in America, prompted us originally to propose an exhibition that would compare the two eras in a single exhibition and catalog. Ultimately, however, we decided upon a fuller presentation of Russian art, utilizing the opportunity to show Suprematism and Constructivism to the utmost. Still, the connection with contemporary art remained of interest, not only to ourselves, but to working artists. This connection had been subjected to widely varying interpretations in the past decade, from a complete rejection of its significance to an extraordinarily wide and ambitious claim for the influence of the Russian avant-garde.

Donald Karshan, for example, claims that only American abstract painter Ad Reinhardt and French sculptor Jean Tinguely made full use of Malevich, and he states that the Minimalist movement of the 1960s "is not related to Suprematism."[1] At the extreme opposite position, Willi Rotzler, in his survey of Constructivism,[2] features work by artists as far removed from the Russians as Mark Rothko, Richard Diebenkorn, Al Jensen, and Arakawa. George Rickey's *Constructivism: Origins and Evolution,* published as early as 1967, more wisely focuses on sculptors who inherited Russian Constructivist precepts. Although Rickey may not be completely sympathetic to Suprematist ambitions, he fully acknowledges the Constructivist lineage. In any case our primary concern here is with artists whose work was just maturing in the 1960s and early 1970s and who largely fall outside the range of Rickey's view. Karshan, however, directly addresses the matter of Suprematist influence and zeroes in on the Minimalist movement as a possible inheritor of Malevich's work and theory. Surprisingly, he concludes that for "several basic reasons" Minimalism is not related to Suprematism. "First, it is essentially an art of three-dimensional forms." To this, one might argue that while Judd and Andre are indeed sculptors, Sol LeWitt, Bernard Venet, Mel Bochner, and other Minimalists are also painters; and to be sure, sculpture has often been inspired by painting (i.e., Cubist sculpture, Surrealist sculpture, individuals such as John Chamberlain proceeding from Abstract Expressionist tenets). "Secondly," writes Karshan, "Minimalist works are usually staggered out, mathematically, in space, in their own

seriality of distance."[3] On this subject one must point to the extraordinary experiments and postulations of Rodchenko who in 1920 offered the possibility of a permutational art in which forms remain similar while their context evolves from painting to painting. Other Russians, as well, made work that clearly had sequential intentions. (Nevertheless, Karshan is correct in pointing out a dominant characteristic in American work.) Karshan does cite one major affinity between the Russians and the Americans: the "dependency on Suprematist concepts" in the shapes selected; "with Andre, the square, with Judd, often the long, pure rectangle, reminiscent of Malevichian beams...a utilization of pure geometric abstract shapes, free of any anthropomorphic connections."[4] Perhaps one might say that such an aesthetic connection a Karshan concedes is more than is needed to make the case for the kinship of the two periods under consideration. might add that Karshan views the Malevich-Reinhardt connection—and Reinhardt's ultimate "black" paintings in particular—as "close in spirit," and in this I am fully in accord. Indeed Reinhardt was the wellspring for many younger artists of the 1960s to whom we have referred, and it was he who transmitted the Russians' attainments in his writing and conversation as well as in his painting.

In the eyes of American artists, the Russians stood for an art that could be relevant to large numbers of people especially those who were not already accustomed to High Art. This stimulated artists of the 1960s who were attempting to move away from the self-oriented expressionism of the Abstract Expressionists. The myth of the Russian artist as societal catalyst held sway, whether identified with Tatlin' engineering/industrialist inclination or Malevich's anti utilitarian approach. Artists here were attracted to the Russians' use of non-art materials in sculpture (including new industrial materials such as steel and plastic), and anti traditional processes and textural elements in two dimensional works (such as torn paper in collage). The tremendous charge given to book design also inspired confidence in new bookmaking fifty years later: this most venerable means of communication was thus given fresh life in the age of electronics.

Among artists in America, Ad Reinhardt, George Rickey and David Hare first called attention to the importance of Suprematism and Constructivism. Reinhardt's work most clearly embodies the spirit of Malevich, as Reinhardt himself allowed, while Rickey and Hare took off from the constellation of Constructivist tenets. (In England, where Russian work was seen early on, the artists found it "terribly alien the Russians 'didn't know how to put paint on,'" as Robert Hughes recalls the attitude in London. In France, Jean Tinguely best comprehended the significance of Malevich and made a brilliant series of kinetic sculpture in the mid-1950 called *Meta-Mécanic* and *Meta-Malevich* reliefs.) Later, David Flavin came to be credited by all the artists who emerged in the 1960s as the figure who most effectively pushed the ideas of Tatlin and others toward the foreground of con

*Unless otherwise indicated, all quotations come from interviews conducted by the author with the artist or critic in New York in August and/or October 1979, supplemented in many case by telephone conversations in November. Additionally, I spoke with Mark Di Suvero in Petaluma, California, Ed Moses in Los Angeles, and Donald Judd in Texas during this period. I also want to thank Carl Andre, Mel Bochner, Bruce Boice, Jeremy Gilbert-Rolfe, Sol LeWitt, Loren Madsen, Robert Morris, Brian O'Doherty (Patrick Ireland), Richard Serra, and Frank Stella for generously and graciously providing me with their recollections and opinions. Obviously I selected these prominent figures because of their interest in the Russian avant-garde; clearly many, perhaps most, contemporary artists have little specific connection to this earlier era.

1. Donald Karshan, "After Malevich," 1977, unpublished manuscript. I am grateful to the author for the use of the manuscript.

2. Willy Rotzler, *Constructive Concepts*, Zurich, 1917.

3. Karshan, "After Malevich."

4. Ibid.

sciousness. By effectively utilizing corner spaces in his own work, by entitling a major series of sculpture "Homages to Tatlin," and by force of conversational argument, Flavin made it necessary for many artists to take Tatlin's precepts into account. Donald Judd was seen by others as expressing this attitude as well, although he says today that he "didn't pay much attention to the Russians at the time. You knew it was there but it didn't take hold. My influence came out of painters in New York."

There is a remarkable concurrence among these younger painters and sculptors about the nature of the Russian "influence." Jeremy Gilbert-Rolfe identifies the relationship as one of "empathy and reconstitution." For Sol LeWitt, "if you had to find a historical precedent, you had to go back to the Russians"; the "area of main convergence between the Russians and Americans in the 1960s was the search for the most basic forms, to reveal the simplicity of aesthetic intentions." The Americans saw the Russians as most deeply understanding the diversity of abstraction. For Reinhardt, the entire twentieth century came down to a choice between Malevich and Duchamp. (When he declared this as late as 1967 to Robert Smithson and Mel Bochner, who recounted it to me, they brushed off the notion with amusement.) By 1974 Malevich was seen by John Coplans and others as the father of Conceptualism. Throughout the 1960s and 1970s Russian abstraction had about it the air of a mission, an attribute virtually absent in abstract art now. Mel Bochner came to understand that "the Russians essentially defined abstraction as having to deal with intellectual content," and "that has its own emotional intensity"; he contrasts this with the different values connoted by Abstract Expressionism, non-figurative abstraction, and non-objective abstraction. Bochner was impressed by the "religious fervor of aesthetics" as practiced by Naum Gabo. Russian abstract art was admired by some painters for its frank dependence on and derivation from folk art (Patrick Ireland), or for its perceived intention "to understand the art of the people" (Sol LeWitt). Richard Serra disparages the role of the American artist in society: "Every artist I know is working for the shopkeeper, the gallery, or the museum"; but he adds, "the Russians implied something else." Patrick Ireland also makes the distinction between West and East along socio-political lines; he contrasts "the punishing and rejecting attitudes of Western art" with ideas brought out by the Russians: "the way they included people in a socialist way in art—the extension of art into installations and into typography (especially El Lissitzky) and into architecture, conceiving of the theater-stage as a lethal thing for artists—generally writing them into the social contract." Paradoxically, the deep penetration of television, movies, and photography into art and society in recent decades in the U.S. has served to deprive art of much of its power to influence; in observer Robert Hughes's view, "the collapse of American formalism links to the rise of Constructivism," and he sees a "nostalgia for belief in the avant-garde as having social effect" coming at a time when this potential is rendered obsolete by the media.

Only certain aspects of the Russian avant-garde were transmitted to the American artists. In the absence of original works of art,[5] information was limited to reproductions that conveyed nothing of the scale, the emphasis on materiality, or the surface qualities of the original. These were mainly black-and-white reproductions, preventing the perception of the boldly contrasted and confidently elemental palette of the Russians. (An extremely interesting exception to this common experience, according to Carl Andre, was Frank Stella's admiration for Malevich's *White on White* in the Museum of Modern Art, "because it was so well painted even though utterly reduced.") But if the Russians could not be seen clearly or fully, the exceptionally acute intelligence of those Americans intrigued by the Russians was compensatory. The Americans were prepared psychologically to glean from the Russian artists as rich a precedent for their own inclinations as possible: the desire to find an alternative to the French line in art remained as compelling for these 1960s artists as it had been for the Abstract Expressionists in the 1950s. "In the 1960s," Patrick Ireland observed, "we talked Paris but looked at Moscow." Some American artists might project more into the Russians' intentions than evidence warranted, but this nevertheless had a salutary effect. Richard Serra, for example, deduced from Constructivism that the artists "investigated material to find what would justify the structure rather than the other way around," and found corroboration in the Russians' writing and art of the ability to find in material its process "and have that process make the form." For Bruce Boice the Russians' idea of abstraction centered on it "counting for something.... Early abstraction had to have a reason to it, not just a way to prove something"; it presented a model of rigor to the emerging generation. Yet very quickly this bracing rigor turned to complacent and self-indulgent exercising, as the artists themselves now declare. In Minimalism, the Russians' socially conscious endeavor is startlingly inverted: in place of the revolutionary artists' desire to change the world, the Americans of the 1960s appeared to want to "torture the middle class," as one artist put it, with art that was "hostile, aggressive, resistant and boring" (Barbara Rose's words about Minimalism). In reproduction, even the rare color facsimile, a painter such as Malevich appeared neat, clean, and hard-edged—characteristics that dramatically appealed to New York artists in the 1960s and certainly seemed to corroborate their work if not directly affect it. But after Malevich was seen in depth, either by visitors to Amsterdam's Stedelijk Museum or the Guggenheim Museum's retrospective in 1974 (the exhibition then traveled to Los Angeles), Malevich, surprisingly, was seen to be "sloppy"—his "glip," to use Boice's word for the animated squirt of Malevich, is comic, and Malevich was seen "not to care or worry" about technique or craft. Donald Judd saw that Malevich "paints in a freewheeling, practical way ... as if he's busy, with a lot of ideas to be gotten down, and with the knowledge that color, form, and ▶

5. Of course there were a few key images, acquired by Alfred Barr, Jr., for the Museum of Modern Art, on permanent view, notably *White on White;* and artists such as Serra knew Yale University's Société Anonyme Collection, while many artists saw Malevich in depth at Amsterdam's Stedelijk.

surface are what matter, and that care doesn't have much to do with these." The "somewhat loose geometry" of Malevich does not reappear again, in Judd's view, until Reinhardt, Newman, and Noland paint this way, although even they are more "deliberate in the process." Similarly, Jeremy Gilbert-Rolfe was surprised and intrigued by Malevich's "concern with delicacy and the possibilities of abstraction as metaphor." Mel Bochner also suggests that the Guggenheim exhibition disproved the perception of a "cleaner Malevich than is the truth of the matter." Malevich was revealed to be "not really a reductive painter; in fact, of all the painters of the century, his paintings are the most complex and difficult to decode." The exhibition shed light on Minimalism's "Platonic and idealistic" nature, and also that Minimalism was, by contrast, clearly revealed to be an aesthetic tied to industrialism. In Bochner's view, Minimalism was unraveling at that moment, and the Malevich show may have hastened its decline by accelerating the growth of artists such as Robert Smithson and Eva Hesse into other directions. Malevich was seen in 1974 as much closer to the then-emerging artists in his "openness" and his way of working directly.

Because of his singular importance in American art of the 1960s, Frank Stella's admiration for Malevich and other Russians should be recorded. He regarded *White on White* as an "unequivocal landmark," an "iceberg": the painting "kept us going, as a focus of ideas," until the appearance of Barnett Newman in the 1950s. Stella points to Flavin's use of the corner as heralding the first impact of Constructivism in the 1960s. (While others may point to scores of artists influenced by the Russian Constructivists, Stella may be expected to be concerned with those artists whom he himself highly regarded, presumably for their truer understanding of the Constructivist propositions.) He stresses that knowledge of Constructivism was restricted to reproductions and small reconstructions and that the link in sculpture from the early to contemporary periods was therefore "artificial." Interestingly, Stella maintains that Judd, Andre, and Flavin were led to Rodchenko by the example of Brancusi, which allowed them to "skip Surrealism and the organic and the figurative."

For artists not attracted to a reductivist aesthetic in the 1960s, the first place to turn was to the work of David Smith. According to Mark Di Suvero, the Park Place group of sculptors—including Frosty Myers, Ed Ruda, Peter Forakis, and Robert Grosvenor—formed this cooperative endeavor under the inspiration of Rodchenko and other Russians, the Bauhaus artists, and David Smith. From Smith, the method of constructing from a lexicon of discrete elements was readily absorbed. These Constructivist artists were primarily interested in how and where the Russians located their sculpture: the example of Rodchenko's hanging constructions, certainly, and also Tatlin's corner-bound assemblages. Di Suvero points to the startling asymmetry in Rodchenko and recalls that most sculptors in New York and Europe were still figurative, not abstract, and Rodchenko was not only confidently non-figurative but innovative in his compositional intentions. "The main problem was to deal with space, non-figuratively, and to charge it with emotion," says Di Suvero, who also remembers the "energy" so admired by Dean

Fleming in Russian art. On another level the Russians were important to the Park Place group for their strong social intentions. "That drew us a lot," commented Di Suvero, who stresses the Park Place group's "fight to put works into public—an idea that finally caught on." These Americans thought of themselves as "pioneers, breaking down the capitalist system; we were anti-gallery."

Interestingly, Di Suvero was not taken with Tatlin, as might be expected, but with Malevich. And then in 1962 "Rodchenko was the real discovery." He also speaks with warmth and admiration of Kandinsky: "such a free man—he broke up composition," and one may discern passages in Di Suvero's sculpture that may trace to Kandinsky quite as much as to Franz Kline, whose gestural paintings are often related to Di Suvero's constructions.

For sculptor Carl Andre, whose early work reveals striking affinities to Rodchenko's cycle of constructions, Russian art posed "a great alternative to the semi-Surrealistic work of the 1950s such as Giacometti's and to the late Cubism of David Smith." Frank Stella sounds a cautionary note about the Russian's predominant influence upon Andre, citing the example of Brancusi's post-and-lintel sculptures as being of great importance as well. But Andre articulates his fascination with Rodchenko, whose work he knew in photos in *Art News* magazine in the 1950s "where they looked big but you could tell they were not from the end-grain." They were striking to Andre because they were "uncarved...cuts in space," attached one to the other, sections that were to be glued and nailed. For Andre this meant that doing the work, making sculpture, was a method of thinking. To his eyes there was a "look of nascence" about this work; it didn't have "a second-generation look about it." Andre—like Patrick Ireland and other artists—also points to the "romance that was allowed to form about the work since it wasn't around."

Kandinsky's major status was perceived by the Abstract Expressionist generation, but his art was not regarded as germane by the most innovative artists of the 1960s. Most younger Americans inclined toward one or the other pole in Russian avant-garde art, and only recently has Kandinsky attracted the kind of compelling attention that is influential upon the formation of artists. This can be traced to the shift in taste in the mid-1970s from "the slick to the crude," from the "simplistic to the complicated." Kandinsky's paintings, for example, were probably more influential upon Frank Stella's Exotic Birds than any other. Kandinsky's work had previously been seen by younger American artists as too pictorial. Mark Di Suvero's interest in Kandinsky, noted above, remains more the exception than the rule. "He works in a naturalistic space. His pictures always fall into deep space and don't come back up front," remarked Mel Bochner. In the current climate in art, with artists looking for the potential in decorative and complex formations, Kandinsky appears heraldic.

In the Los Angeles art community, interest in the Russian avant-garde has not been especially keen, in spite of the signal sent by John McLaughlin's abstract painting. The Malevich exhibition that came to the Pasadena Art Museum in 1974 from the Guggenheim Museum (comprised of Stedelijk Museum holdings) did not attract great interest

although it had a substantial influence on the work of Ed Moses and younger artists such as Joel Bass. Moses was involved with Suprematism earlier in his work, as is evidenced by a lithograph made at Tamarind in 1968 that seems almost a homage to Malevich, relating directly to the Russian's *Fading Away* in this exhibition (Moses' work is reproduced in the UCLA catalog of his drawing retrospective, 1976, unpaginated). He had been led to Malevich by Reinhardt's work when shown at the Los Angeles Dwan Gallery earlier in the 1960s. Even earlier, when Moses worked near New York's Coenties Slip in 1959–60, he was aware of his neighbor Agnes Martin's interest in Malevich. After the Pasadena Malevich show, Moses made a series of red abstract paintings, shown at this Museum in 1976, which were triggered by Malevich's paintings and his writings. Indeed, Moses states that the distinction in his recent work between the series of so-called "abstract" as compared to his "Cubist" work derives from Malevich, the intention being to make works that are "not meant to be objects, not declarations, not statements of personal psychology."

By the mid-1970s the bracing intellectual and stylistic stimulus provided by the Russians over a half-century earlier had become so widespread as to appear trite. "Abstract art becomes genre abstraction," comments Bochner; "abstraction has become a way of depicting, almost a format, actually a kind of representational art," claims Serra. Many artists wonder whether our society can support the idealism necessary for artistic adventures of the early Russian kind, whether the absence of a sociological imperative in America renders this possibility remote. Yet the multilayered meanings found in Suprematism and Constructivism—the resonance and rich ambiguity of original abstraction—are in this viewer's opinion likely to yield still other possibilities of thought to artists now being formed, and now being informed, by direct contact with many more original works than have hitherto been seen.

The Russian works themselves will in all likelihood be found to contain important qualities that have not before been obvious. A notable example of this may be found in the art of sculptor Loren Madsen, who creates startling configurations by intuiting aspects of tension and equilibrium. Madsen was "interested in how the Russians took to the air," citing Rodchenko's hanging constructions; Tatlin's development—off-the-wall reliefs, soaring monuments, actual flying machines, Letatlin—and the Stenberg brothers' "launching of one part of sculpture into air with [the] base" (comparing this to the launch platform at Cape Kennedy).

Madsen's view of Russian art is characteristic of that of the emerging generation, taking fully into account not only the pioneering Russians but also the American artists of the 1960s and 1970s who had been attracted to them. Consequently, Madsen regards the recent period and the Russian era in the light of "many apparent parallels" to the social situation and to ideological issues. He writes (in a letter to me in November 1979) that the "two issues which interest me most are (a) Artists' Guilt (also called Social Responsibilities) and (b) The End of Art. They are linked issues. Regarding (a), is the artist or can the artist be an integral, productive member of society? Or is the artist just the last vestige of a laissez-faire individualism, a producer of luxury items for, and a plaything of, an economic elite?" In regard to (b), the "End of Art," Madsen concludes that the Russian experience apparently indicated that "art had become formally and morally bankrupt," leaving artists of today "up a tree." Yet in signaling art's "ability to anticipate events and conditions of society, as the Russians did," Madsen's rather despairing view is kept in check by the Russian achievement. Refreshing too is his avowal of "the great privilege" of "following one's own fantasies in the making of art." The Russians, I believe, will remain exemplars of the power of pure imagination in the life of society. ●

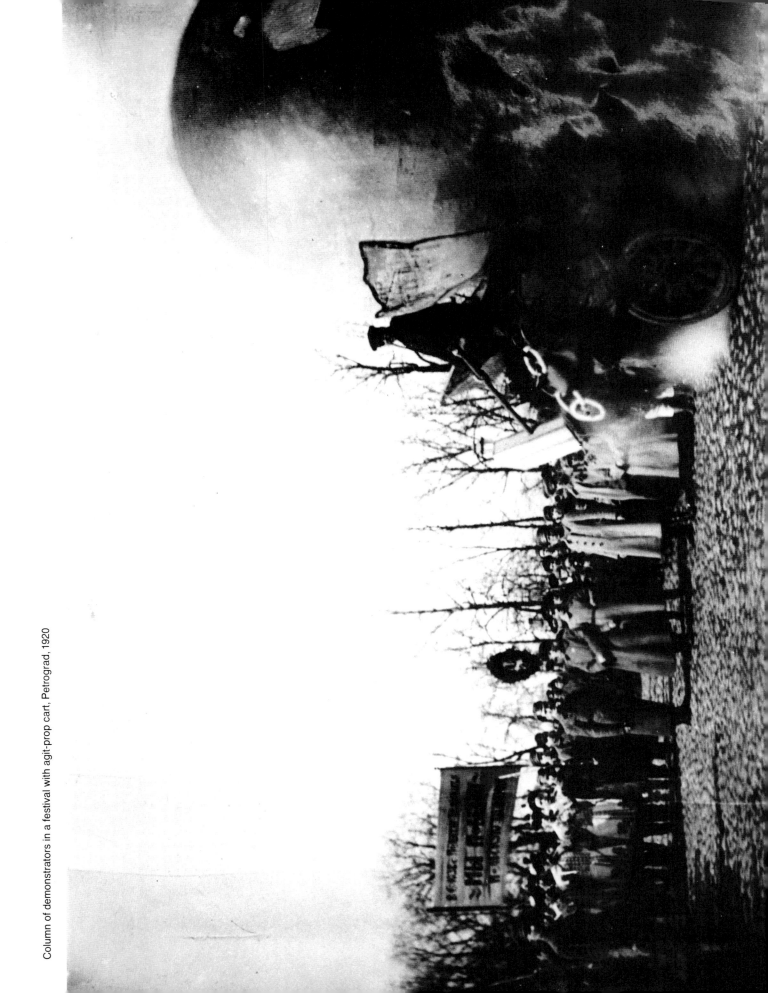

Column of demonstrators in a festival with agit-prop cart, Petrograd, 1920

Notes to the Reader

1. All dimensions of works of art are indicated by height x width x depth.

2. More complete entries of the books can be found in Arthur A. Cohen, *Ex Libris 6: Constructivism & Futurism, Russian & Other,* New York: Ex Libris, a division of T. J. Art, Inc., 1977.

3. The biographies and bibliographies of the artists were written and compiled by John E. Bowlt, professor of Slavic Languages at the University of Texas at Austin.

4. Catalog entries on the artists and their works were prepared by Anne Ayres, research assistant, and Stella Paul, curatorial assistant.

5. The present city of Leningrad is referred to as St. Petersburg or Petersburg until 1914 and as Petrograd from 1914 to 1924.

6. The transliteration system is a modified version of that of the Library of Congress, although the soft and hard signs have been rendered by "i" or have been omitted. When a Russian name has already received a conventional transliteration that varies from the above system—for example, *benois,* not *benua,* or Marc Chagall, not Mark Shagal—this has been preserved in the text.

7. The following abbreviations have been used in the catalog:

Inkhuk: Institute of Artistic Culture, Moscow; founded in May 1920; affiliations in Petrograd and Vitebsk.

IZO NKP: Visual Arts Department of the People's Commissariat for Enlightenment, established shortly after the October Revolution; Anatolii Lunacharsky, commissar of enlightenment; David Shterenberg made the director of the Visual Arts Department in January 1918; most of the avant-garde at one time associated with it.

Lef: Left Front of the Arts, a radical journal from 1923 until 1925; resumed under the title **Novyi lef** *(New Left Front of the Arts),* 1927–28; among the founders were Boris Arvatov, Osip Brik, Sergei Tretiakov, and Vladimir Maiakovsky.

Novyi lef: see **Lef.**

Obmokhu: Society of Young Artists, Moscow; founded in 1919 by Nikolai Denisovsky, Georgii and Vladimir Stenberg, and others, and later attracted Rodchenko, Georgii Yakulov, et. al.; four exhibitions in 1919–21.

OST: Society of Easel Artists, founded formally in 1925; initial members of the exhibition society were Yurii Annenkov, Alexandr Deineka, Yurii Pimenov, and Shterenberg; four exhibitions in 1925–28 demonstrated its orientation toward a figurative, often Expressionist style of painting.

Posnovis: Followers of the New Art, a group founded under Malevich in Vitebsk in 1919; in early 1920, changed its name to Unovis (Affirmers of the New Art); the group, including Chashnik, Ermolaeva, Lissitzky, Suetin, and Yudin, issued two journals, *AERO* (1920) and *Unovis* (1920–21).

Proletcult: Proletarian Culture, a group led by Alexandr Bogdanov, stressed the need for a proletarian, i.e., industrial, art and advocated ignoring much of the pre-1917 heritage; in 1918–19 Proletcult maintained a considerable degree of independence, operating its own studios, organizing its own exhibitions, etc.; it was annexed to NKP in 1922.

Proun: Project for the Affirmation of the New, the name Lissitzky gave to his architectonic compositions of 1919–24; indebted to Malevich's Suprematism, the Prouns represented what Lissitzky called the "station on the path of the construction of the new form."

RAKhN: Russian Academy of Artistic Sciences, a research institution founded in Moscow in 1921 partly with the help of Kandinsky; it contained a Physicomathematical and Physicopsychological Department, a Philosophical Department, and a Sociological Department; it later changed its name to GAKhN (State Academy of Artistic Sciences).

RM: State Russian Museum, Leningrad.

Svomas: In 1918 the old Moscow Institute of Painting, Sculpture, and Architecture and the Stroganov Art School were integrated to form the Free Art Studios (Svomas), and the St. Petersburg Academy of Arts was abolished to be replaced by the Petrograd State Free Art Educational Studios (Pegoskhuma—later Svomas and then the Academy again); the Moscow Svomas was renamed Vkhutemas (Higher State Art-Technical Studios) in 1920 and then Vkhutein (Higher State Art-Technical Institute) in 1926; similar changes were implemented in provincial cities.

TG: State Tretiakov Gallery, Moscow.

Unovis: see **Posnovis**

Vkhutein: see **Svomas**

Vkhutemas: see **Svomas**

Altman, Natan Isaevich

Born 1889 Vinnitsa; died 1970 Leningrad.

1.

Relief, c. 1915
Wood
60 x 28.5 x 14.3 cm. (28⅝ x 11¼ x 5½ in.)
Hamburger Kunsthalle, Hamburg, West Germany

2.

Relief, 1922
Painted wood with rakes
44 x 53 cm. (17⅜ x 20⅞ in.)
Galerie Jean Chauvelin, Paris

3.

Kultura-liga (Culture League)
by N. Altman, M. Chagall, D. Shterenberg
Moscow, 1922
8 pp. with illustrations and design by N. Altman, M. Chagall, D. Shterenberg
21.6 x 14 cm. (8½ in. x 5½ in.)
The Institute of Modern Russian Culture, Blue Lagoon, Texas

4.

Natan Altman by B. Arvatov
Moscow? Petrograd?, 1924
62 pp. text with 42 reproductions
Ex Libris 6, no. 10
31.9 x 24.8 cm. (12⅝ x 9¾ in.)
National Gallery of Art Library, Washington, D.C.

Bibliography

M. Etkind, *Natan Altman,* Moscow, 1971.

V. Petrov, "O vystavke N. I. Altmana," *V. N. Petrov: Ocherki i issledovaniia,* ed. D. Chebanova, Moscow, 1978, pp. 250–54.

1901–7 studied painting and sculpture at the Odessa Art School; 1910–12 lived in Paris, attending Maria Vasilieva's Russian Academy; became interested in Cubism; 1912–17 contributed to the satirical journal *Riab (Ripple)* in St. Petersburg; active in the avant-garde group called the Union of Youth; contributed as a painter, sculptor, and designer to many avant-garde exhibitions including *0–10* and *Jack of Diamonds*; 1918 professor at Svomas; member of IZO NKP; designed agit-decorations for Uritsky Square in Petrograd and elsewhere; supported the cause of Russo-Jewish artists; contributed to the *Exhibition of Paintings and Sculpture by Jewish Artists* in Moscow; 1919 leading member of Komfut (Communist Futurism); contributed to the *First State Free Exhibition of Works of Art* in Petrograd; 1921 published his album of Lenin drawings; designed décor for Maiakovsky's play *Mystery-Bouffe*; 1922 contributed to the *Erste Russische Kunstausstellung* in Berlin; 1924 contributed to the *Esposizione internazionale* in Venice; 1925 represented at the *Exposition internationale des arts décoratifs et industriels* in Paris; late 1920s represented at many exhibitions at home and abroad; 1929–35 lived in Paris; 1933 appearance of the Waldemar George and Ilia Ehrenburg monograph on Altman in Yiddish in Paris; 1935 returned to the Soviet Union; 1936 settled in Leningrad; 1930s onward active as a portraitist, still-life and landscape painter, as well as a sculptor and stage designer; 1969 major retrospective of the artist's work in Leningrad.

■ As a young man Altman studied Cubism in Paris, but he returned to Russia at the outbreak of war. By 1918 he was a prominent organizer of agit-prop activities, in charge of planning events marking the first anniversary of the October Revolution in Petrograd. Using canvas, he camouflaged all of the buildings surrounding the square in front of the Winter Palace with Cubist and Futurist designs. Altman was appointed head of the Petrograd section of IZO by Lunacharsky and worked with this government agency in setting up a series of galleries and museums to purchase and exhibit contemporary abstract art.

In his work during the 1920s, Altman introduced utilitarian objects into painting, but the intention here is completely removed from the French Cubism that had been so strong an influence earlier in his life. The reliefs show the influence of Tatlin's concept of "the culture of materials." Each object dictated its own repertory of forms; it is stripped of its function. The objects were selected on the basis of their formal and textural attributes.

Kultura-liga (Culture League, published 1922) is representative of Altman's contribution to book design during the 1920s and contains some of the artist's finest work. This book, produced in collaboration with Chagall and David Shterenberg, is one of the relatively rare Jewish productions of the period. Altman actively supported the cause of Russo-Jewish artists in Moscow.

1

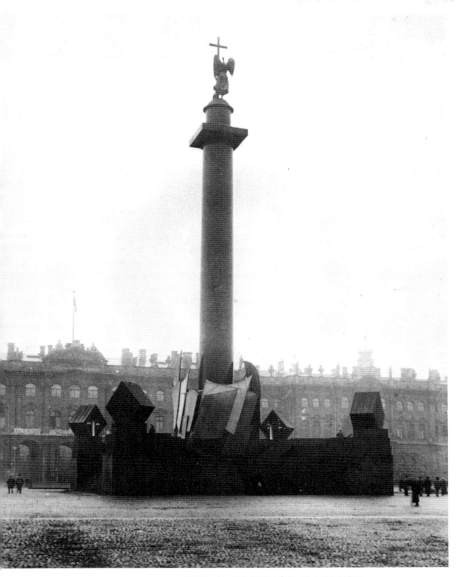

Design for Alexander Column celebrating
the Red Army's 1st Anniversary, Petrograd, 1919.

■ Take any work of revolutionary, futurist art. People who are used to seeing a depiction of individual objects or phenomena in a picture are bewildered. You cannot make anything out. And indeed, if you take out any one part from a futurist picture, it then represents an absurdity. Because each part of a futurist picture acquires meaning only through the interaction of all the other parts; only in conjunction with them does it acquire the meaning with which the artist imbued it.

A futurist picture lives a collective life:

By the same principle on which the proletariat's whole creation is constructed.

Try to distinguish an individual face in a proletarian procession.

Try to understand it as individual persons—absurd.

Only in conjunction do they acquire all their strength, all their meaning.

How is a work of the old art constructed—the art depicting reality around us?

Does every object exist in its own right? They are united only by extrinsic literary content or some other such content. And so cut out any part of an old picture, and it won't change at all as a result. A cup remains the same cup, a figure will be dancing or sitting pensively, just as it was doing before it was cut out.

The link between the individual parts of a work of the old art is the same as between people on Nevsky Prospekt. They have come together by chance, prompted by an external cause only to go their own ways as soon as possible. Each one for himself, each one wants to be distinguished.

Like the old world, the capitalist world, works of the old art live an individualistic life.

Only futurist art is constructed on collective bases.

Only futurist art is right now the art of the proletariat.

Natan Altman, "'Futurizm' i proletarskoe iskusstvo," *Iskusstvo kommuny,* Petrograd, 1918, no. 2, p. 3; trans. John E. Bowlt, *Russian Art of the Avant-Garde: Theory and Criticism 1902– 1934,* New York, 1976, pp. 163–64.

Annenkov, Yurii Pavlovich

Born 1889 Petropavlovsk-on-Kamchatka, Siberia;
died 1974 Paris.

5.

The First Distiller, 1911–29
Gouache on paper
26 x 31.8 cm. (10¼ x 12½ in.)
Mississippi Museum of Art,
Jackson, The Lobanov Collection

6.

The Cathedral of Amiens, c. 1919
Wood, cardboard, and wire on
paperboard
71.1 x 52.1 cm. (28 x 20½ in.)
Leonard Hutton Galleries,
New York

7.

**State Design for "The Storming
of the Winter Palace,"** 1920
Watercolor and pencil
20.3 x 59.7 cm. (8 x 23½ in.)
Mississippi Museum of Art,
Jackson, The Lobanov Colletion

8.

Untitled, 1921
Collage
58 x 48 cm. (22⅞ x 18⅞ in.)
Galerie Jean Chauvelin, Paris

9.

Portrety (Portraits)
Petrograd, 1922
170 pp. with 80 lithographs,
unbound
34.3 x 24.8 cm. (13½ x 9¾ in.)
Mr. and Mrs. A. L. de Saint-Rat,
Miami University, Oxford, Ohio

10.

Moi dodyz, by Y. Annenkov
Leningrad-Moscow, 1925
21 pp. with illustrations by
Annenkov
27.9 x 22.4 cm. (11 x 8¾ in.)
Mr. and Mrs. A. L. de Saint-Rat,
Miami University, Oxford, Ohio

11.

17 Portretov (17 Portraits)
Moscow/Leningrad, 1925
Portfolio of 17 lithographs
63.5 x 47 cm. (25 x 18½ in.)
Miami University Library, Oxford,
Ohio

1908 entered University of St. Petersburg and simultaneously took lessons at the private studio of Savelii Zeidenberg; 1909–10 studied under Yan Tsionglinsky (initial teacher of Elena Guro, Mikhail Matiushin, and other members of the St. Petersburg avant-garde); 1911–12 in Paris, where he attended the studios of Denis and Vallotton; 1913 traveled to Switzerland and then returned to St. Petersburg; created décor for Nikolai Evreinov's *Homo Sapiens* produced at the satire theater The Crooked Mirror; worked regularly for the journal *Teatr i iskusstvo (Theater and Art)*; 1913–14 close to members of the Union of Youth both in St. Petersburg and in the *dacha* region of Kuokkala, where Evreinov, Matiushin, the Punis, et al. also resided in the summer months; this proximity led to a number of joint ventures, e.g. Annenkov's illustrations (with Kulbin's) of Evreinov's *Teatr dlia sebia (The Theater for Itself)*, Petrograd, 1915–16, and to his cover design for the separate edition of Evreinov's *Predstavlenie liubvi*

(Presentation of Love), Petrograd, 1916; 1917 onwa Annenkov formulated a number of innovative spectacle including Georg Kaiser's *Gas* (1922) and Alexei Tolsto *Bunt mashin (Mutiny of the Machines,* 1924); 1918 too part in the decoration of the Field of Mars, Petrograd, f the May Day celebrations; 1920 with Mstislav Dob zhinsky and Vladimir Shchuko decorated the mass dran *Gimn osvobozhdennomu trudu (Hymn to Liberate Labor)* in front of the old Petersburg stock exchang organized decoration of the mass spectacle *Vziatie zir nego dvortsa (Storming of the Winter Palace)* in 192 1922 member of the second generation of World of *I* association; contributed to the *Erste Russische Kuns ausstellung*, Berlin; 1924 contributed to the *Esposizior internazionale*, Venice; emigrated to Paris, where I worked on typographical design, film sets, theater bills, well as on portraits and still lifes.

Bibliography

G. Andreev, "Na razgromlennom Parnase," *Novoe Russkoe slovo,* New York, September 15, 1974, p. 3.

Y. Annenkov, *Dnevnik moikh vstrech,* New York, 1966, vols. 1 and 2.

M. Babenchikov, "Annenkov-grafik i risovalshchik," *Pechat i revoliutsiia,* Moscow, book 4, June 1925, pp. 101–29.

P. Courthion, *Georges Annenkov,* Paris, 1930.

8

Annenkov studied from 1911 to 1912 in Paris, where he saw the famous Italian Futurist exhibition at the Galerie Bernheim Jeune (1912). In 1913 Annenkov returned to his homeland where he was closely associated with the Russian avant-garde for the next ten years.

By 1915 Annenkov had begun to work in collage; in 1917 he became involved with innovative theater designs. To both these interests he brought a profound concern for the intrinsic qualities of abstract form and raw materials, as seen in *The Cathedral of Amiens* (c. 1919) and *Untitled* (1921). Annenkov advocated a "total theater"; his manifesto "Theater to the End" (1921) called for projections of light that animated abstract structures. He shared with Constructivist stage designers a passion for sets and costumes based on mechanical movement.

The best known of Annenkov's theater projects was among the greatest of all mass outdoor spectacles: "The Storming of the Winter Palace," staged on November 7, 1920, in Petrograd by Nicolai Evreinov with decorations and costumes by Annenkov. Mass spectacles were favored events in revolutionary Russia. Similar in spirit to those staged after the French Revolution, the grandiose pageants encouraged the populace to abandon passivity and to participate in an ongoing celebration of the new society. On the first anniversary of the Revolution, Natan Altman had staged a reenactment of the historic taking of the Winter Palace in Petrograd. Annenkov's 1920 spectacle took place on the third anniversary in Uritsky Square, the site of the original event: the cast consisted of 150,000 people.

As scenographer of this symbolic drama, Annenkov drew upon the medieval mystery play: with the entire square as his stage, he divided the spectacle into three zones of action. At one end of the square was the Winter Palace itself. Huge constructed screens reached to its third story; its sixty-two windows were ablaze with light. Across the square two vast platforms rested against a semicircular stretch of buildings. Scaffolds, brick walls, and constructed factory chimneys designated the "red stage" from which the revolutionary spirit erupted. The other platform was the "white stage"—the domain of Kerensky's provisional government. An arch bridged the platforms and provided the meeting point of the conflict. As the performance unfolded, hostilities flowed among the three playing areas eliminating traditional barriers between spectators and actors. At length, armored trucks and soldiers advanced for the assault; machine guns and cannons thundered; a shadow-box struggle was seen through the Palace windows; finally the lights were extinguished and fireworks announced victory for the people.

Annenkov's participation in contemporary history led to a series of portraits done in Russia *(Portrety,* 1922) and in Paris *(17 Portretov,* 1926) after his emigration in 1924. He depicted such political and artistic figures as Akhmatova, Lenin, Lunacharsky, Meierkhold, and Trotsky.

Burliuk, David Davidovich

Born 1882 Kharkov; died 1967 Long Island, New York.

12.

Landscape, 1912
Oil on canvas
33 x 46.4 cm. (13 x 18¼ in.)
Thyssen-Bornemisza Collection,
Lugano, Switzerland

13.

**Poshchechina obshchestven-
nomu vkusu (A Slap in the Face
of Public Taste)** by D. and N.
Burliuk, A. Kruchenykh, V. Kandinsky,
B. Livshits, V. Maiakovsky, and
V. Khlebnikov
Moscow, 1912
113 pp. with sackcloth covers
Ex Libris 6, no. 37
24.2 x 18.7 cm. (9½ x 7⅜ in.)
Australian National Gallery,
Canberra

14.

Dokhlaia luna (The Croaked Moon),
ed. A. Shershenevich
Moscow, 1913
134 pp. with 19 colored etchings,
3 black-and-white drawings by
D. Burliuk, V. Burliuk, and N. Burliuk
Ex Libris 6, no. 51
24.2 x 18.4 cm. (9½ x 7¼ in.)
Mr. Alexander Rabinovich

15.

Dokhlaia luna (The Croaked Moon),
ed. A. Shershenevich
Moscow, 1914, second edition
134 pp. with 19 colored etchings,
3 black-and-white drawings by
D. Burliuk, V. Burliuk, and N. Burliuk
Ex Libris 6, no. 51
24.2 x 18.4 cm. (9½ x 7¼ in.)
Collection Martin-Malburet

16.

Sadok sudei (A Trap for Judges)
by D. and V. Burliuk, E. Guro,
V. Khlebnikov, A. Kruchenykh,
V. Maiakovsky, et al.
St. Petersburg, 1913, second edition
112 pp., reproductions of 15
drawings; 2 each by V. Burliuk,
N. Goncharova, M. Larionov; 3 by
D. Burliuk; 6 by E. Guro
Ex Libris 6, no. 39
20 x 16.5 cm. (7⅞ x 6½ in.)
George Gibian, Ithaca, New York

1898–1904 studied at various institutions in Kazan, Munich, Paris; 1907 settled in Moscow; soon established contact with many members of the emergent avant-garde; 1908 organized the *Link* exhibition in Kiev, at which he issued his first manifesto; 1910–11 attended the Odessa Art School; 1911 contributed to the first *Blaue Reiter* exhibition in Munich; entered the Moscow Institute of Painting, Sculpture, and Architecture, but was expelled with his friend Vladimir Maiakovsky in 1914; during this time he became one of the most energetic organizers of avant-garde exhibitions and publications; 1912 cosigned the Russian Futurist manifesto *A Slap in the Face of Public Taste*; 1913 onward illustrated many Futurist booklets, e.g., *Rykaiushchii Parnas (Roaring Parnassus,* 1913), *Sbornik edinstvennykh futuristov v mire (Anthology of the Only Futurists in the World,* 1914) and *Lyseiushchii khvost (Balding Tail,* 1918); 1910–15 contributed to many exhibitions including the *Triangle, Jack of Diamonds,* the *Union of Youth,* the *Exhibition of Painting, 1915*; 1915–17 lived with his wife's family in the Urals, but often traveled to Moscow and Petrograd; 1918 with Vasilii Kamensky and Maiakovsky published *Gazeta futuristov (Newspaper of the Futurists)* in Moscow; 1918–22 by way of Siberia, Japan, and Canada arrived in the U.S.; 1920s had many exhibitions in U.S. cities; 1930–66 published (with Marusia, his wife) the journal *Color and Rhyme.*

Bibliography

Vahan D. Barooshian, *Russian Cubo-Futurism 1910–1930,* The Hague, 1974, esp. chap. 3.

David Burliuk: Years of Transition, 1910–1931, exh. cat., Parrish Art Museum, Southampton, New York, 1978.

B. Livshits, *Polutoraglazyi strelets,* Leningrad, 1933; trans. John E. Bowlt, *The One and a Half-Eyed Archer,* Newtonville, Massachusetts, 1977.

Kazuo Yamawaki, "Burliuk and Palmov: Russian Futurists in Japan," *Pilotis,* Hyogo, 1978, no. 28, pp. 4–5; no. 29, pp. 1–2 (in Japanese).

■ A personality of formidable energies and organizin ability, David Burliuk played an important role in the incep tion of the Russian Futurist movement in art and literatur after 1910. Like many of their colleagues, David Burliu and his brother Vladimir turned toward Munich rather tha Paris for study from 1903 to 1905. Their return to Russi and the impact of the work of Larionov and Goncharov marked a growing interest in national folk art tradition which would occupy the brothers until 1911. For Davi Burliuk, the three major interests of the Neo-Primitivi movement were childhood, pre-history, and Russia folklore.

Landscape (1912) is typical of Burliuk's Neo-Primitivi phase; it indicates his focus on scenes from the provinci countryside executed in a deliberately childlike manne This work comes very close in feeling to that of Munich *Blaue Reiter* group, reflecting his student years in Ge many and his close association with Kandinsky. Und David Burliuk's auspices, works by the German Expre sionists were exhibited in Russia in 1911 and 1912. Th was an association that put an end to Burliuk's friendsh with Larionov and Goncharova, who accused him of bein "a decadent Munich follower."

In 1912 Burliuk re-directed his energies to poetry. Th polemical manifesto *Poshchechina obshchestvennom vkusu (A Slap in the Face of Public Taste)* is the first an most famous joint publication of Burliuk and his intima circle of colleagues: Maiakovsky, Livshits, Kandinsk Kruchenykh, and Klebnikov. The work is an attack o popular figures of the time and it calls for an end t traditional art. Burliuk posited three artistic principles: di harmony, dissymmetry, and disconstruction. By 1913 Bu liuk's tremendous enthusiasm and organizational pow had earned him widespread recognition as the "father Russian Futurism." He and his colleagues continued t publish journals of poetry and manifestos of creative prii ciples, such as *Trebnik troikh (The Missal of the Three Sadok sudei (A Trap for Judges),* and *Dokhlaia luna (Th Croaked Moon).*

With the "Futurist Tour of Russia" (1913–14), Dav Burliuk organized the first activity of direct proselytizir that had been attempted outside of Moscow and Peter burg. The Burliuk brothers, Maiakovsky, and Kamensh visited seventeen towns in Russia, giving poetry readinç and lecturing on this new movement. Returning to Mo cow, they recited poetry on street corners and organize highly entertaining public lectures. The artists dresse in outlandish costumes, painted Rayonist signs ar hieroglyphics on their faces, and wore wooden spoor and radishes in their buttonholes. They produced a fil in 1913, *Drama in Cabaret No. 13,* which documents th frantic showmanship of their everyday lives. The film a parody of the Symbolists, who were considered effet

David Burliuk's affinities remained with the Futuri movement throughout his career. He traveled throug Japan and Canada, settling in the United States in 1922

2

From David Burliuk, "Texture," 1912

■ Painting is colored space. (Isn't music colored time?) Aren't pictures like fabulous unknown countries stretching out at your feet; aren't you the high-flier of contemporaneity?... The color orchestration of a picture. Color constructions—definitions: major scales, minor colors....

The study of the facts and phenomena of painting according to the nature of their origin:

Pictorial Plane: Texture (character of the picture's
(surface) surface). Painting is plastically contiguous to sculpture. (This potential was at one time outlined in Egypt ...Russian folk gingerbread.)

Plane Construction in a Picture
Linear Construction
 I. Line as a unit
 II. Linear correlations....
Color Orchestration
 I. Color (paint) as a unit
 II. Correlation of colors

This is what is meant today by the task of analyzing the subject of Painting: to comprehend the path upon which the Free Art of the New Painting has embarked; ▶

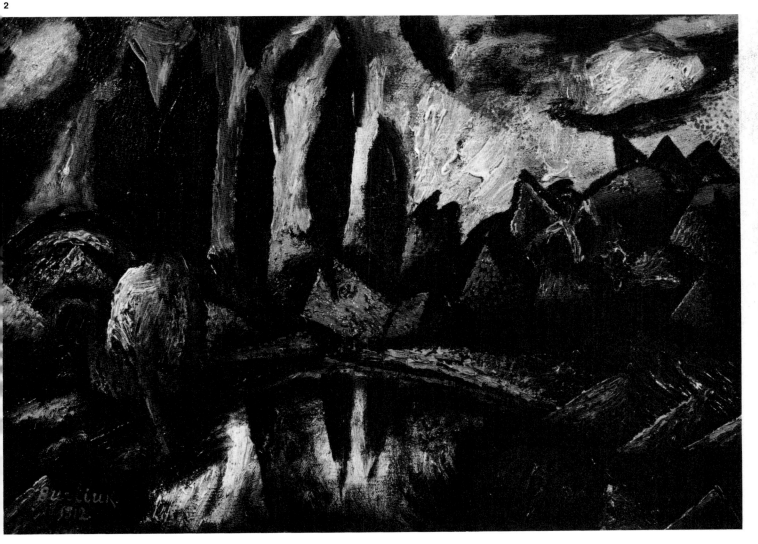

to comprehend discourses on the ideological content of pictures, discourses imprisoned under lock and key; to comprehend the painting of color aromas.

Aren't paints the colored visible honey of these joyous marvels?

But in these lines we want to devote all our attention to a topographical analysis of the pictures of these beautiful images of art (doesn't the spider of time superimpose its web on them—images scratched by the nails of time's subtle claws?)....

We consider it the duty of scientific criticism to examine the Object of delight not in the soul of the spectator or the creator—but in the Object itself. It is time to study the soil which generates the spectator's most delicate experiences. It is time to study the furnace and combustible materials in the secrets of the influence of the art of Painting on our souls. I now invite you to study the refined petrography of these tiny, secret, wonderful countries in which mountains, planes, chasms, grayness, and metallic brilliance are mingled together—the petrography of these colorful spaces created from Man's ability to see, of these essences of vision-pictures.

The time has now come to ascertain, or rather, one should say, to infer Painterly Dimensions (poetry), painterly Orders (architecture), counterpoint (music) from certain allusions afforded by the New art. One thing is beyond any doubt: Ultimately, such an ascertainment must inevitably be, in our day and age, the result of studying Modern Painting—of analyzing previous painting, the New Painting and the old Painting (as an inference from the past which imparts freedom to the future).

In order—when analyzing a subject of Painting—to grasp and exhaust it in its entirety, the ascertainment of an exhaustive (perhaps only for a while) Counterpoint of Painting (in the broad sense of the word) should be the result of the correct solution of the problem.

...let us move on to the elucidation of the First Point—Painterly Counterpoint—the Petrography of Painting.

The Study of—Surface—its Character
 the picture
 and the structure of the surface....
The Plane of a picture: can be
A. Even and B. Uneven.
A. *Even plane.*
 I. It can be extremely brilliant, brilliant, not very brilliant.–Glimmering.
 II. The plane of a picture can be dull.
 According to the character of brilliance Group I can be divided into:
 1) metallic brilliance.
 2) glassy brilliance.
 3) greasy brilliance.
 4) pearly brilliance.
 5) silky brilliance.
B. *Uneven plane.*
 I. Splinter-like surface.
 II. Hook-like surface.
 III. Earthy surface
 (dull and dusty)
 IV. Blistered surface (flat, deep...)
 big and small blisters.
 complete or incomplete blisters.

Structure of a picture's surface.
 I. Granular
 II. Fibrous.
 III. Lamellar.
This is the bare skeleton of the only possible classification of works of painting according to texture.

This winter in one of the halls of S. I. Shchukin Gallery of Western European Painting, I carefully scrutinized C. Monet's *Rouen Cathedral*. In this, just under the glass, were growing kinds of moss—delicately colored in subtle orange, lilac, yellowish tones: the paint seemed to and really did, have roots to its threads—they stretched upward from the canvas, recherché and aromatic. "Fibrous structure (vertical)," I thought, "the delicate threads of strange and wonderful plants."

There in an adjacent hall was hanging a bearer of the Gallic spirit, a representative of that race, blood brothers of which are the ancient Cimmerians who lived in 120 B.C. where I'm writing these very lines. This was Cézanne whose painting in its Structure, could be said to be typically Lamellar.

If the painting in the first picture is an Organic world, then the painting in the second is inorganic.

Cézanne's pictures are colored stones: Slates cut open by a sharp sword....

V. V. Kandinsky, the Spaniard P. Picasso (in his latest works), Metzinger (Alsatian), and a few other French artists have been working on Texture: they indicate a possibility of painterly discoveries which was completely closed to the daubers of all kinds of panoramas and bespoke portraits. They used to clothe their pictures in a glossy colored oilcloth—whereas real artists' pictures are clothed now in a skin as tender as the bloom on a girl's cheeks, now in delicate plates of antique bronze corroded by time, now they are remindful of the glassy surface of a frozen lake, now of the fluffy coat of some fabulous wild beast!...

David Burliuk, *Poshchechina obshchestvennomu vkusu* (*A Slap in the Face of Public Taste*), Moscow, 1912, pp. 102–10 Translated from the Russian by John E. Bowlt.

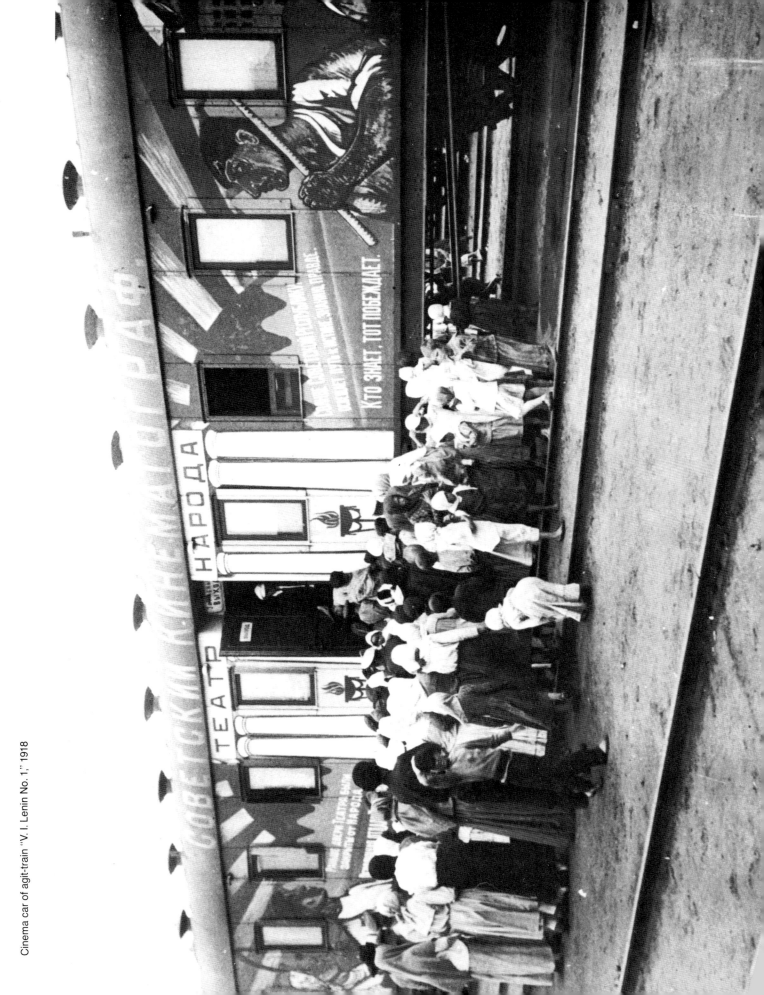

Cinema car of agit-train "V. I. Lenin No. 1," 1918

Burliuk, Vladimir Davidovich

Born 1886 Chernianka, Ukraine; died 1917 in action in the War.

19.

Portrait of Poet Benedikt Livshits, 1911

Oil on canvas

45.7 x 35.5 cm. (18 x 14 in.)

Ella Jaffe Freidus, New York

20.

Nude with Mandolin, 1912–13

Oil on canvas

84 x 69 cm. (33⅛ x 27⅛ in.)

Galerie Jean Chauvelin, Paris

21.

Zatychka (The Stop Gap)

Moscow, 1913

14 pp. with 4 lithographs,

1 hand-colored by V. Burliuk

Ex Libris 6, no. 104

23.8 x 18.7 cm. (9⅜ x 7⅜ in.)

Collection Martin-Malburet

1904 took part in the Russo-Japanese War; 1907 contributed to the *Exhibition of Paintings* in Kharkov; 1907–8 took part in David Burliuk's *Wreath-Stephanos* exhibition in Moscow; 1908–9 active in Kiev art life, contributing to the *Link* (1908), at which Alexandra Exter, Larionov, and others were also represented; 1909 contributed to the *Wreath* exhibition in St. Petersburg; 1910 contributed to Nikolai Kulbin's *Triangle* exhibition in St. Petersburg; 1910–11 contributed to Vladimir Izdebsky's Salon in Odessa; drew illustrations for the first "Futurist" collection *Sadok sudei (A Trap for Judges)*; member of the *Neue Künstlervereinigung* in Munich, contributing an article to the catalog of its second exhibition (September 1910); member of the Jack of Diamonds group and the Union of Youth; 1911 entered the Odessa Art School; contributed to the first *Blaue Reiter* exhibition in Munich; 1912 illustrations appeared in the *Blaue Reiter Almanach;* 1913 represented at Walden's *Erster Deutscher Herbstsalon* at Galerie der Sturm in Berlin; 1913–14 illustrated many Futurist collections including *Miristel* (St. Petersburg), *Dokhlaia luna (Croaked Moon), Moloko kobylits (Milk of Mares)*; represented at the *Exhibition of Painting, 1915,* Moscow; 1916 mobilized.

Bibliography

V. Markov, *Russian Futurism: A History,* Berkeley, 1968.

B. Livshits: *Polutoraglazyi strelets,* Leningrad, 1933; trans. John E. Bowlt, *The One and a Half-Eyed Archer,* Newtonville, Massachusetts, 1977.

19

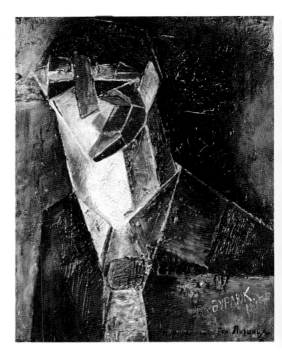

20

In close association with his artist brother David Burliuk, Vladimir was active in launching the Futurist movement in pre-Revolutionary Russia. While David's attention was directed toward organizing events and writing, Vladimir's strength lay in the plastic arts.

Portrait of Poet Benedikt Livshits (1911) is an outstanding example of Burliuk's Cubo-Futurist technique and gives an insight into the tenor of contemporary life. The subject of the work is the Futurist poet Benedikt Livshits, best known as author of *The One and a Half-Eyed Archer,* a memoir of the period (1911–14) that represents the first attempt to present a systematic exposition of the principles of Futurism. The title refers to the one-eyed David Burliuk, whose foresight and powers of persuasion brought together the founding members of the Futurist movement for Christmas holidays in 1911, at the Burliuk family estate in Chernianka. In the words of Livshits, "Chernianka proved to be the intersection of those coordinates which brought forth the Futurist movement." The young Burliuk brothers were preparing a body of work for the second *Jack of Diamonds* exhibition (Moscow, 1912), and it is in this context that Vladimir produced the Livshits portrait. Livshits described the artists as "possessed by an ecstacy of procreation"; they "created work after work in frenzied transport." Vladimir's "frenzy" extended to covering his freshly painted canvases with mud in order to effect a more tangible surface.

Vladimir Burliuk maintained strong ties to the contemporaneous *Blaue Reiter* group in Munich, both by exhibiting work there and by contributing illustrations to the *Blaue Reiter Almanach.* The second *Jack of Diamonds* exhibition in Moscow marks the first complete introduction of the Munich artists to Russia. Burliuk's work of this period *(Nude with Mandolin,* 1912–13) shows an awareness of movements in Western Europe, specifically Cubism. The artist modified and redirected these influences to accommodate his leanings toward Russian Neo-Primitivism.

Unfortunately, Vladimir Burliuk's career was tragically cut short; he was the only artist in avant-garde circles to be killed in combat during World War I. Mobilized in 1916, he died in 1917.

Chagall, Marc (Shagal, Mark Zakharovich)
Born 1887 Vitebsk; lives in France.

22.

Composition with Goat, 1917
Oil on cardboard
16.5 x 23.5 cm. (6½ x 9¼ in.)
Franz Meyer, Basel, Switzerland

23.

The Traveler (Forward!), 1919–20
Oil on paper
31.7 x 45.4 cm. (12½ x 17⅞ in.)
The George Costakis Collection

Bibliography

S. Alexander, *Marc Chagall*, New York, 1978.

M. Chagall, *My Life,* London, 1957.

F. Meyer, *Marc Chagall*, New York, 1964.

1907 enrolled in the school of the Society for the Encouragement of the Arts, St. Petersburg; 1908 switched to Zeidenberg's private art school and then to Lev Bakst's and Mstislav Dobuzhinsky's; 1910 moved to Paris, eventually moving into La Ruche; 1912 contributed to Salon des indépendants and Salon d'automne; also contributed to Larionov's *Donkey's Tail* exhibition in Moscow; 1913 met Apollinaire; contact with many of the Parisian bohemia; contributed to Larionov's *Target* exhibition in Moscow; 1914 one-man show at Galerie der Sturm, Berlin; traveled to Vitebsk; 1915 married Bella Rosenberg; moved to Petrograd; close to the collector and gallery owner Nadezhda Dobychina; contributed to the *Exhibition of Painting, 1915*; 1916 contributed over forty works to the *Jack of Diamonds* exhibition in Moscow; worked on theater designs for Nikolai Evreinov in Petrograd; 1917 accepted the Revolution initially; moved back to Vitebsk; until 1927 contributed to several state exhibitions such as the *Exhibition of Modern Painting and Drawing* (Petrograd, 1918) and the *Exhibition of Contemporary Trends in Art* (Leningrad, 1927); 1919 took over directorship of the art school in Vitebsk, although soon ousted by Malevich and the Suprematists; 1920 moved to Moscow, where he became active in stage design; 1921 executed murals and some sets for Granovsky's Chamber Jewish Theater; 1922 emigrated to Berlin via Kaunas; paid particular attention to lithographs and woodcuts; contributed to the *Erste Russische Kunstausstellung;* 1923 moved to Paris; 1924 first comprehensive retrospective at the Galerie Barbazanges-Hoderbart; mid-1920s painted a series of gouaches illustrating the La Fontaine *Fables*; represented at many exhibitions in Paris; 1931 traveled to Palestine in preparation for his work on the Bible etchings; 1935 visited Poland; 1941–46 lived in U.S.; 1968 exhibition of his works from private collections organized by the Academy of Sciences in Novgorod; 1973 traveled to Moscow in connection with a small retrospective of his work there.

■ Marc Chagall's art holds an equivocal position in the Russian avant-garde experience. He equated the social revolution with the artistic revolution and called for a non-narrative proletarian art without "content." Yet the poetic imagery of Chagall's expressionism led to condemnation by non-objective painters. He triumphed at the *First State Exhibition of Revolutionary Art* (Petrograd, 1919) and was called the hero of a Russian fairy tale; the state bought twelve of his paintings, but these were its last major purchases. Chagall was made commissar of art for his hometown of Vitebsk for a tumultuous period in 1918–19. Against impossible odds he opened a museum, staged mass spectacles, and was founder, director, and the most popular teacher at the Vitebsk Academy. Recruited by Chagall to teach at Vitebsk were many avant-garde artists, including Ivan Puni, Xana Boguslavskaia-Puni, and perhaps most notably El Lissitzky. Yet Chagall's desire for a "free" school expressing all points of view ultimately caused his ouster by a Malevich faction led by the new director, Vera Ermolaeva. In Moscow by 1920, Chagall associated himself with the Jewish experimental theater (Granovsky's Kamerny State Jewish Theater and Wachtangoff's Habimah) which was engaged in a constant struggle to overcome the naturalistic tradition of Stanislavsky. Yet Chagall's figurative fantasies were out of step with Constructivist theater design.

Chagall's interest in stage design drew him to the works of Nikolai Gogol (1809–1852), whose peculiar fusion of sharp satire, realistic detail, and flights of fantasy appealed to many of the avant-garde. Chagall designed scenery for three Gogol comedies: *The Inspector General, The Gamblers,* and *The Marriage,* although he only received a commission for the first.

The Traveler (Forward!) of 1919–20 is a sketch for either the curtain or the backdrop of Gogol's *The Marriage.* In the play, the reluctant bridegroom Podkoliosin jumps from a window to avoid his wedding; he survives the short drop, cries "Hi, coachman!…off! off!" and flees from his bride in a carriage. Gogol's character is selfish and sexually repressed, but Podkoliosin's colorful, lyrical treatment by Chagall expresses the joy Chagall found in his own marriage. The 1919–20 sketch places the leaping figure against large, geometric forms; it is a freer replica of a 1917 gouache that shows the same figure in more detail. Chagall also used the design for a banner during the 1918 Vitebsk celebration of the October Revolution. These depictions are related to many ebullient theater designs from about 1917, but Chagall's famous *The Holy Carter,* painted in Paris as early as 1911–12, is perhaps the genesis of the motif.

Composition with Goat, although dated 1917, shares with *The Traveler (Forward!)* of 1919–20 an interest in geometric shapes which approach the non-objective. *Composition with Goat* also can be related to Chagall's stage work, perhaps specifically to the 1920 designs for the realized production of Gogol's *The Inspector General.*

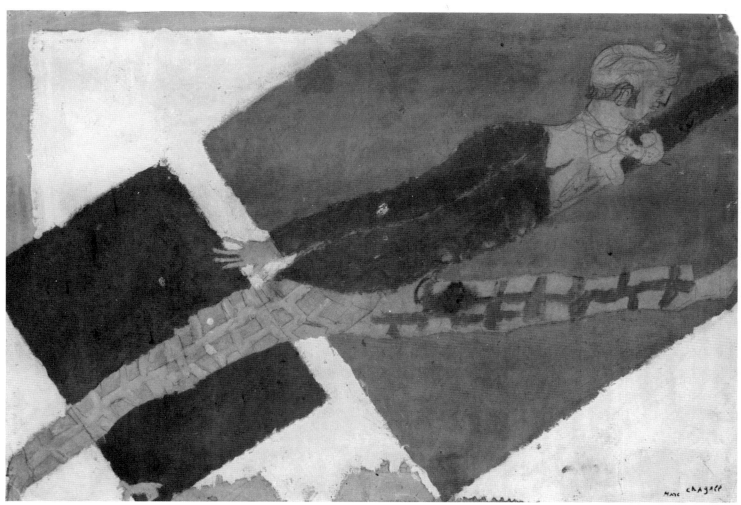

23

Chashnik, Ilia Grigorievich

Born 1902 Liuchite; died 1929 Leningrad.

24.

Suprematist Composition,
1921–22
India ink and watercolor on paper
34 x 37.8 cm. (13⅜ x 14⅞ in.)
Bruce and Kathy Gallagher-
McCowan, New York

25.

Floating Suprematist Forms,
1922
Watercolor on paper
73.5 x 52.8 cm. (29 x 20⅞ in.)
Leonard Hutton Galleries, New York

26.

White Monochrome Relief, 1922
Painted wood
98 x 147 cm. (38⅝ x 57⅞ in.)
Leonard Hutton Galleries, New York

27.

**Suprematist Color Lines in
Horizontal Motion,** 1922
India ink, watercolor, gouache, and
pencil on paper
36.6 x 33.6 cm. (14⅜ x 13¼ in.)
Leonard Hutton Galleries, New York

With Nikolai Suetin was one of Malevich's closest collaborators; 1919 onward was a member of Posnovis, later called Unovis, in Vitebsk; within this group led by Malevich, worked closely with Vera Ermolaeva, Lazar Khidekel, Gustav Klucis, El Lissitzky, Nikolai Suetin, and Lev Yudin; 1920 with Khidekel edited the group's journal *AERO*; 1921 co-founded the journal *Unovis*; 1922 with Malevich, Suetin, Yudin, et al. moved to the Petrograd Inkhuk, where he assisted Malevich with the architectural constructions *arkhitektony* and *planity* and worked on ceramic designs as well as on his own Suprematist paintings; 1923 contributed to the *Exhibition of All Trends* in Petrograd; 1928 with Suetin designed residential quarters for the Bolshevik Factory in Leningrad.

Bibliography
Ilja G. Tschaschnik, exh. cat.,
Kunstmuseum, Düsseldorf, and
Bauhaus-Archiv, Berlin, 1978.

John E. Bowlt, "Malevich and His
Students," *Soviet Union,* Arizona
State University, vol. 5, part 2, 1978,
pp. 256–86.

Ilya Grigorevich Chasnik, exh. cat.,
Leonard Hutton Galleries, New York,
November 2, 1979–March 15, 1980.

27

At the age of seventeen Chashnik began his studies under Malevich at the Practical Art Institute in Vitebsk. Under Malevich's direction Chashnik, like his fellow student Suetin, applied a Suprematist aesthetic to the industrial arts. This close association with Malevich strongly influenced the next ten years of his brief life.

Chashnik immersed himself in a study of Malevich's Suprematism from 1919 to 1921, developing a unique style. He focused on two distinct modes: one incorporated floating elements on two color fields, the other utilizing fully symmetrical Suprematist compositions.

In 1922 Chashnik joined Suetin in assisting Malevich at the Lomonosov porcelain factory in Petrograd. He worked at the factory for over two years and created hundreds of drawings, studies, and models for porcelain, all in the Suprematist manner. Examples of Chashnik's pieces were exhibited in Paris at the *Exposition internationale des arts décoratifs et industriels* in 1925.

Chashnik's interest in architecture was stimulated by Malevich's research into idealized architectural models called "architectons." In October 1925, Chashnik was invited to work as researcher at the Decorative Institute in the laboratory headed by Malevich. At the same time Chashnik worked on his own models. The two artists had radically different approaches to their architectons, particularly in matters of scale and symmetry. Chashnik concentrated on a symmetrical approach and visualized architectons of tremendous size; Malevich's asymmetrical models had a utilitarian character scaled to the human body.

Unfortunately, Chashnik's unique contribution to Suprematism was cut short by his untimely death at the age of twenty-seven from appendicitis.

24

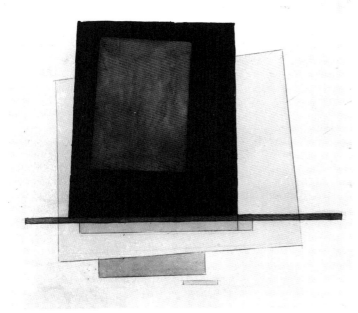

25

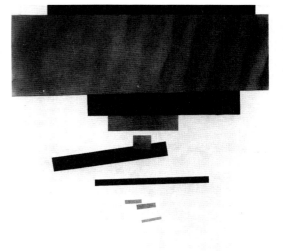

28.
Vertical Axes in Motion, 1922–23
India ink and watercolor on paper
28.9 x 21.6 cm. (11⅜ x 8½ in.)
Leonard Hutton Galleries, New York

29.
Suprematist Watercolor, c. 1922–23
Watercolor on paper
12.7 x 21.6 cm. (5 x 8½ in.)
Ruth and Marvin Sackner

30.
Design for a Black Suprematist
Cup with Red Middle Axis, 1923
India ink and watercolor on paper
13.5 x 19.2 cm. (5⅜ x 7⅝ in.)
Leonard Hutton Galleries, New York

31.
Plate, c. 1923
Porcelain
diam: 23.5 cm. (9¼ in.)
Galerie Jean Chauvelin, Paris

32.
Soup Tureen with Cover, 1924
Porcelain
22 x 33 cm. (8⅝ x 13 in.)
Galerie Jean Chauvelin, Paris

33.
Design for a Suprematist
Architecton, 1924–25
India ink, watercolor, and pencil on
paper
23.2 x 16.5 cm. (9⅛ x 6½ in.)
Leonard Hutton Galleries, New York

34.
Cosmos—Red Circle on Black
Surface, 1925
India ink and watercolor on paper
37.2 x 32.8 cm. (14⅝ x 12⅞ in.)
Thomas P. Whitney, Connecticut
(Los Angeles County Museum of
Art only)

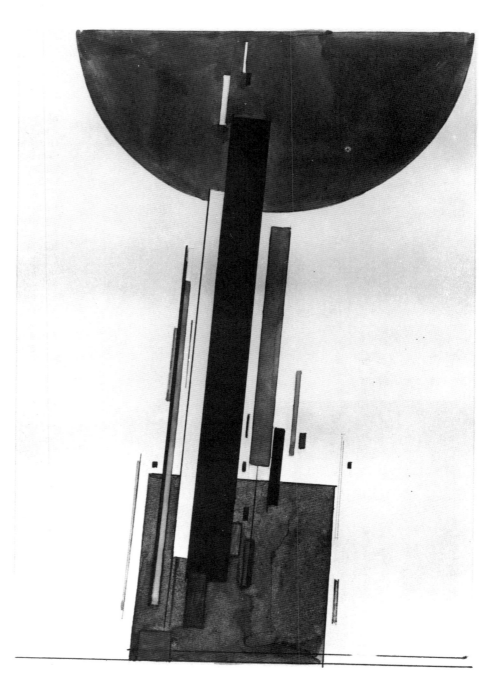

30

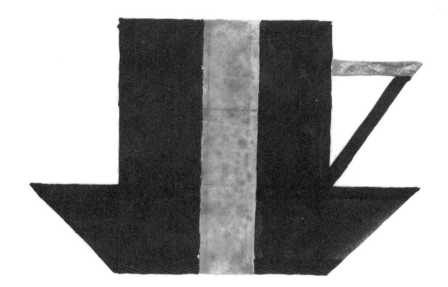

34

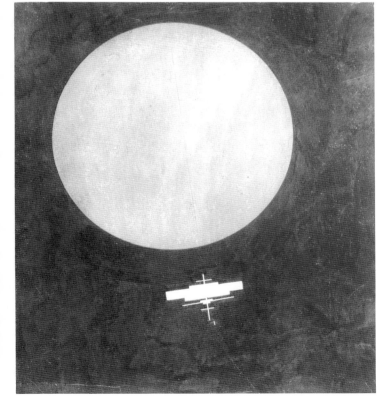

32

▶

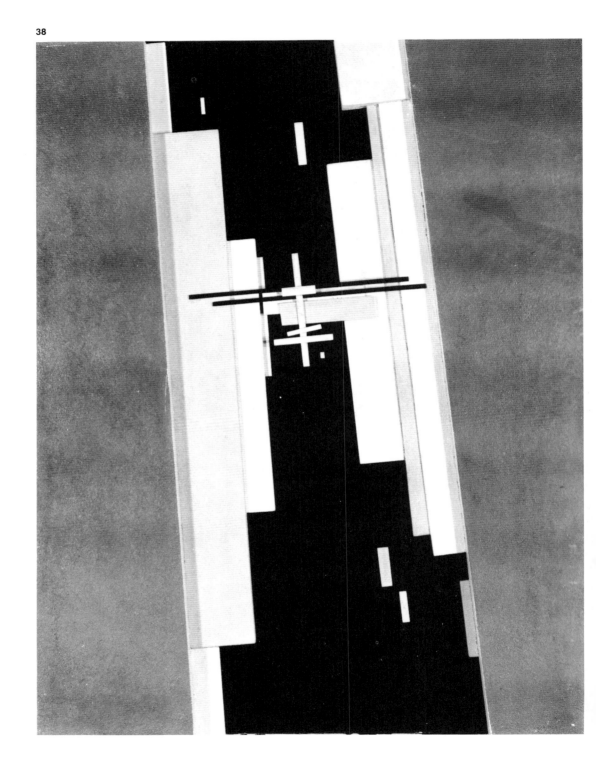

37

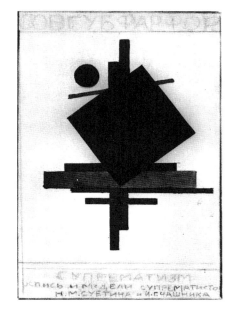

35.

**"The Seventh Dimension":
Suprematist Stripe Relief,** 1925
Painted wood, paper, cardboard,
and glass
26 x 22.5 cm. (10¼ x 9⅞ in.)
Leonard Hutton Galleries, New York

36.

Untitled, c. 1925
Watercolor on paper
19 x 15.5 cm. (7½ x 6⅛ in.)
N. Seroussi, Galerie Quincampoix,
Paris

37.

**Design for a Poster for the
Exhibition Chashnik-Suetin,** 1926
India ink, watercolor, and pencil on
paper
19.7 x 14.3 cm. (7¾ x 5⅝ in.)
Private collection, Switzerland

38.

Relief Suprematism No. II, c. 1926
Painted wood and glass
85 x 63 cm. (33½ x 24⅝ in.)
Thyssen-Bornemisza Collection,
Lugano, Switzerland

39.

**Suprematist Architectural Model:
Cross and Circle,** 1926
Plaster
18.7 x 16.4 x 2.7 cm. (7⅜ x 6½ x
1⅛ in.)
Leonard Hutton Galleries, New York

■ …Taking courses in all the departments of painting and in the geometrization of Cubism and Futurism simply prepares [one] for approaching Suprematism, for studying its system and its laws, for elucidating its planned movement in space. The constructions of Suprematism are blueprints for the building and assembling of forms of utilitarian organisms. Consequently, any Suprematist project is Suprematism extended into functionality. The Department of Architecture and Technology is the builder of new forms of utilitarian Suprematism; as it develops, it is changing into a huge workshop-laboratory, not with the pathetic little workbenches and paints in departments of painting, but with electric machines for casting, with all kinds of apparatuses, with the technological wealth of magnetic forces. [This deparment works] in concert with astronomers, engineers, and mechanics to attain a single Suprematism, to build organisms of Suprematism—a new form of economics in the utilitarian system of contemporaneity….

Long live the Unovis party, affirming the new forms of Suprematist utilitarianism.

Ilia Chashnik, "Arkhitekturno-tekhnicheskii fakultet," *Unovis*, Vitebsk, no. 2, 1921, pp. 12–13. Translated from the Russian by John E. Bowlt.

39

Ermilov, Vasilii Dmitrievich

Born 1894 Kharkov; died 1968 Kharkov.

40.

Constructivist Composition,
c. 1920
Wood, metal, and cloth on sand-
covered board
77.5 x 77.5 cm. (30½ x 30½ in.)
Mr. and Mrs. Roald Dahl

41.

**Project for a Monument to the
Chairman of the World Khlebnikov,**
1924/1967
Wood and papier-mâché
59.1 x 41 x 41 cm. (23¼ x 16⅛ x
16⅛ in.)
Thomas P. Whitney, Connecticut

42.

Untitled, c. 1925
Oil and collage on wood
91.4 x 66 cm. (36 x 26 in.)
Galerie Jean Chauvelin, Paris

43.

Composition, 1926
Gouache on paper
32.5 x 30.5 cm. (12¾ x 12 in.)
Mr. and Mrs. Ahmet Ertegün

44.

Poster, 1927
Woodblock print (artist's proof)
74 x 100 cm. (29⅛ x 39⅜ in.)
Bruce Fine Art Ltd., London

45.

Poster, 1927
Woodblock print (artist's proof)
74 x 100 cm. (29⅛ x 39⅜ in.)
Bruce Fine Art Ltd., London

46.

Untitled, 1928
Gouache and collage
27 x 41.5 cm. (10⅝ x 16⅜ in.)
N. Seroussi, Galerie Quincampoix,
Paris

Bibliography

Z. Fogel, *Vasilii Ermilov,* Moscow,
1975.

V. Polishchuk, *Vasilii Ermilov:
Ukrainske maliarstvo,* Kharkov, 1931.

L. Zhadova, "Proekty V. Ermilova,"
Dekorativnoe iskusstvo, Moscow,
no. 9, 1972, pp. 30–32.

1905–9 attended the School of Decorative Arts,
Kharkov; 1910–11 attended the Kharkov Art School and
private studios; 1913 entered the Moscow Institute of
Painting, Sculpture, and Architecture, attending the
studios of Petr Konchalovsky and Ilia Mashkov; made
contact with the Cubo-Futurists including David Burliuk
and Vladimir Maiakovsky; until 1916 rapidly assimilated
the principles of Neo-Primivitism, Cubo-Futurism, and
then Suprematism; 1917 returned to Kharkov; contributed
decorations to the Futurist album *7 + 3* published in
Kharkov—which formed the basis for his important sub-
sequent work in book design and illustration, e.g., for the
first edition of Velimir Khlebnikov's *Ladomir* (1920) and
the journal *Avangard (Avant-Garde,* 1928–30); 1918
joined the group of monumental artists known as the
Union 7; 1919–20 designed agit-posters, interiors of
clubs, agit-trains, etc.; 1922 co-organizer of the Kharkov
Art Technicum and lecturer at the Kharkov Art Institute;
late 1920s–30s worked on several architectural and the-
atrical designs; 1931 Valerian Polishchuk's monograph
on Ermilov published in Kharkov; 1937–38 with Anatolii
Petritsky designed the interior of the Ukrainian pavilion
for the All-Union Agricultural Exhibition in Moscow.

41

40

■ Vasilii Ermilov was a leading member of the Ukrainian avant-garde. Three years of training in Moscow (1913–16) introduced him to the leading figures of the Russian avant-garde; there he quickly assimilated the principles of Neo-Primitivism, Cubo-Futurism, and Suprematism.

By 1917 Ermilov had reached a stylistic maturity consonant with Constructivist tenets. He became committed to the Productivist ideal of bringing mass art to the population; he produced huge agit-prop murals, painted agit-prop trains, and engaged in architectural and stage design. He also worked extensively in graphic design during the 1920s. The posters of 1927 are characteristic of his interest in typography.

Ermilov's achievement was not limited to mass art or government commissions; his reliefs, which he called "Experimental Constructions," were investigations into a purely formal vocabulary. True to the logic of Constructivism, the technical, structural potential of materials such as wood and metal is respected. *Constructivist Composition* (1920) and *Untitled* (1925), an oil and collage on wood, are typical of Ermilov's expression. He was unique among the Constructivists in his attention to color; his work utilized an extremely rich palette.

Monument to Khlebnikov was conceived as an homage to the Futurist poet Vladimir Khlebnikov in 1924, but it was probably not executed until 1967. This "orb on a pedestal" with its basic geometric volumes and the contrast of curvilinear and rectilinear forms is typical of Ermilov's style.

Ermilov's formalist approach fell out of favor in the Ukraine by the late 1920s. Like many of his colleagues, he was ostracized by the authorities, and much of his work was lost or destroyed as a result of persecution. The artist's shift to a quasi-classicism in the late 1930s must be seen in light of these pressures.

▶

■ Studio painting was swept aside completely by the demands of that time [1920]. Decorative form held preeminence—even portraits were made by means of stencils. That is what the scale of the streets and squares required. New Constructivist forms emerged, forms that satisfied the visual and emotional perception of the masses and were appropriate to the designs for the great October and May Day festivities.

From a letter to Zinovii Fogel of December 1, 1966. Quoted in Z. Fogel, *Vasilii Ermilov,* Moscow, 1975, p. 30. Translated from the Russian by John E. Bowlt.

42

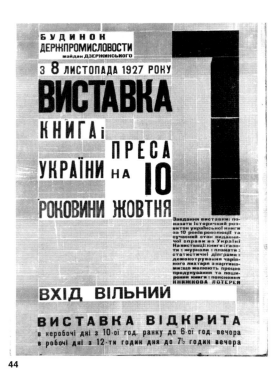

44

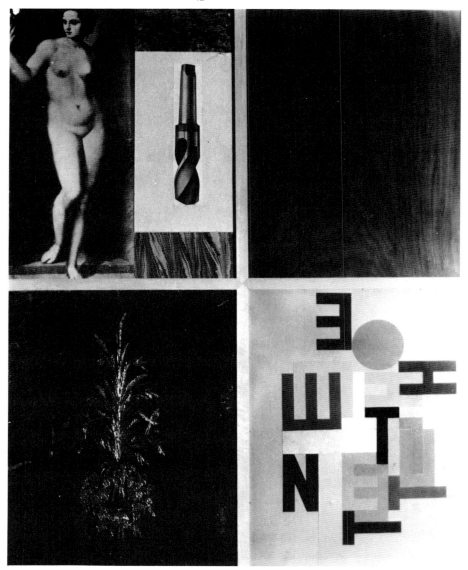

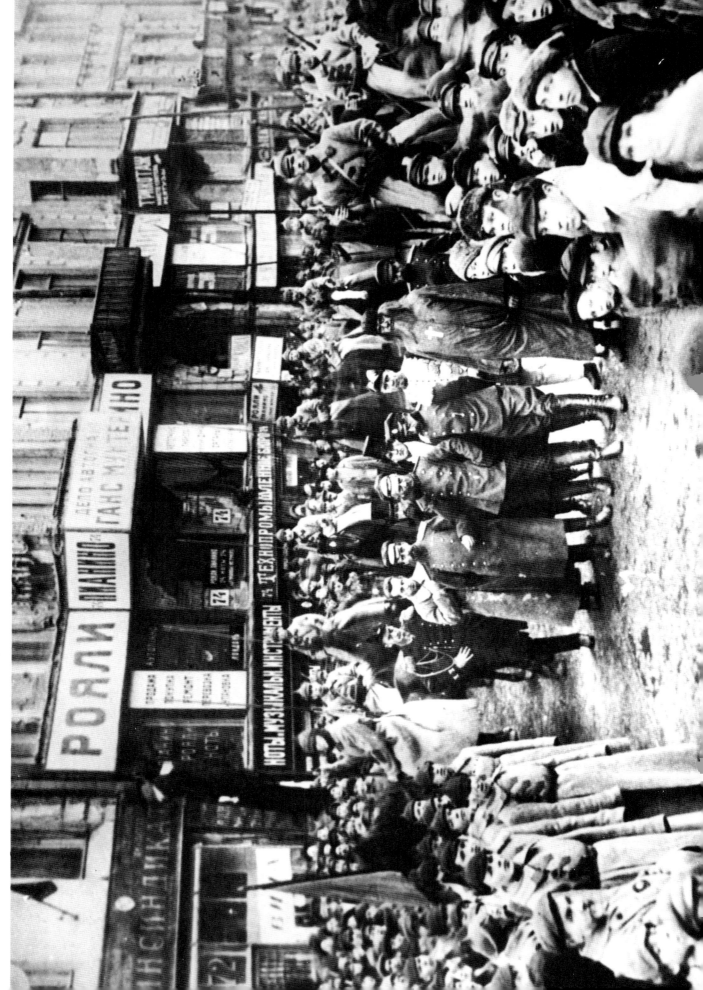

Participants in a mass theatrical procession in Petrograd, 1919

Ermolaeva, Vera Mikhailovna

Born 1893 Petrovsk; died 1938 Siberia.

47.
Design for "Victory Over the Sun," 1920
Woodcut with watercolor additions
16.7 x 20 cm. (6⅝ x 7⅞ in.)
Collection, The Museum of Modern Art, New York, Larry Aldrich Fund, 431.77

Bibliography

John E. Bowlt, "Malevich and His Students," *Soviet Union,* Arizona State University, vol. 5, part 2, 1978, pp. 256–86.

E. Kovtun, "Khudozhnitsa knigi Vera Mikhailovna Ermolaeva," ed. D. Shmarinov et al., *Iskusstvo knigi,* Moscow, 1975, pp. 68–81.

E. Kovtun, "Vera Mikhailovna Ermolaeva," *Women Artists of the Russian Avant-Garde 1910–1930,* exh. cat. in German and English, Galerie Gmurzynska, Cologne, 1979, pp. 102–10.

About 1912 finished high school in St. Petersburg; 1914 entered Mikhail Bernstein's art school in St. Petersburg; contact with the members of the Union of Youth, including Pavel Filonov, Malevich, and Matiushin; 1917 graduated from the Archaeological Institute, Petrograd; 1918 member of IZO NKO in Petrograd; 1918–19 worked at the City Museum, Petrograd; at this time was especially interested in folk art; 1919 published an article on old shop signboards in *Iskusstvo kommuny (Art of the Commune)*; began to work on illustrations for children's books, making contact with Annenkov, Lebedev, et al.; moved to Vitebsk, becoming rector of the Art Institute there until 1923; invited Malevich to teach there; until 1920s Ermolaeva was influenced by Malevich's ideas of Suprematism, joined his group, and contributed to its several exhibitions; 1922 contributed set designs for the Kruchenykh/Matiushin opera *Victory Over the Sun* to the *Erste Russische Kunstausstellung,* Berlin; 1923 with Malevich and Malevich's students moved to Petrograd where, until 1926, she headed the color laboratory within the Petrograd affiliation of Inkhuk; mid-1920s onward worked on many children's books by Aseev, Kharms, Vvedensky, Zabolotsky, et al., and on editions of Krylov's fables; 1934 arrested and exiled because of her brother's involvement with the Mensheviks; 1936–38 serious illness caused progressive amputation of her legs; died in Siberia.

■ The impact of Vera Ermolaeva on the development of the Russian avant-garde has only recently come to light. Her role as catalyst and her pioneering work in book design profoundly shaped the course of the avant-garde during the 1920s and 1930s. Ermolaeva's artistic development was marked from the start by a close affiliation with the leading personalities of the time—Tatlin, the Union of Youth members, and Larionov.

After the Revolution of 1917 her role in shaping the avant-garde assumed greater proportions. She worked in Petrograd along with Annenkov and Altman on stage design projects, and at this point she began work in book design. Her apartment became the setting for gatherings of artists and poets, including Maiakovsky; she was the first artist to illustrate Maiakovsky's poetry.

In 1919, then twenty-six, Ermolaeva was appointed director of the Vitebsk Art School; she replaced its founder, the well-known Chagall, who by 1919 had fallen out of favor and was considered too conservative and bourgeois. At Ermolaeva's invitation Malevich moved to Vitebsk and set up a workshop. Ermolaeva's development during the 1920s must be seen in terms of her constant creative relationship with Malevich, who exerted a powerful influence over the school.

By 1920 Ermolaeva was immersed in Suprematism. She played an active role in Unovis, the association that steered the artistic community in Vitebsk by organizing exhibitions, public discussions, and theatrical events. Ermolaeva was known for arranging demonstrations of experimental drawing that were open to the public. Her specialty was Cubism, and she explained and demonstrated its principles. Unovis was also responsible for restaging in 1920 the famous Futurist opera *Victory Over the Sun* in a version more modest than the original 1913 production by Malevich, Kruchenykh, and Matiushin. Ermolaeva's sketches in linocut for the stage design and costuming were shown in Berlin in 1922 at the *Erste Russische Kunstausstellung* and illustrated in the catalog for the show.

In 1923 Ermolaeva and Malevich moved to Petrograd to work at Inkhuk, the Institute of Artistic Culture. Along with Chashnik and Suetin, Ermolaeva formed the original core of "scientific" collaborators and practitioners in Malevich's department. Ermolaeva managed the color laboratory.

Ermolaeva's work is considered to have reached its peak at the State Children's Book Publishing House, from 1925 to 1934. She was among the first to seek out new criteria for the form and content of children's literature, and her work greatly influenced a number of artists in that field. Unfortunately, most of her work in book design is now lost. Ermolaeva turned away from an orthodox conception of Suprematism in the late 1920s, in order to explore further her longstanding interest in Cubism. Her last works are somberly depicted still lifes.

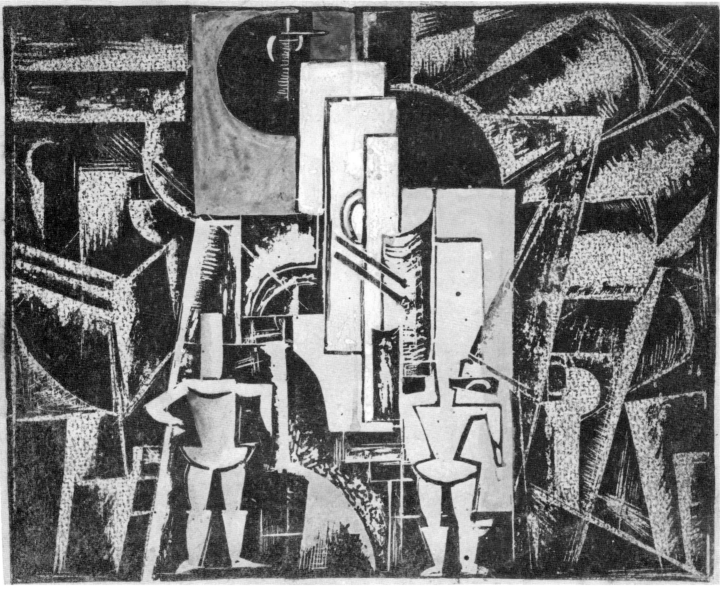

47

Exter, Alexandra Alexandrovna

Born 1882 Belestok, near Kiev; died 1949 Paris.

48.

Colored Rhythms, c. 1916–17
Gouache on paper
71.3 x 56 cm. (29⅛ x 22 in.)
Galleria Milano, Milan, Italy

49.

Dynamic Composition, c. 1916
Gouache on paper
65 x 50 cm. (25⅝ x 19⅝ in.)
Guido Rossi, Milan, Italy

50.

Pikasso i okrestnosti (Picasso and Environs) by I. Aksenov
Moscow, 1917
70 pp. with color cover by Exter, 12 reproductions
Ex Libris 6, no. 1
26.7 x 20.6 cm. (10½ x 8⅛ in.)
Australian National Gallery, Canberra

51.

Composition, c. 1921
Gouache on paper
42 x 39 cm. (16½ x 15⅜ in.)
Albright-Knox Art Gallery, Buffalo, New York, Edmund Hayes and Charles W. Goodyear Funds, inv. 1974: 24

52.

Alexandra Exter by I. Tugendhold, Paris, 1922
22 pp. text, 40 black-and-white reproductions, 3 in color
Ex Libris 6, no. 325
21.7 x 15.7 cm. (8⅝ x 6¼ in.)
Leonard Hutton Galleries, New York

Until 1907 attended the Kiev Art School; 1908 onward was a regular visitor to Paris and other Western European cities; took part in several Kiev exhibitions, including David Burliuk's *Link* and that of the journal *V mire iskusstv (In the World of Arts)*; also represented at the St. Petersburg New Society of Artists (1908, 1909), the Izdebsky Salons (1909–10, 1911), the Moscow Salon (1911–12), etc.; 1912 moved to St. Petersburg, although continued to travel frequently, coming into closer contact with the Russian and Western avant-gardes; became particularly close to the poet Benedikt Livshits and gave him several of her works; was associated with the Union of Youth, contributing to its first and last exhibitions; 1915–16 contributed to *Tramway V* and *The Store*; began her professional theater work for Innokentii Annensky's *Thamira Khytharedes,* produced by Alexandr Tairov at his Chamber Theater, Moscow—the first of several collaborations with Tairov; 1918 founded her own studio in Kiev whence emerged many artists who were to achieve fame in later years such as Ignatii Nivinsky, Anatolii Petritsky, Isaak Rabinovich, Nisson Shifrin, Pavel Tchelitchew, Alexandr Tyshler; it was here that Exter and her pupils created huge Suprematist designs for several agit steamers on the Dnepr River; 1921 contributed to the exhibition *5 x 5 = 25*; then turned to textile design while still maintaining her interest in stage design; 1923 began to work on her sets and costumes for the movie *Aelita* (produced in 1924); with Nivinsky designed decorations for the *First Agricultural and Handicraft-Industrial Exhibition* in Moscow; 1924 emigrated to Paris, where she worked on designs for the stage, for fashion, interiors, and books.

51

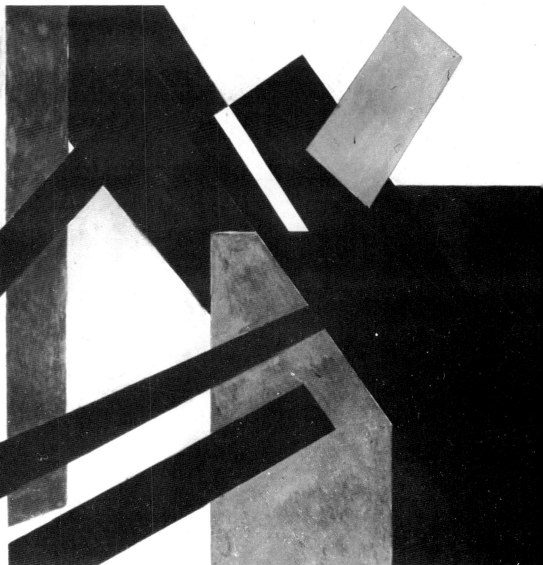

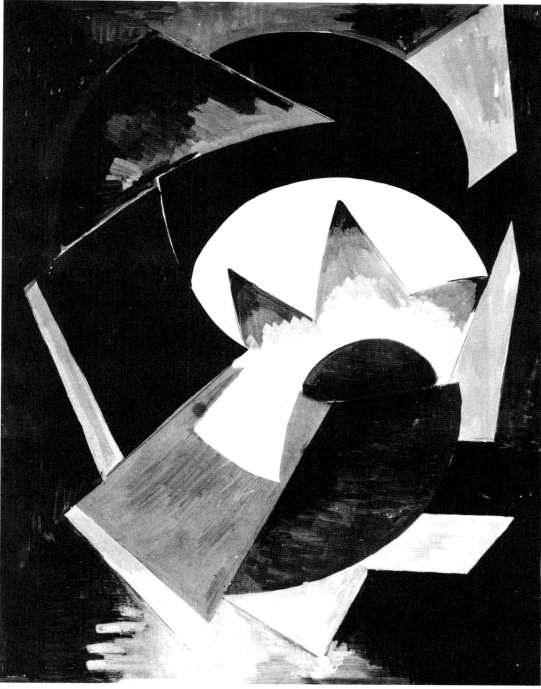

49

53.
Construction of Lines, 1923
Watercolor and gouache on paper
56 x 56 cm. (22 x 22 in.)
Galerie Jean Chauvelin, Paris

54.
**Costume for Male for the Film
"Aelita,"** 1924
Gouache on paper
53 x 34 cm. (20⅞ x 13⅜ in.)
Mississippi Museum of Art,
Jackson, The Lobanov Collection

55.
**Costume for Female for the Film
"Aelita,"** 1924
Gouache on paper
47.6 x 17.8 (18¾ x 7 in.)
Mississippi Museum of Art,
Jackson, The Lobanov Collection

56.
**Costume Design for the Queen
of the Martians for the Film
"Aelita,"** 1924
Ink and gouache on paper
50.2 x 42.5 cm. (19¾ x 16¾ in.)
Mississippi Museum of Art,
Jackson, The Lobanov Collection

57.
Dress, c. 1924
Reconstruction 1979, models
realized by van Laack according to
original artist's sketches
Flannel/serge; size 8/10
Collection van Laack Company,
West Germany

58.
**Stage Design and Lighting Study
for Scene 3, "Don Juan,"** 1926
Gouache on paper
67.3 x 49.5 cm. (26½ x 19½ in.)
Mississippi Museum of Art,
Jackson, The Lobanov Collection

53

liography

xandra Exter: Marionettes, exh.
, Leonard Hutton Galleries,
v York, 1975.

*st of the Theatre: Alexandra
r,* exh. cat., Lincoln Center,
v York, 1974.

n E. Bowlt, "Aleksandra Exter: A
table Amazon of the Russian
nt-Garde," *Art News,* New York,
btember 1974, pp. 41–43.

Jakov, *Alexandra Exter,*
erie Jean Chauvelin, Paris,
. cat., 1972.

Rakitin, "Marsiane A. Exter,"
korativnoe iskusstvo,* Moscow,
4, 1977, pp. 29–30.

n-Claude Marcadé, "Alexandra
er or the Search for the
ythms of Light-Color," *Women
sts of the Russian Avant-Garde
0–1930,* exh. cat. in German
d English, Galerie Gmurzynska,
ogne, 1979, pp. 125ff.

■ A much traveled artist, Alexandra Exter provided an important link between the Russian and Western avant-garde. As a major contributor to such Russian pre-Revolutionary exhibitions as *Tramway V,* 1915, and *The Store,* 1916, Exter participated with Malevich and Tatlin in the creation of non-objective art. She was interested in Cubist theory and designed the cover for J. Aksenov's *Picasso and Environs (Pikasso i okrestnosti);* this polemical treatise on art and criticism, of much interest to the Russian avant-garde, was published in Moscow in 1917. After the Revolution, Exter and her many students were active in popularizing Suprematist compositional principles in designs for agit-prop vehicles. In 1921 she helped pave the way for Constructivism by joining with Rodchenko, Popova, Stepanova, and A. Vesnin in the historic *5 x 5 = 25* exhibition. In the 1920s Exter directed her Productivist interest toward theater, cinema, and industrial design both in Russia and in Paris, where she settled in 1924.

Exter's paintings, textile designs, and marionettes were celebrated both in Russia and the West. Her fully realized non-objective *Composition* (c. 1921) establishes her control over an interlocking equilibrium of dynamic shapes positioned in flattened space. *Dress* (c. 1924, reconstructed 1974) exploits non-objective motifs in its geometricized pattern and stark black and eggshell white contrasts; its deceptively simple structure and shape are designed to be animated by the human figure moving through space. Most often cited for her pioneering set and costume designs for Alexandr Tairov's Kamerny Theater in Moscow, Exter was true to Constructivist ideals in emphasizing the use of industrial materials and the concrete construction of space. Her designs for the theater can be studied closely in I. Tugenhold's *Alexandra Exter,* published in Paris in 1922.

Exter's work for the revolutionary Russian cinema is particularly interesting. Yakov Protazanov's science fiction film *Aelita* was produced in Moscow in 1924 by the Mezhrabpon-Russ company. Based on a story by Alexei Tolstoi, the film concerns an engineer, a Red Army soldier, and a detective who are all transported to Mars. Against the background of a Martian revolutionary uprising, the engineer conducts a love affair with Aelita, the Queen of Mars. Realistic and satiric scenes of Moscow during the New Economic Plan period are contrasted with Martian hallucinations. The nature of the film medium enabled Exter to experiment with contrived spatial situations undergoing constant change. Into such fluid space Exter integrated bizarre costumes that emphasized geometric asymmetry, harsh black-and-white contrast, and innovative juxtaposition of such machine-cult media as aluminum, metal-foil, glass, and perspex. Although *Aelita* was not received well by the critics, it was immensely popular with the people. Exter's experiments in spatial construction were continued in Paris, as illustrated by the *Stage Design and Lighting Study for Scene 3, "Don Juan,"* done after Exter's emigration.

■ The works on display are part of a general program of experiments in color which partly resolves the problems of color interrelationship, co-intensity, rhythmization, and the transition to color construction based on the laws of color itself.
Alexandra Exter, statement in *5 x 5 = 25* catalog, Moscow, 1921. Translated from the Russian by John E. Bowlt.

56

Filonov, Pavel Nikolaevich

Born 1883 Moscow; died 1941 Leningrad.

59.
Head, 1925
Pencil and watercolor on paper
25.5 x 18.5 cm. (10 x 7¼ in.)
George Riabov, New York

Bibliography

John E. Bowlt, "Pavel Filonov: An Alternative Tradition?" *Art Journal*, New York, vol. 34, no. 3, spring 1975, pp. 208–16.

J. Kříž, *Pavel Nikolajevič Filonov*, Prague, 1966.

M. Ostrovsky (compiler), "P.N. Filonov," *Sto pamiatnykh dat. khudozhestvennyi spravochnik*, Moscow, 1973, pp. 13–15.

Pervaia personalnaia vystavka. Pavel Filonov 1883–1941, exh. cat., Novosibirsk, 1967.

K. Sokolov, ed., "Pavel Filonov: 'The Ideology of Analytic Art and the Principle of Craftedness,'" *Leonardo*, Boulogne-sur-Seine, 1977, vol. 10, pp. 227–32.

1897 Filonov, an orphan, moved to his married sister's apartment in St. Petersburg; attended classes in house painting and decorating; simultaneously attended evening classes at the Society for the Encouragement of the Arts; 1903–8 attended the private studio of the Academician Lev Dmitriev-Kavkazsky; 1908–10 attended the Academy of Arts; 1910 expelled from the Academy; close to the Union of Youth, contributing to three of its exhibitions; 1912 traveled to Italy and France; 1913 with Iosif Shkolnik designed décor for Maiakovsky's tragedy *Vladimir Maiakovsky*; 1914–15 illustrated Futurist booklets and published a long, transrational poem with his own illustrations called *Propoved o prorosli mirovoi (Chant of Universal Flowering)*; began to work on his so-called "Ideology of Analytical Art and Principle of Madeness"; 1916–18 military service on the Rumanian front; 1919 represented at the *First State Free Exhibition of Works of Art* in Petrograd; 1923 professor at the Academy of Arts in Petrograd and associate of Inkhuk there; published his "Declaration of Universal Flowering" in *Zhizn iskusstva (Life of Art)*; 1925 established the Collective of Masters of Analytical Art (the Filonov School); 1929–30 one-man exhibition planned at the Russian Museum, Leningrad, but not opened; 1931–33 supervised the illustrations for the Academia edition of the Kalevala; 1932 contributed to the exhibition *Artists of the RSFSR over the Last 15 Years*; 1941 died of pneumonia during the Siege of Leningrad; 1967 first one-man show opened in Novosibirsk.

■ Pavel Filonov held a unique position in the Russi[an] avant-garde. As one of the founding members of [the] Union of Youth, Filonov was closely associated with lea[d]ing figures of the period. Nevertheless, his work did [not] follow the general trends and tendencies of his c[ol]leagues' development; he had already reached his m[a]ture style by 1910.

Filonov came from an impoverished backgrou[nd] and was orphaned early in life. An emotional attachm[ent] to the working class resulted in a refusal to sell his pai[nt]ings or to sign them. Filonov thought of the paintings [as] universal symbols and hence as popular property. [His] conception of art was basically expressionistic, gea[red] toward intuition, and his work remained figurati[ve] throughout his career. Filonov's theoretical foundat[ion] was of the utmost importance in his work. By 1914 he h[ad] already begun formulating the complex "Ideology of A[na]lytical Art and Principle of Madeness" which would pre[oc]cupy him for the rest of his life. The theory is a care[ful] synthesis of intellect and intuition. His notion was that [the] world is basically chaotic and that the chaos could [be] overcome only through intuition. He did not share [the] future Constructivists' rational and tectonic attitud[e]. Filonov was profoundly concerned with the actual exe[cu]tion of a painting, which he termed "madeness." He [de]voted an almost fanatical attention to a technique t[hat] concentrated on line as the expressive force. Unfor[tu]nately, very little of Filonov's work is available in the W[est] and fully worked out canvases are particularly rare. The[se] compositions are exceptionally intricate, with a profus[ion] of detail and multiple figures. The angularity and caref[ully] delineated forms in *Head* (1925) share characterist[ics] with his painting. The linear precision can be traced ba[ck] to his training in the studio of the Academician L[ev] Dmitriev-Kavkazsky. *Head* also exemplifies Filono[v's] interest in the icon, Byzantine art, and early Russian a[rt].

After the Revolution, Filonov's theory gained increa[s]ing recognition. He taught at the Academy of Art in Pet[ro]grad and became an associate of Inkhuk. By 1925 [he] had a devoted following of students and established [the] Collective of Masters of Analytical Art (which came [to] be known as the Filonov School).

Filonov began to come under attack in the m[id] 1920s. His refusal to embrace Socialist Realism resul[ted] in ostracism; he was not represented at any offi[cial] exhibition from 1934 to 1941.

■ I completely reject as unscientific all dogmas in painting from the extreme rightists to the Suprematists and Constructionists together with all their ideologies. Not one of their leaders can paint, draw, or understand in analytical terms what, how, and why he paints.

I declare Picasso's "reformation" to be merely scholastic and formal and, essentially, to be lacking in revolutionary significance. I declare further that there are two methods for approaching the object and its resolution: (1) the absolutely spontaneous, analytically intuitive method; and (2) the absolutely scientific and absolutely analytical-intuitive method. I declare also that the artist's ideology and the ideology of his paintings—construction, form, color, texture—are measured by the science and ideology of his own time (or of a subsequent time).

"Realism" is a scholastic abstraction of only two of the object's predicates: form and color. Speculation with these predicates results in aesthetics.

I would sum up the whole "rightist-leftist" front as aesthetic speculation precisely with these two predicates; and, essentially, I would call this front realist—but a realism of obsolete scholasticism....

Since I know, analyze, see, feel by intuition that in any object there are not just the two predicates of form and color, but a whole world of visible and invisible phenomena, their emanations, reactions, interfusions, geneses, separate realities, and known or unknown qualities which, in turn, sometimes contain innumerable predicates—I reject once and for all as unscientific and moribund the dogma of the contemporary realism of two predicates together with all its rightist/leftist sects.

In its place I advocate scientific, analytical-intuitive naturalism; I advocate the researcher's initiative, the researcher who examines all the object's predicates, the phenomena of the whole world, the phenomena of human processes seen and unseen by the naked eye, I advocate the master-researcher's persistence and the principle of the biologically made picture....

I define Russian art (in general) as an exclusive variety of European art (in general) because of its specific, textural peculiarities: weight, moisture, spontaneous manner of execution, organic aesthetics. These factors indicate that the artist has achieved his goal by inner conviction and not by canon.

In this situation the master's spirit dynamically enters the material of the object, dominating the condition of depiction while consciously or unconsciously rejecting the canon. The French school (in general) consists of the realism of two predicates and speculative aesthetics. The Russian school (in general) consists of the realism of two predicates, organic aesthetics, but also an elemental, essential derivation from canon (cf. Surikov, Savitsky, Courbet, Cézanne). Hence the conception of the Russian contribution to universal leftist art as a chronological and consistent development.

It is precisely because of this that I renounce the contemporary conception of the Russian contribution and, instead, advance my own: the Wanderers Surikov and Savitsky, the Jack of Diamonds, the Donkey's Tail, my own Rayonist works, Malevich and the Burliuks, Cubo-Futurism, my works and the thesis of pure, functioning form and the transference of the artistic center of gravity to Russia, Suprematism, Mansurov, my present (repeated) opposition to realism....

In Petrograd in 1914 and thereafter I declared for the first time the following slogans: The Made Picture, Rejection of Contemporary Art Criticism, Transference of the Gravitational Center of Contemporary Art to Russia, Pure Functioning Form, Universal Flowering.

Pavel Filonov, *Zhizn iskusstva*, Petrograd, no. 20, 1923, pp. 13–15. Translated from the Russian by John E. Bowlt.

Gabo, Naum
(pseudonym of Naum Neemia Pevsner)
Born 1890 Briansk; died 1977 Connecticut.

60.

Study for Constructed Head, 1915
Pencil on paper
10 x 18 cm. (3⅞ x 7⅛ in.)
Nina S. Gabo, London

61.

Constructed Head No. 2,
1950s replica of 1916 galvanized
iron original
Bronze
h: 45.1 cm. (17¾ in.)
Miriam Gabo

62.

Study for Constructed Head, 1916
Pencil on paper
19 x 17 cm. (7½ x 6¾ in.)
Nina S. Gabo, London

63.

Realist Manifesto, 1920
Single sheet
Approx. 91 x 76 cm. (36 x 30 in.)
Nina S. Gabo, London

Bibliography

Naum Gabo, *Of Divers Arts,* New
York, 1962.

Alexei Pevsner, *Naum Gabo and
Antoine Pevsner: A Biographical
Sketch of My Brothers,* Amsterdam,
1964.

Herbert Read and Leslie Martin,
*Gabo: Constructions, Sculpture,
Paintings, Drawings, Engravings,*
London, 1957.

1910–11 graduated from Kursk Gymnasium; entered medical school at Munich University; attended Heinrich Wölfflin's lectures there; met Kandinsky; 1912 transferred to the Polytechnicum Engineering School, Munich; traveled to Italy, visiting the collections of Old Masters in Venice, Milan, Bologna, and other cities; 1913–14 visited Paris, where his brother Antoine Pevsner was studying; studied the Cubist painters; 1914 traveled to Scandinavia; 1915 made his first constructions in metal in Norway; 1916 exhibited in Oslo; 1917 returned to Russia; 1920 compiled and published the "Realist Manifesto" (co-signed by Antoine Pevsner) in connection with an outdoor exhibition of abstract, geometric constructions; 1919–22 designed a number of utilitarian and kinetic objects such as models for a radio station and a monument for a physics laboratory; 1922 emigrated to Berlin; contact with the *Novembergruppe*; took part in the *Erste Russische Kunstausstellung*; 1920s close contact with Mies van der Rohe, Kandinsky, Paul Klee, Walter Gropius; 1924 one-man show at the Galerie Percier, Paris; 1926 included in the De Stijl group at the Little Review Gallery in New York; 1927 designed sets and costumes for Sergei Diaghilev's production of *La chatte* in Monte Carlo and Paris; represented at the *Machine Art Exposition* in New York; 1932 settled in Paris; leader of the Abstraction-Création group; 1930s many exhibitions in Europe; moved to England; 1946 arrived in the U.S.; 1971 knighted by Queen Elizabeth II; 1977 Tate Gallery, London, organized a large retrospective of his work.

■ With the expectation of becoming a physician, Na Gabo was sent in 1910 to Munich, where he stud physics and engineering; he also attended art histor Heinrich Wölfflin's famous lectures. This course of stu which merged art and science, had a tremendous imp on the aesthetic that Gabo began to develop in the 19 and which would become, after World War I, the basis Constructivist sculpture. His training in physics inclu making three-dimensional models illustrating exact m surements of mathematical formulae. This experie prompted Gabo to evolve a new method of measur space in sculpture, in which the traditional reliance mass and volume was rejected in favor of an explorat of structural forms that would leave the surface open a the interior visible.

The original *Constructed Head No. 2* of 1916 da from the period of Gabo's first tangible expression of theories. He and his brother Alexei spent the war year Norway, where Gabo began making representatio constructions of heads and torsos, at first experiment in cardboard, then in wood, and finally in metal. In radical approach, Gabo neither carved nor cast, constructed volumes through an open cellular structure intersecting planes as opposed to closed, solid mass

The original version of *Constructed Head No. 2* c sisted of galvanized sheet-iron plates covered with yel ochre paint. It was exhibited in Moscow in 1917 and Berlin and Holland in 1922–23. After the latter exhibitic was mistakenly returned to the Soviet Union while Ga remained in Berlin. Gabo did not see the work again u the 1950s, when it was sent to him in pieces. Ga stripped the paint, reassembled the work, and sub quently made six replicas in varying sizes and mediums

Gabo came into contact with his contemporaries Tatlin, Malevich, and Rodchenko—when he returned Russia in 1917. The "Realist Manifesto" of 1920, autho by Gabo but cosigned by his brother Antoine Pevsn was compiled and published in connection with an c door exhibition of abstract, geometric construction; Gabo's first show in Moscow. The work, which represe the crystallization of his aesthetics, sets forth principles non-objectivity in the plastic arts. The word "realist" v used because Gabo proposed an art that was based on realities of time and space, on the universal properties planes, edges, penetrations, depth, and kinetic rhythm

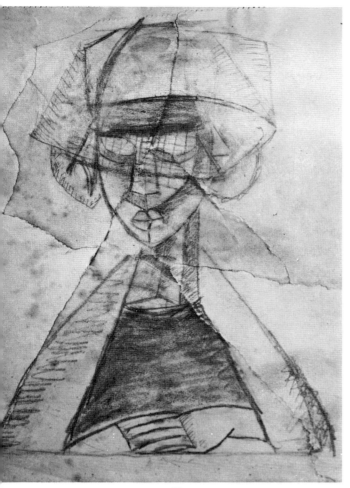

60

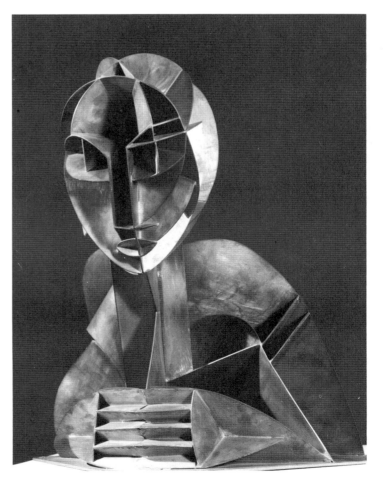

61

Goncharova, Natalia Sergeevna

Born 1881 Ladyzhino, near Tula; died 1962 Paris.

64.
Looking Glass, 1908
Oil on canvas
115 x 92 cm. (45¼ x 36¼ in.)
Private collection

65.
Red Bather, 1912
Oil on canvas
138.4 x 95.3 cm. (54¼ x 37½ in.)
Private collection

66.
Rayonist Garden: Park,
c. 1912–13
Oil on canvas
140.6 x 87.3 cm. (55⅜ x 34⅜ in.)
Collection, Art Gallery of Ontario,
Toronto, Canada
Gift of Sam and Ayala Zacks, 1970

67.
Pustynniki (Hermits) by
A. Kruchenykh
Moscow, 1913
22 pp. with 16 lithographs by
Goncharova
Ex Libris 6, no. 123
18.7 x 14.2 cm. (7⅜ x 5⅝ in.)
Australian National Gallery,
Canberra

68.
**Misticheskie obrazy voiny (The
Mystical Forms of War)**
Moscow, 1914
Book with 14 lithographs by
Goncharova
32.8 x 25.3 (12⅛ x 10 in.)
Australian National Gallery,
Canberra

69.
**Costume for a Spanish Female
Dancer, "España,"** 1914
Stencil
42.5 x 26 cm. (16¾ x 10¼ in.)
Mississippi Museum of Art,
Jackson, The Lobanov Collection

70.
Spanish Dancer, c. 1916
Oil on canvas
172.7 x 76.2 cm. (68 x 30 in.)
Ronald and Susanne Tepper

1898 enrolled at the Moscow Institute of Painting, Sculpture, and Architecture to study sculpture; 1900 changed to painting; met Larionov, who became her lifelong companion; 1906 exhibition in the Russian section at the Salon d'automne, Paris; 1908–10 contributed to the three exhibitions organized by Nikolai Riabushinsky, editor of the journal *Zolotoe runo (The Golden Fleece)*; interested in peasant and primitive art; later turned to Cubism and Futurism; 1910 founder-member of the Jack of Diamonds group; 1911 co-founder with Larionov of the Donkey's Tail group, contributing to its only exhibition in 1912; 1912 took part in Roger Fry's Post-Impressionist exhibition in London; 1913 co-founder of the Target group; 1912–13 moved from her Neo-Primitivist style to one that relied more on a synthesis of Futurism and Rayonism; illustrated a number of Futurist booklets such as *Pustynniki (Hermits)* and *Igra v adu (Game in Hell)*; 1914 with Larionov exhibited at the Galerie Paul Guillaume, Paris; designed Diaghilev's *Le Coq d'or,* the first of several spectacles for Diaghilev; 1917 settled in Paris with Larionov; 1922 with Larionov exhibited at the Kingore Gallery, New York; 1920s illustrated Russian fairy-tales such as *Tsar Saltan*; 1930s–50s continued to paint, but exhibited little; 1948 had a retrospective at the Galerie des Deux-Iles, Paris; 1956 retrospective at the Galerie de l'Institut, Paris; 1961 the Arts Council of Great Britain organized a large exhibition of her works and those of Larionov.

64

67

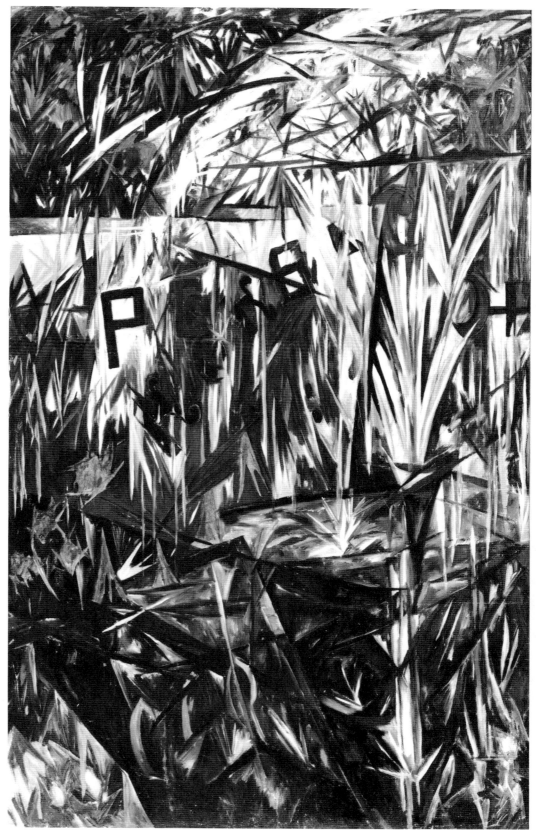

71.

Espagnole, 1916
Mixed media on paper
77 x 53 cm. (30⅜ x 20⅞ in.)
Robert L. B. Tobin

72.

Samum (Simoom) by V. Parnak
Paris, 1919
44 pp. with 3 color lithographs by
Goncharova
Ex Libris 6, no. 214
22.9 x 15.9 cm. (9 x 6¼ in.)
Robert L. B. Tobin

73.

Gorod. Stikhi (The City. Verses)
by A. Rubakin
Paris, 1920
55 pp. handwritten lithographed
text with lithograph illustrations by
Goncharova
Ex Libris 6, no. 230
25.4 x 16.2 cm. (10 x 6⅜ in.)
Robert L. B. Tobin

74.

**Slovodvi (Motdinamo) ("La
Cible")** by V. Parnak
Paris, 1920
24 pp. with 8 lithographs after
Goncharova and 7 after Larionov
Ex Libris 6, no. 215
28.3 x 19 cm. (11⅛ x 7½ in.)
a) Robert L. B. Tobin
b) Australian National Gallery,
Canberra

75.

**Conte de Tsar Saltan et de son
fils le glorieux et puissant Prince
Gvidon Saltanovich et de sa
belle princesse cygne (Tale of
Tsar Saltan and of His Son
Glorious and Powerful Prince
Gvidon Saltanovich and of His
Beautiful Swan Princess)**
Paris, 1921
48 pp. unbound with hand colored
illustrations
Ex Libris 6, no. 288
29.8 x 22.9 cm. (11¾ x 9 in.)
a) Parmenia Migel Ekstrom
b) Robert L. B. Tobin

76.

Zharptitsa (The Firebird)
Paris/Berlin, 1921–26
Vols. 1–14 bound together, 35–80
pp. each vol., covers by Gon-
charova, Larionov, I. Bilibin, et al.
Ex Libris 6, no. 258
31 x 25 cm. (12¼ x 9⅞ in.)
University of Southern California
Architecture and Fine Arts Library,
Los Angeles

77.

**Die Mär von der Heerfahrt Igors
(The Lay of Igor's Campaign)**
Translated from the Old Russian by
A. Luther
Munich, 1923
88 pp. with hand-tinted plates by
Goncharova
Robert L. B. Tobin

78.

Le thè du capitaine Sogoule by
N. Goncharova, ed. Kessel
Paris, 1926
19.7 x 14.6 cm. (7¾ x 5¾ in.)
Mr. and Mrs. A. L. de Saint-Rat,
Miami University, Oxford, Ohio

79.

Untitled, n.d.
Gouache
26.7 x 17.2 cm. (10½ x 6¾ in.)
Donald Judd

Bibliography

M. Chamot, *Gontcharova,* Paris,
1972.

T. Loguine, ed., *Gontcharova et
Larionov,* Paris, 1971.

G. Orenstein, "Natalia Goncharova,
Profile of the Artist—Futurist Style,"
The Feminist Art Journal, New York,
summer 1974, pp. 1–6.

Rétrospective Gontcharova, exh.
cat., Maison de la Culture de
Bourges, 1973.

Dmitri Sarabianov, "Talent and
Hard Work: The Art of Natalia
Goncharova," *Women Artists of the
Russian Avant-Garde 1910–1930,*
exh. cat. in German and English,
Galerie Gmurzynska, Cologne,
1979, pp. 139–43.

Mary Chamot, "Goncharova's Work
in the West," ibid., p. 150.

From its early years the Russian avant-garde was characterized by the leadership of women artists. Natalia Goncharova joined her lifelong companion, Mikhail Larionov, to propagate the new ideas of pre-Revolutionary Russia. The initially shocking Neo-Primitivist style, illustrated by Goncharova's 1908 *Looking Glass,* was launched at the third exhibition of the *Golden Fleece* in December 1909. This movement stressed a self-conscious nationalism; it drew not only upon the non-naturalistic conventions of the Russian religious icon, but also upon a peasant heritage—crude and brightly painted signboards, toys and other handcrafted objects of folk arts, and, especially, cheap and popular printed images called *lubki.* Goncharova maintained a lifelong interest in books. Working with the Futurist poet Kruchenykh, she made lithographs to illustrate *Pustynniki (Hermits,* 1913). Surrealistic images focusing on the lives of holy men, her illustrations reflect the influence of icon painting.

Goncharova's Primitivism was deflected by her fascination with Rayonism. Introduced by Larionov and Goncharova at *The Target* exhibition in 1913, Rayonism proposed to reduce a perceived image to the sum of the rays which emanate from it. *Red Bather,* 1912, and *Rayonist Garden: Park,* c. 1912–13, convey Goncharova's emphasis on the materiality of paint, as well as her love of expressive line and bold color. Characteristic too of Goncharova was her emotional preoccupation with the machine-oriented passion of the Italian Futurists. According to Goncharova, "the principle of 'movement' in the machine and the human being is the same, the joy of my work is to reveal the equilibrium of movement."

Her interest in the city was also reflected in illustrations for *Gorod Stikhi (The City. Verses,* 1920). This was a book by Rubakin of lyrical poems on an urban theme. The poems and pictures unite to give an impression of a city that is exciting, full of movement, and that encompasses the human and emotional elements of urban life.

Goncharova's interests were never specifically nationalistic. A long and close collaboration with the impressario Serge Diaghilev began in 1914 when she designed his production of *Le Coq d'Or.* From 1916 *Costume for a Spanish Female Dancer, "España,"* and *Spanish Dancer* both reflect her captivation with Spanish themes. *Espagnole,* 1916, a mixed-media collage, is one of her most abstract works. In 1917 Goncharova left revolutionary Russia and settled in Paris, where with Larionov she devoted herself to painting and to her highly original work in theater design.

She also continued her activity in book illustration and was especially interested in introducing the West to Russia. In 1921 Goncharova illustrated Pushkin's *Conte de Tsar Saltan et de son fils...(Tale of the Tsar Saltan and of His Son...).* These brightly colored works preserve the flavor of Russian folk art despite her absence from Russia for nearly a decade. *Zharptitsa (The Firebird),* published in Western Europe during the early 1920s, was intended to present the best of Russian art and literature abroad. It contains many examples of folk art and of the folk art revival popular at the turn of the century.

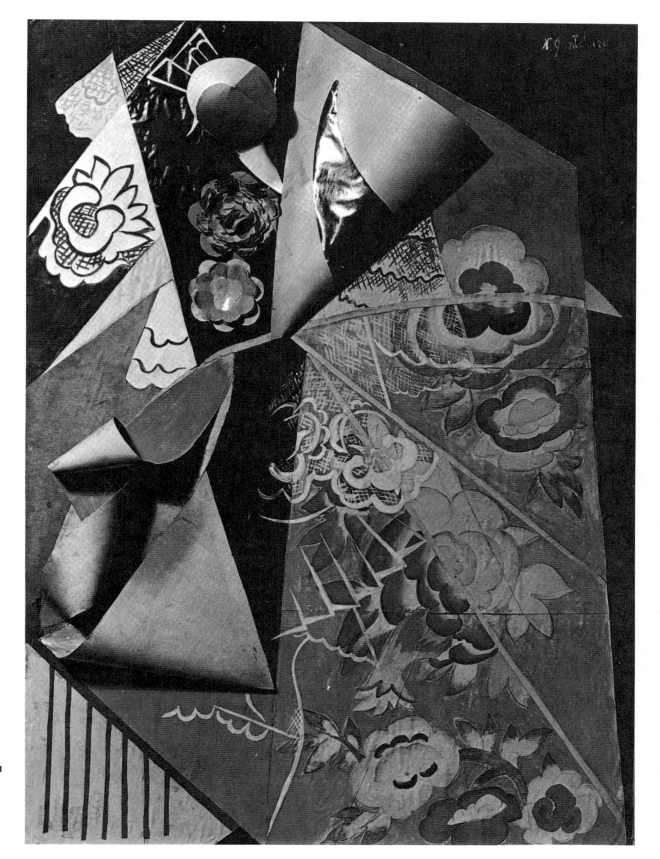

80.

**Reinforced Concrete Poem to
the Sun,** c. 1913

Linocut

22.9 x 34.9 cm. (9 x 13¼ in.)

Thomas P. Whitney, Connecticut

81.

**Poem of Reinforced Concrete
(Ferro-Concrete),** 1913

Relief print on paper

35 x 27.5 cm. (13¾ x 10⅞ in.)

Michail Grobman, Jerusalem, Israel

82.

Poem on Letter "K," 1918

Linocut

22.2 x 10.2 cm. (8¾ x 4 in.)

Thomas P. Whitney, Connecticut

Bibliography

V. Markov, *Russian Futurism: A
History,* Berkeley, 1968.

Savvatii Gints, *Vasilii Kamensky,*
Perm, 1974.

Spent childhood and adolescence in Perm; 1902 visited
Turkey; joined a theatrical troupe in Perm; 1905 involved
in political demonstrations in Perm; 1906 moved to St.
Petersburg via Iran; enrolled in the Higher Agricultural
Courses; 1908 active as a poet and critic, contributing to
the almanac *Vesna (Spring)* among others; 1909 made
the acquaintance of Nikolai Kulbin, contributing to the
Impressionists exhibition in St. Petersburg; worked in
David Burliuk's studio; 1910 contributed to the *Triangle*
exhibition in St. Petersburg; published *Zemlianka (Mud
Hut),* an anti-urban romance; 1910–12 very interested in
aviation; 1912 onward took part in many of the Futurist
activities; contributed to many Futurist booklets, includ-
ing *Tango s korovami (Tango with Cows),* 1914; 1913
organized the *Exhibition of Contemporary Painting* in
Perm; 1914 contributed examples of his ferro-concrete
poems (also called poem-pictures) to Larionov's exhibi-
tion *No. 4* in Moscow; 1915 contributed to the *Exhibition of
Painting, 1915* in Moscow, at which many of the avant-
garde were represented; contributed to *0–10* in Petro-
grad; 1916 published his first novel, *Stenka razin,* with
illustrations by Aristarkh Lentulov and himself; 1918 with
Vladimir Maiakovsky et al. starred in the movie *Not Born
For Money*; with Maiakovsky and David Burliuk published
the *Gazeta futuristov (Newspaper of the Futurists)* in
Moscow; 1920s–30s published many plays, poems, and
autobiographical sketches; gradually changed to a more
Realist style of writing, but continued to paint in a Primi-
tivist manner.

■ Vasilii Kamensky was one of the leading poets of th
Futurist movement in pre-Revolutionary Russia. By 19
he had published his first novel, *Zemlianka (Mud Hut),* ≀
extensive presentation of his favorite subject, the natur
world, with specific attention to hunting and fishing. Bas
cally true to a Primitivist ideology, Kamensky preache
a return to the natural world. Unfortunately, the critic
extremely negative reaction to the book, coupled w
his wife's disapproval of his writing, led Kamensky
a complete disillusionment with writing. He abandone
literary pursuits for a career as a stunt pilot. Kamens
traveled around Europe, visiting air fairs until he suffere
a major plane crash that left him unharmed but unwillir
to go back to flying.

By late 1912 Kamensky was once again actively wr
ing. In close association with the famous Futurist art
and impressario David Burliuk, Kamensky participated
many Futurist events, including the Futurist Tour of Russ
(1913–14). He joined Burliuk and Maiakovsky in tourir
seventeen towns in order to propagandize the mov
ment. Kamensky spoke frequently about his three cruci
concerns of Futurism: intuition, individual freedom, ar
abstraction. He proved to be a great showman during th
tour and established a reputation for public speaking.

Kamensky's greatest achievement was the de
velopment of his concept of "ferro-concrete" poetry,
method of writing which utilized the purely graphic as we
as the symbolic meaning of words. The term "ferr
concrete" refers to the newly developing technology
reinforced concrete. Just as concrete is poured into
mold that is reinforced with structural supports, so too
poem is a square occupying a page (the "mold"), and th
segments, which are often divided by lines, act as th
structural support. *Poem on Letter "K,"* 1918, is characte
istic. Its typographical design represents the visualizatic
of verbal structure and meaning. The page is divided in
segments, representing "stanzas" of different sizes ar
shapes. Each segment is filled with letters, syllable
or words, and the placement *en page* is as much a pa
of the meaning of the poem as the letters themselve
The poems were so visual, in fact, that they were e
hibited at Larionov's exhibition of painting called *No.*
(Moscow, 1914).

Kamensky continued to publish extensively durin
the 1920s and 1930s, gradually changing to a mo
Realist approach to writing, in accord with official gover
ment policy. His themes shifted from a celebration
nature to a celebration of industrialization or collectiviz
tion of agriculture. He was paralyzed for the last fiftee
years of his life.

80

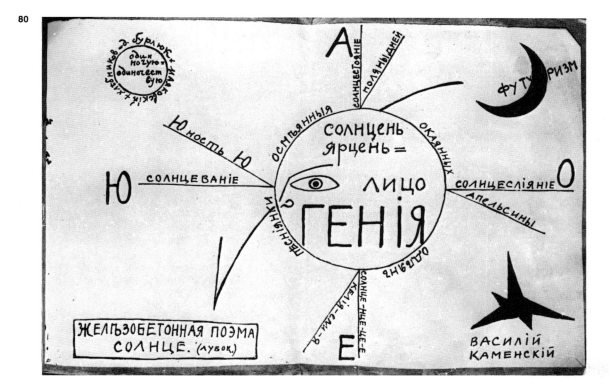

82

К (КЛИНОК)

КАК
КИРКА КОЛКО
КОЛЕТ КАМ(К)ЕНЬ
ТАК КУКУШКИ
КРИК КУ-КУ
КОВ КА ГАЛ КА
КОВ КА ПАЛ КА

КА-КЕ-КИ
1918

КО КАМЕНСКІЙ
 ВАСИЛІЙ.

Kandinsky, Vasilii Vasilievich

Born 1866 Moscow; died 1944 Paris.

83.

Über das Geistige in der Kunst, insbesondere in der Malerei (On the Spiritual in Art, Especially in Painting) by V. Kandinsky
Munich, 1912
137 pp. (second and third editions)
20.5 x 17.5 cm. (8⅛ x 6⅞ in.)
a) second edition: April 1912
with original color woodcut cover
and ten woodcut illustrations by
Kandinsky
b) third edition: fall 1912 with ten
woodcut illustrations by Kandinsky
The Robert Gore Rifkind Foundation, Beverly Hills, California

84.

Der Blaue Reiter Almanach (The Blue Rider Almanac) by V. Kandinsky and Franz Marc
Munich, summer 1914 (second edition)
152 pp. with 142 illustrations, 8 vignettes, 3 musical pieces, and color cover design by Kandinsky; 3 initial letters designed by H. Arp; 4 initial letters and 1 vignette designed by F. Marc
29.5 x 23 cm. (11⅝ x 9 in.)
The Robert Gore Rifkind Foundation, Beverly Hills, California

85.

Tekst khudozhnika (An Artist's Text)
Moscow, 1918
58 pp. with 25 illustrations
Ex Libris 6, no. 98
30.8 x 21 cm. (12⅛ x 8¼ in.)
K. P. Zygas

86.

Red Oval, 1920
Oil on canvas
71.5 x 71.4 cm. (28⅛ x 28⅛ in.)
The Solomon R. Guggenheim Museum, New York

1886 began to study law and economics at the University of Moscow; 1889 took part in an ethnographical excursion to Vologda Province, where he examined specimens of folk art—stimulating him to write an article; visited St. Petersburg and Paris; 1893 appointed to the Department of Law, University of Moscow; 1896 invited to the University of Dorpat as a visiting lecturer; moved to Munich, entering Anton Ažbè's school in 1897; 1900 entered the Munich Academy where he studied under Franz Stuck; contact with the St. Petersburg World of Art group; 1900–1908 exhibited regularly with the Moscow Association of Artists; 1901 founded the Phalanx group; taught at a private art school in Munich, where Gabriele Münter was one of his pupils; 1904 contributed to the New Society of Artists' exhibition in St. Petersburg; 1903–6 traveled with Münter extensively in Europe; late 1900s interested in Bavarian glass painting, icons, and primitive art; 1909 began *Improvisations*; co-founded the group *Neue Künstlervereinigung*; 1909–10 contributed to Vladimir Izdebsky's first Salon in Odessa and other cities; Munich correspondent for the St. Petersburg magazine *Apollon (Apollo)*; 1910 joined the Jack of Diamonds group, contributing to its first and second exhibitions; 1911 contributed to Izdebsky's second Salon in Odessa, where his article "Content and Form" appeared in the catalog; with Marc, Münter, and Kulbin established the *Blaue Reiter* group, contributing to its exhibitions (1911–12) and its almanac (1912); Russian version of *On the Spiritual in Art* read on his behalf by Nikolai Kulbin at the All-Russian Congress of Artists in St. Petersburg; 1912 published *Über das Geistige in der Kunst* in Munich; 1914 returned to Moscow via Switzerland; 1917 married Nina Andreevskaia; active on various levels of IZO NKP—teaching, museum work, writing, lecturing, conference participation, exhibiting; 1920 compiled program for Inkhuk; 1921 took active role in the organization of RAKhN; left for the Bauhaus at the end of that year; 1922 represented at the *Erste Russische Kunstausstellung,* Berlin; 1922–33 taught at the Bauhaus; 1924 with Feininger, Jawlensky, and Klee founded the "Blue Four"; 1929 first one-man show in France at the Galerie Zak, Paris; 1933 moved to Paris; joined Abstraction-Création group; active as a painter and writer until his death.

■ At the age of thirty Kandinsky gave up a successf career in law and economics to move from Moscow Munich and become a painter. He played an extreme active role in the Munich art world, founding several a associations. The famous *Blaue Reiter* group wa founded in 1911 under the guiding forces of Kandinsky an Franz Marc. The *Blaue Reiter Almanach* (published 1922) was the first programmatic publication of th group. A statement of intentions and philosophy by a loos association of artists, the *Almanach* represents one the most important concepts in twentieth-century ar The artists believed in the birth of a new spiritual epoc and were engaged in the creation of symbols for the own time. The *Almanach* had fourteen major articles, in terspersed with notes, quotations, and illustrations. It in cluded music (with texts by the Symbolist poets) an articles by Burliuk, Macke, and Schönberg, among others Kandinsky presented his concept of "inner necessity" i this work and also in an earlier publication: *On th Spiritual in Art, Especially in Painting,* 1912. For Kar dinsky art was a portrayal of spiritual values. All art build from the spiritual and intellectual life of the twentiet century. While each art form appears to be differer externally, their internal properties serve the same inne purpose, of moving and refining the human soul. *On th Spiritual in Art* is noteworthy for its exposition of Kar dinsky's theoretical doctrines, but also important as consideration of the last phase of abstraction before hi leap into non-objective painting. The woodcuts used fo illustration in this text are abstractions from nature tha show an extreme simplification of form.

Kandinsky wrote an autobiographical essay that ex amines this period in his life. The piece was originally published in *Der Sturm* as "Ruckblicke 1901–1913" an later revised in Moscow, where it was published under the title of *Tekst khudozhnika (An Artist's Text,* 1918).

At the outbreak of World War I, Kandinsky returnec to Russia. He was active from 1917 to 1921 as a teacher lecturer, and administrator of the arts, and was responsi ble for designing the pedagogical program for Inkhuk (The Institute of Artistic Culture) in 1920. Kandinsky's program embraced Suprematism, Tatlin's concept of the "culture o materials," and his own theories. The program met with

84

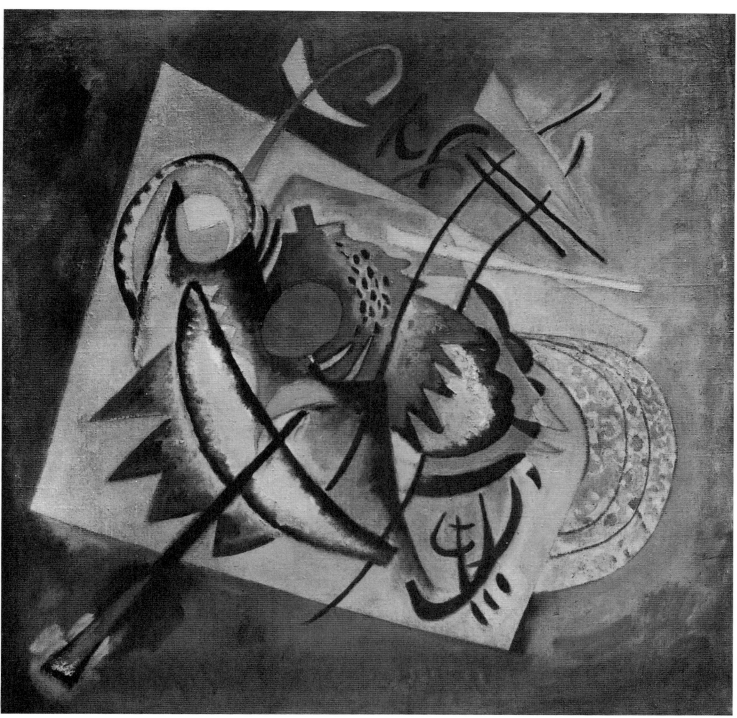

87.

Circles on Black, 1921
Oil on canvas
136.5 x 120 cm. (53¾ x 47⅛ in.)
The Solomon R. Guggenheim
Museum, New York

88.

Cup and Saucer (two sets),
designed 1922, executed 1972
Porcelain (Haviland Limoges,
France)
diam: 11.5 cm. (4½ in.)
The Robert Gore Rifkind Collection,
Beverly Hills, California

89.

In the Black Square, 1923
Oil on canvas
97.5 x 93 cm. (38⅜ x 36⅝ in.)
The Solomon R. Guggenheim
Museum, New York

Bibliography

John E. Bowlt and Rose-Carol
Washton Long, *Vasilii Kandinsky:
"On the Spiritual in Art,"* Newton-
ville, Massachusetts, 1979.

R. Gollek, *Der Blaue Reiter im
Lenbachhaus München,* Munich,
1974.

W. Grohmann, *Wassily Kandinsky,*
New York, [1958].

E. Hanfstaengl, *Kandinsky: Zeich-
nungen und Aquarelle im Len-
bachhaus München,* Munich, 1974.

Kandinsky, exh. cat., Musée Na-
tional d'Art Moderne, Centre
Georges Pompidou, Paris, 1979.

Wassily Kandinsky 1866–1944, exh.
cat., Haus der Kunst, Munich,
1976–77.

H. Roethel, *Kandinsky: Das
graphische Werk,* Cologne, 1970.

Peg Weiss, *Kandinsky in Munich —
The Formative Jugendstil Years,*
Princeton, 1979.

strong opposition on the part of the future Constructivists and was not realized until Kandinsky moved in 1921 to Weimar, where it formed the basis for his Bauhaus course. Kandinsky deeply believed in the underlying connection and affinity between all the arts and in the possibility of their synthesis. He did not limit his artistic production to painting, but explored other media as well. Kandinsky's experiments with industrial design included applying his designs to porcelain, such as cups and saucers (1922).

The artist painted no pictures between November 1917 (when the Bolsheviks came to power) and July 1919. *Red Oval* is one of ten oil paintings he produced in 1920. This work exhibits the presence, for the first time, of the receding rectangle suspended in a unified square field, a compositional element that figures prominently in the later *In the Black Square* (1923). This motif suggests a reference to Malevich's Suprematism, although the question of whether or not Kandinsky was significantly influenced by Malevich and Lissitzky remains the subject of study.

Circles on Black (1921) is one of the last works painted by Kandinsky before he left Russia to accept a post at the Bauhaus. The impact of Suprematism begins to be discernible at this point in an increasing geometricization of forms. This painting, together with *Variegated Circle* (1921), represents the beginning of Kandinsky's intense preoccupation with the circle, which by 1923 would play a dominant compositional role. The circle was revered for its symbolic significance, and not simply for its formal qualities.

88

■ The usual approach to the organization of a museums is the historical one. This has been followed everywhere (i.e., both in Russia and abroad). A museum delineates the process of art period by period, century i century, but apart from historical sequence it ignore whether one period is connected or not with another. S the conventional museum reminds us of a chronicle whi records fact upon fact without going into their inner mea ing. These historical art museums have a certain value a depositories of artistic phenomena and can serve as ra material for various researches and deductions. But th common defect of these museums is, obviously, the a sence of a guiding principle, of a system.

In this respect the Visual Arts Section has been th first to embark upon a new path. With regard to museu construction it has advocated a definite principle and system in accordance with a single, overall objective.

This single, overall objective consists in the aspir tion to show the development of art not in a chaoti historical sequence, but in a sequence of strict su cessiveness:

(1) from the standpoint of new contributions to th field of pure art, i.e., from the standpoint of the invention new artistic devices; and

(2) from the standpoint of the development of pure artistic forms independent of their content, i.e., from th standpoint of the craft of art.

The general and very obvious needs of the tim i.e., the democratization of all walks of life, prompted th Section to consider this unusual method of creatir museums. This method opens the door to the artist studio; it illuminates that aspect of the artist's activi which had remained unknown to the general public.. The popular conception of the artist creating his art i some mysterious, abnormal way; the general igno ance of what was essential to the artist, i.e., the persi tence, the torment of his work on the purely practic aspect of his art, i.e., his craft—these things tended to p the artist outside the general working conditions of lif The artist was regarded as a child of fortune, one wh usually lived in idleness and who occasionally create important values by his own individual and very simpl (for him) method. In exchange for these values he ac quired all the greatest blessings of this earth.

As a matter of fact, the artist works double time:

(1) he himself is the inventor of his art; and

(2) it is he who develops his own essential methods The more of these two qualities he has, the greater h value to the history of art.

Illumination of the artist's activity from this standpoir (hitherto lost in darkness) will reveal a new facet of h work. He will be seen as a worker who created practic values with genius and hard work. This will prove his righ to occupy at least an equal place in the ranks of th working population.

This point of view will provide the general public wit the veracious conception of art—i.e., art as the result of kind of labor process just as necessary to life as any othe kind of creative work, and not as some kind of appendag to life which the state can do without if worse comes t worst....

The Museum of Painterly Culture aims to present th stage of achievement in pure painting, of methods an media in painting in their entirety—insofar as they ar expressed in the painting of any one time and of an

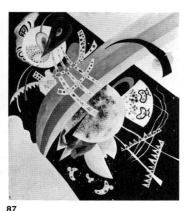

87

one nation.

The methods which enrich the media of painterly expression, the devices used in the correlation of color tones, the relationship of the color tone to the way in which the paint is applied, compositional methods, i.e., the construction of a whole composition and of its individual parts, the treatment of them, the general texture, the structure of the parts, etc.—these are the kinds of things by which a museum determines acquisition of a work of art....

The Section supports the view that all the art museums and depositories in the Russian Republic are entirely state property. So it has taken steps to acquire works from the Moscow collections of Western European art, works which are essential to the Museum of Painterly Culture, but which can be taken from these collections without spoiling their fullness or strength.... To this end, paintings of the following were selected: Braque, van Gogh, Gauguin, Dérain, Le Fauconnier, Matisse, Manet, Monet, Picasso, Pissarro, Rousseau, Renoir, Cézanne, Signac, Vlaminck, and Friesz.... The materialist, realist

direction in nineteenth-century painting, which maintained an organic link with the extreme passion for materialist systems in science, morality, literature, music, and other spheres of spiritual life, severed its connection with the purely painterly methods of the preceding centuries. The thread stretching down from archaic times was broken. The most important task of any art—composition—was abandoned as an artistic medium by the materialist-realist tendency. The composition of pure painting was replaced by the composition of nature. Deprived of its essential foundation, painting ceased to be a self-sufficient, expressive art. It became a figurative art: all the devices of painting were oriented exclusively towards depiction, almost toward a mechanical reflection of nature's creation. Since the middle of the nineteenth century (for the most part, under the influence of Japanese engraving) European artists seemed to realize that painting had come to lead not an independent life, but an illustrative one: the result was an outward appearance devoid of soul. ▶

89

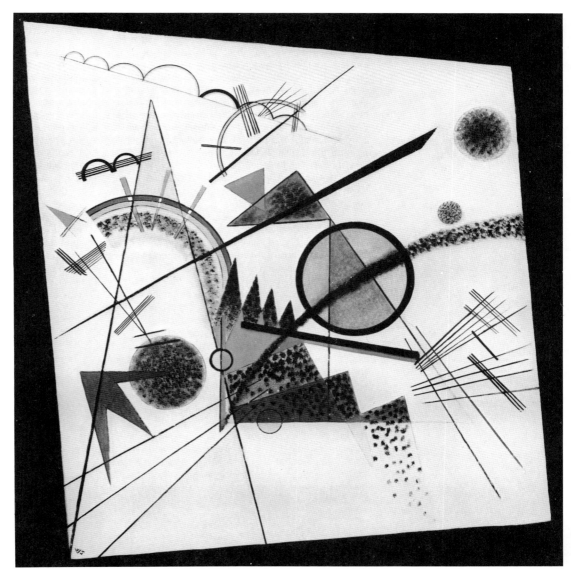

The Museum of Painterly Culture is a collection of art works based on painterly principles—painterly content in painterly form. Therefore, there just isn't room for works of a purely or exclusively formal value. Nevertheless, these works must be assembled—as an index and as a monument to a specific attitude toward the art of our time, and as a stimulus to subsequent formal research. Enriching the means of artistic expression will be the first consequence of this proposed section.

This section should cover all experiments—from formal construction right up to technique in the most specific meaning of the word, i.e., ending with various experiments in priming....Of course, it is difficult to draw a distinction between the experiment and the work of art itself because an experimental project might end up being the work itself, or a work-project might not go beyond the limits of experiment. But any mistakes that we might make in this distinction or the inevitable subjectivity that we may bring to bear on our evaluation of a work should not hinder this, the first attempt to assemble a specific collection of experiments in technique....

Petrograd is purchasing works for museums through a mixed commission, consisting of representatives of the Visual Arts Section, the Museum Section, and professional organizations. Works of all trends are being purchased, from the late-nineteenth-century Realists onward: didactic art (Repin, both Makovskys, Kustodiev, etc.); naturalism, Neo-Academism, retrospectivism; then Impressionism, Neo-Impressionism, Expressionism, from which begins modern art or the so-called new art (historically, Cézanne marks the point of departure); Primitivism, Cubism, Simultanism, Orphism, Suprematism, non-figurative art, and the transition from painting to the new plastic art—the relief and the counter-relief.

In this way, both the Petrograd and Moscow Sections have given the concept of museum administration a new sense of breadth and freedom. Whenever museum administrators build up their museums, they are overcautious. They fear any new movement in art and, as a rule, do not recognize it even at its highpoint (only in rare instances do they do so). When they do recognize it, it is at its moment of withering and decline....

Exceptions have been so rare that they created the impression of total revolution and are remembered most vividly. State officials who decided to oppose convention in museums had to possess the heroic qualities of bravery, energy, persistence, and, at the end of the day, self-sacrifice. They were victims not only of the government's wrath, but also of the servile elements of social opinion, especially the press....

Russia presents a unique conception of state museum organization. The firm principle behind the Museum of Painterly Culture, the complete freedom and the right which every artist-innovator has to seek and obtain official recognition and encouragement in the museum world—this is the unparalleled achievement of the Commissariat of Enlightenment. And if the Section has been able to put its principles into effect, then for this it is obliged to the Commissar of Enlightenment, A. V. Lunacharsky.

Vasilii Kandinsky, Khudozhestvennaia zhizn (Artistic Life),
Moscow, no. 2, 1920, pp. 18–20. Translated from the Russian
by John E. Bowlt.

■ Recently two major processes have been occurring, one, a process of self-deepening in each art—the aspiration to study its own basic elements, to elucidate their essence and value; the other, a process of unification among the arts. It is natural that each art in its process of self-deepening should watch, involuntarily and interestedly, the adjacent art in order to learn the means used by the other to reach the same objective. Never before has such interest been shown by musicians toward painting, by painters toward architecture, by architects toward poetry, etc.

We already know of certain examples in which individual arts have been combined in a single work (recitation to music, chamber dancing, etc.). These are very simple examples of synthetic art. In theater, music is being synthesized with dancing, decor, and costumes.

To study this synthetic art, the Institute of Artistic Culture was established in Moscow on May 12, 1920. Experiments showed that art could be broken into separate parts and placed in a certain mathematical correlation. Important work along these lines by the composer Shenshin indicated that it was possible to translate from one art language into another. Taking Michelangelo's mausoleum and Liszt's musical composition on the same theme, he broke down the music into its parts, obtained a certain correlation of measures, and reduced them graphically to a definite form that coincided with a mechanical form to which Michelangelo's work had been reduced.

I personally had the opportunity of performing small experiments abroad with a young musician and a dancer. From several of my watercolors the musician would select the one he found clearest in musical form. He would play this watercolor while the dancer was out of the room. The dancer would then appear and the music would be played for him: he would dance it and then find the watercolor that he had danced.

In the Institute of Artistic Culture, experiments such as these have been carried out; musicians would take three basic chords, painters would be invited to depict them first in pencil, then a table would be compiled, and each artist would have to depict each chord in color.

These experiments show that the Institute is on the right road.

Vasilii Kandinsky, from a paper
delivered in December 1920, Vestnik
rabotnikov iskusstv, Moscow, no. 4–6,
1921, pp. 74–75.

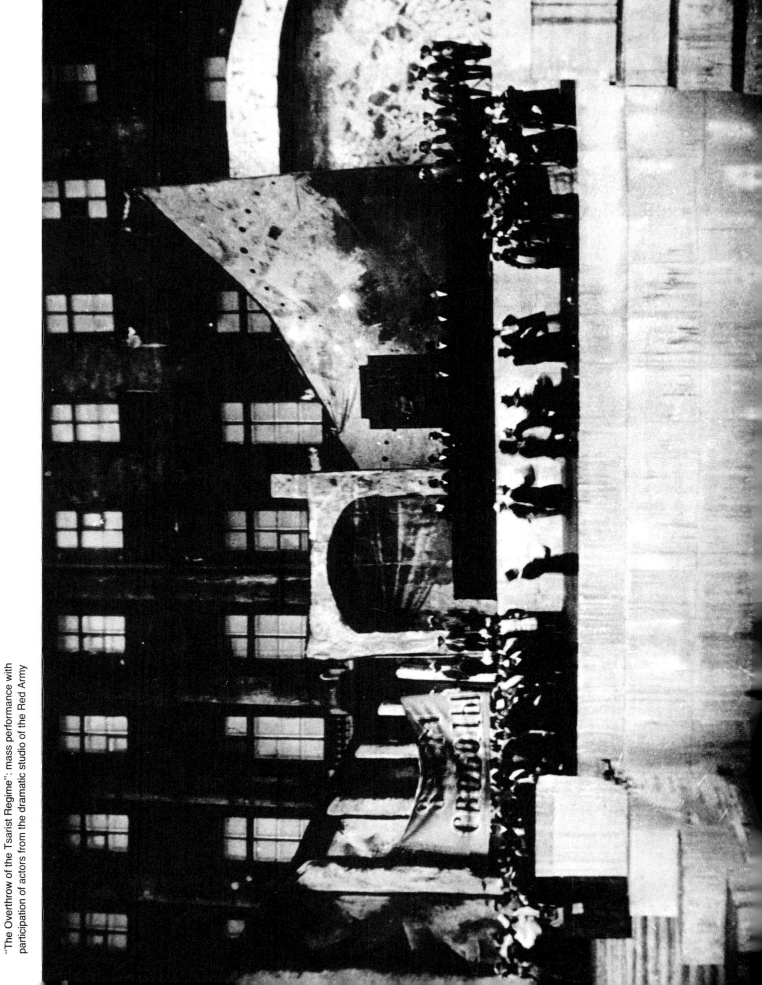

"The Overthrow of the Tsarist Regime": mass performance with participation of actors from the dramatic studio of the Red Army

Kliun, Ivan Vasilievich

Born 1873 Bolshie Gorki; died 1943 Moscow.

90.

**Tainye poroki akademikov
(Secret Vices of Academicians)**
by A. Kruchenykh, I. Kliun, and
K. Malevich
Moscow, 1916
32 pp. with 4 lithographs by I. Kliun
Ex Libris 6, no. 138
22.8 x 18.9 cm. (9 x 7½ in.)
Collection Martin-Malburet

91.

Composition, 1917
Oil on canvas
69 x 88 cm. (27⅛ x 34⅝ in.)
Thyssen-Bornemisza Collection,
Lugano, Switzerland

92a.–g.

Geometric Forms, c. 1917
Oil on paper
7 paintings, each approx.
27 x 22.5 cm. (10⅝ x 8⅞ in.)
The George Costakis Collection

93.

Untitled, c. 1920
Gouache
34 x 30.5 cm. (13⅜ x 12 in.)
Galerie Gmurzynska, Cologne,
West Germany

94.

Composition, 1921
Gouache
22 x 26.4 cm. (8⅝ x 10⅜ in.)
Thyssen-Bornemisza Collection,
Lugano, Switzerland

95.

Red Circle, c. 1921
Oil on canvas
69.4 x 68.9 cm. (27⅜ x 27⅛ in.)
The George Costakis Collection

96.

Untitled, c. 1921
Watercolor
25.4 x 19.7 cm. (10 x 7¾ in.)
Ruth and Marvin Sackner

97.

Untitled, 1921
Gouache on paper mounted on
cardboard, varnished
24.3 x 24.9 cm. (9⅝ x 9¾ in.)
Mr. and Mrs. German Jimenez,
Caracas, Venezuela

1890s studied in Warsaw; early 1900s attended private studios in Moscow, including those of Fedor Rerberg and Ilia Mashkov; 1910 co-founded the Moscow Salon, an exhibition society; established contact with the Union of Youth, contributing to its last exhibition in 1913–14; 1912 befriended Kruchenykh, Malevich, Matiushin, and other members of the avant-garde; interested in Cubism and Futurism; first experiments in three dimensions; 1915 supported Suprematist painting; 1916 published his article, "Primitives of the Twentieth Century," in the Futurist booklet *Tainye poroki akademikov (Secret Vices of Academicians)*; joined the Jack of Diamonds group, contributing to its exhibitions of 1916 and 1917; 1915–16 contributed to *Tramway V, 0–10,* and *The Store*; 1917 head of the Central Exhibition Bureau of NKP; 1918 took part in the November agit-decorations for Moscow; 1919 contributed to the *Tenth State Exhibition: Non-Objective Creation and Suprematism;* 1918–21 professor at Svomas/Vkhutemas; 1920 member of Inkhuk; contributed to the *Erste Russische Kunstausstellung* in Berlin and to many other exhibitions during the 1920s and 1930s in the Soviet Union; 1923 illustrated Kruchenykh's *Faktura slova (Facture of the Word)*; 1925 member of the Four Arts group; turned to a more representational kind of painting much in the style of Ozenfant.

■ One of the oldest members of the Russian avant-garde, Ivan Kliun was forty-four when the Revolution exploded. He belongs to the generation of Malevich and to the pre-Revolutionary Futurist ferment: indeed, Kliun is the subject of Malevich's 1913 lithograph *Portrait of a Builder Completed* (cat. no. 173). By 1915 Kliun's own lithographs for the book *Secret Vices of Academicians* (published 1915, with cover date 1916) carries abstraction further: Kliun is at the transition point between Cubist fragmentation and Suprematist assertion of flat, geometric shapes. The book is an attack by Kruchenykh, Malevich, and Kliun on the decadent Symbolist past in literature and the visual arts. Kliun's essay, "Primitives of the Twentieth Century," asserts that "After accepting the straight line as a point of departure, we have arrived at an ideally simple form: straight and circular planes (sounds and letters in words)."

As a painter and theoretician, Kliun threw himself totally into pre-Revolutionary avant-garde activity *(Jack of Diamonds, Tramway V, 0–10, The Store)* and drew inspiration from both Malevich and Malevich's ideological opponent, Tatlin. Kliun's 1917 *Composition* (cat. no. 91) suggests Malevich's use of non-objectivity as a vehicle for pure feeling—in this case a sense of falling away reminiscent of Malevich's work of 1917–18. The seven paintings comprising the group *Geometric Forms* c. 1917, (cat. no. 92) are, however, alien to Malevich: bold presentations of eccentric shapes, they fuse the figure-ground relationship and emphasize material actuality.

Following the Revolution, Kliun plunged into the usual round of reconstruction activities: he was associated with MKP; he taught at Vkhutemas; he joined Inkhuk. A contributor to the 1919 *Tenth State Exhibition: Non-Objective Creation and Suprematism,* Kliun speaks of the "congealed, motionless forms of Suprematism"—a criticism of Malevich's intuitive syntheses. Kliun's demand for a Color Art in which "compositions are subject only to the laws of color, and not to the laws of nature" is indicative of the evolving Constructivist credo.

Kliun's paintings of the early 1920s give a sense of constant experimentation. Catalog number 93, a gouache of about 1920, reveals a fascination with compositional complexity. The 1921 watercolor (cat. no. 96) investigates intricate color relations and asymmetrical spatial tensions. At the same time, a painting such as the *Red Circle* of about 1921 uses modulated color and vibrating edges in an examination of the optical impact of a centrally placed image. Kliun's commitment to formal investigations never denied easel painting. Thus he was twice asked to exhibit with artists who were looking for alternatives to Productivism and industrial design: the 1925 show of the Society of Easel Painters and the 1926 exhibition of the Four Arts Society of Artists. The latter group, eclectic enough to have shown Lissitzky and Puni, was dissolved by the Communist Party's 1932 Decree on the Reconstruction of Literary and Artistic Associations. During the 1930s, Kliun returned to a style that was reminiscent of Ozenfant's Purism, but he never totally gave up his avant-garde ideals.

Bibliography

Nothing substantial has been written on Kliun. Some biographical and artistic details will be found in: M. Kolpachki, ed., *Gosudarstvennaia Tretiakovskaia galereia. Skulptura i risunki skulptorov kontsa XIX-nachala XX veka,* Moscow, 1977, pp. 435–37.

P. Pertsov, *Khudozhestvennye muzei Moskvy. Putevoditel,* Moscow/Leningrad, 1925, p. 88.

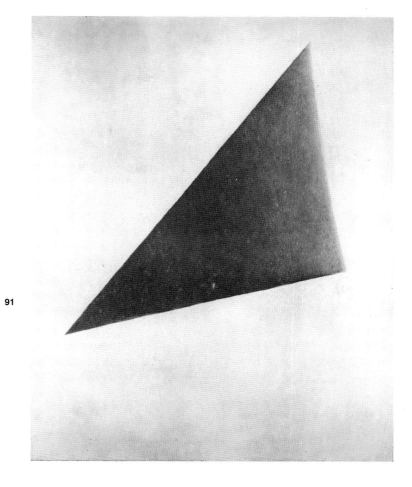

91

92

▶

From Ivan Kliun, "Cubism as a Painterly Method: A Few Words on the Art of P. Cézanne," 1928

■ …that Cubism originated in France during the first decade of this century and that its ancestor was Cézanne …has been written and talked about many times. But when speaking about Cubism it is quite impossible to pass over this remarkable artist….

P. Cézanne strove to transmit Nature not as it appears to us in its fortuitous conditions, in our ephemeral impressions and in various lights (Nature's moods), but as it always is in its essence.

Cézanne did not recognize chiaroscuro or the colored spot in a picture, and therefore his contours are always sharply outlined. In nature he sought volumetrical forms, and moreover he tried to reduce these volumetrical forms to very simple, geometrical solids.

But Cézanne is still not a Cubist because he did not attain complete geometrization and schematization of form, and to understand his work he must be approached not with a Cubist evaluation, but only with a synthetic one.

Cubism. The General Concept

Cubism is the most defined trend in the field of modern art….

By means of a strictly objective artistic analysis Cubism introduced basic transformations into art:

First—

It broke with the basic and age-old traditions of the old art by refusing to depict nature in its intact and relative state.

Then—

It liberated art from sensual content and mood, from thematic figurativeness and led it on the path of broad and free creation….

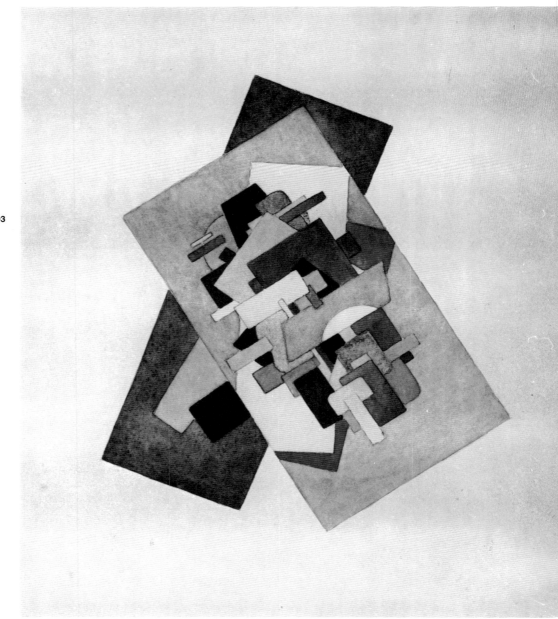

93

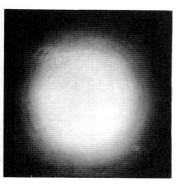

95

The basic premises of Cubism as a painterly method are:

(1) The object is depicted simultaneously from several points of view;
(2) instead of a whole object its individual parts are taken;
(3) these parts are grouped according to the principle of balance and contrast.

Synthetic (Static) Cubism

...The simplification of form, the reduction of Nature to abstraction, to its geometrical purity, weight, gravity, and monumentality formed the basis of Cubism in its first stage.

In this stage Cubism can be called *synthetic* or *static Cubism* since it is the furthest development of Cézanne's volumetrical expressionism remaining both rationalistic and concrete.

Static Cubism subordinated form to mass as a volumetrical block: hence its painting became convincing and monumental.

Extended Perspective. Displacement

Cézanne rejected linear perspective and depicted objects in a so-called *extended perspective.*

But extended perspective is still not Cubism, because it affords the opportunity of only partially presenting "en face" to the spectator the side that is receding from him....

Volume

The outer form of a Cubist construction derived from the conception of volume...the depicted object is examined as the aggregate of volumetrical forms expressed by simple planes, i.e., the sides of them are given a primary (basic) geometrical form....

Space

Whereas all trends in art existing before Cubism employed chiaroscuro and, in the main, an aerial-linear perspective in order to depict space, Cubism uses only form....

Plane

...An object, one of its sides or a part of it depicted on one plane can, with part of its form, enter another plane: this presents the eye with a greater intensity and joins up the disparate forms into a single, organic whole.

The Fourth Dimension

But with the transference of an object into another plane, these planes must be displaced to ensure the displacement of an object's form: otherwise the planes will not be sensed in the picture and only the line that is committed to transmitting the edge of the planes will be visible.

The transference of an object into another plane prompted by displacement of object or spectator is characteristic of the situation that is conventionally called the *fourth dimension*....

Movement. Kinetic Cubism

...Futurism, and then *Cubo-Futurism,* particularly *kinetic Cubism,* gave the maximum opportunities of evoking the conception of movement in us by transmitting several instants of this movement as well as broken impressions and the interchange of phenomena in their logical succession.

This movement was captured through the introduction of time as the fourth dimension of space—which gives an impression of movement identical to cinematography....

The Building of a Work. Its Construction

"The beauty of a work of art lives in the work itself and not in that which serves as the pretext for it," says Gleizes.

And Cubism sets as its primary aim: not to paint an object, but to build a picture. In this lies the whole force and meaning of a Cubist work.

One of the reasons for the emergence of Cubism was the aspiration towards greater constructiveness in a picture—a reaction against étude-like character of painting and against the cursory sketch which had been firmly established in the art of the recent past.

A work of Cubism is not copied from nature but is built independently according to its own particular principles and structure....

Cubism proceeds from construction of a picture to depiction of an object and not vice-versa, and uses the object only nominally....

An indispensable condition of a well-constructed Cubist work is its dynamism, i.e., the sensation of acute tension which should be felt in every part of the work, in its every line and form....

Deliberate dissonance and inter-penetration of planes and volumes have great significance in Cubism.

Volumetrical correlations, constructive asymmetry, color, and textural dissonance are the basis of Cubist construction....

These new theses were taken by the Cubists to construct their pictures; moreover, they were constructed so that an unexpected confrontation of planes and lines would produce a high-tension dissonance....

In a Cubist construction the artist does not confine himself to statics, but also introduces a dynamic sensation by saturating painting to a high tension of color.

A Cubist construction, aspiring to economy, rejects repetition of forms.

A part or the sides of an object are taken inasmuch they are essential to the completeness of construction.

If the artist finds too few painterly, textural, volumetrical, etc., forms in a given object and not enough tension, he is free to take them from another. In the same way an object's reiterated parts can be omitted.

Alongside the big, very simple forms in a Cubist work it is extremely interesting to see any details or intricacies.

To sum up the above one can conclude that a Cubist work is built up on a constructive rhythm of elements: color, texture, form, volume, etc.; it aspires to make the object, depicted at different moments in time, express the unity of its plastic essence in Cubist asymmetry.

Ivan Kliun, *SA*, Moscow, 1928, no. 6, pp. 194–99. Translated from the Russian by John E. Bowlt.

Klucis, Gustav Gustavovich

Born 1895 near Riga, died 1944.

98.

Axiometric Painting, c. 1920
Oil on canvas
66 x 47.5 cm. (26 x 18¾ in.)
Thyssen-Bornemisza Collection,
Lugano, Switzerland

99.

Buka Russkoi literatury (The Bogeyman of Russian Literature)
by D. Burliuk, S. Tretiakov,
T. Tolstaia, and S. Rafalovich
Moscow, 1923
48 pp. with lithographs by Klucis
and I. Kliun
Ex Libris 6, no. 42
14 x 19.1 cm. (5½ x 7½ in.)
George Gibian, Ithaca, New York

100.

Zhiv Kruchenkykh! (Kruchenykh's Alive!) by B. Pasternak, S.
Tretiakov, D. Burliuk, et al.
Moscow, 1925
48 pp. with 3 lithographs by Klucis
and I. Kliun
Ex Libris 6, no. 131
19.1 x 14.1 cm. (7½ x 5⅝ in.)
Collection Martin-Malburet

101.

Na borbu s khuliganstvom v literature (Against Hooliganism in Literature) by A. Kruchenykh
Moscow, 1926
32 pp. with lithographs
Ex Libris 6, no. 121
17.2 x 13.2 cm. (6¾ x 5¼ in.)
Australian National Gallery,
Canberra

102.

Izofront. Klassovaia borba na fronte prostranstvennykh iskusstv. Sbornik statei obedineniia "oktiabr" (The Art Front. The Class Struggle for the Front of Three-Dimensional Arts. A Collection of Articles from "October")
Moscow/Leningrad, 1931
162 pp. with photomontages
Ex Libris 6, no. 91
12.7 x 17.2 cm. (5 x 6¾ in.)
National Gallery of Art Library,
Washington, D.C.

1918 arrived in Moscow as a rifleman in the 9th Latvian Infantry Regiment, summoned to guard the Kremlin; Klucis took an active role in the art workshop organized by the regiment and led by Voldemar Andersen, painting scenes from army life; enrolled in Svomas/Vkhutemas; 1919–20 already working on poster designs and interested in typographical and architectural design; 1920–22 influenced by Lissitzky; particularly interested in spatio-color combinations in graphic and photomontage work; 1922 contributed to the *Erste Russische Kunstausstellung* in Berlin; 1923 member of Inkhuk; 1924 started to teach at Vkhutemas; 1925 executed photomontage designs for Maiakovsky's poem "V. I. Lenin," and did many such designs thereafter; 1927 contributed to Lissitzky's *All-Union Polygraphical Exhibition* in Moscow and then to many exhibitions in graphics, posters, and applied arts both in the Soviet Union and abroad; co-designed Kruchenykh's book *Chetryre foneticheskikh romana (Four Phonetic Novels)*; 1928 co-founder of the group October, contributing to its single exhibition in 1930 and playing a vital role in its Photo-Section until the group's disbandment in 1932; continued to be active as a poster and typographical designer until the late 1930s; stopped exhibiting in 1938; 1959 and 1970 retrospective exhibitions of his work in Riga.

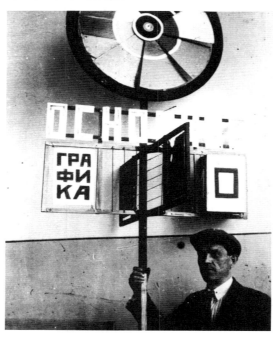

Bibliography

L. Oginskaia, "Khudozhnik-agitator," *Dekorativnoe iskusstvo,* Moscow, no. 5, 1971, pp. 34–37.

M. Ostrovsky (compiler), *Sto pamiatnykh dat. Khudozhestvennyi kalendar,* Moscow, 1974, pp. 17–20.

N. Shantyko, "Klutsis-illiustrator Maiakovskogo," *Khudozhnik,* Moscow, no. 2, 1970.

■ Born in 1895, Gustav Klucis was of the generation that belonged wholly to the Revolution. At twenty-two he participated in both the February and October Revolutions; the following year found him in Moscow with the Latvian Infantry Regiment, defending the Kremlin during the Civil War. Klucis's basic art training came from the "laboratory art" experience of Vkhutemas. Devoted to the new Soviet society, Klucis quickly absorbed the new art ideas: "Revolution demands from art forms that are absolutely new, forms that have not existed before."

Klucis developed a high regard for Malevich. Although never a doctrinaire Suprematist, Klucis exhibited with the Unovis group in Vitebsk (1920) and in Moscow (1921). Less mystically inclined than Malevich, he also was open to the sculptural ideas of Gabo and to the design theories of Lissitzky. *Axiometric Painting* (c. 1920) shows Klucis's special emphasis on textural and color values, as well as his Constructivist interest in the mathematical derivation of forms in space. These spatial concerns were developed in the three-dimensional suspended constructions of 1920–22: volumetric forms which turned away from the enclosed "architecton" models of Malevich and incorporated the open and linear rhythms of Lissitzky's "Proun" structures. By 1924 Klucis's association was with Inkhuk Productivists—Popova, Stepanova, Rodchenko, and Vesnin—who had broken completely with easel painting and were committed to graphic and industrial design for a mass public.

Klucis's Productivist desire to bring a mass art to the streets resulted in his agit-constructions (the so-called "Radio Announcers," designed to serve as newspaper kiosks, loudspeakers, public speaker platforms, etc.) and in his innovative work in graphics and photomontage. The art of photomontage, as practiced by the avant-garde of the 1920s, was especially successful because it combined experimental formal concerns and Dada-like paradox with images accessible to the public. Klucis's photomontages for Maiakovsky's poem "V. I. Lenin" are celebrated, but his closer association was with the work and theories of the poet Kruchenykh. *The Bogeyman of Russian Literature* (1923) was inspired by Kruchenykh's literary gatherings at Tiflis. Essays by D. Burliuk, Tretiakov, and others establish the unique position of Russian Futurism; the Constructivist interior lithographs are by Klucis and Ivan Kliun. *Kruchenykh's Alive!* (1925) has a Constructivist cover and two interior lithographs by Klucis; the essays by Pasternak, D. Burliuk, Tretiakov, and others are concerned with experimental literature. *Against Hooliganism in Literature* (1926) is one of the last Futurist avant-garde productions; the book, with a cover design by Klucis, is a collection of poems and

98

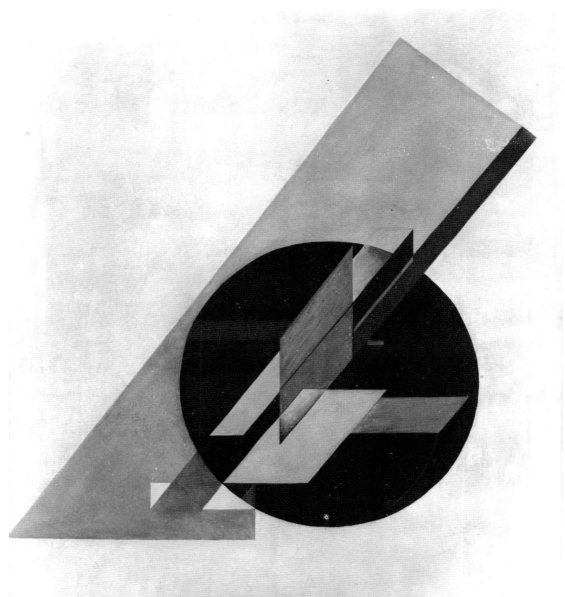

А. КРУЧЕНЫХ

НА БОРЬБУ
С ХУЛИГАНСТВОМ

В ЛИТЕРАТУРЕ

ИЗДАНИЕ АВТОРА МОСКВА 1926 г.

criticism by Kruchenykh directed to the Soviet cinema.

In 1928 Klucis became a founding member of October, a Productivist association calling for artists to serve "the concrete needs of the proletariat, the leaders of the peasantry, and the backward national groups." Its interests were the industrial and applied arts, architecture, film and photography, book and poster design, mass festivals, and art education. Among contributors to its single exhibition in 1930 were Klucis, Lissitzky, Rodchenko, and Stepanova. Reproductions and articles by October members are collected in *The Art Front: The Class Struggle for the Front of the Three-Dimensional Arts*. Accused of "abolishing art," October was dissolved by the Communist Party's 1932 Decree on the Reconstruction of Literary and Artistic Associations. Klucis's avant-garde passions eventually ran him afoul of the Communist Party. Arrested in 1938 during the terror of the Stalinist purges, Klucis died in the labor camps in 1944.

Konchalovsky, Petr Petrovich

Born 1876 Slaviansk; died 1956 Moscow.

103.
Spanish Boy, 1910
Oil on canvas
99 x 77 cm. (39 x 30¼ in.)
Jay S. Cantor

Bibliography

M. Neiman, *P. P. Konchalovsky,* Moscow, 1967.

Late 1880s moved from Kharkov to Moscow; attended evening classes at the Stroganov Art Institute; 1896–98 studied at the Académie Julien in Paris; 1898–1905 studied at the Academy of Arts, St. Petersburg; 1908–9 studied at Moscow College; 1910 with Mikhail Larionov, Aristarkh Lentulov, et al. co-founded the avant-garde Jack of Diamonds group; contributed regularly to its exhibitions until 1918 and maintained close contact with members of the avant-garde, especially Lentulov and Georgii Yakulov; c. 1910 traveled in France, Italy, Spain; 1918–21 taught at the Higher State Art Technical Studios in Moscow; 1926–29 taught at the Higher State Art Technical Institute in Moscow; 1920s traveled extensively in Russia, including the Caucasus; 1930s onward continued to work in many genres, especially the still life and the portrait.

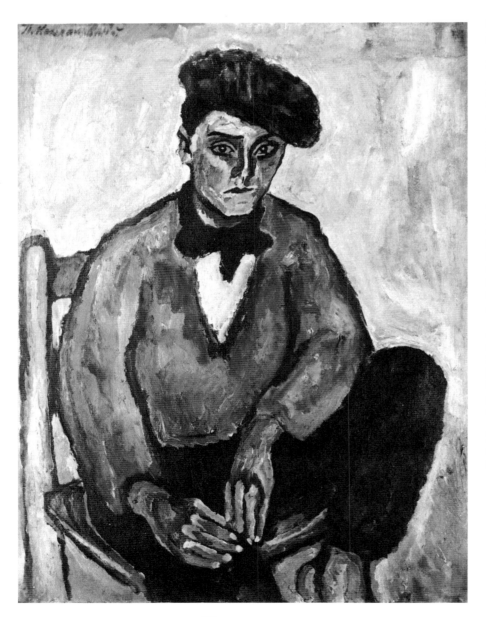

■ Konchalovsky's lifelong devotion to Cézanne, van Gogh, and Matisse began during his student years in Paris (1896–98), where he studied at the Académie Julien. Upon returning to Russia, Konchalovsky attended the Academy of Arts in St. Petersburg. From 1905 to 1909 he studied in Moscow under the famous painter Korovin, who was an important liberal influence in the Moscow College early in the century. Most Russian avant-garde artists were Korovin's pupils, including the Neo-Primitivists Goncharova and Larionov, the Constructivist Tatlin, and the Futurist poets Kruchenykh, Maiakovsky, and the Burliuk brothers. Konchalovsky was expelled from the college in 1909 for being too "leftist."

In 1910 Konchalovsky traveled in Western Europe, stopping in France, Italy, and Spain. Upon his return that year he co-founded the avant-garde group known as the Jack of Diamonds and contributed regularly to its exhibitions until 1918. This society sponsored exhibitions that united many of the young artists in Moscow for the first time. The first exhibition featured work by the French Cubists (Gleizes, Le Fauconnier, Lhote), underlining the importance of the French influence on the Russian avant-garde at this time.

Konchalovsky's *Spanish Boy,* 1910, is characteristic of the artist's work during this period. Portraits and still lifes such as this work show his marked devotion to the great French movements. Konchalovsky's use of brilliant color, intense surface patterning, and a radical simplification of form reveal his close connection to Matisse. The Cézannesque structure, so evident in this painting, became a critical influence in Konchalovsky's later work.

During the 1920s Konchalovsky traveled extensively in his native land. He never forgot his connection with an older generation of painters and continued his commitment to easel painting.

103

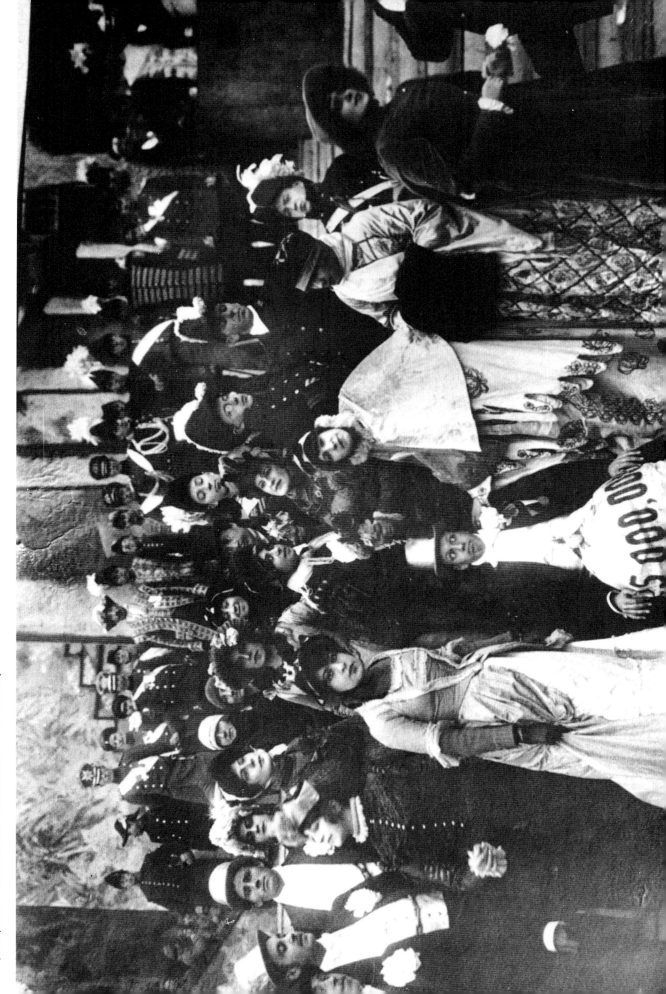

"The Overthrow of the Tsarist Regime": mass performance with
participation of actors from the dramatic studio of the Red Army

Kudriashev, Ivan Alexeevich

Born 1896 Moscow; died 1970 Moscow.

104.

Untitled, 1918

Watercolor

19 x 13 cm. (7½ x 5⅛ in.)

Robert and Maurine Rothschild
Collection

105.

Drawing, 1922

Pencil

30 x 22 cm. (11¾ x 8⅝ in.)

Robert and Maurine Rothschild
Collection

Bibliography

Nothing substantial has been
written on Kudriashev. Some
biographical and artistic details
will be found in:

V. Kostin, *OST,* Leningrad, 1976,
passim.

Koudriachov, exh. cat., Galerie
Jean Chauvelin, Paris, 1970.

1913 entered the Moscow Institute of Painting, Sculpture,
and Architecture; contact with artists such as Malevich
and Kliun; 1918 worked on agit-designs for automobiles in
connection with the first anniversary of the Revolution in
Moscow; 1920 worked on interior designs for the Summer
Red Army Theater and the First Soviet Theater in Oren-
burg; 1920s worked on the principles of luminosity and
refractivity in painting, producing works similar to the "en-
gineerist" paintings of Kliment Redko; 1922 contributed to
the *Erste Russische Kunstausstellung* in Berlin; 1925
contributed to the *First State Traveling Exhibition of Paint-
ings* in Moscow, Saratov, and other cities; member of
OST; 1925–28 contributed to the first, second, and fourth
OST exhibitions in Moscow; he was represented here
by abstract paintings such as *Luminescence, Dynamics
in Space,* and *Spatial Painting*; after 1928 stopped
exhibiting.

 Ivan Kudriashev belongs to the generation of artists
that came to maturity in a transitional period in the history
of the Russian avant-garde. Trained as a Suprematist at
the height of the movement, by the time the artist was in
his mid-thirties, government policy had altered drastically
and endorsed Socialist Realism.

Kudriashev came into contact with the leading Su-
prematists Malevich and Kliun during his student years
immediately preceding the Revolution at the Moscow
Institute of Painting, Sculpture, and Architecture. But Ku-
driashev's unique brand of Suprematism was a peculiarly
eclectic one. The *Untitled* watercolor of 1918 points to a
strong influence of the French Cubists. Similarly unor-
thodox was the artist's focus on properties of light: his
painting from the 1920s was based on principles of
luminosity and refractivity. Kudriashev's interior designs
for the Summer Red Army Theater and the First Soviet
Theater in Orenburg (1920) adhere more strictly to the
Suprematist aesthetic; clear, bright, and unmodulated
color is applied to a simple geometry in these gouache
studies.

Like many of the younger generation of artists, Kud-
riashev became a member of OST (Society for Easel
Painting, 1925)—the organization that rejected the Produc-
tivist trend toward merging art and industry and called
for a return to traditional studio art. Pointing the way
toward Socialist Realism, OST supported a figurative
style. Interestingly, Kudriashev did not embrace Realism,
or even a representational approach. He continued to
paint and exhibit abstract compositions until 1928. Ku-
driashev died in Moscow in 1970.

104

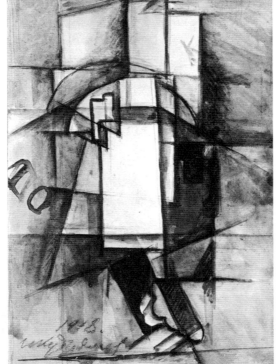

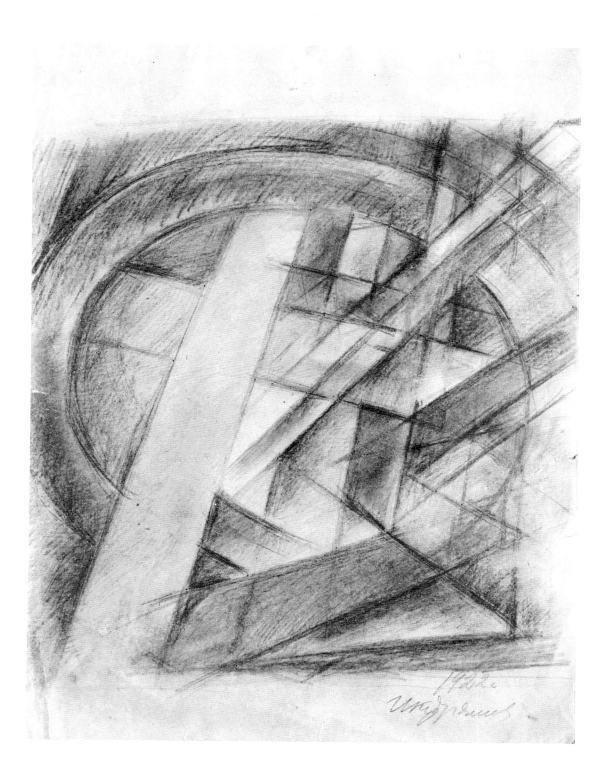

105

Larionov, Mikhail Fedorovich

Born 1881 Tiraspol; died 1964 Fontenay-aux-Roses, France.

106.
Portrait of Tatlin in a Seaman's Blouse, 1908
Oil on canvas
76.8 x 59.1 cm. (30¼ x 23¼ in.)
Jay S. Cantor

107.
Dancing Soldiers, 1909–10
Oil on canvas
88 x 102. 4 cm. (34⅝ x 40⅜ in.)
Leonard Hutton Galleries,
New York

108.
Autumn, 1911
Oil on canvas
136 x 115 cm. (53½ x 45¼ in.)
Musée National d'Art Moderne,
Centre Georges Pompidou, Paris

109.
Head of a Soldier, 1911
Oil on canvas
69.9 x 50.2 cm. (27½ x 19¾ in.)
Leonard Hutton Galleries,
New York

110.
Portrait of Tatlin, 1911
Oil on canvas
90.2 x 71.8 cm. (35½ x 28¼ in.)
Musée National d'Art Moderne,
Centre Georges Pompidou, Paris

111.
Mir s kontsa (The World Backwards) by V. Khlebnikov and A. Kruchenykh
St. Petersburg, 1912
37 pp. with lithographs and rubber stamps by N. Goncharova, Larionov, V. Tatlin, and I. Rogovin
Ex Libris 6, no. 137
20 x 14.9 cm. (7⅞ x 5⅞ in.)
Collection Martin-Malburet

112.
Starinnaia liubov (Old-Time Love) by A. Kruchenykh
Moscow, 1912
14 pp. with five lithographs by Larionov
Ex Libris 6, no. 126
14.5 x 9.7 cm. (5¾ x 3⅞ in.)
a) Australian National Gallery, Canberra
b) Mr. Alexander Rabinovich

1898 entered the Moscow Institute of Painting, Sculpture, and Architecture; 1900 met Goncharova; 1902 entered the studio of Valentin Serov there; 1904 expelled; 1906 traveled with Diaghilev to Paris in connection with the Russian section at the Salon d'automne; contributed to several exhibitions in Russia including the *Exhibition of Posters and Placards* organized by the Leonardo da Vinci Society in Moscow and the annual exhibition of the Moscow Association of Artists; 1907 member of the Society of Free Aesthetics, Moscow; 1908–10 contributed to the three exhibitions organized by Nikolai Riabushinsky, editor of the journal *Zolotoe runo (The Golden Fleece)*; 1910 with Goncharova et al. organized the Jack of Diamonds society; 1912 organized the Donkey's Tail group; took part in Roger Fry's Post-Impressionist exhibition in London; 1913 organized the Target group; at its exhibition Larionov showed Rayonist works for the first time publicly; publication of Larionov's Rayonist manifesto; organized the exhibition of icon originals and *lubki* in Moscow; illustrated several Futurist booklets including Kruchenykh's *Pomada (Pomade)* and *Starinnaia liubov (Old-Time Love)*; 1914 organized the exhibition *No. 4* in Moscow; went to Paris to work for Diaghilev; at the outbreak of the War was mobilized; 1915 wounded and hospitalized; contributed to the *Exhibition of Painting, 1915*; left Russia to join Diaghilev in Lausanne; 1917 with Goncharova settled in Paris; 1920–22 contributed designs to Diaghilev's productions of *Chout* and *Le Renard;* 1930s–50s except for occasional contributions to exhibitions lived unrecognized and impoverished; 1961 the Arts Council of Great Britain organized a large exhibition of his works and those of Goncharova.

106

107

113.

Venus, 1912
Tempera on canvas
56 x 73.5 cm. (22 x 28⅞ in.)
Collection Rubinger, Cologne,
West Germany

114.

**Oslinyi khvost i mishen (The
Donkey's Tail and the Target)**
by Larionov, N. Goncharova,
A. Shevchenko, et al.
Moscow, 1913
152 pp. with numerous
black-and-white illustrations, some
tipped in
Ex Libris 7, no. 959
28.2 x 21.9 cm. (11⅛ x 8⅝ in.)
a) Australian National Gallery,
Canberra
b) Ruth and Marvin Sackner

115.

Pomada (Pomade) by A.
Kruchenykh
Moscow, 1913
34 pp. with hand-colored
lithographs
16 x 10.5 cm. (6¼ x 4⅛ in.)
Collection Martin-Malburet

116.

**Costume for a Cricket, "Histoires
naturelles,"** 1915
Stencil on paper
49.5 x 32.4 cm. (19½ x 12¾ in.)
Mississippi Museum of Art,
Jackson, The Lobanov Collection

117.

**Costume for a Peacock,
"Histoires naturelles,"** 1915
Stencil on paper
46.4 x 31.1 cm. (18¼ x 12¼ in.)
Mississippi Museum of Art,
Jackson, The Lobanov Collection

118.

**Costume for a Funeral March,
"Théâtre des ombres colorées,"**
c. 1915
Stencil on paper
44.5 x 30.5 cm. (17½ x 12 in.)
Mississippi Museum of Art,
Jackson, The Lobanov Collection

■ Mikhail Larionov's contribution to the Russian avant-garde before World War I was crucial. A leader in encouraging the most revolutionary artistic ideas in Europe and Russia, Larionov organized such landmark exhibitions as *Jack of Diamonds* (1910), *Donkey's Tail* (1912), *The Target* (1913), and *No. 4* (1914). With his companion, the artist Natalia Goncharova, he spearheaded modernist Neo-Primitive tendencies; the couple developed the brief but important abstract movement called Rayonism. Larionov was a collaborator on many innovative Russian Futurist books. A significant figure in theater design, he settled in 1917 in Paris, where he and Goncharova found inspiration in the circle surrounding Diaghilev.

Larionov's early, Neo-Primitivist style, launched at the 1909 third exhibition of the Golden Fleece group, is evident in his 1908 *Portrait of Tatlin in a Seaman's Blouse*; his knowledge of French Fauvism is made personal by his deliberate use of expressive crudeness. In *Dancing Soldiers* of 1909–10 Larionov further discards Fauvist sophistication; his blunt Primitivism, with its pictorial distortions and crudely lettered graffiti, borrows from the Russian tradition of the peasant *lubok* (popular woodblock illustration). This insistence upon a flourishing Russian nationalism led to a revival of Old Russian religious art. Larionov's 1911 *Autumn* incorporates within its spirit of folk-art design an icon-like *orans* figure in the traditional blessing posture.

A conscious use of themes from ancient and peasant art developed side by side with Larionov's interest in the more formal aspects of pictorial modernism. His 1911 *Head of a Soldier* sheds with finality the Matisse-like echoes of the earlier 1908 portrait in favor of a direct presentation of a profile view and a willful emphasis upon the physical act of painting itself. A 1911 second *Portrait of Tatlin*, with its abstract and delicate network of brush strokes, appears to be a transitional step toward Larionov's development of Rayonism. The surface writing of *Portrait of Tatlin* is not the crude graffiti of *Dancing Soldiers* but, rather, an alogical scattering of letters resembling print. Larionov's painting of this period is related to many of the literary devices of Russian Futurist poetry: letters out of context, jumbled words, deliberate misprints, erratic spacing, crude and inexpensive printing processes, an emphasis on the handmade and on the process of artmaking itself. *Mir s kontsa (The World Backwards),* a Futurist book with a rubber-stamped text by the poets Klebnikov and Kruchenykh, was published in 1912 with a collage cover and interior lithographs by Larionov, Goncharova, and others. The 1913 collaboration of Larionov and Kruchenykh produced *Starinnaia liubov (Old-Time Love)* and *Pomada (Pomade).*

The Target exhibition of 1913 was the occasion of the official presentation of Rayonism. A 1913 miscellany, illustrated by Larionov and Goncharova, *The Donkey's Tail and the Target (Oslynyi khvost i mishen),* includes a manifesto stating: "Hail to our Rayonist style of painting independent of real form existing and developing according to the laws of painting...." The 1916 *Rayonist Composition,* characteristic of Larionov's style of muted and monochromatic Rayonism, is concerned with spatial form obtained through the crossing of light rays reflected from various objects selected by the artist. While developing Rayonism, Larionov also began to work in the theater. Among his many original and amusing designs are the 1915 Futurist *Costume for a Cricket* and *Costume for a Peacock,* planned for a Diaghilev production of *Histoires naturelles.* Larionov choreographed this ballet with the famous Fokine, but it was never produced. Inspired by Diaghilev, both Larionov and Goncharova left Russia before experiencing the turmoil of the Revolution; they settled permanently in Paris in 1917.

108

119.
Costume for a Male Character,
"Théâtre des ombres colorées,"
c. 1915
Stencil on paper
43.2 x 27.9 cm. (17 x 11 in.)
Mississippi Museum of Art,
Jackson, The Lobanov Collection

120.
Rayonist Composition, 1916
Gouache on paper
45 x 56 cm. (17¾ x 22 in.)
Galerie Gmurzynska, Cologne,
West Germany

Bibliography

John E. Bowlt, "Neo-primitivism
and Russian Painting," *The Bur-
lington Magazine,* London, March
1974, pp. 364–68.

M. Dabrowski, "The Formation and
Development of Rayonism," *Art
Journal,* New York, vol. 34, no. 3,
spring 1975, pp. 200–207.

W. George, *Larionov,* Paris, 1966.

Michel Larionov, *Une Avant-Garde
Explosive,* Lausanne, 1978.

T. Loguine, ed., *Gontcharova et
Larionov,* Paris, 1971.

G. Pospelov, "O 'valetakh' bub-
novykh i valetakh chervonnykh,"
Panorama iskusstv 77, Moscow,
1978, pp. 127–42.

D. Sarbianov, *Russkaia zhivopis
konsta 1900kh–nachala 1910kh
godov,* Moscow, 1971, pp. 99–116.

115

■ …Rayonism leads to the discovery of the possibili
of explaining—not only philosophically and psycholog
cally, but also physically—the phenomena of aestheti
ecstasy and pleasure which one experiences before
spot of color, before such-and-such a technical process
painting, before luminosity or opacity of shade, befor
artistic style, etc.

It is the analysis and utilization of a certain order
sensations which have no part in plastic or any othe
representational genres. For example, a wall painted i
one and the same color can appear in a different ton
depending on the way in which the paint is put on (usual
the problems of color and technique are considered a
two distinct things). To determine changes of tone purel
by a change in technique is one of the problems
Rayonism—while taking into account not only surfac
differences but also the radiance emanating from th
layer's surface and from its thickness….

Some time I shall be able to explain this hypothesis t
you in a more detailed fashion, and perhaps some of th
ideas about Rayonism will seem clearer to you. Ultimate
Rayonism admits of the possibility of a definition an
physical measurement of love, ecstasy, talent—thos
spiritual qualities of the lyrical and epic state. Rayonisr
aims to define all that concerns the province of sensation
belonging to the human and animal world in their relatio
to the so-called non-organic world. The visible radiance
light is material and measurable; invisible radianc
(radioactivity, etc.) is in certain cases also measurable
the radiance of a human being or animal (which one coul
perhaps call intuitive or sympathetic) would also b
measurable if one could establish the correlation betwee
radiance not yet measured, that is to say, radiance
thought.

Thus, if one can place radiance of thought in th
same category as all other radiance, that is to say, brilliar
or non-brilliant radiance, one has only to find a correlatio
between them to be able to define its qualities. It is obvi
ous that these qualities are measurable only by means
movements which are quicker than those of light….

Rayonism opens the way of translating aestheti
problems from the purely philosophical province to th
physical one. This translation throws light on many thing
and affords them a new explanation. And, above all,
abolishes the value of time and, hence, of fashion, as we
as explaining various styles in a new way….

Mikhail Larionov, excerpt from a letter to Alfred H. Barr, Jr.

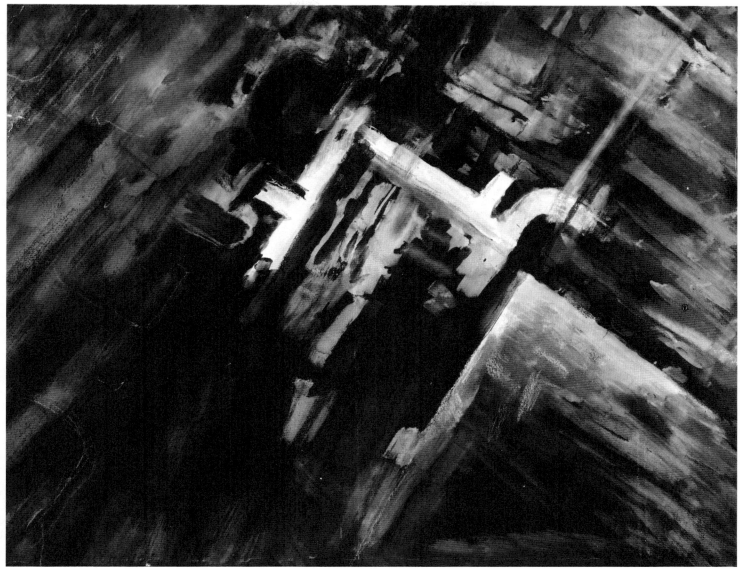

120

Lissitzky, El (Lisitsky, Lazar Markovich)

Born 1890 Polshchinok, near Smolensk; died 1941 Moscow.

121a.–k.
Chad Gadya, 1918–19
11 color lithographs
30 x 27 cm. (11¾ x 10⅝ in.) each
Private collection

122.
Proun Construction, No. 25,
c. 1919
Watercolor, india ink, and pencil
with collage on paper
28 x 20.3 cm. (11 x 8 in.)
Private collection

123.
Proun 1 C, 1919
Oil on canvas
68 x 68 cm. (26¾ x 26¾ in.)
Antonina Gmurzynska, Cologne,
West Germany

124.
Proun 23, No. 6, 1919
Oil on canvas
77 x 52 cm. (30⅜ x 20½ in.)
Mr. and Mrs. Eric E. Estorick
(Hirshhorn Museum and Sculpture
Garden only)

125a.–f.
Proun (Kestner Series), 1919–23
6 lithographs
60.4 x 44.2 cm. (23¾ x 17⅜ in.)
Private collection

126.
Proun, 1919–20
Gouache on paper
15 x 15.5 cm. (5⅞ x 6⅛ in.)
Mr. and Mrs. Ahmet Ertegün

127.
Proun 5 A, 1919
Watercolor on paper
17.5 x 22 cm. (6⅞ x 8⅝ in.)
Thyssen-Bornemisza Collection,
Lugano, Switzerland

128.
Proun, c. 1920
Gouache on paper
43 x 75 cm. (16⅞ x 29½ in.)
Private collection, Germany

129.
Proun 3 A, c. 1920
Oil on canvas
71.1 x 58.4 cm. (28 x 23 in.)
Sidney Janis Gallery, New York

1909–14 studied at the Technische Hochschule in Darmstadt; traveled in France and Italy; 1914 returned to Russia; worked in Moscow as an architectural draftsman; 1916 designed a Futurist cover for Konstantin Bolshakov's book of poetry *Solntse na izlete (Spent Sun)*; 1917 exhibited with the World of Art in Petrograd, contributing decorative paintings under the titles of *The Leader* and *Jericho*; thereafter contributed to many exhibitions at home and abroad; 1918 designed the title-page for Yakov Tugenkhold's monograph on Gauguin *Zhizn i tvorchestvo Pola Gogena (The Life and Work of Paul Gauguin,* 2nd edition); member of IZO NKP; 1919 professor at the Vitebsk Art School; close contact with Chagall and then with Malevich; member of Posnovis/Unovis; began to work on his Prouns; close to Lazar Khidekel, Chashnik, Suetin; 1920 member of Inkhuk in Moscow; 1920–21 professor at Vkhutemas; 1921 designed the cover for *Wendingen,* the monograph on Frank Lloyd Wright (Amsterdam); 1922 with Ilia Ehrenburg edited the journal *Veshch/Gegenstand/Objet* in Berlin; he began to work increasingly on typographical and architectural design; published *Pro dva kvadrata (Story of Two Squares)*; created the Proun Room for the *Grosse Berliner Kunstausstellung* of 1923; 1923 produced his mechanical figures for *Victory Over the Sun* as a lithographed album; also published his six Proun lithographs in the *Kestnermappen* in Hanover; designed Maiakovsky's book for reading aloud called *Dlia golosa (For the Voice)*; 1925 returned to Moscow; taught interior design at Vkhutemas; thereafter active primarily as an exhibition and typographical designer, creating new concepts for the exhibition room as in his *Abstrakte Kabinett* at the Niedersächsische Landesgalerie in Hanover in 1927–28; 1928 joined the group October; 1930 published his treatise on modern architecture *Russland: Architektur für eine Weltrevolution*; 1930s worked for the propaganda magazine *USSR in Construction.*

123

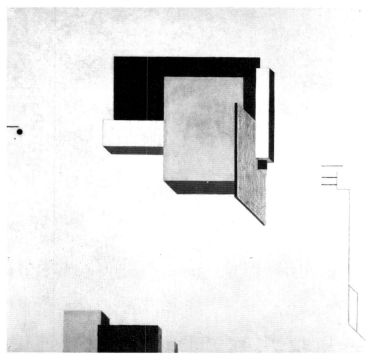

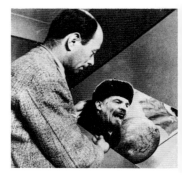

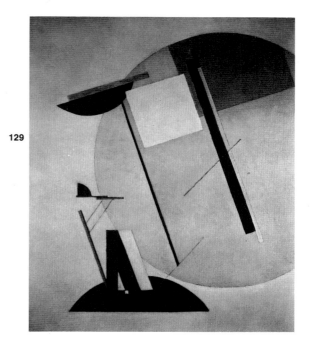

129

124

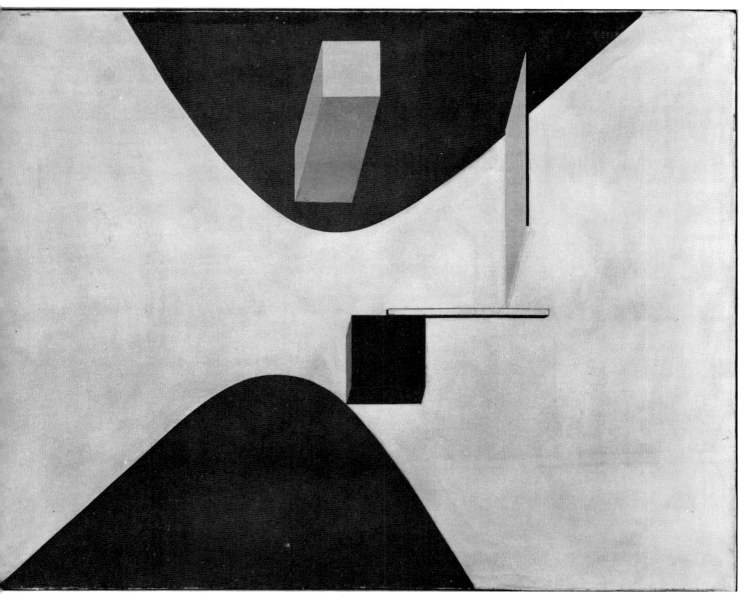

185

130.

Proun 4 B (study), c. 1920
Gouache, watercolor, and pencil on
paper
21.9 x 17.5 cm. (8⅝ x 6⅞ in.)
Mr. and Mrs. Ahmet Ertegün

131.

Study for Proun 1 E, c. 1920
Gray and white gouache, india ink,
and pencil on paper
19 x 23 cm. (7½ x 9 in.)
Private collection

132.

**Tatlin and the Monument to the
Third International,** c. 1920
Collage, watercolor, pencil, and
photomontage
33 x 24.5 cm. (13 x 9⅝ in.)
Mr. and Mrs. Eric E. Estorick
(Hirshhorn Museum and Sculpture
Garden only)

133.

Proun 12 E, c. 1920
Oil on canvas
57.2 x 42.4 cm. (22½ x 16¾ in.)
Busch-Reisinger Museum, Harvard
University, Cambridge, Purchase,
Busch-Reisinger Museum

134.

Proun Study, c. 1920
Pencil and gouache on paper
15 x 10.5 cm. (5⅞ x 4⅛ in.)
Mr. and Mrs. Ahmet Ertegün,

135.

Preliminary Study for Proun 2 D,
c. 1920
Pencil and gouache on paper
20 x 13 cm. (7⅞ x 5⅛ in.)
Mr. and Mrs. Ahmet Ertegün,

136.

Proun 4 B, 1920
Tempera on canvas
70 x 55.5 cm. (27½ x 21⅞ in.)
Thyssen-Bornemisza Collection,
Lugano, Switzerland

■ El Lissitzky's contribution to the Russian avant-garde encompassed an extraordinarily wide range of activities, including painting, architecture, book design and typography, photomontage, city planning, teaching, and theoretical inquiry.

Lissitzky was trained in engineering and architecture in Darmstadt, Germany. For him, as for many of his compatriots, the outbreak of war in 1914 prompted a return to Russia. Under the tutelage of Chagall, Lissitzky began to work in book design as early as 1917. A year later the artist was invited to join Chagall at the Vitebsk Art School, where he continued to work in a figurative style strongly influenced by the Cubo-Futurist movement. The *Chad Gadya* series of 1918–19 is characteristic of this period. The folkloristic subject matter and treatment are representative of the prevailing tradition of the *lubok,* which was particularly prevalent in Jewish book design.

Chagall's departure from Vitebsk, and the subsequent arrival of Malevich, proved to be a decisive influence on Lissitzky. Lissitzky quickly abandoned his figurative mode and developed the unique visual sense that found its expression in his famous "Prouns" (an acronym for "Project for the Affirmation of the New"). The Prouns represent a radically new conception in art; these geometrical compositions focus on a complex notion of simultaneous perception. Traditional pictorial space is denied, as is the issue of a single perspective. Ideas of equilibrium and gravity are rejected in favor of an assertion of disquieting weightlessness without scale. Many of the Prouns exist as studies in gouache and watercolor, as lithographs, or as fully developed paintings on canvas (*Proun 4 B* is an example of the last).

Lissitzky's longstanding commitment to his mentor, Malevich, is expressed in his series of twelve color lithographs (published 1923) which use the famous Futurist opera *Victory Over the Sun* (1913) as their point of departure. He developed the lithographs from a set of watercolors that were exhibited in Berlin in 1922. The series, conceived as an electromechanical peepshow, became known as the "puppet portfolio."

The next step in Lissitzky's development was the application of his schemes toward utilitarian ends, and in this respect that the Prouns represent a cross between Constructivist and Suprematist ideals. He was committed to a universal application of this new perception to Social Realism. The first public lecture that Lissitzky gave to explicate his theories was titled, "Prouns: a Changing-Trains between Painting and Architecture." A series of

architectural studies—bold concepts like "horizontal skyscrapers"—represent an effort to apply his radical concepts to a utilitarian purpose. Unfortunately, none of these projects was ever realized.

Lissitzky's pioneering advances in book design are the typographical extension of his theories of spatial dynamics. He proposed a kind of "architecture of the book," in which the structure of a book would be determined by its purpose and content. The first fully developed project is the children's book *Pro dva kvadrata (Story of Two Squares),* published 1922; typography is as much a complex of geometric forms as a sequence of linguistic signs. *For the Voice (Dlia golosa,* 1923) is considered to be Lissitzky's most spectacular achievement in "book construction." The contents, thirteen of Maiakovsky's most famous poems, was intended to be read aloud (hence, the title). The visual component is not simply illustrative, but a graphic guide to the contents. Lissitzky designed a thumb index for easy reference. The type was set entirely mechanically by a German compositor who knew no Russian.

During the 1920s Lissitzky spent a great deal of time traveling in Europe, where he played a major role in disseminating information about the Russian avant-garde. He contributed to several books and journals such as *Weningen* (1921), *Veshch* (1922), *Broom* (1923), and *Die Kunstismen* (1925), a trilingual publication intended as a cultural link between Russia and Western Europe. He was responsible for the spectacular installation design and innovative catalog for the landmark *Erste Russische Kunstausstellung* at the Van Dieman Gallery in Berlin 1922. Lissitzky considered exhibition design to be of crucial significance as a way of familiarizing the populace with new ideas in the design of tangible space—he used whole walls as positive entities. This concept of environmental design culminated in the *Proun Space* (1923). Lissitzky created an integrated environment designed to introduce active participation by the viewer, a space that was not simply a series of walls hung with pictures.

Lissitzky abandoned painting in the mid-1920s to concentrate on exhibition and typographical design. In the 1930s, despite failing health, he joined with the experimental group known as "October" in developing new methods for using photography. Experimental photography had been a continuing interest and for Lissitzky throughout his career. During the early 1920s he produced a series of photograms, such as *Composition with Spoon* (1920); later he was particularly drawn to photomontage.

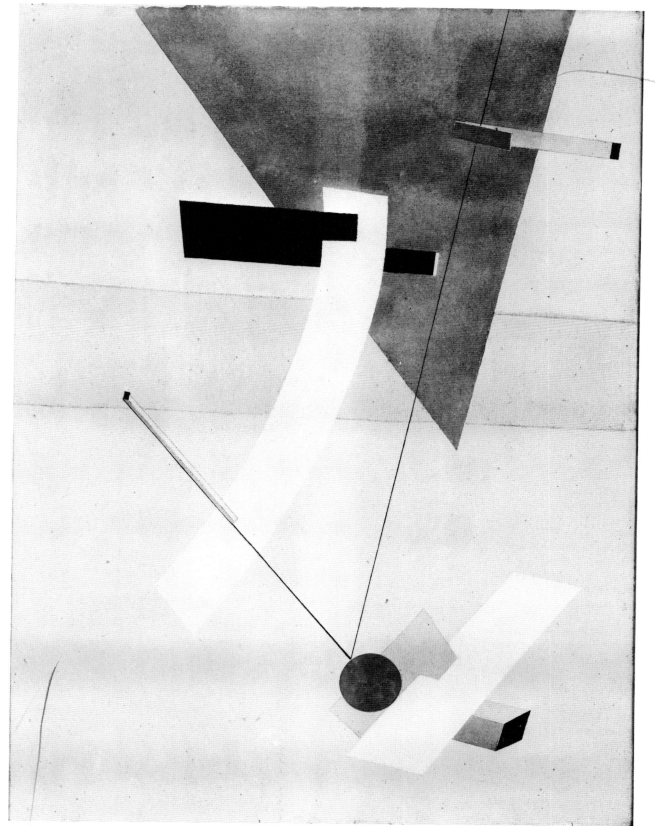

137.
Proun Study, c. 1920
Lithograph, pencil, and crayon on
paper
25.4 x 16.4 cm. (10 x 6½ in.)
Private collection

138.
Proun, c. 1920
Gouache and watercolor on paper
39.1 x 40.3 cm. (15⅜ x 15⅞ in.)
Indiana University Art Museum,
Bloomington

139.
Composition with Spoon, 1920
Photogram
29 x 23 cm. (11⅜ x 9 in.)
Museum Ludwig, Cologne
West Germany

140.
**A Suprematist Story about Two
Squares in Six Constructions,**
1920
Watercolor and pencil on cardboard
25.6 x 20.2 cm. 10⅛ x 8 in.)
Collection, The Museum of Modern
Art, New York, The Sidney and
Harriet Janis Collection

141.
Proun 2 C, c. 1920
Lithograph
39.4 x 29.2 cm. (15½ x 11½ in.)
Ruth and Marvin Sackner

142.
**Pro dva kvadrata (Of Two
Squares)**
Berlin, 1920, published 1922
20 pp. with cover
Ex Libris 6, no. 156
27.8 x 22.7 cm. (11 x 8⅞ in.)
a) Stedelijk Municipal Stadtisches
van Abbemuseum, Eindhoven, The
Netherlands
b) Madeleine Chalette Lejwa,
New York

143.
Wendingen ed. H. T. Wijdeveld
Amsterdam, 1921, volume 1
20 pp. with color lithographs by
Lissitzky
33 x 33 cm. (13 x 13 in.)
The Institute of Modern Russian
Culture, Blue Lagoon, Texas

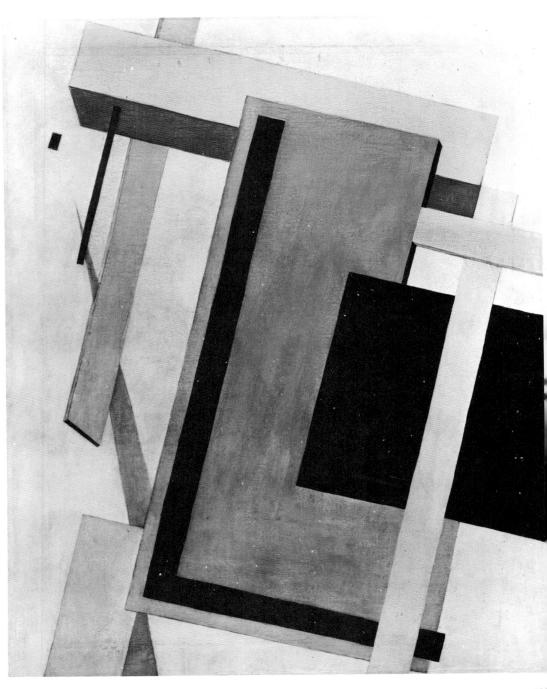

■ Today, many of us who have destroyed the object are moving toward the creation of a new object, of a new concrete reality. Such is our path. This is not the path of the engineer, who moves by mathematical tables, algebraic computations, and blueprints. The path of the engineer can serve as a method for only one particular time and it has absolutely no categorical value. Not a single written mathematical tract has survived from Egypt. But Egypt created a vast OBJECT-ful culture without logarithmic tables. Our age possesses a much greater number of component parts; their mechanical and dynamic properties are also new. And the skeleton of their constitution (assembled to fulfill new tasks) must be made in a new form. Those who used to be painters are now building this form—because of all the creative art-workers, they, more than anyone, have managed to scrape off the old, tautened skin so as to grow free....

When we saw that the content of our canvas was no longer a pictorial one, that it had begun to rotate even though, for the moment, it was like a geographical map, like a design or like a mirror with its reflections, and remained hanging on the wall—we decided to give it an appropriate name. We called it PROUN.

We gave it life. We gave it an aim: TO BUILD FORMS CREATIVELY (consequently, to master space) VIA THE ECONOMIC CONSTRUCTION OF TRANSFORMED MATERIAL.

At this juncture we must specify certain premises:

1. FORM OUTSIDE SPACE = 0
2. FORM OUTSIDE MATERIAL = 0
3. THE RELATIONSHIP OF FORM TO MATERIAL IS THE RELATIONSHIP OF MASS TO FORCE
4. MATERIAL ACQUIRES FORMS IN CONSTRUCTION
5. THE MEASURE BY WHICH THE GROWTH OF FORM IS LIMITED IS ECONOMY....

Reprinted with kind permission from *El Lissitzky*, exh. cat., Galerie Gmurzynska, Cologne, 1976, pp. 66, 67.

40

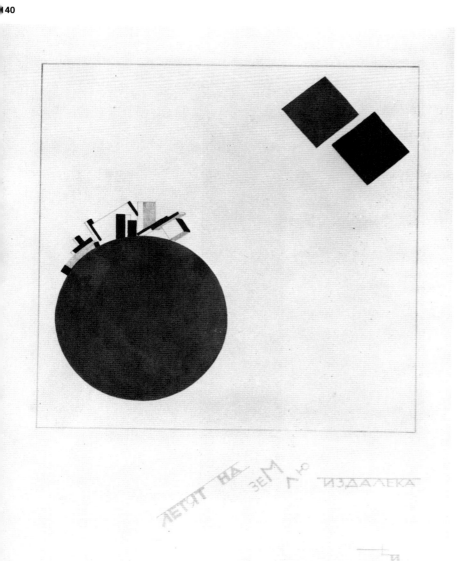

139

144.
Proun 1 C, 1921
Lithograph
24.1 x 23.8 cm. (9½ x 9⅜ in.)
(with frame)
Celeste and Armand Bartos

145.
Veshch/Gegenstand/Objet
ed. Lissitzky and Ilia Ehrenburg
Berlin, 1922
32 pp. with several photographs
and lithographs; printed paper
covers by Lissitzky
Ex Libris 6, no. 282
30.8 x 23.5 cm. (12⅛ x 9¼ in.)
The Institute of Modern Russian
Culture, Blue Lagoon, Texas

146.
**Cover Design for "Veshch/
Gegenstand/Objet,"** 1921–22
India ink and pencil on paper
31 x 23 cm. (12¼ x 9 in.)
Stedelijk Municipal Stadtisches van
Abbemuseum, Eindhoven, The
Netherlands

147.
**Cover Design for "Veshch/
Gegenstand/Objet,"** 1921–22
India ink and collage on paper
31.5 x 23.6 cm. (12⅜ x 9¼ in.)
Stedelijk Municipal Stadtisches van
Abbemuseum, Eindhoven, The
Netherlands

148.
**Proof for a Cover of "Veshch/
Gegenstand/Objet,"** 1921–22
Lithograph
31.3 x 23.6 cm. (12⅜ x 9¼ in.)
Stedelijk Municipal Stadtisches van
Abbemuseum, Eindhoven, The
Netherlands

149.
**Shest povestei o legkikh
kontsakh (Six Tales with Easy
Endings)** by I. Ehrenburg
Moscow/Berlin, 1922
164 pp. with color lithograph cover
and 6 illustrations by Lissitzky
Ex Libris 6, no. 61
20.2 x 13.8 cm. (8 x 5⅜ in.)
a) Australian National Gallery,
Canberra
b) Ruth and Marvin Sackner

150.
**Erste Russische
Kunstausstellung (First Russian
Art Exhibition)**
Galerie Van Diemen, Berlin, 1922
31 pp. and 44 illustrations; cover by
Lissitzky
Ex Libris 6, no. 279
22.6 x 14.6 cm. (8⅞ x 5¾ in.)
a) Leonard Hutton Galleries,
New York
b) Stedelijk Municipal Stadtisches
van Abbemuseum, Eindhoven, The
Netherlands
c) Peter Eisenman

151.
**Cover Design for "Broom,"
October, Vol. 5, No. 3,** c. 1922
Pencil on paper
29 x 23.1 cm. (11⅜ x 9⅛ in.)
Stedelijk Municipal Stadtisches van
Abbemuseum, Eindhoven, The
Netherlands

152.
**Cover Design for "Broom,"
October, Vol. 5, No. 3,** c. 1922
Watercolor on paper
22 x 35.3 cm. (8⅝ x 13⅞ in.)
Stedelijk Municipal Stadtisches van
Abbemuseum, Eindhoven, The
Netherlands

153.
**Cover Design for "Broom,"
October, Vol. 5, No. 3,** c. 1922
India ink and watercolor on paper
27.6 x 20.7 cm. (10⅞ x 8⅛ in.)
Stedelijk Municipal Stadtisches van
Abbemuseum, Eindhoven, The
Netherlands

154.
**Cover Design for the First
Kestner-Map,** 1923
Gouache on paper
22 x 15 cm. (8⅝ x 5⅞ in.)
Stedelijk Municipal Stadtisches van
Abbemuseum, Eindhoven, The
Netherlands

154

153

►

166.
Union der Sozialistischen
Sowjet Republiken Pressa-Köln
Exhibition Catalog
Cologne, 1928
20.3 x 14 cm. (8 x 5½ in.)
Peter Eisenman

167a.–h.
The Four Mathematical
Processes (eight designs), 1928
Pencil and gouache on paper
23.5 x 62 cm. (9¼ x 24⅜ in.) each
Private collection

168.
Stroitelstvo Moskvy (Presidium of
the Moscow Soviet of Workers,
Peasants, and Red Army
Deputies)
Moscow, 1929, vol. 5
Photomontage cover by Lissitzky
30.2 x 21.3 cm. (11⅞ x 8⅜ in.)
Peter Eisenman

169.
Chair, 1973 reconstruction of 1930
original
Plywood
67.5 x 58 x 47 cm. (26⅝ x 22⅞ x 18½
in.)
Wilhelm Hack Museum,
Ludwigshafen, West Germany

170.
Pro dva kvadrata (Of Two
Squares), c. 1930
Pen and ink on paper
2 pp. of Lissitzky's book designed
and translated into English by Louis
Lozowick
27.9 x 20.3 cm. (11 x 8 in.)
Mrs. Louis Lozowick

Bibliography

El Lissitzky, exh. cat., Galerie
Gmurzynska, Cologne, 1976.

Lissitzky, exh. cat., Museum of
Modern Art, Oxford, 1977.

S. Lissitzky-Küppers, *El Lissitzky:*
Life, Letters, Texts, London, 1968.

J. Tschichold, *Werke und Aufsätze*
von El Lissitzky (1890–1941), Berlin,
1971.

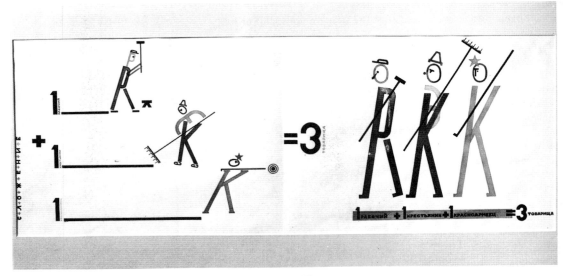

167

169

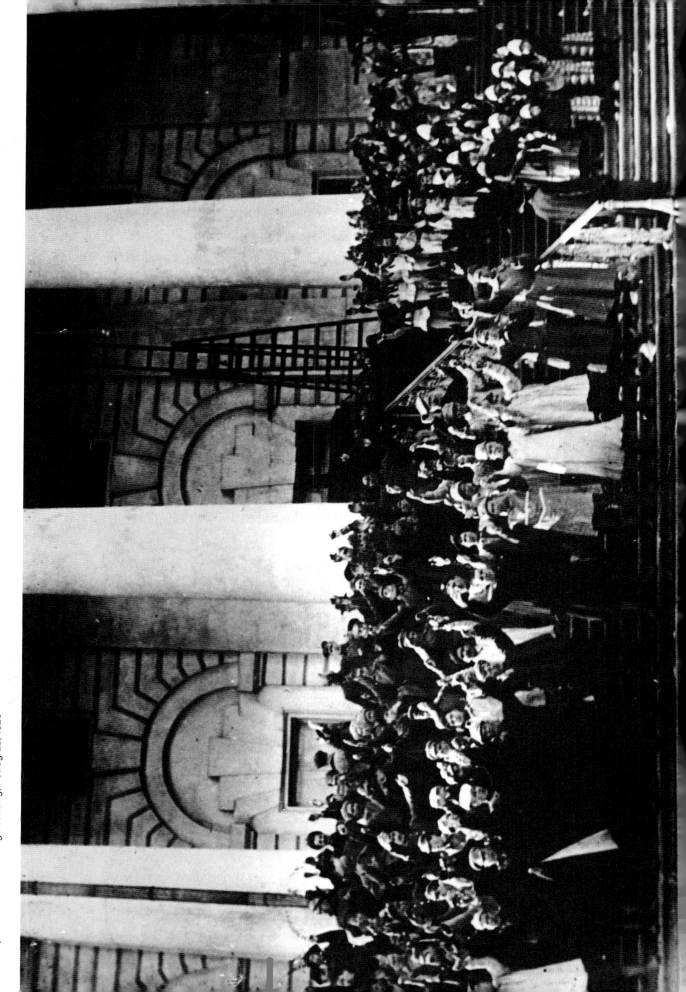

"Toward a Worldwide Commune": mass performance on the steps of the stock exchange building, Petrograd, 1920

Malevich, Kazimir Severinovich
Born 1878 near Kiev; died 1935 Leningrad.

171.
Igra v Adu (A Game in Hell) by
A. Kruchenykh and V. Khlebnikov
St. Petersburg, 1913, second edition
40 pp. with 4 lithographs by
Malevich and 22 by Rosanova
Ex Libris 6, no. 136
20.3 x 14.3 cm. (8 x 5⅝ in.)
a) Mr. Alexander Rabinovich
b) Robert Shapazian Inc.

172.
**Pobeda nad Solntsem (Victory
Over the Sun)** by A. Kruchenykh
St. Petersburg, December 1913
24 pp. libretto for opera with
reproductions of lithographs by
K. Malevich
Ex Libris 6, no. 140
25.4 x 17.8 cm. (10 x 7 in.)
a) Carus Gallery, New York
b) N. Seroussi, Galerie
Quincampoix, Paris

173.
Portrait of a Builder Completed,
1913
Lithograph
17.8 x 10.8 cm. (7 x 4¼ in.)
Thomas P. Whitney, Connecticut

174.
Troe (The Three) by E. Guro,
V. Khlebnikov, A. Kruchenykh
St. Petersburg, 1913
96 pp. with lithographs by Malevich
Ex Libris 6, no. 79
20 x 18.1 cm (7⅞ x 7⅛ in.)
a) Robert Shapazian Inc.
b) Private collection

175.
**Vozropshchem (Let's
G-r-r-rumble)** by A. Kruchenykh
St. Petersburg, 1913
12 pp. with original lithographs by
Malevich and O. Rozanova
Ex Libris 6, no. 128
19.1 x 14.6 cm. (7½ x 5¾ in.)
a) Australian National Gallery,
Canberra
b) Robert Shapazian Inc.
c) Madeleine Chalette Lejwa,
New York

1896 moved from Kiev to Kursk, where he attended art school; 1903 entered the Moscow Institute of Painting, Sculpture, and Architecture; 1910–12 influenced by Neo-Primitivism, then Cubism and Futurism; took part in Larionov's *Jack of Diamonds* exhibition; associated with the Union of Youth group in St. Petersburg; 1913 took part in Futurist conference in Uusikirkko, Finland; designed décor for the Kruchenykh/Matiushin opera *Victory Over the Sun*; illustrated Futurist booklets such as *Troe (The Three), Porosiata (Piglets),* and *Vozropshchem (Let's G-r-r-rumble)*; 1914 met Marinetti on the latter's arrival in Russia; 1915 arrived at Suprematism; published the first of his major theoretical essays, *Ot kubizma i futurizma k suprematizmu. Novyi zhivopisnyi realizm (From Cubism and Futurism to Suprematism: The New Painterly Realism);* 1911–17 contributed to many avant-garde exhibitions including the *Donkey's Tail, 0–10* (the first public showing of Suprematist works), *The Store;* 1918 active on various levels of IZO NKP; 1919 contributed to the *Tenth State Exhibition: Non-Objective Creation and Suprematism* and to many other exhibitions in the 1920s at home and abroad; published his important tract *O novykh sistemakh v iskusstve (On New Systems in Art)* in Vitebsk, where he took charge of the art school from Chagall; founded Posnovis/Unovis, creating a group of highly talented students—Chashnik, Lissitzky, Suetin, and others; 1920 designed the covers for Nikolai Punin's *Tsikl lektsii (Cycle of Lectures)*; 1922 moved to Petrograd with his students, founding a branch of Inkhuk there; 1920s worked on architectural models known as *arkhitektony* and *planity;* also worked on textile design and maintained an interest in porcelain design; 1927 visited Warsaw and Berlin with one-man exhibition; left a large number of works with a friend in Germany; c. 1930 returned to a more figurative kind of painting, even working on political subjects such as *Working Woman, The Smith,* and *Red Cavalry.*

174

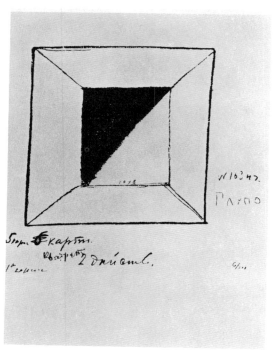

172

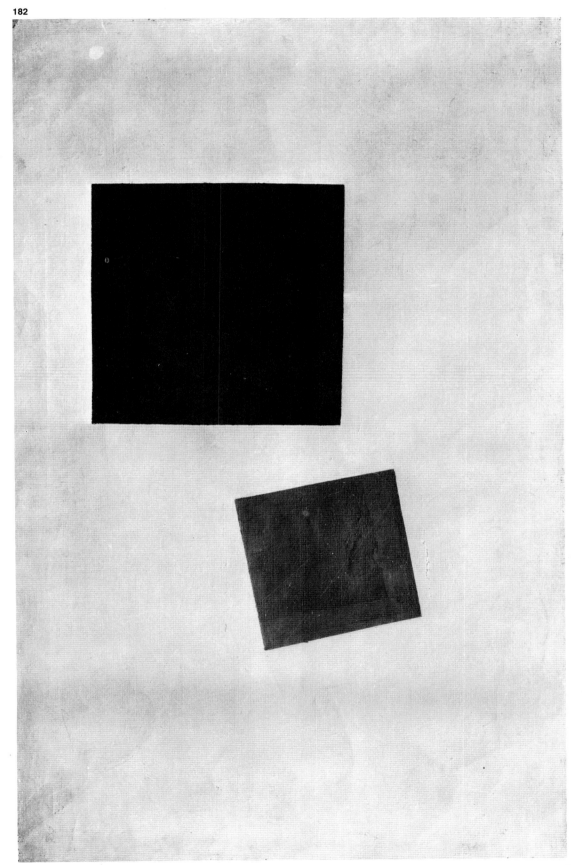

6.
orval (Explodity)
A. Kruchenykh
Petersburg, 1913
pp. with lithographs by Malevich,
zanova, Goncharova, and Kulbin
Libris 6, no. 130
.2 x 13 cm. (7½ x 5⅛ in.)
bert Shapazian Inc.

7.
prematist Composition,
14–15
ncil on paper
.4 x 9.5 cm. (7¼ x 3¾ in.)
ane Love and George Friedman

8.
prematist Composition,
14–15
ncil on paper
.4 x 11.4 cm. (7¼ x 4½ in.)
ane Love and George Friedman

9.
prematist Composition,
14–15
ncil on paper
.5 x 11.4 cm. (6½ x 4½ in.)
ane Love and George Friedman

0.
prematism, 1915
ncil on paper
x 13 cm. (6¼ x 5⅛ in.)
: and Mrs. Ahmet Ertegün

1.
prematism, No. 50, 1915
on canvas
dersen no. 56
x 66 cm. (38¼ x 26 in.)
edelijk Museum, Amsterdam

2.
prematist Composition: Red
quare and Black Square, 1915
on canvas
.1 x 44.4 cm. (28 x 17½ in.)
dersen no. 46
llection, The Museum of Modern
t, New York, 1935

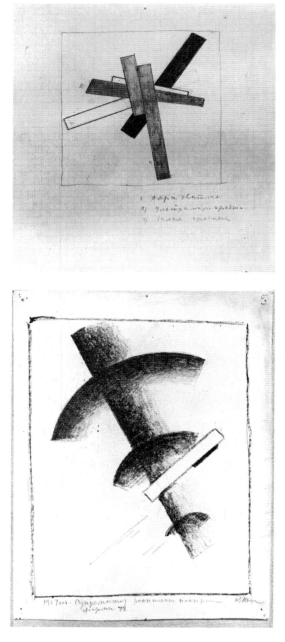

198

183.
Suprematist Element, Circle, 1915
Pencil on paper
47 x 36.5 cm. (18½ x 14⅜ in.)
Collection, The Museum of Modern
Art, New York

184.
**Suprematist Painting: Black
Rectangle, Blue Triangle,** 1915
Oil on canvas
66.5 x 57 cm. (26¼ x 22½ in.)
Andersen no. 54
Stedelijk Museum, Amsterdam

185.
**Suprematism, Red Square and
Black Square,** c. 1915
Watercolor on paper
32.5 x 24.5 cm. (12¼ x 9⅝ in.)
Mr. and Mrs. Ahmet Ertegün

186.
Drawing, c. 1915–16
Pencil on graph paper
29.5 x 21 cm. (11⅝ x 8¼ in.)
Robert Shapazian Inc.

187.
Suprematist Drawing, 1915–16
Pencil on paper
21 x 10 cm. (8¼ x 3⅞ in.)
Robert Shapazian Inc.

188.
Untitled, 1915–17
Pencil on paper
14 x 20.3 cm. (5½ x 8 in.)
Ruth and Marvin Sackner

189.
Black Cross, 1916
Pencil and india ink on paper
32.5 x 25 cm. (12½ x 9⅞ in.)
Mr. and Mrs. Ahmet Ertegün

190.
Magnetic Suprematism, 1916
Pencil on paper
17 x 21 cm. (6¾ x 8¼ in.)
Mr. and Mrs. Ahmet Ertegün

Kazimir Malevich, by leaving behind vestiges of imi
tive subject matter still retained by Cubism and by go
beyond an abstract lyrical response to nature, is ce
brated as the first modern artist to enter into the realm
pure geometric simplification. He introduced his no
objective theories in 1915 with a first public showing
thirty-six Suprematist compositions at *0–10,* an ava
garde group effort billed as *The Last Futurist Exhibition
Pictures. Suprematist Composition: Red Square a
Black Square* is one of the revolutionary works shown
0–10. By banishing descriptive elements and reduci
form to a black square balanced by a smaller, tilted r
square, Malevich concentrated on building an elementa
self-referential geometric order. Suprematist comp
sitions are self-contained harmonies divorced from ass
ciative meaning; they key a response of "pure feelin
and even can suggest "the sensitivity of pure nc
objectivity."

Malevich's historic Suprematism was the culmin
tion of earlier investigations that compressed Europe
modernism and paralleled contemporary Russian F
turist experiments. His paintings shown at the 1910 *Ja
of Diamonds* exhibition were Post-Impressionist; those
the 1912 *Donkey's Tail* contributed to the period's Ne
Primitivist trend. His lithograph of 1913 *Portrait of
Builder Completed* depicted the mechanization of
man's brain within a context of Cubist faceting and F
turist force-lines: Malevich's "Cubo-Futurist" style. Tl
lithograph was an illustration for a booklet of poetry, *P
lets* by Kruchenykh—one of the many Futurist nonsen
books (including *Let's G-r-r-rumble, The Three, A Game
Hell*) illustrated by Malevich during this prolific period
interchange among the arts.

The ferment of prewar artistic collaboration led to tl
provocative 1913 opera *Victory Over the Sun,* an alogic
sung drama extolling the triumph of modern man's se
sustaining energy sources; the text was by Kruchenyk
with a prologue by Khlebnikov and music for a sinc
out-of-tune piano by Matiushin.

Malevich's oil paintings are extremely rare. With
Soviet Russia, approximately 125 works are suppress
by the government and unviewable in museum stora
rooms. Western collections, public and private, we
formed from a group of about seventy paintings fort
tously left behind in Berlin after a 1927 retrospective ex
bition. In the United States, the largest holding is a me
seven paintings at the Museum of Modern Art in Ne
York. Understandably, owners are loath to lend such e
tremely rare and valuable works. Thus, key examples
Malevich's pre-Suprematist oeuvre were, for one re
son or another, unavailable for this exhibition.

Malevich's characteristic Suprematist variations an
however, represented by the exhibition's paintings. Aft
the pure reductivism of *Suprematism: Red Square ar
Black Square,* subtle spatial inferences are insinuated I
the overlap in *Suprematist Painting: Black Rectangl
Blue Triangle.* This introduction of the third dimension
developed further in *Suprematism, No. 50,* with I
number and complexity of elements, use of seconda
colors, and dynamic diagonal placements. In 1917–
Malevich returned to geometric simplifications with
series reducing color to tonal and textural manipul
tions of white. Perhaps best known by the often repr
duced *Suprematism: White on White* (unavailable fro

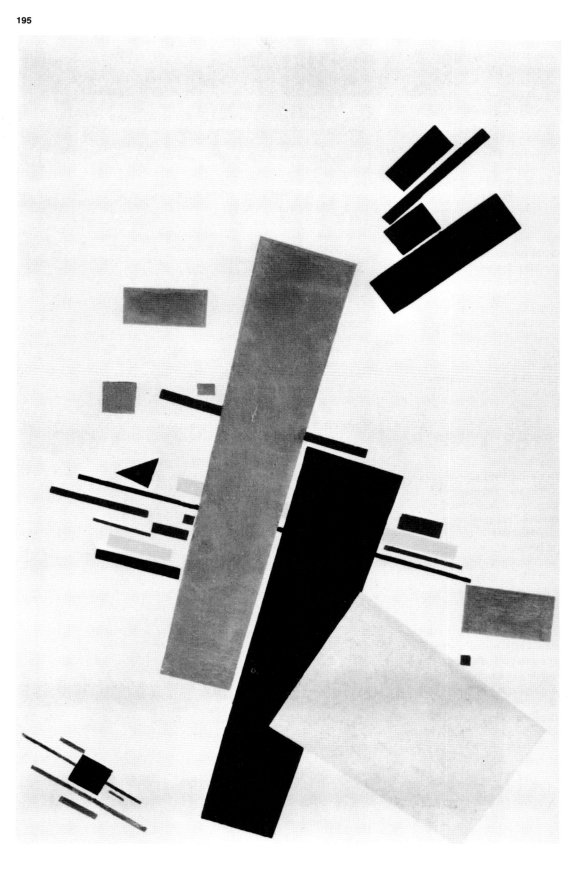

191.
**Ot kubizma i futurizma k su-
prematizmu. Novyi zhivopisnyi
realizm (From Cubism and Fu-
turism to Suprematism: A New
Painterly Realism)**
Moscow, January 1916
31 pp.
17.8 x 12.7 cm. (7 x 5 in.)
David Segal, Cambridge,
Massachusetts

192.
Suprematism, 1916
Watercolor on paper
19 x 10.5 cm. (7½ x 4⅛ in.)
Mr. and Mrs. Ahmet Ertegün

193.
Suprematism, 1916
Pencil on paper
17 x 12 cm. (6¾ x 4¾ in.)
Mr. and Mrs. Ahmet Ertegün

194.
Suprematism, c. 1916
Watercolor on paper
18 x 12 cm. (7⅛ x 4¾ in.)
Mr. and Mrs. Ahmet Ertegün

195.
Suprematist Composition, c. 1916
Oil on canvas
102.4 x 66.9 cm. (40¼ x 26⅜ in.)
Museum Ludwig, Cologne, West
Germany

196.
**Three Designs for Suprematist
Enamel Brooches,** c. 1916
Gouache on paper
10.5 x 6 cm. (4⅛ x 2⅜ in.)
Mr. and Mrs. Roald Dahl

197.
Suprematist Composition,
c. 1916–17
Pencil on buff paper
18.5 x 23 cm. (7⅛ x 9 in.)
Mr. and Mrs. Ahmet Ertegün

198.
**Suprematism, Splitting of
Construction Form 78,** 1917
Pencil on paper
32.5 x 24.5 cm. (12¾ x 9⅝ in.)
Andersen no. 76
Stedelijk Museum, Amsterdam

199.

Vertical Construction, 1917
Pencil on paper
41.6 x 29.5 cm. (16⅜ x 11⅝ in.)
Andersen no. 77
Stedelijk Museum, Amsterdam

200.

Suprematist Painting, 1917–18
Oil on canvas
97 x 70 cm. (38¼ x 27⅝ in.)
Andersen no. 64
Stedelijk Museum, Amsterdam

201.

**O novykh sistemakh v iskusstve
(On New Systems in Art)**
Vitebsk, 1919
Book with original lithographs
26 x 21 cm. (10¼ x 8¼ in.)
N. Seroussi, Galerie Quincampoix,
Paris

202.

**Enamel Brooch, "Supremus
No. 2,"** 1920
Enamel
4.7 x 4.6 cm. (1⅞ x 1⅞ in.)
Mr. and Mrs. Ahmet Ertegün

203.

**Ot Cezanna do suprematizma.
Kriticheskii ocherk. (From
Cézanne to Suprematism: A
Critical Essay)**
Moscow, 1920
16 pp.
Ex Libris 6, no. 196
17.4 x 11 cm. (6⅞ x 4⅜ in.)
Australian National Gallery,
Canberra

204.

**Pervyi tsiki lektsii chitannykh na
kratkosrochnykh kursakh dlia
uchitelei risovania (First Cycle
of Lectures, Read at a Short
Term Course for Teachers of
Drawing)** by N. Punin
Petrograd, 1920
84 pp. with color lithographs by
Malevich
Ex Libris 6, no. 225
21.2 x 14.9 cm. (8½ x 5⅝ in.)
a) Robert Shapazian Inc.
b) Private collection

the Museum of Modern Art), "white on white, expressing the feeling of fading away" is here freshly studied in *Suprematist Painting* (cat. no. 200).

The years immediately following the Revolution found Malevich exhibiting with Rodchenko, Popova, Rozanova, Stepanova, Vesnin, and others at the huge 1919 *Tenth State Exhibition: Non-Objective Creation and Suprematism.* This immensely influential exhibition established non-objectivity as the Soviet revolutionary style. Malevich emphasized, however, the spiritual and visionary foundation of art activity—and thus he was at odds with the merging Moscow Constructivism and its artist-as-technician "art production" ethos. By the end of 1919, Malevich's one-man show *From Impressionism to Suprematism* announced the death of Suprematism and of painting: "the cross is my cross." Malevich was a mystic, and his non-objectivity presented a revelation of absolute order: the black and red *Suprematist Painting* made after 1920 suggests a restatement of the universal cross theme in Suprematist terms.

Leaving Moscow to concentrate his activities at the Vitebsk School of Art, Malevich became a prolific writer, publishing the lithograph-illustrated texts *On New Systems in Art* (1919) and *Suprematism: 34 Drawings* (1920). He also founded the student group Unovis ("Affirmers of the New Art") which included Chashnik, Suetin, Ermolaeva, Yudin, and Lissitzky. His students' textile, pottery, and jewelry designs—and such examples as Malevich's *Saucer* and enamel brooches—are evidence that the Unovis group was by no means uninterested in utilitarian design. For Malevich, however, these works represented abstract ideals to be developed in the hands of craftsmen-specialists. Even Malevich's intense interest in architecture was based on the problem of form in three dimensions and on a concept of abstract creation. *Suprematist Architecton No. 3* and *No. 4* are "ideas" from which architects could develop the new style.

In 1922 Malevich left Vitebsk with a group of students and joined Petrograd's branch of Inkhuk (Institute of Artistic Culture). His pedagogy is preserved in a series of twenty-two "wall-charts" which analyze paintings as documents of formal values and as consequences of experienced sensation. These didactic charts were prepared between 1922 and 1927 by four Malevich students in the FTO (Formal Theoretical Department) group of Inkhuk. Malevich's work and theory were introduced to Europe in the late 1920s through the 1927 retrospective in Warsaw and Berlin, and the publication of *The Non-Objective World* as Bauhaus Book II. By the end of the decade, however, an official style of Socialist Realism began to replace non-objectivity in Russia. Malevich developed a more representational approach to his continuing formalist concerns; he also produced many portraits of family and friends. The historic Suprematist paintings were suppressed by the government and remain today a disgraced style.

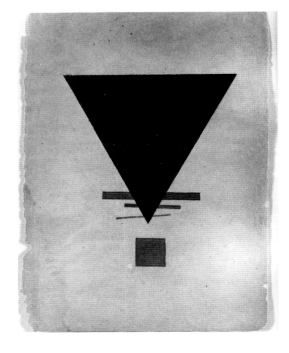

205.
Suprematism, 1920
Watercolor on paper
17.5 x 10.5 cm. (6⅞ x 4⅛ in.)
Mr. and Mrs. Ahmet Ertegün

206.
Suprematism, 1920
Watercolor on paper
29.5 x 21.5 cm. (11½ x 8½ in.)
Los Angeles County Museum of
Art, Purchase with funds provided
by Kay Sage Tanguy, Rosemary B.
Baruch, Mr. and Mrs. Charles Boyer
M. 78.34

207.
**Suprematizm: 34 risunka
(Suprematism: 34 Drawings)**
Vitebsk, 1920
4 pp. with 34 lithograph drawings
and handwritten text by Malevich
Ex Libris 6, no. 198
19.4 x 17.8 cm. (8⅝ x 7 in.)
a) Mr. and Mrs. Roald Dahl
b) Private collection
c) Dallas Museum of Fine Arts,
Dallas Art Museum League in
honor of Mr. and Mrs. James H. Clark

208.
**Bookcover with Square, Cross,
and Circle,** c. 1920
Watercolor on paper
32 x 22 cm. (12⅝ x 8⅝ in.)
Private collection, Paris

209.
Brooch #1, c. 1920
Enamel
3.7 x 4.5 cm. (1½ x 1¾ in.)
N. Seroussi, Galerie Quincampoix,
Paris

210.
Brooch #2, c. 1920
Enamel
4 x 3.2 cm. (1⅝ x 1¼ in.)
N. Seroussi, Galerie Quincampoix,
Paris

211.
Brooch #3, c. 1920
Enamel
7.9 x 10.5 cm. (3⅛ x 4⅛ cm.)
N. Seroussi, Galerie Quincampoix,
Paris

207

208

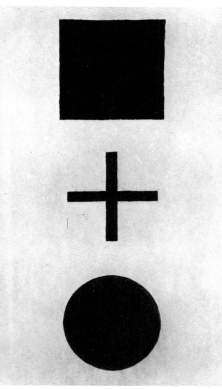

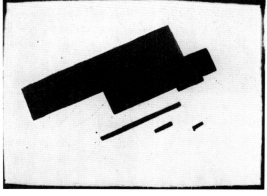

211

▶

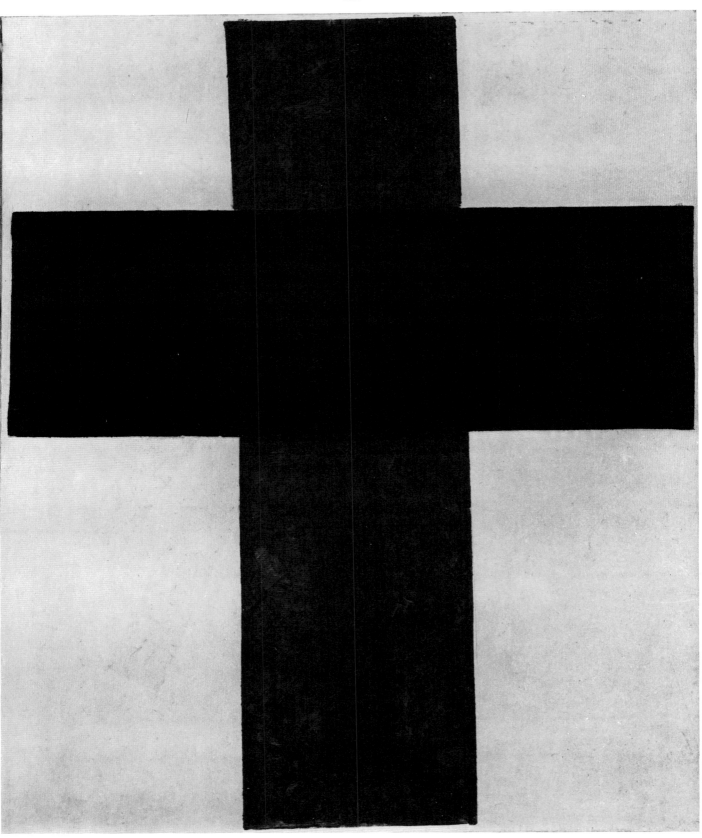

212.

Brooch, c. 1920

Enamel

4 cm. x 4 cm. (1⅛ x 1⅛ in.)

Alexandre Polonski

213.

Brooch, c. 1920

Enamel

11 x 8.5 cm. (4⅜ x 3⅜ in.)

Robert Shapazian Inc.

214.

Suprematist Painting, after 1920

Oil on canvas

84 x 69.5 cm. (33⅛ x 27⅜ in.)

Andersen no. 69

Stedelijk Museum, Amsterdam

215.

Bog ne skinut (God Is Not Cast Down)

Vitebsk, 1920, published 1922

Book

17 x 11 cm. (6¾ x 4⅜ in.)

Collection Martin-Malburet

216.

Red Square in Black, c. 1922

Gouache on paper

28 x 11.5 cm. (11 x 4½ in.)

Museum Ludwig, Cologne, West
Germany

217.

Suprematist Architecton No. 3, 1922

Painted wood on base

5 x 37 x 19.5 cm. (2 x 14⅛ x 7¾ in.)

Galerie Jean Chauvelin, Paris

218.

Suprematist Architecton No. 4, 1922

Painted wood on base

5 x 37 x 19.5 cm. (2 x 14⅛ x 7¾ in.)

Galerie Jean Chauvelin, Paris

219.

Saucer, c. 1923

Porcelain

13.2 x 13.2 cm. (5¼ x 5¼ in.)

Alexandre Polonski

Resolution "A" in Art

1. A fifth dimension (economy) is established.

2. All creative inventions, their building, construction, and system must be developed on the basis of the fifth dimension.

3. All inventions developing the movements of elements, of painting, color, music, poetry, and constructions (sculpture) are evaluated from the viewpoint of the fifth dimension.

4. The perfection and contemporaneity of inventions (works of art) are determined by the fifth dimension.

5. Aesthetic control is rejected as being a reactionary measure.

6. To put all the arts—painting, color, music, constructions—under the umbrella of "technological creation."

7. To reject the spiritual force of content as belonging to the vegetable world of flesh and bone.

8. To temporarily recognize dynamism as the power that brings form into action.

9. To recognize light as the color of rays whose invention contains a metallic basis, and as the correlation of the economic development of the town.

10. To relate the sun as a bonfire of illumination to the system of the vegetable world of flesh and bone.

11. To free time from the hands of the state and to turn it to the benefit of inventors.

12. To recognize labor as a relic of the old world of violence, since the contemporary world is built on creation.

13. To recognize in every m an the ability to invent things, and to proclaim that for their realization unlimited resources of material will be found in and above the earth.

14. To recognize life as an auxiliary bread-and-butter path to what for us is of the most importance, movement.

15. All heavenly blessings are rejected, as are those on the earth and as are all their representations by art workers—they are a lie concealing reality.

16. To commit to social security all the workers of academic arts, as invalids and reactionaries of the economic movement.

17. Cubism and Futurism are defined as the economic perfection of 1910 and their constructions and systems are to be defined as the classicism of the first decade of the century.

18. To summon an economic council (of the fifth dimension) to liquidate all the arts of the old world.

Kazimir Malevich, *O novykh sistemakh v iskusstve,* Vitebsk, 1919. Translated from the Russian by John E. Bowlt.

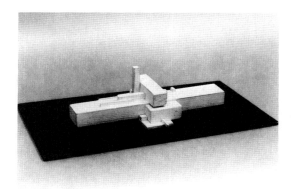

217

220.
Self-Portrait, 1927
Pencil on paper
29 x 17.5 cm. (11⅜ x 6⅞ in.)
Galerie Bargera, Cologne, West
Germany

221.
Die gegenstandslose Welt by
Malevich
Munich, 1928, Bauhausbücher
no. 11
100 pp. with 92 illustrations by
Malevich
Ex Libris 6, no. 517L
23.5 x 18.4 cm. (9¼ x 7¼ in.)
a) Arthur and Elaine Cohen
b) National Gallery of Art Library,
Washington, D.C.

222.
Figure, 1928
Pencil on paper
15 x 22 cm. (5⅞ x 8⅝ in.)
Mr. and Mrs. Ahmet Ertegün

223.
Figures, 1928
Pencil on paper
13.5 x 14 cm. (5⅜ x 5½ in.)
Mr. and Mrs. Ahmet Ertegün

224.
**Vystavka proizvedenii K. S.
Malevicha (Exhibition of Works
by K. S. Malevich),** 1929
Catalog by Malevich
17.2 x 12.7 cm. (6¾ x 5 in.)
Ex Libris, New York

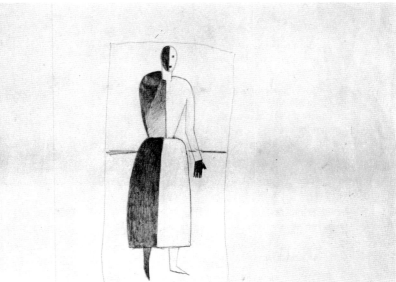

Bibliography

T. Andersen (compiler), *Malevich,*
Amsterdam, 1973.

T. Andersen, ed., *K. S. Malevich:
Essays on Art,* vols. 1, 2, 3, 4,
Copenhagen, 1968, 1976, 1978.

Donald Karshan, *Malevich: The
Graphic Work 1913–1930,* exh. cat.,
Jerusalem Museum, 1975.

Nikolai Khardzhiev, ed., *K istorii
russkogo avangarda (The Russian
Avant-Garde),* Stockholm, 1976.

Evgenii Kovtun, ed., "K. S. Male-
vich. Pisma k M. V. Matiushinu," ed.,
M. Alexeev et al., *Ezhegodnik
rukopisnogo otdela Pushkinskogo
doma,* Leningrad, 1976.

Malevitch, exh. cat., Musée Na-
tional d'Art Moderne, Centre
Georges Pompidou, Paris, 1978.

Malewitsch, exh. cat., Galerie
Gmurzynska, Cologne, 1978.

L. Shadowa, *Suche und Experi-
ment,* Dresden, 1978.

Soviet Union, Arizona State Univ.,
vol. 5, part 2, 1978 (special edition
on Malevich).

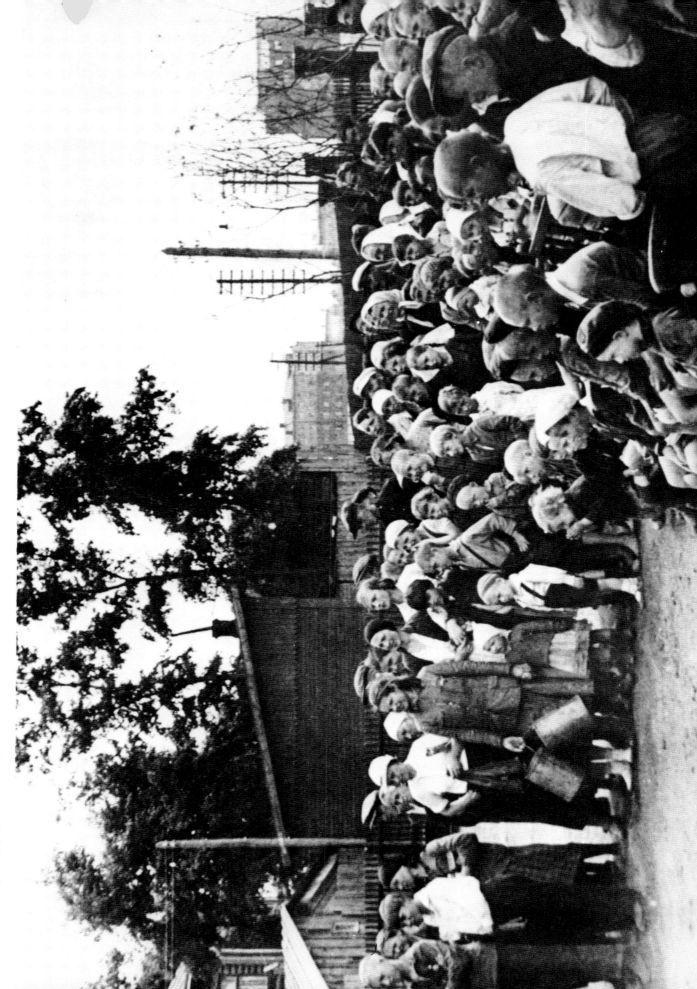

Spectators listening to agit-prop demonstration, c. 1921

Mansurov, Pavel Andreevich
(Mansouroff, Paul)
Born 1896 St. Petersburg; lives in Paris.

225.
Pictorial Forms, 1918
Mixed media on plate
Approx. 37 x 54 cm. (14½ x 21¼ in.)
Private collection, West Germany

226.
Pictorial Forms, 1918
Oil on wood
133 x 26 cm. (52⅜ x 10¼ in.)
Thyssen-Bornemisza Collection,
Lugano, Switzerland

227.
Untitled, 1919
Mixed media on plate
168 x 38 cm. (66⅛ x 15 in.)
Galerie Gmurzynska, Cologne,
West Germany

228.
Pictorial Forms, 1920
Mixed media on plate
135 x 27.5 cm. (53⅛ x 10¾ in.)
Galerie Gmurzynska, Cologne,
West Germany

229.
Untitled, c. 1921
Gouache on paper
149 x 46 cm. (58⅝ x 18⅛ in.)
Collection Roger Diener, Basel,
Switzerland

Bibliography

P. Mansouroff, exh. cat., Musèe d'Art
Moderne de la Ville de Paris, 1973.

Toshiharu Omuka, "A Short Note on
Paul Mansouroff," *Soviet Union,*
Univ. of Pittsburgh, vol. 3, part 2,
1976, pp. 188–96.

1909 onward attended the Stieglitz School, St. Peters-
burg, then the studios of the Society for the Encourage-
ment of the Arts; 1915–17 military service; 1917 onward
close contact with Pavel Filonov, Malevich, Matiushin,
Tatlin; 1919 contributed to the *First State Free Exhibi-
tion of Works of Art* in Petrograd (a huge exhibition which
covered all the main trends, left and right); 1922 with
Malevich, Matiushin, Nikolai Punin, Tatlin, and others
helped to organize the Petrograd Inkhuk; was head of
the experimental section; contributed to the *Erste
Russische Kunstausstellung* in Berlin; 1923 contrib-
uted to the *Exhibition of Pictures of Petrograd Artists
of All Directions;* 1919–23 published two declarations in
the journal *Zhizn iskusstva (Life of Art);* 1924 contributed
to the *Exposizione internazionale,* Venice; 1927 contrib-
uted to the jubilee Exhibition of Visual Arts at the Lenin-
grad Academy of Arts; 1928 emigrated to Italy; 1929
exhibition at Bragaglia fuori Commercio, Rome; left for
Paris; in emigration continued to work on non-objective
painting.

225

226

■ Mansurov is known for his remarkably individualistic non-objective painting, which seems to have emerged full-blown by 1917. Little is known of his early development as an artist, except that he attended the Stieglitz School (1909, St. Petersburg), which was known then for its design course. It was in this context that precision of draftsmanship was ingrained in the artist, along with an interest in properties of line and form that continues to fascinate him even today.

Mansurov's unique contribution to the avant-garde in Russia was a wholly non-objective art that used elongated vertical surfaces to explore questions of space and spatial correlations. The vertical surfaces (usually planks of wood) are used as monochromatic planes that are subtly and precisely modeled through line. A rigid economy is employed in which the work of art is stripped to its essential components. Mansurov called the works *Pictorial Formulae,* a reflection of the artist's carefully considered and almost scientific methods. Mansurov was concerned ultimately not only with depicting form within a painting, but with the concept of the art object as a physically discreet form in itself. He considered the vertical format (wooden planks) as the embodiment of these issues. By painting both the front and back of the plank, he was exploring spatial possibilities of the painting as an autonomous unit.

From 1917 Mansurov was in close contact with many of the leading figures in the avant-garde, including Malevich, Filonov, Tatlin, and Matiushin. While Mansurov's methodology seems to show the influence of Matiushin's experiments in visual perception, he was by no means a follower. Mansurov's individuality is his salient characteristic. In the words of the artist, "The only genuine art is one that does not repeat previous trends."

Like so many of his colleagues, Mansurov divided his attention between producing his art and his pedagogical research and teaching. He worked with Malevich, Matiushin, Punin, and Tatlin in organizing the Petrograd Inkhuk in 1922. This agency, The Institute of Artistic Culture, was concerned with working out a theoretical approach to art under a Communist society, and Mansurov was head of the experimental section.

▶

228

1. Long live utilitarianism (economy).
2. Technology is our Liberation, the Liberation Animals.
3. Down with the parasite of Technology "architecture."
4. Culture is purity and lightness of form.
5. Beauty (health) is economy and precision calculation.
6. Down with religion, the family, aesthetics, a philosophy.
7. Down with the bloody parasites—t bourgeoisie.
8. Down with the frontiers between peoples.

A precise slogan is the essense of any ideolog prefer a mass meeting to newspaper polemics w cheats from *Russian Art* or from the "central" "assoc tion" of "leftist" "trends" (yes, naughty boys and gir cover yourself up with a bit more leftism, because y have nothing else to cover yourselves with). I prote against the organization of Competition Committees f building construction headed by the "architects" Zh tovsky, Shchusev et al., by aesthetes and the bittere enemies of the Proletariat and the Revolution. I take r sponsibility for my words. I demand the organization such Committees (not made up of "architects," of cours on the basis of the utilitarian economy, hygiene, and t healthy comfort of constructions. These are things that t workers really need. (If you're going to smash in the m of the artistocracy, you may as well go the whole way.)

Pavel Mansurov, *Zhizn iskusstva,* no. 20, 1923, p. 15. Translated from the Russian by John E. Bowlt.

229

■ During the period between Cubism and Suprematism, represented by the artists Braque and Malevich, the disorganized painterly chaos of forms and colors was reduced to an economic system of color and form distribution on the pictorial plane.

The manifestos of the Italian Futurists played an important formal and organizational role in creating this system.

Prior to that, and also parallel with the achievements of Cubo-Futurism, the Intuitists (artists)—who started with the classical notion of facture and advanced via primitive art, the naive realism of Cézanne and van Gogh mixed with Easter Island (Picasso), and also the Russian icon plus the counter-relief as a complex form of Cubism (Tatlin)—provided, and continue to provide, an aesthetic basis, the "scrolls" on the architectural facade. The attempts to be utilitarian have failed, for the main element of contemporary construction, ECONOMY, was not taken into account. Instead, artists were guided by mysticism.

The technological slogans that I have advanced and that I published in the last issue (no. 20) of *The Life of Art* (some people knew about them even before that) are undoubtedly contemporary. I shall not cease to assert that *aesthetics (art) belong to the savage.* Via the strict system of Cubo-Suprematism we now have a way out (of abstraction) into Technology.

Only Technology (Utilitarianism and Economy) is the motive force of life.

Its victories are our Liberation, the Liberation of Animals. N.B.: I have not mentioned the "Formula of World Flowering" on purpose because Comrade Filonov himself has demonstrated his attitude toward modern art in his own Declaration.

Pavel Mansurov, *Zhizn iskusstva*, no. 22, 1923, p. 7. Translated from the Russian by John E. Bowlt

Matiushin, Mikhail Vasilievich
Born 1861 Nizhnii Novogord; died 1934 Leningrad.

230.
Sea, Widening of Vision, 1916
Watercolor on paper
21 x 30.8 cm. (8¼ x 12⅛ in.)
Galerie Gmurzynska, Cologne,
West Germany

231
Composition, c. 1922
Gouache on paper
23 x 24 cm. (9 x 9½ in.)
Robert and Maurine Rothschild
Collection

Bibliography

Charlotte Douglas, "Colors without Objects: Russian Color Theories (1908–1932)," *The Structurist,* Saskatoon, no. 13/14, 1973/1974, pp. 30–41.

Evgenii Kovtun, ed., "A. E. Kruchenykh. Pisma k M. V. Matiushinu" and "K. S. Malevich. Pisma k Matiushinu," M. Alexeev et al., ed., *Ezhegodnik rukopisnogo otdela Pushkinoskogo doma,* Leningrad, 1976, pp. 165–76, 177–95.

A. Povelikhina, "Matyushin's Spatial System," *The Structurist,* Saskatoon, no. 15/16, 1975/1976, pp. 64–71; reprinted in *Die Kunstismen in Russland/The Isms of Art in Russia,* exh. cat., Galerie Gmurzynska, Cologne, 1977, pp. 27–41.

L. Zhadova, "Tsvetovaia sistema M. Matyushina" *Iskusstvo,* Moscow, no. 8, 1974, pp. 38–42; Italian trans. "Il sistema cromatico di Matjusin," *Rassegna sovietica,* Rome, no. 1, January/February 1975, pp. 121–30.

L. Zhadova; "Eto my, illiuminatory zavtrashnikh gorodov," *Tekhnicheskaia estetika,* Moscow, no. 9, 1975, pp. 34–36.

1876–81 attended the Moscow Conservatory of Music; 1882–1913 was violinist with the Court Orchestra, St. Petersburg; 1898–mid-1900s attended the school of the Society for the Encouragement of the Arts, where he met his future wife, Elena Guro; also attended Zvantseva's Art School, where he studied under Bakst and Dobuzhinsky; 1909 joined Nikolai Kulbin's Impressionist group; met the Burliuks and other members of the avant-garde; end of 1909 broke with Kulbin and then co-founded the Union of Youth, in which he played an active role only toward the end, contributing to its last booklet (1913) and last exhibition (1913–14); 1911 began to formulate his spatial system; 1913 with Khlebnikov, Kruchenykh, and Malevich published *Troe (The Three)* in memory of Guro, who had died earlier that year; composed music for the opera *Victory Over the Sun*; 1914 wrote music for Kruchenykh's *Pobezhdennaia voina (Conquered War),* for which Malevich also did some designs (not produced); 1914 onward active as a writer and publisher, producing Khlebnikov's *Novoe uchenie o voine (New Doctrine of the War),* Filonov's *Propoved o prorosli mirovoi (Chant of Universal Flowering)* and Malevich's *Ot kubizma i futurizma k suprematizmu (From Cubism and Futurism to Suprematism)* at his own printing press The Crane; 1919–26 headed the Studio of Spatial Realism at the Petrograd Svomas/Academy of Arts, heading his group known as Zorved (See-Know); 1922 onward headed the Research Department of Organic Culture at the Petersburg Inkhuk; 1932 published some of his findings in his book *Zakonomernost izmeniaemosti tsvetovykh sochetanii. Spravochnik po tsvetu (The Laws of Variability in Color Combinations),* Moscow-Leningrad.

■ Trained as a musician at the Moscow Conservatory of Music, Matiushin's involvement with the arts extended to painting, writing, and publishing. His wife was the poet and painter Elena Guro.

Matiushin's best-known achievement was the score he composed for the Futurist opera *Victory Over the Sun,* produced in collaboration with the painter Malevich and the poet Kruchenykh. Matiushin wrote the score during the summer of 1913, disconsolate over the premature death of his wife earlier that year. The score is composed of unexpected intervals and dissonances, including the sound of cannon shots, the stamping of machines, and the crashing of an airplane; the music was accompanied by spirited bursts of indignation from packed audiences.

Extremely active as a writer and publisher, Matiushin established his own printing press, called The Crane, and produced Malevich's book *From Cubism and Futurism to Suprematism* in 1915. His impact as a translator is notable; he was the first to translate the theoretical writings of Gleizes and Metzinger from French into Russian.

In the plastic arts Matiushin's most significant contribution lies in the theoretical inquiry into the interaction of color and its environment, an approach to art based on scientific research. In developing a pictorial style which he termed "Spatial Realism," the artist was striving for heightened awareness of the natural world, not through imitation of nature, but through persistent observation, analysis, and research. Formulations were begun as early as 1911 that would later preoccupy him during the 1920s in his position as Head of Inkhuk's Department of Organic Culture. *Composition,* painted about 1922, is an exemplary work of this period. Using models based on geometry, mathematics, and organic chemistry, Matiushin performed experiments in optical perception and also in the effect of sound on the perception of color. According to Matiushin, an artist trained in his methods would gain consciousness of the future. He believed that color vision was evolving in man; that color-receiving cones in the eye would spread from the center of the retina toward its periphery. Notebooks and tables were compiled using eight basic colors, their complements, and a third set of contiguous colors that balanced the two. In 1932 these studies were put together in book form entitled *The Rules and Variability of Color Combinations: A Color Primer.* The primer was to be used in architecture, textiles, ceramics, wall paper, and in the printing industry.

230

■ There are times when man, piling experience upon experience, creates a conditional sign into which he infuses his creative urge, and he begins to call this art. In the beginning, however, there was simply a reflection of impressions, a rhythmical repetition like a sound. This was the ingenuous and simple *step of life itself.* And now, in its inexorable movement and development, art has attained the *fragmentation* of that sign and is now called *"rightist," "central,"* and *"leftist."*

Art has now become a *Force divided.*

"Zorved"—by its very act of seeing (the field of vision is 360°)—has come to the primordial, virgin soil of perception.

Zorved signifies a physiological change in the previous way of looking and offers a completely *different means* of reflecting visual reality.

Zorved is the first to introduce the observation and experience of what was hitherto the concealed *background*—all the space that remained *outside* man's sphere of vision because of his lack of *experience.*

New data have demonstrated the influence of *space, light, color,* and *form* on the cerebral centers at the *back of the neck.* A number of experiments and observations undertaken by the *Zorved* artists have clearly established a space sensitivity located in the visual centers in the brain at the back of the neck. Since the most valuable gift to man and artist is the cognition of space, he now perceives a new *step,* a new *rhythm of life* which cannot be accommodated by any form or by the sign "rightist" / "leftist." For the moment this is still *"the most primitive life,"* one that is advancing together with the extraordinary discoveries brought about by the monstrous explosion of the *Russian Revolution.* This has set free, has given life to all that is vital and aspiring.

Mikhail Matiushin, *Zhizn iskusstva,* Petrograd, no. 20, 1923, p. 15. Translated from the Russian by John E. Bowlt.

231

Medunetsky, Konstantin Konstantinovich
(also Kazimir Konstantinovich)
Born 1899 Moscow; died c. 1935.

From Konstantin Medunetsky, Vladimir Stenberg, and Georgii Stenberg, "Constructivists to the World," 1921

232.

Construction No. 557, 1919
Tin, brass, and iron; base: painted metal
45.5 x 17.8 x 17.8 cm. (17⅞ x 7 x 7 in.)
Yale University Art Gallery, New Haven, Connecticut, Gift of Collection Société Anonyme

Bibliography

Nothing substantial has been published on Medunetsky.

1914 studied with Mikhail Sapegin, Nikolai Prusakov, Vasilii Komardenkov, and others at the Stroganov Industrial Art School, Moscow, specializing in stage design; 1919 co-organized Obmokhu; contributed to its first exhibition; worked on freestanding abstract constructions; 1920 contributed to the second exhibition of Obmokhu; 1921 with Georgii and Vladimir Stenberg organized the exhibition *The Constructivist* at the Café of the Poets, Moscow; contributed to the third Obmokhu exhibition; 1922 represented at the *Erste Russische Kunstausstellung,* Berlin; 1924 with the Stenbergs made designs for Tairov's production of Ostrovsky's *The Storm* at the Chamber Theater; contributed to the *First Discussional Exhibition of Associations of Active Revolutionary Art*; designed movie posters at this time; 1925 represented at the *Exposition Internationale des Arts Décoratifs,* Paris; early 1930s contributed to exhibitions at home and abroad; 1935 according to the directory *Teatralnaia Moskva* (Moscow, 1935), Medunetsky was still living in Moscow.

A pupil of Tatlin and the Pevsner brothers, Medunetsky was a prominent member of the Obmokhu group, the Society of Young Artists in Moscow. The students explored the particular aesthetic, physical, and functional properties of material, with an emphasis on materials used in industry. The results of these experiments were open spatial constructions as opposed to closed or solid masses.

Construction No. 557 was included in the Obmokhu exhibition in Moscow 1921. The piece was also shown in the *Erste Russische Kunstausstellung* in Berlin in 1922, where it was purchased by Katherine Dreier.

"With a minimal expenditure of energy, Constructivism will bring mankind to possession of the maximum achievement of culture" (Slogan).

■ Anyone born on this globe, until the day he kicks the bucket, could take the shortest path to the factory that produces the single organism of the earth—

The factory that produces the creators of the great springboard for the jump into universal human culture. And the name of this path is CONSTRUCTIVISM.

The great corruptors of the human pedigree, aesthetes and artists, have destroyed the rigorous bridges of this path and have replaced them with a pile of sugary anesthetic—art and beauty.

The essence of the earth is the brain of man, and this is being used up uneconomically for fertilizing the morass of aestheticism.

Weighing the facts on the scales of an honest attitude towards the philistines of the earth, the Constructivists declare art and its priests to be outside the law.

Konstantin Medunetsky, *Konstruktivisty,* exh. cat., Moscow, 1921. Translated from the Russian by John E. Bowlt.

232

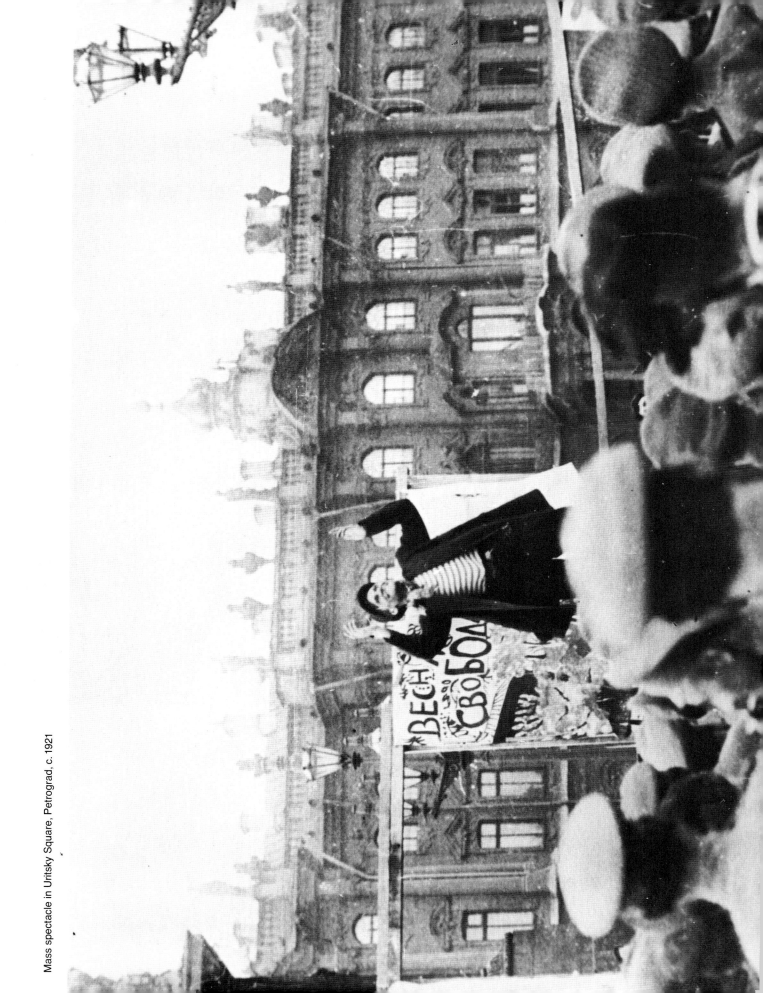

Mass spectacle in Uritsky Square, Petrograd, c. 1921

Miturich, Petr Vasilievich

Born 1887 St. Petersburg; died 1956 Moscow.

233.
Spatial Paintings, 1920
2 painted cardboard cubes
5.5 x 5.5 x 8 cm. (2⅛ x 2⅛ x
3⅛ in.) each
Galerie Gmurzynska, Cologne,
West Germany

234.
Zangezi by V. Khlebnikov
Moscow, 1922
35 pp. with cover illustration by
Miturich
24.1 x 15.2 cm. (9½ x 6 in.)
The Institute of Modern Russian
Culture, Blue Lagoon, Texas

Bibliography

N. Rozanova, *Petr Vasilievich
Miturich,* Moscow, 1973.

1899–1905 studied at Pskov Military School; 1906–9 attended Kiev Art Institute; impressed by the work of Mikhail Vrubel; 1909–16 attended the Academy of Arts, St. Petersburg, specializing in battle paintings under Nikolai Samokish; 1914 first serious interest in aviation, which would culminate in his designs for dirigibles in the late 1920s; 1915 onward contributed to various exhibitions including the *Exhibition of Painting, 1915* in Moscow, *Contemporary Russian Painting* in Petrograd (1916), and the *World of Art* in Petrograd (1915–18); 1915–17 military service; 1918 member of the Left Association of Petrograd Artists; 1918–22 worked on his so-called spatial graphics and spatial paintings; 1920–22 designed a number of covers of the music of Artur Lurie such as *Roial v detskoi (The Piano in the Nursery)*; also designed the cover of Khlebnikov's *Zangezi*; close to Khlebnikov; 1923 onward professor in the Graphic and Architectural Departments at Vkhutemas; 1924 contributed to the *Esposizione internazionale* in Venice; 1925–29 member of the group Four Arts; 1928 designed children's books, including *Miau (Meow)* by the Oberiuty writer Alexandr Vvedensky; 1930 onward worked predominantly on landscapes and portraits.

■ Peter Miturich came into contact with the Russian avant-garde relatively late in its development, finishing his traditional studies in 1916 at the Academy of Arts in St. Petersburg, where he specialized in battle painting. At this juncture he was called for military service which occupied him until 1917.

By 1918 he had encountered the avant-garde community, and was working on his "Spatial Graphics" and "Spatial Painting." The Spatial projects, which he worked on until 1922, demonstrate Miturich's affinity for a volumetric approach. In fact, the "Paintings" are actually three-dimensional, sculptural forms of cardboard, meant to be viewed from all sides. These works characterize the artist's interest in displacing the conventional one-side focal point. Miturich was particularly drawn to aerial perspective, as seen in his fascination with aviation and aerodynamics. This interest preoccupied him as early as 1914 and finally culminated in his projects for dirigibles in the late 1920s. The dirigible designs anticipate Tatlin's projects for flying machines, which were not completed until the early 1930s.

234

■ Adopt the pose of the model and you'll understand what you have to draw. You should begin the drawing from this inner move, from the framework itself. Indeed, in sculpture you have to start with the framework. You can't start with the head—it simply won't have anything to hold on to. So that's how you should draw—from the general to the particular, not vice versa....[The eraser] accustoms you to working without tension. You ought to touch the paper lightly, after giving it some thought. Don't hurry, think of it first like chess. After all, you don't grab the figure straightway, you think about it first. The same on paper. Work with your head, your head, not with your hand....

Petr Miturich, untitled statement quoted in N. Rozanova, *Petr Miturich,* Moscow, 1973. Translated from the Russian by John E. Bowlt.

3

Morgunov, Aleksei Alekseevich

Born 1884 Moscow; died 1935 Moscow.

235.

Portrait of Goncharova and Larionov (?) c. 1911

Oil on canvas

104.1 x 136.5 cm. (41 x 53¾ in.)

The Art Institute of Chicago, Mary and Leigh Block Fund for Acquisitions, 1975.666

Bibliography

O. Obolsina, "Zabytye stranitsy sovetskogo iskusstva," *Iskusstovo,* Moscow, no. 3, 1974, pp. 32–37.

Mid-1900s attended the Stroganov Institute, Moscow; attended the studio of Sergei Ivanov; also studied under Konstantin Korovin; habitué of K. Krakht's intellectual salon; 1907 exhibited with the Moscow Association of Artists; 1909–10 traveled in Germany, France, and Italy; impressed by Puvis de Chavannes, Manet, Courbet, and Cézanne; 1910 onward contributed to many important exhibitions of the avant-garde, including *Jack of Diamonds* and *Union of Youth*; close to Konchalovsky, Lentulov, and Mashkov; interested in primitive art and Cubism; 1912 contributed to Larionov's *Donkey's Tail* exhibition; 1915 contributed to *Tramway V,* Petrograd; 1916 to Tatlin's *The Store,* Moscow; influenced by Malevich's Suprematism at this time; 1918 member of IZO NKP; contributed to agit-decorations for Moscow; member of Proletkult organization; teacher at Svomas, Moscow; 1918–19 contributed to *Fifth State Exhibition*; 1920s painted comparatively little but continued to exhibit, for example the *Erste Russische Kunstausstellung,* Galerie Van Diemen, Berlin (1922); increased orientation away from experimental style towards realism; 1927–32 member of OMKh (Society of Moscow Artists); early 1930s made several trips to industrial complexes such as the Donbas area and the Dnepr Hydroelectric Station.

Aleksei Morgunov's emergence in the Moscow world coincided with the development of Russia's Ne Primitivist movement. From 1910 Morgunov contributed most of the important avant-garde exhibitions. He was member of the Neo-Primitivist group the Jack of D monds, which aimed at a deliberate simplification and v garization of form. For inspiration its members look not toward the most advanced art of Europe, but towa Russia's tradition of craft and folk art, and toward primiti artifacts. The 1910 *Jack of Diamonds* exhibition marke branching-off point for the Neo-Primitivist movement. the one hand, Larionov and Goncharova increasin came to stress the importance of Russian folklore, wh Konchalovsky, Lentulov, and Morgunov looked more a more toward French art.

Morgunov's *Portrait of Goncharova and Larionov* of about 1911, with its roughness of brush stroke a heavy delineation of form, is clearly Neo-Primitivist. T subject is most probably a depiction of the assertive lea ers of the movement. The self-conscious references the French show the artist's departure from the path p scribed by Larionov and Goncharova. The compositior clearly a reference to Manet's famous *A Bar at t Folies-Bergères* (1881–82). Here Goncharova maintai the same stance as Manet's barmaid and wears a markably similar costume. The bar itself and the bottl and still life are repeated by Morgunov. He does dep from the Manet composition in the placement of the figu of Larionov and in the background. While Manet's bac ground is the reflection (in a mirror) of the bar's cliente Morgunov used a backdrop (or painting) depicting number of clowns dancing in its upper portion and so curvilinear figures in motion below. The upper portion quite evidently a reference to Picasso and the lower Matisse. The reference to Matisse is not surprising, sin Sergei Shchukin, a well-known Moscow collector, h commissioned Matisse to paint murals for his hor in 1909.

By 1916 Morgunov had abandoned his interest Primitivism and French art for Malevich's Suprematis Like so many of his colleagues, he contributed to admin trative endeavors after the Revolution, including IZO NH (the Department of Fine Arts of the Commisariat People's Education) and Proletkult (the organizati devoted to establishing a proletarian art). Toward the ends he designed agit decorations in Moscow. In the la 1920s Morgunov redirected his energies toward Social Realism.

235

Nikolskaia, Vera Nikolaievna
(née Shuiemina)
Born 1890 Seratov; died 1964 Leningrad.

236.
Color Study (Target), 1927
Watercolor on paper
16 x 22 cm. (6¼ x 8⅝ in.)
Museum Ludwig, Cologne,
West Germany

237.
Color Plate, 1927
Watercolor on paper
16 x 22 cm. (6¼ x 8⅝ in.)
Galerie Gmurzynska, Cologne,
West Germany

Bibliography

John E. Bowlt, biography and
bibliography in *Women Artists of
the Russian Avant-Garde 1910–
1930,* exh. cat. in German and
English, Galerie Gmurzynska,
Cologne, 1979, p. 172.

Very little is known at this time of Nikolskaia's life and
work.

■ Vera Nikolskaia had no formal academic training as
young woman. She married the well-known architect Ale
andr Nikolski and traveled with him to Florence ar
Ravenna in 1912. Her close study of Italian frescoe
particularly the use of color, had significant impact
her development as an artist. Very little is known of h
life and work except that she returned to Russia fro
her travels and became an apprentice to Matiushin, w
was head of Inkhuk's Department of Organic Cultur
Nikolskaia worked with him on his research in col
theory, particularly with the experiments on color in m
tion. Her *Color Studies* of 1927 probably stem from the
experiments. In these works, which are also calle
Targets, the use of symmetrical circular composition
combined with a transparency and delicacy inherent
the watercolor medium. The *Color Studies* may hav
been produced in conjunction with Matiushin's *Col
Primer,* a series of tables and charts to be used in archite
ture and the industrial arts. Nikolskaia is also known
have studied color in its relationship to architecture.

236

237

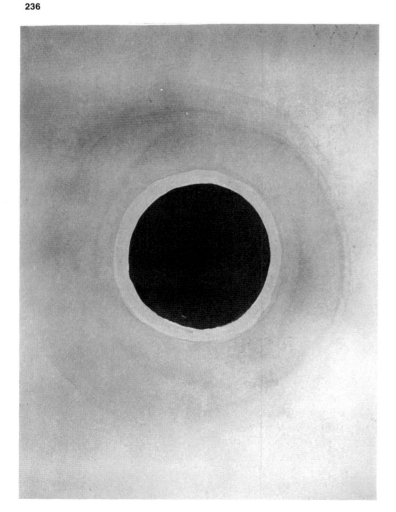

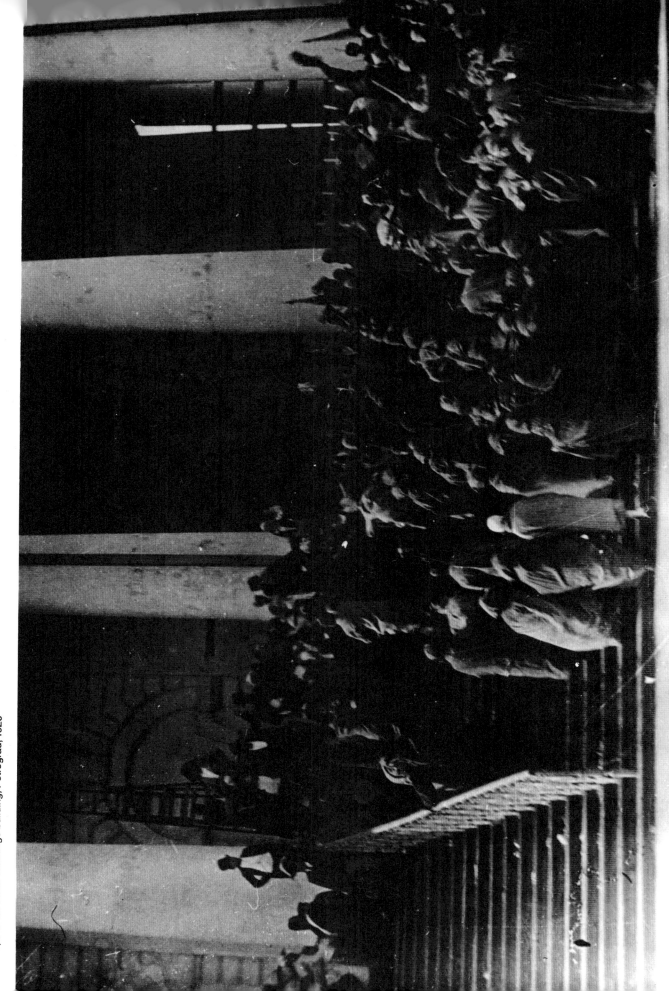

"Toward a Worldwide Commune": mass performance on the
steps of the stock exchange building, Petrograd, 1920

Popova, Liubov Sergeevna
Born 1889 near Moscow; died 1924 Moscow.

238.
Cubist Cityscape, 1914
Oil on canvas
137.1 x 91.4 cm. (54 x 36 in.)
Private collection

239.
Untitled, 1914
Gouache on paper mounted on board
35.6 x 27.9 cm. (14 x 11 in.)
Mr. and Mrs. Curtis Lowell, Mexico

240.
The Factory, c. 1914–15
Gouache on paper mounted on board
42 x 31.1 cm. (16½ x 12¼ in.)
Ruth and Marvin Sackner

241.
Still Life (Instruments), 1915
Oil on canvas
105.5 x 69.2 cm. (41½ x 27¼ in.)
Thyssen-Bornemisza Collection, Lugano, Switzerland

242.
Traveling Woman, 1915
Oil on canvas
157.8 x 123.5 cm. (62⅛ x 48⅝ in.)
The George Costakis Collection

243.
Supremus, c. 1916
India ink
10 x 8 cm. (4 x 3⅛ in.)
Collection Rubinger, Cologne, West Germany

244.
Supremus, c. 1916
India ink
9 x 11 cm. (3½ x 4⅜ in.)
Collection Rubinger, Cologne, West Germany

245.
Architectonic Composition,
c. 1917
Oil on canvas
70.5 x 70.5 cm. (27¾ x 27¾ in.)
Thyssen-Bornemisza Collection, Lugano, Switzerland

1907–8 attended the studios of Stanislav Zhukovsky and Konstantin Yuon in Moscow; late 1900s made many trips to ancient Russian cities such as Pskov and Vologda, studying Russian church architecture and art; 1910 traveled to Italy, where she was especially impressed by Giotto; 1912 worked in the Moscow studio known as The Tower with Viktor Bart, Tatlin, and Kirill Zdanevich; 1912–13 worked in Paris, frequenting the studios of Le Fauconnier and Metzinger; met Vera Pestel and Nadezhda Udaltsova there; 1913 returned to Russia; again worked close to Tatlin and also to Udaltsova and Alexandr Vesnin; 1914 traveled to France and Italy again; 1914–16 contributed to the *Jack of Diamonds* (Moscow, 1914 and 1916), *Tramway V, 0–10,* and *The Store;* 1915–21 painted in a non-objective style; 1916–18 painted so-called "architectonic compositions"; 1919–21 painted so-called "painterly constructions"; 1918 professor at Svomas / Vkhutemas; 1919 contributed to the *Tenth State Exhibition: Non-Objective Creation and Suprematism* and to other exhibitions thereafter; 1920 member of Inkhuk; 1921 took part in *5 x 5 = 25;* rejected studio painting and experimented with design in various fields including book design, porcelain, textiles, and dresses; 1922 created set and costume designs for Meierkhold's production of Crommelynck's farce *The Magnanimous Cuckold;* contributed to the *Erste Russische Kunstausstellung* in Berlin; 1923 designed sets and costumes for Sergei Tretiakov's *Earth on End;* 1923–24 worked on dress and textile designs for the First State Textile Factory, Moscow; 1924 posthumous exhibition in Moscow.

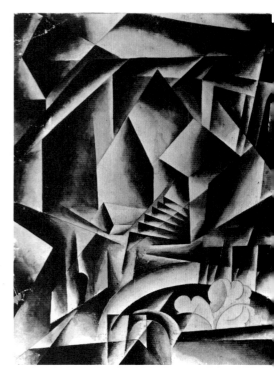

240

238

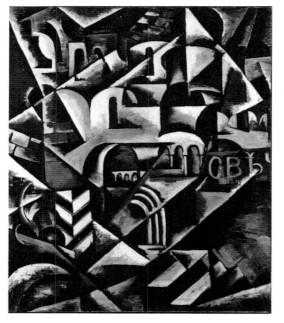

▶

246.
Untitled, 1917
Collage of cut and pasted papers
23.9 x 15.6 cm. (9⅜ x 6⅛ in.)
Collection, The Museum of Modern
Art, New York, Gift of Mr. and Mrs.
Richard Deutsch

247a. –g.
**Portfolio of 7 Suprematist
Compositions,** 1917–20
Watercolor and linocut
each approx. 39 x 30 cm. (15⅜ x
11¾ in.)
Private collection, Switzerland

248.
Architectonic Composition, 1918
Oil on board
50.8 x 44.5 cm. (10 x 17½ in.)
Mr. and Mrs. Roald Dahl

249.
Architectonic Composition, 1918
Oil on board
59 x 39.4 cm. (23¼ x 15¼ in.)
Donald Morris Gallery/
Carus Gallery

250.
Architectonic Composition, 1918
Watercolor on paper
34.9 x 26 cm. (13¾ x 10¼ in.)
Private collection

251.
Pictorial Architectonic, 1918
Oil on burlap
45 x 53 cm. (17¾ x 20⅞ in.)
Thyssen-Bornemisza Collection,
Lugano, Switzerland

252.
Untitled, 1919
Gouache on paper
15.4 x 71.7 cm. (6⅛ x 28¼ in.)
La Boetie, Inc., New York

253.
Composition with Letters, c. 1919
Gouache and india ink
14.5 x 75.5 cm. (5¾ x 29¾ in.)
Mr. and Mrs. Roald Dahl

254.
Architectonic Composition, 1921
Gouache on board
31.4 x 25.7 cm. (12⅜ x 10⅛ in.)
Thomas P. Whitney, Connecticut

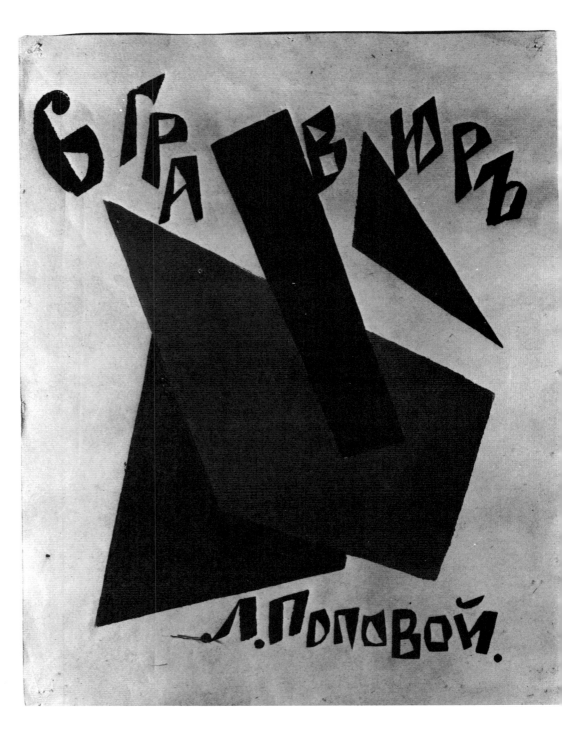

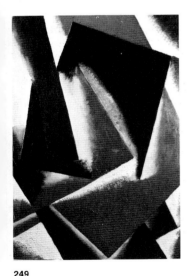

249

Liubov Popova is especially striking among the Russian avant-garde artists for her visual sophistication and breadth of learning. Her prewar travels and studies exposed her to European "isms," as well as to her own country's ancient icons, frescoes, and architecture. Early associated with Tatlin's experimental studio The Tower, Popova went on to contribute to major avant-garde exhibitions both before and after the Revolution. Popova occupied a pioneering position in a specifically Russian interpretation of Cubo-Futurism. She early became a practitioner of non-objective art, although she rejected Malevich's spiritual philosophy and emphasized the painterly spatial relationships of her "architectons." Following the Revolution, Popova was in the forefront of the Constructivist / Productivist ethos.

Cubist Cityscape, an early watercolor of 1914, draws upon Popova's knowledge of French Cubism for its structure and subject matter, although a special concern for non-representational color relationships and surface patterning is already evident. A major oil painting of the following year, *Traveling Woman,* is a satisfying resolution of Cubo-Futurist eclecticism. The 1915 *Still Life (Instruments)* also refers to Cubism in its shallow space, buildup of centralized shapes, and musical objects. This transitional oil painting presages the removal of all vestiges of recognizable figuration. The small india ink works of about 1916, often simply called *Supremus,* are reminiscent of Malevich's Suprematist drawings and lithographs, especially those incorporating letters as formal design shapes. By the following year, Popova's originality and formal discipline asserted itself in the concise yet never austere color, shape, and spatial relationships of the completely non-objective *Portfolio of 7 Suprematist Compositions* (1917–20).

Popova's "architectonic compositions," developed from 1916 to 1918, comprise a significant contribution to Russian avant-garde theory and practice. A 1918 *Architectonic Composition* flattens the shallow space of Cubism into a purely pictorial space that clings to the picture plane; the centralized buildup of Cubism is spread out into an "all-over" composition defying traditional perspective; conventional warm and cool color movement is subverted; space is articulated by the materiality of painterly texture and intuition of light-as-shape. Popova's theoretical stance, expressed in the catalog of the 1919 *Tenth State Exhibition: Non-Objective Creation and Suprematism,* treats painting as a construction of purely formal values and denies that painting is imitation, storytelling, or emotional expression.

In 1920 Popova became a member of Inkhuk. The 1921 *Constructivist Composition* shares the group's interest in mathematics as the basis of a constructed pictorial art: it concentrates Popova's concern with line-as-color and with lines as spatial indicators of planes passing through space. As a member of the historic *5 x 5 = 25* exhibition of 1921, Popova joined with those who urged the death of easel painting and who contributed to the emerging Productivist posture. Popova's wide range of interests embraced both stage design (for Meierkhold) and industrial design. A 1923 textile *Sketch* and a series of reconstructed *Dresses* illustrate her attention to the material properties of fabric and to patterns dictated by the human figure moving through space. Popova's book illustration often was connected to the lesser-known aspects of avant-garde music: *On the New Shore of Musical Art* (1923) and *Musical Virgin-Soil* (1924). Her cover for Bobov's poetry anthology, *Rebellion of Misanthropes* (1922), indicates her skill at photomontage. In 1924 Popova contracted scarlet fever from her child; she died on May 25. The catalog of her posthumous exhibition of 1924 memorializes Popov's profoundly influential position among the Russian avant-garde.

▶

255.

Constructivist Composition, 1921
Oil on panel
93 x 61.5 cm. (36⅝ x 24¼ in.)
Mr. and Mrs. Roald Dahl

256.

Untitled, 1921
Gouache on paper
27 x 34.5 cm. (10⅝ x 13⅝ in.)
Galerie Gmurzynska, Cologne,
West Germany

257.

Med Vervis, c. 1921
Brush and india ink and watercolor
34.5 x 27.5 cm. (13⅝ x 10⅞ in.)
Robert and Maurine Rothschild
Collection

258.

Space Construction: Vern 34,
c. 1921
Watercolor and gouache on paper
35 x 27.5 cm. (13¾ x 10⅞ in.)
The George Costakis Collection

259.

5 x 5 = 25 Exhibition Catalog,
1921
Catalog with five original works by
A. Exter, L. Popova, A. Rodchenko,
V. Stepanova, and A. Vesnin
Charcoal and colored crayons
11.8 x 8.6 cm. (4¾ x 3⅜ in.)
Michail Grobman, Jerusalem, Israel

260.

**Vosstanie mizantropov
(Rebellion of Misanthropes)** by
S. Bobov
Moscow, 1922
Photomontage cover by Popova
16.4 x 11.8 cm. (6½ x 4⅝ in.)
Australian National Gallery,
Canberra

261.

**K novym beregam muzykalnago
iskusstva (On the New Shore of
Musical Art)** by V. Beliaev and
V. Derzhanovsky
Moscow, 1923, vols. 1 (72 pp.) and
2 (82 pp.)
Lithograph cover after drawings by
Popova
29.8 x 21.9 cm. (11¾ x 8⅝ in.)
Alma H. Law

255

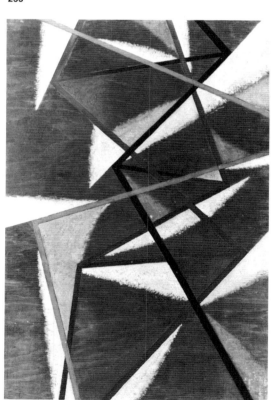

■ It's clear, surely, from this title itself what I'll be talking about? True, the subject is rather new, but there's actually not that much to make a fuss about. *That the aesthetic criterion for evaluating the object is invalid* is known to absolutely everyone and has been for quite some time. In any case, Tolstoi discredited this criterion brilliantly.... Even so, that's not enough, the dose is inadequate, if it hasn't worked yet and if ten times a day we are obliged to demonstrate that this very aesthetic criterion (or absence of any criterion) still holds sway whether in the boondocks or in the studies of our government centers.

Why do we still not have a precise formula that would once and for all cut short all these absurd polemics and, like the best vacuum-cleaner construction, would remove all this aesthetic trash from life and transfer it to the jurisdiction of those who protect antique monuments and items of luxury?

Let this formula be infallible, like the formula of a chemical compound, like the calculated tension of the walls of a steam boiler, like the self-confidence of an American advertisement, like 2 x 2 = 4....

Ah! *Expediency! Please* be our criterion at least for a moment. Our entire life in the form of sociology, chemistry, physics, mathematics, engineering, technology, etc., brings us thousands of things to think about, dictates a single, integrated approach to evaluating the facts of everyday life.

From the simplest blobs of protoplasm in the organic world to the most complex inventions of the human consciousness, all the living elements of our world are controlled by their own expediency, they change according to its will or they are generated by it. If that is indeed the case, then why the hell should the most *subjective* and most uncertain of all subjective judgments—the notorious *aesthetic* judgment—be able to serve as a *criterion*?

Indeed, how much more dependable is the deck equipment and activities of a battleship's crew, how much more dependable from every point of view, than any kind of aesthetic-cum-theatrical movements of an actor on *ridiculous* "stage platforms"!...

And the only oasis, alone and forlorn, among all this nonsense is the *Institute of Labor* and Meierkhold's biomechanics....

Let's hurry up and find formulae for working with the materials on hand, whether in two dimensions, in three, or in four. Only with such precise calculations can we even think of working in the field of so called "artistic" material design—until that happy moment when the very principle of "artistry" (in contrast to whatever seemingly is "unartistic") will be studied only as part of this history of superstition and prejudice.

So in vain do aesthetes take shelter behind the visual, poetic, musical, and theatrical arts by talking about *formal and aesthetic "searches and achievements"* (such as "the problem of form and color in studio painting" or "the construction of scenic space"). Their "art for art's sake" days are numbered....But they persist in *condemning Picasso* from their "formal and aesthetic viewpoint"—to the effect that he has become a Realist and has betrayed the Dardanelles of his "formal researches," has begun to paint *portraits like photographs*....

Liubov Popova, *Zrelishcha*, Moscow, no. 1, 1922, pp. 5–6. Translated from the Russian by John E. Bowlt.

EXPEDIENCY

UTILITARIANISM

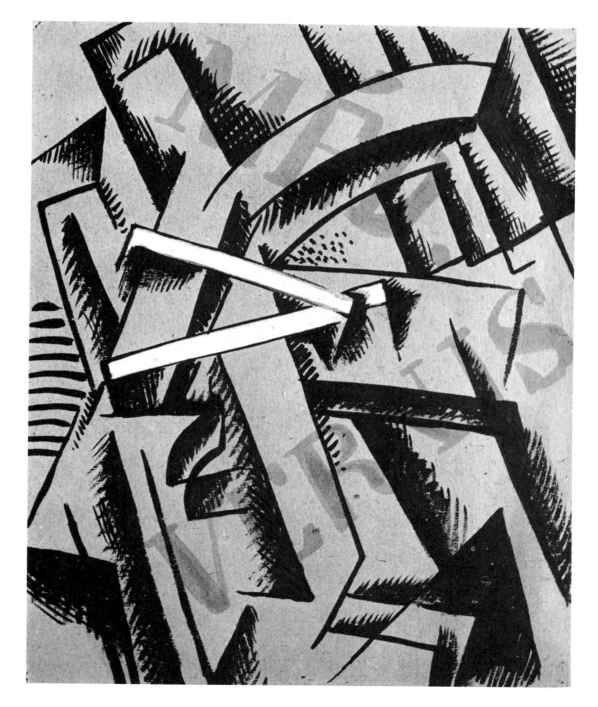

262.
Textile Sketch, 1923
Gouache and pencil on paper
28x 35 cm. (11 x 13¾ in.)
The George Costakis Collection

263.
Untitled, 1923
Watercolor on paper
35.6 x 26.7 cm. (14 x 10½ in.)
Ruth and Marvin Sackner

264.
**Catalog of the Posthumous
Exhibition of the
Artist-Constructor L. S. Popova**
Moscow, 1924
21 pp. with color lithograph by
Popova
Ex Libris, 6 no. 221
17.1 x 14.1 cm. (6¾ x 5¾ in.)
Leonard Hutton Galleries,
New York

265.
**Musykalnaia Nov (Musical Virgin
Soil)**
by A. Sereyev, S. Chemodanov, and
D. Chernomordikov
Moscow-Leningrad, 1924, vol. 5
48 pp. with cover lithograph by
Popova
31.1 x 22.9 cm. (12¼ x 9 in.)
Alma H. Law

266.
Project for an Actor's Costume,
1922
Reconstruction 1979, model
realized by van Laack according to
original artist's sketches
Felt; size 8/10
Collection van Laack Company,
West Germany

267.
Textile Design, c. 1923
Reconstruction 1979, model
realized by van Laack according to
original artist's sketches
Wool jersey; size 8/10
Collection van Laack Company,
West Germany

268.
Textile Design and Shape, c. 1923
Reconstruction 1979, model
realized by van Laack according to
original artist's sketches
Crêpe de Chine; size 8/10
Collection van Laack Company,
West Germany

269.
Textile Design and Shape,
1923–24
Reconstruction 1979, model
realized by van Laack according to
original artist's sketches
Silk, wool; size 8/10
Collection van Laack Company,
West Germany

270.
Textile Design and Shape,
1923–24
Reconstruction 1979, model
realized by van Laack according to
original artist's sketches
Silk, wool; size 8/10
Collection van Laack Company,
West Germany

271.
Textile Design and Dress,
1923–24
Reconstruction 1979, model
realized by van Laack according to
original artist's sketches
Crêpe de Chine; size 8/10
Collection van Laack Company,
West Germany

272.
Dress, Coat, and Scarf, 1923–24
Reconstruction 1979, model
realized by van Laack according to
original artist's sketches
Linen; size 8/10
Collection van Laack Company,
West Germany

Bibliography

L. Adaskina, "Liubov Popova. Put
stanovleniia khudozhnika-konstruk-
tora," *Tekhnicheskaia estetika,*
Moscow, no. 11, 1978, pp. 17–23.

L. Adaskina, "Problemy proizvodst-
vennogo iskusstva i tvorchestva
L. S. Popovoi," *Khudozhestvennye
problemy predmetno-prostranst-
vennoi sredy,* Moscow, 1978.

John E. Bowlt, "From Surface to
Space: The Art of Liubov Popova,"
The Structurist, Saskatoon, no.
15/16, 1975/1976, pp. 80–88.

Vasilii Rakitin, "Liubov Popova,"
*Women Artists of the Russian
Avant-Garde 1910–1930,* exh. cat.
in German and English, Galerie
Gmurzynska, Cologne, 1979,
p. 195.

E. Rakitina, "Liubov Popova.
Iskusstvo i manifesty," ed.
E. Rakitina, *Khudozhnik, stsena,
ekran,* Moscow, 1975, pp. 152–65.

T. Strizhenova, *Iz istorii sovetskogo
kostiuma,* Moscow, 1972, esp.
pp. 58ff.

Puni, Ivan Albertovich (Pougny, Jean)

Born 1894 Kuokkala, Finland; died 1956 Paris.

273.
Self-Portrait, 1911–12
Oil on canvas
84 x 67 cm. (33⅛ x 26⅜ in.)
Musée National d'Art Moderne,
Centre Georges Pompidou, Paris

274.
Still Life—Relief with Hammer,
1920s reconstruction of 1914
original
Gouache on cardboard with
hammer
80.5 x 65.5 x 9 cm. (31⅝ x 25¾ x
3½ in.)
Collection Mr. and Mrs. Herman
Berninger, Zurich, Switzerland

275.
Baths, 1915
Oil on canvas
73 x 92 cm. (28¾ x 36¼ in.)
Collection Mr. and Mrs. Herman
Berninger, Zurich, Switzerland

276.
**Composition (Design for
Sculpture No. 102),** 1915
India ink and watercolor on paper
mounted on cardboard
48 x 26 cm. (18⅞ x 10¼ in.)
Collection Mr. and Mrs. Herman
Berninger, Zurich, Switzerland

277.
Sculpture, c. 1915
Wood relief, iron, and cardboard
70 x 48 x 12.4 cm. (27 x 18⅞ x
4⅞ in.)
National Gallery of Art,
Washington, D.C., Andrew W.
Mellon Fund
(Hirshhorn Museum and Sculpture
Garden only)

278.
Suprematist Composition, 1915
Gouache on paper
69.8 x 47.6 cm. (27½ x 18¾ in.)
Yale University Art Gallery, New
Haven, Connecticut
Gift of Collection Société Anonyme

Received early education in St. Petersburg; 1909 first trip to Paris; 1910 attended the Académie Julien in Paris; 1912 back in St. Petersburg; contact with the Burliuks, Malevich, and other members of the avant-garde; associated with the Union of Youth; 1913 married the painter Xana (Kseniia) Boguslavskaia; 1914 contributed to the Futurist booklet *Rykaiushchii Parnas (Roaring Parnassus)* subsidized by Boguslavskaia; 1912–17 contributed to the Union of Youth exhibitions (1912–13, 1913–14), the *Jack of Diamonds* (1917) and organized *Tramway V* and *0–10;* 1915 at *0–10* with Boguslavskaia issued "Suprematist Manifesto"; 1918 professor at Svomas, Petrograd; 1918–29 exhibited at many Soviet exhibitions such as *Russian Landscape* in Petrograd (1919) and the *Exhibition of New Trends* in Leningrad (1927); 1918–19 took part in agit-decoration for the streets and squares of Petrograd; taught at Vitebsk; 1920 emigrated to Berlin; designed children's books; 1922 rejected Suprematism, voicing a preference for Kandinsky over Malevich; contributed to the *Erste Russische Kunstausstellung;* 1923 settled in Paris; in emigration supported a figurative kind of painting, reminiscent of Bonnard and Vuillard.

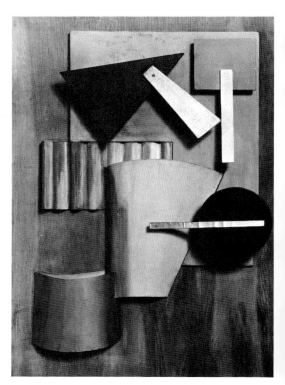

277

278

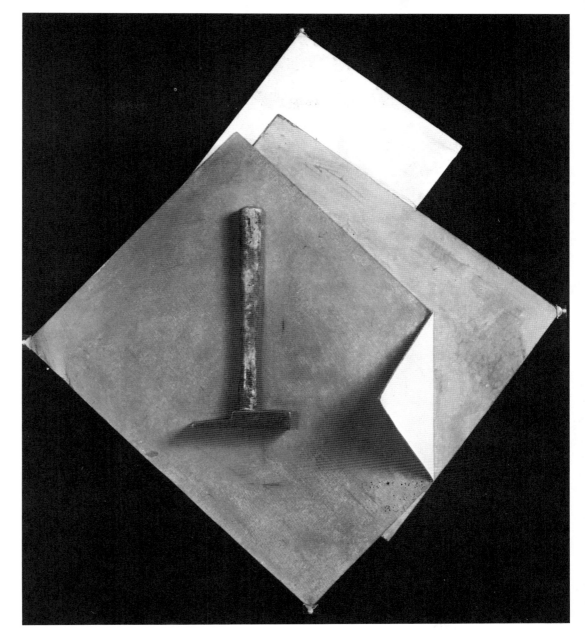

274

Like many of his Russian colleagues, Ivan Puni spent the years before World War I studying art in Paris, where he was influenced by the Cubist movement. Returning to Russia, he made contact with the Cubo-Futurists and contributed to the Union of Youth exhibitions. Puni and his wife, the painter Xana Boguslavskaia, played a significant role in the development of the avant-garde. In 1915 he organized and financed the *First Futurist Exhibition of Pictures: Tramway V* in Petrograd. This exhibition was the first real "swelling of the ranks" in the Russian avant-garde, an occasion which brought together all of the leading figures. Puni designed the catalog for the show and exhibited *Relief with Hammer* (1914). In this work, a collage technique incorporates real materials (in this case, a hammer and pieces of wood) into a synthetic Cubist structure.

Puni and his wife were among the earliest followers of Malevich's Suprematism. Late in 1915 they financed a second major exhibition in Petrograd called *The Last Futurist Exhibition of Pictures: 0–10.* This show marked the public debut of Malevich's Suprematist work and also brought to the fore the aesthetic and emotional antipathy between Malevich and Tatlin, the two leading figures in the

avant-garde. Puni's work during this pioneering phase offers the only example of Suprematist painting extended into actual three-dimensional space. Illusionistically painted objects, real objects, enigmatic words, and attached wooden pieces were incorporated into the major works by Puni that were shown on this occasion, including *Baths, Suprematist Sculpture,* and *White Ball* (all produced during 1915). While these works do utilize materials usually associated with Tatlin, they are linked more closely to Malevich in philosophical orientation and formal vocabulary. In fact, the reliefs were produced during the height of Puni's Suprematist phase, and their exhibition was accompanied by a *"Suprematist Manifesto"* in which Puni and his wife made one of the first unequivocal declarations of a purely self-sufficient art form: "A picture is a new conception of abstracted, real elements, deprived of meaning."

When Puni emigrated to Berlin in 1920, most of the reliefs were left behind in Russia and lost. He reconstructed some of them, often in larger scale than the original. By 1922 he had dismissed Suprematism as transitory and superficial. Puni settled in Paris in 1923 and changed his name to Jean Pougny.

▶

279.
White Ball, 1915
Plaster and wood relief
34 x 51 x 12 cm. (13⅜ x 20⅛ x
4¾ in.)
Musée National d'Art Moderne,
Centre Georges Pompidou, Paris.

280.
Sculpture, reconstruction from
1916 drawing of 1915 original
Partially painted wood, tin, and
cardboard
77 x 50 x 8 cm. (30¼ x 19⅝ x
3⅛ in.)
Musée National d'Art Moderne,
Centre Georges Pompidou, Paris

281.
Sculpture—Relief with Saw,
reconstruction from 1916 drawing of
1915 original
Partially painted wood, sheet iron,
glass and cardboard with saw
72.5 x 65 x 12 cm. (28½ x 25⅝ x
4¾ in.)
Collection Mr. and Mrs. Herman
Berninger, Zurich, Switzerland

282.
Design for Sculpture, 1915–16
India ink and pencil on paper
mounted on cardboard
39 x 32 cm. (15⅜ x 12⅝ in.)
Collection Mr. and Mrs. Herman
Berninger, Zurich, Switzerland

283.
Composition, c. 1915–16
Ink on paper
48 x 34 cm. (18⅞ x 13⅜ in.)
Guido Rossi, Milan, Italy

284.
Maquette for Sculpture
1915–16
Wood, iron, cardboard, glass,
and oil
24 x 16 x 5.5 cm. (9½ x 6¼ x
2⅛ in.)
Guido Rossi, Milan, Italy

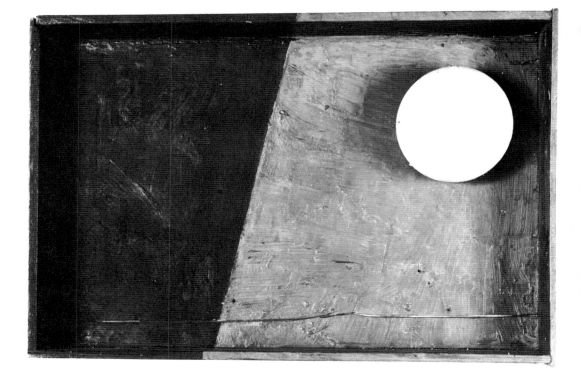

284

281

▶

285.
Poster for Last Futurist
Exhibition: 0–10, 1916
Poster
74 x 55.5 cm. (29⅛ x 21⅞ in.)
Collection Mr. and Mrs. Herman
Berninger, Zurich, Switzerland

286.
Letters, 1919
Gouache on paper
89 x 89 cm. (35 x 35 in.)
Musée National d'Art Moderne,
Centre Georges Pompidou, Paris

287.
Tsveten (Blossoming) by Puni
Berlin, 1922
113 pp. with illustrations by A. Grinev,
Puni, and K. Boguslavskaia
17.8 x 25.4 cm. (7 x 10 in)
A. L. de Saint-Rat, Miami University,
Oxford, Ohio

Bibliography

H. Berninger and J. A. Cartier,
Pougny. Catalogue de l'oeuvre.
Russie-Berlin, 1910–1923,
Tübingen, 1972.

Peter Lufft, "Der Gestaltwandel im
Werk von Jean Pougny," ed.
Eduard Hüttinger and Hans A.
Lüthy, *Gotthard Jedlicka. Eine*
Gedenkschrift, Zurich, 1974,
pp. 181–98.

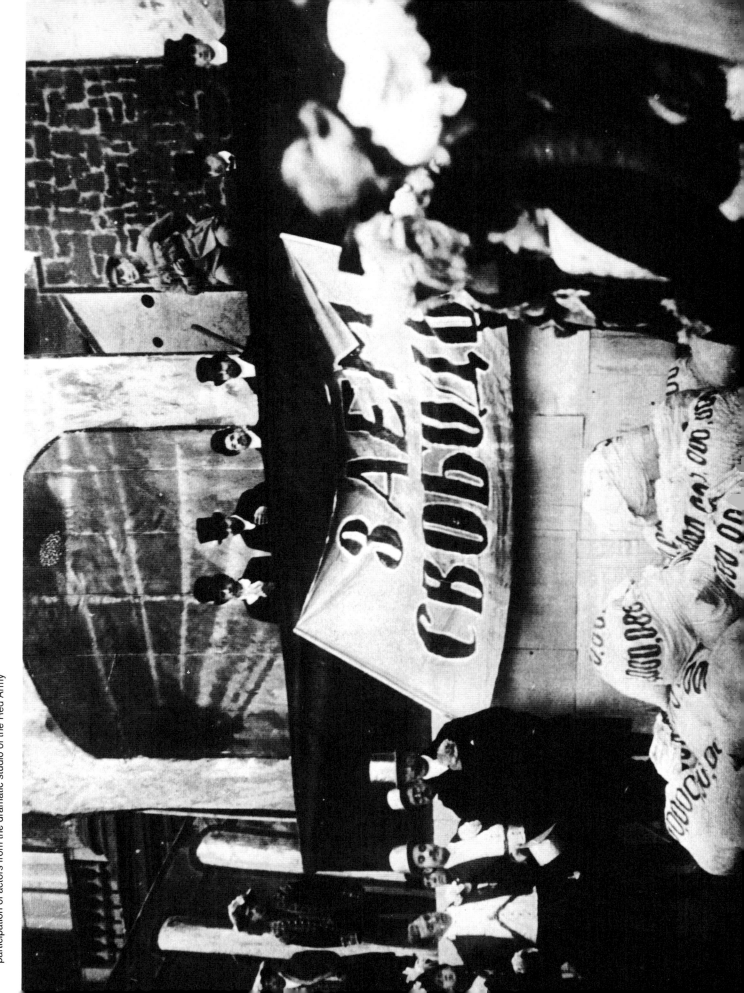

"The Overthrow of the Tsarist Regime": mass performance with participation of actors from the dramatic studio of the Red Army

Rodchenko, Alexandr Mikhailovich

Born 1891 St. Petersburg; died 1956 Moscow.

288.
Untitled Composition, 1915
Gouache on paper
29.5 x 20 cm. (11⅝ x 7⅞ in.)
Ronald and Susanne Tepper

289.
Untitled, 1916–17
Gouache on paper
14.3 x 12.4 cm. (5⅝ x 4⅞ in.)
Harry C. Nail, Jr.

290.
Untitled, 1918
Watercolor on paper
29.2 x 20.6 cm. (11½ x 8⅛ in.)
Harry C. Nail, Jr.

291.
**Non-Objective Painting: Black
on Black,** 1918
Oil on canvas
81.9 x 79.4 cm. (32¼ x 31¼ in.)
Collection, The Museum of Modern
Art, New York, Gift of the artist
through Jay Leyda, 1936

292.
Untitled Composition, c. 1918–20
Oil on cardboard
46.5 x 36.5 cm. (18¼ x 14⅜ in.)
Rosa Esman Gallery and
Adler/Castillo Inc., New York

293.
Untitled, 1919
Linocut
22.2 x 17.8 cm. (8¾ x 7 in.)
Private collection

294.
Composition, c. 1919
Woodcut
16.4 x 11.4 cm. (6½ x 4½ in.)
Robert and Maurine Rothschild
Collection

295.
Study of a Circle, 1919
Oil on wood
45.5 x 40 cm. (17⅞ x 15¾ in.)
Mr. and Mrs. Roald Dahl

1910–14 studied at the Kazan Art School, mainly under
Nikolai Feshin and Georgii Medvedev; then moved to the
Stroganov Institute, Moscow; 1916 contributed ten works
to Tatlin's *The Store,* including six works executed with
compass and ruler; 1917 with Tatlin, Yakulov, and others
designed the interior of the Café Pittoresque, Moscow;
1918 onward worked on various levels of IZO NKP; with
Rozanova was in charge of the Art-Industrial Sub-Section
of IZO; was head of the purchasing committee for the
Museum of Painterly Culture; 1918–26 taught at the
Moscow Proletcult School; 1918–21 worked on "Spatial
Constructions"; 1919–20 with Vladimir Krinsky, Alexandr
Shevchenko, Popova, was a member of Zhivskulptarkh
(Paintsculptarch); 1920 member of Inkhuk; 1921 contrib-
uted to the third *Obmokhu* exhibition and to *5 x 5 = 25* in
Moscow; 1920–30 professor at Vkhutemas/Vkhutein;
1923 created 17 costumes for Alexei Gan's unrealized
spectacle *My (We)*; 1923–28 closely associated with *Lef*
and *Novyi lef,* which published some of his articles and
photographs; during this time Rodchenko concentrated
on topographical design and photography; 1925 designed
a workers' club, exhibited in the Soviet pavilion at the
*Exposition Internationale des Arts Décoratifs et Indus-
triels Modernes,* Paris; 1927 worked on Lev Kuleshov's
film *Zhurnalistka (The Journalist)* also known as *Vasha
znakomaia (Your Acquaintance),* one of several collab-
orations with the Soviet film industry; 1930 joined the
October group; late 1920s onward concentrated on pho-
tographic work and design, although returned to studio
painting in the mid-1930s, producing a series of Abstract
Expressionist canvases in the early 1940s.

288

289

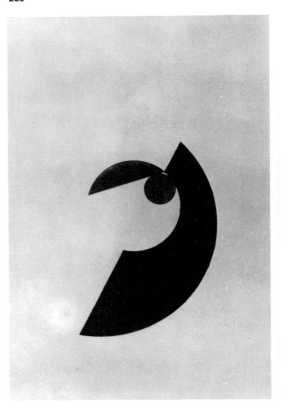

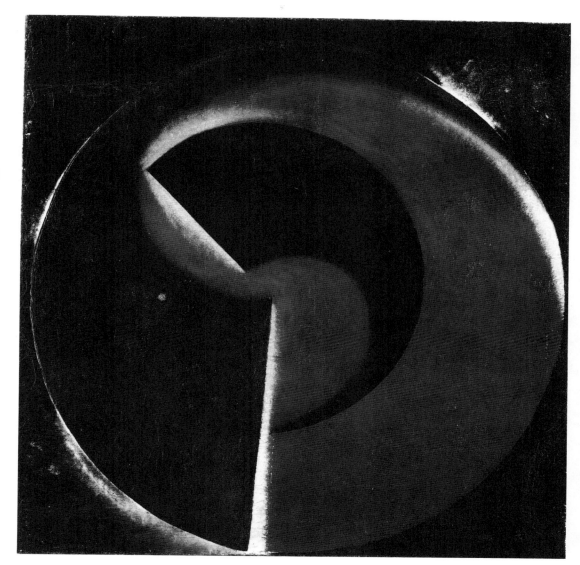

296.

Spatial Construction

1979 reconstruction by John Milner
and Lance Armstrong from photo-
graphs of 1920 lost original
Wood
34.3 x 30.5 x 22.9 cm. (13½ x
12 x 9 in.)
Dr. John Milner, Newcastle-upon-
Tyne, England

297.

Spatial Construction

1974 reconstruction by John Milner
from a photograph of 1920 lost
original
Wood
25.5 x 15 x 15 cm. (10 x 5⅞ x 5⅞ in.)
Dr. John Milner, Newcastle-upon-
Tyne, England

298.

Hanging Oval Construction

1974 reconstruction by John Milner
from 1920–21 original in the
George Costakis Collection
Wood
85 x 55 x 47 cm. (33½ x 21⅝ x
18½ in.)
Dr. John Milner, Newcastle-upon-
Tyne, England

299.

Untitled, c. 1920
Oil on wood
85 x 64 cm. (33½ x 25¼ in.)
Galerie Jean Chauvelin, Paris

300.

New Year's Favor, c. 1921
Paper collage
3.2 x 24.1 x 3.2 cm. (1¼ x 9½ x
1¼ in.)
Private collection

301.

5 x 5 = 25 Exhibition Catalog,
1921
Catalog with five original works by
A. Exter, L. Popova, A. Rodchenko,
V. Stepanova, and A. Vesnin
Crayon
15.7 x 9.4 cm. (6¼ x 3½ in.)
Michail Grobman, Jerusalem, Israel

294

■ The *5 x 5 = 25* exhibition in Moscow, 1921, argued for
the death of traditional easel painting and paved the way
for Constructivism—a movement that dominated the
1920s and claimed Alexandr Rodchenko as a guid-
ing force. Very few copies of the unusual, hand-made
5 x 5 =25 Exhibition Catalog are extant; each contains
an original work by Rodchenko, Exter, Popova, Stepa-
nova, and A. Vesnin. Rodchenko's catalog statement
traced his contribution to the experimental "laboratory
art" spirit of the post-Revolutionary years; he declared
space, line, and primary color as the major factors of
Constructivism.

The background of Rodchenko the Constructivist art
technician and professional photographer reveals an
early interest in the tools of science. After attending art
school in Kazan, he arrived in Moscow in 1914 and was
immediately caught up by the new ideas of Malevich. By
the following year, however, Rodchenko developed his
own style of abstract ruler-and-compass compositions;
these works were introduced at Tatlin's 1916 *The Store*
exhibition. Based on compass and ruler, the 1915 gouache
Untitled (cat. no. 288), although non-objective, is still
Futurist-oriented in its complexity of intersecting lines; the
1916–17 gouache *Untitled* (cat. no. 289) develops a radi-
cal simplification of form that denies illusionistic space
and asserts the picture plane as a self-referential reality.

Following the Revolution of 1917, Rodchenko's fasci-
nation with the formal procedures of art-making is shown
in the 1918 *Non-Objective Painting: Black on Black*; this
heavily textured exploration of spatial tension vied with
Malevich's "white on white" series. Although still within
the conventions of easel painting, the 1919 *Study of a
Circle* and *Untitled* of about 1920 (cat. no. 299) are highly
textural investigations of repeating forms and mono-
chromatic color modulation.

Rodchenko has been most celebrated for his re-
markable use of real materials in three-dimensional
geometric constructions—works that dispense with tra-
ditional pedestals and perspectives, thus encouraging
fresh perceptions. Today, Rodchenko's only extant con-
struction is the 1920–21 *Hanging Oval Construction* from
the collection of George Costakis, unfortunately not avail-
able for this exhibition because of its fragile condition. The
1974 reconstruction of the work, however, reveals a
rhythm of echoing forms interacting with space; designed
to be viewed from below, the *Hanging Oval Construction*

pioneers in bringing actual movement to Constructivi
sculpture. A 1920 floor piece, *Spatial Construction,* wa
reconstructed in 1974; the work contrasts brute textu
and massiveness with an easily grasped vertica
horizontal geometry.

After the turning point of the 1921 *5 x 5 = 25* exhib
tion, Rodchenko's Constructivist commitment to serve th
rapidly industrializing society through a practical applica
tion of art led him to embrace an extremely wide range
activities. The Constructivists were convinced of the in
portance of popular design in influencing mass tast
Rodchenko worked closely with the avant-garde po
Vladimir Maiakovsky in designing posters, signboard
package designs, and other objects of everyday co
sumption. In 1923, captivated by Dada photomontag
from Germany, Rodchenko designed a cover and seve
illustrations for Maiakovsky's long, experimental poe
Pro eto (About This); the photomontages capture th
poet's deeply private emotions, afloat in the Soviet indu
trial bureaucracy. Other examples of Rodchenko's prolif
interest in book illustration are the photomontage an
typography covers for the popular detective serial *Mes
Mend or a Yankee in Petrograd: a Novel*, by "Jim Dolla
(a.k.a. M. Shaginian),1924. He also contributed numerou
illustrations to the important Constructivist journal *L*
(Left Front of the Arts), edited by Maiakovsky and pu
lished in Moscow from 1923 to 1925, and to its reviv
Novyi lef (New Left), 1927–28.

The world of cinema and theater, revolutionized k
Constructivist theory, naturally attracted Rodchenk
Costume for the Meeting Manager was for Maiakovsky
comedy *The Bed Bug,* staged by Meierkhold in 1929 wi
music by the young Dmitri Shostakovich. As a profe
sional photographer from 1923, Rodchenko's form
discoveries were based upon his compositional an
perspectival innovations as an abstract artist. He al
produced many evocative portraits of the avant-gard
such as that of his wife *Stepanova in a Cap Designed l*
Rodchenko. His "Robotanimals" (photographs of thre
dimensional cutouts produced in collaboration with Step
nova) were made to illustrate a children's book by
Tretiakov. They exhibit that same spirit of play evidence
in the whimsical *Party Favor*—a light-hearted contrast
Rodchenko's ultimate struggles during the Stalinist "an
formalist" purges.

299

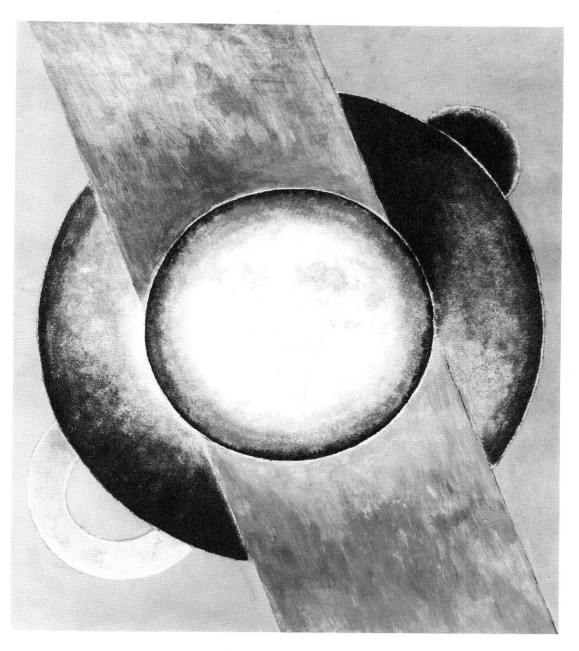

295

302.
Line Construction, No. 7, 1921
Pencil and crayon on paper
46 x 30 cm. (18⅛ x 11¾ in.)
Galerie Jean Chauvelin, Paris

303.
Untitled, 1921
Chalk on paper
33 x 23 cm. (13 x 9 in.)
Galerie Gmurzynska, Cologne,
West Germany

304.
Zaumniki (Transrationals) by A.
Kruchenykh, V. Petrikov, and
V. Khlebnikov
Moscow, 1922
Linocut cover by Rodchenko
20.3 x 12.6 cm. (8 x 5 in.)
Australian National Gallery,
Canberra

305.
**Pro eto. Ei i mne (About That:
To Her and Me)** by V. Maiakovsky
Moscow/Petrograd, 1923
43 pp. with photomontages by
Rodchenko
Ex Libris 6, no. 181
22.1 x 14.7 cm. (8¾ x 5¾ in.)
a) Australian National Gallery,
Canberra
b) Collection Martin-Malburet

306.
**Izbran. Stikhi (The Choice:
Verses)** by N. Aseev
Moscow/Petrograd, 1923
132 pp. with typography by
Rodchenko
Ex Libris 6, no. 416
20.3 x 14.3 cm. (8 x 5⅝ in.)
George Gibian, Ithaca, New York

307.
**Lef (Levyi front iskusstv)
(The Left Front of the Arts)**
ed. V. Maiakovsky
Moscow, 1923, nos. 2, 3
180 pp. with designs by Rodchenko
and V. Stepanova
Ex Libris 6, no. 154
No. 2: 24.5 x 15.6 cm. (9⅝ x 6⅛ in.)
No. 3: 23.8 x 15.6 cm. (9⅜ x 6⅛ in.)
Alma H. Law

308.
**Original Photomontage for
"Pro eto,"** 1923
Photomontage
43.2 x 29.2 cm. (17 x 11½ in.)
Ruth and Marvin Sackner

309.
**Mess Mend ili Ianki v Petrograde:
Roman (Mess Mend or a Yankee
in Petrograd: A Novel)** by Jim
Dollar (pseud. for M. Shaginian)
Moscow, 1924, vols. 1–10
Approx. 30 pp. each with photo-
montage and typography by
Rodchenko
Ex Libris 6, no. 431
17.9 x 12.4 cm. (7⅛ x 4⅞ in.)
Collection Martin-Malburet

310.
**V. V. Maiakovsky with
Three-Quarter View,** 1924
Photograph
32 x 24.6 cm. (12⅝ x 9⅝ in.)
Museum of Modern Art, Oxford,
England

311.
V. V. Maiakovsky with Cigarette,
1924
Photograph
49.5 x 29.5 cm. (19½ x 11⅝ in.)
Museum of Modern Art, Oxford,
England

312.
**Stepanova in a Cap Designed by
Rodchenko,** c. 1924
Photograph
15.2 x 11.4 cm. (6 x 4½ in.)
Samuel Wagstaff

313.
**V. V. Maiakovsky with Hat and
Scarf,** 1924
Photograph
60 x 50 cm. (23⅝ x 19⅝ in.)
Museum of Modern Art, Oxford,
England

314.
Ossip Brik, 1924
Photograph
40 x 30 cm. (15¾ x 11¾ in.)
Colin Osman (Creative Camera),
London

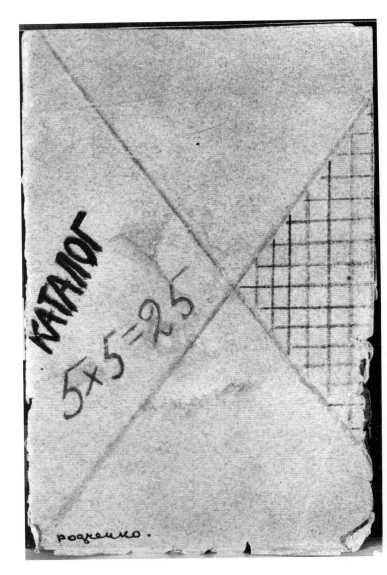

301

■ People are saying: "We're fed up with Rodchenko's photographs. They're all taken from above down and from below up."

Well, people have been photographing from "middle to middle" for about a hundred years. Not just I, but the majority of people should photograph from below up and from above down.

Well, I'm going to photograph "from side to side."

When I look at the mountains of my paintings from previous years I sometimes wonder what to do with them all.

It's a pity to burn them all. I worked ten years on them. It's all an empty business like a church building.

Can't do a damn thing with them!

While I'm staying at my dacha in Pushkino I go and look at nature. A bush here, a tree there, a ravine here, a nettle.....

It's all fortuitous, unorganized. Nothing to take a photograph of. Boring.

Well, the fir trees aren't bad. Long, naked, like telegraph poles.

The ants live like people....And as I recall the buildings in Moscow all heaped up, all different like the ants, I realize that a lot of work has to be done yet.

When he was viewing the movie *The Journalist* Trainin said: "Rodchenko is all too real. Now Utkin, he has imagination." So they put on "life with imagination."

It's interesting to work with experimental photography....How much of photography is aesthetics?—I would say ninety percent.

That's why I'm also working with radio—for discipline's sake.

Radio doesn't have more than ten percent art.

Translate everything from art into device, into a training session. See something new even in the ordinary, in the everyday.

Otherwise people here try to see the old in the new. It's difficult to find something extraordinary in the very ordinary.

That's the point.

You run up against an object, a building, or a person, and you wonder how to photograph it, this way, that way, or that way? All been done before....

That's how we were taught, brought up on millennia of various pictures so that we'd see everything according to the composition rules of our grandmothers.

We have to revolutionize people so that they'll see from all viewpoints and under any light.

It's great to go off on an expedition to the north or to Africa, to photograph new people, new things, new nature.

But what do they do? They photograph through the bloated eyes of Corot and Rembrandt, with museum eyes, with the eyes of the whole history of painting.

They pour painting and theater into the cinema by the ton.

They pour opera and drama into radio by the ton.

No Africa whatsoever...stay at home and try and find something totally new here.

If you've been to China, you don't bring back a packet of "How to make tea" instructions....

It would be interesting to gather statistics on how many articles/reports have been written for our journals on foreign art workers and how many on Soviet ones.

As far as I have observed, there are dozens more on foreign art workers. And the latter are always praised, whereas the Soviet ones are nearly always censured....

What's the explanation for this?

"Well, you see, first, it's cultured to write about foreign art workers (so the author will be esteemed at work), and, second, it's less troublesome—you don't get accused of being biased."

Well, our art critics seem to work more from fear than conscience....

One morning you arrive at the place where you work. People throw themselves upon you from all sides.

"Comrade Rodchenko, we need you today..."

305

▶

315.
Lef (Levyi front iskusstv)
(The Left Front of the Arts)
ed. V. Maiakovsky
Moscow/Leningrad, 1924, no. 2
160 pp. with designs by L. Popova,
V. Stepanova, and Rodchenko
Ex Libris 6, no. 154
22.8 x 15.4 cm. (9 x 5⅞ in.)
Australian National Gallery,
Canberra

316.
L'Art décoratif et industriel de
l'URSS (Decorative and Indus-
trial Art in the USSR) by P. Kogan,
V. Nicolsky, and J. Tugenhold
Moscow, 1925
Book with color lithograph cover by
Rodchenko
Ex Libris 7, no. 232
27 x 20 cm. (10⅝ x 7⅞ in.)
K. P. Zygas

317.
Pine Tree in Pushkin Forest, 1925
Photograph, vintage silver print
29 x 23 cm. (11⅜ x 9 in.)
Robert Shapazian Inc.

318a.–d.
Samozveri: Four Illustrations
for a Children's Book, 1926,
by S. Tretiakov
Photographs by Rodchenko and
Stepanova
23.5 x 17.2 cm. (9¼ x 6¾) each
Samuel Wagstaff

319.
Page from "Novyi lef" (New
Left), 1927
(Samzoveri: Illustration for a
Children's Book)
Reproduction of photograph by
Rodchenko and V. Stepanova
40 x 30 cm. (15¾ x 11¾ in.)
Colin Osman (Creative Camera),
London

320.
Materializatsiia fantastiki
(Materialization of Fantasy)
Moscow/Leningrad, 1927
32 pp. with photomontage cover
design by Rodchenko
Ex Libris 6, no. 58
17.3 x 13.7 cm. (6¾ x 5⅜ in.)
Collection Martin-Malburet

321.
Novyi lef (New Left) ed. V.
Maiakovsky (1927) and S. Tretiakov
(1928)
Moscow, 1928, nos. 1, 2
Journal with photomontage and
typographical design by
Rodchenko
Ex Libris 6, no. 209
22.5 x 15.2 cm. (8⅞ x 6 in.)
Alma H. Law

322.
Costume for the Zoo Director,
"The Bed Bug," 1929
Watercolor and pencil on paper
32.7 x 24.8 cm. (12⅞ x 9¾ in.)
Mississippi Museum of Art,
Jackson, The Lobanov Collection

323.
Costume for the Meeting
Manager, "The Bed Bug," 1929
Collage, india ink, and pencil
on paper
33 x 24.1 cm. (13 x 9½ in.)
Mississippi Museum of Art,
Jackson, The Lobanov Collection

Bibliography

Alexander Rodchenko, exh. cat.,
Museum of Modern Art, Oxford,
1979.

G. Karginov, *Rodcsenko,*
Budapest, 1975; French trans.
Rodtchenko, Paris, 1977; English
trans. *Rodchenko,* London, 1979.

Rodtschenko. Fotografien 1920–
1938, exh. cat., Museum Ludwig,
Cologne, 1978.

"What's up?"

"Tomorrow's the 1st of May. The club has to be deco-
rated. It was resolved to put aside 200 rubles for decorat-
ing the club, and we've already got the slogans ready and
bought the material, pine-wood..."

A month goes by and it's the same thing.

"Tomorrow's Aviation Chemistry Day...200 rubles—
decorate...pine-wood...etc.

But the club has dirty walls, has torn furniture, its
clock is broken, etc.

Dear Comrades, wouldn't it be better to purchase a
dozen chairs for the 1st of May "in the name of the 1st of
May?"

Or to whitewash the walls for Aviation Chemistry
Day?...

Visiting foreigners, critics, and artists often visit us
Lef people to see us at work. They're delighted, but
astonished—why hasn't all this been printed, published,
exhibited?

We say nothing....

Because our critics and art high-ups also go around
astonished—and from over there in the West write back
reams to the USSR.

Such a lot of interesting things in the West. In the
USSR...foreigners are printed, published, exhibited.

Each day this entire summer, in all the newspapers
and magazines, Kogan and Lunacharsky have been writ-
ing on and on about the West and nothing else. Probably
wrote themselves out.

But we don't say anything.

It wouldn't hurt for the Union of Art Workers to say
something.

We've been quiet for long enough.

Translated from the Russian by John E. Bowlt

319

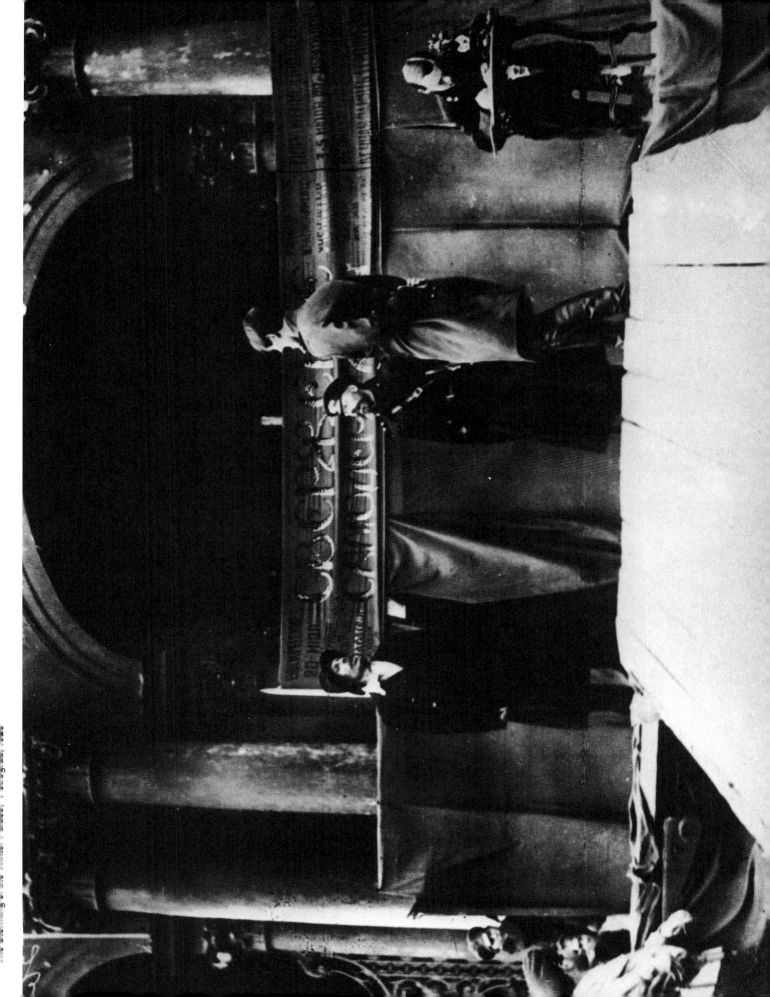

Rozanova, Olga Vladimirovna
Born 1886 Vladimir Province; died 1918.

324.
Soiuz Molodezhi (The Union of Youth) contributions by D. and N. Burliuk, E. Guro, A. Kruchenykh, V. Khlebnikov, B. Livshits, and others
St. Petersburg, 1912, no. 2; 1913, no. 3
Magazine with illustrations by Rozanova and I. Shkolnik
No. 2: 24.4 x 16.2 cm. (9⅝ x 6⅜ in.)
No. 3: 24 x 24 cm. (9½ x 9½ in.)
Ex Libris 6, no. 241
Australian National Gallery, Canberra

325.
Port, 1912
Oil on canvas
100.3 x 79.2 cm. (39½ x 31¼ in.)
Leonard Hutton Galleries, New York

326.
Bukh lesinnyi (A Forestly Rapid) by A. Kruchenykh and V. Khlebnikov
St. Petersburg, 1913
21 pp. with lithographs by Rozanova and N. Kulbin
Ex Libris 6, no. 135
14.8 x 9.7 cm. (5¾ x 3¾ in.)
Mr. Alexander Rabinovich

327.
Dissonance (Directional Lines), 1913
Oil on canvas
104.1 x 81.9 cm. (41 x 32¼ in.)
Private collection

328.
Man on the Street, 1913
Oil on canvas
83 x 61.5 cm. (32⅝ x 24¼ in.)
Thyssen-Bornemisza Collection, Lugano, Switzerland

329.
Utinoe gnezdyshko durnykh slov (A Duck's Nest of Bad Words) by A. Kruchenykh
St. Petersburg, 1913 (incomplete text)
Book with handcolored lithographs by Rozanova
18 x 12.3 cm. (7⅛ x 4⅞ in.)
Australian National Gallery, Canberra

1904–10 attended the Bolshaov Art College and the Stroganov Art School in Moscow; 1911 in St. Petersburg; made contact with the Union of Youth group, including Vladimir Markov (Waldemars Matvejs) and Matiushin; 1912–13 attended Zvantseva's Art School; 1911–17 contributed to the Union of Youth exhibitions, *Tramway V, 0–10, Jack of Diamonds,* and other exhibitions; 1912 onward illustrated Futurist booklets such as Kruchenykh's *Te li le* (1914), *Zaumnaia gniga (Transrational Book,* 1915), *Balos* (1917), and most importantly the famous albums *Voina* (War, 1916) and *Vselenskaia voina (The Universal War,* 1916); married Kruchenykh; 1916 arrived at Suprematism after Cubist and Futurist experiments; with Malevich, Matiushin, Popova, the composer Nikolai Roslavets, and others worked on the first numbers of the projected journal *Supremus* (not published); 1918 member of IZO NKP and of Proletcult; with Rodchenko was in charge of the Art-Industry Subsection of IZO: helped to organize Svomas in several provincial towns; 1919 posthumous exhibition in Moscow; 1922 represented at the *Erste Russische Kunstausstellung.*

325

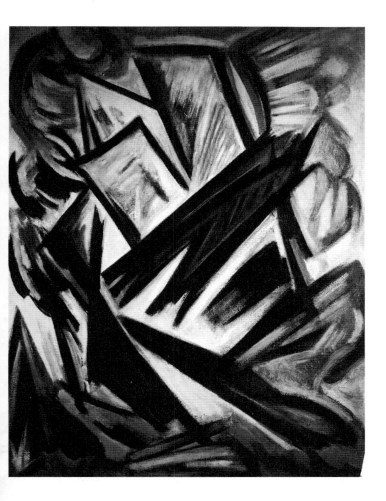

327

328

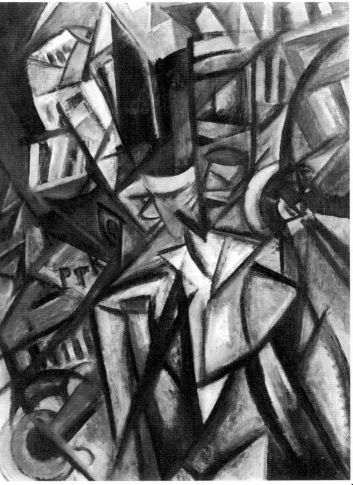

▶

330.

Te li le by A. Kruchenykh
Petrograd, 1914
17 pp. printed in color with
illustrations by Rozanova and
N. Kulbin
24 x 17 cm. (9½ x 6¾ in.)
Alexandre Polonski

331.

T-Geometric Composition, 1915
Collage on paper
22 x 33 cm. (8⅝ x 13 in.)
The George Costakis Collection

332.

The Universal War, 1916, by
A. Kruchenykh
Booklet
22.5 x 32.5 cm. (8⅞ x 12¾ in.)
Collection Mr. and Mrs. Edgar H.
Brunner, Bern, Switzerland

333a.–l.

The Universal War, 1916
12 collages
22.9 x 33 cm. (9 x 13 in.) each
Collection Mr. and Mrs. Edgar H.
Brunner, Bern, Switzerland

334.

The Universal War, 1916
Collage (cover)
31.1 x 19.7 cm. (12¼ x 7¾ in.)
La Boetie, Inc., New York

335.

**Color Construction, Green on
White,** 1917
Oil on canvas
61 x 48.3 cm. (24 x 19 in.)
The George Costakis Collection

336.

1918 god. (The Year 1918) by
V. Kamensky, A. Kruchenykh,
K. Zdanevich
Tiflis, 1917
Book collages and lithographs
26.5 x 35 cm.
Alexandre Polonski

337.

Zaumniki (Transrationals) by
V. Khlebnikov
Book with one collage by Olga
Rozanova
21.5 x 15 cm. (8½ x 5⅞ in.)
Ex Libris 6, no. 134
a) Alexandre Polonski
b) Collection Martin-Malburet

■ Rozanova's wide range of interests—painting, poetry, public speaking, industrial design—typifies the Russian avant-garde. In 1911 she became an active member of the Union of Youth, an organization that sponsored two exhibitions per year as well as numerous public lectures and discussions. She contributed illustrations to the group's publication, *Soiuz Molodezhi* (1912). She participated in almost every major exhibition in Russia during this period, and was an ardent speaker in pre-War public discussions. She was among the first of her colleagues to become associated with the Futurist movement, both as a painter and a poet. *Port* (1912) and *Man on the Street* (1913), with their dynamic composition, are exemplary of this early Futurist phase, which reflects the influence of the Italian Futurists more than the French Cubists.

A close collaboration between poets and painters marked the Futurist movement in Russia; Rozanova's association with the leading poets of the period (Khlebnikov, Kulbin, Kruchenykh) resulted in pioneering advances in book design. *Te li le* (c. 1914) represents Rozanova's attempt to interlace verbal and pictorial elements. By using her own handwriting for the text, Rozanova not only fused the words with the design, but she also presented the text in a manner intended to convey mood and emotion. Rozanova continued to work in book design, especially in collaboration with Kruchenykh, whom she married in 1916. The two artists produced several books together, including *Bukh lesinnyi (A Forestly Rapid,* 1913), *Utinoe gnezdyshko durnykh slov (A Duck's Nest of Bad Words,* 1913), and *Zaumnaia gniga (Transrational "Book,"* 1916)—the title of the last incorporates a deliberate misspelling of the word for book *(Kniga)*

as a reference to something rotten *(Gniga).*

The culmination of the artistic union of Rozanova an Kruchenykh was reached with *The Universal War,* 1916 By this date Rozanova had arrived at pure non-objectiv painting independently of Malevich, through an explora tion of Kruchenykh's concept of "transrational" language in which the sound of a word is divorced from its contex tual meaning. *The Universal War* is a book whose them is the prediction of a war in 1985; it was inspired b Khlebnikov's theory that the periodicity of history could b calculated by mathematical speculation. Kruchenyk wrote twelve titles with poems consisting of columns c words, as well as a preface that stresses the historica importance of Rozanova's experiments in non-objectiv art. The twelve collages that comprise *The Universal Wa* are considered to be one of the heights of this first phas of non-objective art in Russia. It is difficult to attribute th collages solely to Rozanova, because of her close rela tionship with Kruchenykh. It has been proposed tha Rozanova designed the works, and that Kruchenykh exe cuted some of the pieces. One hundred copies of *Th Universal War* were made by hand, each copy differin slightly. The collages combine fabrics and translucen papers on a dark blue ground. *The Universal War* mark Russian Futurism's clearest crystallization and its evo lutionary climax—from Impressionism through Primi tivism and finally to abstraction.

After the Revolution, Rozanova devoted herse to the reorganization of the industrial arts in Russia, bu she did not live to see any of her plans realized. She died suddenly and prematurely of diphtheria in No vember, 1918.

333

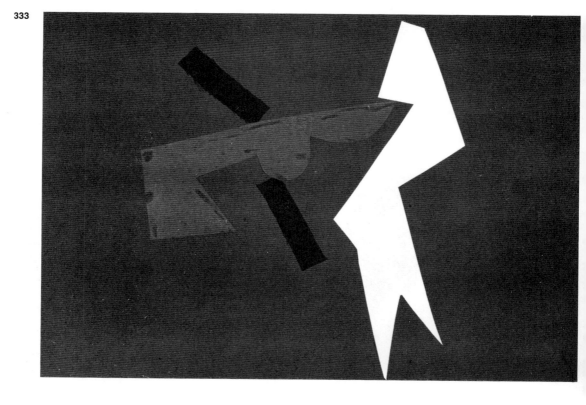

334

■ Only the absence of honesty and of true love of art provides some artists with the effrontery to live on stale tins of artistic economics stocked up for years, and year in, year out, until they are fifty, to mutter about what they had first started to talk about when they were twenty.

Each moment of the present is dissimilar to a moment of the past, and moments of the future will contain inexhaustible possibilities and new revelations!

How can one explain the premature spiritual death of the artists of the Old Art, if not by laziness?

They end their days as innovators before they are barely thirty, and then turn to rehashing.

There is nothing more awful in the World than repetition, uniformity.

Uniformity is the apotheosis of banality.

There is nothing more awful in the World than an artist's immutable Face, by which his friends and old buyers recognize him at exhibitions—this accursed mask that shuts off his view of the future, this contemptible hide in which are arrayed all the "venerable" tradesmen of art clinging to their material security!

There is nothing more terrible than this immutability when it is not the imprint of the elemental force of individuality, but merely the tested guarantee of a steady market!

It is high time that we put an end to the debauch of critics' ribaldry and confessed honestly that only Union of Youth exhibitions are the pledge of art's renewal. Contempt should be cast on those who hold dear only peaceful sleep and relapses into past experience.

Olga Rozanova, "Osnovy novogo tvorchestva i princhiny ego neponimaniia," *Soiuz molodezhi*, St. Petersburg, March 1913, pp. 20–21; trans. John E. Bowlt, *Russian Art of the Avant-Garde: Theory and Criticism 1902–1934*, New York, 1976, pp. 108–9.

Bibliography

A. Efros. "O. Rozanova," *Profili*, Moscow, 1930, pp. 228–29. This first appeared as an obituary to Rozanova: "Vo sled ukhodiash-chim," *Moskva. Zhurnal literatury i iskusstva*, Moscow, no. 3, 1919, pp. 4–6.

Posmertnaia vystavka kartin, etiudov i risunkov O. V. Rozanovoi, exh. cat., Moscow, 1919.

Ivan Kliun, "Olga Rozanova (1918)," *Women Artists of the Russian Avant-Garde 1910–1930*, exh. cat. in German and English, Galerie Gmurzynska, Cologne, 1979, pp. 218–19.

Hubertus Gassner, "Olga Rozanova," ibid., pp. 230–35.

Olga Rozanova, "Suprematism and the Critics (1918)," ibid., pp. 245–46.

Vasilii Rakitin, "Illusionism Is the Apotheosis of Vulgarity," ibid., pp. 251–56.

335

Stenberg, Georgii Avgustovich
Born 1900 Moscow; died 1933 Moscow.

Stenberg, Vladimir Avgustovich
Born 1899 Moscow; lives in Moscow.

**338.
KPS 11**
1975 reconstruction of 1919–21
original
Wood, iron, and glass
82 x 28 x 41.3 cm. (32¼ x 11 x
16¼ in.); base: 155 x 46.4 x 84.5
(61 x 18½ x 33½ in.)
Galerie Jean Chauvelin, Paris

**339.
KPS 13**
1974 reconstruction of 1919
original
Wood, iron, and steel
224 x 71 x 133 cm. (94⅞ x 28¾ x
44⅞ in.) with base
Galerie Jean Chauvelin, Paris

**340.
Headgear for a Costume Design
in "Phèdre,"** 1923
Pencil on paper
40.6 x 20.3 cm. (16 x 8 in.)
Mississippi Museum of Art,
Jackson, The Lobanov Collection

**341.
Imazhisty: Mariengof, Ivnev,
Roizman, Shershenevich
(Imagists)**
Moscow, 1925
Color lithographs by G. and
Vladimir Stenberg
22.5 x 18.5 cm. (8⅞ x 7¼ in.)
Collection Martin-Malburet

**342.
Kto, chto, kogda v Moskovskom
Kamernom teatre (Who, What,
When at the Moscow Kamerny
Theater)**
Moscow, 1924
40 pp.
Ex Libris 7, no. 295
34.9 x 16.4 cm. (13¾ x 10⅜ in.)
Mr. and Mrs. H. C. Levy

**343.
Kamernyi Teatr (Kamerny
Theater)** by I. Apushkin
Moscow-Leningrad, 1927
64 pp. with color lithographs by
G. and Vladimir Stenberg
Ex Libris 6, no. 96
17.8 x 13.3 cm. (7 x 5¼ in.)
Alma H. Law

1912–17 studied at the Stroganov Art School, Moscow; 1917–20 at Svomas, where they were enrolled in the so-called Studio Without a Supervisor; together with Nikolai Denisovsky, Vasilii Komardenkov, Konstantin Medunetsky, Nikolai Prusakov, and Sergei Svetlov they were among the first Svomas graduates; 1918 contributed to the May Day agit-decorations in Moscow, working on designs for the Napoleon cinema and the Railroad Workers' Club; also worked on agit-decorations for the first anniversary of the October Revolution; 1919–21 members of Obmokhu; 1920 members of Inkhuk; with Medunetsky organized an exhibition of constructions there; 1921 with Alexei Gan, Rodchenko, Stepanova, and others opposed the *veshch* (object) group at Inkhuk, rejecting "pure art" for industrial Constructivism; 1922 contributed to the *Erste Russische Kunstausstellung* in Berlin (Vladimir only); 1923 began to work on film posters; with Exter, Ignatii Nivinsky, Vera Mukhina, and others worked on the design and decoration for the *First Agricultural and Handicraft-Industrial Exhibition* in Moscow; 1923–25 closely associated with *Lef;* 1924 with Medunetsky contributed under the title of "Constructivists" to the *First Discussional Exhibition of Associations of Active Revolutionary Art* in Moscow; 1924–31 worked on many sets and costumes for Alexander Tairov's Chamber Theatre, including productions of Ostrovsky's *Groza (Storm),* Shaw's *Saint Joan,* and Brecht's *Beggars' Opera*; 1925 contributed to the *Exposition Internationale des Arts Décoratifs et Industriels* in Paris, where they received a Gold Medal; thereafter contributed stage designs and film posters to many exhibitions at home and abroad; 1929–32 taught at the Architecture-Construction Institute, Moscow; after Georgii's death, Vladimir continued to work on poster design.

Georgii Stenberg was born of a Russian mother and a Swedish father. Although the senior Stenberg returned to Sweden in 1921, both Georgii and his brother Vladimir remained in Russia as Swedish citizens. Each year they received an extension of residency in the Soviet Union until finally taking Soviet citizenship in 1933.

The young Georgii Stenberg received his earliest art training at the arts and crafts oriented Stroganov School in Moscow. After the Revolution, this traditional school combined with the old Moscow Institute of Fine Arts to become Svomas (Free Art Studios) and then, in 1920, Vkhutemas (Higher State Art-Technical Studios). Out of a Svomas Studio Without a Supervisor, the famous Obmokhu group (Association of Young Artists) developed in 1919; Georgii and Vladimir Stenberg were founding members. The Productivist artist-workers of Obmokhu exhibited four times between 1919 and 1923. In 1921 the Stenbergs, joined by Konstantin Medunetzky, held the first "Constructivist" exhibition of non-objective structures. Such "laboratory" researches, preparatory studies for the production of utilitarian objects, were shown also at Obmokhu's third exhibition of 1921.

An important series of three-dimensional constructions made by the Stenbergs between 1919 and 1921 were called "Construction of Spatial Apparatus" *(Kostruktsiia prostannogo sooruzheniia),* or simply "KPS." The use of the term "apparatus" implies that a KPS, no matter how "purely" non-objective, was designed for a particular use—or, more exactly, provided the experimental, conceptual basis of a potentially utilitarian structure. Georgii Stenberg's *KSP 11* and *KPS 13* both evolve from a skeletal "drawing" in space based upon the intersection of clearly defined angles. This linear structure—which, in effect, subverts the traditional distinction between the object and its pedestal/base—is expanded in the top portion of the structures; with carefully balanced planes of iron and glass, Stenberg investigates the interaction of stable and dynamic forms in space. Georgii Stenberg's KPS constructions focused on exploiting the technologically new and traditionally ignoble media of glass and iron for their visual, textural, and symbolic meaning; further, the elements of the "apparatus" were bolted and welded in the revolutionary "assemblage" technique expressive of a utopian, technological society.

The Stenberg brothers, like many Productivist artists in the 1920s, worked prolifically in poster design and book illustration, as well as in the theater for both Meierkhold and Tairov. Georgii Stenberg's *Headgear for a Costume Design for "Phèdra"* (1923) was for Tairov's Moscow Kamerny Theater production of Racine's play. The actors performed like living sculptures in an awesome Cubist-derived set by Alexandr Vesnin.

Often working together, Georgii and Vladimir Stenberg collaborated on the cover design and numerous illustrations for *Who, What, When at the Moscow Kamerny Theater (Kto, chto, kogda v Moskovskom Kamernon teatre)* in 1924, a book dedicated to Tairov and to the theater's activities from 1911 to 1924. The Stenbergs' geometricized four-color lithographic covers, for *The Kamerny Theater (Kamernyi Theatr)* in 1927, enhance the text's discussion of Tairov's innovative and popular theater. Georgii Stenberg died in 1933. Through consultation with Vladimir, the reconstructions of Georgii Stenberg's *KPS 11* and *KPS 13* were made possible.

339

Stenberg, Vladimir

344.

**The Moscow Kamerny Theater:
Guest Performances in the
German Theater, Berlin
(Moskauer Kamerny Theater:
Gastspiel im Deutschen Theater,
Berlin)**
ed. E. Angel
Potsdam, c. 1923
color lithograph (cover)
24.2 x 17.8 cm. (9½ x 7 in.)
Mr. and Mrs. H. C. Levy

338

345.

Drawing, 1973
(Design for KPS IV and VI)
Pen and ink on paper
48 x 65 cm. (23¼ x 26¼ in.)
Galerie Jean Chauvelin, Paris

345

Bibliography

Y. Gerchuk, "Klassiki plakatnogo
iskusstva," *Dekorativnoe iskusstvo,*
Moscow, no. 11, 1972, pp. 22–23.

2 Stenberg 2, exh. cat., Galerie
Jean Chauvelin, Paris, and
elsewhere, 1975.

Obmokhu exhibition, Moscow, 1921

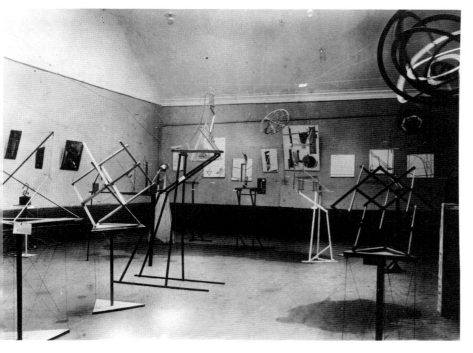

■ In 1919 Vladimir Stenberg joined his brother Georgii
Stenberg and ten other artists to form the Obmokhu (Association of Young Artists). The group's first exhibition,
held in May 1919 at the old Stroganov School, declared a
utilitarian bias for the "real" art of stage and urban decoration, and focused especially on poster propaganda. The
young revolutionary artists embraced a democratic
anonymity and refused to sign their works.

The second Obmokhu exhibition was held at its own
premises in an old Fabergé shop obtained by Commissar
Lunacharsky. This show of May 1920 established the philosophical difference between a Productivist "real" object
and a "pure" object of the so-called "laboratory" stage of
production. Such laboratory experiments were not considered elitist sculpture or easel painting: they were
studies in non-objective form preparatory to producing the
utilitarian object. Vladimir and Georgii Stenberg, joined
by Konstantin Medunetzky, not only exhibited their researches at Obmokhu, but in January 1921 held a separate showing of sixty-one constructions. The catalog used
the term "Constructivist" for the first time in the context
of an exhibition of constructed, non-objective forms. Although dedicated to experiments in non-objective form,
the Stenbergs adopted an anti-art and anti-beauty posture: "art and its priests" were proclaimed outlaws. For
Constructivists, experimental art was allied with experimental science; both were considered a means of
knowledge.

Following the independent Constructivist showing,
the Stenbergs exhibited again at the third Obmokhu exhibition of May 1921. The installation, photographed by
Rodchenko, shows floor constructions by the Stenbergs,
Medunetsky, and Ioganson; hanging constructions by
Rodchenko; and two-dimensional projects by the Stenbergs. A fourth Obmokhu exhibition was held in 1923. Although the group's activities after 1921 remain obscure,
Obmokhu's principles were discussed in art journals and
later became known in Germany at the Bauhaus.

Vladimir Stenberg's 1973 *Drawing* recreates the
design-projects for his *KPS 4* and *KPS 6.* Like Georgii
Stenberg's *KPS 11* and *KPS 13,* the two KPS constructions by Vladimir Stenberg dematerialize traditional
sculpture's mass and volume. Unlike Georgii Stenberg's
"apparatus," Vladimir Stenberg's constructions eschew
the use of glass in favor of developing structural/
functional tensions based on a series of diagonal thrusts.
KPS 4 investigates the tensile strength of iron by focusing
on a curvilinear motif; *KPS 6* deals with a "floating"
superstructure cantilevered into space.

The Stenberg's interest in spatial construction found
a natural outlet in the theater. Vladimir Stenberg joined his
fellow Constructivist Konstantin Medunetsky in designing
the set of Ostrovsky's *The Thunderstorm.* He collaborated
with his brother on illustrations for many books, as well
as designing a color lithograph cover for *The Moscow
Kamerny Theater: Guest Performances in the German
Theater, Berlin (Moskauer Kamerny Theater: Gastspiel
im Deutschen Theater, Berlin* (1923), a book that makes
evident the success of Tairov's productions in Western
Europe. The greater part of Vladimir Stenberg's career
was occupied with poster design, especially for the
cinema. In 1952 he was arrested during the Stalinist
purges; after Stalin's death he was "rehabilitated" and
freed.

Stepanova, Varvara Fedorvna
(pseudonyms: Agrarykh, Varst)

Born 1894 Kovno; died 1958 Moscow.

346a.–p.
Untitled: Illustrations from the
Book "Gaust Tschaba," 1919
16 collages on newsprint
17.5 x 27.5 cm. (6⅞ x 10⅞ in.) each
Museum Ludwig, Cologne,
West Germany

347.
5 x 5 = 25 Exhibition Catalog,
1921
Catalog with five original works by
A. Exter, L. Popova, A. Rodchenko,
V. Stepanova, and A. Vesnin
Brush and ink, watercolor, oil, and
gouache
17.5 x 14 cm. (6⅞ x 5½ in.)
Collection, The Museum of Modern
Art, New York, Gift of Mrs. Alfred
H. Barr, Jr.
240.76.1–6.

348.
Poster for "Tarelkin's Death,"
1922
Lithograph
70.5 x 106 cm. (27¾ x 42 in.)
Mississippi Museum of Art,
Jackson, The Lobanov Collection

349.
Upper Half, Poster for "Tarelkin's
Death," 1922
Lithograph
72.4 x 106.7 cm. (28½ x 42 in.)
Mississippi Museum of Art,
Jackson, The Lobanov Collection

350.
Costume for a Man, "Tarelkin's
Death," 1922
Ink and pencil on paper
35.6 x 22.9 cm. (14 x 9 in.)
Mississippi Museum of Art,
Jackson, The Lobanov Collection

351.
Costume Design of a Military
Costume for Rasimov, "Tarelkin's
Death," 1922
Ink and pencil on paper
35.6 x 22.2 cm. (14 x 8¾ in.)
Mississippi Museum of Art,
Jackson, The Lobanov Collection

1911 studied at Kazan Art School, where she met Rodchenko; 1912 moved to Moscow; studied under Ilia Mashkov and Konstantin Yuon; 1913–14 attended the Stroganov Art School; gave private lessons; 1914 contributed to the Moscow Salon; 1918 onward closely involved with IZO NKP; represented at many exhibitions into the 1920s at home and abroad, including the *Fifth* and *Tenth State Exhibitions* (1918, 1919), the *Exposition Internationale des Arts Décoratifs et Industriels* in Paris (1925) and *Russian Xylography of the Past Ten Years* in Leningrad (1927); 1920 member of Inkhuk; 1921 contributed to *5 x 5 = 25*; 1922 designed sets and costumes for Meierkhold's production of *Tarelkin's Death*; represented at the *Erste Russische Kunstausstellung* in Berlin; 1923 with Popova, Rodchenko, and others worked at the First State Textile Factory, Moscow, as a designer; 1923–28 closely associated with *Lef* and *Novyi lef*; 1924–25 professor in the Textile Department at Vkhutemas; mid-1920s onward worked mainly on typography, posters, and stage designs; 1930s worked on the propaganda magazine *USSR in Construction*.

346

Varvara Stepanova reached stylistic maturity in post-Revolutionary Russia. Her emergence in the avant-garde took place in the context of a gradual disenchantment with the Suprematist aesthetic and the ascendancy of a Constructivist ideal.

Stepanova was closely associated with IZO NKP (The Department of Fine Arts under the Commissariat for People's Education) from its inception in 1918. IZO was the government agency responsible for organizing and running the artistic life of the entire country and, as such, was the scene of intense debates and proclamations regarding the establishment of a proletarian art. Stepanova's work in book design during this early period still shows more indebtedness to the Futurists than to the emerging Constructivists. *Gaust Tschaba* (1919) is a handmade book comprised of collages on newsprint. The title and text are "transrational," as is the overall conception; the nonsensical text is written out by hand, alogically placed against a typeset, intelligible background of newspaper.

By 1920 Sepanova was affiliated with Inkhuk, and actively engaged in the concept of "laboratory art," a rationalizing, analytical attitude toward art that led away from easel painting and toward "production art." The group exhibition in 1921 called *5 x 5 = 25* marks the last moment for pure easel painting.

Stepanova, her husband Rodchenko, Exter, Popova, and Vesnin each contributed five works to the exhibition, and each contributed an original work to the accompanying catalog. The catalog sums up the previous year's work in "laboratory art," with rationalized description of the paintings listed and with written declarations by each of the artists. Stepanova argued for the primacy of technology and industry and wrote, "The sanctity of a work as a single entity is destroyed."

One of Stepanova's most notable projects was the unequivocally Constructivist theatrical production of *Tarelkin's Death* in 1922. A bitter satire of tsarist police methods, the play was directed by the well-known Constructivist Meierkhold. His theory of "bio-mechanics" called for actors to dress and function as part of the machinery of stage design. Stepanova designed sets and costumes for the production. Each piece of stage furniture was constructed in such a way that it would jump, collapse, or in some other way respond to the actor's actions. Tremendous acrobatic skills were required of the actors in working with this trick furniture. Not surprisingly, the furniture bears a significant resemblance to her husband Rodchenko's wooden constructions of the same period. The costumes, made of striped and patched cotton, were based on two principles: first, they were designed to underscore the movements of the body, and second, to create prototypes for sports costumes and work uniforms.

Stepanova became increasingly committed to the Constructivist aesthetic and was associated closely with the Constructivist journal *Lef*. Stepanova's work in fabric design at the First State Textile Factory (Moscow, 1923) represents an attempt to devote herself to practical, industrial design.

352.
Tarelkin's Death, 1922
Costume for Tarelkin
Reconstruction 1980, model
realized by van Laack according to
original artists' sketches
Cotton, size 8/10
Collection van Laack Company,
West Germany

353.
Tarelkin's Death, 1922
Costume for Rasplyuev
Reconstruction 1980, model
realized by van Laack according to
original artists' sketches
Cotton, size 8/10
Collection van Laack Company,
West Germany

354.
Tarelkin's Death, 1922
Two costumes for Mrs. Bran-
dakhlystova's children
Reconstruction 1980, model
realized by van Laack according to
original artists' sketches
Cotton, size 8/10
Collection van Laack Company,
West Germany

355.
Tarelkin's Death, 1922
Costume for Washerwoman
Reconstruction 1980, model
realized by van Laack according to
original artists' sketches
Cotton, size 8/10
Collection van Laack Company,
West Germany

356.
Tarelkin's Death, 1922
Costume for Doctor
Reconstruction 1980, model
realized by van Laack according to
original artists' sketches
Cotton, size 8/10
Collection van Laack Company,
West Germany

357.
Tarelkin's Death, 1922
Costume for Policeman
Reconstruction 1980, model
realized by van Laack according to
original artists' sketches
Cotton, size 8/10
Collection van Laack Company,
West Germany

▶

358.

Tarelkin's Death, 1922

1980 reconstructions of trick furniture by Douglas Reed, assisted by Ah Sim Lee, under the supervision of Paul Lubowicki
9 painted plywood pieces
Platform: 2.4 x 17.2 m. (8 x 56½ ft.)
Los Angeles County Museum of Art

359.

Textile design, c. 1922

Reconstruction 1979, model realized by van Laack according to original artists' sketches
Silk wool, size 8/10
Collection van Laack Company, West Germany

Bibliography

R. Antonov, "K 80-letiu Varvary Stepanovoi," *Dekorativnoe iskusstvo,* Moscow, no. 7, 1975, pp. 44–45.

T. Strizhenova, *Iz istorii sovetskogo kostiuma,* Moscow, 1972, pp. 82ff.

Varvara Stepanova, "Non-objective Creation (1919)," *Women Artists of the Russian Avant-Garde 1910–1930,* exh. cat. in German and English, Galerie Gmurzynska, Cologne, 1979, pp. 272, 276.

■ Fashion, which used to be the psychological reflection of everyday life, of customs and aesthetic taste, is now being replaced by a form of dress designed for use in various forms of labor, for a particular activity in society. This form of dress can only be *shown during the process of work.* Outside of practical life it does not represent a self-sufficient value or a particular kind of "work of art."

The most important aspect of this dress is its cut (the way the fabric has been shaped), i.e., the actual *execution* of the dress. It's not enough to provide the design for a comfortable dress with a clever resolution—you must *make* it and reveal it at work. Only then will we see it and understand its intention.

Store windows with their dresses exhibited on wax mannequins are becoming an aesthetic leftover from the past. Today's dress must be seen in action—beyond this there is no dress, just as the machine cannot be conceived outside the work it is supposed to be doing.

The entire decorative and ornamental aspect of the dress is now destroyed by the slogan *"comfort and expediency of dress for the specific industrial function..."*

In organizing the dress for today, one has to proceed *from the task itself to its material formulation,* from the characteristics of the work for which it is intended to the way it's cut.

Aesthetic aspects must be replaced by the actual process of sewing. Let me explain: don't stick ornaments onto the dress, the seams themselves—which are essential to the cut—give the dress form. Expose the ways in which the dress is sewn, its fasteners, etc., just as such things are clearly visible in a machine....

Varst, "Kostium segodniashnego dnia—prozodezhda," *Lef,* Moscow, no. 2, 1923, p. 65. Translated from the Russian by John E. Bowlt.

Photograph of performance *Tarelkin's Death,* 1922
Sets and costumes by Stepanova

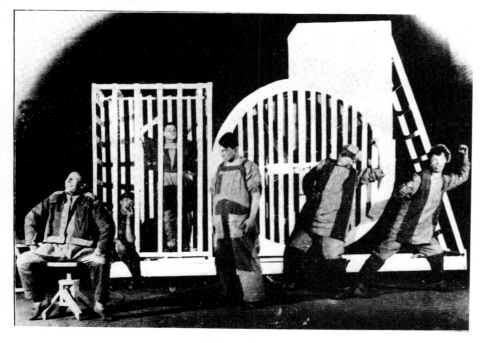

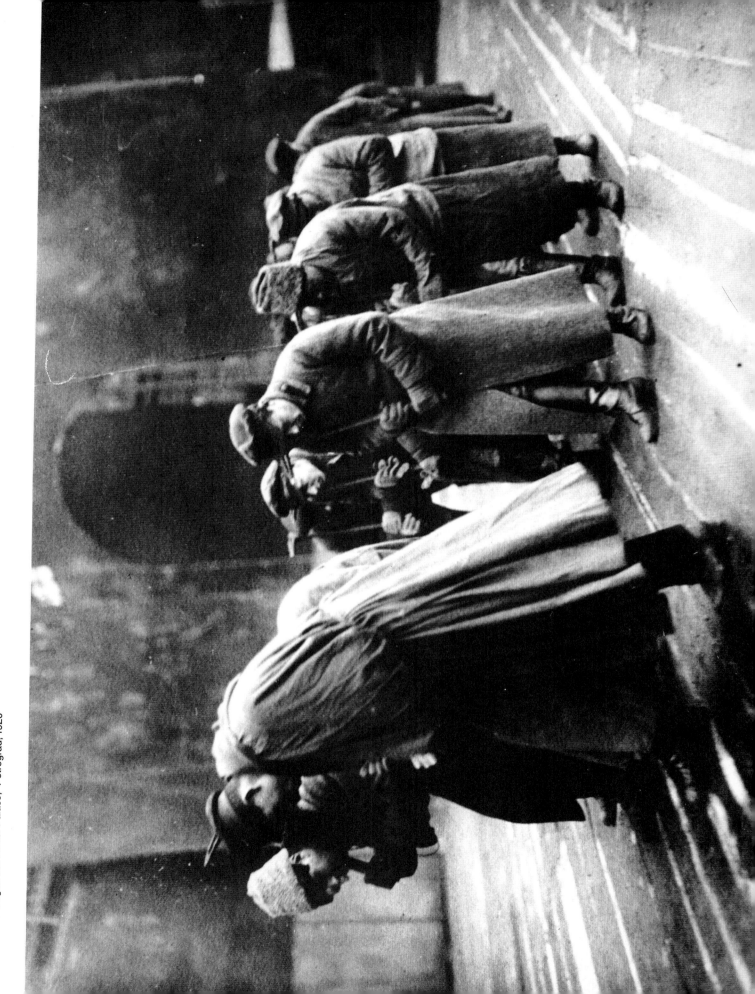

"The Storming of the Winter Palace," Petrograd, 1920

Suetin, Nikolai Mikhailovich

Born 1897 Metlevsk Station, Kaluga region; died 1954 Leningrad.

360.
Untitled, c. 1922
Mixed media on paper
32 x 20.5 cm. (12⅝ x 8⅛ in.)
Galerie Gmurzynska, Cologne,
West Germany

361.
Plate, 1922–23
Porcelain
diam: approx. 30 cm. (7⅞ in.)
Robert Shapazian Inc.

362.
Cup and Saucer, 1923–28
Porcelain
cup: 5.7 x 8.2 cm. (2¼ x 3¼ in.)
saucer diam: 14.7 cm. (5¾ in.)
Robert Shapazian Inc.

Bibliography

I. Riazantsev, *Iskusstvo sovetskogo vystavochnogo ansamblia 1917–1970,* Moscow, 1976, p. 353, and elsewhere.

L. Zhadova, "O farfore N. M. Suetina," ed. K. Rozhdestvensky et al., *Sovetskoe dekorativnoe iskusstvo 73/74,* Moscow, 1975, p. 211.

L. Zhadova, "Blokadnaia grafika N. M. Suetina" ed. M. Nemirovskaia, *Sovetskaia grafika 74,* Moscow, 1976, pp. 185–90.

With Ilia Chashnik was one of Malevich's closest collaborators; 1918–22 studied at the Vitebsk Art School; 1919 onward was a member of Posnovis/Unovis in Vitebsk; 1922 with Chashnik, Ermolaeva, Malevich, Lev Yudin and others moved to Petrograd and entered the Inkhuk affiliation there, where he assisted Malevich with the architectural constructions *arkhitektony* and *planity*; during the 1920s and 1930s decorated many porcelain pieces, including tea services, at first with Suprematist designs; 1928 with Anna Leporskaia worked on the interior design of the exhibition *The Construction of the NKVD House* in Leningrad; 1930 contributed to the *First All-City Exhibition of Visual Arts* at the Academy of Arts, Leningrad; 1932 appointed Artistic Director of the Lomonosov Porcelain Factory, Leningrad; contributed to the jubilee exhibition *Artists of the RSFSR During the Last 15 Years* at the Academy of Arts, Leningrad; during the 1930s was represented at several exhibitions abroad, including the international exhibition in Paris, 1937, for which he helped to design the Soviet pavilion.

As a student in post-Revolutionary Russia, Suetin's earliest development occurred within the climate of the avant-garde. Suetin studied under Malevich at the Vitebsk Art School from 1918 to 1922. This association with the Suprematist aesthetic had immeasurable impact on the young artist and was to preoccupy him for his entire career.

Suetin is known for applying Suprematist forms to functional objects. Malevich was interested in a conceptual framework for designing functional objects, but he left the actual execution of such work to his followers, particularly Suetin and Chashnik. Suetin concentrated on porcelain design; he decorated cups, saucers, and plates with highly colored, asymmetrical designs. This affinity for working in porcelain eventually led to Suetin's appointment as artistic director of the Lomonosov Porcelain Factory in Leningrad in 1932.

Suetin's oeuvre was not confined simply to porcelain design, but extended to architectural design and theoretical writing. His work in architectural design was produced at Inkhuk (Institute of Artistic Culture) in Petrograd, where he moved with Malevich and many of the leading Suprematists in 1922. As Malevich's assistant, Suetin became involved with "architectons," idealized architectural studies that were never realized in more than model format. Suetin also worked in Inkhuk's theoretical section; his writings of this period tend towards a poetization of Suprematism, exploring its sensual possibilities. On a drawing from the 1920s we read, "before seeing you must feel," while in other works of the period he tried to know (and render plastically) the "relations of the temperature of the planes."

In 1935 Suetin was responsible for organizing what might be considered the last Suprematist performance: he painted the Suprematist coffin and arranged the funeral for his mentor, Kazimir Malevich.

361

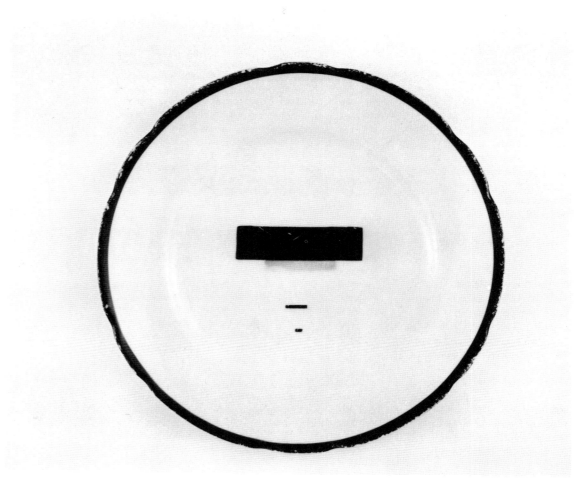

362

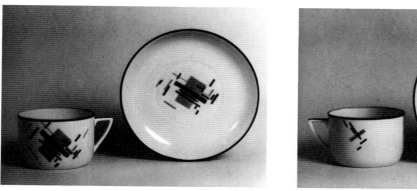

Tatlin, Vladimir Evgrafovich

Born 1885 Moscow; died 1953 Moscow.

363.

Study for Counter-Relief, 1914
Gouache and charcoal on paper
49.4 x 34.2 cm. (19½ x 13½ in.)
Collection, The Museum of Modern
Art, New York, Gift of The Lauder
Foundation

364.

Counter-Relief
1966–70 reconstruction by Martyn
Chalk from photographs of 1915
original
Wood and metal
68.6 x 83.2 x 78.7 cm. (27 x 32¾ x
31 in.)
Annely Juda Fine Art, London

365.

Corner Counter-Relief
1966–70 reconstruction by Martyn
Chalk from photographs of 1915
original
Iron, zinc, aluminum, wood, paint
78.7 x 152.4 x 76.2 cm. (31 x 60 x
30 in.)
Annely Juda Fine Art, London

366.

Vladimir Evgrafovich Tatlin
(Autobiographic Statement)
Petrograd, December 17, 1915
4 pp.
35.5 x 21.6 cm. (14 x 8½ in.)
George Gibian, Ithaca, New York

Tatlin was the son of a railroad engineer who, during the
1890s, had visited the U. S. to study American railroad
engines—the father's profession, undoubtedly, influ-
enced the young Tatlin; 1902 Tatlin became a merchant
seaman, visiting the Mediterranean and the Middle East;
c. 1908 studied at Penza Art School; 1909, prompted by
Larionov, he entered the Moscow Institute of Painting,
Sculpture, and Architecture, where he studied painting
under Konstantin Korovin, Valentin Serov, and others;
1911 contributed to Izdebsky's second Salon in Odessa;
close to Larionov and Goncharova; acquainted with
Malevich; contributed to the Union of Youth exhibition;
executed costume designs for the folk drama *The Em-
peror Maximilian and His Son Adolph* produced in
Moscow; 1912 represented at several exhibitions includ-
ing Larionov's *Donkey's Tail,* the Union of Youth exhibi-
tion, and *Contemporary Painting* in Moscow; his exhibits
were marked by an intense concern with the structure of
the composition and betrayed the influence of the icon
and primitive art forms; 1913 contributed to the *Jack of
Diamonds* exhibitions in Moscow and St. Petersburg;
traveled to Berlin and then to Paris, where he met
Picasso; the reliefs of Picasso impressed him deeply and,
on his return to Moscow, inspired him to begin working
on his own Painterly Reliefs; 1914 close to Alexei
Grishchenko, Morgunov, Popova, Udaltsova, and Alex-
andr Vesnin; continued to work on Painterly and Counter
Reliefs; 1915 contributed seven painterly reliefs to *Tram-
way V;* also represented at the *Exhibition of Painting, 1915;*
1915–16 contributed to *0–10* exhibition; 1916 or-
ganized his own exhibition *The Store* at which Lev Bruni
and Sofia Dymshits-Tolstaia were also represented by
three-dimensional works; 1917 took a minor role in the
interior design of the Café Pittoresque in Moscow (under
the guidance of Georgii Yakulov); 1918 became head of the
Moscow IZO NKP; 1919–20 director of the Painting De-
partment at the Moscow Svomas/Vkhutemas; in Petrograd
worked on his model for the Monument to the Third Interna-
tional; 1921 appointed head of the Department of
Sculpture at the restructured Academy of Arts in Petro-
grad; 1922 exhibited a canvas painted entirely in pink at
the *Union of New Trends in Art* at the Museum of Artistic
Culture in Petrograd; contributed to the *Erste Russische
Kunstausstellung* in Berlin; 1923 organized a production
of Khlebnikov's poem *Zangezi* at the Petrograd Inkhuk;
mid-1920s interested in practical design; entered the
Theater and Cinema Section of NKP in Kiev (until 1927),
then returned to the Moscow Vkhutemas where he
worked in the Woodwork and Metalwork Department;
1929–32 developed his project for a man-propelled
glider; during the 1930s and 1940s worked on several
theatrical designs; returned to figurative painting.

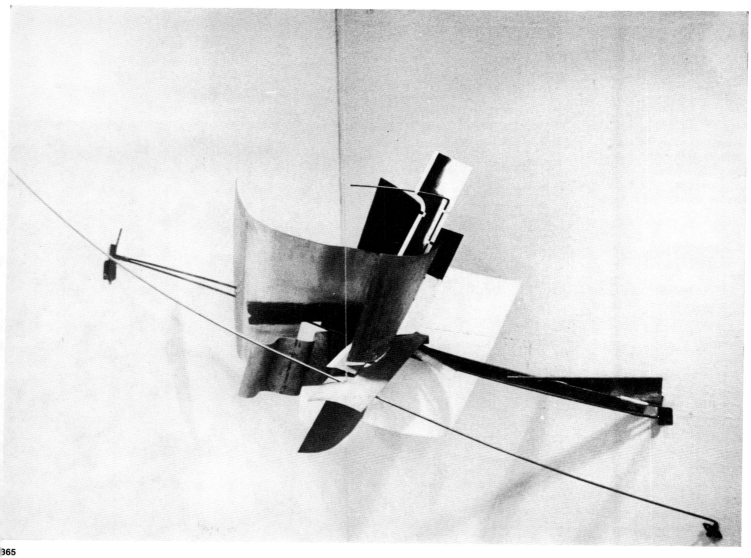

365

363

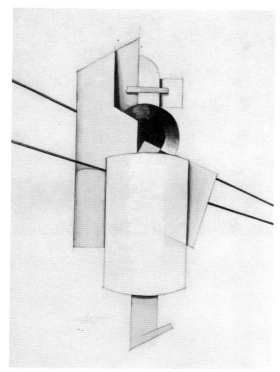

364

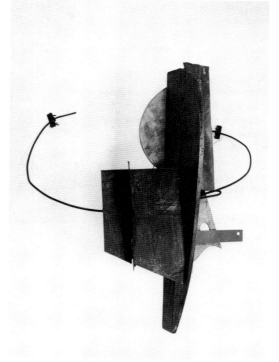

▶

367.
Project for a Construction,
1915–16
Gouache on paper
53 x 41 cm. (20⅞ x 16⅛ in.)
Galerie Jean Chauvelin, Paris

368.
Composition, 1916
Mixed media on wood
52 x 39 cm. (20½ x 15⅜ in.)
Staatliche Museen Preussischer
Kulturbesitz, Nationalgalerie, Berlin

369.
Study for Board No. 1, 1917
Watercolor, metalic paint, gouache,
and pencil on paper
43.9 x 29.6 im. (17¼ x 16j5 in.)
Collection, The Museum of Modern
Art, New York, Gift of The Lauder
Foundation

370.
**Monument to the Third
International**—Project for
Petrograd
1980 reconstruction of 1920
proposal, by Mike McClung and
Russell Myers, University of
Southern California School of Archi-
tecture; Professor K. P. Zygas,
adviser
Plexiglas on plywood base
Approx. h: 76 cm. (30 in.);
Approx. diam: 46 cm. (18 in.)
Los Angeles County Museum of Art

371.
**Pamiatnik III Internatsionala. Pro-
ekty V. E. Tatlin
(Monument to the Third Interna-
tional: A Project by V. E. Tatlin)**
by N. Punin
Petrograd, 1920
44 pp. with lithographs
Ex Libris 6, no. 224
25.4 x 21.9 cm. (10 x 8⅝ in.)
George Gibian, Ithaca, New York

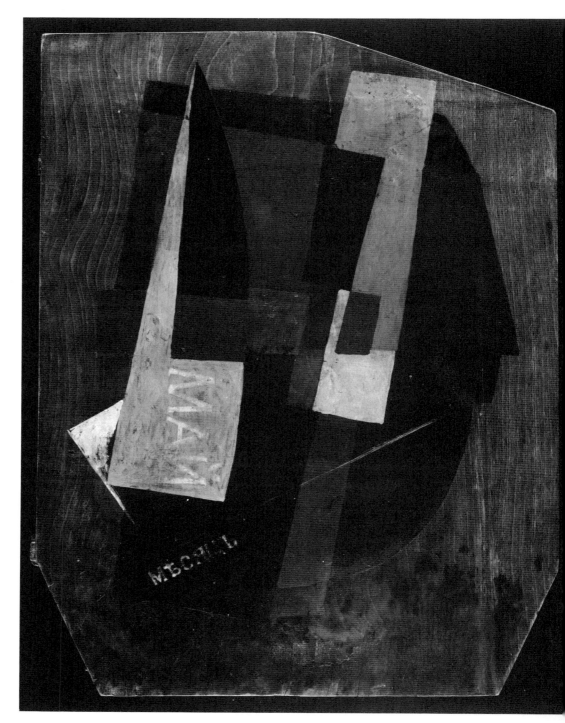

368

Vladimir Tatlin stands out among the Russian avant-garde as the artist whose wholly unique vision and ideology formed the basis for the Constructivist movement. Tatlin endured a rigorously disciplined and unhappy childhood and ultimately ran away from home at the age of seventeen to become a merchant seaman (1902). His experience as a sailor had a tremendous impact on his later artistic development. Not only did life at sea ingrain certain visual forms in the artist's imagination, but more tangibly Tatlin gained an extensive knowledge of the tensile properties of various materials and developed exceptional manual skills. There is some indication that Tatlin was trained as a marine carpenter during this period at sea; drawings for his later work follow the basic format of shop drawings.

Tatlin returned to Russia by 1908 and renewed a boyhood friendship with Larionov, whose fascination with the icon and with primitive art was a major influence on the young Tatlin. Larionov invited Tatlin to exhibit his painting at the Union of Youth exhibition of 1911, thereby marking Tatlin's debut as a professional artist. Tatlin's friendship with Larionov ended in 1913 with a quarrel (Tatlin was then, and would remain, an extremely difficult and distrustful personality). The influence of the icon, however, would resurface in his later work.

During this period Tatlin was aware of advanced European art; he had a particular interest in Cézanne and Picasso. Late in 1913 Tatlin traveled to Paris, with the express purpose of visiting Picasso's studio. The experience was overwhelming, and Tatlin pleaded with Picasso to let him stay on in his studio. Picasso declined, and Tatlin returned to Russia determined to make his first series of planar reliefs, which he called "Counter-Reliefs." These reliefs of 1913–14 were more radical in their abstraction than Picasso's; fundamentally they are an expression of non-Western traditions, specifically that of the icon. The Counter-Reliefs are non-objective assemblages of industrial materials—metal, wire, wood, etc.—based on the concept that each material generates its own precise repertory of forms. Similarly, color derives from the tone inherent in each natural substance. This concept of the integrity of a material's expressive potential was termed *factura*. Tatlin's constant refrain was "real materials in real space." Real space, as opposed to pictorial space, was the overriding concern. The Counter-Reliefs exist three-dimensionally, not hung flat against a wall but projected outward into the spectator's "real" space. This projection outward into the viewer's space may relate to the peculiarly inverted perspective employed in the traditional Russian icon. Today the Reliefs exist in the West only in photographs, studies, and recent reconstructions. Ultimately, Tatlin aimed for nothing less than reforming the sensibilities of the populace. His respect for the inherent qualities of materials was, in his opinion, a question of obeying natural laws; it would create forms of universal significance that would relate to a mass audience. In his respect for materials as well as in his synthesis of utilitarian materials and aesthetic forms, Tatlin heralded what would become known as Constructivism.

Tatlin's most radical works were his Corner Counter-Reliefs, of 1915–16. With these works, Tatlin attempted to solve the problem of a single, frontal vantage point, which prevented the penetration into the space of the relief from all sides. The solution was to suspend the relief across a corner—the way in which such works were exhibited at the *Last Futurist Exhibition of Pictures: 0–10* in Moscow in 1915. The corner environment allowed for greater penetration of space between the sections of the reliefs, which were a continually intersecting rhythmn of planes whose movements quite literally jut out into real space. The use of the corner has important connotations in the history of Russian art. Icons had been traditionally placed in the corners of Russian homes. An icon corner was known as the "red corner," which in Old Russian also means "beautiful corner." Although the choice of the corner was no doubt motivated by Tatlin's search for new presentations of artistic material and the introduction of space into the Corner Counter-Reliefs, it is likely that Tatlin also appreciated the fact that he had, in effect, created a "modern icon."

The next step in Tatlin's career was the study of individual materials in basic geometric forms, a continuation of the concept of *factura*, or "culture of materials." *Composition* of 1916 and *Study for Board No. 1*, 1919, are characteristic of this phase, which formed the basis of Tatlin's system of design. In 1919–20 he taught this design system at the Vkhutemas in Moscow.

Early in 1919 the Department of Fine Arts (IZO) commissioned Tatlin to design a monument to be erected in the center of Moscow: the *Monument to the Third International.* For various reasons the Monument was never realized beyond the model stage. Tatlin pursued the project through 1920 and, with the help of three assistants, built a number of models in metal and wood. The plan called for a monument twice the height of the Empire State Building, made of glass and iron: four thermal glass enclosures—a cylinder, hemisphere, pyramid, and cube—were to be supported within a complicated framework of spirals, curves, and diagonals. Each of the glass enclosures would revolve on its axis at a different rate—once a month, once a year, once a day, etc. In Tatlin's words, the project was to be "a union of purely artistic forms (painting, sculpture, and architecture) for a utilitarian purpose." The tower would house conference centers, offices for legislative functions of the International Congress, an administration center for the International Proletariat, and a propaganda center with telegraph, telephone, radio, and open-air screen to broadcast the latest news and proclamations. Tatlin's lack of technological training, combined with severe shortages of industrial materials in Russia at this time, made the project an impossibility.

In 1929 Tatlin began work on another project whose conception was beyond the artist's technological capacity. For four years, he studied and made models for a man-propelled glider called *Letatlin*—the word is a combination of "to fly" and Tatlin's own name. *Letatlin*, built entirely of wood, was based on a close study of flying insects. Unfortunately, the glider never did fly.

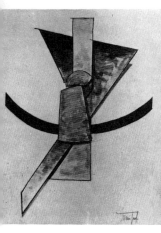

From Alexandr Rodchenko,
"A Souvenir of Tatlin"

372.

Tatlin. Protiv kubizma (Tatlin: Against Cubism) by N. Punin
Petrograd, 1921
22 pp.
Ex Libris 6, no. 226
30.5 x 23.5 cm. (12 x 9¼ in.)
National Gallery of Art Library,
Washington D. C.

Bibliography

T. Andersen (compiler), *Vladimir Tatlin,* exh. cat., Moderna Museet, Stockholm, 1968.

G. Davenport, *Tatlin!,* New York, Scribner's, 1974.

A. Strigalev, "O proekte 'Pamiatnika III Internatsionala' khudozhnika V. Tatlina," ed. I. Kriukova et al., *Voprosy sovetskogo izobrazitelnogo iskusstva i arkhitektury,* Moscow, 1973, pp. 409–52.

Tatlin, exh. cat., Fyns Stifts Kunstmuseum, Copenhagen, 1976.

Tatlin, exh. cat., Union of Writers of the USSR, Moscow, 1977.

1. Alexandr Vesnin (1883–1959), architect. Probably this meeting took place in 1915.

2. Varvara Stepanova (1894–1958), artist, wife of Rodchenko.

3. This was the Futurist exhibition *The Store* held in Moscow in 1916.

4. Yakov Tugendkhold (1882–1928), art critic.

5. Nikolai Punin (1888–1953), art critic.

I became acquainted with Tatlin when I was once visiting with Vesnin.[1] Varvara and I had come to get a stretcher (Varvara knew him).[2] Varvara and I lived in a little room of 10 square meters, but even so I had decided to paint a large work—although we had neither stretchers nor money. So I asked [Vesnin] to lend me a stretcher of 1½ x 1 meter. I had also to buy a genuine canvas, so I bought some cheap, coarse calico, primed it and, instead of the easel, attached it to the bed.

Tatlin was visiting Vesnin and Vesnin introduced us. I started to go on about how I was going around trying to take part in the "World of Art" exhibition, but just couldn't get anywhere. Tatlin also complained.

"I have grey hair, but 'they' still refuse to recognize me!"

"Don't worry. We'll soon organize a Futurist exhibition. Just leave me your address and you'll take part in it."

"Thanks," I replied. "That would be great."

Indeed, V. E. Tatlin came by to see me shortly thereafter. Looked over my works, approved them and said:

"We've organized an exhibition group which includes the artists V. Tatlin, L. Popova, N. Udaltsova, A. Exter, Pestel, I. Kliun, L. Bruni, K. Malevich and also, you see, Rodchenko. Everyone has contributed money to the exhibition, but since, no doubt, you don't have any, you'll make your reimbursement by your work, just as I will. I'm the organizer, and you're my assistant. What's more, you'll be selling the tickets....Okay?"

"Of course," I replied.

So we rented an empty store at No. 17 on the Petrovka[3] for one month and started to hang."

The store consisted of two premises, one big one, the other—at the back—small. We put up the counter-reliefs of Tatlin, and works by Popova, Exter, Udaltsova, Bruni, Kliun, and Malevich in the first space. M. Vasilieva, myself, Pestel, and later the young Ostetsky were put in the back space. And so began my debut in Moscow. I exhibited a non-objective composition called *Two Figures* (150 x 100 cms.) plus a few small canvases and some non-objective graphic pieces. As I've just mentioned, Tatlin showed his counter-reliefs and some painting. Udaltsova contributed Cubist paintings as did Popova, Kliun, Malevich, and Pestel. Bruni, however, showed a broken cement barrel and a piece of glass shot through by a bullet. This really made the public indignant.

On weekdays there were very few visitors. There were different kinds, but most just turned up by chance. They had a good laugh, and some were highly indignant. Still, there were also those who expressed interest and who supported us. I tried to explain the works, even though I myself did not understand Cubism very well. A few came who did not laugh, although they were seeing such works for the first time. They tried to understand them and came several times. They listened to my explanations and were terribly grateful when and if they understood something. They became our supporters.

Except that it was difficult to explain those artists (and their works) who were devoid of talent, being mere epigones of the Futurists. Actually, there were no Futurists at the exhibition. Only Cubism and abstract art.

Malevich came to the vernissage and, for some reason or other, got into a nasty scene with Tatlin. At the time I didn't realize what was going on. I just removed my works from the exhibition. Aside from Tatlin, of course,

Malevich's works appealed to me more than anyone's. They were fresh, they were distinctive and did not resemble Picasso. But I did not take to Malevich himself. He was somehow very square. He had shifty, unpleasant eyes. He was insincere, conceited, and one-sided to the point of stupidity. He came up to me and said: 'You're the only [artist] here, but do you know what you're doing?' I answered: 'No, I don't!...' 'you know, what they are all doing is passé and derivative. It's all finished. What we have now is something new, something Russian. And I'm the one who's doing it. Come visit me. Intuitively, you have it too. It's in the air!' And he gave me his address. I often used to visit Tatlin, I respected him and felt him to be a talented artist, so I told him everything about Malevich.

His response was: "Don't go to see him!"

So I didn't go.

Vladimir Evgrafovich lived on Staro-Basmannaia St in the building of a railroad organization. He lived on the 8th and 9th stories and built his studio in the attic, cold-proofing it himself. This was a curious studio made out of sheets of plywood. He lived alone and everything was neat and tidy, as you would expect from an old sailor. At that time he was working on a production of Wagner's opera *The Flying Dutchman.* He had not been commissioned, he did it just for himself. Maybe thirty years have passed since then, but he's probably still working on it right now. He was designing costumes and architectural details for sets, and I was amazed at how many there were, at the number of versions of a single detail—the way in which a ceiling was attached to a room. Tatlin did all this with thoroughness and great artistic taste.

Tatlin is a great artist, a genuine one, a Russian. He likes fame, but he...waits...and knows how to wait. And I am sure that fame will be his. Only genuine Russian artists can work like that, going years without due recognition, working industriously, with a simple, unadulterated taste for an unknown future—until the day they die.

Tatlin's studio contained a joiner's bench, a vise, and all the other instruments that a joiner and locksmith use.

I used to visit Tatlin a lot and we had long conversations. Tatlin always had his own particular view of things. From everyone he demanded the qualities of skill and art. He liked simple people, people who knew what they were about. He liked simple things, well-made, strong. He used to wear a sailor's flannel, sailor's pants, and also simple British military boots with iron soles. He also wore a woollen jersey and socks. He used to carefully wax his boots with goose lard.

I learned everything from Tatlin—my attitude to the profession, to objects, to material, to food, to life itself—and this left an imprint on my entire life. He was, however, suspicious of everyone since he thought that people wished him evil, were betraying him. He thought that his enemies such as Malevich were sending certain persons round to him to find out his artistic plans. Consequently, he revealed himself to me only very gradually, for he was constantly on the *qui vive.*

In vain. I was completely devoted to him. Even now—and we haven't seen each other for several years—my attitude hasn't changed, and perhaps one day he will be sorry for his suspicious nature and for the loss of what was a genuine friendship. But like him, nurtured by him, I am also suspicious, something of an egoist and, as a result, am not taking any steps to renew our friendship.

Even though I am obliged to that first. But he has caused me not to do this, and we know that the situation is irremediable. Of all modern artists whom I have met, Tatlin has no equals.

Of the other participants in the exhibition, A. Exter treated me very cordially. Exter was older than the rest and already had a name since she had been working in the Chamber Theater. She tried to get me work in the Chamber Theater too and introduced me to Tairov, but nothing came of it. She used to invite me home, and one evening I remember Tugendkhold being there.[4] We drank vodka. V. Pestel [also there], an admirer of Tatlin, was loquacious, but had little stature either in character or in her painting. Popova, from a rich family, treated us with condescension and disdain since she did not consider our company or class to be appropriate to her position. Later on, during the Revolution, she changed radically and became a real friend—but more of that later. She scarcely spoke to me, didn't turn up very often, and at the exhibition always left behind the fragrance of expensive perfume and lovely clothes.

Udaltsova came to the exhibition many times, talking quietly and ingratiatingly about Cubism. As if affirming the principles of Cubism, Udaltsova possessed a very interesting face, like a nun's; she had a squint and both eyes looked in totally different directions; her nose was somewhat deformed in the Cubist manner and her lips were thin, like those of a nun. She understood Cubism more clearly, and worked more earnestly, than anyone else.

Bruni was not serious about the exhibition and took part because he was friends with Tatlin. He himself was completely in the "World of Art" tradition. But he was fond of Tatlin, was young, fervent, audacious.

Vasilieva was a gray-haired but lively woman who was living in Paris and had seen something of the world. As an artist she was quite talented, a Cubist, but rather lightweight, a bit shallow, and did not inspire much interest on the part of the public.

I have already written about Malevich. My first impression of him did not change until the day he died.

Tatlin and I dreamt of going off to the Urals and to Siberia, and to this end we procured two rifles. This was during the First World War. Vladimir Evgrafovich found himself a Japanese carbine and got hold of a German one for me. We had a whole box of cartridges, a machine-gun belt, and explosive bullets. I brought all this home unknown to the police. Varvara and I were then living on the Karetno-Sadovaia St., and our landlady's husband had been deported as being a German, so I never saw him. We rented one room with two windows on the first floor. I put the cartridges under the wadding between the window frames and hung my carbine behind the window blind and this concealed it both day and night.

I remember that we had night duty down in the yard as protection against thieves. But there was only one rifle for five people, and when it was my turn to stand duty, this rifle could not be found. So I refused to stand duty without a rifle saying that I had nothing to protect—and if thieves really came, they wouldn't get much from me.

Tatlin and Morgunov, who had received a mandate from the Moscow Soviet of Workers and Peasants Deputies, came to see Gan to discuss how to protect city houses from plunder. They also brought me along to the meeting. So I made the acquaintance of Alexei Gan.

I was entrusted with guarding Morozov's villa on the Sretenka which contained engravings and porcelain. A group of "Anarchist-Communists" was living in the villa then. Every day I went to the villa and made it my business to see that everything of artistic value was put into one room, the keys to which remained in my possession. There were several "Anarchists," including a few women....I've no idea what they did in the evenings because I used to leave at 5 or 6 p.m. They didn't do a damn thing in the daytime either, as far as I could see. They used to go some place, come back and then just sleep. Where they took their meals, I don't know. They treated me with some hostility and suspicion: I might have been an observer from the Moscow Soviet, from the Communists....

The Morozov villa had several rooms, including a porcelain museum and two rooms for engravings. The vestibule contained Vrubel's panneau *Faust and Margarita*. At that time these works of art had hardly any interest for me, even though I was acquainted with them and had studied them. I guarded them carefully, looked after them, but did not respect them. This now seems strange even to me, and I cannot understand that feeling of indifference now—when I take delight in Russian porcelain and in Vrubel, but at that time I was keen on my own leftist art. I wandered about those alien rooms with their alien art and experienced no delight. I viewed the "Anarchists" without astonishment, I admired neither the porcelain nor the "Anarchists." I found both very ordinary and of little interest.

What kind of people were they? I didn't see anything special in them, apart from their title, and I expected no good from them. They were ordinary people, a bit sentimental, lacking ideals and, above all, untalented. They lived no differently from the tenants who lived in our apartment building. They created nothing new either in everyday life or in their personal relationships. They slept wherever they could. Ate wherever they could. Played on the mandolin and quarreled like everyone else.

What kind of "Anarchism-Communism" was that? Just a title, that's all. They themselves were just philistines. One fine day, as we say, the "Anarchists" were routed and disarmed.

One evening Vladimir Evgrafovich dropped by. With a secretive look, he began to tell me that N. Punin,[5] Altman, and Shterenberg (Commissar for Art) had arrived in Moscow, that he (Tatlin) had been appointed the Moscow Commissar in the Visual Arts Section, and that I was to join him there. Soon I was also part of IZO, in the Sub-Section for Industrial Art led by O. V. Rozanova. We organized a Union of Artists for the city of Moscow with three federations—right, central and left. Tatlin became chairman of the left section with me as its secretary. The Club of the Left Federation was organized in the private apartment of a certain Tumerin, an acquaintance of Popova, I think. He put two fully furnished rooms at our disposal, fearing that anyway they would be requisitioned. We made our first exhibition there a general one. The second one was mine.

Translated from the Russian by John E. Bowlt from a text provided by Szymon Bojko.

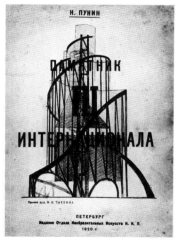

371

Udaltsova, Nadezhda Andreevna

Born 1886 Orel; died 1961 Moscow.

373.

At the Piano, 1914
Oil on canvas
106.7 x 88.9 cm. (42 x 35 in.)
Yale University Art Gallery, New
Haven, Connecticut, Gift of Collection Société Anonyme

374.

Untitled (collage-type), c. 1916
Gouache on paper
27 x 23.5 cm. (10⅝ x 9¼ in.)
Galerie Gmurzynska, Cologne,
West Germany

375.

Untitled (collage-type), c. 1916
Gouache on paper
24.5 x 16 cm. (9⅝ x 6¼ in.)
Galerie Gmurzynska, Cologne,
West Germany

376.

Untitled (collage-type), c. 1916
Gouache on paper
37 x 24 cm. (14⅝ x 9½ in.)
Galerie Gmurzynska, Cologne,
West Germany

377.

Untitled (Suprematist-type), c. 1916
Gouache on paper
20 x 20 cm. (7⅞ x 7⅞ in.)
Galerie Gmurzynska, Cologne,
West Germany

Bibliography

M. Miasina, ed., *Stareishie
sovetskie khudozhniki o Srednei
Azii i Kavkaze,* Moscow, 1973,
pp. 220–22.

Sovetskie khudozhniki. Avtobiografii, Moscow, 1937, vol. 1.

"Nadezhda Udaltsova's Cubist
Period," *Women Artists of the
Russian Avant Garde 1910–1930,*
exh. cat. in German and English,
Galerie Gmurzynska, Cologne,
1979, pp. 288–97.

Kazimir Malevich, "Udaltsova
(1924)," ibid, pp. 298, 302.

Nadezhda Udaltsova, "How Critics
and the Public Relate to Contemporary Russian Art (1915)," ibid,
p. 304–8.

Nadezhda Andreevna Udaltsova,
"Autobiography, (1933)," ibid,
p. 309–12.

1892 the Udaltsova family moved to Moscow; 1905–9 Udaltsova attended the Moscow Institute of Painting, Sculpture, and Architecture; 1906 entered Konstantin Yuon's private art school where she studied under Yuon, Ivan Dudin, and Nikolai Ulianov; 1909 attended Kim's private studio; 1911–12 lived in Paris, where she worked under Metzinger, Le Fauconnier, and de Segonzac, assimilating the principles of Cubism; 1913 back in Moscow worked in Tatlin's studio known as The Tower; close contact with Alexei Grishchenko, Popova, Alexandr Vesnin; interested in the theory of Rayonism and painted some Rayonist compositions during 1913–14; 1914 contributed to the *Jack of Diamonds* exhibition, Moscow; thereafter contributed to many exhibitions both at home and abroad, including *Tramway V, 0–10,* and *The Store;* 1915–16 interested in Suprematism, but gradually returned to Cubism and, eventually, to naturalism; 1917–18 helped Yakulov, Tatlin et al with the interior design of the Café Pittoresque, Moscow; worked in IZO NKP; professor at Svomas; c. 1920 onward close to Alexandr Drevin; 1921–34 professor at Vkhutemas/Vkhutein; 1922 contributed to the *Erste Russische Kunstausstellung* in Berlin; 1930–31 traveled in the Urals and the Altai region; 1930s and 1940s continued to exhibit regularly.

■ The development of Udaltsova's work is linked closely with that of her great friend and colleague, Popova. The two women shared a studio in Moscow until 1912, when they went to Paris to study with Le Fauconnier and Metzinger. At the outbreak of war in 1914, they returned to Russia where they were considered to be the chief representatives of Cubism, along with Malevich.

Udaltsova's *At the Piano* (1914) is an outstanding work of her Cubist phase, exemplary in delineating the differences between French and Russian Cubism. While the French were concerned with a strict and ruthless analysis of subject matter, the Russians were interested in a new way of constructing a painting, not in interpreting the thing seen. Thus *At the Piano* is composed of decorative coordinates of flat planes, with no suggestion of depth. The Russian artist's palette was also considerably brighter than that of the French. Udaltsova participated in almost all the major exhibitions in Russia, and *At the Piano* may in fact be the same painting as *Music,* which was exhibited at the *0–10* exhibition.

Udaltsova became friendly with Tatlin and Vesnin, and by 1916 she was exhibiting her completely nonobjective "painterly constructions" at the *Jack of Diamonds* exhibition. With their floating geometries and use of superimposed planes, these works bear a strong similarity to Malevich's Suprematist paintings of the period. Her affiliation with Suprematism was relatively shortlived. After 1916, Udaltsova gradually returned to Cubism, and eventually to naturalism. A record of a report Malevich made about Udaltsova in 1924, concerning her teaching of first-year students at Vkhutemas, indicates that by that date Malevich was disenchanted with Udaltsova's approach. In his words, Udaltsova "possessed a rich individuality, but it is one that is obsolete...she did not fully understand Suprematism, and sensed everything in terms of objects."

377

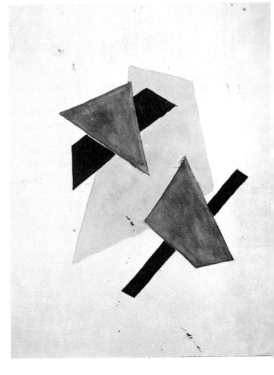

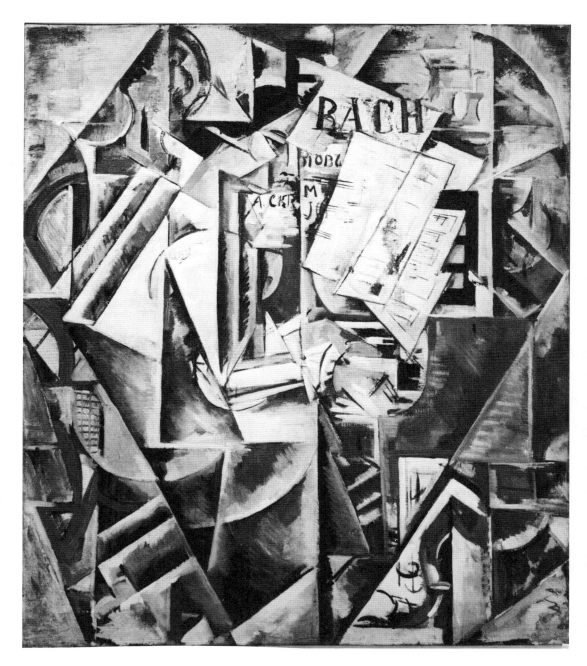

373

Vesnin, Alexandr Alexandrovich

Born 1883 Yurevets, Volga Province; died 1959 Moscow.

378.

Untitled, c. 1920–21
Ink on paper
33 x 24.8 cm. (13 x 9¾ in.)
Thyssen-Bornemisza Collection,
Lugano, Switzerland

379.

Construction of Lines, 1921
Gouache on paper
40 x 34 cm. (15¾ x 13⅜ in.)
Galerie Jean Chauvelin, Paris

380.

**Drawing for a Monument for
the Third Congress of the
Communist International,** 1921
Gouache on paper
53 x 70.5 cm. (20¾ x 27¾ in.)
Collection, The Museum of Modern
Art, New York, Acquired through the
Mrs. Harry Lynde Bradley and the
Katherine S. Dreier Bequests

381.

"Phèdre," 1922
India ink, graphite, gouache,
gold and silver paint on paper
48 x 31.4 cm. (18⅞ x 12⅜ in.)
Michail Grobman, Jerusalem, Israel

382.

Costume Design for "Phèdre,"
1922
51.5 x 35.6 cm. (20¼ x 14 in.)
Theatermuseum, Cologne, West
Germany

383.

**Stage Design (Preliminary
Sketch) for "Phèdre,"** 1922
Gouache on paper
16.5 x 21.6 cm. (6½ x 8½ in.)
Mississippi Museum of Art,
Jackson, The Lobanov Collection

384.

Palace of Labor—Project for
Moscow
1980 reconstruction by William
Lippens of 1923 proposal by the
Vesnin Brothers
Strathmore board, basswood core,
plywood base
Approx. 61 x 76.2 x 45.7 cm. (24 x
30 x 18 in.)
Los Angeles County Museum of Art

The youngest of the three Vesnin brothers who worked closely on many Soviet architectural and design projects during the 1920s and early 1930s; 1901–12 after finishing the Moscow Practical Academy, Alexandr Vesnin entered the Institute of Civil Engineers in St. Petersburg; 1912–14 worked in Tatlin's studio known as The Tower, establishing close contact with Popova, Udaltsova and others; 1918 worked on agit-decorations for the streets and squares of Petrograd and Moscow; 1920 designed sets and costumes for Claudel's *L'Annonce faite à Marie* produced by Alexandr Tairov at the Chamber Theatre, Moscow; thereafter active in a number of stage productions, including his most famous *The Man Who Was Thursday,* produced by Tairov in 1923; member of Inkhuk; 1921 contributed to the exhibition *5 x 5 = 25;* 1923–25 close to *Lef;* keen supporter of Constructivism; 1923–33 worked with his brothers Leonid and Viktor on various architectural and industrial designs; co-founded OSA (Association of Contemporary Architects); late 1920s with his brothers worked on important projects such as the Lenin Library, Moscow, the Palace of Soviets for Moscow, house-communes for Kuznets, etc.; 1930–40s with the death of Leonid (1933) and the censure of Constructivism, Vesnin reduced his architectural and artistic activities considerably.

■ Alexandr Vesnin is prominent for the design of important Soviet architectural projects during the Constructivist 1920s and 1930s. Trained as a civil engineer, he early became acquainted with pre-Revolutionary avant-garde ideas discussed at Tatlin's The Tower studio. After the Revolution, he was active in producing agit-prop decorations; he then joined with Rodchenko, Stepanova, Exter, and Popova at the historic 1921 *5 x 5 = 25* exhibition which announced the death of easel painting and presaged the Constructivist/Productivist ethos. Not surprisingly, Vesnin is celebrated also for his contributions to Tairov's Moscow Kamerny Theater and for his work with Meierkhold. With Exter and Popova, Vesnin stands as a major influence on Constructivist stage design.

Vesnin's 1921 *Construction of Lines* combines the new Constructivist emphasis on line with a tonal shading reminiscent of Malevich and Cubo-Futurism. These formal concepts were translated into the third dimension in Vesnin's designs for Racine's *Phèdre,* produced by Tairov in February 1922. The *Stage Design for "Phèdre"* is both stark and chaotic in its interplay of zig-zag lines; it suggests the deep space and sloping stage of the realized design—a set carved out of space and inhabited by Cubist forms in striking primary colors. A *Costume Design for "Phèdre"* by Vesnin illuminates the mythic import of the tragedy. Co-designed with Georgii Stenberg, the costumes turned the actors into ritually gesturing sculptures.

Drawing for a Monument for the Third Congress of the Communist International and the *Untitled* gouache are both works of 1921. Although still calculated in the Cubo-Futurist mode, they foreshadow the elaborate skeletal Constructivism of Vesnin's 1923 set for *The Man Who Was Thursday.* Alexandr Vesnin is, however, best known for collaborative architectural ventures with his brothers Leonid and Viktor Vesnin. The Vesnins' 1923 competition entry for the Moscow *Palace of Labor* was awarded third prize and is of considerable historic significance. The Vesnins avoided both academic Neoclassicism and ingenuous technological symbols in developing a vocabulary of form and function that would greatly influence emerging Constructivist architecture. Among many other notable projects is the 1924 *Leningrad Pravda.* Both projects are seen here in 1980 reconstructions made especially for this exhibition.

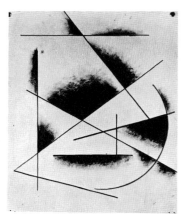

385.
Leningrad Pravda—Project for
Moscow
1980 reconstruction by Alan
Morishige of 1924 proposal by the
Vesnin brothers
Plexiglas, plywood base
Approx. 61 x 22.9 x 22.9 cm. (24 x
9 x 9 in.)
Los Angeles County Museum of Art

Bibliography

A. Chiniakov, *Bratia Vesniny,*
Moscow, 1970.

K. Usacheva "Teatralnye raboty
A. A. Vesnina," ed. I. Kriukova et al.,
*Voprosy sovetskogo izobrazitel-
nogo iskusstva i arkhitektury,*
Moscow, 1975, pp. 304–31.

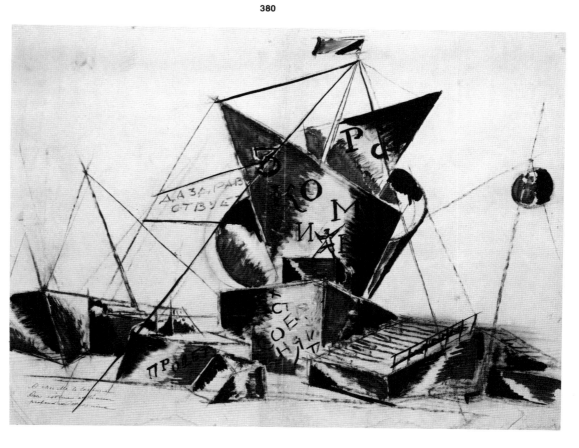

378

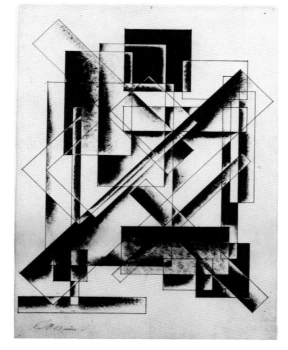

Vialov, Konstantin Alexandrovich

Born 1900 Moscow; lives in Moscow.

386.
Worker, 1923
Gouache and leather collage
32.3 x 24.8 cm. (12¾ x 9¾ in.)
Rubinger, Cologne, West Germany

Bibliography

O. Voltsenburg et al, ed., *Khudozhniki narodov SSSR. Bio-bibliograficheskii slovar,* Moscow, vol. 2, 1972, p. 370.

V. Koston, *OST,* Leningrad, 1976.

Russian and Soviet Painting, exh. cat., Metropolitan Museum of Art, New York, 1977.

1914–17 studied at the Stroganov Art Institute, Moscow, specializing in textile design; 1917–24 attended Svomas/Vkhutemas, studying under Aristarkh Lentulov and Alexei Morgunov; 1923 began to exhibit; 1925 onward member of OST and contributor to all its exhibitions (1925, 1926, 1927, 1928); favored an expressionistic, even surrealistic style at this time; 1920s worked as a studio painter and also as a stage designer, contributing to a number of important theatrical productions, including the staging of Vasilii Kamensky's *Stenka Razin* in 1924; also worked as a poster designer, e.g., for the movie *When the Dead Awaken* of 1927, and as a book illustrator, e.g., for the translation of L. Mitchell's *Skyscraper* of 1930; until the 1960s continued to paint and to exhibit regularly; after the early 1930s favored simple landscapes.

■ A member of the generation of artists who came of age after the Revolution, Konstantin Vialov's student years (1914–24) coincide with the height of the avant-garde movement. Vialov's training drew upon an aesthetic that increasingly declared easel painting untenable and directed artists to work in industrial design. The young artist's specialty in textile design at the Stroganov Art Institute (Moscow, 1914–17) is no doubt a reflection of this trend, as are his years at Vkhutemas (1917–24), the school that was committed to bringing together art and industry.

It was not until 1923 that Vialov began to exhibit his work professionally, and by this time the political climate in Russia was already beginning to dictate a return to more traditional forms of art making. Vialov's *Worker* (1923) represents an important moment in the history of modern Russian art. The painting is composed of the geometric configurations and bold forms favored by the avant-garde, while at the same time its forceful representation points the way toward Socialist Realism. This work employs the simplified geometry of the Russian *lubok* and icon; as such it becomes an archetypically "Russian" work of art.

By 1925 the transition towards Socialist Realism had been effected, and Vialov became a founding member of OST, the Society of Easel Painters. The organization supported the primacy of studio art, specifically a figurative style. Interestingly, Vialov continued work in theater and book design throughout the 1920s. From the 1920s to the 1960s he painted simple landscapes.

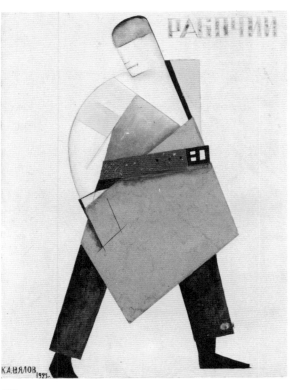

386

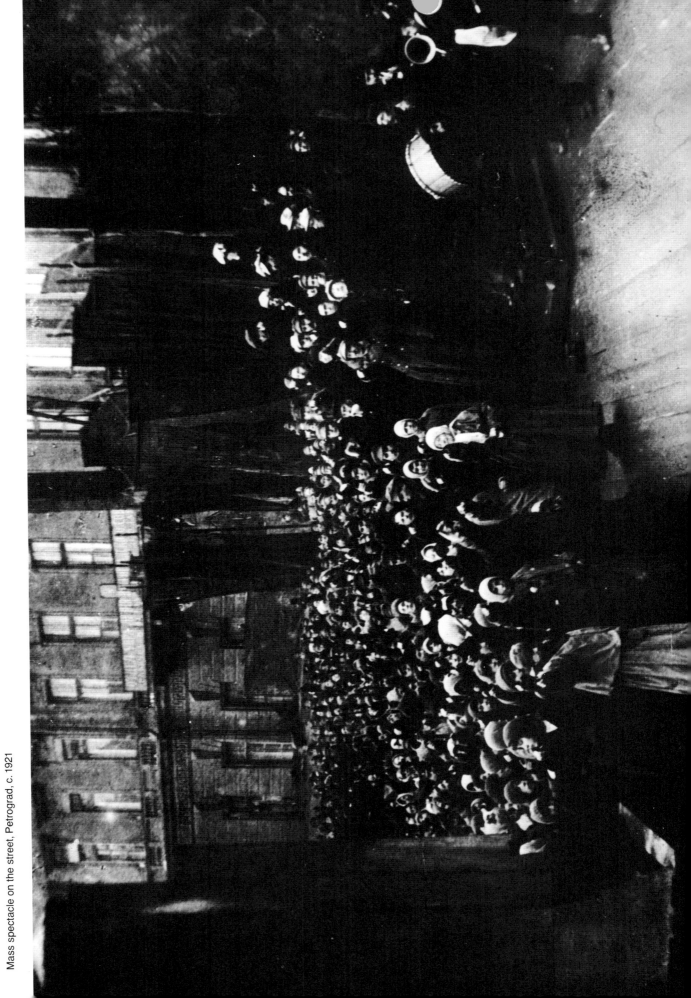

Mass spectacle on the street, Petrograd, c. 1921

Yakulov, Georgii Bogdanovich

Born 1882 Tifilis (Tbilisi); died 1928 Erevan.

387.
Girofle-Girofla, 1922
Maquette of stage set
54 x 100 x 70 cm. (21¼ x 39⅜ x 27½ in.)
Theatermuseum, Cologne, West Germany

Bibliography

Notes et documents édités par la Société des amis de Georges Yakoulov, Paris, 1967–75, vols. 1–4.

S. Aladzhalov, *Georgii Yakulov,* Erevan, 1971.

E. Kostina, *Georgii Yakulov,* Moscow, 1979.

1901–3 attended the Moscow Institute of Painting, Sculpture, and Architecture; 1904 mobilized for the Russo-Japanese front; spent time in Manchuria, where he was deeply impressed by the distinctive light effects of that area; 1905 began to develop his theory of light; 1907 first professional exhibition with the Moscow Association of Artists; thereafter represented at many exhibitions in Russia and abroad; 1910–11 often involved in spectacles, private balls, etc., as decorator; 1913 traveled to Paris, where he met the Delaunays; found that some of his ideas on light corresponded with their theory of Simultanism; 1914–17 periodic military service; 1917 planned the interior design of the Café Pittoresque in Moscow, assisted by Rodchenko, Tatlin, and others; 1918 onward very active as theater designer; 1919 co-signed the "Imagist Manifesto"; professor at Vkhutemas in Moscow; early 1920s active principally as a stage designer; 1923 designed monument to the 26 Baku Commissars; 1925 traveled to Paris; worked on décor for Diaghilev's production of *Le Pas d'Acier* (realized 1927); returned to Moscow later that year; 1928 died of pneumonia.

■ Georgii Yakulov's artistic career began with turn-of-the-century Symbolism and culminated with the fully developed Constructivism of the 1920s. In a reaction against the preciousness and European-oriented sophistication of the "World of Art" Symbolists, Yakulov was among those second-generation Moscow Symbolists who formed the "Blue Rose." Although still inclined toward mysticism and spirituality, the Blue Rose artists denied the value of representational subject matter and technical mastery. Works by Yakulov, Larionov, Goncharova, Malevich, and others who showed at the 1907 Moscow Association of Artists exhibition emphasized bold, abstract rhythms of color and line, and thus announced Russian Neo-Primitivism.

By 1913, Yakulov was among the many Russian artists (Exter, Popova, Udaltsova, Chagall, Puni, Altman) who had traveled to Paris. He returned home to military service during World War I and was severely wounded. Back from the front in 1917, Yakulov allied with Tatlin and Rodchenko in decorating the outrageously bohemian Café Pittoresque with dynamic wall and ceiling constructions of wood, metal, and cardboard. Coeval with Zurich Dadaism, this Moscow theater-cafe provided a setting for proclaiming manifestos, reciting *zaumniki* (nonsense or alogical poetry), and performing masquerades and other purposeful provocations of the middle class.

After the revolution, Yakulov became a member of *Obmokhu* (Society of Young Artists) and a professor at Vkhutemas (Higher State Art-Technical Studios) in Moscow. He is best known for his work in theater design, primarily for the productions of A. Tairov's Kamerny Theater. His 1920 set for E.T.A. Hoffmann's *Princess Brambilla* was intended, in Tairov's words, "to intimately unify all elements on an unencumbered stage, to capture the fantasy and engulf the audience in a swirl of theatrical phantasmagoria...." Yakulov's rococo fairyland in a Cubist idiom remained highly decorative. It was not until two years later, with the music hall and circus ambience of the operetta *Girofle-Girofla,* that Yakulov achieved a stage design in the Constructivist spirit.

Yakulov's structure gave the actors "acting instruments" with which to interact: a system of staircases, ladders, trapdoors, and shifting screens that provided a total environment or "machine for actors." In 1925 in Paris, Yakulov designed for the Ballets Russes production of *Le Pas d'Acier* a functional and machine-oriented Constructivist setting depicting modern Russia. His amazingly innovative career was cut short in 1928 when he died of pneumonia at Erevan, Armenia.

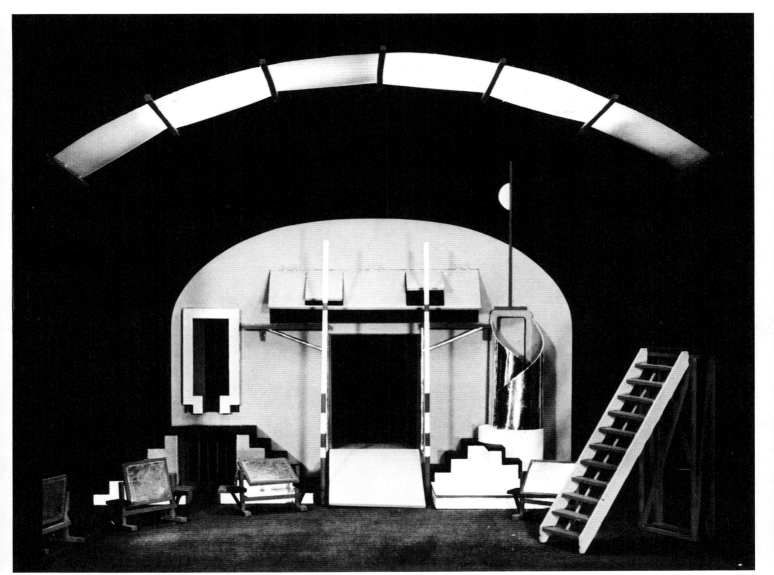

Architectural Reconstructions

Textile Reconstructions

Exhibition Catalogs

Reconstructions made by University of Southern California School of Architecture students under the supervision of Professor K. P. Zygas

388.
Agit-Prop Billboards for Trains,
c. 1918–20
1980 reconstructions by Justine Clancy
Oil on photographic paper mounted on model trains
Approx. 7.6 x 20.3 cm. (3 x 8 in.)
Los Angeles County Museum of Art

389.
Yakov Chernikhov
Architectural Fantasy
#28—Project, 1933
1980 reconstruction by William Lee
Strathmore board, basswood core, plywood base
Approx. 38.1 x 61 x 61 cm. (15 x 24 x 24 in.)
Los Angeles County Museum of Art

390.
Ivan Leonidov
Dom Narkomtiazhprom—Project
for Moscow, 1933
1980 reconstruction by Beatrice A. Costillo
Plexiglas, plywood base
Approx. 61 x 30.5 x 61 cm. (24 x 12 x 24 in.)
Los Angeles County Museum of Art

Vladimir Tatlin
Monument to the Third Interna-
tional—Project for Petrograd,
1920
1980 reconstruction by Mike McClung and Russell Myers
(see Tatlin checklist no. 370)

Alexandr Vesnin
Palace of Labor—Project for
Moscow, 1923
with his brothers Leonid A. Vesnin and Viktor A. Vesnin
1980 reconstruction by William Lippens
(see Vesnin checklist no. 384)

Alexandr Vesnin
Leningrad Pravda—Project for
Moscow, 1924
with his brothers Leonid A. Vesnin and Viktor A. Vesnin
1980 reconstruction by Alan Morishige
(see Vesnin checklist no. 385)

Alexandra Exter
(see Exter checklist no. 57)

391.
Nadezhda Lamanova
Dress, c. 1922–25
Reconstruction 1979, model realized by van Laack according to original artist's sketches
Linen with wool crepe; size 8/10
Collection van Laack Company, West Germany

Liubov Popova
(see Popova checklist nos. 266–272)

Varvara Stepanova
(see Stepanova checklist nos. 352–357, 369)

392.
Oslinyi khvost (Donkey's Tail),
1913
Exhibition catalog
Organized by M. Larionov
16.5 x 12.1 cm. (6½ x 4¾ in.)
Ex Libris, New York

393.
Luchizm (Rayonism), 1913
Exhibition catalog by Larionov
14.9 x 11.4 cm. (5⅞ x 4½ in.)
Ex Libris, New York

394.
Tramway V
Petrograd, 1915
Exhibition catalog
Collection Mr. and Mrs. Herman Berninger, Zurich, Switzerland

395.
Poslednyaya futuristicheskaia
vystavka kartin 0–10
The Last Futurist Exhibition
of Pictures: 0–10
Petrograd, December 19,
1915–January 19, 1916
Collection Mr. and Mrs. Herman Berninger, Zurich, Switzerland

396.
Bubnovyi valet (Jack of
Diamonds), 1916
Exhibition catalog
Organized by D. Burliuk, et al.
17.8 x 12.4 cm. (7 x 4⅝ in.)
Ex Libris, New York

397.
Futuristicheskaia vystavka
"Magazin" (The Store), 1916
Exhibition catalog
Organized by V. Tatlin
23.5 x 15.3 cm. (9¼ x 6 in.)
Ex Libris, New York

398.
5 x 5 = 25, 1921
Exhibition catalog with original works by Alexandra Exter, Liubov Popova, Alexander Rodchenko, Varvara Stepanova, and Alexander Vesnin
17.5 x 14 x 2 cm. (6⅞ x 5½ x ⅛ in.)
Individual drawing sizes vary
Nazca Gallery
(see checklist nos. 259, 301, 347)

Erste Russische Kunstaus-
stellung (First Russian Art
Exhibition)
Galerie van Diemen, Berlin, 1922
(see Lissitzky checklist no. 149)

Catalog of the Posthumous Ex-
hibition of the Artist-Constructor
L. S. Popova
Moscow, 1924
(see Popova checklist no. 264)

Vystavka proizvedenii K. S.
Malevicha (Exhibition of works
by K. S. Malevich), 1929
(see Malevich checklist no. 224)

398

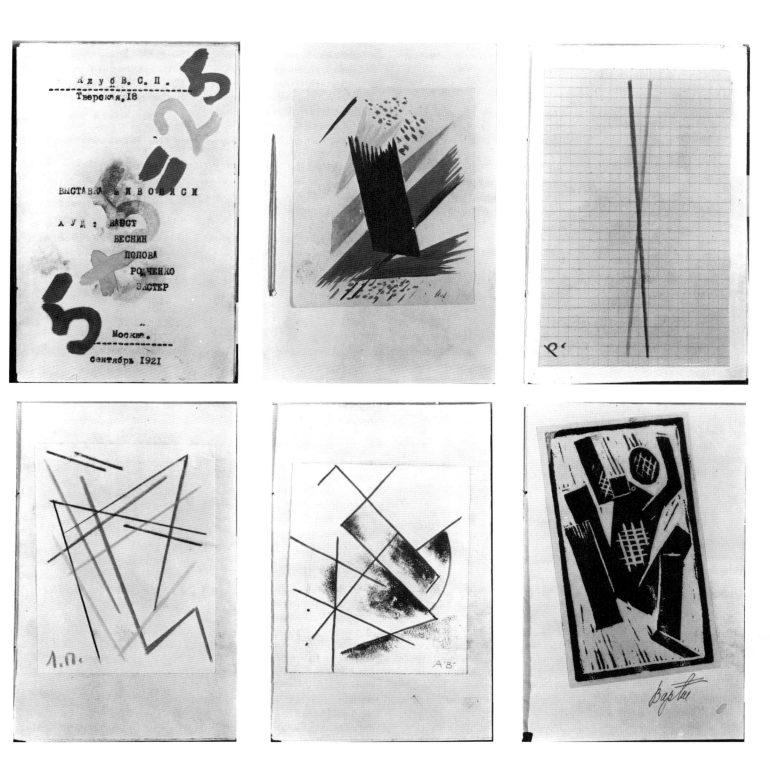

Art History and Criticism

399.

Printsipy kubizma i drugikh so-vremennykh techenii v zhivopisi vsekh vremen i narodov (Princi-ples of Cubism and Other Con-temporary Trends of All Times and Countries) by A. Shevchenko
Moscow, 1913
33 pp. with lithographs by M. Larionov, N. Goncharova, A. Shevenchko, and V. Bart
Ex Libris 6, no. 237
17.5 x 11.9 cm. (6⅞ x 4⅝ in.)
Australian National Gallery, Canberra

400.

Izobrazitelnoe iskusstvo (Visual Art) by O. Brik, N. Punin, K. Malevich, and V. Kandinsky
Petrograd, 1919, no. 1
87 pp. with cover by D. Shteren-berg
Ex Libris 6, no. 90
35.7 x 25.9 cm. (14 x 10¼ in.)
The National Gallery of Art Library, Washington, D.C.

401.

Neue Kunst in Russland (New Art in Russia) by K. Umanskii
Potsdam, 1920
104 pp. with cover by O. Rozanova
Ex Libris 6, no. 375
24.8 x 18.7 cm. (9¾ x 7⅜ in.)
The National Gallery of Art Library, Washington, D.C.

402.

Iskusstvo v proizvodstve (Art in Production) by O. Brik, S. Filippov, and D. Shterenberg
Moscow, 1921
44 pp. with cover lithograph by Shterenberg
Ex Libris 6, no. 33
22.9 x 18.1 cm. (9 x 7⅛ in.)
K. P. Zygas

403.

A vse taki ona vertitsa (And Yet the World Goes Round) by I. Ehrenburg
Moscow/Berlin, 1922
142 pp. with illustrations of stage designs by F. Léger, El Lissitzky, A. Rodchenko, et al., and with original Léger stencil cover design
Ex Libris 6, no. 55
21.9 x 15.9 cm. (8⅝ x 6¼ in.)
Australian National Gallery, Canberra

404.

Konstruktivizm (Constructivism) by Alexei Gan
Tver, 1922
70 pp.
Ex Libris 6, no. 69
23.8 x 20.3 cm. (9⅜ x 8 in.)
George Gibian, Ithaca, New York

405.

Ot molberta k mashine (From Easel to Machine) by N. Tarabukin
Moscow, 1923, vol. 1
44 pp. with color lithograph by L. Sofronova
Ex Libris 6, no. 245
22.9 x 15.7 cm. (9 x 6¼ in.)
The Institute of Modern Russian Culture, Blue Lagoon, Texas

406.

Europa Almanach: Malerei, Liter-atur, Musik, Architektur, Plastik, Bühne, Film, Mode ausserdem nicht unwichtige Nebenbemerk-ungen, ed. Carl Einstein and Paul Westheim
Potsdam, 1925
282 pp.
23.5 x 15.3 cm. (9¼ x 6 in.)
The Robert Gore Rifkind Founda-tion, Beverly Hills, California

407.

Modern Russian Art by L. Lozowick
New York, 1926
60 pp. with lithograph by Lozowick
Ex Libris 7, no. 961
25.4 x 16.5 cm. (10 x 6½ in.)
Mrs. Louis Lozowick

408.

15 Let russkogo futurizma: Ma-terialy i Kommentarii 1912–1927 (15 Years of Russian Futurism: Materials and Commentary, 1912–1927) by A. Kruchenykh
Moscow, 1928
69 pp.
Ex Libris 6, no. 116
17.2 x 13 cm. (6¾ x 5⅛ in.)
George Gibian, Ithaca, New York

409.

Brigada khudozhnikov. Organ federatsii rabotnikov pros-transtvennykh iskusstv (Brigade of Artists. Organ of the Federa-tion Workers in Three-Dimen-sional Arts), ed. P. Viliams et al.
Moscow, 1931 (vol. I, nos. 2–6)
32 pp. each
Ex Libris 6, no. 31
31.1 x 22.5 cm. (12¼ x 8⅞ in.)
K. P. Zygas

410.

Sovetskoe iskusstvo: Materialy i dokumentatsiya (Soviet Art: Materials and Documentation) by I. Matsa
Moscow, 1933
644 pp.
Ex Libris 6, no. 202
26 x 17.1 cm. (10¼ x 6¾ in.)
The National Gallery of Art Library, Washington, D.C.

411.

Polutoraglazyi strelets (The One and a Half-Eyed Archer) by B. Livshits
Leningrad, 1933
296 pp. book with cover by V. Burliuk
20.3 x 14 cm. (8 x 5½ in.)
The Institute of Modern Russian Culture, Blue Lagoon, Texas

■ Architecture

412.

Sovremennaia arkhitektura "SA" (Contemporary Architec-ture), ed. M. Ginsburg and A. Vesnin
Moscow, 1926 (nos. 1, 2, 4), 1927 (nos. 4, 5), 1930 (nos. 1, 6)
30–50 pp. each with covers by Alexei Gan
Ex Libris 6, no. 243
30.5 x 22.9 cm. (12 x 9 in.)
Peter Eisenman

413.

USSR im Bau, ed. G. Pyatakov
Moscow, 1930 (no. 9), 1931 (nos. 4, 10), 1932 (no. 10), 1933 (no. 2) 1937 (nos. 9–12), 1940 (no. 7)
Approx. 40 pp. each
43.2 x 29.9 cm. (17 x 11¾ in.)
Peter Eisenman

414.

Sotsgorod. Problema stroitelstva sotsialisticheskikh gorodov (Socialist City: The Problem of Building Socialist Cities) by N. Milyutin
Moscow/Leningrad, 1930
84 pp.
Ex Libris 7, no. 46
23.2 x 26.4 cm. (9⅛ x 10⅜ in.)
Collection Martin-Malburet

415.

Russland 1930. Die Rekonstruk-tion der Arkhitektur in der Sow-jetunion (Russia 1930: The Reconstruction of Architecture in the USSR) by El Lissitsky
Vienna, 1930
103 pp.
Ex Libris 6, no. 275
30.5 x 22.9 cm. (12 x 9 in.)
Stedelijk Municipal Stadtsches van Abbemuseum, Eindhoven, The Netherlands

416.

Ornament. Kompositsionno-klassicheskie postroeniya (Or-nament: Compositional-Classical Construction) by I. Chernikhov
Leningrad, 1930
Ex Libris 7, no. 11
29.9 x 21.6 cm. (11¾ x 8½ in.)
Ruth and Marvin Sackner

417.

Konstruktsii arkhitekturnykh i mashinnykh form (The Construc-tion of Architectural and Ma-chine Forms) by I. Chernikhov
Leningrad, 1931
232 pp.
Ex Libris 6, no. 47
30.2 x 21.3 cm. (11⅞ x 8⅝ in.)
a) Carus Gallery, New York
b) Ruth and Marvin Sackner

418.

Osnovy sovremennoi arkhitek-tury (The Foundations of Contemporary Architecture) by I. Chernikhov
Leningrad, 1931
Ex Libris 7, no. 10
31.4 x 22.2 cm. (12⅜ x 8¾ in.)
a) Ruth and Marvin Sackner
b) Carus Gallery, New York

Леже.
Рисунокъ къ поэмѣ Голя
„Чаплиніада“.

Léger.
Dessin pour „Chapliniade"
de Goll.

406

403

419.
Sovetskaya arkhitektura (Soviet Architecture), ed. N. Milyutin
Moscow, 1932 (nos. 2, 3), 1933 (nos. 2, 4, 5)
40–80 pp. each
Ex Libris 6, no. 242
27.9 x 21.6 cm. (11 x 8½ in.)
Peter Eisenman

420.
Arkhitektura SSSR (Architecture USSR), ed. K. Alabian
Moscow, 1933, no. 1
38 pp. designed by Lissitzky
Ex Libris 6, no. 7
30.5 x 22.9 cm. (12 x 9 in.)
Peter Eisenman

421.
101 Arkhitekturnykh fantazii (101 Architectural Fantasies) by I. Chernikhov
Leningrad, 1933
102 pp. with 101 color plates of designs by I. Chernikov
31.1 x 22.2 cm. (12¼ x 8¾ in.)
a) K. P. Zygas
b) Ruth and Marvin Sackner

■ **Literature**

422.
Intimité by V. Dmitriev and V. Voinov
Petrograd, 1918
88 pp. with cover by B. Grigorev
Approx. 35.6 x 22.9 cm. (14 x 9 in.)
John E. Bowlt

423.
Der goldene Hahn (The Golden Hen) by A. Pushkin
Berlin, 1923
Designed by N. Masiutin
48.9 x 34.9 cm. (19¼ x 13¾ in.)
Mr. and Mrs. A. L. de Saint-Rat,
Miami University, Oxford, Ohio

424.
Lidantiu farat (Lidantiu as a Beacon) by Ilia-zd (Ilia Zdanevich)
Paris, 1923
61 pp. with cover design by N. Granovsky
13.3 x 18.4 cm. (5¼ x 7¼ in.)
a) Australian National Gallery,
Canberra
b) Carus Gallery, New York

425.
Sorok sorokov. Dialekticheskie poemy nichevokom soediannye (40 x 40. Dialectical Poems for the Nothingist) by R. Ruirok
Moscow, 1923
32 pp. with design and cover by B. Zemenko
Ex Libris 6, no. 228
22.5 x 18.1 cm. (8⅞ x 7⅛ in.)
Alma H. Law

426.
Boui-boui au bord de la mer (Bou-boui on the Seashore) by S. K. Makovskii
Berlin, 1924
Designed by B. Grigoryev
36.2 x 28 cm. (14¼ x 11 in.)
Mr. and Mrs. A. L. de Saint-Rat,
Miami University, Oxford, Ohio

427.
Kak vesennei teploi poroi (How Warm is the Springtime) by Pushkin
Berlin, 1924
Illustrated by N. Masuitin
28.6 x 21.6 cm. (11¼ x 8½ in.)
Mr. and Mrs. A. L. de Saint-Rat,
Miami University, Oxford, Ohio

428.
Izvestiia L. Ts. K. Prilozhenie k knige Gosplan literatury (News of the Literary Center of Constructivists: Supplement to the Book Gosplan literatury), ed. K. Zelinskii and I. Selvinskii
Moscow, 1925
4 pp. with photomontage
45 x 33 cm. (17¾ x 13 in.)
Ex Libris 6, no. 93
Australian National Gallery,
Canberra

429.
Moe puteshestvie v Europe (My Travels in Europe) by Charlie Chaplin
Moscow, 1926 (translated from the English)
72 pp.
15 x 11.4 cm. (5⅞ x 4½ in.)
Alma H. Law

430.
K. Malevich
Selected Poems, 1930
Front and back covers, Suprematist designs
Lithographs printed in color
Front cover: 15.5 x 10.8 cm. (6⅛ x 4¼ in.)
Back cover: 16.5 x 3.2 cm. (6½ x 1⅛ in.)
Dallas Museum of Fine Arts, Dallas Art Museum League Fund in Honor of Mr. and Mrs. James H. Clark

431.
Slovo predstavliaetsia Kirsanovu (The Word Belongs to Korsanov)
by K. Kirsanov
Moscow, 1930
84 pp. designed by S. Telingater
20.3 x 9.2 cm. (8 x 3⅝ in.)
Ex Libris 6, no. 107
Collection Martin-Malburet

432.
Tribun poetov (The Tribune of Poets) by A. Kruchenykh, V. Maiakovsky, et. al.
Moscow, 1930
19 pp. designed by K. Zdanevich and I. Terentev
Ex Libris 6, no. 139
18.4 x 22.9 cm. (7¼ x 9 in.)
Collection Martin-Malburet

■ **Theater**

433.
Misterii-Buf: Geroicheskoe, epicheskoe i satiricheskoe izo-brazhennie nashei epokhi sde-lannoe Vladimirom Mayakovskiim (Heroic, Epic and Satirical Pre-sentation of Our Epoch by Vladimir Maiakovsky) by V. Maiakovsky
Petrograd, 1919
22 x 17.5 cm. (8⅝ x 6⅞ in.)
Collection Martin-Malburet

434.
Masterstvo teatra: Vremenik Kamernogo Teatra (The Theater Workshop: The Provisional Kamerny Theater)
Moscow, December 1922 (vol. 1), January 1923 (vol. 1)
20.3 x 12.7 cm. (8 x 5 in.)
Mr. and Mrs. H. C. Levy

435.
Teatr i muzyka (Theater and Music)
Moscow, 1923
vol. 35: 24 pp.; vol. 36: 66 pp.
31.5 x 22.9 cm. (12 x 9 in.)
Alma H. Law

436.
Zrelishcha (Performance)
ed. L. Kolpachki
Moscow, 1923 (vols. 67, 68)
40 pp. (40 pp.)
Vol. 67: 25.4 x 17.2 cm. (10 x 6¾ in.)
Vol. 68: 26.1 x 17.2 cm. (10¼ x 6¾ in.)
Alma H. Law

437.
Das entfesselte Theater by A. Tairov
Potsdam, 1923
112 pp. with illustrations designed by Lissitzky
Ex Libris 6, no. 278
24.8 x 17.8 cm. (9¾ x 7 in.)
a) Stedelijk Municipal Stadtisches van Abbemuseum, Eindhoven, The Netherlands
b) Leonard Hutton Galleries, New York

438.
Arena. Teatralnyi almanakh (Arena. Theatrical Almanac)
by M. Kuzmin, N. Evreinov, I. Annekov
Petrograd, 1924
114 pp.
Ex Libris 6, no. 6
25.2 x 15.2 cm. (9⅞ x 6 in.)
Alma H. Law

439.
Zhizn iskusstva (The Life of Art)
Petrograd, 1924 (vol. 42)
24 pp.
30.2 x 22.8 cm. (11⅞ x 9 in.)
Alma H. Law

440.
Teatr Meyerholda (Meierkhold's Theater) by I. Brukson
Leningrad, 1925
136 pp.
21 x 15 cm. (8¼ x 5⅞ in.)
Alma H. Law

441.
Teatry i zrelishcha (Theaters and Performances)
Leningrad, December 22–27, 1925
16 pp.
25.4 x 17.5 cm. (10 x 6⅞ in.)
Alma H. Law

442.
Les Bubus Mandat Rychi Kitai TIM (Forest Bubus Mandate Roar China TIM) by V. Meierkhold
Moscow, summer 1926
80 pp.
17.5 x 13.3 cm. (6⅞ x 5¼ in.)
Alma H. Law

443.
Teatralnyi Oktiabr (Theatrical October) by A. Goozden, V. Meier-khold, et al.
Moscow/Leningrad, 1926
184 pp.
25.1 x 16.2 cm. (9⅞ x 6⅜ in.)
Alma H. Law

444.
Afisha TIM (Playbill of TIM Theater)
Moscow, November 1926, vol. 3
32 pp.
17.2 x 13 cm. (6¾ x 5⅛ in.)
Alma H. Law

445.
Revizor v teatre imeni Meyer-holda (The Director in the Thea-ter Named for Meierkhold)
Leningrad, 1927
72 pp. designed by Meierkhold
17.8 x 13.1 cm. (7 x 5⅛ in.)
Alma H. Law

446.
Das Russische Theater (The Russian Theater) by J. Gregor and R. Fülöp-Miller
Zurich, 1928
138 pp. with 405 illustratons
Ex Libris 6, no. 336
31.1 x 22.9 cm. (12¼ x 9 in.)
a) Los Angeles County Museum of Art
b) Mr. and Mrs. H. C. Levy

447.
Printsessa Turandot teatralno-tragicheskaia Kitaiskaia skazka v 5 Aktakh (The Princess Turandot. A Theatrical-Tragic Chinese Story in Five Acts) by C. Gozzi
Moscow/Petrograd, n.d.
222 pp. with 11 reproductions
Ex Libris 6, no. 76
33.3 x 27.7 cm. (13⅛ x 9¼ in.)
Ars Libri, Ltd., Boston

■ **Film**

448.
Kino (Film) ed. I. Bursak
Moscow, 1925
Book with designs by E. Mukhina, et. al.
Jay Leyda

449.
Eizenshtein. Bronenosets Potemkin (Eisenstein: Battleship Potemkin)
Moscow/Leningrad, 1926
16 pp.
14.9 x 11.5 cm. (5⅞ x 4½ in.)
Alma H. Law

450.
Kinotriuki (Film Tricks)
by F. Talbot
Leningrad, 1926
64 pp. with cover by N. P. Akimov
18.4 x 14 cm. (7¼ x 5½ in.)
Alma H. Law

451.
Le Cinema en URSS (The Film in the USSR)
Moscow, 1936
307 pp. with designs by V. Stepanova and A. Rodchenko
26.7 x 19.1 cm. (10½ x 7½ in.)
Australian National Gallery, Canberra

■ **Music**

452.
Elektricheskii shimmi-foks (An Electric Shimmy Foxtrot)
Moscow, 1926?
4 pp. with cover design by B. Titov
35.6 x 26 cm. (14 x 10½ in.)
The Institute of Modern Russian Culture, Blue Lagoon, Texas

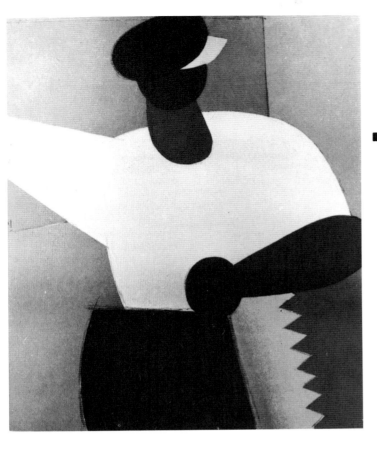

453.
**Kariera Pirpointa Bleka. Kongo
(The Career of Pierpoint Blake.
Congo)** by B. Fomin
Moscow, 1926
4 pp. with cover design by N.
Rogovitsky?
35.6 x 26 cm. (14 x 10½ in.)
The Institute of Modern Russian
Culture, Blue Lagoon, Texas

454.
Lunnyi svet (Moonlight)
by G. Bruni
Leningrad, 1926?
4 pp.
33 x 26 cm. (13 x 10¼ in.)
The Institute of Modern Russian
Culture, Blue Lagoon, Texas

455.
Valse Clishy (misprint for Valse
Clichy) by Anatolii Pereselentsev
Moscow, 1926, vol. 1
4 pp. with cover design by A. F.
(not known)
35.6 x 26 cm. (14 x 10½ cm.)
The Institute of Modern Russian
Culture, Blue Lagoon, Texas

■ **Children's Books**

456.
**Apelsinnyia Korki (The Orange
Peels)** by M. Moravskaia
Berlin, 1923?
56 pp. with illustrations by S.
Chekhonin
23.5 x 17.8 cm. (9¼ x 7 in.)
The Institute of Modern Russian
Culture, Blue Lagoon, Texas

457.
Okhota (The Hunt) by V. V. Lebedev
Leningrad, 1925
12 pp. with illustrations by Lebedev
27.9 x 22.2 cm. (11 x 8¾ in.)
The Institute of Modern Russian
Culture, Blue Lagoon, Texas

458.
**Primus. Detskie stikhotvoreniia
(Primus. Children's Verses)**
by O. Mandelshtam
Leningrad, 1925
Book with color lithograph cover by
Dobuzhinsky
29.5 x 22.5 cm. (11⅝ x 8⅞ in.)
Alexandre Polonski

■ **Posters**

459.
K. Malevich
**Nu i tresk, nu i grom-zhe...(What
a Boom! What a Blast!...)**
Anti-German propaganda poster,
text by Maiakovsky
Moscow, 1915
Color lithograph
38 x 55.9 cm. (55 x 22 in.)
Dallas Museum of Fine Arts, Dallas
Art Museum League in Honor of Mr.
and Mrs. James H. Clark

460.
V. Khlebnikov
Trumpet of the Martians, 1916
Poster
77 x 43 cm. (30⅜ x 16⅞ in.)
Alexandre Polonski

461.
The Last Futurist Exhibition: 0–10
Petrograd, December 19, 1915–
January 19, 1916
Poster
74 x 55.5 cm. (29⅛ x 21½ in.)
Collection Mr. and Mrs. Herman
Berninger, Zurich, Switzerland

462.
**Sezd Komitetov derevenskoi
bednoty (Congress of Commit-
tees of Peasant Poverty),** 1918
Color lithograph
(Front cover also used as poster;
back cover with simplified image)
Dallas Museum of Fine Arts, Dallas
Art Museum League Fund in Honor
of Mr. and Mrs. James H. Clark

V. Stepanova
Poster for "Tarelkin's Death,"
1922
(see Stepanova checklist no. 348)

V. Stepanova
**Upper Half, Poster for "Tarelkin's
Death,"** 1922
(see Stepanova checklist no. 349)

463.
V. Lebedev
**Russkii plakat (Russian
Placards)**
Petrograd, 1923
Portfolio with 23 color lithographs
Ex Libris 6, no. 153
21.6 x 19 cm. (8½ x 7½ in.)
Mr. and Mrs. A. L. de Saint-Rat,
Miami University, Oxford, Ohio

464.
V. Lebedev, V. Maiakovsky, D. Moor,
M. Cheromnykh, et al.
**Revoliutsionnyi plakat (The
Revolutionary Poster)**
Moscow, 1924
Ex Libris 7, no. 87
34.9 x 26.7 cm. (13¾ x 10½ in.)
Mr. and Mrs. A. L. de Saint-Rat,
Miami University, Oxford, Ohio

465.
Robert Bonfils
Paris 1925, poster for **Exposition
internationale des arts décoratifs
et industriels modernes**
Color lithograph poster mounted
on linen
55.9 x 38.1 cm. (22 x 15 in.)
The Robert Gore Rifkind Founda-
tion, Beverly Hills, California

465

After the revolution of 1905, half-hearted reforms coupled with severe repressions and "punitive expeditions" into the countryside had gradually brought quiet to the Russian political scene. Most dissenters were either in exile in Siberia or living abroad.

1910

Publication of *The Spiritual Crisis of the Intelligentsia* (Moscow) by Nikolai Berdiaev, elaborating an earlier essay in Peter Struve's anthology of essays, *Landmarks (Vekhi),* 1909.

November. Death of Leo Tolstoi at a railroad station, in "flight" from his estate, Yasnaya Polyana, which touches off civil disorders in several Russian cities.

1913

The Romanov dynasty celebrates its 300th anniversary; celebrations include amnesty for most of the exiled Russian political figures and outlawed parties.

1914

June. Assassination of Archduke Francis Ferdinand, heir to the throne of Austria-Hungary.

July. Austria declares war on Serbia, sparking a general mobilization in Russia. Lenin and Trotsky emigrate to Switzerland.

August. Germany declares war on Russia. St. Petersburg is renamed Petrograd. Russians abroad return at the outbreak of war.

1915

May. Collapse of Russia's southern front before an Austro-German offensive in Galicia. Russian armies on this front completely demoralized. By September, Russia will lose all of Poland and Lithuania.

December–January. Gallipoli, the failure of the British offensive against the Dardanelles. The Straits remain closed, cutting Russia off from supplies.

1916

June–September. Strait of the Russian offensive on the southern front, directed by General Brusilov, which is stopped by the arrival of German divisions from the western front. Heavy Russian losses again demoralize the troops.

1917

February. Petrograd, the Revolution begins. The Duma meets and deliberates, forming a provisional government.

March. The Republic is established; the provisional government is declared, with Kerensky soon at

its head; he attempts to continue the war effort in common with the Allies. Proletkult (proletarian cultural organization) is established as a formal entity.

April–May. Return of Lenin, Lunacharsky, Trotsky, and other Bolshevik leaders.

September. General Kornilov marches on Petrograd with the remnants of the army in an unsuccessful counter-revolutionary movement.

October 25 (November 7, New Style). The Storming of the Winter Palace, Petrograd. Bolshevik Revolution places Lenin at the head of the government.

November. The new Bolshevik regime offers the Germans an armistice, which is concluded December 15.

December. Revolt of the Don Cossacks, led by General Kornilov and General Kaledin, marks the start of the Civil War.

1918

January 31. Gregorian calendar is introduced, marking the end of Old Style dating system.

March. Government is moved to Moscow due to the German advance and to the establishment of independent governments in territories along Russia's frontier.

April. Versailles, signing of the Covenant of the League of Nations.

June. Signing of the Treaty of Versailles.

July. Promulgation of the first Soviet Constitution, adopted by the Fifth All-Russian Congress of Soviets.

Murder of the tsar and his family.

1919

March. Founding of the Third International (Komintern) for the propagation of communist doctrine abroad.

1920

November. The White Army is forced to evacuate the Crimea, retreating to Constantinople. The Russian economy collapses, and a severe famine lasts the winter.

1921

February–March. The mutiny of the officers and uprising of the sailors at Kronstadt serves to force the government to institute the New Economic Policy, unveiled at the Tenth Party Congress; this NEP restores a free market system and encourages production. The terror abates somewhat as reconstruction gets under way.

1922

December. Union of Soviet Socialist Republics is declared.

1924

January 21. Death of Vladimir Ilich Lenin marks the beginning of the power struggle between Trotsky and Stalin; the latter will be victorious in 1927–28.

January 26. Petrograd renamed Leningrad.

January 31. Formal adoption of the second Constitution of the USSR.

February. Great Britain recognizes the Soviet Union.

October. France recognizes the Soviet Union.

1925

July. The Communist Party Central Committee's resolution "On the Party's Policy in the Field of Artistic Literature" calls for a style "comprehensible to the millions" while also advocating continued open competition among different artistic tendencies.

1926

April. Germany signs a treaty of friendship and neutrality with the Soviet Union.

1927

November. Trotsky expelled from the Party, the Politburo, and the Central Committee of the Communist Party.

Winter. A bad harvest leads the wealthier peasants to hoard their grain; the poor peasants are encouraged to turn on their kulak neighbors. Terror resumes its full strength. NEP comes to an end.

December. Adoption of the first Five Year Plan.

1929

New York, the stock market crash signals the Depression.

1930

September. In Germany, Hitler's National Socialist (Nazi) Party emerges as a major force during the Reichstag elections; the beginning of a period of clashes between Nazi and Communist groups.

1932

Decree issued "On the Reconstruction of Literary and Art Organizations" disbanding all cultural groups.

1934

Socialist Realism ratified as official Soviet style at First All-Union Congress of Soviet writers.

1910

Publication of Andrei Bely's anthology of articles, *Symbolism,* and his novel, *Silver Dove,* in Moscow.

Anton Pevsner enters his second year at St. Petersburg Academy of the Arts; Tatlin enters the Moscow Institute of Painting, Sculpture, and Architecture.

January. The first Izdebsky Salon enters its second month in Odessa; this large, international art exhibition brings together both Russian and Western art, and a section of children's drawings, to several cities in Russia (Kiev, March; St. Petersburg, May; Riga, July). Alexandre Mercereau assisted in organizing the Western contemporary art section.

February. St. Petersburg, formal registration of the Union of Youth, one of the most long-lived avant-garde exhibition societies, which also publishes a magazine and sponsors debates and plays.

March. St. Petersburg, first exhibition of the Union of Youth; concurrent exhibition of the Triangle group, organized by Kulbin, contains sections of drawings by Russian writers, and a painting section, Venok-Staphanos. Publication of *Impressionists' Studio,* edited by Kulbin.

April. St. Petersburg, publication of *Sadok sudei (A Trap for Judges).* Appearance in Moscow of the last number of *Solotoe runo (Golden Fleece).*

December. Odessa, second Izdebsky Salon, including work by Kandinsky and the Burliuks, and large numbers of work by artists of the Western and Russian vanguards; the catalog contains essays by Kandinsky and Arnold Schönberg. In Moscow the first *Jack of Diamonds* exhibition is organized by Larionov.

1911

Publication in Germany of Skriabin's *Prometheus (Poem of Fire),* composed 1909–10. Publication in St. Petersburg of P. D. Uspensky's *Tertium Organum.* Tatlin designs set and costumes for the play *Tsar Maxmillian and his Unruly*

Son Adolphe, staged in Moscow at the Literary-Artistic Circle.

Summer. Khlebnikov and Larionov visit the Burliuks at their home in the south, Chernianka.

September. Larionov graduates from the Moscow Institute of Painting, Sculpture, and Architecture; he breaks with the Burliuks over the organization of the second *Jack of Diamonds* exhibition.

December. Moscow, one-day exhibition of Larionov's work at Society of Free Aesthetics. E. Gordon Craig's production of *Hamlet* at the Moscow Art Theater uses spare, geometric sets and props; it is attended by David Burliuk and Vladimir Mayakovsky. The poet Benedikt Livshits stays with the Burliuks at Chernianka, after being introduced to them by Alexandra Exter, who is just returned from Paris with photos of Picasso's latest Cubist paintings. In St. Petersburg, the first All-Russian Congress of Artists opens, at which Kandinsky's *Concerning the Spiritual in Art* is read by Nikolai Kulbin in Kandinsky's absence. A St. Petersburg cabaret, the Stray Dog, opens and remains a gathering place for artists and literati until its close in spring 1915.

1912

Publication of a Russian translation of Walter Pater's *Renaissance.*

January. Moscow, the second *Jack of Diamonds* exhibition opens, without Larionov; organized by the Burliuks, it includes many Western vanguard artists, such as Delaunay, Matisse, Picasso, Léger, and Kandinsky.

March. Moscow, the exhibition of Larionv's new group "Donkey's Tail."

April. St. Petersburg, first issue of *The Union of Youth.*

June. Second issue of *The Union of Youth,* containing a Russian translation of Henri LeFauconnier's catalog statement from the second *Neue Kunstlervereinigung,* Munich, 1910, the Italian Futurist manifesto to the public, and V. Markov's principles of creativity.

Summer. I. and K. Zdanevich and M. Le-Dantiu find the Georgian folk painter, Niko Priosmanashvili, in Tifilis.

August. Publication of the first Russian Futurist poetry book, *Old-time Love,* by Aleksei Kruchenykh, with "ornament" by Larionov. Goncharova decorates another book, *A Game in Hell,* by Kruchenykh and Khlebnikov.

November. Publication of Alexandr Benois' hostile article "Cubism or Ridiculism?" in response to David Burliuk's talk on Cubism at the previous week's Union of Youth debate.

December. The opening in St. Petersburg of the fourth exhibition of the Union of Youth, including both the Larionov group and the Burliuks; some examples of Rayonist painting included. Publication of Kruckenykh and Khlebnikov's *World Backwards,* illustrated by Larionov, Goncharova, Tatlin, and Togovin, and *A Slap in the Face of Public Taste,* the most famous manifesto of the Hylaea group.

1913

February. Publication of *Sadok sudei II (A Trap for Judges II),* and Kruchenykh poems, *Hermits,* illustrated by Goncharova; *Half-Alive* and *Pomade,* illustrated by Larionov; also *Jack of Diamonds,* a collection of essays by LeFauconnier, Apollinaire, and Ivan Aksenov.

March. Moscow, third *Jack of Diamonds* exhibition. St. Petersburg, third issue of *The Union of Youth* marks the official amalgamation of the Union of Youth group with the Hylaea group of Russian Futurists, headed by the Burliuks. In Moscow, *The Target* exhibition, with a large number of Rayonist paintings; Malevich included in this exhibition, but soon splits with Larionov's group in favor of the Union of Youth.

Spring. Publication of Russian translations of Signac's *From Eugène Delacroix to Neo-Impressionism,* and of *Du Cubisme* by Gleizes and Metzinger. Moscow, Grishchenko publishes his book, *On the Links of Russian Painting with Byzantium and the West,* dedicated to Sergei Shchukin. A large show of Russian icons opens. In St. Petersburg,

at Dobychina's Art Bureau, the current exhibition includes Altman, Tozanova, and Shkolnik.

April. Moscow, Larionov organizes a show of icons and popular prints. In Moscow, the publication of Larionov's theory of Rayonism and the poetry collection *Service-Book of the Three.*

Mid-year. Moscow, foundation of the new journal of art and literature. *Sofiia,* edited by P. P. Muratov. Yakov Tugendkhold, art critic for the St. Petersburg journal *Apollon,* delivers a series of lectures in Moscow on French art of the 19th and 20th centuries. The poet, Benedikt Livshits, serves in the military. The Russian Futurists parade in Moscow with painted faces; Larionov's article in *Argus,* December 1913, explains why.

June. Publication of Alexandr Shevchenko's *Principles of Cubism and Other Contemporary Trends in Painting of All Ages and Nations*; Kruchenykh and Khlebnikov poem, *A Forestly Rapid,* illustrated by Rozanova, Kulbin, and Kruchenykh; Kruchenykh's *Let's G-r-r-rumble,* illustrated by Malevich and Rozanova; and Kruchenykh's *Explodity,* illustrated by Malevich, Rozanova, Kulbin, and Goncharova.

July. First All-Russian Congress of Singers of the Future (Poet-futurists) is held at Matiushin's dacha in Finland; present are Matiushin, Malevich, and Kruchenykh, who make plans for the opera *Victory Over the Sun.* Publication of *Donkey's Tail and Target,* and the first monograph on Goncharova and Larionov.

August. Moscow, exhibition of Goncharova's oeuvre (768 works, 1900–1913); a smaller show opens in St. Petersburg in early 1914.

September. St. Petersburg, publication of *The Three*; Kruchenykh's essay here uses the word *zaum,* "transrational," "trans-sense," or "translogical," for the first time.

October. Publication of *The Word as Such* by Kruchenykh and Khlebnikov, with illustrations by Malevich and Rozanova.

November. Publication of Shevchenko's *Neo-Primitivism.* Exhibition in St. Petersburg of the Union of Youth.

December. Futurist tour, in which D. Burliuk, V. Maiakovsky, and V. Kamensky give evenings of poetry and lectures on the new art throughout Russia. In St. Petersburg, the production of Kruchenykh's opera, *Victory Over the Sun,* and *Vladimir Maiakovsky: A Tragedy.* Publication of Andrey Bely's novel, *Petersburg.*

At a St. Petersburg cabaret, the Stray Dog, Alexandr A. Smirnov lectures on simultaneism and Robert Delaunay, and exhibits *La Prose du Transsibérien* by Cendrars, with ornamentation by Sonia Delaunay-Terk.

1914
January. Publication of the Burliuks' *Croaked Moon.*

February. Publication of *Futurists: Roaring Parnassus,* with funds provided by Ivan Puni (Pougny) and his wife, Xana Boguslavskaia, and of the second edition of *A Game in Hell,* with illustrations by Rozanova and Malevich.

March. Moscow, the *Jack of Diamonds* exhibition. Publication of *Vladimir Maiakovsky: A Tragedy* and the *First Journal of Russian Futurists*; Larionov's exhibition *No. 4,* which includes Kamensky's "ferro-concrete" poetry.

Spring. Posthumous publication of V. Markov's brochure on *Texture*; and the first number of the bimonthly *Russian Icon,* edited by S. Makovsky.

November. Kandinsky returns to Russia, along with numerous other Russian artists and writers living abroad. Publication of Goncharova's album of lithographs, *Mystical Images of War.*

1915
Gabo makes his first constructions. *Exhibition of Leftist Trends,* Petrograd.

February–March. Petrograd, *Tramway V* exhibition, at which Malevich shows "alogical" paintings and Tatlin shows his "painterly reliefs." Publication of Pavel Filonov's

Sermon-Chant about Universal Sprouting and of the miscellany *The Archer,* which includes writings of Blok, Kuzmin, Remizov, the Hylaea group, and an interview with Ezra Pound. In Moscow, the *Exhibition of Painting, 1915,* includes Rayonism, Tatlin's reliefs and "counter-reliefs," and his "constructions of materials"; the Burliuks show a pair of trousers with a bottle stuck to them, Maiakovsky a top hat cut in two, with two gloves nailed next to it, and Kamensky, a live mouse in a trap.

April. Death of Scriabin.

May. Possible creation of Suprematist work in a drawing of the curtain, a black square, for the second, unrealized publication of Kruchenykh's opera *Victory Over the Sun.*

Late. Publication of *Took: a Futurist Drum,* influenced by the English Vorticist Publication *Blast.* Foundation of the Jewish Society for the Encouragement of the Arts, with branches in Petrograd, Moscow, Kiev, and Kharkov.

December. Publication of Malevich's *From Cubism to Suprematism: The New Painterly Realism* (a second printing in January 1916). In Petrograd *The Last Futurist Exhibition of Pictures: 0–10* contains a separate room of Suprematist painting by Malevich and one of reliefs by Tatlin; also shown is a collective painting by Boguslavskaia, Kliun, Malevich, Puni, and Mikhail Menkov. Malevich's Suprematist room is the first public showing of Suprematist works like the famous *Black Square.*

1916
Publication of Berdiaev's *The Meaning of the Creative Act,* Moscow.

March. Moscow, *The Store* exhibition, to which Rodchenko sends geometric drawings.

Fall. Alexandra Exter designs the production of Annensky's *Famira Kifared.* Malevich moves to Vitebsk. The *Exhibition of Contemporary Russian Painting* includes Kandinsky, Malevich, and Popova, who shows her "painterly architectonics."

October. Petrograd, at the cabaret Comedians' Halt a tenth anniversary celebration is held for the poet Mikhail Kuzmin.

November. Moscow, the fifth *Jack of Diamonds* exhibition. Publication of the revised edition of Malevich's theory, under the title *From Cubism and Futurism to Suprematism: The New Painterly Realism.*
1917
Publication of Ivan Aksenov's monograph on Picasso, with cover by Exter. In Moscow, Yakulov, Tatlin, and Rodchenko decorate the Café Pittoresque.

End 1917. In Petrograd, Nikolai Punin is made Commissar of the Russian Museum, and formulates his radical ideas about the destruction of the old, bourgeois art. In Moscow, private art collections are requisitioned by the government.
1918
Publication in Petrograd of Alexandr Blok's poem *The Twelve,* with illustrations by Yuri Annenkov. In Moscow, Kandinsky publishes his autobiography. Nikolai Roerich emigrates. Tatlin heads IZO Narkompros, Moscow.

April. Resolution by art students at a conference in Petrograd, maintaining the autonomy of artistic creation. The Academy of Fine Arts is replaced by Free Art Studios (Svomas.) Lenin promulgates his Decree on Monumental Propaganda.

September. First All-Russian Proletarian Cultural and Education Organizations, Moscow.

October. Petrograd, Natan Altman in charge of decorations for the first anniversary celebration of the Revolution. Maiakovsky's *Mystery-bouffe,* in honor of the first anniversary of the Bolshevik Revolution, with sets by Malevich and directed by Meierkhold.

December. Petrograd, first numbers of *Iskusstvo kommuny,* the journal of IZO Narkompros, which published until April 1919; it is a platform for the anarchical statements of artists in Komfut (Communist-Futurists).
1919
Petrograd, the posthumous publica-

tion of V. Markov's *Art of the Negroes*; in Vitebsk, Malevich publishes *On New Systems in Art,* which will be revised and republished in 1920 in Moscow (in a much larger edition) as *From Cézanne to Suprematism*; both books continue his polemic against the official materialism of the young nation. S. Sudeikin and A. Yakovlev emigrate. Malevich begins work on a Suprematist architecture. Chagall resigns as director of the Vitebsk Practical Art Institute, Malevich takes over. Tatlin heads the painting department at Svomas, Moscow, then goes to Svomas in Petrograd. He begins work on his *Monument to the Third International.*

January. Moscow, the *Tenth State Exhibition: Non-Objective Creation and Suprematism* contains 220 works, all supposedly abstract; this is one of the last major collective vanguard exhibitions and inspired El Lissitzky to create his first "Proun" works.

May. Moscow, exhibition of Obmokhu (Society of Young Artists) at the Svomas, which is equipped with industrial machinery. K. Medunetsky and the Stenberg brothers advance Constructivism as the only guideline for a socialist art.

Summer. Petrograd, Nikolai Punin reads his Cycle of Lectures for student teachers of drawing; this will be published in May 1920.
1920
Publication of V. Maiakovsky's poem, *150,000,000,* Punin's *First Cycle of Lectures* (with covers by Malevich), his pamphlet on Tatlin's Tower, and Kandinsky's plan for Inkhuk. Roman Jakobson, poet, linguist, and central member of the Moscow Linguistic Circle since 1915, leaves for Prague. Puni emigrates to Berlin, and then to Paris in 1923. David Burliuk, in the process of emigrating to the U.S., exhibits in Tokyo. In Moscow, the second exhibition of Obmokhu, the foundation of the first working group of Constructivists.

May. Formation of Inkhuk (Institute of Artistic Culture) based in Moscow, under Kandinsky originally; later affiliates in Petrograd, under Tatlin and Punin, and in Vitebsk, under Malevich.

August. Publication of Gabo and Pevsner's "Realist Manifesto," simultaneously with their open-air exhibition.

October. Moscow, Nineteenth Exhibition of the All-Russian Central Exhibition Bureau of IZO Narkompros, including work of Rodchenko, Stepanova, Shevchenko.

End 1920. Kandinsky leaves Inkhuk after his educational program is rejected; the administration is reorganized by Rodchenko, Stepanova, the sculptor Babichev, and the musician Briusova, on theoretical, laboratory principles.

December. Publication in Vitebsk of Malevich's *Suprematism, 34 Drawings,* lithographed by El Lissitzky, to accompany a large Malevich retrospective in Moscow.
1921
Roman Jakobson, in Prague, publishes an analysis of Khlebnikov's *zaum* in *The Newest Russian Poetry.*

Restoration of the Academy of Fine Arts in Petrograd.

May. Moscow, third exhibition of Obmokhu.

Fall. Advocacy within Inkhuk of industrial and applied arts, to the exclusion of fine arts, thus associating Inkhuk with the Productivist movement.

September. Moscow, the exhibition *5 x 5 = 25* includes Rodchenko's red, yellow, and blue canvases; Stepanova, Vesnin, Popova, and Exter also exhibit.

November. Plenary session of Inkhuk, in which a majority of the group condemns easel painting as outmoded and advocates industrial art and construction.

Isadora Duncan performs at the Bolshoi Theater, Moscow.

Late 1921. Inkhuk is attached to the Russian Academy of Artistic Sciences, established in October 1921.
1922
Publication of El Lissitzky's *Story of Two Squares.* Proletkult is annexed to IZO Narkompros, of

which the general head is Shterenberg. Naum Gabo leaves Russia for Germany; Pevsner begins his constructions.

January. Exhibition of the resurrected World of Art, including A. Drevin, P. Konchalovsky, A. Lentulov, N. Udaltsova, R. Falk, et al. The 47th exhibition of the Wanderers, from whose ranks is organized the Association of Artists Studying Revolutionary Life (renamed the Association of Artists of Revolutionary Russia—AKhRR).

Spring. Popova designs sets and costumes for Meierkhold's production of Crommelynck's *The Magnanimous Cuckold,* staged April 25. Malevich moves from Vitebsk to Petrograd, followed by several of his students.

May. Moscow, *Exhibition of Pictures of Realistic Trends,* considered to be the first exhibition of AKhRR and the beginning of Socialist Realism. First exhibition in Moscow of the Makovets groups.

June. Petrograd, the exhibition *Union of New Trends in Art* includes work of Malevich and Tatlin. Exhibitions of AKhRR in Moscow.

Fall. Stepanova designs sets for Meierkhold's production of Sukhovo-Kobylin's *Tarelkin's Death.*

October. Publication of A. Gan's *Konstruktivizm*; Gan is dismissed in late 1920 from Narkompros for his trenchant, extremist position.

November. First exhibition of *NOZh (New Society of Painters),* former pupils of Exter, Malevich, and Tatlin, which helps reverse the trend away from easel art.

1923
Emigrations: Chagall, Korovin, Pevsner, and Somov to Paris; Nikolai Feshin (Rodchenko's teacher) to the U.S. Publication of Maiakovsky's poems *Pro eto (About That)* with photomontages by Rodchenko.

Brik and Maiakovsky found *Lef,* which publishes until 1925, succeeded by *Novyi Lef,* 1927–28. Popova designs sets and costumes for Tretiakov's *Earth on End,* pro-

duced by Meierkhold. Khlebnikov's *Zangezi* is staged by the Petrograd Inkhuk, with sets by Tatlin. The Vesnin brothers design a project for a Palace of Labor. Chashnik and Suetin apply Suprematist motifs to porcelain.

1924
Emigrations: Exter, Serebriakova, Annenkov, and Puni to Paris; M. Dobuzhinsky to Lithuania, Western Europe, and finally the U.S. Posthumous exhibition of the "artist-constructor," Popova.

January. Moscow, second exhibition of Makovets. Lenin's Mausoleum in Red Square is designed in a Constructivist vein by Shchusev.

Late spring. Moscow, Vkhutemas, *First Discussional Exhibition of Associations of Acting Revolutionary Art.* Publication of A. Lunacharsky's *Theater and Revolution.*

September. Moscow, establishment of the Psychophysical Laboratory in the State Academy of Artistic Sciences (GAKhN) by G. Shpet, L. Sabaneev, and others, based on Kandinsky's plan presented in June 1921. Exter designs sets and costumes for the science-fiction film *Aelita.* Publication of Trotsky's *Literature and Revolution.*

1925
Viktor Shklovsky publishes his main work, *On the Theory of Prose.* Pavel Filonov establishes the Collective of Masters of Analytical Art, Leningrad. Tatlin heads the department of theater and cinema, Kiev. The Party takes control over literature as a whole by the creation of the All-Union Association of Proletarian Writers. Lissitzky returns to Russia. Baranoff-Rossine emigrates to Paris. Publication of *Kunstismen* by Lissitzky and Arp in Zurich.

Early. Moscow, the foundation of the Society of Easel Artists (OST,) which upheld the continuing vitality of easel art. The foundation of the Four Arts Society, Moscow, interested in the decorative and lyrical aspects of art.

April. Melnikov designs the Soviet Pavilion for the Paris *Exposition internationale des arts décoratifs et industriels modernes*; Rodchenko

designs the furnishings for a workers' club, shown there; Shterenberg wins prizes in painting and engraving.

December. The suicide of the poet Essenin.

1926
Benois emigrates to Paris; Sarian visits for three years. Eisenstein releases his film *The Battleship Potemkin* and Pudovkin his film version of Gorky's *Mother.* The journal *Contemporary Architecture* is founded; ceases in 1930. Publication of *Asnova News,* edited by Lissitzky and Ladovsky.

1927
Esther Shub's film *The Great Road* in honor of the tenth anniversary of the October Revolution. Tatlin teaches at Vkhutein (until 1931); exhibits at the Russian Museum. Yakulov emigrates to Paris. Shterenberg has a one-man exhibition at the Museum of Painterly Culture, Moscow. Inkhuk is closed. Construction of the Izvestia Building, Moscow, designed by G. and M. Barkhin.

March. Malevich takes his one-man exhibition to Warsaw, Berlin, and Dessau; most of the paintings will never return to Russia.

April. Leningrad, Filonov's group exhibits.

May. Tokyo hosts a large exhibition of Soviet art.

November. Leningrad, the *Exhibition of Newest Trends in Art* is very much a retrospective affair.

1928
Venice, the Biennale includes a large section of Soviet art. Cologne, Lissitzky supervises the USSR pavilion at the *International Pressa* exhibition.

February. Moscow, the tenth exhibition of AKhRR.

March. Leningrad, exhibition of the Four Arts Society.

May. AKhRR, which has flourished economically under NEP, meets with difficulties in the first Five Year Plan. Its first Congress adopts a new declaration of artistic aims, replacing passive documentation with

more active revolutionary goals; AKhRR is shortened to AKhR. In Brussels, an exhibition of Old and New Russian Art opens.

August. Berlin, several Soviet avant-garde artists participate in an exhibition with German artists.
1929
Publication in Moscow of a collection of articles, *Russian Painting of the 19th Century,* by Y. M. Friche, the founder of a new school of Marxist art history. AKhR begins publication of the short-lived journal *Art to the Masses.* Anatolii Lunacharsky is replaced as Commissar of Instruction by Andrei Bubonov, formerly an administrator in the Red Army. Malevich is given a one-man show at the Tretiakov Gallery. Tatlin begins work on his flying machine, the *Letatlin* (exhibited in 1932). Dziga Vertov completes his film *Man With a Movie Camera.*

February. Moscow, first performance of Maiakovsky's play *The Bedbug.*

May. Moscow, exhibition of the Four Arts Society.

June. Moscow, the eleventh exhibition of AKhR, entitled *Art of the Masses.*

August. Establishment of the Union of Proletarian Architects.
1930
Publication of V. M. Lobanov's *Artistic Groups for the Last 25 Years.* In Kiev, Malevich publishes his last essay, "Architecture, Studio Painting, and Sculpture," while preparing for an unrealized one-man exhibition. Leningrad, Tatlin participates in the exhibition entitled *War and Art.* Moscow, Maiakovsky's last play, *The Bathhouse,* is performed. Vienna, publication of Lissitzky's *Architecture for World Reconstruction.* Leipzig, Lissitzky supervises the USSR contribution to the International Fur Trade Fair.

April. Maiakovsky commits suicide and his body lies in state in a catafalque built at Vkhutein.

June. Formation of the Federation of Soviet Artists' Associations which, despite its inclusive intentions, managed to attract only a small number of groups. In Moscow, work of Malevich is shown with that of 163 other artists whose works were bought in 1928–29 by the State Commission for the Acquisition of Works of Art. Malevich participates in the *Exhibition of Soviet Art* in Berlin.

1910
Travels. N. I. Altman in Paris at the Académie Russe of Marie Vasilieva. Chagall at the Academie de la Grande Chaumière. D. P. Shterenberg, studying with A. Marten, E. Anglada, and K. van Dongen, lives at La Ruche with J. Lipchitz and C. Soutine. P. P. Konchalovsky and C. S. Kruglikova also in Paris. El Lissitzky at the Technische Hochschule, Darmstadt, also travels to Italy and France. Naum Gabo begins medical studies at Munich University, but transfers in 1912 to the Polytechnicum Engineering School.

February. Publication of the "Manifesto of Italian Futurist Painters" as a leaflet by *Poesia* (Milan); a Russian translation of excerpts from this document appears in *Apollon,* July–August 1910.

Ernst Barlach travels to Russia.

June. Paris, Diaghilev's Ballets Russes performs Rimsky-Korsakov's *Scheherazade* (Bakst, Fokine) and Stravinsky's *Firebird* (Bakst, Golovine, Fokine). At Bernheim-Jeune an exhibition opens which contains work of Bakst and Chiurlionis, and others.

July. London, Third Allied Artists' Association exhibition includes Kandinsky's *Composition I.*

October. Kandinsky in Russia until December.

Paris, Salon d'Automne sponsors a lecture on Russian poetry, organized by A. Mercereau, which includes examples of contemporary verse in original Russian and French translation. Apollinaire writes of the Russian Artists of the Société Artistique et Littéraire Russe, Paris, and their current show.

November. London, Grafton Galleries exhibition of Manet and the Post-Impressionists, organized by Roger Fry.
1911
Travels. Paris. Anton Pevsner, in contact with Archipenko, Modigliani, and other artists of La Ruche; A. Lunacharsky writes theater criticism for *Teatr i Iskusstva,* St. Petersburg. N. A. Udaltsova studies along

with A. V. Lentulov at the studio La Palette, run by Metzinger, Le Fauconnier, and de Segonzac. Yuri P. Annenkov studies with M. Denis and F. Vallotton.

Summer. St. Petersburg, construction of Peter Behrens' German embassy.

June. Paris, Ballets Russes production of *Petrushka* (Stravinsky, Benois, Fokine). Kandinsky begins to plan for an artistic almanac with F. Marc, later named *Der Blaue Reiter*.

September. Blaise Cendrars visits St. Petersburg.

October. Matisse travels to Russia.

December. Munich, the first exhibition organized by the editors of the *Blaue Reiter*.

1912
Travels. Paris. L. S. Popova joins Udaltsova at La Palette. Vera V. Khlebnikova, sister of the Russian Futurist poet, studies with K. van Dongen at the Academie Wittig. I. Puni and X. Boguslavskaia study at the Académie de la Grande Chaumiére. Pavel Filonov travels to Italy and France, most likely through Germany.

January. Publication in Munich of Kandinsky's *Über das Geistige in der Kunst*.

Munich, second exhibition of the *Blaue Reiter*.

D. Burliuk travels to Germany, visits Munich, where Kandinsky has just published the *Blaue Reiter Almanach*. In Paris, the Ballets Russes performs Debussy's *L'après-midi d'un faune* (Bakst, Nijinsky).

Autumn. Kandinsky briefly visits Russia.

October. London, Grafton Galleries, Second Post-Impressionist Exhibition, organized by Roger Fry, with a section of Russian art organized by Boris Anrep. Paris, at the Salon d'Automne, F. Kupka first exhibits the "Amorpha" series of paintings; the exhibition also includes work of D. P. Shterenberg. At the Galerie La Boetie the *Section d'Or* exhibition is mounted.

November. André Salmon publishes *Le jeune peinture française,* Paris.

1913
Travels. Tatlin to German and Paris (his famous visit to Picasso's studio, where he sees the constructed guitars).

January. Munich, publication of Kandinsky's *Klange*; some of its poems also appear in the Russian vanguard publication *A Slap in the Face of Public Taste*.

February. New York, Armory Show, the introduction of European modern painting to the American public; the exhibition travels to Chicago and Boston. Blaise Cendrars begins work on *La prose du transsibérien,* the long poem which will be ornamented by Sonia Delaunay-Terk.

Summer. G. Yakulov and A. A. Smirnov visit with the Delaunays in Paris; later, Yakulov will claim Delaunay stole his ideas on solar and spectral combinations.

Mid-year. The Russian pavilion at the Venice exposition, designed by A. V. Shchusev (later to design Lenin's Mausoleum).

In Munich, Kandinsky continues preparations for a second volume (never realized) of the *Blaue Reiter,* with contributions from Larionov and others.

September. Berlin, first exhibition of Sonia Delaunay-Terk's and Blaise Cendrars's simultaneous book, *La prose du transsibérien. Erster deutscher Herbstsalon* opens at Galerie der Sturm, including work of Italian Futurists and Russian vanguard.

October. Paris, Salon d'Automne includes a section of Russian folk arts.

November–December. Emile Verhaeren visits Russia.

December. St. Petersburg, *La prose du transsibérien* exhibited at a cafe, the Stray Dog.

1914
London, publication of Clive Bell's *Art* partly in reaction against

Tolstoi's *What is Art?,* originally published in 1896.

January. Visit of F. T. Marinetti to Russia; with the exception of Malevich, the vanguard artists are united in their animosity toward Marinetti.

March. Paul Fort, French poet, feted in St. Petersburg at the Stray Dog. In Munich, Hugo Ball plans a book on the new theater with the participation of Kandinsky, Marc, von Hartmann, Fokine, Bekhteev, and Klee, but the War interrupts the venture.

Berlin, Archipenko exhibits at Galerie der Sturm with the catalog by Apollinaire. Paris, Carrà, Papini, Soffici visit as guests of Baroness Hélène d'Oettingen, sister of Serge Ferat (both compatriots of Alexandra Exter), publishers of *Les soirées de Paris.*

April. Rome, exhibition of Russian avant-garde art, includes Archipenko, Exter, Kulbin, Rozanova, and the Italian, Morandi.

May. Paris, Ballets Russes production of Rimsky-Korsakov's *Le Coq d'Or* (Goncharova, Fokine).

Paris, Apollinaire reports on Léger's lecture at the Académie Russe de Marie Vassilieff and announces the forthcoming exhibition of Larionov and Goncharova's works at Galerie Paul Guillaume.

June. Berlin, Chagall exhibits at Der Sturm. Larionov and Goncharova exhibit at Galerie Paul Guillaume; catalog includes preface by Apollinaire and French translation of Larionov's Rayonist theory.

Summer. Munich, second and last edition of *Der Blaue Reiter.*

July 14–August. Paris, publication of Apollinaire's calligrammes, in *Les Soirées de Paris.*

December. Kandinsky in Stockholm until March 1916, for his last meeting with Münter.

1917
Publication of Ivan Aksenov's *Pikasso i okrestnosti (Picasso and Environs)* in Moscow; the work was

written largely before the War, while Aksenov was still in Paris.

May. Paris, Ballets Russes performs *Les contes russes* (Larionov, Massine), and *Parade* (Cocteau, Satie, Picasso, Massine), the first "Cubist" ballet. The program contains an essay by Apollinaire which uses the word "sur-realisme" for the first time.
1919
Walter Gropius founds the Bauhaus in Weimar. In New York, the Société Anonyme is founded, in effect, the first museum of modern art in America. Also in New York, Max Eastman's *Education and Art in Soviet Russia in Light of Official Decrees and Documents* is published.
1920
Venice, twelfth International Art Exhibition, includes work of Goncharova, Larionov, Jawlensky, and other Soviet artists.
1921
December. Kandinsky returns to Germany. In 1922 he will head the Bauhaus painting class. In Amsterdam, El Lissitzky's design is used as the cover of the fourth number of *Wendigen*.
1922
George Grosz breaks with the Dada artists and makes a trip to Russia. In Moscow and Berlin, publication of I. Ehrenburg's *And Yet the World Goes Round*. In New York, Goncharova and Larionov exhibit at the Kingore Gallery.

Fall. Berlin, major exhibition of Russian and Soviet art at Gallery Van Diemen.

October. Weimar, Kongress der Konstruktivisten, led by Van Doesburg, which includes El Lissitzky. In Berlin, Lissitzky edits *Veshch/ Gegenstand/Objet* with Ilia Ehrenburg, and will stay abroad until 1925. Others in Berlin at this time: the poet Vladimir Maiakovsky, in contact with George Grosz, Raoul Hausmann, and John Heartfield; Diaghilev, who helps to obtain a visa for Maiakovsky to visit France.
1923
Berlin, an exhibition of Russian art, including El Lissitzky's *Proun Space*.

1924
Founding of the Blue Four group (Kandinsky, Klee, Jawlensky, and Feininger). First American presentation of the works of Exter, Malevich, Medunetsky, Stenberg, Tatlin, and others at the Galleries of the Société Anonyme, New York.

March. New York, Grand Central Palace, *Exhibition of Russian Art,* organized by Igor Grabar with a catalog by Christian Brinton.

June. Venice, International Exhibition includes a large section of Soviet art.
1925
The Bauhaus moves to Dessau; new building designed by Gropius is completed in late 1926.
In New York, the publication of Louis Lozowick's *Modern Russian Art* and Huntley Carter's *The New Theater and Cinema of Soviet Russia.*

Before Autumn. Yakulov visits Paris, where Diaghilev asks him to design sets and costumes for the ballet later called *Le pas d'acier.*
1926
El Lissitzky designs the Hanover Gallery room of abstract art. Roman Jakobson participates in the Prague Linguistic Circle. Publication of Kandinsky's *Punkt und Linie zu Flache.*

The Sesquicentennial Exposition of the Philadelphia Museum of Art includes a Russian section; an exhibition of modern art at the Brooklyn Museum of Art also includes Russian painting.
1927
Publication of the German edition of Malevich's *Die Gegenstandslose Welt,* a Bauhaus book.

December. Alfred Barr travels to Russia.
1928
Publication in Paris of A. Salmon's *L'art russe moderne.* Le Corbusier visits Russia.

Fall. Alfred H. Barr, Jr., publishes an article, "The 'LEF' and Soviet Art," in *Transition.*
1929
Berlin, publication of Jan Tschichold's *Die neue Typographie.* Le Corbusier again visits Russia.

Spring. New York, Alfred H. Barr, Jr., includes discussion of Russian art in a series of lectures at the Museum of Modern Art, entitled "Cubism and Abstract Art."
1930
Le Corbusier visits Russia for the third time. L. Aragon attends the Second International Congress of Revolutionary Writers in Kharkov.

1937
Constructive Art, London Gallery, London.

Konstruktuvisten, Kunsthalle, Basel.
1938
International Nutidskunst—Konstruktivisme, Neoplasticisme, Abstracte Kunst, Surrealisme, Oslo Museum, Oslo.
1957
Rodchenko, House of Journalists, Moscow.
1958
Kasimir Malewitsch, Kunstverein, Braunschweig.
1959
Kasimir Malevich, 1878–1935, Whitechapel Gallery, London.

Casimir Malevic, Galleria Nazionale d'Arte Moderna, Rome.
1961
Larionov-Goncharova, Galerie Beyeler, Basel.

Art abstrait constructif international, Galerie Denise René, Paris.
1962
Two Decades of Experiment in Russian Art, 1902–1922, Grosvenor Gallery, London.

Konstruktivisten, Stadtisches Museum, Leverkusen.
1963
Goncharova-Larionov, Musée d'art moderne de la ville de Paris.

Pavel Mansurov, Galleria Lorenzelli, Milan.
1964
Russkii vklad v plasticheskie avangarde. Il contributo russo alle avanguardie plastiche, Galleria del Levante, Milan.
1966
An Introduction to El Lissitzky, Grosvenor Gallery, London.

Gonjarova-Larjonov-Mansourov, Galleria Lorenzelli, Bergamo.

El Lissitzky, Stedelijk van Abbe-museum, Eindhoven.

Konstruktive Malerei, 1915–1930, Kunstverein, Frankfurt.

Weiss auf Weiss, Kunsthalle, Bern.
1967
Aspects of Russian Experimental

Art, 1900–1925, Grosvenor Gallery, London.

Michel Larionov, Musée des beaux-arts, Lyon.

Agitatsionno-massovoe iskusstvo pervykh let oktiabr'skoi revoliutsii, Moscow.

Pavel Filonov. Pervaya personal' naya vystvka, Novosibirsk.
1968
Vladimir Tatlin, Moderna Museet, Stockholm.

Russische Kunstler aus dem 20. Jahrhundert, Galerie Gmurzynska-Bargera, Cologne.

L'art d'avant-garde russe, Musée d'art moderne, Paris.

Alexander Rodchenko, Moscow.
1969
Larionov, Galerie de Paris, Paris.

L'art d'avant-garde russe, 1905–1925, Galerie Jean Chauvelin, Paris.
1970
The Non-Objective World, 1914–1924, Annely Juda Fine Art, London; Galerie Jean Chauvelin, Paris; Galleria Milano, Milan.

Kasimir Malevich, Stedelijk Museum, Amsterdam.

Koudriachov, Galerie Jean Chauvelin, Paris.

Malevitch: Dessins, Galerie Jean Chauvelin, Paris.
1971
Art in Revolution: Soviet Art and Design since 1917, Hayward Gallery, London; subsequently at the New York Cultural Center, New York.

The Non-Objective World, 1924–1939, Annely Juda Fine Art, London; Galerie Jean Chauvelin, Paris; Galleria Milano, Milan.

Kasimir Malevic, Galleria Breton, Milan.
1972
The Non-Objective World, 1939–1955, Annely Juda Fine Art, London; Galerie Liatowitsch, Basel; Galleria del Levante, Milan.

Alexandra Exter, Galerie Jean Chauvelin, Paris.

Konstruktivismus. Entwicklungen and Tendenzen seit 1913, Galerie Gmurzynska-Bargera, Cologne.

Larionov, Maison de la culture de Nevers et la Nièvre, France.
1973
The Non-Objective World, 1914–1955, Annely Juda Fine Art, London; subsequently at University Art Museum, Austin, Texas.

Tatlin's Dream: Russian Suprematist and Constructivist Art, 1910–1930, Fischer Fine Art Ltd., London.

Progressive russische Kunst. Der Sufbruch bis 1930 & Lev Nussberg und die Moskauer Gruppe/Bewegung, Galerie Gmurzynska, Cologne.

Progetti di Sant'Elia & Tchernikov: La Citta Macchina, Assessora Cultura, Vicenza.

Retrospective Goncharova, Maison de la culture de Bourges.
1974
Russian Constructivism Revisited, Hatton Gallery, University of Newcastle, Newcastle-upon-Tyne, England.

Von der Flache zum Raum/From Surface to Space: Russland/Russia 1916–1924, Galerie Gmurzynska, Cologne.

Kunst—über Kunst. Malewitsch, Klee, nach 1945, Kunstverein, Cologne.

Der Konstruktivismus und seine Nachfolge in Beispielen aus dem Bestand der Staatsgalerie Stuttgart und ihrer graphische Sammlung, Staatsgalerie, Stuttgart.

Der Beitrag Russlands Avantgarde der Zehner und Zwanziger Jahre, Galerie Johanna Ricard, Nuremberg.
1975
2 Stenberg 2 et la période "laboratoire" (1919–1921) du constructivisme russe/The "Laboratory" Period (1919–1921) of Russian Constructivism, Annely Juda Fine Art, London; Art Gallery of Toronto, Toronto.

European Exhibitions

Maiakovski: 20 ans de travail, Musée national d'art moderne, Centre Georges Pompidou, Paris; traveled to Le Havre, Bordeaux, Rennes, Amiens, Avignon, St. Etienne, Grenoble; also shown and published as *Maiakovski: 20 jahre Arbeit,* Kunstlerhaus Bethanien, Berlin.

The Graphic Art of Kasimir Malevich, Stedelijk Museum, Amsterdam; Musée d'art moderne de la ville de Paris; Stadtische Galerie im Lenbachhaus, Munich; organized by and first shown at The Israel Museum, Jerusalem, 1975–76.
1976
El Lissitzky, Galerie Gmurzynska, Cologne

Russian Pioneers and the Origins of Non-Objective Art, Annely Juda Fine Art, London.

Larionov-Goncharova Retrospective, Musée d'Izelles, Brussels.

Russian Suprematist and Constructivist Art, Fischer Fine Art Ltd., London.

Kasimir Malevich, Tate Gallery, London.

Kasimir Malevich, Stedelijk Museum, Amsterdam.
1977
El Lissitzky, 1890–1941, Museum of Modern Art, Oxford, England.

Malevich: The Graphic Work, Institute of Contemporary Art, London.

The Suprematist Straight Line: Malevich, Suetin, Chashnik, Lissitzky, Annely Juda Fine Art, London.

Tendenzen der Zwanziger Jahre, Nationalgalerie, Akademie der Kunste, and Grosse Orangerie des Schlosses Charlottenburg, Berlin.

Die Kunstismen in Russland (The Isms of Art in Russia, 1907–1930), Galerie Gmurzynska, Cologne.

Aspects Historiques du Constructivisme et de l'Art Concret, Musée d'art moderne de la ville de Paris.

Suprematisme, Galerie Jean Chauvelin, Paris.

Rodtchenko. Photographe, Musée d'art moderne de la ville de Paris.

V. E. Tatlin, Central House of Literature, Moscow.
1978
Petr Miturich, 1887–1956, Tretiakov Gallery, Moscow.

Liberated Form and Color: Russian Non-Objective Art, Scottish National Gallery of Modern Art, Edinburgh.

The World Backwards: Russian Futurist Books, 1912–1916, British Library, London.

Russische Avantgarde 1910–1930, Galerie Bargera, Cologne.

Kasimir Malewitsch zum 100. Geburtstag, Galerie Gmurzynska, Cologne.

Malevitch, Musée national d'art moderne, Centre Georges Pompidou, Paris.

L'espace urbain en URSS, 1917–1978, Centre de création industrielle, Centre Georges Pompidou, Paris.
1979
Alexander Rodchenko, Museum of Modern Art, Oxford, England.

Kandinsky, Trente Peintures de Musée Sovietiques, Centre Georges Pompidou, Paris.

Paris-Moscou, Centre George Pompidou, Paris.

Oeuvres Russes de collections privées, 1913–1925, Galerie Jean Chauvelin, Paris.

Künstlerinnen der russischen Avantgarde 1910–1930, Galerie Gmurzynska, Cologne.
1980
Kazimir Malewitsch, Kunsthalle, Düsseldorf.

United States Exhibitions

1930
35th Exhibition of the Société Anonyme, Rand School of Social Science, New York, October (including works by El Lissitzky).

36th Exhibition of the Société Anonyme, Rand School of Social Science, New York, November (including works by Burliuk and Peri).
1931
37th Exhibition of the Société Anonyme, Rand School of Social Science, New York.

"Russica": An Exhibition of Contemporary Russian Art, Wilmington Society of the Fine Arts, Delaware (1931–32).
1934
The Art of Soviet Russia, America-Russia Institute of the Pennsylvania Museum of Art, Philadelphia, Pennsylvania (1934–35).
1936
Cubism and Abstract Art, Museum of Modern Art, New York.
1939
The Collection of the Société Anonyme: Museum of Modern Art, 1920, George Walter Vincent Smith Art Gallery, Springfield, Massachusetts.
1941
Exhibition of Russian Art: Christian Brinton Collection, Circulated (1941–42) by the Philadelphia Museum of Art to:
The Museum of Fine Arts, Houston, Texas
M. H. deYoung Memorial Museum, San Francisco, California
The Museum of New Mexico, Santa Fe, New Mexico
Grand Rapids Museum, Michigan
The Cincinnati Museum, Ohio
The Fort Wayne Art School and Museum, Indiana
The Toledo Museum, Ohio
The George Walter Vincent Smith Art Gallery, Springfield, Massachusetts
The Reading Museum, Pennsylvania
The Washington County Museum of Fine Arts, Hagerstown, Maryland.
1942
The Collection of the Société Anonyme, Yale University Art Gallery, New Haven, Connecticut.
1944
Variety in Abstraction, circulated by The Museum of Modern Art (1944–46) to:
Isaac Delgado Museum of Art, New Orleans, Louisiana
Vassar College Art Gallery, Poughkeepsie, New York
University of Delaware, Newark
Cincinnati Art Museum, Ohio
Indiana University, Bloomington
Dartmouth College, Hanover, New Hampshire
Alfred University, Alfred, New York
Rochester Memorial Art Gallery, Rochester, New York
Cornell University, College of Home Economics, Ithaca, New York
Arts Club of Chicago, Illinois
Museum of The Cranbrook Academy, Bloomfield Hills, Michigan.
1945
Russian Art, Philadelphia Museum of Art, and at William Rockhill Nelson Gallery of Art, Kansas City, Missouri.
1948
Naum Gabo and Anton Pevsner, Museum of Modern Art, New York.
1949
The Société Anonyme Collection, lent by Yale University, Institute of Contemporary Art, Boston, and The Dwight Art Memorial, South Hadley, Massachusetts.

El Lissitzky, Pinacoteca Gallery, New York.
1950
Collection of the Société Anonyme: Museum of Modern Art, 1920, Yale University Art Gallery, New Haven, Connecticut.
1953
Gabo: Space and Kinetic Constructions, Pierre Matisse Gallery, New York.
1960
Construction and Geometry in Painting from Malevich to Tomorrow, Galerie Chalette, New York.
1962
Modern Sculpture from the Joseph H. Hirshhorn Collection, Solomon R. Guggenheim Museum, New York.
1967
Russian Stage and Costume Designs for the Ballet, Opera and Theater: A Loan Exhibition from the Lobanov-Rostovsky, Oenslager and Riabov Collections, circulated by the International Exhibitions Foundation (1967–69).

A Survey of Russian Painting, from the Fifteenth Century to the Present, Museum of Modern Art, New York.

1968

Naum Gabo, Albright-Knox Art Gallery, Buffalo, New York.

Plus by Minus: Today's Half-Century, Albright-Knox Art Gallery, Buffalo, New York.

1969

Michel Larionov, Acquavella Galleries, New York.

1971

Alexander Rodchenko, Museum of Modern Art, New York.

Russian Art of the Revolution, Andrew Dickson White Museum, Cornell University, Ithaca, New York; The Brooklyn Museum, Brooklyn, New York.

Constructivist Tendencies, Andrew Dickson White Museum, Cornell University, Ithaca, New York.

Russian Avant-garde, 1908–1922, Leonard Hutton Galleries, New York.

Art and Architecture—USSR —1917–1932, Institute for Architecture and Urban Studies, New York.

Art in Revolution: Soviet Art and Design since 1917, New York Cultural Center, New York (organized by the Arts Council of Great Britain).

1972

Vasily Kandinsky, 1866–1944, in the Collection of the Solomon R. Guggenheim Museum, New York, Guggenheim Museum.

The Constructive Line, St. Peter's College Centennial Art Gallery, Jersey City, New Jersey.

1973

The Non-Objective World, 1914–1955, University Art Museum, University of Texas at Austin (organized by Annely Juda Fine Art, London).

Kasimir Malevich, Solomon R. Guggenheim Museum, New York, and the Pasadena Museum of Art, California (organized by the Stedelijk Museum, Amsterdam).

Futurism, A Modern Focus: The Lydia and Harry Lewis Winston Collection, Dr. and Mrs. Barnett Malbin, Solomon R. Guggenheim Museum, New York.

1975

Alexandra Exter: Marionettes, Leonard Hutton Galleries, New York.

Russian Avant-Garde Graphics and Books, Carus Gallery, New York.

1976

Stage Designs and the Russian Avant-Garde (1911–1929): A Loan Exhibition of Stage and Costume Designs from the Collection of Mr. and Mrs. Nikita D. Lobanov-Rostovsky, New York Public Library of Performing Arts at Lincoln Center, New York (organized and circulated by the International Exhibitions Foundation).

1977

Russian Painters and the Stage, 1884–1965: A Loan Exhibition of Stage and Costume Designs from the Collection of Mr. and Mrs. Nikita D. Lobanov-Rostovsky, University Art Museum, University of Texas at Austin.

Russian and Soviet Painting: An Exhibition from the Museums of the U.S.S.R., Metropolitan Museum of Art, New York, and The Fine Arts Museums of San Francisco.

Graphic Design of the 1920s and 30s, Museum of Modern Art, New York.

1978

Malevich and his Circle: An Anniversary Tribute, Rosa Esman Gallery, New York.

The Work of Ivan Leonidov: Russian Visionary Architect, 1902–1959, Institute for Architecture and Urban Studies, New York.

1979

Constructivism and the Geometric Tradition: Selections from the McCrory Corporation Collection, Albright Knox Art Gallery, Buffalo, New York, and travels to Dallas Museum of Fine Arts, Texas; San Francisco Museum of Modern Art, California; La Jolla Museum of Contemporary Art, California; Carnegie Institute, Pittsburgh, Pennsylvania; Nelson-Atkins Museum, Kansas City, Missouri; Detroit Institute of Arts, Michigan; Milwaukee Art Center, Wisconsin.

Ilya Gregorevich Chashnik, Leonard Hutton Galleries, New

York, November–March 1980.

1980

Journey into Non-Objectivity: The Graphic Work of K. Malevich and Other Members of the Russian Avant-Garde, Dallas Museum of Fine Arts, Texas, January–February.

Alexandra Exter, Hirshhorn Museum and Sculpture Garden, Washington, D.C., spring 1980.

1930
Burliuk, D., ed., *Color and Rhyme,* pub. Burliuk, Hampton Bays, New York, 1930–66.

Gregor, J., and R. Fülöp-Miller, *The Russian Theater,* trans. P. England, Philadelphia.
1937
Schapiro, M., "On the Nature of Abstract Art," *Marxist Quarterly,* January–March.
1944
Dreier, K. S., *Burliuk,* Museum of Modern Art—Société Anonyme, New York.
1949
Gabo, N., et al., *Three Lectures on Modern Art,* New York.
1955
Benua, A., *Zhizn' khudozhnika. Vospominaniya,* TT. 1 and 2, New York.

Makovskii, S., *Portrety sovremennikov,* New York.

Sherbatov, S., *Khudozhnik v ushedshei Rossii,* New York.
1959
Malevich, K., *The Non-Objective World,* trans. Howard Dearstyne, Chicago.
1960
Jalensky, K. A., "The Avant-garde and the Revolution," *Arts,* October.

Ilin, M., *Vesiny,* Moscow.
1961
Khardzhiev, N., "A. M. Rodchenko," *Iskusstvo knigi,* 2nd ed. of 1956–57 pub., Moscow.
1962
Gray, C., *The Great Experiment: Russian Art, 1863–1922,* New York.

Khardzhiev, N., "El Lissitzky—Konstruktor knigi," *Iskusstvo knigi,* Moscow.

Abolina, R., *Sovetskoe iskusstvo perioda grazhdanskoi voiny i pervykh let stroitel'stva sotsializma,* Moscow, 1917–1932.
1963
Conrads, U., and H. Sperlich, eds., *The Architecture of Fantasy,* trans. Christianne Crasemann Collins and George R. Collins, New York.

Abramova, A. "Odna iz pervykh" (on Stepanova), *Dekorativnoe iskusstvo SSSR,* September.

Katanyan, V., *Khudoznik Vladimir Mayakovsky,* Moscow.

Afansyev, K. N., ed., *Iz istorii sovetskoi arkhitektury, 1917–1925: Dokumenty i materialy,* Moscow.
1964
Gerchuk,Yu.,"Telingater—Khudozhnik knigi, " *Dekorativnoe iskusstvo SSSR,* March.
1965
Abramova, A., "2 Stenberg 2," *Dekorativnoe iskusstvo SSSR,* September.
1966
Abramova, A., "A. M. Rodchenko," *Iskusstvo,* February.

Semenova, E., "Vkhutemas, Lef, Mayakovsky," *Trudy po russkoy slavyanskoy filology,* vol. IX, (Tartu).

Bibikova, I., "Kak prazdnovali desiatiletie oktiabria," *Dekorativnoe iskusstvo,* November.

Shklovsky, V., "Alexandr Rodchenko—khudozhnik-fotograf," *Prometei,* Moscow.
1967
Rickey, G., *Constructivism: Origins and Evolution,* New York.

Goncharov, A., "Vkhutemas," *Dekorativnoe iskusstvo SSSR,* April.

Sidorov, A., *Grafika pervogo desiatiletiya, 1917–1927,* Moscow.
1968
Frampton, K., et al., *The Avant-Garde. Art News Annual,* New York, no. 34.

Volkov-Lannit, *Alexander Rodchenko: risuyet, fotografiruyet, sporit,* Moscow.

Marc, L., "Gustav Klutsis," *Tekhnicheskaya estetika,* January.

Marc, L., "Propedevtichesky kurs Vkhutemasa-Vkhuteina," *Tekhnicheskaya estetika,* February, April, December.

Strigalev, A., "Prozvedeniya agitatsionnogo iskusstva '20 - x godov," *Iskusstvo,* April.

Uvarova, I., "Veshchy tyanut k seve v Noru" (on Rodchenko), *Dekorativnoe iskusstvo SSSR,* September.

Khardzhiev, N., "Pamyaty Natalyi

Goncharovy i Mikhaila Laryonova," *Iskusstvo knigi,* 5th ed. of 1963–64 pub., Moscow.
1969
Schafran, L., "Larionov and the Russian Vanguard," *Art News,* May.

Birnholz, A., " 'For the New Art': El Lissitzky's Prouns," *Artforum,* October and November.

Braun, trans. and ed., *Meyerhold on Theater,* New York.

Goldwater, R., *What is Modern Sculpture?,* The Museum of Modern Art, New York.

Starr, S. F., "Konstantin Melnikov," *Architectural Design,* July.
1970
Kopp, A., *Town and Revolution: Soviet Architecture and Town Planning, 1917–1935,* trans. Thomas E. Burton, New York.

Lissitzky, El., *An Architecture for World Revolution,* trans. Eric Dluhosch, Cambridge, Massachusetts. (This edition includes an appendix of reports on architecture and urbanism.)

Besançon, A., "The Dissidence of Russian Painting (1860–1922)," *The Structure of Russian History,* ed. Michael Cherniavsky, New York.

Shishlo, B., "Ulitsy revoliutsii." *Dekorativnoe iskusstvo,* March.

Zhadvoa, L., "Vkhutemas-Vkhutein," *Dekorativnoe iskusstvo,* November.

Rakitin, V., "Vkhutemas. Traditsii i eksperimenty," *Tvorchestvo,* December.

Chiniakov, A., *Bratia Vesniny,* Moscow.

Afanasyev, K. N., ed., *Iz istorii sovetskoi arkhitektury 1926–1932: Dokumenty i materialy,* Moscow.
1971
Andersen, T., ed., *K. S. Malevich: Essays on Art, 1915–1933,* trans. X. Glowacki-Prus and A. McMillin, New York.

Martin, J. L., B. Nicholson, and N. Gabo, eds., *Circle: International Survey of Constructivist Art,* New York, reprint of 1937 original.

Licht, J., "Rodchenko, Practicing Constructivist," *Art News,* April.

Elderfield, J., "On Constructivism," *Artforum,* May.

Starr, S. F., "Writings from the 1960s on the Modern Movement in Russia," *Journal of the Society of Architectural Historians.*

Bowlt, J. E., "The Failed Utopia: Russian Art 1917–1932," *Art in America,* July–August.

Hilton, A., "When the Renaissance Came to Russia," *Art News,* December.

Galushkina, A., et al., ed., *Agitatsionno-massouye pervykh let oktiabria,* Moscow.

Alexandrov, P., *Ivan Leonidov,* Moscow.

Khlebnikov, L. "Borba realistov i futuristov vo Vkhutemase," *Literaturnoe nasledstvo,* t. 80. Moscow.

Matsa, I., "O konstruktivizme," *Iskusstvo,* August.
1972
Bojko, S., *New Graphic Design in Revolutionary Russia,* trans. Robert Strybel and Lech Zembrzuski, New York.

Birnholz, A., "El Lissitzky's Writings on Art," *Studio International,* March.

Birnholz, A., "A Note on the Chronology of El Lissitzky's Proun Paintings," *Art Bulletin,* September.

Birnholz, A., "El Lissitzky, the Avant-Garde, and the Russian Revolution," *Artforum,* September.

Barooshian, V., "The Avant-Garde and the Russian Revolution," *Russian Literature Triquarterly,* fall.

Birnholz, A., "The Russian Avant-Garde and the Russian Tradition," *Art Journal,* winter.

Kirillov, V. *Put'poiska i eksperimenta (iz istorii sovetskoi arkhitektury 20-x–nachala 30-x godov),* Moscow.

Khan-Magomedov, S. O., *M. Ia. Ginzburg,* Moscow.

Publications

Chiniakov, Ia., *Brat'ia Vesniny,* Moscow.

Strizhenova, T., *Iz istorii sovet-skogo kostiuma,* Moscow.

Shklovsky, V., "Alexander Rodchenko-khudozhnik-fotograf," *Prometei,* March.

Strizhenova, T., "U istokov sovet-skogo massovogo kostiuma," *Dekorativnoe iskusstvo,* June.

Matsa, I., "Alexander Rodchenko," *Iskusstvo,* July.

Terston, L., "Interes k avangard-nomu iskusstvu proshlogo," *Amerika,* no. 192, New York.
1973
Nakov, A. B., "Alexander Rodchenko. Beyond the Problematics of Pictorialism," *Arts Magazine,* April.

Coplans, J., "Mel Bochner on Male-vich: An Interview," *Artforum,* June.

Long, R.-C. W., "Kandinsky's Abstract Style: The Veiling of the Apocalyptic Folk Imagery," *Art Journal,* spring.

Long, R.-C. W. "Kandinsky and Abstraction: The Role of the Hidden Image," *Artforum,* June.

Bowlt, J. E., "Pavel Filonov," *Studio,* July.

Bowlt, J. E., "The Semaphors of Suprematism: Malevich's Journey into the Non-Objective World," *Art News,* December.

Douglas, C., "Colors without Objects," *The Structurist,* December–January, 1973–74.

Bann, S., ed., *The Tradition of Constructivism,* New York.

Maiakovsky, V., *Pro eto,* illustrated by A. Rodchenko, facsimile of 1923 original, Ann Arbor, Michigan.
1974
Douglas, C., "Birth of a 'Royal Infant': Malevich and 'Victory Over the Sun,'" *Art in America,* March–April.

Judd, D., "Malevich: Independent Form, Color, Surface," *Art in America,* March–April.

Kuspit, D., "Malevich's Quest for Unconditioned Creativity," *Artforum,* June.

Bowlt, J. E., "Alexandra Exter, A Veritable Amazon of the Russian Avant-Garde," *Art News,* September.

Barr, A. H., Jr., *Cubism and Abstract Art,* The Museum of Modern Art; New York Graphic Society, New York. Published in paperback with cover illustration of Malevich's *Red Square and Black Square.*

Constantine, M., and A. Fern, *Revolutionary Soviet Film Posters,* Baltimore and London.

Senkevitch, A., Jr., *Soviet Architecture 1917–1962: A Bibliographic Guide to Source Material,* Charlottesville, Virginia.
1975
Art Journal, spring. Issue devoted to the Russian avant-garde.

Deak, F., "Russian Mass Spectacles," *The Drama Review,* Political Theater Issue, June.

Hedgbeth, L. H., "Meyerhold's D E," *The Drama Review,* Political Theater Issue, June.

Bowlt, J. E., "Art of Construction," *Art and Artists,* September.

Birnholz, A., "Time and Space in the Art and Thought of El Lissitzky," *The Structurist,* December–January 1976.
1976
Betz, M., "Graphics of the Russian Vanguard," *Art News,* March, *The Print Collector's Newsletter,* Special Issue, "The Russian Avant-Garde, 1910–1930," March–April.

Bowlt, J. E., "Malevich's Artistic and Political Testament," *Art News,* May.

Zygas, K. P., "Veshch/Gegenstand/Objet: Commentary, Bibliography, and Translations," *Oppositions,* summer.

Vartanov, A., V. Stepanova, A. Rodchenko, "Photomontage: A Composite View," *Print Collector's Newsletter,* September/October.

Bowlt, J. E., "Rodchenko and Chaikov," *Art and Artists,* October.

Frampton, K., "Constructivism: The Pursuit of an Elusive Sensibility," *Oppositions,* fall.

Gibian, G. and H. W. Tjalsma, ed., *Russian Modernism: Culture and the Avant-Garde, 1900–1930,* Ithaca, New York.

Bann, S. and J. E. Bowlt, ed., *Russian Formalism,* New York.

Kovtun, E. G. and A. V. Povelikhina, "Utes iz budushchego," *Tekhnicheskaya estetika,* May–June.
1977
Birnholz, A., "On the Meaning of Kazimir Malevich's *White on White*," *Art International,* January–February.

Birnholz, A., "Forms, Angles, and Corners: On Meaning in Russian Avant-Garde Art," *Art Magazine,* February.

Cohen, R. H., "Alexander Rodchenko," *Print Collector's Newsletter,* July–August.

Propper, R. A., "Typography of the Right and Left," *Print,* May–June.

Betz, M., "The Icon and Russian Modernism," *Artforum,* summer.

Nakov, A. B. "Back to the Material: Rodchenko's Photographic Ideology," *Artforum,* October.

Zygas, K. P., "Punin's and Sidorov's Views of Tatlin's Tower," *Oppositions,* fall.

Sidorov, A. A., "Review of Punin's Pamphlet about Tatlin's Monument to the Third International," *Oppositions,* fall.

Cohen, A. A., G. Harrison, *Constructivism & Futurism: Russian & Other,* Ex Libris, New York.

Fitzpatrick, S., ed., *The Cultural Revolution of 1918–1932 in the USSR,* Bloomington, Indiana.

Williams, R., *Artists in Revolution: Portraits of the Russian Avant-Garde, 1905–1925,* Bloomington, Indiana.
1978
Livshits, B., *The One and a Half-Eyed Archer,* trans. J. E. Bowlt, Newtonville, Massachusetts.

Salisbury, H. E., *Russia in Revolution 1900–1930,* New York.

Starr, S. F., *Melnikov: Solo Architect in a Mass Society,* Princeton, New Jersey.

October, special issue devoted to Soviet Revolutionary Culture, winter.

Khan-Magomedov, S. O., "A. Rodchenko. Put khudozhnika v proizvodstvennoe isskusstvo," *Tekhnicheskaya estetika,* May and June.
1979
Douglas, C., and J. E. Bowlt, ed., *Kazimir Malevich (1878–1935): A Centenary Tribute,* special issue of *Soviet Union,* Tempe, Arizona, March.

Guerman, M., *Art of the October Revolution,* New York.

Special Events

1930

Lectures on the *35th Exhibition of the Société Anonyme,* Rand School of Social Science, New York, October–November.

Lectures on the *36th Exhibition of the Société Anonyme,* Rand School of Social Science, New York, November–December.

1947

"My Trip to Russia," lecture by Alfred H. Barr, Jr., Museum of Modern Art, New York.

1948

"A Retrospective View of Constructive Art," lecture by Naum Gabo, Yale University (The Thomas Rutherford Trowbridge Art Lecture Foundation), New Haven, Connecticut.

1949

Opening reception sponsored by the Mt. Holyoke Friends of Art. Guests were invited to make collages and abstractions in the spirit of the works in the collection of the Société Anonyme on the occasion of its exhibition at The Dwight Art Memorial, South Hadley, Massachusetts.

"Abstract Painting," lecture by Frederick S. Wight, Institute of Contemporary Art, Boston (in connection with Société Anonyme/Yale University exhibition).

1951

Willem de Kooning claims to have learned from certain European art styles, including Constructivism ("I have learned a lot from...them and they have confused me plenty, too")—at symposium, "What Abstract Art Means to Me," Museum of Modern Art, New York; quoted in *The Bulletin of The Museum of Modern Art,* vol. XVIII, no. 3.

1959

"Of Divers Arts," lectures by Naum Gabo, National Gallery of Art, Washington, D.C. (The A. W. Mellon Lectures on the Fine Arts, published as part of The Bollingen Series, XXXV/8, by Princeton University Press in 1962).

1970

Russian Paintings, Drawings and Watercolors, 1900–1925, auction, Sotheby's, London.

1971

"The Russian Avant-Garde and the Modernist Movement," lecture series, Cornell University, Ithaca, New York.

1972

Twentieth Century Russian Paintings, Drawings and Watercolors, auction, Sotheby's, London.

"The Russian Avant-Garde in Art," lecture by John E. Bowlt, University of California, Los Angeles.

"Constructivism, The Pursuit of an Elusive Sensibility," lecture by Kenneth Frampton, The Solomon R. Guggenheim Museum, New York.

1973

"Art and Politics," symposium, including discussions of Russian and Soviet art, Massachusetts Institute of Technology, Cambridge, Massachusetts.

"Russian Art," lecture by George Costakis, Solomon R. Guggenheim Museum, New York, and Princeton University, Princeton, New Jersey.

Twentieth Century Russian Paintings, Drawings and Watercolors, auction, Sotheby's, London.

1974

"The Magnificent Cuckold," production with reconstructions of Liubov Popova's sets, Albright-Knox Art Gallery, Buffalo, New York.

Twentieth Century Russian and European Art, 1900–1930, auction, Sotheby's, London.

Moderne Kunst und Literatur, auction, Holstein & Co., Konigstein-im-Taunus, West Germany.

1975

"The Architecturalization of Wassily Kandinsky's Spatial Imagery, Moscow, 1917–1921," lecture by Philip I. Eliasoph, College Art Association Convention, Washington, D.C.

1977

"Estrangement and Form: Mayakovsky and his Circle," lecture by Anthony Vidler, Institute for Architecture and Urban Studies, New York.

"The Russian Avant-Garde: On the Spiritual in Form," lecture by John E. Bowlt, College Art Association Convention, Los Angeles.

"Malevich and the Dialectic of Nature," lecture by Simon Pugh, College Art Association Convention, Los Angeles.

"Kandinsky's Unpublished Stage Plays," lectures by Jelena Hahl, Harvard University, University of California, Los Angeles, University of Michigan (Ann Arbor), University of Illinois, Wayne State University, Stanford University.

1978

Sol LeWitt credits the publication of Camilla Gray's book in 1962 with reinforcing his artistic ideas and tendencies; at a session on Minimalism, College Art Association Convention, New York.

Mel Bochner refers to the 1973 Malevich exhibition at The Solomon R. Guggenheim Museum as an important factor in clarifying Malevich's work to him; at a session on Minimalism, College Art Association Convention, New York.

"Russian Avant-Garde Art and Literature," symposium, City University of New York, Graduate Center (broadcast on radio).

"Russian Constructivism and the 'Machine Esthetic,'" lecture by Robert Herbert, Institute for Architecture and Urban Studies, New York.

"Vladimir Tatlin: The Culture of Materials," lecture by Margit Rowell, Institute for Architecture and Urban Studies, New York.

"El Lissitzky: Art as Montage," lecture by Kurt Forster, Institute for Architecture and Urban Studies, New York.

1979

"Vladimir Tatlin's Monument to the Third International: A Paradigm of Russian Revolutionary Thought," lecture by Gail Harrison, symposium, "The Trotsky-Stalin Conflict and Russia in the 1920s," Hofstra and Adelphi Universities, Long Island, New York.

A demonstration of Meierkhold's Biomechanics, directed by Alma H. Law and Mel Gordon, The Kitchen, New York.

Performance of an excerpt from *The Magnanimous Cuckold,* with reconstruction of a set after the original design by Popova; directed by Alma H. Law and Mel Gordon, The Kitchen, New York.

1980

"Russian Art and Architecture from the mid-19th century to the Second World War," session at College Art Association Convention, New Orleans, Louisiana.

Selected Bibliography

I. Monographs

Over recent years a considerable number of publications on the Russian avant-garde have appeared in Europe and the US. The titles below supplement the detailed bibliographies provided in the four major studies of the subject, i.e., Camilla Gray, *The Great Experiment: Russian Art 1863–1922*, London, 1962 (and later edition); Troels Andersen, *Moderne russisk kunst 1910–1930*, Copenhagen, 1967; Vladimir Markov, *Russian Futurism: A History*, Berkeley and Los Angeles, 1968; Valentine Marcadé, *Le Renouveau de l'art pictural russe*, Lausanne, 1971; John E. Bowlt, *Russian Art of the Avant-Garde: Theory and Criticism 1902–1934*, New York, 1976; Larissa Shadowa, *Suche und Experiment Russische und sowjetische Kunst 1910 bis 1930*, Dresden, 1978.

Soviet Constructivism, special issue of *Soviet Union*, University of Pittsburgh, vol. 3, part 2, 1976.

G. Sternin, *Khudozhestvennaia zhizn Rossii nachala XX veka*, Moscow, 1976; German Trans. *Das Kunstleben Russlands an der Jahrhundertwende*, Dresden, 1976.

N. Khardzhiev, *K istorii russkogo avangarda/The Russian Avant-Garde*, Stockholm, 1976.

Robert Williams, *Artists in Revolution*, Bloomington, Indiana, 1977.

Janet Kennedy, *The Mir iskusstva Group and Russian Art 1898–1912*, New York, 1977.

Gail Harrison, *Constructivism and Futurism: Russian and Other*, Catalog No. 6 from Ex Libris, New York, 1977.

Susan Compton, *The World Backwards: Russian Futurist Books 1912–16*, London, 1978.

"Soviet Revolutionary Culture," special issue of *October*, MIT Press, winter 1978.

Sheila Fitzpatrick, *Cultural Revolution in Russia 1928–1931*, Bloomington, Indiana, 1978.

Mikhail Guerman, *Art of the October Revolution*, New York, 1979.

John E. Bowlt, *The Silver Age: Russian Art of the Early Twentieth Century and the "World of Art" Group*, Newtonville, Massachusetts, 1979.

John Milner, *Russian Revolutionary Art*, London, 1979.

II. Exhibition Catalogs

Die Erste Russische Kunstausstellung, Galerie Van Diemen, Berlin, 1922.

L'Exposition internationale des arts decoratifs et industriels modernes, section russe: l'art decoratif et industriel de l'URSS, Paris, 1925.

Two Decades of Experiment in Russian Art (1902–1922), Grosvernor Gallery, London, 1962.

Il Contributo Russo alle Avanguardie Plastiche, Galleria del Levante, Milan, 1964.

Avantgarde Osteurope 1910–1930, Akademie der Künste, West Berlin, 1967.

Russische Künstler aus dem 20. Jahrhundert, Galerie Gmurzynska, Cologne, 1968.

L'Art d'avant-garde russe, Musée d'art moderne, Paris, 1968.

Aspects de l'avant-garde russe, 1905–1925, Galerie Jean Chauvelin, Paris, 1969.

Osteuropaische Avantgarde, Galerie Gmurzynska, Cologne, 1970–71.

The Non-Objective World 1914–1924, Annely Juda Fine Art, London, and other galleries, 1970–71.

The Non-Objective World 1924–1939, Annely Juda Fine Art, London, and other galleries, 1971.

Russian Art of the Revolution, Andrew Dickson White Museum of Art, Ithaca, New York, and Brooklyn Museum of Art, New York, 1971.

Russian Art of the Avant-Garde 1908–1922, Leonard Hutton Galleries, New York, 1971.

Art in Revolution: Soviet Art and Design Since 1917, Hayward Gallery, London, and other galleries, 1971–72; opened as *Kunst in der Revolution*, Frankfurt and other cities, 1972–73.

Konstruktivismus. Entwicklungen und Tendenzen seit 1913, Galerie Gmurzynska, Cologne, 1972.

Progressive Russische Kunst, Galerie Gmurzynska, Cologne, 1973.

Vision Russe, Galerie Motte, Geneva, 1973.

Tatlin's Dream: Russian Suprematist and Constructivist Art 1910–1923, Fischer Fine Art, London, 1974.

Der Beitrag Russlands zur der Geschichte der Avantgarde der zehner und zwanziger Jahre, Galerie R. Johanna Ricard, Nuremberg, 1974.

Von der Flache zum Raum/From Surface to Space: Russland/Russia 1916–24, Galerie Gmurzynska, Cologne, 1974.

2 Stenberg 2. The "Laboratory" Period (1919–1921) of Russian Constructivism, Galerie Jean Chauvelin, Paris, 1975.

Die 20er Jahre in Osteuropa/The 1920s in Eastern Europe, Galerie Gmurzynska, Cologne, 1975.

Echoes of Russia, Washington Art Gallery, Washington, Connecticut, 1975.

Dibujos y acuarelas de la vanguardia rusa, Sala de seposiciones, Caracas, Venezuela, 1975.

Russian Avant Garde, Carus Gallery, New York, 1975.

Maiakovski 20 ans de travail, Centre national d'art et de culture Georges Pompidou, Paris, 1975–76.

Russian Pioneers at the Origins of Non-Objective Art, Annely Juda Fine Art, London, 1976.

Russian Suprematist and Constructivist Art 1910–1930, Fischer Fine Art, London, 1976.

El Lissitzky, Galerie Gmurzynska, Cologne, 1976.

Malewitsch-Mondrian und Ihre Kreise, Kölnischer Kunstverein, Cologne, 1976.

Russische Malerei 1890–1917, Stadelsches Kunstinstitut, Frankfurt am Main, 1976–77.

Stage Designs and the Russian Avant-Garde (1911–1929): A Loan Exhibition of Stage and Costume Designs from the Collection of Mr. and Mrs. Nikita Lobanov-Rostovsky, circulated by the International Exhibitions Foundation, Washington, D.C., 1976–78.

Berlin/Hanover: the 1920s, Dallas Museum of Fine Arts, 1977.

Sammlung Costakis, Kunstmuseum, Düsseldorf, 1977.

Malevich Suetin Chashnik Lissitzky, Annely Juda Fine Art, London, 1977.

Knizhnye oblozhki russkikh khudozhnikov nachala XX veka, Russian Museum, Leningrad, 1977.

Russische Avantgarde 1910–1930, Galerie Bargera, Cologne, 1978.

Russian and Soviet Painting, Metropolitan Museum of Art, New York, 1977.

Liberated Colour and Form, Scottish National Gallery of Modern Art, Edinburgh, 1978.

Malevich and His Circle, Rosa Esman Gallery, New York, 1978.

Russian Painters and the Stage 1884–1965, University of Texas at Austin, 1978–79.

Abstract and Constructivist Works 1912–1930, Helen Serger, La Boetie, New York, 1979.

The Russian Revolution in Art, Rosa Esman Gallery, New York, 1979.

Russian Graphic Art XVIII–XX CC., University of Newcastle and other institutions, 1979.

Paris-Moscou, Centre Georges Pompidou, Paris, 1979.

The Planar Dimension, The Solomon R. Guggenheim Museum, New York, 1979.

Constructivism and the Geometric Tradition, Albright-Knox Art Gallery, Buffalo, New York, and other institutions, 1979–80.

Künstlerinnen der russischen Avantgarde, Galerie Gmurzynska, Cologne, 1979–80.

Russian Theater and Costume Designs, The Fine Arts Museums of San Francisco, 1980.

Kazimir Malewitsch, Kunsthalle Düsseldorf, 1980.

III. Auction Catalogs

Twentieth Century Russian Paintings, Drawings and Watercolours 1900–1925 Sotheby & Co., London, July 1, 1970.

Twentieth Century Russian Paintings, Drawings and Watercolours 1900–1930 Sotheby & Co., London, April 12, 1972.

Twentieth Century Russian Paintings, Drawings and Watercolours 1900–1930 Sotheby & Co., London, March 29, 1973.

Twentieth Century Russian and East European Paintings, Drawings and Sculpture 1900–1930, Sotheby & Co., London, July 4, 1974.

Russian and European Avant-Garde Art 1905–1930, Sotheby Parke Bernet, New York, 1978.

Russian and European Avant-Garde Art 1905–1930, Sotheby Parke Bernet, New York, 1979.

Photographic Credits

Gerald S. Ackerman, New York: Harrison Roman fig. 13.

Art Gallery of Ontario, Toronto, Canada: cat. no. 66.

The Art Institute of Chicago: cat. no. 235.

Australian National Gallery, Canberra: Bowlt fig. 3; Harrison Roman figs. 2, 3, 8, 9; cat. nos. 67, 101, 112, 403.

Mr. and Mrs. Herman Berninger, Zurich, Switzerland: Douglas fig. 1.

La Boetie, Inc., New York: cat. no. 252.

The archives of Szymon Bojko, Warsaw, Poland: Bojko agit-prop figs. 1, 2, 3, 4a, 4b, 5, 6, 7, 8, 9, 10, 11, 12, 13, 14, 15; Bojko Vkhutemas fig. 1 and unnumbered figs. Douglas fig. 2; Harrison Roman figs. 1, 4, 5, 14; V. Marcadé fig. 7; Rakitin fig. 3; cat. nos. 80, 82, 108, 115, 154, 174, 234, 319, 348, 371; IDs: Klucis, Lissitzky, Malevich, Mansurov, Matiushin, Popova, Rodchenko, V. Stenberg, Stepanova (photo by Rodchenko), Suetin, Tatlin (photo by Moisey Nappelbaum), Udaltsova, Vesnin (photo by Rodchenko), Yakulov; documentary photos of Altman column, Miturich installation, Obmokhu, and performance of *Tarelkin's Death;* all agit-prop photos

Bruce Fine Art, London: cat. no. 44.

Foto Brunel, Lugano, Switzerland: Dabrowski fig. 7; cat. nos. 12, 91, 98, 136, 226, 241, 328.

Dr. Edgar Brunner: cat. no. 333.

Busch-Reisinger Museum, Harvard University, Cambridge, Mass.: cat. no. 133.

Jay S. Cantor, Beverly Hills, California: cat. nos. 103, 106.

Carus Gallery, New York: cat. no. 334.

Galerie Jean Chauvelin, Paris: Dabrowski figs. 10, 11; Douglas fig. 15; Rakitin fig. 2; cat. nos. 8, 20, 42, 53, 208, 217, 299, 301, 338, 339, 345, 367, 379, 398; ID: G. Stenberg.

Martien Coppens, Eindhoven, The Netherlands: Brodsky fig. 4; Harrison Roman figs. 10, 11; cat. no. 153.

George Costakis Collection: cat. no. 92.

Prudence Cuming Associates, Ltd., London: Harrison Roman fig. 6; cat. nos. 40, 207, 255, 295.

Cuming Wright-Watson Associates, Ltd., London: cat. no. 120.

A. E. Dolinski, San Gabriel, California: Sarabianov fig. 4.

Charlotte Douglas: Douglas figs. 5, 8.

Walter Dräyer, Fotograf, Zurich, Switzerland: cat. no. 61.

Ahmet Ertegün, N.Y.: cat. nos. 190, 222.

Rosa Esman and Adler/Costello Galleries: Zygas fig. 11.

John Evans Photography, Ltd., Ottawa, Canada: cat. no. 238.

Christine Fischbacher Company, Ltd., St. Gall, Switzerland: cat. no. 247.

Fischer Fine Art Ltd., London: Valentine Marcadé fig. 1.

Ella Jaffe Freidus: Dabrowski fig. 3; cat. no. 19.

Nina Gabo, London: cat. no. 60.

Galerie Gmurzynska, Cologne, West Germany: J. C. Marcadé fig. 5; cat. nos. 93, 123, 225, 228, 229, 230, 233, 243, 266, 270, 271, 272, 346, 377, 386; IDs: Ermolaeva, Exter, Goncharova, Medunetsky, Miturich, Nikolskaia, Rozanova.

Michail Grobman, Jerusalem, Israel: cat. no. 462.

Solomon R. Guggenheim Museum, Robert E. Mates, New York: Dabrowski fig. 5; Douglas fig. 6; Sarabianov, fig. 7; cat. nos. 23, 86, 87, 89.

Wilhelm Hack Museum, Ludwigshafen, West Germany: cat. no. 169.

Hamburger Kunsthalle, Ralph Kleinhempel, GmbH & Co., Hamburg, West Germany: cat. no. 1.

The Hermitage Museum, Leningrad, USSR: Dabrowski fig. 4.

Leonard Hutton Galleries, New York: Dabrowski fig. 2; IDs: D. Burliuk, Chashnik.

Jacqueline Hyde, Paris: Douglas fig. 14: cat. nos. 110, 279.

Institute of Modern Russian Culture, Blue Lagoon, Texas: Bowlt figs. 1, 2, 5, 7, 8; Douglas fig. 7; Sarabianov figs. 3, 6; IDs: Altman, Annenkov, V. Burliuk, Ermilov, Filonov, Kamensky, Kliun, Konchalovsky, Kudriashev, Larionov, Morgunov, Puni, Vialov.

Sidney Janis Gallery, New York: cat. no. 129.

Annely Juda Fine Art, London: Douglas figs. 3, 9; cat. nos. 167, 364, 365.

Kunstmuseum Basel, Switzerland: cat. no. 22.

Kunstmuseum Basel, Kupferstichkabinett, Switzerland: J. C. Marcadé fig. 8.

Landesbildstelle Rheinland, Düsseldorf, West Germany: Bowlt fig. 6; Rakitin fig. 1; cat. nos. 95, 335.

Alma H. Law: Law figs. 1, 2, 3, 4, 5, 6, 7, 8, 9, 10, 11, 12, 13, 14.

Galleria del Levante, Milan, Italy: cat. no. 64.

Los Angeles County Museum of Art: cat. nos. 172, 206, 406, 464.

Museum Ludwig, Cologne, West Germany: cat. nos. 139, 195, 236.

Jean-Claude Marcadé: Douglas fig. 12; J. C. Marcadé figs. 1, 2, 3, 4.

Valentine Marcadé: V. Marcadé figs. 2, 3, 4, 5, 6, 8, 9.

McGranahan Photography, Buffalo, New York: cat. no. 52.

Mississippi Museum of Art, Jackson, Mississippi: cat. no. 56.

Donald Morris Gallery/Carus Gallery, New York: cat. no. 249.

Service Photographique du Musée National d'Art Moderne, Centre National d'Art et de Culture Georges Pompidou, Paris: cat. no. 286.

Museum of Art, Rhode Island School of Design, Providence: Brodsky fig. 1.

Collection, The Museum of Modern Art, New York: Brodsky fig. 3; Dabrowski figs. 1, 9; Douglas fig. 4; J. C. Marcadé fig. 7; Harrison Roman fig. 12; Zygas fig. 9; cat. nos. 47, 140, 182, 291, 363.

Harry C. Nail, Jr., California: cat. no. 289.

National Gallery of Art, Washington, D.C.: cat. no. 277.

Nationalgalerie, Berlin, West Germany: cat. no. 368.

Otto E. Nelson, Fine Art Photography, New York: cat. nos. 6, 24, 25, 27, 28, 30, 32, 34, 37, 38, 39, 107, 325.

Louise R. Noun: cat. no. 327.

Novosty Press Agency, Moscow: Brodsky: figs. 5, 6.

Odeon, Prague: Zygas fig. 10.

Eric Pollitzer, New York: cat. no. 378.

G. P. Putnam's Sons, New York: ID: Chagall.

George Riabov, New York: cat. no. 59.

The Robert Gore Rifkind Foundation, Beverly Hills, California: cat. nos. 84, 88.

Gail Harrison Roman: Harrison Roman fig. 7.

F. Rosenstiel, Studio für Werbefotografia, Zurich, Switzerland: Douglas fig. 13; cat. nos. 274, 275, 281.

Professor Guido Rossi, Milan, Italy: cat. no. 284.

The Russian Museum, Leningrad: Dabrowski fig. 6.

Ruth and Marvin Sackner: cat. nos. 240, 305.

N. Seroussi, Galerie Quincampoix, Paris: cat. no. 211.

Robert Shapazian Inc.: Bowlt fig. 4; cat. nos. 361, 362.

Stedelijk Museum, Amsterdam: Dabrowski fig. 8; Douglas figs. 10, 11; cat. nos. 198, 214.

Studio Sintesi, Fotografia di Gianmaria, Fontana, Milan, Italy: cat. no. 49.

Tate Gallery Photograph, London: cat. no. 124.

Dr. Ronald Tepper: cat. no. 288.

Theatermuseum, Cologne, West Germany: cat. no. 387.

Robert L. B. Tobin: cat. no. 71.

The Tretiakov Gallery, Moscow: J. C. Marcadé fig. 6.

Charles Uht, New York: cat. nos. 104, 231, 257, 294.

© VAPP/VAGA, 1980: Sarabianov figs. 2, 5; Zygas fig. 16.

Verlag der Kunst, Dresden, East Germany: Brodsky fig. 2.

John Webb F.R.P.S. Photography, Surrey, England: Sarabianov fig. 8.

Thomas P. Whitney, Conn.: cat. no. 41.

Yale University Art Gallery, Joseph Szaszlai, New Haven, Connecticut: cat. nos. 232, 278, 373.

Kestutis Paul Zygas: Zygas figs. 1, 2, 3, 4, 5, 6, 7, 8, 12, 13, 14, 15, 16, 17, 18, 19.

Addenda and errata

p. 102 3rd column, 3rd paragraph should read:
Alexei Kruchenykh (1886–1969)

p. 141 Cat. no. 35: not in exhibition

p. 148 Cat. no. 48: not in exhibition
Cat. no. 49: not in exhibition

p. 156 Cat. no. 64: not in exhibition
Cat. no. 70 should read:
Oil on paper on board

p. 164 Addition to Kandinsky checklist:
Punkt und Linie zu Flache
(Point and Line to Plane) by V. Kandinsky
Munich, 1926
196 pp. with 102 illustrations
Ex libris 6, no. 517j
23.5 x 18.5 cm. (9¼ x 7¼ in.)
Arthur and Elaine Cohen

p. 178 Credit line for cat. no. 107 should read:
Los Angeles County Museum of Art,
Deaccession Funds

Cat no. 112b bound together with
cat. no. 326 (see cat. no. 326 for correct
dimensions)

p. 190 Cat. no. 150c: not in exhibition

p. 191 Cat no. 160: not in exhibition
Cat. no. 163b: not in exhibition
Cat. no. 164: not in exhibition

p. 192 Cat. no. 168 should read:
Moscow, 1929, vol. 8–9; 1931, vol. 3
Cover design by Stenberg brothers

p. 194 Addition to Malevich checklist: Portfolio of
facsimiles of Malevich's costume and set
designs for *Victory Over the Sun*, published
by Galerie Gmurzynska, 1973
43.2 x 30.5 cm. (17 x 12 in.)
Galerie Gmurzynska, Cologne,
West Germany

p. 199 Addition to Malevich checklist:
Brooch, c. 1920
Enamel
8.3 x 10.8 cm. (3¼ x 4¼ in.)
Robert Shapazian Inc.

p. 201 Dimensions for cat. no. 212 should read:
10.3 x 14.4 cm. (4⅛ x 5⅝ in.)

p. 202 Addition to Malevich checklist:
Facsimile of letter by K. Malevich,
Berlin, 1927
Reproduced in:
Lettres autographes de peintres et
sculpteurs du XVᵉ siècle à nos jours
(Autograph Letters of Painters and
Sculptors of the 15th Century to Our Time),
ed. Christophe Czwiklitzer
Paris, 1976
521 pp.
35.6 x 25.4 cm. (14 x 10 in.)
The Robert Gore Rifkind Foundation,
Beverly Hills, California

p. 204 Addition to Mansurov checklist:
Pictorial Forms, 1925
Oil on wood
132 x 35.6 cm. (52 x 14 in.)
Galerie Gmurzynska, Cologne,
West Germany

p. 216 Addition to Nikolskaia checklist:
Color Study (Two Circles), 1927
Watercolor
16.5 x 21.6 cm. (6½ x 8½ in.)
Museum Ludwig, Cologne, West Germany

p. 228 Cat. no. 283: not in exhibition
Cat. no. 284: not in exhibition

p. 230 Cat no. 285: not in exhibition

p. 234 Credit line for cat. no. 299 should read:
Los Angeles County Museum of Art,
Purchased with Funds Provided by
Anna Bing Arnold

p. 236 Addition to Rodchenko checklist:
Lef (Levyi front iskusstv)
(The Left Front of the Arts),
ed. V. Maiakovsky
Moscow/Leningrad, 1923, no. 2
180 pp. with designs by Rodchenko and
Stepanova
24 x 15.5 cm. (9½ x 6⅛ in.)
Australian National Gallery, Canberra

p. 240 Cat. no. 326 bound together with
cat. no. 112b. Dimensions should read:
18 x 13.3 cm. (7 x 5⅛ in.)

p. 246 Illustrated work labeled 346: not in
exhibition

p. 247 Illustrated work labeled 346: not in
exhibition

p. 258 Illustrated work labeled 377: not in
exhibition
Cat. no. 377: not illustrated

p. 260 Addition to Vesnin checklist:
5 x 5 = 25 Exhibition Catalog, 1921
Catalog with five original works by
A. Exter, L. Popova, A. Rodchenko,
V. Stepanova, A. Vesnin; cover by Vesnin
22.2 x 16.5 cm. (8¾ x 6½ in.)
Galerie Gmurzynska, Cologne,
West Germany

p. 266 Cat. no. 394: not in exhibition
Cat. no. 395: not in exhibition

p. 268 Cat. no. 409 should read: Moscow 1931,
nos. 2–3, 4, 5–6, 7
Cat. no. 412 should read: Moscow, 1926
(nos. 1, 5–6), 1927 (nos. 4–5), 1930
(nos. 1–2, 5)
Cat. no. 413 should read:
Moscow, 1932 (no. 10), 1933 (no. 2)

p. 269 Cat. no. 419 should read: Moscow, 1932
(no. 1), 1933 (no. 3)
Cat. no. 427 should read: Illustrated by
N. Masiutin
Cat. no. 428: not in exhibition
Addition to Literature checklist: *Gosplan*
lituratury. Tsentr konstruktivistov. Stati.
Stikhi. (State Plan of Literature. Literary
Center for Constructivists. Essays. Poetry.)
Moscow/Leningrad, 1924
144 pp.
Ex Libris 6, no. 74
22.2 x 17.5 cm. (9 x 6⅞ in.)
Australian National Gallery, Canberra

p. 270 Cat. no. 437b: not in exhibition
Cat. no. 446b: not in exhibition
Addition to Theater checklist:
Kamerny Teatr i ego khudozhniki
1914–1934 (The Kamerny Theater and
Its Artists 1914–1934)
with introduction by Abram Efros
212 pp. illustrated
Ex Libris 6, no. 95
30.5 x 22.9 cm. (12 x 9 in.)
Mr. and Mrs. H. C. Levy

p. 271 Cat. no. 461: not in exhibition